3D STUDIO MAX R3

In Depth

Rob Polevoi

CORIOLIS

3D Studio MAX R3 In Depth

Limits Of Liability And Disclaimer Of Warranty

Trademarks

The Coriolis Group, LLC
14455 N. Hayden Road, Suite 220
Scottsdale, Arizona 85260

(480)483-0192
FAX (480)483-0193
http://www.coriolis.com

Library of Congress Cataloging-In-Publication Data
Polevoi, Rob.
 3D Studio MAX R3 in depth / by Rob Polevoi.
 p. cm
 Includes index.
 ISBN 1-57610-432-X
 1. Computer animation. 2. 3D Studio.
3. Cinematography—Special effects. I. Title.
TR897.7.P67 1999
006.6'96 21--dc21 99-044601
 CIP

Printed in the United States of America
10 9 8 7 6 5 4 3 2 1

President, CEO
Keith Weiskamp

Publisher
Steve Sayre

Acquisitions Editor
Mariann Hansen Barsolo

Marketing Specialist
Beth Kohler

Project Editor
Meredith Brittain

Technical Reviewer
Jon McFarland

Production Coordinator
Meg E. Turecek

Cover Design
Jody Winkler
additional art provided by Brandon Riza

Layout Design
April Nielsen

CD-ROM Developer
Robert Clarfield

OTHER TITLES FOR THE CREATIVE PROFESSIONAL

3D Studio MAX R3 f/x and design
by Jon A. Bell

Adobe ImageStyler In Depth
by Daniel Gray

After Effects 4 In Depth
by R. Shamms Mortier

AutoCAD 2000 3D f/x and design
by Brian Matthews

Bryce 4 f/x and design
by R. Shamms Mortier

Character Animation In Depth
by Doug Kelly

CorelDRAW 9 f/x and design
by Shane Hunt

Digital Compositing In Depth
by Doug Kelly

Flash 3 Web Animation f/x and design
by Ken Milburn and Janine Warner

Illustrator 8 f/x and design
by Sherry London and T. Michael Clark

LightWave 3D 6 Character Animation
by Doug Kelly

ABOUT THE AUTHOR

Rob Polevoi is Assistant Professor, Computer and Video Imaging, at Cogswell College in Sunny-vale (Silicon Valley), California. A nationally respected leader in computer graphics education, he teaches 3D modeling and animation using 3D Studio MAX, Lightwave 3D, Softimage, and other major applications.

Rob has long covered the 3D graphics world for the **internet.com** family of Web sites. His 3D Animation Workshop at **www.webreference.com** is a leading source of news, information, training, and ideas for current and aspiring 3D artists. He can be contacted through that site, or directly at **robert@internet.com**.

Rob was born in Los Angeles in 1955 and graduated from the University of California, Los Angeles with a degree in Political Science. He then attended law school at Hastings College of the Law (University of California) in San Francisco. Upon graduation in 1981, he was admitted to the California Bar. He practiced law for a number of years, specializing in federal taxation.

In 1990, Rob decided to follow his heart and move into the new and exploding field of computer graphics. He joined with his wife, an artist and designer, to establish Vellum, a firm engaged in the design and manufacture of greeting cards and fine paper products for a national market. Through this period in 2D print graphics, Rob quickly came to discover the emerging world of 3D graphics and began to study it intensely at both the programming and artistic level. He developed skills on a number of 3D applications and began to sell 3D graphics and animation as a freelance artist. From there, he moved quickly into full-time teaching at the college level.

Rob is committed to raising the quality of computer graphics education to the standard of traditional artistic media. In his view, computer graphics has little to do with learning programs, but much to do with assimilating subtle concepts and developing artistic instincts and discipline.

Rob lives with his wife, Andrea, and daughter, Hannah, in Oakland, California.

ACKNOWLEDGMENTS

Any serious teacher learns as much from his students as they learn from him. What I offer in this book is what I have learned from working at Cogswell College with the most intelligent and creative group of students a teacher could hope to have. I have to run as fast as I can to pretend to stay ahead of them.

Writing this book required considerable diversion from my teaching responsibilities, for which I must thank the indulgence of my provost, Tim Harrington, a leading figure in new media education at the college level. It's a pleasure to work with him, and with the Cogswell College faculty, in building a new and exciting kind of learning environment. Tim and everyone at Cogswell have been extraordinarily supportive in my efforts to produce this book.

Of course, I must thank Mariann Barsolo, my acquisitions editor at Coriolis, for taking me on for this project and working with me to keep it going smoothly to the very end. Meredith Brittain, my editor, has done a great job making it all come together, for which she has both my sincere thanks and admiration. Thanks also to the other members of the Coriolis team who worked on this book: Meg, April, Beth, Robert, and Jody. David Fugate, my agent at Waterside Productions, is a true professional and any writer's greatest asset. The origin of this project is due to his efforts.

Andy King, my editor at **internet.com**, must be credited with the origin and much of the success of my 3D Animation Workshop at **www.webreference.com**. It would be hard to thank him enough.

In the end, it's your family that keeps you going when you've got a long and difficult task on your hands. My parents were there for me, as always, as was my wife. And, at the end of a long day alone in front of a computer, struggling with the mysteries of 3D Studio MAX, my little daughter's smile was like a breeze that blows a cloud off the face of the sun.

CONTENTS AT A GLANCE

PART I 3D STUDIO MAX—THE BIG PICTURE

Chapter 1 Thinking Like MAX
Chapter 2 The MAX 3 Interface

PART II WORKING IN MAX

Chapter 3 Selection And Transform Tools
Chapter 4 Managing The Display
Chapter 5 Working Smart

PART III MODELING

Chapter 6 Using Primitives And Splines
Chapter 7 Mesh-Level Modeling
Chapter 8 Modeling With Modifiers
Chapter 9 Compound Objects
Chapter 10 Patch Modeling
Chapter 11 NURBS Modeling

PART IV MATERIALS AND TEXTURES

Chapter 12 Materials And The Material Editor
Chapter 13 Maps And Mapping

PART V LIGHTS, CAMERA, RENDER!

Chapter 14 Lights
Chapter 15 Cameras
Chapter 16 Rendering Tools
Chapter 17 Environment And Render Effects
Chapter 18 Using Video Post

PART VI ANIMATION

Chapter 19 Animation Essentials
Chapter 20 Animating The Transforms
Chapter 21 Deforming The Geometry
Chapter 22 Special Animation Topics

TABLE OF CONTENTS

Introduction .. xxi

PART I 3D STUDIO MAX—THE BIG PICTURE

Chapter 1
Thinking Like MAX ... 3

The "Object" In MAX 3
Parametric Objects 4
Editable Mesh 7
The Modifier Stack 7
 Using A Single Modifier 7
 Adding A Second Modifier 10
 Rearranging The Stack 11
Instancing And Referencing 14
A Word About Track View 18

Chapter 2
The MAX 3 Interface ... 21

Introduction To The MAX 3 Interface 21
Customizing The Interface 22
 Managing The Tab Panel 22
 Loading And Saving Custom User Interfaces 26
Using MAXScript 27
 Macro Scripts Behind Toolbar Buttons 28
 Creating Custom Toolbar Buttons 30
 Using MAXScript To Build Custom Dialog Boxes 34
The Schematic View 35
 Objects And Object Hierarchies 36
 Modifiers And Instances 38
The Isolate Tool 41

PART II WORKING IN MAX

Chapter 3
Selection And Transform Tools **45**

Selection Methods 45

 Direct Methods: Clicking Or Dragging 45

 Picking An Object Off A List 46

 Selecting Multiple Objects 46

 Using Named Selection Sets 47

Grouping 48

 Grouping Vs. Parenting (Linking) 48

 Working With Groups 49

Transform Tools 49

 Understanding Coordinate Space 50

 Selecting Transform Tools And Constraints 52

 Choosing A Coordinate System 53

Pivot Points 58

 The True Pivot Point And Temporary Pivot Points 58

 Resetting Transforms And Bounding Boxes 66

Linking (Parenting) Objects 72

 Using The Link And Unlink Buttons 74

 Overriding Inheritance 75

 Using Null Objects To Create Coordinate Systems 76

Chapter 4
Managing The Display **81**

The Viewing Windows 81

 Perspective And Orthographic Views 81

 User View 84

Viewport Navigation Tools 85

 The Min/Max Toggle 85

 The Zoom Extents Buttons 85

 The Pan Tool 85

 The Zoom And Zoom All Tools 85

 The Arc Rotate Tool 86

Viewing And Layout Options 87

Display Properties 88

Hiding And Freezing Objects 89

Grids 90
 Using The Home Grid 90
 Creating New Grids 90

Chapter 5
Working Smart **93**
Duplicating (Cloning) Objects 93
 Cloning Basics 94
 The Array Tool 97
 The Snapshot Tool—Cloning Along A Path 109
 Mirroring Objects And Subobjects 115
Precision Tools 121
 Snaps 122
 Alignment Tools 124
 Tape And Protractor 127
Keyboard Shortcuts 128

PART III MODELING

Chapter 6
Using Primitives And Splines **133**
3D Primitives 134
 Standard Primitives 134
 Extended Primitives 139
2D Primitives 140
Splines (Bezier Splines) 143
 Terminology Confusion: Splines And NURBS 143
 Spline Creation And Editing Tools 144

Chapter 7
Mesh-Level Modeling **153**
What Is Polygonal Mesh Modeling? 153
 Organic Modeling Vs. Low-Poly Modeling 154
Mesh-Editing Tools Overview 155
 The Editable Mesh Object Vs. The Edit Mesh Modifier 155
 Mesh Subobject Editing (Vertices, Edges, and Faces) 157
 Vertex Sub-Object Level 157
 Face, Polygon, and Element Sub-Object Levels 160
 Edge Level 172

Putting It Together: A Low-Polygon Head 183
Using MeshSmooth 196
 Classic Smoothing 197
 Quad Output And NURMS Smoothing 199
 MeshSmooth In Action: A Simple Car 201

Chapter 8
Modeling With Modifiers **207**
The Modifier Theory Of Modeling 207
Basic Axial Deformers 208
 Bend 208
 Taper 214
 Stretch 219
 Twist 220
 Skew 224
Noise 224
 Nonfractal Noise 225
 Fractal Noise 225
Polygon Optimization 229
 Using The Optimize Modifier 231
Displacement Mapping And The Displace Modifier 237
 The Displace Modifier 239
 Displacement Mapping In The Material Editor 245
Free Form Deformation (Lattice Deformation) 248
Spline-Based Modifiers 250
 Extrude 251
 Lathe 252

Chapter 9
Compound Objects **255**
Loft Objects 255
 Using A Single Cross-Section Shape 256
 Display And Resolution 258
 Multiple Shapes On A Path 260
 Open Cross-Sections And Closed Paths 263
 Loft Deformation Tools 263
Boolean Operations 264
 Using The Collapse Utility 265
 Boolean Compound Objects 270

ShapeMerge Objects 273
Connect 275
Terrain 278
Scatter 281
 Using Transforms Only 281
 Using A Distribution Object 283
Morph Objects And Conform Objects 284

Chapter 10
Patch Modeling **287**
Understanding Bezier Patches 287
 The Quad Patch 287
 The Tri Patch 291
Building With Patches 292
 Adding Patches Together 293
 Coplanar And Corner Vertices 295
 Subdividing Patches And Binding Vertices To Edges 299
 Extruding Patches 303
Creating A Torso 306
 The Basic Architecture 306
 Extruding The Arm 310
 Subdivision For Local Detail 312
Modeling With Spline Networks 315
 The Torso Again 315
 Using The CrossSection Modifier 318

Chapter 11
NURBS Modeling **323**
NURBS And MAX NURBS 323
 Overview Of NURBS Modeling 324
 Overview Of The MAX 3 NURBS Implementation 334
Lofting Surfaces 342
 Creating A Loft 342
 Editing The Loft 344
 Relofting The Surface 347
Surface Curves And Trimming 348
 Projecting A Surface Curve 349
Surface Approximation 355

PART IV MATERIALS AND TEXTURES

Chapter 12
Materials And The Material Editor 361
What Is A Material? 361
 Materials In 3D Computer Graphics 361
 Materials In 3D Studio MAX 365
Using The Material Editor 366
 Moving Materials Between Slots And Objects 367
 The Material/Map Browser 368
 A Couple Of Shortcuts 370
 Using The Material Library 370
The Standard Material 370
 Phong And Blinn Shaders 371
 Metal Shader 375
 Anisotropic Shader 375
 Other Shaders 376
Other Material Types 377
 Raytrace And Matte/Shadow Materials 377
 Multi/Sub-Object Material 378
 Composite, Blend, And Shellac Materials 380
 Top/Bottom Material And Double-Sided Materials 380

Chapter 13
Maps And Mapping 381
Mapping Material Parameters 381
 Maps For Standard Material Parameters 382
 Other Map Channels 383
Using Bitmaps 386
 Creating Mapping Coordinates 386
Procedural Maps 412
 2D Maps 412
 3D Maps 413
Reflections, Refractions, And Ray Tracing 416
 True Object Reflections And Refractions 416
 Using Reflection Maps 416

PART V LIGHTS, CAMERA, RENDER!

Chapter 14
Lights 421

Lighting In Computer Graphics 421
 Diffuse Reflection And Global Illumination 421
 Ambient Light 423
 Shadow Casting 425
 Inclusion And Exclusion Of Objects 426
Light Types And Their Parameters 428
 Creating Lights 429
 Setting General Parameters 429
 Attenuation 432
Shadows 434
 Basic Shadow Parameters 434
 Choosing Between Ray Traced Shadows And Shadow Maps 436
Using The Light Lister 439

Chapter 15
Cameras 443

Creating And Transforming Target Cameras 443
Creating And Transforming Free Cameras 445
Camera Parameters 448
 Converting Between Camera Types 448
 Adjusting Field-Of-View 449
 Clipping Planes 449
Camera Viewports And Navigation 450
 Dollying The Camera 450
 The Field-Of-View Tool 451
 The Perspective Tool 451
 Rolling The Camera 452
 Trucking The Camera 453
 Orbiting The Camera 454
 Panning The Camera 454

Chapter 16
Rendering Tools 457

Rendering Essentials 457
 Production And Draft Rendering Configurations 457
 The Virtual Frame Buffer 459

Outputting To Disk 461

Rendering Animation 461

Output Size And Other Options 465

Rendering Regions And Selections 466

MAX Scanline Rendering Options 468

Motion Blur 470

Anti-Aliasing 474

Rendering Previews 476

Chapter 17
Environment And Render Effects **479**

Render Effects 479

Lens Effects 481

Other Render Effects 492

Environment 494

Environment Maps 495

Atmospheric Effects 497

Chapter 18
Using Video Post **519**

The Video Post Queue 519

Video Post Events 519

The Video Post Panel 520

Video Post Essentials 521

First Steps In Video Post 521

Adding A Fade 525

Cutting Between Views Or Cameras 527

Adding A Cross Fade 530

Using Prerendered Sequences 532

PART VI ANIMATION

Chapter 19
Animation Essentials **537**

What Is Animation In 3D Studio MAX? 537

Understanding Function Curves 538

Working With Keys 539

Managing Keys In Track View 540

Using The Animate Button 548

Using The Track Bar 550

Ranges And Out-Of-Range Types 553
 Using Child And Parent Ranges 553
 Out-Of-Range Parameters 555

Chapter 20
Animating The Transforms————————————————————**559**
Transforms And Controllers 559
Animating Position 560
 The Bezier Position And Position XYZ Controllers 560
 The Path Controller 576
 Other Position Controllers 587
Animating Rotations 590
 The TCB Rotation Controller 592
 The Euler XYZ Controllers 595
Inverse Kinematics 598
 Inverse Kinematics In MAX 598
 Animating A Step With Bones 599
Animating Scale 607

Chapter 21
Deforming The Geometry————————————————————**609**
Introduction To 3D Character Animation 609
 Skeletal Deformation 610
 Morphing 610
 Modifiers And Space Warps 611
The Skin Modifier 612
 Getting Started 612
 Vertex Weighting 613
 Adjusting The Envelopes 616
 Using Editable Mesh Cages 620
The Morpher Modifier 629
 Creating Morph Targets 629
 Applying The Morpher Modifier 630
 Making The Most Of Targets 632
 Animating The Morphs 634
 Morphing Materials 635
The XForm And Linked XForm Modifiers 636
 Cluster Animation With A MeshSmoothed Cage 636
 Using A Finished Mesh 638
 Animating The Cluster With Linked XForm 638

Other Deformation Tools 639
> Path And Surface Deformation 639
> Flex 641

Chapter 22
Special Animation Topics 643
Space Warps 643
> Two Classes Of Space Warps 644
> Space Warps For Geometric Deformation 646
Dynamic Simulations 651
> A Basic Simulation 651
> Adding Collisions 655
Particle Systems 657
> Choosing A Particle System 657
> Particle Generation And Rendering 661
> Controlling Particle Streams With Space Warps 664
Animating With Expressions 667
> Expressions For Interdependent Animation 668
> Expressions Based On Time 674

Index 677

INTRODUCTION

3D graphics and animation is an exciting and glamorous field that is attracting ambitious and creative people from all walks of life. They soon discover that the subject is as deep and challenging as it is attractive. There is so much to learn, and the more you learn, the faster the horizon seems to recede before you, opening new realms to conquer.

The purpose of this book is twofold. On one hand, it is a reference that covers the large majority of 3D Studio MAX 3 features, at least in a general way, with emphasis on those areas that I consider most essential. Thus, for example, graphing animation in Track View receives considerable attention, whereas space warps and particle systems are merely introduced. MAX is such a huge application that no single book can be complete. Even as a general reference, this book has been selective and necessarily reflects my own biases as to the relative importance of features. In short, there are some things that are missing, and others that are covered briefly, in order to address the primary areas adequately.

The second, and equally imporant, purpose of the book is to serve as a teaching tool. As a professional teacher of 3D graphics and animation, I am acutely aware of the difficulty of learning this subject without personal instruction and interaction. No one would think of learning to play the piano from a book alone. Yet relatively few interested people have access to quality instruction in 3D computer graphics, or to any instruction at all. Thus, the book is designed to fill the need for the kind of instruction that I provide in my own classroom. I seek to teach not just the details of a specific program, but far more importantly, the instincts and concepts that underlie all work in 3D computer graphics, regardless of the application.

In this regard, it's important to distinguish between learning 3D Studio MAX 3 and learning 3D computer graphics. The latter is a far broader subject than the former and is not dependent on a single program. My goal is always to teach 3D computer graphics in its own right, although always in the practical context of a particular application—in this case, MAX.

Who Is This Book For?

The needs of many different kinds of readers were balanced in creating this book. Some readers will be starting in 3D graphics with MAX as their first application. Others will have experience in other 3D applications, but are beginning to work in MAX. Still others are intermediate MAX users seeking greater insights and stronger background, or those who are interested in assimilating the many new developments in the current release of the program. Others will be knowledgeable MAX practitioners who are simply looking for a desk resource and reference that provides more guidance than the product documentation.

I believe that the needs of all of these classes of readers can be met at once on the basis of respect. 3D graphics is such a difficult field that the serious practitioner will always be seeking a stronger understanding of the basics. Nor is there any need to "talk down" to the relative beginner. This book contains everything to get you started, even if you have little or no experience with 3D graphics or MAX. The more sophisticated user can simply bypass the more introductory material. But there is nothing simple about the more basic elements of this book. Indeed, I greatly improved my own command over the program by organizing my understanding of the basics for this text.

What Is "In Depth" About This Book?

Like all professional-level 3D applications, 3D Studio MAX 3 is so deep and complex that no book can sound its bottom. The "Depth" of this text is in its tone as much as in its coverage. The serious student or practitioner is less in search of additional facts and tools than of a richer and more subtle understanding of the creative environment. Although I've certainly provided enough resource material about MAX to choke a horse, my greater hope is to provide the serious user with a more profound understanding of the subject. I stress this because 3D graphics is evolving very rapidly, and it is not enough to know what you know right now. To survive and flourish in this field, you must learn how to learn. You must develop an ever-deeper level of understanding to support further extension and growth into new areas as the need arises, whether in different applications or in the use of MAX. This book is entitled to call itself "In Depth" because it was written in a spirit that seeks basic and fundamental understanding of a complex and subtle creative toolset. Every real artist works "In Depth."

How To Use This Book

This book is largely organized into exercises. These exercises have been carefully developed to teach you principles that I consider important. Thus, they do not always go by a direct route to an intended end, but are rather designed to explore a topic to a minimum level of completeness so that you develop skills and techniques along the way. With this knowledge, you may be expected to continue on your own. In this regard, these exercises are different than tutorials in that it will rarely be possible to complete a significant project in any exercise. The exercises are, rather, launching pads to your own efforts. I'm reminded of the Confucian aphorism that, with the serious student, you teach only a quarter and he or she will figure out the rest. I have found in my teaching experience that serious 3D students want only enough to get started on a firm footing, so that they begin their own explorations as quickly as possible. The subject is visual art—not paint by numbers.

Most of the exercises are organized into larger groups to some cumulative purpose. For the student trying to learn MAX, it's best to take the time to work through the entire series because it builds from concept to concept. However, those who are looking for a quick introduction to a very specific topic can generally get what they need from an isolated exercise.

What's In The Book

The book attempts a balanced coverage of MAX from the point of view of the average user. There is a basic direction through the text, with the more fundamental aspects of the program addressed in the early chapters. Modeling precedes materials on the theory that you have to create geometry before you can surface it. Using the same reasoning, animation is presented last, when you presumably have learned enough that you're able to develop models to animate. Thus, each chapter assumes knowledge of the material in previous chapters. Many, and perhaps most, readers will move more randomly through the book as their needs dictate, and they may encounter material that requires some conceptual preparation. That preparation can always be found in preceding chapters.

Here's a short synopsis of the contents.

Part I: 3D Studio MAX—The Big Picture

Chapter 1, "Thinking Like MAX," introduces those concepts that run through the program at every level of use. This chapter, which is essential for getting up to speed, includes an introduction to the parametric object, the modifier stack, and the practice of instancing and referencing.

Chapter 2, "The MAX 3 Interface," focuses primarily on those interface features that are either new or substantially improved in the new version of MAX. It is directed at current users seeking to update their knowledge.

Part II: Working In MAX

Chapter 3, "Selection And Transform Tools," provides the basic knowledge of the most important tools in the creative workflow. Only when you are absolutely at ease with the selection and transformation of objects can you proceed to the serious use of MAX.

Chapter 4, "Managing The Display," provides basic knowledge about the display of objects and the scene. Topics include the use of the many viewport options, hiding objects, viewport navigation, and layout issues.

Chapter 5, "Working Smart," is the last of the introductory chapters that address the basic toolset. The focus is on tools that allow for greater speed and precision in the creative workflow, including the arrays, mirroring of objects, alignment, and the use of MAX's powerful snap tools.

Part III: Modeling

Chapter 6, "Using Primitives And Splines," begins the section on modeling with coverage of the fundamental building blocks. We look at the range of 3D and 2D parametric primitive objects, devoting particular attention to the creation and editing of Bezier curves (splines).

Chapter 7, "Mesh-Level Modeling," may be the most important chapter in the book. The subject is the creation of polygonal meshes through the editing of their component faces and vertices. The entire Editable Mesh toolset is reviewed, in both low-poly and organic contexts.

Chapter 8, "Modeling With Modifiers," focuses on MAX's broad range of modifiers as applied in the modeling context. This includes the standard axial deformation modifiers (Bend, Twist, Taper, etc.) and more general tools such as Noise, displacement mapping, and polygon reduction.

Chapter 9, "Compound Objects," addresses that important group of tools in which two or more objects are used to produce a single one. Primary attention is devoted to Boolean operations and to the use of Loft Objects that create surfaces through the extrusion of Bezier curves.

Chapter 10, "Patch Modeling," was particularly exciting to write because it introduces MAX 3's vastly improved implementation of Bezier patches. Even long-time MAX users may want to take a look at this chapter to explore a powerful method for creating organic surfaces that is particularly suited to character modeling.

Chapter 11, "NURBS Modeling," introduces the most sophisticated part of the MAX toolset. MAX 3's improved NURBS implementation raises the program into the top tier of professional 3D applications. Because the text can only break the surface of this profound subject, I have provided illustrative NURBS modeling examples in the color section of the book.

Part IV: Materials And Textures

Chapter 12, "Materials And The Material Editor," explains the concept of a material in 3D graphics as a collection of parameters that govern the appearance of a surface. A number of exercises are provided to assure that you have absolute command over the materials interface.

Chapter 13, "Maps And Mapping," covers a difficult but essential subject. You'll explore how mapping coordinates are created, by projection or otherwise, to apply 2D images to 3D surfaces. The use of multiple maps on an object is addressed in an exercise, as is the use of 3D procedural textures.

Part V: Lights, Camera, Render!

Chapter 14, "Lights," stresses the difference between the lighting model used in standard computer graphics and our intuitive sense of lighting from physical reality. This leads to an exploration of options for creating shadows, the use of alternative light types, and the attenuation (falloff) of light sources.

Chapter 15, "Cameras," examines the two camera types in MAX and the relationship between them. All of the important camera parameters are considered, including field-of-view and clipping plane controls. You'll also review the use of the camera navigation tools that are used to manipulate a camera from within a camera viewport.

Chapter 16, "Rendering Tools," covers all of the essential tools for rendering MAX scenes into bitmapped images, including the use of Production and Draft rendering modes, how to save single images and animations, and how to use the Virtual Frame Buffer. It explores the main

features of MAX's Default Scanline Renderer, comparing Object Motion Blur and Image Motion Blur, and stressing the importance of anti-aliasing.

Chapter 17, "Environment And Render Effects," considers the tools used to create visual phenomena by means other than the rendering of geometry. The new Render Effects toolset permits you to add post-processing elements, such as glows, in the normal workflow. The chapter also discusses environmental mapping tools and the broad range of atmospheric effects, including Fog, Volume Fog, Combustion, and Volume Light.

Chapter 18, "Using Video Post," introduces the Video Post utility in its most useful contexts. The concept of a Queue is explained, and you learn to use a Queue to edit animated sequences together, to create fades and dissolves, and to cut between multiple cameras in an animation.

Part VI: Animation

Chapter 19, "Animation Essentials," introduces you to the fundamental concepts of 3D computer animation. Animation is presented as the variation of parameters over time, as described by function curves in Track View. The basics of creating and editing keys using the Animate Button, Track View, and the new Track Bar are covered.

Chapter 20, "Animating The Transforms," is the core chapter on animation. The central role played by MAX's animation controllers is stressed, and a series of exercises compares the most important controllers for animating object position and rotation. An extensive exercise introduces the use of inverse kinematics to create a stepping motion for a character leg.

Chapter 21, "Deforming The Geometry," focuses on the essential tools of character animation in the standard MAX 3 toolset. Skeletal deformation is considered in depth in an exercise in which bones are used to bend a knee. The new morphing tools in MAX 3 are also covered, as are the basics of path and surface deformation.

Chapter 22, "Special Animation Topics," is a catchall chapter to introduce specialized animation tools that every MAX practitioner should understand in at least a fundamental way. It includes a discussion of animating with coded expressions, particle systems, dynamics, and space warps.

The CD-ROM

The CD-ROM contains more than 250 MAX files illustrating stages in many of the exercises in the text, arranged by chapter. They are certainly useful as a reference, and you'll often find them valuable. But try to use them only after you have made every effort to work through the exercises without them. The exercises are designed for self-teaching and exploration, and you'll only limit yourself if you jump ahead to look at the "answer." Note that MAX generally closes dialog boxes and panels (such as Track View) when a scene is saved, so you will often have to reopen them when using the reference files.

Other Resources

I cover the 3D graphics landscape for the **internet.com** family of publications through their outstanding WebReference site. You can reach my 3D Animation Workshop through the WebReference home page at **www.webreference.com**, or directly at **www.webreference.com/3d**. You'll find tutorials, product reviews, and general commentary about important happenings in the world of 3D computer graphics. Please write me anytime at **robert@internet.com** with any comments or ideas.

PART I

3D STUDIO MAX—THE BIG PICTURE

THINKING LIKE MAX

To use MAX to its fullest potential, you have to learn to think the way the program does. Once you've mastered its central concepts, these principles will open the doors to the full range of power and flexibility for which MAX is so famous.

Every program has its own personality. 3D Studio MAX has a style of workflow and organization that is both powerful and unique, and the more you work with it, the more comfortable you become with its seamlessly integrated toolset. More than any other 3D graphics application I know of, MAX is built on certain underlying concepts that must be understood in a general way if you want to work with the program. A mark of the serious MAX practitioner is in the mastery of these few subtle concepts on which the towering edifice is built. With these concepts in hand, you begin to think like MAX, and the overwhelming number of tools and options becomes manageable.

MAX requires you to strategize and think according to a plan that best exploits its toolset. If you can learn to think as MAX does, you'll see the same principles repeating themselves in every corner and at every level of the program. Not only will you be able to learn new features more quickly, but you will also understand their logical connections to the rest of the program. MAX, for all its complexity, is extremely well thought out.

In the famous story, three blind men examining an elephant with their hands come to completely different conclusions about the creature's shape. MAX is such a big and complex application that each user tends to see it from a different perspective. To get you started from the same vantage point I'm using, consider the concept of an "object" in MAX.

The "Object" In MAX

If you're a programmer, you're likely to have your own understanding of the term "object-oriented programming." This huge concept encompasses many things, and MAX is all of them. It is a masterpiece of object-oriented software design, maybe the best-written application I have ever seen (certainly for its size). But the 3D artist who is not a programmer must still understand at least the single most important aspect of MAX's object-oriented nature: There is no clear distinction between data and functions.

In traditional programming theory, data and functions are two distinct concepts. Data is simply information—a numerical value, a string of text characters, whatever. It is static.

A function (or procedure) is an action. A function acts on data, generally to create new data. Data is passed into a function, which processes it to produce output data. This is a bit of an oversimplification, but not much. Suppose that we write a function designed to add two numbers together. The two numbers are data that are input into the function. The sum is the output, which is also data. The function must contain "slots" into which the two numbers can be input, and these slots are the function's "parameters." This concept of parameters is, as you will soon see, one of the most basic concepts in 3D Studio MAX.

In most 3D applications (even though they are typically programmed using object-oriented tools), the distinction between data and functions remains clear to the user. When you create a primitive object (a sphere, for example), a function is called that produces the sphere data object. If you want to change the sphere in some way, another function is called that takes the current sphere data as input and processes it to produce new data. In pure object-oriented theory, however, there is no clear distinction between data and functions. Instead, data and related functions are packaged together into units called *objects*. A MAX Sphere primitive (or indeed, any MAX primitive) is more easily thought of as a function used to draw a box, rather than the box itself. This concept applies throughout the program.

Let's take a closer look.

Parametric Objects

I've just introduced the idea of the "object" in MAX. To give this concept some practical meaning, go to the Create panel and click on the Box primitive to create a box. Look down the panel to the section named Parameters. If you haven't begun to draw the box yet, the screen should look like Figure 1.1.

> *Note: 3D objects that can be created directly by an application (without building from component parts) are called* **primitives** *in the language of computer graphics.*

Think of this as a function. If you were a programmer writing a function that permitted a user to create a Box primitive, what input values would be necessary? What parameters would the function require to generate a valid output?

You would have to tell the function how tall, how wide, and how long the box should be. Because you are working with 3D polygonal models, you would also have to tell the function

Figure 1.1
The default parameters for a Box primitive.

how many polygonal units there should be in each dimension. Leaving the issue of the mapping coordinates for later, notice that these are precisely the parameters (input values) that the box object is seeking. So by entering values into these slots, either by direct keyboard entry or by drawing interactively on the screen, the function gets the input values it needs to generate the output.

Compare the input parameters for a sphere, as seen in Figure 1.2. Once again, think of the information a function would need to create a polygonal sphere—it would need to know the radius (or diameter) and the amount of polygonal segmentation. MAX adds some more parameters because a MAX Sphere primitive is a bigger concept than a mere ball (it contains chopped spheres as well). This should be enough to give you the idea. The Sphere primitive is a function asking for input parameters.

So what? Doesn't every program do this? In every other program, there's a basic distinction between the function used to create the primitive and the primitive itself. The primitive is just data, the output of the function. Once the function has been used to create the data, it's gone until you call it again to create another object. MAX is completely different, however. The box or sphere that you create in MAX is not just data; it is the function and its input data together in the purest object-oriented style. The function persists, and if you change the input values (the parameters) at any later time, the primitive object is redrawn from scratch.

Try the following exercise:

1. Draw a box on the groundplane without troubling about its dimensions. It might look like the one shown in Figure 1.3.

2. Switch to a wireframe view (right-click on the word "Perspective" in the top-left corner of the window) to see the polygonal segmentation. Now, enter new values in the input parameters, as I've done in Figure 1.4. The box on the screen changes accordingly, both in dimensions and in segmentation.

3. This may not impress you because you are still in the Create mode. It may just be that you are previewing different dimensions and segmentation options until you actually confirm your decision. So switch to the Modify panel with the box still selected.

Figure 1.2
Default parameters for a Sphere primitive.

Figure 1.3
Box drawn on the groundplane, with parameters visible in the Create panel.

Figure 1.4
Box from Figure 1.3, with parameters changed in the Create panel.

4. The box object has definitely been created, or else there would be nothing to modify. Even though it has been created, its creation parameters are still available for modification in the Modify panel. I changed the dimensions and segmentation of the box using the Modify panel shown in Figure 1.5. Notice that this portion of the Modify panel is identical to that in the Create panel.

In short, the box object you created is not simply data; it's a function that outputs a box, and the output changes every time you change the input. The result is the same as creating a new box from scratch. In any other application, you would have to delete a primitive object and re-create it. In MAX, your primitive objects are reborn every time you change your parameters, which is why these objects are called *parametric objects*.

Note: It can take quite awhile to develop an intuitive understanding of the value of parametric objects. The more you work with MAX, the more you come to understand the value of being able to resize an object by re-creating it from scratch rather than rescaling it with the scale transform. And the ability to change the initial segmentation of a polygonal model after it's already been created and modified is invaluable—one of MAX's most important competitive features.

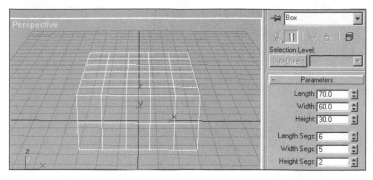

Figure 1.5
Box from Figure 1.4, with parameters changed in the Modify panel.

Editable Mesh

Even though a primitive object starts out parametric, you can choose to abandon its parametric nature. When a parametric object is changed into an Editable Mesh, it becomes simply data, like the polygonal mesh models in any other 3D application. You can no longer change its creation parameters because they are no longer available in the Modify panel. A parametric object is converted into an editable mesh object through the Edit Stack button on the Modify panel. Give this a try with the parametric box in the exercise to see what happens.

WHY CONVERT A PARAMETRIC OBJECT?

If parametric objects are so great, why would you ever want to convert them to mere mesh data? An Editable Mesh object is more easily edited at the mesh level than a parametric object. In other words, it's easier to move vertices and faces to sculpt the geometry. Mesh-level modeling is definitely possible with parametric objects, but it raises complications because the segmentation is not fixed in a parametric object. You can always change it in the Modify panel.

The Modifier Stack

The modifier stack encloses two intertwining concepts: the modifier and the stack. A modifier, like the parametric object, is an *object* (a function with input values that produce an output). The inputs, which come from different sources, are of two types:

- The state of the object being passed to the modifier
- The values the user chooses to apply to the modifier

These ideas are quite difficult to grasp. Here are some examples to help you understand these different types of inputs.

Using A Single Modifier

To use a single modifier, follow these steps:

1. Create a moderately tall box on the groundplane without any segmentation (1 in Length, Width, and Height). Change to the Modify panel. The relevant portion of

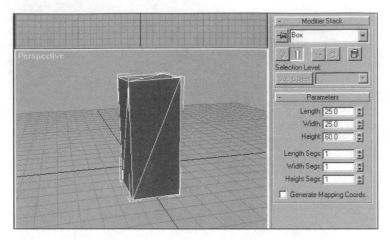

Figure 1.6
Box on groundplane with Modify panel. Edged Faces are used to display wireframe geometry on top of the shaded view of an object.

your screen should look something like Figure 1.6. You may want to use the Edged Faces option (right-click on the word "Perspective" in the upper-left corner of the window) to see your wireframe geometry superimposed on the shaded model.

2. Now, you can get a better idea of what it means to think of the box object as a function that outputs a box. Add a first modifier by clicking on Bend at the top of the Modify panel. This modifier is placed directly on top of the parametric box object in the modifier stack, which means that the box function is executed first and its result is sent as input to the Bend modifier function. The output of the Bend modifier depends both on its own values and the input values it received from beneath it on the stack. Figure 1.7 shows the current stack (Box and Bend) before the default values of the Bend modifier are changed.

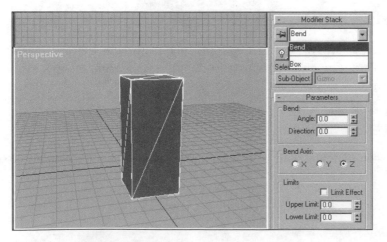

Figure 1.7
Box with Bend modifier applied with default values (no curvature). Stack shows Box below and Bend above.

3. Set the Bend angle to 60 degrees on the (default) z-axis. The modifier's gizmo (curved bounding box) illustrates the intended effect, but the box isn't bending correctly because it doesn't have any segmentation. Without a finer polygonal mesh, its surfaces can't hold curvature. Your screen should look like Figure 1.8.

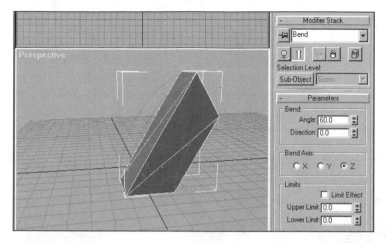

Figure 1.8
Same as Figure 1.7, but with the Bend modifier set to 60 degrees in the z-direction. The modifier gizmo shows the intended effect, but the box doesn't have enough segmentation to hold any curvature.

4. Because the box is a parametric object, you can fix this by going back down to the bottom of the modifier stack and increasing the segmentation of the box. And you can do this without having to delete or undo the Bend modifier. You just increase the segmentation (in Height) until the object is smoothly following the bend. Take a look at Figure 1.9.

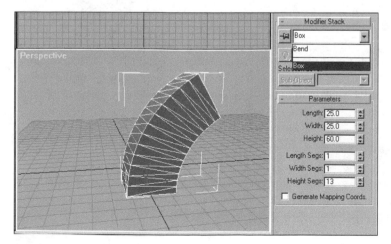

Figure 1.9
Same as Figure 1.8, but the height segmentation of the box is increased at the bottom of the stack.

5. The Bend modifier also remains modifiable. Remember that the output of the modifier depends on two kinds of input: the state of the object as received from below and the user input to the modifier. You just changed the first of these by changing the input from below the modifier, but you also can change the values in the modifier at any time.

Adding A Second Modifier

Continue building your modifier stack by adding a Twist modifier on top of the Bend modifier. Follow these steps:

1. Click on the Twist button when you are currently on the Bend modifier in the Modify panel. A Twist gizmo appears around the bent box. Set the twist angle to –180 degrees in the default z-axis. Your result should look like Figure 1.10.

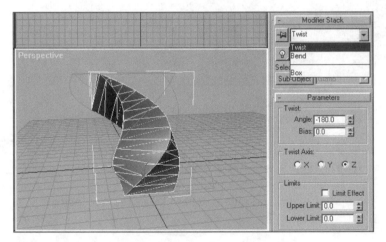

Figure 1.10
Twist modifier is applied on top of the stack for Figure 1.9, and the twist angle is set to –180 degrees in the z-axis. The bend box is twisted around the vertical axis.

2. A couple of things are wrong with this, and fixing them will help you further understand the operation of the modifier stack. First, the object is (once again) not displaying smooth curvature. You increased the segmentation in one direction to correct the bend, but the twist requires increased segmentation in all three dimensions. So go back to the parametric object at the bottom of the stack and increase the segmentation parameters until the geometry is dense enough to hold the curvature. Don't go overboard—you want geometry that is heavy (dense) enough for your purposes without creating more polygons than you need. Your object should now look like the one shown in Figure 1.11. You'll notice a subtle difference between Figures 1.10 and 1.11, especially when the object is rendered.

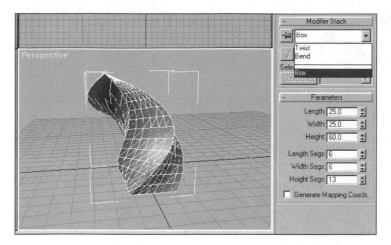

Figure 1.11
Back to the bottom of the stack to increase the segmentation in the width and length dimensions. The object's geometry is now dense enough to hold the twist.

Rearranging The Stack

Even with better resolution, the shape is a little confusing. The Twist modifier acts on the input it receives from below, and with the box already bent, the twist around any straight axis is very different from a twist applied along the original axes of the box. The box would probably look a lot better if you twisted it when it was still straight and then bent it.

In MAX, there's no need to undo or start over again. Just move the Twist modifier down the stack so that it precedes (rather than follows) the Bend modifier. Follow these steps:

1. Click on the Edit Stack button on the Modify panel to bring up the Edit Modifier Stack dialog box. Use the cut and paste buttons to cut the Twist modifier and paste it beneath the Bend modifier. Your stack should now look like the one in Figure 1.12. Click on the OK button to confirm the change.

2. Now, you can make all kinds of adjustments at every level of the stack to create what you want. Go down to the parametric Box at the bottom of the stack to make it taller by increasing the Height parameter. To see the effect at only this point in the modifier stack, click on the little tube icon to the right of the bulb icon (which toggles the evaluation of the stack—it's called the Show End Result toggle). If the tube is full (white from top to bottom), the screen displays the result of the entire stack, regardless of the level at which you're currently editing. If the tube is half-full, the screen displays only to the current level of the modifier stack. With the button set to the half-full stage, you see only the box before the application of the Twist and Bend modifiers. Take a look at Figure 1.13.

3. Move up to the Twist level in the modifier stack and make sure that the Show End Result button is toggled to the half-full stage. Thus, you see only the effect of the Twist modifier before the application of the bend. Change the twist-angle value

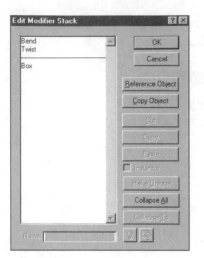

Figure 1.12

The Edit Modifier Stack dialog box after the Twist modifier has been moved beneath the Bend modifier.

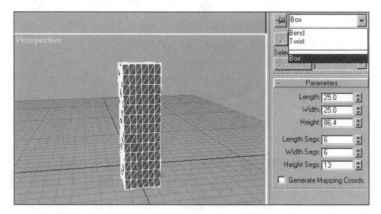

Figure 1.13

The box height parameters are increased. The screen displays the state of the primitive object before the application of the modifiers.

from –180 to +360 to get twice as much twist, and in the opposite direction. But notice something peculiar: The Twist gizmo doesn't completely enclose the object as it's been doing up until now. Look at the object in a front wireframe view (rather than a shaded perspective view) to see this more clearly. Your screen should look like Figure 1.14.

4. The Twist gizmo has retained the size it was before you moved it down the stack. To make it the correct size, click on the Sub-Object button in the Modify panel, which turns yellow. Now, you can operate directly on the gizmo. Click on the Scale button on the MAX Main Toolbar, and then hold that button down to reveal three options. The middle of the three buttons is for non-uniform scaling, which means that you can resize independently in each of the three dimensions. Select the non-uniform scaling option.

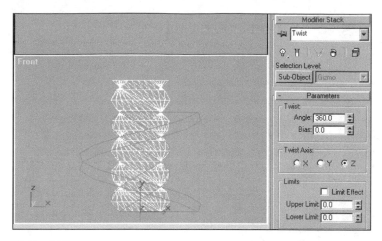

Figure 1.14
Front wireframe view, showing the effect of Twist modifier with new settings. The Twist gizmo is shorter than the object.

5. Now, get set up to perform the scaling. Make sure that you are in the local coordinate system, using the drop-down box in the center of the Main Toolbar (the default is View). Once in the local coordinate system for the selected gizmo, notice how the vertical dimension is z. Set your constraints to the z-axis by clicking on that button in the Main Toolbar. Go down to the gizmo in the window and drag the cursor to scale it vertically. Watch how the effect of the modifier on the object changes as the gizmo is scaled. When you've scaled it to fit the object, your screen should look like Figure 1.15.

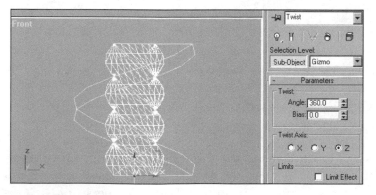

Figure 1.15
Using the Sub-Object mode, the gizmo is scaled in the local z-dimension to fit the object.

6. Finally, move up to the Bend modifier and play with the bend angle until you have something that you like. You have a twisted object that's bent, and because MAX permits you to animate modifier values, you could create a clip in which the twisted box object bends back and forth. You may want to go back down to the bottom of

THE TRANSFORMS AND THE MODIFIER STACK

In all computer graphics, the three operations of moving (translating), rotating, and scaling objects are known as the *transforms*. You'll get deeply into the transforms in Chapter 3 and elsewhere, but for right now it's important to understand how the transforms relate to the modifier stack.

In general, it makes sense to translate, rotate, or scale a finished model. Thus, in MAX, the transforms are applied after the evaluation of the modifier stack. Seen as a process, an object is output from the end of the modifier stack, and then the transforms are applied. This simple fact has many important consequences. For example, as explained in Chapter 3, the nonuniform scaling of an object with modifiers can have a completely different result from the resizing of the parametric object at the bottom of the stack. As you saw in the exercise with the Twist and Bend modifiers, it matters a great deal where in the process an operation is applied. Rescaling applies at the level of the finished object, whereas resizing the creation parameters operates at the beginning. If you rescale and then change your modifier stack in any way, the scaling may no longer make sense.

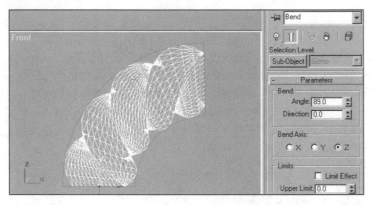

Figure 1.16
The twisted object's bend angle is adjusted in the Bend modifier. The segmentation has also been increased at the bottom of the stack for greater smoothness.

the stack and adjust the segmentation of the parametric object to get a pleasing smoothness for the final model. Take a look at Figure 1.16.

If you've made it all the way through these exercises, you should have a basic grasp of the modifier stack concept. The modifier stack is a process. You can add steps to the process, delete them, change their operation at any time, and even change the order of the steps. Each step in the process feeds the next step, and the final result is the output of the last step.

Instancing And Referencing

Repeat after me: Instanced objects share the same modifier stack. Instanced objects share the same modifier stack. Instanced objects share the same modifier stack.

This central concept takes a moment to get used to, but it's one of the things that make MAX so powerful. Duplicate objects can be connected to maintain the very same modifier stacks. Thus, they always remain identical as you model, and any change made to one affects the other. Give this concept a try by doing the following:

1. Create a box on the groundplane. Duplicate it by using Edit|Clone and choose the Instance option. Move the two boxes apart so that you can see them both. The Move tool is available on the Main Toolbar.

2. Select one of the boxes and put a Bend modifier on it. Notice that a Bend gizmo appears on both objects.

3. Select the other box and notice that there's a Bend modifier on this object in the Modify panel. Play with the bend angle and watch both objects bend together. Your screen should look something like Figure 1.17.

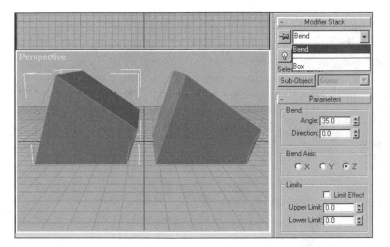

Figure 1.17
Two instanced boxes with Bend modifiers. They bend in tandem.

4. It doesn't matter which one you operate on—any changes affect both. Select the other box and delete the Bend modifier by using the little trashcan icon on the Modify panel. The modifier and its gizmo disappear from both objects.

5. Put a Taper modifier on one of the boxes and adjust the taper amount so that both boxes come to an identical point. Now, go up to the Main Toolbar and select the Rotate tool. Rotate one of the boxes in the vertical axis. Your screen might look like Figure 1.18.

 Why don't the boxes rotate together? Remember the rule: Instanced objects share the same modifier stacks. You already learned that the transforms (move, rotate, and scale) are applied to objects only after they have been output from the modifier stack. So transforms are not among the things that instanced objects share. If you want them to rotate together, just as they taper together, you must get the transform process onto the modifier stack.

Figure 1.18
Two instanced boxes with Taper modifiers. The selected one has been rotated in the vertical axis, but the other box remains as is.

6. The XForm modifier does precisely that. Put the XForm modifier on one of the objects, and it will appear on both. (You'll need to access the More button to get the full list of modifiers.) Activate the Sub-Object button if it's not already activated and rotate the XForm gizmo. Both boxes now rotate together because they share the same modifiers. Look at Figure 1.19.

Figure 1.19
Two instanced boxes with XForm modifiers added to the stack. Rotating the XForm gizmo of either one rotates both boxes.

7. Instanced objects share all elements of the modifier stack. Referenced objects are instances with respect to only part of their stacks. Turn your instances into references by clicking on the Edit Stack button in the Modify panel. In the Edit Modifier Stack dialog box that appears, click on the Reference Object button. A new line appears at the top of the stack. Click on OK to confirm the change. Take a look at Figure 1.20.

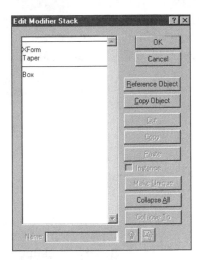

Figure 1.20

The Edit Modifier Stack dialog box, showing a new line at the top of the stack. The two box objects are now references.

8. Any modifiers added above the line apply only to the selected object; modifiers added below the line are added to both. Give this a try. With one object selected, find the upper line back in the Modify panel and add a Bend modifier. The new gizmo appears on only the selected object, and if you apply a bend angle, only the selected object bends (see Figure 1.21). However, changes applied to the shared part of the stack (the XForm and the Taper modifiers) still affect both objects.

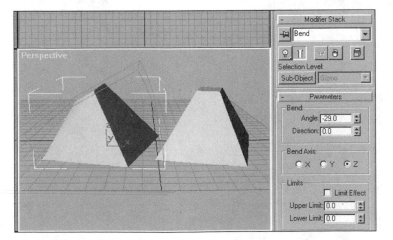

Figure 1.21

The left box with a Bend modifier applied above the line. This modifier is not shared by the two objects, so the left box bends by itself.

9. You can break the instancing so that the objects are completely independent. In the Modify panel, find the line that is at the bottom of the stack, right above the box parametric object. When this line appears in the window, the Make Unique button beneath it becomes activated. Click on this button and the objects no longer share a single modifier stack. Delete the Taper modifier from one of the objects and note that it remains on the other.

A Word About Track View

Track View is, in my opinion and that of many others, MAX's outstanding competitive feature. It's where everything in the program comes together in an organized way, and working with Track View provides the greatest insights into the way MAX "thinks."

Every program has scene graphs to tell you what objects are in the scene and their hierarchical relationships. And every program has animation graphs. But Track View, by combining both of these features with everything else the program offers, provides a bird's-eye view that is astoundingly logical and well-organized. Track View is invaluable, even when there is no animation in the scene.

Look at a Track View for the exercise you just completed. You can open a Track View window from the menu bar or from the button on the Main Toolbar. A fully expanded view of all tracks is seen in Figure 1.22.

Figure 1.22

A Track View window showing the scene as it existed in Figure 1.21.

There are no materials in the scene, no environmental elements are used, and there are no Video Post effects, so I've collapsed all these tracks. Only the Objects section has been rather fully (but not completely) expanded. Notice the two objects, Box01 and Box02. For each of these, the three transforms—position (move), rotation, and scale—sit above the Modified Object. That means that the output of the modifier stack (the Modified Object) is sent to the transforms. The numbers to the right of each transform indicate their current values in the scene. You already learned that transforms are applied after the modifier stack is evaluated, and Track View illustrates this graphically.

Compare the modifier stacks of the two objects. Box01 has a stack composed of two levels. The lower level contains the same modifiers as Box02. The upper level contains a Bend modifier that is unique to this object. This illustrates the referenced relationship between the two objects. The two boxes share a common modifier stack up through the XForm modifier, but Box01 has a second layer containing an independent Bend.

For Box02, the XForm modifier is expanded to show its subobjects, the gizmo and the gizmo center. The XForm gizmo's transforms are also expanded to show the separate Position, Rotation, and Scale components. Remember that you rotated the XForm gizmo. If you expanded the same tracks for Box01, you would find identical transform values because these are instanced objects for this part of the stack. By contrast, notice that the position values of the two objects differ in the true transforms above the modifier stacks.

GET STARTED WITH TRACK VIEW RIGHT AWAY

Many people think of Track View as a complex feature of MAX that they will get around to learning when they have more experience with the program. Nothing could be more wrong. The serious student of MAX will want to get started with Track View from the very beginning. Track View is your best teacher. Don't shy away from this amazing tool.

Moving On

In this chapter, you worked through the core principles of 3D Studio MAX—principles that find their way into every corner of your work. You learned about the nature of a parametric object and how a parametric polygonal model can lose its parameteric nature by conversion into an Editable Mesh object. You worked through a series of exercises in which you built a modifier stack and rearranged it, using the modifier gizmos in the process. You also learned how instancing and referencing can be used to allow different objects to share all or part of their respective modifier stacks. Finally, you saw how all your work was reflected in Track View.

In the next chapter, we'll focus on the many features in the highly customizable MAX 3 interface.

THE MAX 3 INTERFACE

Any professional-level 3D modeling and animation package must have a deep and complex interface to support an extraordinary number of tools. The MAX 3 interface is well organized and highly customizable.

3D graphics applications are extremely complex, and MAX is no exception. In such an environment, the design of the user interface is very important. The interface reflects the logic of the program, and the experienced MAX user must be able to find things quickly.

MAX 3 has introduced some major improvements to the interface that will be immediately evident to the long-time user. A new Tab panel provides ready access to the full range of MAX tools. Most importantly, the interface can be readily customized to suit individual needs. The tools you need most often can be added to an existing toolbar or arranged on a new toolbar. And MAXScript can be used to generate custom tools. Also new to MAX 3 are a Schematic View of all scene elements and an Isolate tool that eliminates all but the selected object from the scene.

Introduction To The MAX 3 Interface

Figure 2.1 illustrates the standard MAX 3 interface. The menu bar runs along the top. Beneath it is the Tab panel, with the Main Toolbar currently selected. The Tab panel replaces the original MAX toolbar, which is now called the Main Toolbar and is only one of the toolbar options available in the Tab panel.

To the right of the four viewports is the Command panel. The six tabs across the top of the Command panel are Create, Modify, Hierarchy, Motion, Display, and Utilities. This is certainly the deepest part of the MAX interface. Under each of these tabs runs a labyrinth of panels, subpanels, and rollouts that give access to most of the MAX toolset. The contents of these panels are the subject of most of this book and will be discussed in their particular contexts. For the present, it's important to note the role of the new toolbars in the Tab panel. A consistent complaint about MAX has been the difficulty of reaching tools through the maze of the Command panel. MAX 3 addressed this problem by providing alternative routes to tools through the Tab panel. But note that pressing a button in a toolbar in the Tab panel is nothing other than a shortcut to an underlying command in the Command panel. For example, you can create a Sphere by pressing the Sphere icon in the Objects toolbar. When

Figure 2.1
The standard MAX 3 interface. The menu bar runs along the top with the Tab panel immediately beneath it. The former MAX toolbar is now the Main Toolbar, which is only one of the toolbars available in the Tab panel. The Command panel is at the right of the screen.

you do this, however, the Command panel immediately jumps to the proper command (Create|Standard Primitives|Sphere), and all of the creation parameters for a Sphere become available in the Command panel. The buttons in the toolbar simply activate a Macro Script that calls the command in the standard way. It will certainly take a while for long-time MAX users to become accustomed to new habits for calling tools, but newer users should get started with the new toolbars right away.

Customizing The Interface

MAX is a complex program with a correspondingly complex interface. The power to customize the interface makes an enormous difference to the serious user. Not only can a customized interface speed up workflow, it can also create a less cluttered screen. It's very difficult to do creative work in visual arts when your vision is confused and distracted by unnecessary buttons and panels.

Managing The Tab Panel

The new Tab panel at the top of the screen is easy to customize. Let's look at some possibilities.

Floating A Toolbar

The toolbars in the Tab panel can be freed to float on the screen or docked to a side. Here's an exercise to get you started:

1. Right-click on the Objects tab in the Tab panel. A small menu appears. Click on the Convert To Toolbar option. This language is a bit confusing because the row of Objects icons is already a toolbar when it's still in the Tab panel. The Objects toolbar is converted into an independent toolbar, and the Objects tab disappears from the Tab panel.

2. The Objects toolbar is now a floating toolbar that can be dragged anywhere on the screen. It can also be resized by dragging on the sides or corners. This can create a much more useful format. Figure 2.2 shows the Objects toolbar compressed into a convenient block shape.

Figure 2.2
The Objects toolbar is freed from the Tab panel and resized into a useful block shape. This floating toolbar can be positioned anywhere on the screen.

3. Right-click on the floating toolbar and use the Dock option to dock the toolbar to the left side of the screen. The Objects toolbar now runs vertically down the left side of the screen in a single column. To free it again, right-click on the horizontal line at the very top of the toolbar, and then choose Float. The toolbar returns to its floating state.

4. To hide the Objects toolbar, bring up the right-click menu again and notice the checked options at the bottom. These options indicate that the Command panel, the Tab panel, and the Objects toolbar are all visible. Click on the Objects option and the toolbar disappears.

5. To make the Objects toolbar visible again, right-click anywhere in the menu bar. You'll get the same menu as before. Click on the unchecked Objects option to restore the toolbar.

HIDING AND UNHIDING PANELS

Hiding the Command panel and Tab panel opens up more workspace on your screen, which is especially important when working with a smaller monitor. In addition to these menu commands, you can hide and unhide the Tab panel by pressing the 2 key, and you can hide and unhide the Command panel by pressing the 3 key. Get used to using these valuable hot keys.

6. Once the toolbar is restored, move it back into the Tab panel. Use the Move To Tab panel command in the right-click menu and note that the Objects tab is now at the end of the Tab panel. When you started, it was to the left, immediately to the right of the Main Toolbar tab. To return the Objects tab to that position, right-click directly on the tab and choose the Move Right command. Because the tab is already at the extreme right, it wraps around to the beginning at the left. Use the Move Right command a second time to move it back to its original position.

7. Delete the Objects tab by using the same right-click menu. To restore it, go to the Customize menu on the menu bar and select Revert To Startup UI Layout. This command restores the user interface as it existed when you started the program. If you exited the program with a new user interface (UI) layout, the changes would be saved and would appear the next time you open MAX. To prevent changes from being saved, uncheck Save UI Configuration On Exit in the Preference Settings dialog box (choose Customize|Preferences|General).

Editing A Toolbar

Regardless of whether a toolbar is in the Tab panel or independent of it, you can customize its contents however you wish. The following exercise walks you through the basic steps.

1. Click on the Shapes tab to reveal the Shapes toolbar. As shown in Figure 2.3, the default toolbar includes two NURBS curve-creation tools at the far right.

Figure 2.3
The default Shapes toolbar has two NURBS curve-creation tools at the far right.

2. Suppose you want to have separate toolbars for Bezier splines and NURBS curves, so that all of the various NURBS tools can be clustered together. Right-click on the Shapes tab and use the Rename Tab command to rename the tab Splines.

3. To delete the two NURBS curves buttons, right-click on each of them and choose the Delete Button option. That leaves an unnecessary gray Separator button (with a vertical line) at the end. Delete the Separator button in the same way. Your Splines toolbar should look like Figure 2.4.

Figure 2.4
The default Shapes toolbar is renamed Splines, and the two NURBS curve-creation buttons at the far right are deleted, along with the Separator button.

4. The new Splines toolbar might be more useful if it contained the Edit Spline modifier. To add this modifier, right-click anywhere on the toolbar and choose Customize from the menu. The Customize User Interface dialog box appears.

5. Find the Modifiers category in the drop-down list at the top (using the default of Macro Scripts) and select the Edit Spline modifier in the list that now appears. The dialog box now looks like Figure 2.5. Note that the proper icon for the Edit Spline modifier displays in the dialog box. Although you can drag this icon to the toolbar, just press the Add button to close the dialog box.

Figure 2.5
The Customize User Interface dialog box, with the Edit Spline modifier selected from the Modifiers category of Macro Scripts. Pressing the Add button adds the Edit Spline icon to the Splines toolbar.

Creating A New Toolbar

You can create new toolbars and edit them as you do the existing toolbars. Follow these steps to create a toolbar that contains tools that you may use all the time:

1. Right-click anywhere in the menu bar or Tab panel and select Customize to bring up the Customize User Interface dialog box.

2. Type the name "My Tools" in the Toolbar field. Press the Create Toolbar button—you see a tiny, empty floating toolbar appear on the screen. Stretch the new My Tools toolbar out a bit.

3. Now, you can start adding tools. Switch from Macro Scripts to Commands at the top of the Customize User Interface dialog box. Backface Cull is an important command that can be a hassle to reach through the Display panel or Display Floater. (It determines whether both sides of a surface are visible.) Select Backface Cull (toggle) from the list.

4. There isn't a standard icon available for this command, and it probably wouldn't be very comprehensible if there were. Instead, you can make a text label for the button. Click on the Text radio button and note in the sample button that the full name doesn't fit on the button. Type "BFCull" in the Label window. This fits nicely on the button and is understandable. (There are far too many cryptic icons in MAX as it is.)

5. Drag the button from the dialog box right onto the new toolbar. The button is now on the toolbar.

6. Display Edges Only is another important display option that can be hard to reach. Select this command in the dialog box and give it the text label "Edges Only". Drag it onto the My Tools toolbar.

7. Switch to the Macro Scripts and go to the Objects category. Select Box from the list. This Box creation icon is easy to understand, so drag this button to the toolbar and place it to the right of the other two buttons. At this point, your toolbar should look like Figure 2.6.

Figure 2.6
A new toolbar called My Tools is created from the Customize User Interface dialog box. Text buttons are added for the Backface Cull and Display Edges Only commands, and an icon is used for the Box creation Macro Script.

8. For better organization, it makes sense to put a Separator button between the two text commands and the Box creation button. Find the Separator category in the dialog box and drag the icon button onto the Edges Only button. This causes the Separator button to be placed to the right of the Edges Only button, as shown in Figure 2.7.

Figure 2.7
A Separator button is placed between the Edges Only button and the Box creation button on the toolbar.

9. You can go on adding other buttons if you wish; when you finish, close the dialog box. Right-click on the toolbar and move it to the Tab panel. My Tools is now the last tab on the Tab panel. Right-click on the tab to convert it back to an independent toolbar.

Loading And Saving Custom User Interfaces

As already mentioned (unless you deliberately disable this feature), any changes you make to the UI (user interface) are automatically saved when you close MAX and will reappear when you next open the program. You can also save a custom UI as an independent file, and

you can load it when you wish. This enables you to create custom user interfaces for different tasks or different projects (for example, low-poly modeling, character animation, and so on).

Try this out with a short exercise:

1. Delete the Objects tab from the Tab panel.

2. Find the Save Custom UI As command in the Customize menu. This brings up the Save UI File As dialog box, shown in Figure 2.8.

Figure 2.8
The Save UI File As dialog box, reached from the Save Custom UI As command in the Customize menu.

3. The files containing the UI configurations are kept in the ui directory and use the .cui extension. Note that the default file is MAXStart.cui. This is the file that contains the user interface settings that will be automatically loaded when MAX is started. Save the current settings (without the Objects tab) under the name test.cui.

4. Delete the Shapes tab (or the Splines tab if you renamed this tab in the previous exercise) from the Tab panel.

5. Choose the Load Custom UI command from the Customize menu and load the test.cui file. After a moment, your interface will rebuild as it was before you deleted the Shapes (or Splines) tab (but with the Objects tab missing).

6. To make sure that you don't automatically save the current UI as a default, use the Revert To Startup UI Layout command to restore your original UI.

Note: Load some of the UI files that are supplied with MAX in the ui directory to get some ideas for useful configurations.

Using MAXScript

A *scripting language* is a type of programming language. You may be familiar with such full-strength programming languages as C++ or Java. These powerful languages can be used to write commercial applications, and MAX itself is written in C++. These languages are very sophisticated and take quite a serious commitment to learn.

Scripting languages are the baby siblings of full-strength languages. They are more specialized and much easier to learn. They also differ from full-strength languages in an important way: Code that is written in C (or C++) must be compiled to machine language before it can be run. The compilation process produces highly efficient code that is adequate for commercial applications. Java code is semicompiled for efficiency, and an interpreter on the user's computer then interprets this *byte code* at runtime. In contrast, the code written in a scripting language is not compiled at all—it is fed directly into an interpreter program, which executes the code. Because interpreted code runs much more slowly than code that has been compiled, scripting languages are typically used for small add-ons or extensions to existing programs. On the other hand, it's very easy to program in scripting languages because there is no compilation step—you write some code and then execute it immediately to test your result.

MAXScript is a scripting language that is unique to MAX. Code written in MAXScript is interpreted in MAX and causes instructions in MAX to execute. MAXScript has complete access to all of the powers of MAX. It is possible to program anything that MAX can do into a script.

MAXScript is not easy to learn, so it differs from such common and accessible scripting languages as JavaScript (which is completely different from the Java language). There are two reasons for this difficulty. One is that the syntax is different from that of C, Java, or JavaScript, and therefore takes some effort to learn for those who already have a programming background. However, the much more significant reason for the difficulty of coding in MAXScript lies in the sheer ambition of the language. MAXScript is a fully object-oriented language that mirrors the entire object hierarchy of the program. You can't understand MAXScript without a strong command of the object-oriented programming principles that underlie MAX itself, and only a small fraction of MAX users can be expected to have this background. The MAXScript help file contains a fabulous amount of guidance, but it is largely impenetrable to those who do not already have knowledge of contemporary object-oriented programming.

From a practical standpoint, the sophisticated MAX user uses MAXScript in a number of ways. One is to access and repeat previous actions that have been recorded with the Macro Recorder. Another is to create custom toolbar buttons that can execute a series of steps. The more ambitious user can create custom interface elements (dialog boxes with rollouts, list boxes, and so on). Because there are so many intertwining approaches to using the MAXScript toolset, it doesn't make sense to pretend to organize them. Instead, it's best to jump right into an exercise that will give you a feel for what is possible.

Macro Scripts Behind Toolbar Buttons

If you've been using the buttons on the Tab panel, you've already been using MAXScript. You will understand this by following these steps:

1. In the Objects toolbar on the Tab panel, right-click on the Box icon. Choose the Edit Macro Script command. A standard text editor window appears, as illustrated in Figure 2.9.

Figure 2.9
A text editor window with the Box creation Macro Script open. The Box creation script is only one of many object-creation scripts in this file.

2. Note that the name of the file is MacroObjects.mcr. This file is in the ui/macroscripts directory in your MAX 3 directory. It contains the scripts for the creation of all kinds of primitive objects, including the Box. Macro Scripts are only small units of MAXScript. Note the similarities between all these scripts—they all indicate a category, a tooltip (the flyout text), and the icon to be used by the button. This is the encoded information that is entered or edited in the Customize User Interface dialog box.

3. Right-click on the Box icon again and choose Customize. Take a look at the Customize User Interface dialog box that appears. As you can see in Figure 2.10, the Box is the Objects category, the tooltip reads "Box," and the icon is the first one in the Standard group. Confirm that this information is the same as in the Macro Script line highlighted in Figure 2.9.

4. Press the Edit Macro Script button at the bottom of the dialog box. The text editor window jumps to the front. If this window were not already open, the command would open it. Close the dialog box and look at the Box creation script. It consists of a single command between the opening and closing parentheses: StartObjectCreation Box. If you click on the Box icon in the Objects toolbar, this command executes, just as it does if you press the Box button in the Command panel with Create|Geometry| Standard Primitives|Box. Instead of clicking on the button, however, try executing the command directly from the text editor. Drag your cursor across the command to highlight it. Select only the command line between the parentheses. Next, press the Enter key on your number pad—not the main Enter key.

5. Two things happen. First, the MAXScript Listener window appears on your screen. You'll be getting to it shortly, but you can close it for now. Second, and more importantly, you are in Box creation mode. The Command panel has the Box button

Figure 2.10
The Customize User Interface dialog box with the settings for the Box creation button. Note that all these settings are encoded in the highlighted Macro Script line in Figure 2.9.

highlighted and your cursor is a cross hair, ready to draw a Box. Highlight and execute some of the other creation commands in the file, such as those for a Sphere or a Cylinder. This gives you a good sense of what MAXScript does. When a unit of MAXScript code is executed, it performs the designated commands. Close the text editor window.

Creating Custom Toolbar Buttons

At this point, you should understand the role that the MAXScript plays in the existing interface by providing the commands that execute when a toolbar button is pressed. Note that this does not apply to the buttons on the Main Toolbar, but instead to the buttons on all the other toolbars in the Tab panel. You can confirm this by right-clicking on the buttons. Those that are on the Main Toolbar do not provide a menu for editing the button or a Macro Script.

You can create your own Macro Scripts and package them in toolbar buttons. You can write the code yourself, of course, but you can create scripts automatically using the Macro Recorder. The Macro Recorder records actions that you take as MAXScript commands. These commands can then be easily packaged in the button. Take a look.

Using The Macro Recorder

You'll start by recording your steps and executing them from the MAXScript Listener. Follow these steps:

1. Open the MAXScript Listener from the MAXScript Menu on the menu bar. An empty Listener window looks like Figure 2.11. If, for whatever reason, your window is not empty, select the text and delete it.

Figure 2.11
The MAXScript Listener.

2. Enable the Macro Recorder in the MacroRecorder menu in the Listener. (You can also enable and disable the Macro Recorder from the MAXScript menu in the menu bar.) Once enabled, the Macro Recorder keeps track of every action you perform.

3. Pull the Listener panel off to the left side of the screen and create a Box in the standard way from the Create panel. Make the Box 50 units in all three dimensions, and then convert it to an Editable Mesh using the right-click menu. Turn off the Macro Recorder so that you don't record any more steps. At this point, your Listener panel should look like Figure 2.12.

Figure 2.12
The MAXScript Listener after recording the creation of a Box and its conversion to an Editable Mesh.

4. I don't think I'm alone in finding MAXScript a bit cryptic. The first command creates a Box object of the indicated dimensions and segmentation, and is not difficult to understand. But the second command, which converts the object to an Editable Mesh, is not readily comprehensible. One of the great advantages of using the Macro Recorder is that it gently introduces you to MAXScript. Delete the Box from your scene so that you can test the code. Select the first line and press the Enter key on your number pad (not the main Enter key). A Box is created and a confirming message appears in the bottom half of the Listener window, as seen in Figure 2.13. This message indicates that the Box is named Box01 in the scene.

Figure 2.13

Same as Figure 2.12, but the first line in the upper half of the Listener was executed to create a Box. A confirming message in the lower window indicates that the Box is named Box01.

5. Select the second line of code and execute it with the Enter key. The Box converts to an Editable Mesh. The response in the lower window now reads "undefined".

6. Delete the Box from your scene and execute both lines of code together. You can use the Select All command in the Edit Menu if you wish. The result is the same as when both steps are executed separately. Delete the Box from the scene again.

Creating A Toolbar Button

Now that you've created and executed a script, you can package it in a button for easy access:

7. Let's say that you often have a need for a cube that has been collapsed to an Editable Mesh. A good place to put it is on the Objects toolbar in the Tab panel. Open the Objects toolbar. Select both lines of code in the upper window of the Listener and drag to the icon immediately to the right of the Box on the Object toolbar. A new button appears to the right of the Box with the standard MAXScript icon. Press this button and the script executes, creating the Editable Mesh.

8. Close the Listener to get it out of the way. Right-click on the button and choose Edit Macro Script. You see the same kind of text editor window that you would see for any

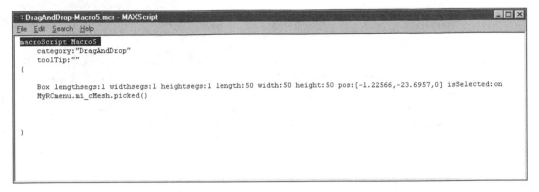

Figure 2.14
After packaging the script in a button, an MCR file is created to load as part of the regular interface.

of the standard buttons. Take a look at Figure 2.14. The file name is DragAndDrop-Macro5.mcr. Your number is certain to be different, although the rest of the name will be the same. The file is in the ui/macroscripts directory, along with all of the other scripts for the toolbar buttons. When you finish examining the code, close the text editor window.

9. The icon isn't very informative, and it would be meaningless if there were more than one on the same toolbar. Right-click on the icon and select Edit Button Appearance. The Edit Macro Button dialog box appears. The three possible MAXScript icons are equally unattractive. The best plan is probably to use a short text label and a tooltip flyout. Enter "Cube" as the text label and "Cube Mesh" as the tooltip, as shown in Figure 2.15. Press OK to accept your choice. Pass your cursor over the newly labeled button to confirm that the tooltip works.

Figure 2.15
The Edit Macro Button dialog box is used to give the new button a more informative text label and a tooltip flyout.

Using MAXScript To Build Custom Dialog Boxes

The real power of MAXScript is in building custom tools in the form of modeless dialog boxes. This subject is well beyond the scope of this book because it requires a combination of general programming skills with a strong knowledge of MAXScript's unique features. The best way to get started, however, is to look at some existing code that is supplied with MAX.

The Light Include/Exclude dialog box, available from the Lights & Cameras toolbar, was created in MAXScript. If you left-click on the icon, you see the dialog box that is shown in Figure 2.16. Note the organization of this dialog box as a single rollout with two sections and a Help button at the bottom. (Note also the misspelling of the word "Excludes" as "Exludes.")

Right-click on the toolbar button to edit the Macro Script. Although this code is much longer and more sophisticated than any you've seen so far, by carefully poking through it and comparing it with the dialog box, you can learn a great deal. For example, a block of code at the top, illustrated in Figure 2.17, defines the layout of the dialog box. The rollout is named and

Figure 2.16
The Light Include/Exclude dialog box is created in MAXScript and packaged in a button on the Lights & Cameras toolbar.

```
MacroScript Light_Include category:"Light Tools" tooltip:"Launch Light Include/Exclude" icon:#("Lights",6)
(
    Rollout Incl "Includes / Exludes"
    (
    local curlight
    local ex_names = #()
    local inc_names = #()|
    local foo = #()

    group "Geometry"
    (
        Radiobuttons inc_ex labels:#("Include","Exclude")
        pickbutton AssignToLight "Assign to Light"
    )
    Group "List Light Properties"
    (
        label l1 "Current displayed light:" across:2
        label sellight "none"
        pickbutton ViewLightExInc "Choose Light" across:2
        button clr "Clear Light" enabled:false
        Radiobuttons ltinex labels:#("Include","Exclude") enabled:false
        listbox lst "Objects" items:#() enabled:false
    )
        Button help "Help"
```

Figure 2.17
A block of code defines the layout of the dialog box. The rollout is named, and the "Geometry" and "List Light Properties" sections are defined as groups, with their components contained between parentheses.

the source of the misspelling is evident. The "Geometry" and "List Light Properties" sections are defined as groups, with their respective components contained between parentheses. The remainder of the code is directed at the operation and consequences of pressing the various buttons, primarily Assign Light and Choose Light, and contains some sophisticated logic and testing. This is a fantastic example of the way MAXScript can be used to add real functionality to the standard package. The List Lister (to the right of the Light Include/Exclude) is an even more powerful demonstration of using MAXScript to develop useful tools.

The Schematic View

MAX 3 has added a Schematic View of scene contents. This kind of graphical window, in which scene elements are arranged in movable nodes, has long been a characteristic feature of the highest-tier commercial 3D packages (for example, Softimage and Maya). In these programs, a Schematic View is necessary and invaluable, and is used at every level of development from modeling through animation.

It's hard to say whether MAX's new Schematic View will play the same central role in the program. MAX already has Track View and the Select Objects dialog box, and these are very serviceable tools for getting around in a scene and maintaining a sense of organization. My guess is that many experienced MAX users will make sparing use of the Schematic View because their habits are already set. Yet another factor that may inhibit the use of the Schematic View is the very complexity of MAX's internal organization. All applications have object hierarchies and materials linkings, and many have instancing. MAX's modifier stack is unique to the program, however. In the NURBS area, MAX uses a basket approach, in which surfaces and curves are subobjects. In short, a schematic representation of such a complex network of relationships can be overwhelming.

Figure 2.18
A portion of the Schematic View of a single NURBS object (a quarter piston) from the NURBS piston project illustrated in the color section of this book. Due to the dependencies between subobjects, the same surfaces and curves are represented many times.

Figure 2.18 illustrates only a portion of the Schematic View of a single NURBS object (a quarter piston) from the NURBS piston project illustrated in the color section of this book. The object, although fairly complex, is not nearly as complicated as the Schematic View might suggest. Due to the network of dependencies between NURBS subobjects, the same surfaces and curves reappear multiple times as nodes in the Schematic View.

Despite its drawbacks, MAX's Schematic View is advantageous because it teaches you the logic of the program. It's in this spirit that I offer an exercise to introduce you to the Schematic View's basic use and operation.

Objects And Object Hierarchies

The simplest use of the Schematic View is to keep track of top-level objects and arrange them into parent-child hierarchies. This is particularly true of intensely hierarchical structures, such as character skeletons. Start by linking and unlinking objects by following these steps:

1. Create a Box on the groundplane and open a Schematic View, either from the Main Toolbar or from the Schematic View menu on the menu bar. A node named Box01 appears in the Schematic View.

2. Create a Sphere in the scene and switch to the Modify panel. Double-click on each of the nodes in the Schematic View and note that this selects the corresponding object in the scene. The node for the selected object is given a white border. Figure 2.19 shows the Schematic View with the Sphere object selected.

3. Note that each node has an icon that identifies the nature of the object and a label that indicates its name. To change the name in the Schematic View, you have to

Figure 2.19
Schematic View of a scene with the Box and Sphere object nodes. The Sphere object is selected in the scene, and the corresponding node is bordered in white.

understand the difference between selecting the object and selecting the node. Right now, the Sphere object is selected and its node is selected. The white border indicates object selection and the yellow color of the node indicates node selection. Click just once on the Box node. It turns yellow, indicating that it is selected. The Sphere node is still bordered in white, however, so the Sphere object remains selected in the scene. Confirm this by looking at the Modify panel.

4. Click a second time on the Box node. You are now permitted to rename it. Call it "MyBox" and press the Enter key. Double-click on this node to select the object and note the new name in the Modify Panel.

5. Link (parent) MyBox to the Sphere. Press the Link button on the Schematic View toolbar to activate it. Click and drag from MyBox to Sphere01. Click on the arrow (Select) button on the toolbar to get out of Link mode. As illustrated in Figure 2.20, the parent-child hierarchy is reflected in the Schematic View by a green arrow extending from parent to child.

6. To break the link, make sure that the MyBox node is selected. Even if the object is selected and the node is bordered in white, you still need to select the node. If it's not yellow, click on the MyBox node to select it. (This distinction between selecting objects and selecting nodes takes some getting used to. You can force the joint selection of nodes and objects by pressing the Synchronize Selection button in the toolbar.)

7. Press the Unlink Selection button on the Schematic View toolbar. The hierarchical link is dissolved, and the two nodes are once again unconnected.

Figure 2.20

The renamed MyBox object is linked to the Sphere in the Schematic View. A green arrow indicates the link from parent to child.

Modifiers And Instances

The Schematic View contains nodes for every modifier on an object's modifier stack and can indicate instancing between modifiers on different objects. Let's continue the exercise:

8. Select the MyBox object by double-clicking on it (a white border will appear around it). Press the red down-arrow beneath the node to open it up. As illustrated in Figure 2.21, the node appearing beneath MyBox is named Box and represents the underlying parametric object. It's connected to the MyBox node by a red arrow. In the Schematic View, the direction of this red arrow is considered to be *downstream*.

9. The Box node represents the object at the bottom of the modifier stack. To confirm this, convert MyBox to an Editable Mesh. You can't do this in the Schematic View, so do it from the Edit Stack button in the Modify panel or from the right-click menu from the selected object in a viewport. When you're done, note that the former Box node is now named Editable Mesh in the Schematic View.

10. Put a Bend modifier on the stack of MyBox in the Modify panel. Then, put a Twist modifier on top of the Bend. Take a look at the Schematic window. As shown in Figure 2.22, the two modifiers are added as nodes beneath a node named Modified Object. This represents the entire modifier stack.

11. Double-click on each of the modifier nodes to select the modifier. Once again, this is different from selecting the node. A single click selects a modifier node, causing it to turn yellow. A double-click selects the modifier itself. (Once again, the Synchronize Selection option eliminates this distinction.) A purple border appears around the node and the selected modifier appears in the Modify Panel. You can also select the underlying Editable Mesh object in this way.

Figure 2.21
The MyBox node is expanded downstream to reveal the underlying parametric Box object.

Figure 2.22
The MyBox object is converted to an Editable Mesh, and Bend and Twist modifiers are added to its stack. The chain of nodes represents the entire modifier stack under the node named Modified Object.

Note: The direction of the arrows in the Schematic View seems counterintuitive, at least to me. It makes sense to think of the base objects flowing downstream through the modifier stack and finally out to sea as a finished object. Yet the Schematic View treats this process as moving upstream.

12. To hide everything downstream of the finished object, click on the MyBox node at the top to select it. Press the Toggle Visibility Downstream button on the Schematic View toolbar to hide all of the downstream nodes. Now, press the red down-arrow button beneath the MyBox node to reveal only the next node in the stream (Modified Object). Select this node and press the Toggle Visibility Downstream button again. This reveals all the downstream nodes.

13. Select the Sphere node and delete the object from the scene by using the Delete Objects button (the X) on the Schematic View toolbar. In a viewport, create an instance of the MyBox object by moving it, with the Shift key held down, and selecting "Instance" as the clone option. The new object node (MyBox01) appears in the Schematic View. Note that arrows now appear to the right of all the downstream nodes of the original MyBox object.

14. Select the new node by clicking on it and expand it downstream with the Toggle Visibility Downstream button. Because you created an instance, both objects share identical modifier stacks. The arrows are indications that a node reflects an element that is shared by more than one object. Click on one of the arrows next to a Bend modifier. Both Bend modifier nodes are selected together. This is the only place in MAX where you can discover the location of all of your instances. Click again on the node to change the name to Bend01. Note that both names change together. Your Schematic View should look like Figure 2.23.

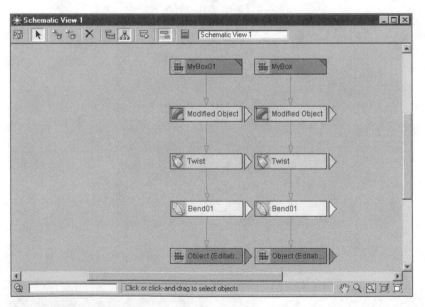

Figure 2.23
After deleting the Sphere object, the MyBox Editable Mesh object is instanced. Arrows in the Schematic View indicate the shared modifiers of both instances. Clicking on one of the Bend modifier arrows selects both nodes at once.

15. Select one (not both) of the Twist modifier nodes by clicking on it in the Schematic View. Press the Delete Objects button. The node, and therefore the modifier, is removed from the stacks of both objects.

The Isolate Tool

The Isolate tool is a little thing that makes a huge difference. Because MAX integrates modeling and layout in a single interface, you are constantly faced with the hassle of hiding everything in a scene except for a single object that requires modeling (or materials) attention. The Isolate tool, introduced in MAX 3, solves this problem in a stroke.

This important tool is found on the Control-right-click menu (hold down the Ctrl key when you right-click) for a selected object. The screen is redrawn with only the selected object visible and a small dialog box titled ISOLATED. Press the Exit Isolation button to return to the full scene. I don't understand why this tool is not more prominently highlighted in the interface. (While you're at it, note the variety of other handy commands in the Control-right-click menu, especially the one that calls up the Material Editor.)

Moving On

In this chapter, you became familiar with a number of important interface features, most of which are new to MAX 3. You saw how to use the toolbars in the new Tab panel and how to customize the user interface to better suit your personal requirements. You then learned a bit about MAXScript, seeing how Macro Scripts are packaged in toolbar buttons. You discovered how the Macro Recorder can be used to generate Macro Scripts for custom toolbar buttons, and you looked briefly at how MAXScript is used to create dialog boxes.

You also looked at the new Schematic View and learned how scene elements can be operated on within it. Finally, you took note of the exciting new Isolate tool that clears that scene of all but the selected object.

In the next chapter, we start developing the core skillset of the MAX practitioner, learning the huge variety of tools available for the selection and transformation of objects in a scene.

PART II

WORKING IN MAX

SELECTION AND TRANSFORM TOOLS

For all its glamour, 3D graphics and animation is painstaking work. For every minute you spend in creative reverie, you must spend hours meticulously selecting and manipulating objects and their components.

If you're not fluent in MAX's selection and transform tools, your artistic dreams will collapse in the frustration of practical execution. But if you're comfortable with these most basic of tools, your thoughts can flow unimpeded. The fundamental challenge of computer graphics today is in the mastery of powerful and complex interfaces at a level that permits creative play. That's why learning powerful applications like Studio MAX requires countless hours of practice beyond the initial intellectual understanding of the tools.

In this chapter, you'll get a firm handle on the tools that permit you to select and transform objects and subobjects.

Selection Methods

You can judge a 3D package by its selection tools, and MAX's are the best. Like all 3D applications, which are based on the concept of objects, you must select an object before you can act on it in any way.

Direct Methods: Clicking Or Dragging

The simplest way to select an object is to click on it. As you pass the cursor over a selectable object, the cursor changes from an arrow to a cross. To select the object, left-click when you see the cross. Rather than clicking on the object, however, I often find it easier to drag a rectangle so that it intersects the object. Dragging uses the region selection tools, which I'll discuss later in this section, to select only a single object. To select the object, left-click just off the object, and then drag your cursor over the object and release.

> **Note: To select by clicking or dragging, you must be in select mode. The arrow button on the Main Toolbar will do the job, but the Move, Rotate and Scale buttons also take you into Select mode. This saves a step because you don't have to use two different tools when you want to select an object and move it.**

Picking An Object Off A List

Direct methods are fine when your scene is not crowded; once it starts filling up, however, you'll often find it easier to pick an object off a list by name. Although the Select Objects dialog box is available from the Main Toolbar (the flyout reads "Select by Name"), you should get comfortable with using the H key to grab this tool. Some hotkeys are really important, and this is one of them. The easier it is to access the Select Objects dialog box, the more likely you are to use it. This dialog box is the object selection control center that has many useful features, but the filter feature is surely the most indispensable. You can filter the list so that only certain object types are shown. When you have a scene packed with dozens of elements and need to find a certain light, choose to view only the lights in the dialog box.

The Selection Filter drop-down box in the Main Toolbar allows you to apply the same mechanism to regular selection with the cursor. The default is All, which permits you to select all types of objects with the mouse. But if you narrow the filter down to select (for example) only lights, all other types of objects become unselectable. A combo option allows you to combine the selectable classes of elements—lights and helper objects, for example. I find that this tool is most useful when I am faced with a crowded scene in which the objects are not properly named (so that it would be difficult to pick them from the Select Objects dialog box).

USING TRACK VIEW FOR SELECTIONS

Track View can also be used for selections. If you are not already using Track View in your scene, it's easier to use the Select Objects dialog box, but if Track View is already open, why clutter the scene with another window? Don't get confused: Objects appear in Track View with a small icon immediately to the left of the object name. Clicking on the name does not select the object in the scene—it only selects the track in Track View, and you must click on the icon to select the object. You'll find Open Track View on the menu bar.

Once an object is selected, you deselect it by left-clicking on an empty part of the scene. As a consequence, it's easy to lose a selection. Learn to press the spacebar to lock your selections. The yellow lock button at the bottom of the screen lights up, telling you that you can't change your selection until you unlock, either by pressing the spacebar again or by clicking on the lock button. Selection locking is especially important when you have made a complex selection of multiple objects that would be great trouble to reselect. But if you forgot to lock and you lose a selection, don't be distressed. A single undo (use Ctrl+Z) will restore the selection. And this time, don't forget to use the lock (don't forget to unlock, either). I'm always clicking on objects that don't respond, only to remember that my current selection is locked in.

Selecting Multiple Objects

Thus far, I've covered selecting only individual objects, but multiple objects can also be selected together. One way to do so is to select a single object and then hold the Ctrl key down to select other objects and add them to the selection. If you want to remove an individual object from a multiple selection, hold the Alt key down while clicking on the object. Another

way to handle multiple selections is with the region selection tools. As already mentioned, you can click and drag a rectangle to select items in the rectangle. There are two possibilities:

- If the Crossing Selection option is used (this is the default), MAX will select any objects that are either partially or entirely within the rectangle.

- With the Window Selection option, objects will be selected only if they are entirely within the rectangle.

The choice between these options can be made from the toggle button at the bottom of the screen or from the Edit menu in the menu bar.

The Edit menu has some other important selection tools. From this menu, you can choose one of the following:

- Select All

- Select None (which clears your selection)

- Select Invert (which deselects your selection and selects everything else)

These tools are most useful when working with subobject geometry. An essential concept in MAX is the distinction between the object as a whole and its subobject elements. If you create a box, you can select and operate on the box as only a single unit, unless you choose to access the subobject elements—meaning the vertices, edges, and polygonal faces of which the box is composed. But once you have accessed the subobject level (the faces, for instance), you still need to select the specific faces before you can act on them. Often, you'll need to select all of the faces (for example, to flip their surface normals); the Select All option in the Edit menu will do the job. That way, you know that you got them all.

> Note: When you're in a Sub-Object mode, the Select All option selects all of the subobjects in the object, not all of the objects in the scene. The Select None option deselects the subobjects without deselecting the object itself.

Using Named Selection Sets

MAX has great tools for preserving multiple selections so that they can be easily recalled. After making a multiple selection, type a descriptive name in the Named Selection Set box in the Main Toolbar. Now, deselect to clear your selection and see if it worked. Check the drop-down list in the Named Selection Set box to find your selection and, voila! Your multiple selection is back.

You can edit the selection sets in the Edit Named Selections dialog box, found through the Edit menu. A list of all the named selection sets appears, which you can combine to make new sets. You can also enter individual selection sets to remove members or add new ones. The Select Objects dialog box is another place to access selection sets. If you choose a named selection set from the drop-down list in the Select Objects dialog box, the members of the selection are highlighted. You can add or subtract from this list to create a new selection set that you can then name in the box in the Main Toolbar.

Using Selection Sets For Subobject Editing

The most important practical use for selection sets is at the subobject level. Because it can be very difficult to select a large number of specific vertices, edges, or faces in a polygonal object, make sure to create a named selection set after they are selected.

The Named Selection Sets tool is sensitive to the object level at which you are working. If you create a selection set of vertices in a given object, for example, the name will not appear in the Named Selection Sets box unless you are at the vertex subobject level. You will not find the name if you are in the faces or edges level or if you are at the object level. At the object level, all the selection sets of objects become available.

The selection editing tools in the Edit menu are especially valuable with subobject selection sets because you often need to combine or divide up vertex (or other subobject) selection sets for management in detailed, mesh-level modeling. Nothing can be as frustrating as discovering, after hours of tedious point-pulling, that you mistakenly ignored a vertex or two that was barely visible in a complex mesh. Named selection sets help keep you organized, and they are the markers of professional work habits.

Grouping

Grouping, a very important concept in MAX, is not often clearly understood. I'll start by discussing the idea of parenting.

Grouping Vs. Parenting (Linking)

If one object is parented to another, the first object (the child) becomes part of the transform system of the second object (the parent). If the parent object is now moved, rotated, or scaled, the child object is also moved, rotated, or scaled, just as if it were a part of the parent object. Parenting multiple objects to a null (nonrendering) object is a basic method of organization in all 3D graphics applications. This method creates a functional group, because by transforming the parent null object, you transform all members together.

The traditional parenting method is implemented in MAX by creating a Dummy object (a MAX object that is a type of null object) and parenting (*linking* in MAX terminology) multiple objects to the Dummy. When you select the Dummy, you have functional control over all of the child objects as a unit.

The most important thing to understand about the grouping method in MAX is that it creates precisely the same structure as when the traditional method is used. Check it out yourself to see. Create two objects (boxes, for example), and then group them by selecting them together and selecting Group from the Group menu. Name the group Both. To see how MAX has handled this internally, go to the Summary Info panel in the File menu. You'll see that a Dummy object, Both, has been created, and this Dummy, as the parent to the group members, is functionally the group itself.

Note: The Summary Info panel doesn't show the hierarchical relationship between the Dummy and its children. To see the relationship, open Track View from the menu bar or the Main Toolbar and note how the Dummy object is the parent of the group members.

So why use MAX's groups rather than the traditional method? First of all, it's often easier to select and group a number of objects than it is to create a Dummy and link (parent) all of the objects to it. Second, selecting a group is easier than selecting a parent Dummy. When objects are grouped, you need only to select any one of the objects to select the group. This creates a functional unit that is easily treated as a whole. MAX's modeling tools invite the user to create complex objects by assembling simpler ones into a package, and grouping effectively creates a higher-level object composed of other objects as its components. In fact, you'll find only the group-level object in the Select Objects dialog box, packaged in brackets. Accordingly, if you need to reach into the group and select one or more of the component objects for some operation, you need to get access.

Working With Groups

To gain access, open a group from the Group menu, and once open, the member objects are available for individual selection. Refer to the Select Objects dialog box to find the list of members now individually selectable. A selected object can be operated on in any way, and it can even be detached from the group by using the command in the Group menu. When your work is done, the group can be closed back up. Opening a group preserves the group while you work with members, but ungrouping eliminates the group altogether. It's possible to create nested groups by grouping separate groups together into a larger unit. To ungroup such units completely, use the Explode command; all of the component objects at every level will be ungrouped.

It's also easy to add new objects to a group using the Attach command in the Group menu. Select an object (which can be a group itself) and click on the Attach command. Now, click on the group you want to add the object to and watch the bounding box expand (in the Perspective view) to include the new object.

CHOOSING AMONG GROUPS, PARENTING, AND SELECTION SETS

It's tempting to seek ready rules of thumb about when to use groups, when to use named selection sets, and when to use traditional parenting to a null object, but individual tastes will often be the most important factor in choosing between these overlapping methods. Artists who come to MAX from other 3D applications may already be so familiar with traditional parenting that they are reluctant to change their practice. And with traditional parenting, you don't need to open a group to select a member. By simply selecting the member, rather than the parent null, you have complete control over that object. So selection sets and traditional parenting may be more useful when you're working more with the component objects and less with the unit as a whole.

Transform Tools

One of the most important actions you can take with an object is to transform it. A 3D artist must have a very firm understanding of the concept of transformation. In the traditional and well-established terminology of computer graphics, the three transforms are called translation, rotation, and scale:

- *Translation*—The MAX interface refers to translation as "move," and I'll use both terms in this book to make sure that you understand the connection. To translate or move an object is to reposition it in the space of the scene, without changing its orientation with respect to a fixed system of coordinates.

- *Rotation*—To rotate an object is to change its orientation with respect to the coordinate system.

- *Scale*—To scale an object is to resize it along any or all of the three coordinate axes.

But this is all talk. A deep understanding of transforms comes out of practice and from discovering the connections between the specific transforms (move, rotate, scale) and the related concepts of coordinate systems and pivot points and coordinate systems.

Understanding Coordinate Space

When you start a new scene that is empty of all objects, there is a framework called *world coordinate space*. A point is established called the *origin*. From this point, you extend three rays, each perpendicular to the other two. These rays point in the directions called x, y, and z. In MAX, the z-direction is up, the x-direction is toward the right, and the y-direction moves in depth, toward the back. Thus, the negative z-direction is down, negative x is toward the left, and negative y moves toward the viewer. All this assumes, of course, that you stay in the position you were in when the scene was first created. If you swing around the back to look toward the origin from the other side, the positive y-direction points toward you and positive x points toward your left, rather than your right.

> **Note: The arrangement of world coordinate space in MAX is different from many other programs, in which the y-direction is vertical and the z-direction is depth.**

Just as there is a point (the origin) that is the key to world space, and three perpendicular directions are associated with that point, so does each object have its own center point and set of perpendicular directions. This point is called the *pivot point*. When I say that an object is located at a certain position, say (30,55,–110) in world space, I mean that its pivot point is located 30 units in x, 55 units in y, and –110 units in z from the origin, which is at (0,0,0). When you rotate an object, the object will move in a circle around its pivot point. If the pivot point is in the center of the object itself, the object will rotate, just as the earth rotates every 24 hours. But if the pivot point is located outside the object, the object will circle the point similar to the way that the earth revolves around the sun every year.

Scaling, which is the least-used of the transforms, can be confusing. Scaling appears to simply make the object bigger or smaller by moving the vertices of the object together or apart, in one or more directions. But this is deceiving. The vertices of an object are defined by their locations in local coordinate space—that is, by their distances in x, y, and z from the object's pivot point. When you scale an object, you do not change these numbers directly; instead, you apply a multiplier to them. In most other 3D applications, this difference has little practical significance, but in MAX it is very important because of MAX's modifier stack approach to modeling.

The modifier stack is processed (or in MAX terms, "evaluated") before any transforms are applied. Thus, the scaling (or multiplication of the size) is applied only after all the modifiers have been applied. This process can lead to some very unexpected results: The object is scaled nonuniformly, meaning that it is scaled unequally in the x-, y-, and z-directions.

Figure 3.1 shows a box object and then a copy of that same box object with a Bend modifier applied. Because the dimensions of the box were fixed before the modifier was applied, the result makes sense.

In Figure 3.2, I start with a box of the wrong size, and then scale it, nonuniformly, to the desired dimensions. When I put the same Bend modifier on, the result is quite peculiar. Even though I scaled the box before I put the modifier on, MAX processes the model by applying the bend to the original, wrongly sized box, and then scaling that result.

This problem is so basic to MAX that the program gives you a warning each time you attempt a nonuniform scale. Of course, if you're done with modeling in the modifier stack, and you intend to scale only the final result, there is no difficulty. But if you need to work a change of scale into the modifier stack, there are two ways to deal with the problem. I wanted to scale the box before any modifiers were applied, so I could simply have changed the creation parameters at the bottom of the stack in the Modify panel. This is effectively the same thing as creating a completely new box with the correct dimensions to begin with. But if I wanted to scale at some stage during the modification process, I could apply an XForm modifier and scale the modifier's gizmo. You'll run into the XForm modifier many times. This modifier moves the transforms into the modifier stack, and it is used to solve many problems that result from the general rule that transforms are applied only to the output of the modifier stack.

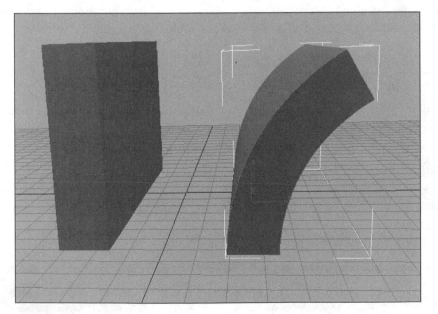

Figure 3.1
Box and copy with Bend modifier applied.

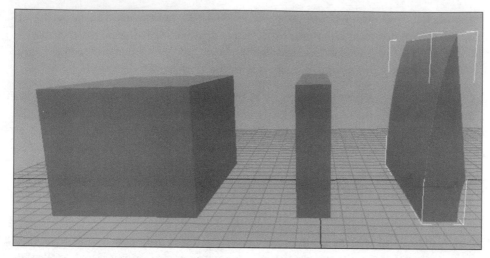

Figure 3.2
Original box, copy scaled to desired dimensions, and scaled copy with Bend modifier applied.

Selecting Transform Tools And Constraints

The transform tools can be selected from the Main Toolbar, although I find it easier to get them by right-clicking on the selected object. There's only one choice for move (translate) and rotate, but there are three choices for scale: Uniform scale operates equally in all three dimensions; Non-Uniform scale adjusts only the selected dimensions; and the Squash option preserves the volume of the object as you scale. If you compress it in one dimension, it expands correspondingly in the other two dimensions. This is a special kind of nonuniform scale and it raises the same kinds of modifier stack problems that I just discussed. The choices among the three kinds of scaling are available only in the Main Toolbar, not in the right-click menu.

A selected transform tool will operate only in the dimensions that you choose. You can choose x, y, z alone, or you can select pairs of xy, yz, and xz to permit operation in two dimensions. This latter option is fine for translations and scaling, but rotations generally make sense around only one single axis at a given time. These *constraints* (as they are called) can be selected on the Main Toolbar.

However, MAX 3 has introduced a much superior method of handling constraints. When objects (or subobjects) are selected, an axis-like Transform Gizmo appears that permits you to interactively choose from all the possible constraints as you transform the object. Moving the cursor over this tool toggles its different options, which light up to indicate the current constraints. It's all so easy and obvious that there will be little reason to use any other method.

Note: The constraints are also available from the right-click menu on selected objects, making it easy to choose both a transform tool and a constraint at the same time.

MAX permits you to disable any of the three transforms for any or all of the three dimensions by setting locks. These locks are found, for a reason not entirely clear to me, in the Link Info panel under the Hierarchy tab in the Command panel. Check the lock option for the move transform in x and y, and you'll be allowed to translate your object only in z, but there's a trick that makes this all rather confusing. The locks apply only to the local coordinate system, so if you're in that system, things make sense. But if you are in another system, such as world or view, you're bound to be surprised, at least at first. The object will be permitted to move only in the unlocked local directions, which, if the object has been rotated, will have no relation to the axes shown on the screen.

HOW DO I ENTER EXACT TRANSFORM VALUES?

To enter transform numbers explicitly from a dialog box, right-click on the selected transform mode (or choose Transform Type-In from the Tools menu). This is a good way to put an object in a precise place in world space, or to enter an exact amount of rotation or scaling. I always use this tool to snap objects to the center of world space or to snap points precisely to a coordinate axis. It's also the best way to get transform information about your object, even if you don't intend to change it. See the "Resetting Transforms And Bounding Boxes" section later in this chapter for more information on using this important dialog box.

Choosing A Coordinate System

MAX has a way of giving you so many choices that things can get bewildering for the poor 3D artist. Frankly, I admire anyone who has truly mastered the list of MAX coordinate systems. I'll try to handle this subject in a practical way that doesn't pretend to cover all the possible ground.

View

The default coordinate system, view, is both confusing and useful. The view coordinate system is a combination of 2D and 3D elements. The orthographic (nonperspective) windows are treated in 2D, with y as the vertical dimension and x as the horizontal one, just like the pieces of graph paper that you used in high school math. As you jump from one orthographic window to another, the coordinate axes change, as necessary. If the constraints are set to XY, it is easy to do translations. You never need to change your constraints as long as you remain in the orthographic windows, because each window is inherently aligned to the XY plane when you enter it. However, the perspective window retains world space coordinates, so that the 3D view of the scene makes sense. In the perspective window, z is vertical, x is horizontal, and y is depth (at least, before you rotate the view). After a while, you'll get used to using View coordinates (even if you never really understand them) because they are a practical solution to working in a combination of orthographic and perspective windows.

Screen

The screen coordinate system applies the view coordinate concept to the perspective as well as the orthographic view. To understand how it works, create a box in the Perspective window. Now, rotate your perspective view around and look at the coordinate axes. The axes in the Perspective window remain square to the screen and are no longer aligned to world

space. Note how the axes drift around the orthographic windows as you rotate your perspective view. When you enter an orthographic window, however, the axes square right up, just as in view coordinates.

The screen coordinate system is useful because it allows you to rotate the scene in a perspective view and move objects or subobjects across the face of the screen. This will often be the easiest way to move vertices or NURBS (Non-Uniform Rational B-Splines) control points on the surface of a complex object.

World And Local

The world and local coordinate systems are pure 3D. They don't change as you jump from window to window, because they are tied to the underlying 3D scene, not to the 2D viewport through which you happen to be (virtually) looking. Once a scene starts getting complicated, and I want to understand where things are located, I'll typically abandon view coordinates for the world or local system. The world system is the best for moving (translating) objects around the scene because the visible axes are constant for all objects. The z-axis is up for every object, regardless of the orientation of its own pivot point. But rotations are usually best done in local space, so that they are made around the axes of the object's own pivot point. I'll try and make this clear.

Figure 3.3 shows two identical cones. When they are first created, their local coordinate systems are square with the world coordinate system, and there is no difference between using world or local systems at this stage.

Next, in Figure 3.4, both cones rotate around their y-axes—look at the result when using local coordinates (notice how the local axes have rotated).

Finally, in Figure 3.5, the left cone rotates around the z-axis by using world coordinates, and the right cone rotates around the z-axis by using local coordinates. Both objects rotate

Figure 3.3
Two identical cones before any rotations. Their local axes are square to the world coordinate system.

Figure 3.4
The cones from Figure 3.3 rotated around their local y-axes, which are initially the same direction as the world y-axes.

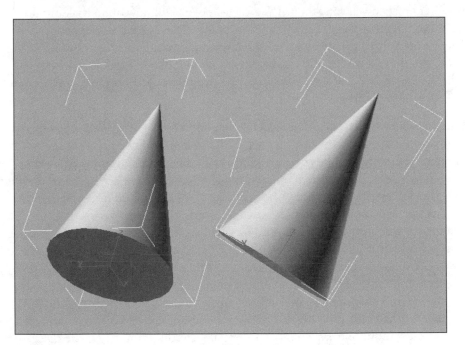

Figure 3.5
The left cone rotated in the world z-direction (around an axis pointing straight up) and the right cone rotated around its local z-axis (a line pointing toward the tip). Both objects display their local coordinate axes for reference.

around their respective pivot points, but the direction of the rotations is entirely different. The cone on the right has rotated around its own z-axis, whereas the one on the left has rotated on an axis that is parallel to the world z-axis (one pointing straight up).

Less-Used Coordinate Systems: Parent, Pick, And Grid

The remaining coordinate systems are much less commonly used. The parent coordinate system aligns an object's axes to the coordinate system of its parent object. If the object is not linked (parented) to another object, the world coordinate system is used when the parent coordinate system is chosen, because unparented objects are effectively the children of the world. But if the object is a child of another object, and the parent object has been rotated with respect to the world coordinate system, the child object's axes will be similarly aligned. I have not found much use for the parent coordinate system. By parenting (linking) one object to another, the parent's local system is typically used for the rotation of the entire hierarchy, and the child object necessarily follows that system. If the child is to be transformed relative to its parent, there is generally no need to use the parent coordinate system to do so. It generally makes more sense to use the child's local system for rotation and scaling, or the world system (or view system, if you prefer) for translation.

The pick coordinate system is much like the parent coordinate system, in that the coordinate axis of one object is aligned with another. But unlike the parent option, the two objects don't have to be hierarchically linked. Select an object and choose the pick coordinate system; then, pick another object by clicking on it. The selected object will now align its coordinate system with that of the picked object, and the name of the picked object will appear in the Reference Coordinate System drop-down box. The name (and, therefore, the coordinate system) is added to the drop-down list and can be directly assigned to other objects without going through the pick process again. Or you can pick another object's coordinate system by selecting the Pick option again.

Grid coordinates are another creature altogether. If you don't create other grids as helper objects, the only grids you see on the MAX screen are those defining the planes of the world coordinate system. These are the grids against which you typically create, edit, and transform objects. If there are no grids other than this "home grid," or if you have created another grid as a helper object but the home grid is the active grid, the grid coordinate system is exactly the same as the view coordinate system. In other words, the x- and y-directions are aligned to the face of whatever orthogonal window you happen to be using, but the Perspective window uses world coordinate space. If you have created another grid and made it active, the grid coordinate system is aligned to the grid. The x- and y-directions are on the grid and the z-direction is perpendicular to it. If you then align your orthogonal viewports to the grid by using the grid view options, the entire setup is precisely equivalent to the view coordinate system for the home grid. In sum, the grid coordinate system allows you to use the very practical view coordinate system, with its unique combination of 2D and 3D systems, for grids other than the home grid. Grids are discussed in more detail in Chapter 4.

Coordinate Systems For Animation

It's extremely important to understand which coordinate systems MAX uses in its animation controllers. Sometimes, the animation data in Track View will seem incomprehensible because you've been transforming scene elements by using whatever coordinate systems seem most convenient or logical. But MAX must inherently choose only one coordinate system when placing transform values in animation keys.

Animation move (translation) keyframes are computed by using the coordinate space of the object's parent. If you think about this for a moment, it should begin to make some sense. If the object is not parented (linked) to another object, it is effectively the child of the origin in world coordinate space. Thus, for objects that are not hierarchically linked, translation keyframes are stored in world space coordinates. So far, so good. But if an object is parented to another object, translation keyframes are computed in the parent coordinate system, measuring the distance from the object's pivot point to its parent's pivot point. This makes sense. If the parent is moved, the child object moves rigidly along, maintaining the same distance between the pivot points. The animation graph shows no change in the position value of the child object, even though it's moving in world space, because it's not changing with respect to the parent's position. The motion graph for the child object will change only if the child is translated relative to the parent.

The same goes for rotations, but the idea takes even more careful effort to grasp. If an object is not parented to another, the rotation keyframes are computed in world coordinates. This means that the orientation of the local axis (the pivot point) is compared with the world space axis as a baseline. This can be terribly confusing because it is usually easier to visualize rotations around an object's own local axes (because these axes rotate with the object and therefore remain oriented to it). But this advantage is precisely the reason why local coordinates cannot be used in animation keyframes. Animation graphing requires a fixed orientation, against which all rotations can be measured. This orientation can be obtained only from a reference coordinate system from beneath the object itself, typically the world system.

If the object is parented to another, the parent system is used for animation graphing. This makes good sense, as shown later in this chapter. When you rotate the forearm of the character relative to its parent's upper arm, you are concerned with the angle between the two units, not with the orientation of the forearm in world space.

> *Note: Rotations are a difficult subject in all 3D animation packages, but especially in MAX because MAX's default animation control, in an attempt to make things easier for the novice, takes a radical approach to animating rotations in a way that cannot be graphed. The capability to control animations through graphs is so essential that the default rotation controller (TCB Rotation), in my opinion, should almost never be used. The discussion here assumes the use of MAX's version of the graphable x, y, z animation controller (Euler XYZ) that is standard in every professional-level 3D animation package.*

Scaling is the exception. Animation keys for scale are always in local coordinates; thus, editing the animation graphs for scale in x, y, and z will expand or contract the object in the direction of its own coordinate axes.

Pivot Points

All of the transforms—move (translation), rotation, and scale—are premised on a specific point and a specific orientation with respect to world coordinate space. Pivot points determine both the location and orientation of an object for these purposes.

The True Pivot Point And Temporary Pivot Points

MAX has a unique approach to pivot points that is astoundingly flexible, but confusing to those who are relatively new to it. MAX has two kinds of pivot points. The first, which I call the "true" pivot point, is the most important and is generally the only one found in other 3D applications. It is the true center of the object's local coordinate system, and the directions of its three arrows define the x, y, and z axes of that system. In animation, the object is always transformed by using this "true" pivot point. We'll discuss the true pivot point in "The True Pivot Point" section later in this chapter.

But MAX also has a wide assortment of temporary pivot points, which cannot be used in animation, but find their use in modeling and the static layout of the scene. Although these temporary pivot points show up in so many places that they are difficult to categorize, I'll give it a try.

Temporary Pivot Points

I actually was talking about temporary pivot points in the discussion of the coordinate systems, although I did not refer to them as such. When an object is selected, the axes icon appears; if you scale, rotate, or translate, you see that the transform follows these axes. It's just as if this icon represents the true pivot point. But it may well differ from the true pivot point in either position or orientation.

Try your hand at the following exercise to get a feeling for working with the axes icon:

1. Create a box near the center of the home grid, but not precisely at the center. It doesn't have to be perfect.

2. Select the local coordinate system and rotate the box around one axis so that it's no longer square to the groundplane grid. Because you're in local coordinates, the axes icon should be at an angle.

3. Switch to world coordinates with the object still selected. The temporary pivot point remains in the same place, but it is no longer aligned with the object. (You already saw this situation with the cones in Figures 3.3 to 3.5.)

4. Immediately to the right of the coordinate system drop-down list are three icons that allow you to choose alternate locations for the temporary pivot point. The three options, from top to bottom, are Use Pivot Point Center, Use Selection Center, and Use Transform Coordinate Center. Hold the cursor over the icons for a second or so

to read their names. Use Pivot Point Center is the default, and thus the temporary pivot point (regardless of its orientation) is located where the true pivot is located. Change to the Use Selection Center option and watch the temporary pivot point jump to the center of the box.

5. With the Use Selection Center option still applied, change back to the local coordinate system. The temporary pivot point stays in the center of the object, but it is now aligned with the true pivot point, which is at the center of the bottom of the box. Rotate the box around an axis and note how it rotates around its center.

6. Still in local coordinates, change to the Use Transform Coordinate Center icon (the bottom one on the list). The temporary pivot point jumps back to the bottom, at the location of the true pivot point. This is the same as when you use the Use Pivot Point Center option, and this makes sense. In local coordinates, the center of the coordinate system is the true pivot point.

7. Now, change the coordinate system from local to world. The temporary pivot point jumps to the origin, the center of world space, and is once again aligned to the world coordinate axis. Rotate the box to see how it now circles the origin, rather than any point within the object.

By playing with combinations of local and world coordinate systems, as well as the three temporary pivot-location options, you'll gradually become comfortable with these tools. They allow you to easily make nonanimated tranforms without going to the trouble of moving or rotating the true pivot point. The coordinate system choices change the orientation of the temporary pivot point without changing its location. By contrast, three center choices change the location of the temporary pivot without changing its orientation.

Temporary Pivot Points With Multiple Objects

If multiple objects are selected, temporary pivot points take on an additional significance because they can be used to unify the selection into a single rotatable unit or to allow independent rotations of the separate objects.

USING THE SELECTION CENTER OPTION

The single most common use of the location options is to center the temporary pivot point in an object for rotation purposes. Many of the primitive objects in MAX are created with pivot points in the center of the initial 2D shape from which they are built, rather than in the center of the final object (the box, cone, and cylinder shapes are all good examples). MAX places the true pivot point in this manner because it is always possible to rebuild the object with modified creation parameters. The initial pivot point placement usually doesn't make sense for rotations, however.

Remember that the temporary pivot point is placed in the center of the bounding box, which is the tightest box that can completely enclose the object. For regularly shaped objects, this will generally be correct; but with irregular objects, the center of the enclosing bounding box may not be an appropriate rotation point. If so, you must move the true pivot point to the specific location you choose and use the Pivot Point Center option in local coordinates.

Try this exercise to get the idea:

1. Create two simple boxes on the groundplane and select them both by either dragging a rectangle around them or by adding selections with the Ctrl key. Choose the local coordinate system and select with the Use Pivot Point Center option (the default). The two temporary pivot points are at the bottom center of the boxes, which is where their true pivot points are located. Your screen should look like Figure 3.6. Note that you'll see the larger Transform Gizmo, rather than the smaller axes icons shown in the following figures, if a transform tool is selected. But either way, you're looking at the same temporary pivot points.

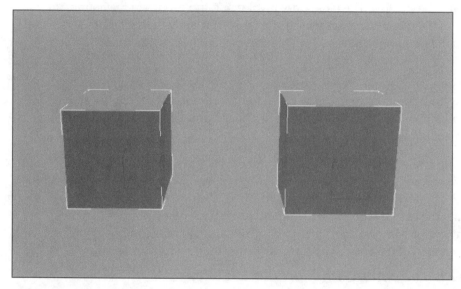

Figure 3.6
Two boxes selected together, using the local coordinate system and the Use Pivot Point Center option.

2. Change to the Use Selection Center option, and the two temporary pivot points will jump into the center of their respective objects.

3. Rotate the multiple selection around the y-axis, and both boxes will rotate independently around their own centers. Your screen should now look like Figure 3.7.

4. Undo the rotation with the Ctrl+Z hotkey or from the Main Toolbar so that your boxes are straight again. Now, change from the local coordinate system to the world coordinate system and notice what happens. If you are still in the Use Selection Center option, the two temporary pivot points are replaced by a single temporary pivot that is centered between the combined boxes. More precisely, this pivot point is centered in the bounding box enclosing both boxes.

5. Rotate around the y-axis and notice how both boxes now rotate as a unit, as shown in Figure 3.8.

Figure 3.7
Two boxes rotated around the local y-axis with temporary pivot points centered with the Use Selection Center option.

Figure 3.8
Two boxes rotated around a single temporary pivot point, using world coordinates with the Use Selection Center option.

Groups Behave Differently

Multiple object selections are very different from groups with respect to temporary pivot points. A group behaves just like a single object with a single true pivot point for the group and only a single temporary pivot point. Just as with a single object, the temporary pivot point may be oriented with different coordinate systems, and because the true pivot point is located at the center of the bounding box enclosing all the member objects, there is no difference between the Selection Center and Pivot Point Center options. There is no method of rotating the group members around their individual centers.

6. While still in world coordinates, change from the Use Selection Center option to the Use Pivot Point Center option. The two temporary pivots reappear, but are aligned to the world system rather than the local systems of the objects.

7. Now jump back to the local coordinate system to see the two temporary pivot points aligned to the local systems. Take a look at Figure 3.9.

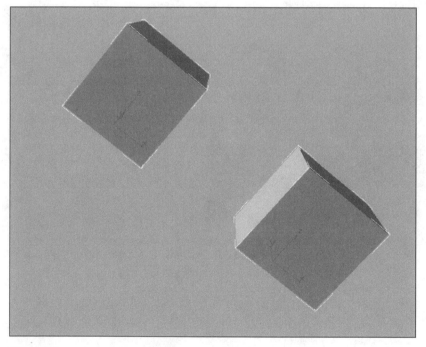

Figure 3.9
The rotated system in local coordinates, showing the location and orientation of true pivot points.

The True Pivot Point

The distinction I've been drawing between the true pivot point and temporary pivot points is important, but when MAX uses the term "pivot" in its interface and documentation, it refers to what I've been calling the "true pivot point." In the rest of the text, I'll use the term to mean what I've been calling the true pivot point, unless further clarification is necessary.

I've already mentioned that the pivot point represents the center of the local space of an object, that it indicates the precise point of translation in animation, and it is the center for scaling and rotation in animation. So it's pretty important. MAX has so many temporary pivot tools that you can often do a great deal of modeling and layout without ever touching the true pivot point. But once you start animating, you'll need to figure out where the pivot point is located and how it's oriented.

The pivot point controls are under the Hierarchy tab in the Command panel at the right of the screen. The following steps walk you through learning about these simple, but important, tools:

1. Create a box on the groundplane, enter the Pivot panel, and select the Affect Pivot Only button. The pivot point appears as a prominent x, y, z tripod. As in all 3D applications I know of, red is x, y is green, and z is blue. This is easy to remember because it follows the rbg (red-green-blue) order of digital color channels.

2. To convince yourself that this pivot point is different from the temporary pivot points discussed previously, make sure that you're in the local coordinate system and change to the Use Selection Center option in the Main Toolbar at the top of the screen. The temporary pivot point will jump to the center of the box, but the true pivot point, with the larger red-green-blue icon, remains in place, as shown in Figure 3.10.

Figure 3.10
The true pivot point remains in its original place, even if the temporary pivot is moved to the center (demonstrating that the true pivot point is unaffected by changes in the coordinate system or in the temporary axis location option).

3. Rotate the pivot point 45 degrees in z, using the local coordinate system. Always stay in local coordinates when you're rotating the pivot point or else you're certain to lose your mind. Using local coordinates assures that you are rotating around one

of the axes on the pivot point, because the local coordinate system is necessarily defined by the pivot point axes. If you have any doubt about this, try rotating in other coordinate systems—particularly the view coordinate system. Keep your sanity and stick with local coordinates for most kinds of rotations, but especially for rotating the pivot point independently from the object.

4. With the pivot point now rotated, the x and y axes are no longer square to the box. Figure 3.11 shows a top view in wireframe.

Figure 3.11
Top view of box, with pivot point rotated around z-axis. The x- and y-axes are no longer square to the object.

5. With the Affect Pivot Only mode still on, move the pivot to a corner of the box. Using the view coordinate system is very helpful here because you can jump from window to window without having to change your directional constraints (the XY option works in all of them). The result should look something like Figure 3.12.

6. Turn off the Affect Pivot Only mode by clicking on the button. The object is now locked to the pivot again; when you move or rotate, the object and its pivot point do so together.

7. Notice also how the object scales from the pivot point. If you try a uniform scale on the box, the pivot point corner stays put while the other corners expand away from it, as shown in Figure 3.13. This is another reason why the location of a pivot point is important.

The alignment and positioning features in the Pivot panel are quite straightforward. If you're in the Affect Pivot Only mode, you can snap the pivot point to the center of the

Figure 3.12
Rotated pivot point is translated to a corner of the box.

Figure 3.13
Scaling an object from a pivot point.

bounding box at the click of a button. As mentioned before, many MAX primitive objects are created with their pivot points on one plane of their bounding boxes, rather than in the center of that box. Although the temporary pivot tools allow you to rotate objects around their centers for layout purposes, rotations can only be performed around the true pivot point for animation. Path animation is often confusing if the pivot is not in the center of the object. Centering a pivot point is routine work. If you're in the Affect Object Only mode, the object is moved so that it's centered about the pivot, rather than moving the pivot to the center of the object. The Align To World button aligns the pivot to world space coordinates without rotating the object; if you're in Affect Object Only mode, it aligns the object (or rather, its bounding box) to world space without reorienting the pivot.

ADJUSTING THE OBJECT INSTEAD OF THE PIVOT

Just as you can detach a pivot point from its object and move or rotate it into a new position or orientation, you can also do the opposite. The Affect Object Only option in the Pivot panel leaves the pivot point alone as you transform the object. Occasionally, but not often, this will be easier than translating or rotating the pivot point. A good example is of an object that is already animated on a path so that the pivot point is locked to the path. To reposition the object relative to the path, select the Affect Object Only option to translate the object from its pivot.

A more important option aligns the pivot point to become square to the bounding box of the object, which is a good way of bailing out of the confusion that often attends the rotation of pivot points. Even with multiple viewports, it can often be difficult to determine precisely where a pivot is located and how it is oriented. The best test is often to rotate the object in different axes and see how it responds. If things get too confusing, use the Reset Pivot button to return the pivot to its initial position when the object was first created, and then start over.

Resetting Transforms And Bounding Boxes

Are you willing to delve into some of the central mysteries of 3D Studio MAX? There are many levels of understanding with this program, so you can easily feel overwhelmed. Sooner or later, you run into problems that can be solved only by getting deeper into the structure of the package. Let's walk through some exercises with the transform resetting tools, with an eye toward wading deeper into the MAX transform concepts.

Resetting Scale

The Scale Reset button is at the bottom of the Pivot panel. Try the following exercise:

1. Create a box on the groundplane.

2. Click on the scale icon on the Main Toolbar to activate the Scale mode. Choose Uniform Scale to start.

3. Before scaling the object, right-click on the scale icon to bring up the Numeric dialog box. Notice that the scale values on the left side of the box are all at 100 percent. This makes perfect sense because this is the baseline against which you'll work. Notice also how the values in the dialog box are in local coordinate space,

regardless of which coordinate system you may be using. (The offset values on the right side are based on your chosen coordinate system.) Leave this dialog box on the screen as you continue this exercise.

4. Scale the box uniformly by dragging the cursor and watch the values in the box change. Try to get to exactly 50 percent; if you can't, try entering the exact values by hand into the x, y, and z slots.

5. Notice how the right side of the box, with a single value, did not change—it remains at 100 percent. Enter 50 percent into this "offset" slot and see what happens.

6. The box was uniformly scaled a second time by 50 percent, reducing the absolute scale values to 25 percent. Thus, the box is 25 percent of its original size. The absolute values are relative to the original size of the box, which is preserved as a reference, but the offset slot jumps back to 100 percent. It has no memory, so if you want to bring the box back to 50 percent scale, you could enter 200 percent in the offset slot. Give it a try.

7. While you're still in the uniform scale mode, try something. Can you still do a non-uniform scale by entering different numbers directly into the dialog box? Type 100 percent into the x slot and see. It works!

8. Now, check this out. Drag on the x spinner (the up and down arrows to the right of the number) and watch the box scale in the viewports while the numbers in the box change. This is an excellent way to handle scaling because you don't have to move between uniform and nonuniform modes, and because you see your numeric values as you work interactively. MAX is full of techniques like this. You'll work a certain way for a long time, and suddenly discover that there are three or four other ways to do the same thing—often more effectively.

9. Take the next logical step by dragging the offset spinner to interactively scale in all three dimensions at once. This is great because you have complete control, and you can bounce back and forth between uniform and nonuniform scaling without leaving the numeric panel. Scale nonuniformly by dragging one of the absolute spinners; then scale uniformly by dragging the offset spinner.

10. Play with these interactive tools to scale the box to some dimensions that please you. Now, go to the Pivot panel and click on the Scale button in the Reset area. The values in the dialog box are all set to 100 percent, but the dimensions of the box are unchanged.

11. A new baseline reference for future scaling is created. Play with the spinners or type new values into the dialog box to check this out.

It's often a good idea to reset your scaling reference in this way because further modifications make more sense. This example is admittedly artificial because it would make much more sense to change the box's creation parameters, which is effectively the same as creating a new box with the desired dimensions. Test this out by playing with Length, Width, and Height spinners for the box in the Modify panel, and notice how these changes do not affect

the scale values in the Scale Transform Type-In dialog box. Scaling is a transform that is applied after the box is generated by its parameters. But the vast majority of your models will not be simple parametric boxes, and there will be no alternatives to scaling. For these models, resetting scale creates a new baseline for further work and for animating scale.

Resetting Rotation For Objects And Bounding Boxes

If you worked through the exercise in resetting scale in the previous section, you can probably figure out where the following exercise in resetting rotation is headed. Resetting rotations exposes you to the concept of orienting the bounding box independently of the orientation of the object. You may remember from earlier in this chapter how the pivot point can be aligned to the object, which really means that it is aligned to the object's bounding box. The following exercise will ultimately bring you to an important level of understanding about the relationship between objects, bounding boxes, and pivot points:

1. Create a box on the groundplane. (Yeah, I know—a box again. But a box is the best object for visualizing rotations and scaling.) Make the box noticeably unequal in length, width, and height so that you can better follow the effects of rotations.

2. Because you're going to do rotations, get into the local coordinate system. At this stage, the pivot point icon will still be aligned with world space (z will be up, and so on). Click on the Rotate button to get into the Rotate mode, and right-click on the same button to bring up the Rotate Transform Type-In dialog box for rotations. All the values are at zero.

3. While you've got this dialog box displayed, you can do some interactive work, as you did in the previous scaling exercises. I'm warning you, though—I'll be testing your grasp of coordinate-systems concepts, and you'll eventually have a healthy respect for all matters dealing with rotations. The left side of the box provides absolute values using world coordinate space, and the right side provides offsets in local space. Take a moment to think about what this might mean before going on. Your screen should look something like Figure 3.14.

4. Because both local and world coordinate systems are aligned at this point, it doesn't matter how you make your first rotation. Type "40" into the y slot on the left side of the screen. Your screen should look like Figure 3.15.

5. Notice that the screen display shows the axis for local coordinates, even though you used world coordinates in the type-in dialog box. This is because the local coordinates option was set on the Main Toolbar. After rotation, the world and local coordinate systems are no longer aligned, and it will make a great deal of difference which side of the dialog box you use to make further rotations. For example, if you decide on 50 degrees of z rotation on the left (world side), the object rotates around the world z-axis, as shown in Figure 3.16.

6. This is pretty confusing, and only rarely typical of something you'll want to do. To do your rotations in local coordinates, use the right side of the dialog box. Return to the previous state of affairs by typing a zero value in the world z slot. Now, drag on the spinner immediately to the right of the z slot on the Offset: Local side of the

Figure 3.14
Box object before rotations, aligned with world space.

Figure 3.15
Box object rotated 40 degrees in y, using world coordinates.

Figure 3.16
Box object from Figure 3.15, rotated 50 degrees in z using world coordinates.

Figure 3.17
Box object from Figure 3.15, rotated 50 degrees in z using local coordinates.

dialog box. Notice how the box rotates around the local z-axis displayed on the screen. This is much more useful. But when you stop at a new rotation value (I used 50 degrees) and release the mouse, the screen looks something like Figure 3.17.

7. You got the rotation you wanted, but the dialog box is pretty confusing. The 50 degree value that was entered in the local z slot changed back to zero. As an offset, it does not preserve a reference, and each subsequent change is measured from the

current state. On the other side, new values have appeared for the rotations in world coordinates. These values are definitely correct, but they sure are confusing.

8. It may often make good sense to realign the pivot of the rotated object back with world space (you saw how to do this in "The True Pivot Point" section earlier in this chapter by selecting Affect Pivot Only and using the Align To World button). But a more direct approach is to select the Reset Transform option at the bottom of the Pivot panel. The pivot point (and therefore local space) becomes aligned with world space, without changing the orientation of the object. The tool is called Reset Transform rather than Reset Rotation because it resets scale (if you've changed it) at the same time. Figure 3.18 shows the screen after reset transform is applied to the box. Notice how the values in the dialog box have all returned to zero.

Figure 3.18
Box object from Figure 3.17 after transform is reset.

9. The pivot point has been realigned to world space, but the bounding box is still aligned to the rotated object. There's another way to reset transforms that reorients both the pivot point and the bounding box to world space. Click on the Utilities tab of the Command panel (the one with the hammer icon), and look for Reset XForm. (You came across the XForm modifier earlier in this chapter in the "Understanding Coordinate Space" section, when I discussed the problem of using nonuniform scaling with modifiers.) XForm is a means of bringing transforms onto the modifier stack. If an XForm modifier is applied to the objects, you can transform the XForm gizmo instead of transforming the object. Undo your scene back to before you applied the Reset Transform. Now, try using Reset XForm instead (remember to click on the Reset Selected button). The result should look like Figure 3.19.

Figure 3.19
Box object from Figure 3.17 after transform is reset by using the Reset XForm utility.

10. The big difference is in the bounding box, which is no longer aligned to the object. The last vestige of the original local space of the object has been lost. This new bounding box may make more sense (depending on the object) for visualization and alignment with other objects. But there's another difference between Reset Transform and Reset XForm: The latter option places an XForm modifier on the stack. Go find it in the modifier stack, select its gizmo, and rotate the gizmo. The object rotates with the gizmo, but this time the bounding box recalculates so that it remains square to world space. Take a look at Figure 3.20.

If you followed this exercise all the way through, give yourself a good pat on the back and take a break. You've learned some subtle but essential principles about the basic structure of 3D Studio MAX. The real professional with MAX or any 3D application is not necessarily someone who has an encyclopedic knowledge of the multitude of tools and options; rather, it is someone who has struggled with the critical concepts that are difficult and time-consuming to master.

Linking (Parenting) Objects

Objects can be arranged in hierarchies to create functional units that are especially important for animation. If an object is made the child of another object, the latter object, called the parent, includes the child in its transforms and as part of its local coordinate system. If the parent is translated, the child is translated as well. If the parent is rotated, the child rotates around the same pivot point. And if the parent object is scaled, the child is scaled as well, also from the parent's pivot. The child itself can be transformed with respect to the parent. If you

Figure 3.20
The box's XForm gizmo is rotated instead of the box, and the bounding box recalculates to remain square with world space.

select the child and move it, the parent stays where it is. Although this applies to the rotations and scaling of the child, independently of the parent, transforms on the parent affect the child as if the child were rigidly attached to the parent object's pivot point.

The act of making one object the child of another is called *parenting* throughout the 3D computer graphics world. However peculiar this term may sound to those just getting used to it, I've never been able to understand why MAX decided to make up its own word for it. In the MAX interface and documentation, parenting is called *linking*. I've always thought that this word was a particularly unfortunate choice because its doesn't suggest direction the way parenting does. I suppose the idea is that the child object is "linked" to the parent, but it's late in the day to be making up new words. So, as a compromise between MAX usage and the way that 3D professionals generally speak, I'll use the two terms interchangeably, much like bouncing back and forth between "move" and "translate." In the computer graphics world, you've got to be able to use correct vocabulary.

Parenting creates hierarchies. If one object is parented to another, and that object is parented to a third, the object at the top of the hierarchy will transform its child and grandchild—in other words, both of its descendants. If the child object in the middle of the hierarchy is selected, its transforms will affect both itself and its child (the grandchild). The best way to understand this is in its most important practical application.

Suppose you create a very simple human body hierarchy (one that includes, for simplicity, only the lower half of the body). The two feet are parented to their respective lower legs, and the two lower legs are in turned parented to their respective thighs. The two thighs are parented to a single pelvis. If you translate or rotate (or even scale) the pelvis, the entire lower body transforms as a unit. If you rotate the thighs, the lower portions of the leg ride along. But if you rotate only a foot, the upper limbs remain unaffected.

Using The Link And Unlink Buttons

When you activate the Select And Link button in the Main Toolbar, you are in Link mode. In Link mode, you can both select the object to be parented (the child) and parent it to another object in one move by dragging with the mouse. If the link is successful, the parent object flashes white.

> *Note: Unlike some other applications, you must always link from child to parent. You can't select a parent and assign it a child.*

When you're in Link mode, you're in it until you get out. The advantage of the Link mode approach is that you can do a lot of linking at the same time, dragging among as many objects as you choose. The child objects don't need to be selected before you begin, because the mode allows you to select any object you click on for parenting. Thus, you can jump from object to object to create a hierarchy. This is especially great for a character hierarchy: You just drag feet to calves, calves to thighs, hands to forearms, heads to necks, and so on, until you're done. But you've got to keep an eye on the process. That means getting out of Link mode periodically, by clicking on the Select By Name arrow in the Main Toolbar, and looking at the Select Objects dialog box to see what you've accomplished. Use the icon on the Main Toolbar or, better yet, press the H key.

Once you do this, you're likely to be surprised. For some reason, MAX does not show you your hierarchical links in the Select Objects dialog box unless you ask to see them. Check the Display Subtree box to see whether any of your linking was successful. As in all applications, a hierarchy is displayed in a scene graph by indentations. In Figure 3.21, Box 01 is at the top of the hierarchy—the common ancestor of all the objects. Box 02 and Sphere 01 are both its children. Sphere 01 has no descendants, but Box 02 is the parent of Cylinder 01. Finally, Cylinder 01 is the parent of Pyramid 1.

When you're in Link mode, the H key and the icon that normally calls the Select Objects dialog box will instead produce the Select Parent dialog box. Personally, I prefer picking things from a list rather than dragging on the screen, especially when the scene gets complicated. The Select Parent dialog box is especially helpful because it presents you with only the possible choices, so that you can't mistakenly try to link objects in a way that violates the logic of the hierarchy.

Figure 3.21
The Select Objects dialog box, with the Display Subtree option checked, displays the hierarchy.

GET OUT OF LINK MODE WHEN YOU'RE DONE

It's so easy to do a quick link and then click around the screen in frustration, wondering why the program isn't doing what you want. It takes practice to learn to leave the Link mode as soon as you're finished with your linking tasks. Clicking on the Select icon or any of the transform icons on the Main Toolbar will free you.

Unlinking objects couldn't be easier, because unlinking is not a mode. If an object is selected and you click on the Unlink Selection button in the Main Toolbar, the object is unparented. Always check in the Select Objects dialog box, with the Display Subtree option checked, to make sure that the unlinking was successful. Because it's not a mode, you can unlink any object, regardless of whether you are in Link mode, Select mode, or any other mode. Thus, you can unlink your mistakes when working in Link mode or simply unlink objects whose hierarchies are no longer necessary.

Overriding Inheritance

Linked objects are often said to "inherit" their transforms from their ancestors in the hierarchy: If the parent object is transformed, the child object is transformed as well. Occasionally, it's useful to override this inheritance.

Near the bottom of the Pivot panel is an option called Don't Affect Children, which is the most general override. While this button is active (it turns blue), you can transform a parent any way you please without affecting its descendant objects. This is a lot easier than unlinking and relinking in the Main Toolbar. This tool is necessary for layout purposes only, because if you really don't want a hierarchy to animate together, you should just unlink the objects.

A more specialized tool is found in the Link Info panel. Here, you select a child object and uncheck the specific transforms and specific axes that you don't want it to inherit from its parent. Now go back and transform the parent to see how it affects the child. This tool can be useful in animation. For example, assume that you have a helicopter following above a car. If the helicopter is the parent, disabling the car's translation (move) in z allows you to move the helicopter vertically without moving the car off the ground. The objects still translate together in the other two dimensions.

Another, more common use for this tool is to disable scale inheritance in all dimensions. In many hierarchical arrangements, it may not be desirable for child objects to scale along with the parent, even though they should rotate and translate together.

Using Null Objects To Create Coordinate Systems

A *null object* in 3D computer graphics is an object that has a pivot point, but does not render. In most programs, there is only one such object, represented on the screen by a small 3D coordinate axes tripod. MAX, however, gives you null objects in two flavors: Points and Dummies. These objects serve exactly the same function and differ only in their appearance on the screen. Use whichever one seems best for your purposes.

Once again, I'm going to have to jump back and forth between MAX's terms (*Point* and *Dummy*) and the standard vocabulary of professional computer graphics. Everyone in the 3D world knows what you mean when you say a null object, but only people with MAX experience are familiar with points and dummies. And the idea of a null object is more general than either the point or the Dummy object, so I'll use the term where either type of MAX object would serve.

Both types of null objects are created in the Helpers panel. A Dummy object is produced by dragging on the screen to get a simple wireframe box of the desired size. The dragging produces a perfect cube, but the dimensions can be adjusted nonuniformly by scaling the Dummy. The Dummy has a pivot point just like a regular box object, but the pivot is automatically centered in the Dummy. You can adjust the pivot point for the Dummy, just as you would for any other object. The value of the Dummy object, as opposed to the point, is that the Dummy can be fitted around an object or group of objects so that its relationship to those objects is easy to see. You've already seen how the grouping tool creates a parent Dummy that enclosed the member objects of the group. In the same way, fitting a collection or hierarchy of objects inside a Dummy frame, and parenting to the Dummy, creates a very workable unit on the screen.

The Point object is more like the traditional null object in other packages. It's just an icon that shows the three perpendicular coordinate axes, labeled x, y, and z. This icon is aligned to the Point object's pivot point, and although you can disengage the pivot point from the icon, I can hardly imagine when this would be desirable.

The primary purpose of using a null object is to create a parent coordinate system that will be applied to objects parented to the null.

I'll make this rather difficult idea as clear as I can. Earlier in this chapter, I made the important point that animation keys are set in only one of the possible coordinate systems. Rotations are animated in the local coordinate system of the parent object. Thus, it is often necessary to create a new local coordinate system, and then parent the object to be animated to it. I'll illustrate with the most basic example, even though it means having to jump into the realities of animation graphing that are the provinces of Part VI of this book, Animation. MAX, perhaps more than any other 3D package, resists a segmented approach to learning. The program's great genius is its fluid integration of modeling, surfacing, materials, and rendering tools. So you'll have to glance a bit at animating rotations in order to understand the most important use of nulls.

Try out this exercise:

1. Create a flattish cylinder on the groundplane, like a wheel. Be sure you're in local coordinates. The result should look like Figure 3.22.

Figure 3.22
Wheel in local coordinates. The z-direction is up because it is still aligned to world coordinates.

2. The goal is to spin the wheel around its own axis, but to be able to rotate the wheel as a whole in any direction. With the wheel tilted a bit around the y-axis, its local coordinate system is no longer square with world space, as shown in Figure 3.23.

3. In Track View, make sure that you are using the correct rotation controller: Euler XYZ, the one that will let you graph your work. Open Track View from the Main Toolbar or the Menu Bar and find the Rotation track for the object (under Transform). Click on the Assign Controller button on the Track View toolbar and choose

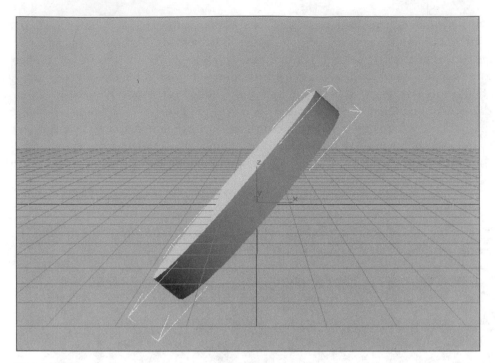

Figure 3.23
Wheel rotated in y. Its local coordinates are no longer square to the world system.

the Euler XYZ controller. In this controller, rotations are graphed in the coordinate system of the object's parent. Because your wheel has no parent object, the controller uses world space. None of the three directions of world space are aligned with the axis of your wheel, so there is no way to spin it properly.

4. To create a custom coordinate system for the rotation, align a null object to the local system (the pivot point) of the wheel, and then parent the wheel to the null. The easiest way to accomplish this is to return the wheel to its original flat orientation.

5. Next, create a Dummy object and scale it nicely so that it fits around the wheel like a bounding box. Parent (link) the wheel to the Dummy, so that the null object transforms the wheel.

6. Rotate the Dummy in world (or local) y, so that the wheel is tilted. With the Dummy selected and in local coordinates, you can see in Figure 3.24 that the Dummy's local axes remain aligned with the original pivot point of the wheel.

7. Now, you can animate the spinning wheel in Track View. The z rotation of the wheel is around the z-axis of its parent, the Dummy. Figure 3.25 shows a graph in Track View of the wheel turning 360 degrees in 100 frames. See if you can build one just like it. With the z rotation track of the wheel (not the Dummy) object selected in Track View, change to a Function Curve view using the toolbar. You'll start with a straight horizontal line, because nothing is animated yet. Click on the Add Keys

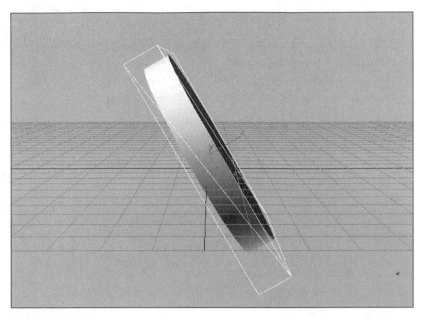

Figure 3.24
Dummy rotated in y with parented wheel inside. The Dummy's local coordinate system is still aligned to the wheel's local system.

Figure 3.25
Animation graph in Track View of wheel (Cylinder) object rotating 360 degrees in the z-dimension over 100 frames.

button on the toolbar and then click on the line at the start and the end, to create keys at frames 0 and 100. Right-click on the key at frame 100 and enter a value of 360 in the dialog box that appears. Use the Zoom Value Extents tool at the bottom of Track View to frame your entire graph.

8. The great thing about this system is that you can rotate (or even translate and scale) the null object however you want, but the spinning rotation of the wheel is on its own animation track. The wheel will continue to spin around the proper axis, even though you animate the Dummy, perhaps to wobble the unit back and forth.

Moving On

There's nothing easy about the material in this chapter. I'm always learning new things about coordinate systems and their use in rotations, and often throwing away old misconceptions. It takes countless hours of careful experimenting to understand the connections between coordinate systems, pivot points, animation controllers, and null objects.

In the next chapter, we look at the many powerful tools in MAX for managing the display of objects. The display is your working environment, the window to your virtual world. MAX permits you to view that world in a variety of ways that are suited to the various tasks you can perform.

4

MANAGING THE DISPLAY

The MAX display windows are your eyes into the virtual world of your creation. In this chapter, you'll learn about the tools you need to intelligently manage the display.

A 3D scene is a virtual world. It is viewed and fashioned through windows, and multiple windows with different views are almost always necessary to understand the objects and their spatial relationships. To keep a clear visual sense of your work, you need to use all the display management tools that MAX provides. You need to be able to navigate confidently through an abstract coordinate space, and you must know how to hide and reveals objects at will. You'll also need to understand the role the grids play in defining your view.

The Viewing Windows

The windows through which you view your work are technically called *viewports*. They can be used to view your scene using perspective or orthographic projections, and also from a "user" projection that is a mixture of both.

Perspective And Orthographic Views

There are two general types of windows: perspective and orthographic. A *Perspective* window functions like a camera or like our own eyes. If you look down a pair of railroad tracks, they seem to converge in the distance. This is the phenomenon of perspective distortion. Even though the tracks are parallel, the portion of them close to you takes up a larger angle of your field of vision than the portion farther away. In the same way, an object appears smaller as it moves away from you. The entire effect is attributable to the fact that all the rays of light are converging toward a single point.

Orthographic views do not have perspective distortion because the rays of virtual light remain parallel. They project on a plane rather than converge at a point. Thus, an object remains the same size on the screen, regardless of how far away it is; and parallel railroad tracks never converge.

The distinction between orthographic and perspective views is evident from the grids in the windows, even absent objects. Figure 4.1 is a screenshot of a front orthogonal view and a perspective view. The grid on the orthogonal window is strictly rectilinear, but the groundplane grid in the perspective view reveals the convergence of parallel lines with distance.

Figure 4.1
An orthogonal front view compared with a perspective view. Note the convergence of parallel lines in the perspective view.

MAX provides all of the possible orthographic views that are square to world space. The front view faces the xz plane looking from the negative y-direction and the back view faces the same plane from the positive y side. The top view looks down on the groundplane from the positive z-direction, and the bottom looks up at the same plane from below. In most scenes, you'll rarely use the back or bottom views. There's nothing inherently preferable about a left view as opposed to a right view. Because the default MAX screen uses the left view, most people stick with it until they need to change.

USE KEYSTROKES TO CHANGE VIEWS

Right-clicking on the name in the upper-left corner of each window (Front, Perspective, and so on) brings up a menu from which you can change views, but it's much faster to use hotkeys. Use the F key to change a window to a front view, press L for a left view, and so on for all the other possibilities.

The perspective view is dependent on a field-of-view concept that corresponds to the focal length of a camera lens. Click on the Perspective window to make it active and look for the icon at the bottom-right of the MAX screen that looks like a slightly open fan. If you click on it and drag in the window, the field-of-view angle changes, and it's important to understand the difference between this tool and the magnifying glass icon just above it. In a perspective view, just as with a true camera, the composition of the frame depends on a combination of position and field-of view. I may speak loosely of zooming in or out on an object, but there is

a considerable difference between moving a camera closer (or farther) from an object and changing the focal length of a camera lens. In photography, *zooming* means narrowing the field-of-view by changing the focal length of the lens. In MAX, however, the Zoom tool with the magnifying glass icon moves the virtual camera without changing the field-of-view. The Field-of-View tool, therefore, corresponds to a true zoom in photography, and anyone with much experience with real cameras is aware of the importance of using the right focal length for the shot.

The effect of field-of-view is most noticeable with indoor scenes because the viewer depends on the corners of the walls, floor, and ceiling to make logical sense of the space. Increasing the field-of-view increases the effect of perspective distortion, and decreasing the field-of-view does just the opposite.

Compare two screenshots of the Perspective window, using different field-of-view values. Figure 4.2 uses a narrow value of about 30 degrees and then uses the Zoom tool to pull the camera back to capture the desired space. The edges of the walls and floors meet in a roughly perpendicular way, corresponding to a natural reading of the space.

In Figure 4.3, the field-of-view has been opened up to 60 degrees and the camera has been moved in correspondingly. Just as with a photographer's wide-angle lens, the scene appears distorted and disorienting. The cone object close to the camera is stretched, and the corners of the walls are less square. Worst of all, the height of the back wall has now been shortened to a point where a glimpse of ceiling is surprisingly visible.

Figure 4.2
Room with 30-degree field-of-view in the perspective view.

Figure 4.3
Room with 60-degree field-of-view for perspective view.

A numeric spinner for the Field-of-View tool is in the Rendering Method panel of the Viewport Configuration dialog box and can be called by right-clicking on any of the viewport navigation icons at the bottom-right corner of the MAX screen. The default value is 45 degrees. I like entering numbers in this spinner, rather than simply interactively dragging in the Field-of-View mode, because I like to have a sense of the actual values. The photographer knows what it means to use a 35mm lens instead of a 50mm lens, and a virtual photographer can benefit from the same approach to his or her virtual camera.

User View

The User view is something that some people love, and others never use at all. The true orthographic projections always look straight down a world coordinate axis, and are therefore always square to world coordinate space. Perspective views can be from any direction, but they produce perspective distortion. The user view is a mix: a view that can be freely rotated, but which maintains parallel lines like an orthographic view. It is an arbitrary parallel projection. This view can take some getting used to, and I count myself among the many who are confused by the distortion of the grid that it necessarily produces. It takes a certain kind of eye to make sense of this kind of projection.

The most important way to obtain a User view is to use the Arc Rotate tool on an Orthographic window. The view changes to User view as soon as you rotate.

Viewport Navigation Tools

If you're going to use MAX in a fluid and creative way, you've got to get the viewport navigation tools down cold. They're generally straightforward, but there are a couple of tricks and little secrets.

The viewport navigation icons are clustered at the bottom-right corner of the MAX screen, and if you bounce back and forth between Perspective and Orthographic windows, you'll notice that only one of the icons changes. The field-of-view option, which is so central to the perspective concept, is irrelevant to orthographic views and is replaced in them with a Region Zoom control. When you click on an Orthographic window and drag a rectangle, the region in the rectangle expands to fit the viewport as much as possible.

GETTING OUT OF NAVIGATION MODES

Some of the viewport navigation tools are one-shot (meaning that they only are in effect for one task) and others are persistent modes. Once you get into a mode, you won't be able to do anything else until you get out of it. You can change to another mode by clicking on another icon, but to leave the mode completely, press the Esc key. Clicking on the Select Object icon on the MAX toolbar will also get you out of a navigation mode, but the Esc key will make your life much easier. Get used to using it.

The Min/Max Toggle

The Min/Max Toggle in the bottom-right corner is easy and essential. Click on the icon and the active viewport is maximized to fill the entire screen. The active viewport is the one you have selected by clicking in it, and you can't do anything in a window until you've selected it.

The Zoom Extents Buttons

The two Zoom Extents buttons zoom the screen in or out to fit the objects. The Zoom Extents buttons apply only to the active viewport; by clicking and holding down the mouse button on the icon, you get a choice of whether to fit the screen to enclose all the objects or just those that are currently selected. The Zoom Extents All button immediately to the right works in exactly the same way, but applies to all the viewports at once.

The Pan Tool

The Pan tool, with the hand icon, simply shifts an orthographic screen over. In the case of a perspective view, it moves the virtual camera in the plane perpendicular to the direction in which it's pointing. The Pan tool is so important that it's always available when you drag the middle mouse button.

The Zoom And Zoom All Tools

The Zoom tool closes in or spreads out your view of an Orthographic window, but as already mentioned, it moves the virtual camera in or out in a perspective view. The Zoom All tool operates on all windows at the same time.

The Arc Rotate Tool

The Arc Rotate tool may seem mysterious, but there is logic here. Click on the icon to enter the mode and, assuming that you're in an active Perspective window, you can rotate the scene. But what exactly are you rotating about, and how can you control it? Hold the mouse button down on the icon, and the now-familiar choice between a white selected objects-only version and a gray version appears, along with a new yellow one. The white option is easy: The view rotates around the selected object or objects. If there's no object in your scene that makes sense all by itself as a center of rotation, select a number of objects and the rotation point will be placed in the middle of these. The yellow option performs in the same way, except that it applies to subobject selections, such as selected vertices, rather than to entire objects.

Using the selected objects-only version is fine if you will be sticking with the selection. More likely, you just want to create a center for rotating your viewport and go on working, selecting new objects all the time. The gray option, which is simply called Arc Rotate, starts out in a new scene by using the world origin as its pivot. But things change fast as you start navigating. To take control for yourself, try this exercise:

1. In a new scene (use Reset in the File menu, if necessary), create a few spheres on the screen, clustered something like those shown in Figure 4.4.

Figure 4.4
Spheres arranged on the groundplane to test the Arc Rotate tool.

2. Use the Arc Rotate tool (not Arc Rotate Selected) in the Perspective window and note that rotation takes place around the world origin. Now, pan (with the hand icon) the Perspective view over a bit and rotate. The center of rotation has moved with the pan.

3. You want to rotate around the sphere that's farthest from the middle. Select that sphere and use Zoom Extents Selected to center the sphere in the viewport.

4. Deselect the sphere and zoom out.

5. Try the Arc Rotate tool again and notice how the sphere remains the center of rotation, even though it's not selected.

6. Select another sphere and rotate some more. The rotation is still centered around the original sphere.

In short, panning moves the rotation center, zooming doesn't affect it, and selecting an object and zooming its extents establishes a new center.

Viewing And Layout Options

The default layout in MAX is four quadrant viewports, any one of which can be temporarily maximized to fill the entire screen. But other layouts are possible and sometimes desirable. Track View takes up a significant portion of the screen, so it's often a good idea when using it to change to a layout with two horizontal panels. One can be covered with Track View, whereas the other provides a larger space to preview your animation, as shown in Figure 4.5.

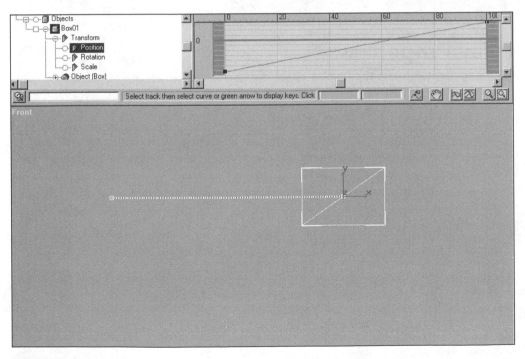

Figure 4.5
Alternative layout, suitable for using Track View by using two unequally sized horizontal viewports.

The layout options are reached through the Configure option at the bottom of the right-click menu. You can set two layout options (A and B), and then toggle between them directly in the right-click menu by clicking on the Swap Layouts option.

Right-clicking on the title in the top-left corner of a viewport brings up a menu that provides access to options affecting both the individual window and the layout of all the viewports. The top set of options let you choose between various flavors of shaded and wireframe views. Smooth + Highlights is your basic Phong-shaded preview displaying both the diffuse color of the object and its specular highlights. Wireframe is, well, wireframe. But you can combine a wireframe and shaded view together by toggling the Edged Faces option while the shaded view is selected. This can be fantastic for mesh-level editing because you see the polygonal structure directly though the shaded surface.

The other options are less important and are readily learned by experimentation. The most important of these is the Facets view, which eliminates the smoothing of a shaded surface and therefore lets you see the raw polygonal structure. I prefer the Edged Faces option for this purpose, but there are times when a faceted view helps you to make sense of complex geometry.

HIDING THE GRID

Sometimes, the best thing you can do for your sanity is to hide the grid. This option is available in the right-click menu (or by pressing Shift+G), and I use it all the time, especially in the perspective view. When you're editing a NURBS surface or polygonal geometry at the mesh level, you need to keep the screen as clean as possible.

Display Properties

The Display panel (under the Display tab in the Command panel) contains a section named Display Properties with a list of checkboxes. Figure 4.6 shows a screenshot of this section.

The choices you make here apply only to the selected object. The most important option is Backface Cull, which is a fancy way of saying that MAX displays only one side of a surface. All surfaces have a direction, which is called the normal direction. With closed surfaces, you never see more than one side (the side facing outward), so it makes sense not to slow down the preview process by forcing the computer to consider the inside faces. When Backface Cull is

Figure 4.6
The Display Properties section of the Display panel, with the default options checked.

checked, the sides opposite the surface normal are "culled," or disregarded. This display option does not affect the renderer, which has separate controls for whether to render one or both sides of surfaces, and there is a good reason for keeping these controls separate. NURBS modeling provides the best example. NURBS objects are assembled out of surfaces that can be difficult to visualize if you can't see both sides. When you rotate a curving NURBS surface, it can seem to reshape itself if you don't have both sides as a visual reference. That's why, when working with NURBS surfaces, it generally makes sense to uncheck the Backface Cull option, even if the renderer needs to render only the front of the surfaces. Similar situations can arise in polygonal modeling as well, when an ultimately closed object is assembled out of separate surfaces.

The Edges Only option toggles the wireframe display of invisible edges that define the triangular units within polygons. The Vertex Ticks option is similar (though opposite in operation), in that clicking displays little dots at the location of polygonal vertices. Normally, you have little reason to use this option, because the vertex ticks automatically become visible when you're editing vertices at the vertex subobject level.

Vertex color is a method of creating color gradients across a surface by assigning colors to individual vertices, which then blend in every direction. To see the effect of vertex colors that you've assigned at the vertex subobject level in Edit Mesh or Editable Mesh, check the Vertex Color option in the Display Properties section. The Shaded button to the right toggles, whether the vertex colors respond to scene lighting like regular diffuse colors or whether they are independent of the lighting. Such "prelit" vertex color is important in games and other realtime 3D applications because it eliminates time-consuming lighting computations.

A *trajectory* is the path of an animated object in space when its position has been keyframed at different points in time. Checking the Trajectory option in Display Properties reveals the path and the location of the keyframes. Trajectories automatically appear when you edit them in the Motion panel, so this display option is rarely useful.

The See-Through option is new to MAX 3. Checking this box makes the selected object semitransparent, so that you can see what's behind it. This will often be more useful than simply hiding foreground or obscuring objects.

Hiding And Freezing Objects

MAX is a program that seamlessly combines modeling, layout, and animation in a single environment. Most of the time, this means that you can jump back and forth between modeling and other tasks very easily. But for this process to work effectively, you have to be able to isolate the objects you're working on (or looking for) in a crowded scene.

The hiding tools can be found in both the Display panel and in the Display Floater that is accessed from the Tools menu. The floater, like all the floaters in the Tools menu, duplicates the same tools found elsewhere on the interface, but it stays persistent on the screen, which can be a convenience. Whichever method you use, you can hide objects in as many ways as you can possibly imagine. Hide entire classes of objects at the same time, or select objects

and hide only the selection. Hide objects by selecting names from a list, or enter the Hide By Hit mode and click on the objects you want to hide. You can unhide hidden objects all together, or by selecting names from a list.

Freezing an object makes it gray and unselectable. This is a good method of keeping objects out of your way without making them disappear from view.

Grids

MAX uses the word *grid* in a slightly peculiar way that ultimately makes sense. It's natural to think of a grid as a 2D plane, but the grid is actually the subdivision of the entire 3D coordinate system.

Using The Home Grid

If you don't create any others, your only grid will be the home grid, which is composed of the three grids intersecting at the world origin. To understand this point, go to the Grid And Snap Settings option on the Customize menu, and click on the Home Grid tab. The dialog box shown in Figure 4.7 will appear.

The grid spacing is in generic units, unless you change them in the Views menu. Drag on the Grid Spacing spinner and watch the grid rescale in your active viewport. When you release the button, the three other grids rescale as well. This makes sense if the user is to be able to jump from viewport to viewport. But it means that the home grid is actually the entire World space system, although you see in only one of the three directions in any one window.

Creating New Grids

The home grid is not the only possible one—MAX permits you to create new grids. You will probably have little reason to create additional grids that are square to the home grid, so you'll typically be rotating a grid after you create it. A good example is a grid that is aligned with a slanting surface, like a roof. New objects can be created directly on the new grid and translated by using it as a reference.

Figure 4.7
The Home Grid dialog box, with the default settings.

To create a new grid, go to the Helpers tab on the Create panel, where you'll find the Point and Dummy objects as well.

1. Drag out the grid in the active viewport. Remember that this grid object is actually a complete 3D coordinate system. Test this grid by trying out the xy, yz, and zx options at the bottom of the panel.

2. At this point, your new grid is an object like any other, so rotate it by using the Rotate tool so that it's no longer aligned to the home grid. Don't worry about the fact that the grid pattern is missing—the grid isn't activated yet.

3. Now activate your grid. Find Grids under the Views menu and activate the selected grid. The grid pattern changes to its working form. To adjust the spacing, go to the Modify panel with the grid object selected.

4. Create a box right on the new grid to see how it works. Take a look at Figure 4.8 for an example.

Figure 4.8
Box created on a custom grid not aligned to world space.

5. The home grid is still visible and may be confusing, so hide the home grid by using the toggle in Views|Grids.

6. To align a viewport to the custom grid, right-click on the title in the upper-left corner, and then pull down to Views. Pull down further to the grid choices to select any

of the six orthographic directions. Or use the Display Planes option, which selects a direction based on your current display plane (xy, yz, zx). You can change your current display plane in the Modify panel if the grid is selected.

Custom Grids Aren't For Everyone

It takes an architect or draftsman's mind to really feel comfortable with custom grids. Using multiple grids at angles to world space can make you feel like you're working out a problem in relativistic physics. They are a revealing link to Autodesk's great tradition of computer-aided drafting.

Moving On

In this chapter, you learned about all of the basic tools for managing your view into your 3D scene. These tools may seem dull in comparison to much of what MAX offers, but to the serious 3D artist, they are critical. Think of 3D Studio MAX as a true studio, and imagine how difficult it is to work in a cluttered room without clear sightlines to the objects you build and work on. It's impossible to work when you can't see what you're doing.

In the next chapter, we continue our theme of efficient, organized workflow with a look at the tools designed for easy duplication and precision arrangement of objects. Working smart in MAX means letting the program handle the tedious or difficult tasks.

WORKING SMART

MAX is packed with features to help you work faster and with greater precision. In this chapter, you'll become familiar with this range of powerful and indispensable tools.

In MAX, there is often a harder way and an easier way to do almost everything. The longer you work with this program, the more shortcuts you discover. Shortcuts are not just a matter of saving time; creative processes are hampered when work becomes tedious and frustrating. When the artist can get exact results easily, work becomes fun, and fun is very often the key to creativity. In this chapter, we'll look at the most important tools for duplicating and ar ranging objects and for achieving precision.

Duplicating (Cloning) Objects

The MAX documentation and interface use the term *clone* to include the three possible ways in which you can duplicate an object—as a copy, instance, or reference. A *copy* is a completely separate object that is not connected to the object from which it was duplicated. Once you make a copy, the new object is on its own. An *instance* is a duplicate object that shares the same modifier stack as the object from which it was duplicated. The two objects are really two instances of a single object. If you add a modifier to one object, it appears on the other as well. If you change the modifier's values, they affect both objects in the same way. The instances are twins that remain connected, unless and until you decide to break the connection. A *reference* is a cross between a copy and an instance. Two referenced objects share only a portion of their modifier stacks, and the portion they share affects both in the same way. The portions that are different apply only to each individual object. Instancing and referencing are very important aspects of 3D Studio MAX; they are discussed generally in Chapter 1.

Every time you clone an object, you're faced with the choice of whether the duplicate should be a copy, an instance, or a reference. You will seldom choose a reference to begin with because an instance can always be changed into a reference as circumstances dictate. In other words, it generally makes sense to create an instance first, and then decide later whether the instanced objects should have some independent portions of their modifier stacks.

Note: I don't think I'm the only one who has trouble with the word clone. A clone sounds like a genetic twin, and it is an unlikely name for a simple copy that can be modified freely so that it differs substantially from the object from which it was duplicated. In Lightwave 3D, for example, clones are essentially multiple instances of a single model.

The choice between copy and instance is a very important one. If you are certain (and this happens often) that the objects will be completely independent, choose copy. If you have any doubts at all, however, it may be a good idea to create an instance. You can always break the instance so that each object has an independent modifier stack if you change your mind later. You can break the instance through the Make Unique button on the Modify panel. If an object is an instance, this button is active. Once you break the instance, the button grays out.

INSTANCING MASS DUPLICATIONS

Sometimes, you simply duplicate finished models that will not be further modified. It can still make sense to instance rather than copy them. Each instance is simply a pointer back to the original object, rather than a full set of data. Thus, you can create hundreds of instances of an object without creating a huge, clumsy file. If you create mass duplications of identical objects—such as leaves, blades of grass, or hairs—instancing is generally the only realistic choice.

Cloning Basics

MAX has easy interactive tools for making basic duplications. These permit you to make both single copies and arrays of multiple duplicates, as necessary.

Cloning An Object

To clone an object, select it and pull down to Clone in the Edit menu. The Clone Options dialog box appears, as shown in Figure 5.1.

Because you are duplicating an object rather than an animation controller, the choices on the right side are grayed out. Choose one of the three clone options and rename the new object if you wish. If you don't type in a new name, the object will be assigned the same name as the original, with its number incremented (for example, Box01 is named Box02). In any case, the new object is created right on top of the original, so you have to move it to be able to see it.

Figure 5.1
The Clone Options dialog box, reached through the Edit menu.

But, in fact, you'll almost never duplicate objects this way. The most intuitive and flexible method of cloning objects is to hold down the Shift key while you move them, which pulls a duplicate right off the original and leaves the original in place. When you release the mouse, the Clone Options dialog box appears, but with a difference. Look at Figure 5.2.

Figure 5.2
The Clone Options dialog box, reached by holding the Shift key down while moving the object (and pulling off a duplicate).

The difference is the power to create multiple copies. This is a great way to make multiple clones quickly and even to create simple arrays. Try the following exercise:

1. Create a small box and zoom out in the top view, so that there's plenty of room to make copies.

2. In the Move mode, and with the Shift key held down, simply click on the object and release without dragging. The Clone Options dialog box appears.

3. Create five clones by entering that number in the box. It doesn't matter whether they are copies or instances.

4. Press the H key to bring up the Select Objects dialog box, in which you should see a list of six boxes. (Note that the number of copies does not include the original, so that if you had wanted five boxes total, you should have made four copies rather than five in Step 3.)

5. In most cases, however, it makes sense to first spread the copies out for easy selection. Select all but one of the boxes in the Select Objects dialog box, and delete them by pressing the Del key. This time, move the box by dragging while you hold down the Shift key. Keep to only a single axis (x, y, or z) while you drag so that the clone is pulled off in a straight line.

6. Pull the copy only a short distance from the original, and, when the dialog box appears, ask for six copies. Your screen should look similar to Figure 5.3.

7. Click on OK or press the Enter key, then see what happens. Six copies are arranged in an equally spaced linear array. The last copy remains currently selected. Look at Figure 5.4.

Figure 5.3
Original box, at right, with clone dragged off a short distance. The dialog box is set to create six copies.

Figure 5.4
Six equally spaced copies. The last one remains selected.

Creating A Circular Array

Try the same process with rotation to create a circular array. You need to call on a number of different MAX techniques to make this work, as follows:

1. Create a sphere centered on the groundplane, but position it some distance in the x-direction from the world origin. A top view of your screen should resemble Figure 5.5.

2. With the object selected, enter the Rotate mode.

3. Switch to world coordinates in the drop-down box in the Main Toolbar, then select the Use Transform Coordinate Center option by holding down the icon immediately to the right of the drop-down box. A temporary pivot point is now positioned at the center of world space because the world origin (0,0,0) is the Transform Coordinate Center in the world coordinate system.

4. Although snap tools will be discussed later in this chapter, you can use them here. Right-click on any of the left three snap tool buttons at the bottom of the screen (they all have little magnets as icons). The Grid And Snap Settings dialog box appears. Click on the Options tab and set the angle value to 30 degrees. Now, when

Figure 5.5
Small sphere positioned on groundplane away from the origin, as viewed from the top.

you rotate the box, it automatically snaps to 30-degree increments if the angle snaps are activated.

5. Activate the angle snaps at the bottom of the screen by clicking on the button with the magnet and angle measure icon. Now, hold down the Shift key while you carefully rotate. A duplicate is pulled off and rotated 30 degrees around the origin. When you release the mouse, the Clone Options dialog box appears. Ask for 11 copies. Your top view should look like Figure 5.6.

6. Click on the OK button and look at what happens. Eleven copies are made in 30-degree increments around the center. Your top view should look like Figure 5.7.

The Array Tool

Although you can use the basic cloning tools to create many useful arrays, MAX provides a very powerful specialized tool for the job: the Array tool. Because its interface can be a little intimidating at first, try the exercises in the following sections to become familiar with it.

A One-Dimensional Array

Follow these steps to create a one-dimensional array:

1. Create a small box on the groundplane, off to the left of the origin in the perspective view. Your screen should resemble Figure 5.8.

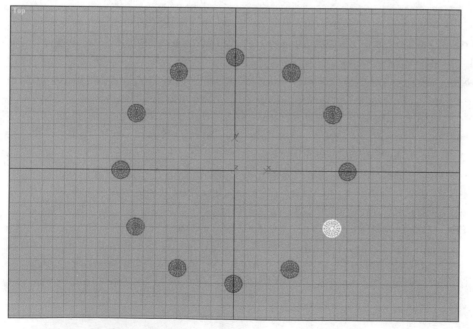

Figure 5.6
Sphere is rotated in the z-axis, with angle snaps activated and set to 30 degrees. The Shift key was depressed during the rotation, so the Clone Options dialog box appears.

Figure 5.7
A circular array of 12 spheres around the world origin.

Figure 5.8
Small box created on the groundplane, to the left of the world origin, as seen in a perspective view.

2. With the box selected, grab the Array tool from the Tools menu or directly from its icon on the right side of the Main Toolbar. The Array dialog box appears with its default settings, as seen in Figure 5.9.

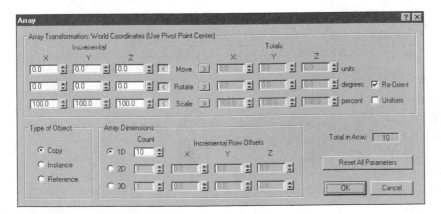

Figure 5.9
The Array dialog box with default settings.

3. Take a moment to look at this dialog box. The top half of the dialog box contains values for each of the three transforms (Move, Rotate, and Scale) in each of the three dimensions (x, y, and z). The bottom half of the dialog box is divided into two panels. On the left is the familiar choice between the three types of clones. The Array Dimensions panel to the right permits you to create arrays in multiple dimensions.

4. Start by asking for a linear array of 5 copies in the x-dimension, to be spaced 30 units apart. Enter "30" in the x-dimension for Move and enter "5" in the Count box next to the 1D option. Note how the Total In Array window at the bottom-right of the dialog box now reads "5". Your dialog box will look like Figure 5.10.

Figure 5.10
The Array dialog box set to create a linear array in x, with 5 copies, 30 units apart.

5. Click on the OK button to create the array, and see what happens. There are now 5 copies in a row, all 30 units apart. Note that, unlike the multiple cloning tool discussed previously, the number of copies you ask for in the Array dialog box is the total number you'll end up with, and not the number of duplicates in addition to the original. Your screen should now look like Figure 5.11.

Adding A Second Dimension

Now, follow these steps to add a second dimension:

1. Use the Undo command to go back to the single box, either by pressing Ctrl+Z or using the Undo button on the Main Toolbar. Now, try a two-dimensional array. Use the same settings as you did for the one-dimensional array, except change from the 1D option to the 2D option and enter a count of "2" in the second dimension. The total at the right now jumps to 10. The dialog box should look like Figure 5.12.

2. When you click on the OK button, the screen should look just as it did before, with five visible boxes in a row. But if you look in the Select Objects dialog box (press the H key) to see what happened, you see 10 objects. Because you didn't enter an offset value, the second row of five boxes was left right on top of the first.

Figure 5.11
Result of the array settings shown in Figure 5.10.

Figure 5.12
A 2D array of 10 copies, 5 in one dimension and 2 in the second.

3. This exercise should give you an insight into the principle behind the dialog box. The array created in the first dimension is then multiplied in the second dimension. In other words, the tool creates arrays of 1D arrays in two dimensions, and creates arrays of 2D arrays in the third dimension. Undo back to a single box and try again, this time using offset values of 20 in the y and 20 in the z (your numbers might have to be larger or smaller, depending on the size of the box you created). The dialog box should now look like Figure 5.13.

Figure 5.13
Settings from Figure 5.12, revised to create an offset in the second dimension.

4. Click on OK and see what happened. The first array of five boxes in a row is created from the settings in the upper half of the dialog box. Then, that array is duplicated by using the settings in the 2D row of the lower half of the dialog box. The row of boxes is copied and translated 20 units up and 20 units back in world space. Figure 5.14 shows a perspective view of the result, rotated around for better visualization.

Figure 5.14
Result of the settings shown in Figure 5.13, rotated in a perspective view.

Adding A Third Dimension

Add a third dimension by following these steps:

1. You should now have a pretty good idea of what will happen if you add a third dimension to the array. The 2D array created in the preceding two sections is duplicated in this section. Undo back to the original box and, starting with the same values as before, change to a 3D array. Enter "3" in the Count box in the third dimension, and offset these 3 copies 100 units in y and 100 units in z. The dialog box looks like Figure 5.15.

Figure 5.15

Adding a third dimension by multiplying the 2D array three times with offsets in y and z.

2. Click on OK and Zoom Extents if you want to see the entire scene. Your finished 3D array should look like Figure 5.16.

3. Now that you have the basic idea, add the rest of the picture. The first dimension is fundamentally different from the other two because all three transforms are available in the first dimension, but the other dimensions can only be translated. Undo the last array back to the single box. Keep the same setting for the 3D array, but add a 40-degree rotation in z and change the scale value in y to 80 percent. The dialog box looks like Figure 5.17.

4. Click on OK to look at the result. The box is rotated 40 degrees and scaled down with every copy in the first row. This row is then duplicated in the next dimension, and the whole unit is then duplicated in the third. The scale and rotations affected only the first dimension, as can be seen in Figure 5.18.

Using Circular Arrays

This may seem a little constrictive. Let's say you want to make a rising tower of circular arrays that scale down as they stack up. In other words, you need a scale factor in the second dimension. To do so:

1. Start with a small sphere on the groundplane, a reasonable distance in the positive x-direction from the origin. You can use the Array tool to create a circular array in a

Figure 5.16
Result of the settings shown in Figure 5.15.

Figure 5.17
The same array settings as in Figure 5.15, but with rotation and a scale added in the first dimension.

manner very similar to the way you used the basic clone tools to do so earlier in this chapter.

2. With the object selected, enter the Rotate mode. Make sure you're in world coordinates, and select the Use Transform Coordinate Center option by holding down the

Figure 5.18
Result of the settings shown in Figure 5.17. Only the first dimension is affected by the rotation and scale settings.

button immediately to the right of the Reference Coordinate System drop-down box on the Main Toolbar. The temporary pivot point jumps to the world origin.

3. Open the Array tool and note that the top line of the dialog box now indicates your current coordinate system and center. You want to make a ring of twelve spheres at equal increments. First, click on the Reset All Parameters button to clear away any settings from the previous exercise. Now, set the count in the 1D array to 12. You could then enter 30 degrees as the z rotation value, but instead, click on the arrow to the right of the word "Rotate" to move to the Totals portion of the panel. Enter 360 degrees in the z rotation slot, which means that the total rotation of the array is 360 degrees, to be divided into 12 equal units. The dialog box looks like Figure 5.19.

4. The result is a horizontal ring of 12 spheres. Because you want to build up vertical rows that scale inward to create a taper, and you already know that only the first dimension of the array can be scaled, select the entire ring and make a 1D array of this entire unit. The selected ring should resemble Figure 5.20.

5. In the Array dialog box, check the Uniform option for scaling and set the Scale value to 80 percent. I set the Move value to 20 units in the z-direction, although you may want a larger or smaller value, depending on the size of your spheres. Make six copies in the array. The dialog box should look like Figure 5.21.

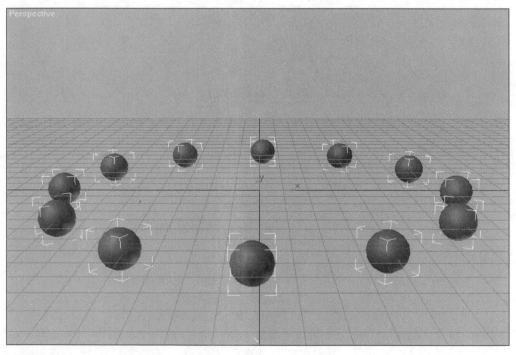

Figure 5.19
Array dialog box for a circular array in z around the world origin. The complete 360-degree circle is divided into 12 equal, 30-degree increments.

Figure 5.20
Ring of spheres, created with the settings shown in Figure 5.19 and selected as a unit.

6. Because you're still using the World Coordinate Center, each subsequent ring scales toward the center, meaning that both the diameter of the ring and the size of the individual spheres are affected. The result is best understood with a couple of orthographic views, as shown in Figure 5.22.

Figure 5.21
Array dialog box settings to create a vertical array of six rings, scaling inward as they rise.

Figure 5.22
Result of settings shown in Figure 5.21, from top and front views.

7. Undo back to the first ring and change from the Use Transform Coordinate Center to the Use Pivot Point Center option on the Main Toolbar. Instead of a single temporary pivot point in the middle, there are now separate temporary pivot points in the middle of each sphere, at the location of their true pivot points. Try the same array settings again, and note how the Use Pivot Point Center option is now displayed in the top line of the Array dialog box. Each sphere now scales only around its own pivot point, so that the rings no longer contract as a unit. Your result should resemble Figure 5.23.

8. Try the last possibility. You now want the rings to scale inward as they rise, but you want the individual spheres to maintain a constant size. Actually, the word "scale" puts you on the wrong track. To decrease the diameter of the rings is not an issue of scale at all, although it might seem like it. Instead, you need to make a circular array of a slanted linear array. To make the linear array, you start with the original single sphere and, using the world coordinate system, bring up the Array dialog

Figure 5.23
Result of settings shown in Figure 5.21, from top and front views, but this time using the Use Pivot Point Center option rather than the Use Transform Coordinate Center option from the Main Toolbar. The spheres scale around their own centers.

box. Because the original sphere is to the right (in x) of the origin, each increment moves it up in z and left in x (using negative x values). Use the values shown in Figure 5.24.

Figure 5.24
Settings to create a slanted linear array of six spheres, tending up and toward the center.

9. The resulting array is then selected as a whole. You should still be in world coordinates, but this time, make sure you're in the Use Transform Coordinate Center option so that the temporary pivot point jumps to the world space origin. Your screen should look like Figure 5.25.

10. Now, you make a circular array of this unit, as you did in Step 3, using the same settings. The result, shown in Figure 5.26, is precisely what you want.

Figure 5.25
Result of the settings shown in Figure 5.24, from top and front views. All of the balls are selected and, in world coordinates, the Use Transform Coordinate Center option is used to move the temporary pivot point to the world origin.

Figure 5.26
Result of a circular array, from top and front views.

Note: MAX is such a tightly integrated program that every aspect necessarily affects every other. Arrays are, at bottom, a kind of automated duplicate-and-transform process. Thus, your choice of coordinate systems and your temporary pivot point locations are critical to getting the array result you want. MAX's transform tools and concepts are discussed in detail in Chapter 3.

The Snapshot Tool—Cloning Along A Path

The Array tool is fine for creating regular patterns of objects, but a completely different approach is required when duplicates follow an arbitrary path. For example, a straight path of stairs is easily created with the Array tool, or even with the multiple-cloning options. But what about a spiral staircase?

The Snapshot tool takes an object that is moving along an animated path and makes copies of it at equal time increments. Therefore, to use it, you have to pass over some animation tools and concepts that will be a main focus of other sections of this book, including the creation of splines (curves) for motion paths.

To create a spiral staircase with the Snapshot tool, follow these steps:

1. First, create a simple spiral curve. Click on the Shapes button in the Create panel to see your spline-creation options. Select a Helix and begin to draw in a top view. Play with the creation tool for a while to see how it works, and click when you've got a shape you're happy with.

2. Now switch to the Modify panel and enter the values shown in Figure 5.27. It's often much easier to adjust your parameters than to try and build an object correctly at the start.

Figure 5.27
Parameter settings for Helix (helical spline).

3. Position the object at the center of world space by getting into Move mode and right-clicking on the Move button to bring up the Move Transform Type-In dialog box. Type zeros into the x, y, and z spaces to snap the object's pivot point to the world origin. Your screen should look like Figure 5.28.

4. Next, you need a step. Create a Box primitive at the very start of the staircase, just as you see in Figure 5.29. The box should have a Length of 3, a Width of 8, and a Height of 2.

5. To animate the step so that it follows your helical curve, you must assign the correct animation controller. If you're not already familiar with this process, slow down and follow these next steps closely. First, with the step selected, enter the Motion panel at the right of the MAX screen (using the little wheel icon). Click on the As-sign Controller rollout to open it. The rollout should look like Figure 5.30.

6. The controller for animating the position transform is Bezier Position. If it isn't al-ready selected, select this controller now and change it to a Path controller. Do this

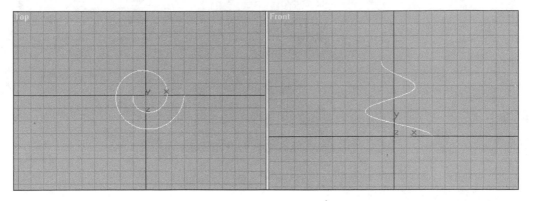

Figure 5.28
Helix generated from values in Figure 5.27, centered to world origin, seen from top and front views.

Figure 5.29
First step created as the start of the helix.

Figure 5.30
The Assign Controller rollout in its default state.

by clicking on the green arrow at the top of the rollout; a dialog box appears with all of the possible controllers for the position transform. Pick the Path option off this list and press OK. Back in the Assign Controller rollout, the Position controller should now indicate "Path".

7. With the Path controller assigned to the step object, it's time to tell it what path to follow. Scroll down the Motion panel to look at the Path Parameters rollout. Open it if necessary. This rollout should look like Figure 5.31.

Figure 5.31
The Path Parameters rollout in its default state.

8. To make the box follow the helical path, click on the button that currently reads None in the rollout; the button will turn green. Now, click on your helix. Test the result by pulling the scrub bar at the bottom of the screen to run though the animation. The step object should now be following the path over 100 frames.

9. But there's a problem. The stair is not rotating as it follows the path to stay aligned to the helix. At most locations on the path, it won't be pointing in the correct direction. Take a look at Figure 5.32.

Figure 5.32
The step at Frame 11 of the animation. The step is not aligned to the path.

10. Check the Follow checkbox in the Path Parameters rollout. Most likely, your box will snap to a peculiar angle. The Follow option keeps a single local axis of the object aligned (tangent) to the path. So switch to the local coordinate system so that you can see your local axes. It's obviously the y-axis of the step that should remain tangent to the path, so choose the y-axis option at the bottom of the Path Parameters rollout.

11. Pull the scrub bar again and check the result. The step should now remain aligned to the helix as it follows the path. Figure 5.33 shows the desired result.

Figure 5.33
The step object at Frame 11 of the animation, now properly aligned to the path by using the Follow option in the Path Parameters rollout.

12. The Snapshot tool can now be used to make copies of the model at increments along the path. To make sure that the step moves at a constant rate, check the Constant Velocity option at the bottom of the Path Parameters rollout.

13. Because you are duplicating the step, make sure that object is selected when you enter the Snapshot tool. The Snapshot tool is available from the Tools menu, but it can also be reached from the Main Toolbar, where its icon hides underneath that of the Array tool. If you don't see it, hold down the Array button until you see the Snapshot icon, which shows tiny spheres following a path. The Snapshot dialog box appears.

14. In the dialog box, you estimate 25 duplicates to be made over a range of 100 frames. Thus, a copy will be made every fourth frame of the animation. With so many identical objects, it's best to make them instances. Any modeling changes you make to the shape of any step should likely apply to all, and you can always break the instancing relationship later if you need to make edits on individual steps. The dialog box should look like that shown in Figure 5.34.

Figure 5.34
The Snapshot dialog box, with settings for 25 instances over a range of 100 frames.

15. Click on OK and check out the result. The basic idea is right, but the number of steps was underestimated, as can be seen in Figure 5.35.

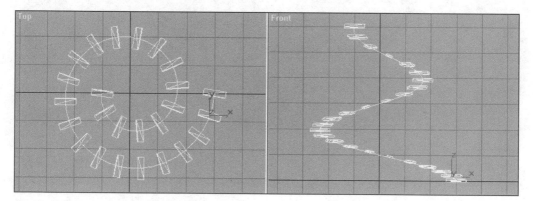

Figure 5.35
Result of the Snapshot dialog box settings shown in Figure 5.34.

16. A better estimate would be 70 instances, so undo back to the single step and try the Snapshot again with this larger number. The result, as shown in Figure 5.36, is much better. Make sure you understand exactly what has happened. Pull the scrub bar and watch the original box animate through the instances on the path. The Snapshot tool created nonanimated instances at every step, but left the original animated object behind. When you are fully satisfied with the array, you should delete (or at least hide) the original box and its spline path.

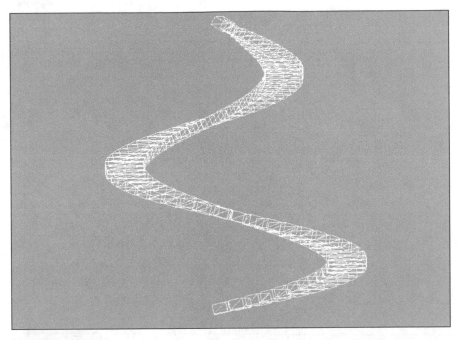

Figure 5.36
Result of Snapshot with 70 instances.

17. But there's still something wrong. Because the stairs are aligned to the curve, they are all tilted vertically and do not remain level with the groundplane. This is a somewhat subtle problem that forces you to consider some MAX basics.

18. You know that, by making a multiple selection of all the steps, you can rotate them simultaneously around their individual pivot points. But this won't work here because the angle of each successive step is steeper (this being the nature of a tightening spiral). Check this out yourself by entering the Rotate mode and right-clicking on the Rotate icon on the Main Toolbar to bring up the Rotate Transform Type-In dialog box. Select the first step and check its x rotation value. Then, compare subsequent steps and note how this value increases. Thus, no single rotation value works for all.

19. You're stuck, therefore, with selecting each one of the steps in order and typing a zero value into the Absolute: World X slot on the left side of the dialog box. This is tedious work to be sure, but it's a small price to pay for precision and to learn some important lessons about snapshots along curving paths and rotations in general. In the end, the result looks like Figure 5.37.

Mirroring Objects And Subobjects

When you mirror an object, you both duplicate it and flip it across a plane. Mirroring is an essential aspect of modeling because many objects, and almost all organic ones, are bilater-

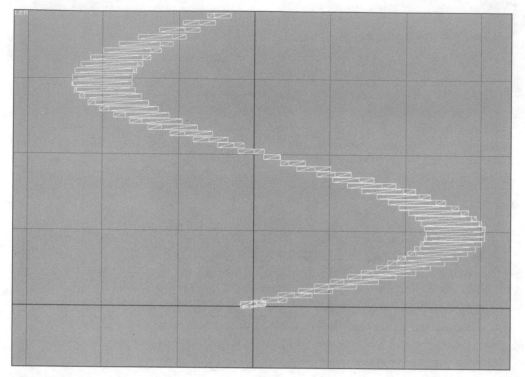

Figure 5.37
The finished staircase, with each step rotated square to the groundplane (0 degrees in the x-dimension using world coordinates).

ally symmetrical. The right side of a human face or body (from the front) is the mirror image of the left. Thus, most character modeling is best done in halves. The experienced organic modeler is adept at fashioning only one half of a head or body, and simply mirrors that half to create both sides. This saves time and assures symmetry. Small asymmetries, if desired, can be edited in after the model is mirrored. Cars, aircraft, and even spacecraft are usually bilaterally symmetrical, and are generally best modeled in halves, especially when built from NURBS (Non-Uniform Rational B-Spline) surfaces.

Note: NURBS have their own specialized set of mirroring tools within the NURBS toolset, in addition to the main Mirror tool.

The same is true at the object level. If a character (a robot, for example) is built out of separate objects for arms and legs and so forth, it makes sense to mirror those elements that occur in pairs, including hands, eyes, and ears. In scene layout, you also often come across architectural elements that are mirrored across a center line.

You'll use mirroring extensively throughout this book, but now the focus is on the logic of the Mirror tool and its dialog box (although you'll continue to learn about MAX's coordinate systems as well):

1. Create a Teapot primitive on the groundplane, somewhat to the right of the center when looking from the front. The Teapot primitive is good for your purposes because it's obviously directional. Get into the local coordinate system so that you can see the teapot's local axes (aligned with their true pivot point). Your screen should look like Figure 5.38. Notice that the spout of the teapot is pointed in the direction of the local x-axis.

Figure 5.38
A teapot on the groundplane, positioned somewhat to the right (positive x) of the world origin.

2. The Mirror tool is available through the Tools menu, but it is more directly reached through its button on the Main Toolbar, immediately to the left of the Array and Snapshot tools. Press this button to call the Mirror dialog box, as seen in Figure 5.39. Notice two things right from the start. First, the current coordinate system is indicated at the top of the dialog box. All of the axis choices you'll make in this dialog box are based on that system. Second, the effect of the current settings is seen immediately, even before pressing the OK button, making it possible to experiment before you confirm or cancel the settings. Note in Figure 5.39 how the teapot has reversed direction.

3. Unlike most other programs, MAX allows you to use its Mirror tool to reverse an object without duplicating it. In most applications, this is achieved by scaling an

Figure 5.39
The teapot with the Mirror dialog box up. The teapot is now reversed in the local x-direction.

object using a negative 100 percent scale value, and you can do this in MAX as well. With the local x-axis chosen for mirroring, the spout of the teapot (and, therefore, the local x-axis) is now facing the origin, but the y-axis and z-axis are still pointed in their original directions. Make sure you understand the distinction between mirroring, which is negative scaling, and rotating 180 degrees around an axis. If, instead of mirroring (negative scaling) in x, you had rotated the object 180 degrees around its z-axis, the x-direction would also be pointing toward the origin. But the y-axis would now be pointing forward.

4. Most people are more comfortable thinking of mirroring across a plane, instead of flipping in a direction. After all, when you stand before a mirror, you get the impression that there is a duplicate (and reversed object) an equal distance through the glass. Mirroring in the x-direction effectively means mirroring across the yz plane, as if that plane were a flat mirror. This becomes clearer if you duplicate the object in the mirror process. Change the dialog box settings from "No Clone" to "Copy," which duplicates the teapot and negatively scales it in the x-dimension. Your screen should look like Figure 5.40.

5. Experiment with the y-axis and z-axis. The z-axis mirrors the teapot vertically, across the xy plane (the groundplane). Using the y-axis doesn't affect the appearance of the teapot because it is bilaterally symmetrical in this direction. But notice that the local y-axis now points in the opposite direction.

Figure 5.40
The same mirror settings as in Figure 5.39, but the teapot is cloned.

6. Try out the double-axis options on the right side of the panel. Your first instinct might be to consider them as mirror planes, so that yz would produce the same result as x alone. These options provide for negative scaling in two dimensions at once, however. For example, the xz option mirrors in both the z (vertical) and the x (horizontal) directions, as seen in Figure 5.41. This kind of mirroring is not very common.

7. Go back to the x option and move the duplicate away from the original by pulling the Offset spinner in the dialog box in the negative direction. This allows you to either position the duplicate by sight (which will often be good enough) or to type in a specific distance value from the original. But it often makes sense to mirror across the center of world space, rather than across the local space of the object. Cancel your mirror settings, change from the local to the world coordinate system in the Main Toolbar, and then choose the Use Transform Coordinate Center option from the button immediately to the right of the Coordinate System drop-down box. The temporary pivot point jumps to the center of world space.

8. Open the Mirror dialog box and note that it is now using world coordinates. Select the x-axis and the Copy option. The object is now mirrored across the world yz plane, as seen in Figure 5.42.

9. If the object is aligned to world space, the choice between local and world coordinate systems is a matter of preference. But if your teapot is rotated with respect to world space, the choice is important. Figure 5.43 demonstrates the use of world

Figure 5.41

Mirroring the teapot in both x- and z-dimensions.

Figure 5.42

Mirroring the teapot in world coordinate space.

coordinates and the world space center on a rotated teapot. Figure 5.44 shows the effect of returning to the local coordinate system for the same model and using an offset to pull the objects apart. The teapot is now mirrored in its local x-direction.

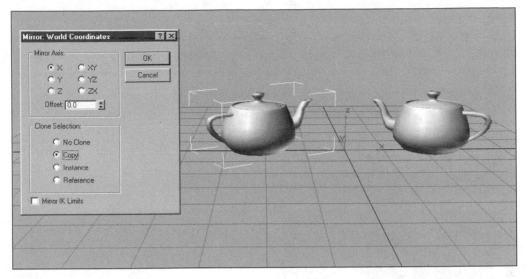

Figure 5.43
The teapot is rotated before mirroring in world coordinates.

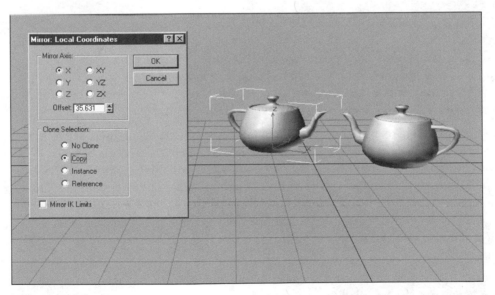

Figure 5.44
The same rotated teapot, mirrored in its local space in the direction of its local x-axis.

Precision Tools

When your work needs to be exact, MAX's precision tools will do the job. And even where absolute precision is not critical, these tools can speed up your work.

Snaps

MAX's snap tools create magnetic attractions that pull toward fixed values as you work. The snaps are all activated and controlled by the row of four buttons with magnet icons at the bottom of the screen. The following exercise introduces the most important snap features:

1. Right-click on any of the right three snap buttons on the bottom of the MAX screen. The Grid And Snap Settings dialog box appears, with the Snaps panel active. This panel is shown in Figure 5.45.

Figure 5.45
The Grid And Snap Settings dialog box, showing the Snaps panel.

2. Look this panel over carefully. You see only the Standard set of choices; there is an alternative set of choices for NURBS objects that I'll leave aside for now. You can check as many options as you want. The Grid Points option is the most important, because it pulls your cursor to the intersection of lines on the grid.

3. Close the dialog box with only the Grid Points option checked. You must activate these settings by left-clicking on the leftmost of the snap buttons at the bottom of the screen. If you hold the mouse button down, you'll find three options: 2D, 2.5D, and 3D snapping. Start by activating the 2D snapping (the button should light up) and create a box on the groundplane in the perspective view. Blue snap markers appear as you move your cursor, indicating that you are snapped to an intersection of grid lines. Draw out the box by using the snaps to get the corners exactly at grid intersections.

4. Once the box is created, return to the Grid And Snap Settings dialog box and add the Vertex option. Although the cursor should snap to the vertices of the box as well as to the grid, it doesn't work quite the way you might expect. The cursor snaps to the set of vertices that are on the groundplane, but it doesn't snap to the upper set of vertices.

5. This is where the dimensional options come in. Even though you have set the snap options to include vertices, you are still limited to 2D snapping, and thus only the vertices that are on the groundplane will snap. Switch from 2D snapping to 2.5D or 3D snapping, and you should see vertex snap markers (tiny crosses) as you pass your cursor on the upper vertices.

6. Try moving the box around and notice how you continue to snap to grid increments. This should be no surprise, but here's something you probably didn't expect. Go into the Rotate mode and snap to one of the upper vertices. Start rotating. The snap tools create a temporary pivot point right at the selected vertex, so that you are rotating around that vertex.

7. Create a second box. Snap to one of its vertices and move the entire object so that the selected vertex snaps to a vertex of the first box. Your screen might resemble Figure 5.46, depending on what vertices you've chosen to snap.

Figure 5.46
Using vertex snapping to snap one corner of a box to the corner of another box. A highlight glow has been added to the image to indicate the point of intersection.

8. Play around with other snaps to see how they work. One of the most useful is the Midpoint, which you snap to the midpoint of an edge, precisely halfway between its end vertices.

SNAPS CAN GET CONFUSING

Snaps are great when you need them, but they can also clutter the screen with distracting markers as you work. I like to keep them off the screen unless I really need them. MAX makes this easy because you can toggle the activation of snapping without losing your options settings.

The primary snap tool that has been discussed thus far is rather sophisticated and takes practice in order to understand the interaction of its many options. But the three other kinds of snapping couldn't be simpler. If angle snapping is activated (by using the Angle Snap Toggle button at the bottom of the screen), interactive rotations will snap to fixed angular increments. Right-click on the button to bring up the Grid And Snap Settings dialog box and switch to the Options panel. Set the desired angular increment in degrees. Percent snapping is for scaling, and the percentage amount is set in the same panel. If the percent snapping is then activated (by using the button to the right of the Angle Snap Toggle), interactive scaling will snap to the fixed percentage. For example, if the 10 percent default setting is used, the Scale tool will snap to fixed 10 percent increments (100 percent, 110 percent, 120 percent, and so on) as you drag it.

The Spinner Snap is a somewhat different creature and remarkably useful. Click on its toggle button (the rightmost of the four snap buttons) to activate it, and then right-click on the same button to bring up the General panel of the Preferences Settings dialog box. Notice the Spinners section of this panel, particularly the Spinner Snap spinner. The default value is 1.0, as seen in Figure 5.47. Change it to 10. Now, whenever you click on a down-arrow or up-arrow of a spinner, anywhere on the MAX interface, it will change in increments of 10 (or whatever value you have set).

Figure 5.47
Spinners section of the General panel of the Preferences Settings dialog box.

Alignment Tools

There are a number of alignment tools hiding under the Align button in the Main Toolbar. Hold this button down to see the choices. The first, and default, choice is the main Align tool. This is much more important than any of the others, and it is the only one I use regularly. It is available from the Tools menu as well.

The concept behind the Align tool is simple to understand. You select an object and then align it to another object. Select an object and click on the Align tool. You must now pick the other object, either by clicking on it or by pressing the H key to bring up a list of objects by name. Once the alignment object is picked, the Align Selection dialog box appears, as shown in Figure 5.48.

You can align any or all of the three transforms, but position alignment is certainly the most common. Your selected object (named at the top of the dialog box) is called the Current Object in the panel, and the alignment object is the Target Object. You have to decide what point of the Current Object and what point of the Target Object are to be aligned. For ex-

Figure 5.48
The Align Selection dialog box, with default settings.

ample, if you choose the pivot point for both and check all three of the dimensions, the selected object will be translated to bring its pivot point to the location of the pivot point of the target object. This is undoubtedly the primary use of the Align tool. Sometimes, an object's center (meaning the center of its bounding box) is a more useful alignment point than the pivot point. You can also use diagonal corners of the bounding box (minimum and maximum). A number of objects may be aligned at once by making a multiple selection before clicking on the Align tool.

> *Note: An alignment need not be in all three dimensions. By checking only a single axis, the objects will line up in that dimension alone. This is a good way of getting a number of objects to line up together quickly with a chosen object.*

The bottom half of the Align Selection dialog box is much less used, and it is self-explanatory. You can align the orientation of the selected object to the target object, in any or all axes, regardless of whether you are aligning its position as well. The Match Scale option sets the scale values of the selected object to those of the target object.

The Normal Align tool aligns an object so that a selected face on the object is flush with the selected face of another object. A *normal* is the imaginary line perpendicular to a polygonal face. If the normals of two faces are in alignment, the two faces are necessarily flush, or at least parallel. The only way to understand this is to see it. Figure 5.49 shows two identical objects before normal alignment, with the one on the left selected.

Just as with the main Align tool, it is this selected object that moves to align itself with a target object. With the left object selected, click on the Normal Align tool button. You can then choose a face on your selected object, perhaps the top one, and a blue line appears out of that face. Next, you choose a face on the other object, then click. The first object is both moved and rotated, so the selected faces are flush. The Normal Align dialog box appears, permitting you to make adjustments to position and rotation. Figure 5.50 shows the result.

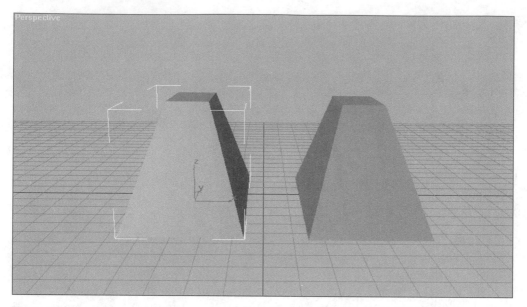

Figure 5.49
Objects before the Normal Align tool is applied. The object on the left is selected.

Figure 5.50
The Normal Align tool, applied to bring selected faces of the objects into alignment, with adjustments in the dialog box.

Tape And Protractor

Distances and angles between objects can be measured with a couple of important helper objects. To create a tape, select it from the Helpers in the Create panel. Drag the cursor to pull out a tape. Watch the Create panel to see the distance measure and the angle of the tape against the world space grid. Two objects are created: The tape object is the head, and the tape target is a dummy object at the tail end. Select either one and move it to change the length of the tape from either end. If you're in the Modify panel while you do this, you'll see the values change as you work. To move or rotate the tape rigidly as a unit, select both the tape and tape target objects together.

If you check the Specify Length box in the Modify panel with the tape object selected, you can enter a specific length value. The tape will continue to point in the direction of the tape target, but the length of the tape will be determined by the value you enter in the spinner.

USE THE ALIGN TOOL FOR PRECISE MEASUREMENT

To measure the exact distances between two objects, use the Align tool. Align the position of the tape object to the pivot point of one object, and align the tape target to the pivot of the other object. Check the distance in the Modify panel with the tape object selected.

The protractor helper object measures the angle between two objects from a given point. Create a protractor and place it in the scene. With the protractor selected, bring up the Modify panel and select two objects. The panel will read out the angle between the pivots. Figure 5.51 shows the protractor in action.

Figure 5.51
Angle measure between two objects from a third point, using a protractor object.

Keyboard Shortcuts

Keyboard shortcuts (often called *hotkeys*) are essential in any graphics application because the interfaces are so deep. Nothing speeds up your work quite as much as being able to grab a tool with a single keystroke. With an interface as complex as MAX's, hotkeys are a life-saver.

Fortunately, MAX makes it easy to customize its default hotkeys and to define your own. Hotkey sets are stored in files in the main MAX directory with a .kbd extension. The default set of hotkeys is called Maxkeys (maxkeys.kbd). Grab the Preference Settings dialog box from the Customize menu and look at the Keyboard panel, as shown in Figure 5.52.

You can examine or edit hotkeys for every command in every part of the user interface (U.I.). For example, with the Main U.I. option selected, scroll through the commands until you find Constrain To X, and notice that the current hotkey is F5. To assign a hotkey to a command or to change an existing one, activate the Press Key button on the right side of the panel, and then pick the desired key and confirm with the Assign button. You'll be warned of any conflicts with existing keys. Save the edited keyset to Maxkeys. The new hotkeys will be available next time you load MAX.

> **Note: You can create different keysets by entering a new name in the drop-down box and saving to create a new KBD file with that name.**

Figure 5.52
The Keyboard panel in the Preference Settings dialog box.

To get a current list of all your hotkeys, press the Save List To File button to create a text file that you can either print out or read in a text editor.

CREATE A SHORTCUT FOR THE SELECT MODE

Do yourself a big favor and create a hotkey for the Select mode. You need to enter this mode constantly, and it's a pain to have to click on the tiny button in the Main Toolbar.

Moving On

In this chapter, we covered the tools in 3D Studio MAX that permit the artist to work with greater speed and precision. You learned a variety of methods for cloning objects and for arranging duplicate objects into structured arrays. You saw how the Snapshot tool allows us to use the animation of an object to create a series of duplicates following an arbitrary path. I discussed the snap tools for positioning objects with accuracy, and you saw how the various alignment tools (including the Mirror tool) permit you to position and orient objects with respect to other objects.

In the next chapter, we'll look into the many 3D primitive objects that MAX provides and explore their remarkable flexibility. We'll also look into MAX's basic tools for creating and editing curves.

PART III

MODELING

USING PRIMITIVES AND SPLINES

<div style="text-align: right;">

6

</div>

The modeling process starts with the most basic of objects. Primitive objects and splines are the building blocks of even the most sophisticated meshes.

Every 3D graphics application generates primitives—basic objects, both 2D and 3D, that are used as the basis for subsequent modeling. But MAX offers far more primitives than any other application, and there is an important reason for this. As you learned in Chapter 1, MAX's primitive objects are parametric objects, often called *parametric primitives*. Their creation parameters can be edited even after they have been created, permitting a remarkable flexibility that is unique to MAX. Having a great variety of primitive objects "in the can" is a big help in any program. In MAX, it's especially valuable because it permits you to make maximum use of the flexibility to edit creation parameters at any time to reshape the object and adjust its segmentation.

To use parametric primitives intelligently in MAX, you have to have a handle on how they all work, and that means playing with the parameters of each one. Spending a little time now exploring the possibilities will save you lots of time down the road, when you might remember that a certain primitive, with the proper parameters, will produce just the right geometry without a lot of mesh editing. Although they are not all equally valuable and you probably will never use some of them, get to know parametric primitives in a general way so that you can call on them when the need arises.

Unlike primitives, which are 3D polygonal objects, splines are simply curves. In the language of computer graphics, 2D curved lines that are defined by the location of key points and the curvature between them are called *splines*. This term refers to the flexible metal strips that are used to define curvature, especially in automobile design. As computer-drafting tools replaced real splines with virtual ones, the word came to refer to all computer-generated curves. Splines are basic to 3D graphics, and they are used to build curving shapes in models and to create curving motion paths in animation.

The terms used in the MAX interface can be confusing. In the general language of computer graphics, a primitive is a 2D shape (such as a rectangle) or a 3D shape (such as a box) that the application can generate directly. But the MAX interface refers only to 3D parametric objects as primitives, and all 2D parametric objects are included in the category of splines. It's certainly true that all of the 2D primitives, such as the circle and rectangle, create spline

objects. But there is a distinct practical difference between spline objects that are created by using parametric values to produce regular shapes and arbitrary spline objects that are created by drawing vertices directly on the screen. The former are primitive objects, and they are parametric primitives, to boot. The latter are not parametric objects in any meaningful sense. As you will see, the splines created by the 2D primitive objects can be edited as true splines at the vertex level. The practical distinction will be made here, however, by treating 2D primitives separately from the nonparametric splines.

3D Primitives

MAX designates only 3D parametric objects as primitives and calls 2D objects *shapes*. The 3D primitives are found under the Create panel. Click on the leftmost tab, under the leftmost, Geometry, button. By default, you are presented with a choice of standard primitives. Click on the drop-down list to see the other choices. This chapter deals only with the standard and extended primitives.

Standard Primitives

The standard primitives are the basic building blocks. They might seem self-explanatory, but they're a lot more powerful and flexible than you might first guess. The following sections discuss them quickly, ignoring the less useful ones.

Box

The Box primitive is simple and straightforward. If you select the Cube option, your box is drawn equally in all three dimensions. If you don't, you can draw without constraints.

The Keyboard Entry rollout allows you to type in the three dimensions and the location of the pivot point. Remember that the pivot point of a Box primitive is in the center of the bottom plane, not in the center of the entire object. Thus, if you enter (0,0,0), your box will sit on the groundplane, not be centered around it.

Sphere And GeoSphere

To Sphere or GeoSphere? What's the difference between these two? Figure 6.1 shows a Sphere (on the left) and a GeoSphere, using the default parameters. The Sphere primitive is composed of a combination of quads (four-sided polygons) and triangles. There is a ring of

WHAT ARE MAPPING COORDINATES?

When creating any primitive or spline, MAX provides a Generate Mapping Coordinates checkbox. *Mapping coordinates* are information about how to apply a bitmap image to the surface of an object. By assigning mapping coordinates at the parametric level of the object, it is often possible to create texturing effects that logically follow the geometry. (See Chapter 13 for a discussion of mapping coordinates.)

Because the creation of mapping coordinates is a feature of parametric objects, you don't need to decide whether or not to generate them when the object is first created. You can always later check (or uncheck) the box in the Modify panel, just as you can change all object parameters.

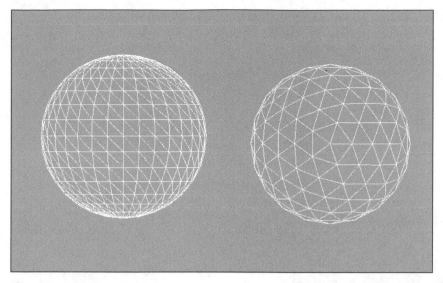

Figure 6.1
A Sphere (left) and a GeoSphere (right), using default segmentation parameters.

triangles around the poles at the top and bottom, and rows and columns of quads in lines of longitude and latitude. Because MAX ultimately triangulates everything, each quad is divided by a diagonal edge into two triangles. The geometric effect remains quadrilateral, however, because there is no crease along these edges. In other words, the two triangles in each quad are coplanar (on a single plane).

In contrast, it would take a poet (or at least a mathematician) to explain the interlocking pattern of triangles used to create the GeoSphere. The main point is that this structure is not implicitly quadrilateral, the way the Sphere is. Because it is not organized into rows and columns, it is therefore completely fluid. None of the triangles are coplanar with each other to create larger polygonal units, so every edge counts. For a given number of triangles, the GeoSphere creates the smoother sphere.

Take a look at a lower-resolution version of the same objects, achieved by changing the segmentation parameter for each. Both objects in Figure 6.2 are composed of 80 triangles, but the GeoSphere is much rounder. It makes use of every edge.

Some highly skilled, low-poly modelers working in the games industry are adept at editing geometry that began as a low-resolution GeoSphere. This really takes practice. For most of us, the regular and comprehensible pattern of the Sphere object usually makes it much more workable as a starting point for modeling. On the other hand, when you don't edit the object on the mesh level (pulling around vertices to shape the mesh), the greater roundness of the GeoSphere may recommend it.

The structural differences between these two primitives are reflected in the parameters for creating truncated versions. The GeoSphere can be changed only into an exact hemisphere, and by

Figure 6.2
The same objects as in Figure 6.1, but with segmentation adjusted to create lower polygon count geometry of 80 triangles in each. The GeoSphere is much rounder.

checking the box, the entire mesh is recomputed. But because it's built in a regular pattern of rows, the Sphere object can be truncated to any degree—to create a cap, for example. Changing from the Chop to the Squash option when you adjust the hemisphere percentage preserves the total number of triangles in the object. This results in smoother geometry because an equal number of triangles is defining a smaller region. Take a look at Figure 6.3.

WHAT DOES THE SMOOTH CHECKBOX DO?

Every 3D primitive object provides a Smooth option. *Smooth* is one of the most confusing terms in computer graphics because it's used in two ways. To smooth geometry can mean to subdivide it into a denser mesh that can resolve curvature. For example, increasing the segmentation parameters of curving primitives "smoothes" them, as does the application of the MeshSmooth modifier. But there's another meaning. Ultimately, because all of the objects are built from flat polygonal faces, to create the impression of roundness and curvature, the renderer (the final renderer or the screen preview renderer) performs computations that effectively "smooth" over the edges between polygons. You can see this difference on any rounded object by switching from a Smooth preview mode to Facets.

Normally, you want objects such as spheres to hide their polygonal edges and render smoothly. Occasionally, though, you'll want to override the smoothing to reveal the polygonal structure (with a faceted gemstone or a disco ball, for example). Uncheck the Smooth box to get this result. In Figure 6.4, the Sphere on the left is smoothed and the one in the center is not. Notice that this smoothing in the renderer cannot hide the rough segmentation along the profile. To create a rounder profile, you need to increase the segmentation of the geometry, as seen on the right. This is the other meaning of smoothness.

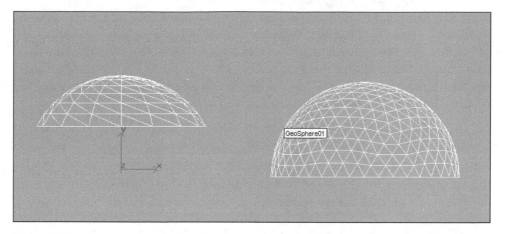

Figure 6.3
The GeoSphere can be converted only into a hemisphere, but the Sphere can be flexibly truncated to any degree.

Figure 6.4
The Sphere on the left is smoothed in the renderer, but still reveals its segmentation along the edge. The same sphere, without the smoothing, is shown in the center. On the left, the segmentation has been increased for a truly round effect.

Another difference between the two spheres has been added in MAX 3. There is now a Slice option that permits you to create angular fractions of a Sphere, just as was always possible with the Cone and Cylinder primitives. This option is not available for GeoSpheres.

Cylinder, Cone, And Tube

The Cylinder, Cone, and Tube primitives are easily understood as a group because they all involve the straight extrusion of a 2D circle into a 3D object. The Cylinder has only one radius, which is constant for the length of the object. The Cone has different parameters for the top and bottom radii. To make a true cone, one of these radii must be set to zero, so that the

circle closes to a point. But a radius can be any value, so a MAX Cone primitive is better understood as a cylinder with different radii at each end. Figure 6.5 shows the possibilities. The Cone at the left has equal radii at the top and bottom, and is therefore the same as a Cylinder primitive. The next cone has a top radius of zero to create a true cone. The other two Cone objects have different values for the top radius. Clearly, a MAX Cone is more than just a cone.

The Tube object also has two radii parameters, but these are for the inner and outer radii of the tube. Just as with the Cone, you shouldn't let its name limit you. By reducing the number of sides, the Tube object can be used for many useful structures that are not round. Figure 6.6 shows the same Tube object with 3, 4, 6, and 24 sides. Smoothing is turned on for the last one to keep it looking round, but the other three are kept faceted.

Figure 6.5
Different possibilities for the Cone primitive, using different values for the upper radius.

Figure 6.6
Tube primitive with 3, 4, 6, and 24 sides. Only the last one has the Smooth checkbox activated.

You can create all three of these primitives (Cylinder, Cone, and Tube) by using a fraction of a circle, if the Slice On checkbox is clicked on. Use these options to get the full sense of what is possible with such seemingly simple tools.

Pyramid And Prism

A Pyramid primitive is a rectangular base with four triangular sides tapering to a point. The Base/Apex option starts drawing at the corner of the base rectangle, and the Center option starts drawing at the center of the base rectangle.

The Prism is an extruded triangle. You can constrain to create only an isosceles triangle (with at least two equal angles), or you can choose the Base/Apex option to create any kind of triangle by dragging out an isosceles triangle and moving around the opposite corner. It takes a moment to get used to, but you are interactively entering parametric values for the lengths of all three sides, however you do it. After the base triangle is created, it is extruded in height to produce a 3D object.

MAX 3 has moved the Prism from the standard primitives to the extended primitives set, and this is rather unfortunate. The Prism is a basic and essential shape that should not be lost in the more subtle and less known extended primitives group.

Extended Primitives

MAX's extended primitives can save you a lot of modeling. Don't let the cryptic names of these objects deter you from exploring them. The most useful are those that provide an automatic transition between two kinds of shapes. Talk is worthless here—you've got to see them.

ChamferBox and ChamferCyl

The ChamferBox bevels every side of a box, and the ChamferCyl bevels the caps of a cylinder. Using them really opens up some opportunities when smoothing is applied to the filleted (connecting) section. Figure 6.7 shows both kinds of primitives. On the left of each pair, the fillet is unsegmented. In the middle, the fillet is segmented into three units to create curvature; on the left, smoothing creates the kind of rounded edges that you find in a huge variety of manufactured items.

OilTank, Spindle, And Capsule

The OilTank, Spindle, and Capsule primitives are further modifications of a cylinder. The OilTank is a cylinder with rounded caps, the Spindle has pointed caps, and the Capsule boasts caps that are true hemispheres. Take a look at Figure 6.8. The OilTank objects are on the left and the Spindle objects are in the center. In each case, a blending option has been applied to the forward example. On the right are two capsules. No blending is available here, so the two examples illustrate the effect of changing heights.

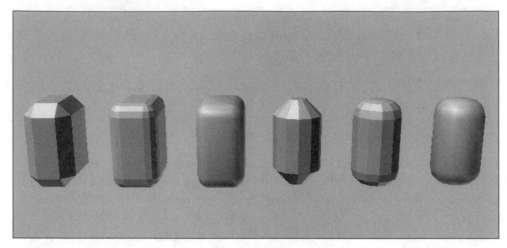

Figure 6.7
ChamferBox and ChamferCyl, showing the effect of segmenting the fillet and smoothing.

Figure 6.8
From left to right are the OilTank, Spindle, and Capsule primitives. The forward versions of the OilTank and Spindle have blending applied. The two Capsule objects have different height parameters.

2D Primitives

The 2D primitives might best be called *parametric splines*. They are splines that are created using input parameters to define characteristic shapes. Like all parametric objects, these values can be changed to redraw the object from scratch. So, what is the relationship between the 2D primitives discussed here and the splines in the next section?

A spline, no matter how it is created, defines a curve by the position of its points and the curvature between them. The spline discussed in the next section (the Line object) is created directly on the screen by the user. Although it has some important parameters, it is

fundamentally different from the true 2D primitives because its shape is not defined by these parameters. All of the other spline objects (except Section) are splines whose shapes are defined directly through input values, and you can change them by entering new values. It is still possible, however, to edit them at the true spline level by moving their vertices. Figure 6.9 shows the true spline, the MAX Line object, in the process of being drawn. The shape of this curve is completely arbitrary, and it is created directly on the screen by laying down points and defining the curvature between them (which can even be a straight line, if desired). The curve can then be edited by moving the points and changing the curvature.

In contrast, the Ellipse object in Figure 6.10 is a parametric primitive. It draws only a perfect ellipse based on length and width parameters, and these parameters can be changed after creation to redraw another perfect ellipse.

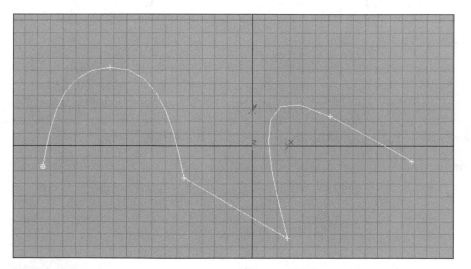

Figure 6.9
The MAX Line object is what is generally called a *spline* in computer graphics. Its shape is arbitrary and is not created from parameters.

Figure 6.10
The MAX Ellipse object is a parametric primitive that draws a perfect elliptical curve based on input parameters.

Figure 6.11
The Ellipse object from Figure 6.10 with the Edit Spline modifier used to edit the spline directly.

This parametric object is, ultimately, a spline defined by vertices. You can access the vertices and edit their positions and the curvature between them by using the Edit Spline modifier, as shown in Figure 6.11.

The Edit Spline modifier allows you to edit the spline directly without losing the original parametric control of the shape. In other words, you can still change the length and width parameters of the Ellipse, as modified. You can also convert the Ellipse to an Editable Spline object in the Modify panel (using the Edit Stack button). The Ellipse parameters are then lost, and the object is the same as a spline drawn directly by using the Line object.

The 2D primitives allow you to easily generate splines that would be difficult to draw by hand and to modify the creation parameters at will. The Helix object is a great example because it's nearly impossible to draw by placing vertices directly on the screen, and even harder to edit while preserving its curvature. The parameters are also animatable. Figure 6.12 illustrates a Helix, with two different height settings, which can be used as the basis for an animated spring.

Figure 6.12
A Helix object, with different height parameters, which is the basis for an animated spring.

The 2D primitives are easy to use and understand, and only the Text object deserves special attention. The Text object creates spline outlines of text characters by using the font you select, and the text is typed into the panel. Click in a window and drag to place the Text object where you want it. Everything remains modifiable, whether you are still in the Creation mode or whether you return to the creation parameters in the Modify panel after creation. Change the text in the box or the size. Kerning adjusts the horizontal space between the characters, and leading adjusts the vertical space between lines of text. To fill in the outlines, convert the Text object to an Editable Mesh (using the right-click menu) to create a 2D version or apply the Extrude modifier for a 3D one. Figure 6.13 illustrates the Text object.

Splines (Bezier Splines)

A spline is created directly by using the Line object or created indirectly through any of the 2D parametric primitives. Splines created with the Line object are immediately editable at the vertex level. To edit parametric splines in this way, you must either apply the Edit Spline modifier or convert the object to an Editable Mesh.

Terminology Confusion: Splines And NURBS

The word "spline" is simply used to mean curve in computer graphics, so why does the MAX interface distinguish between NURBS curves and splines? If NURBS are curves, aren't they splines as well? Absolutely. NURBS stands for Non-Uniform Rational B-Splines, so NURBS are most definitely splines. In fact, they are the most general class of spline. But MAX developed its original spline tools using Bezier splines, and, instead of calling them by this specific name, called them only "splines." When NURBS were added to the package, Kinetix didn't change the name for the original Bezier splines.

This rather confusing situation, in which the category of MAX splines doesn't contain the most important class of spline, makes it rather difficult to communicate. Because so many people are used to the word "spline" in MAX meaning the Bezier splines, and because the MAX interface continues this treatment, I'll use the term the same way in this book. I'll use the term "NURBS curve" as MAX uses it, even though such a curve is also a spline. Another reason to stick with this usage is that the 2D primitives are created as Bezier splines, although some can

Figure 6.13
At left, a Text object in spline form. Converted to an Editable Mesh, at center, it is filled with a polygonal surface but it is only in 2D. A 3D version is produced by applying an Extrude modifier to the original Text object.

be converted afterward into NURBS curves. This chapter deals with the Bezier splines (NURBS are covered in Chapter 12).

Spline Creation And Editing Tools

The shape of a Bezier spline is defined by the location of its vertices (points) and by the length and direction of its tangent handles. MAX has a unique approach to Bezier curves that disguises the effects of the handles. This can be convenient if you understand what it is doing, but make sure you understand the concepts.

Shaping A Spline

The following exercise takes you through the spline creation and editing tools.

1. Create a Line object with three vertices in the front view, by clicking (and not dragging) from left to right to create the linear spline shown in Figure 6.14. After the third vertex is created, right-click to end the process.

Figure 6.14
Linear (Bezier) spline created with three vertices, from left to right.

2. With the spline still selected, move to the Modify panel. Click on the Sub-Object button to enter the Vertex mode. Select all three vertices by dragging a rectangle around them. When they are selected, place your cursor over any one of them and right-click. The four vertex types are located on the right-click menu. Notice that the Corner type is currently checked. Corner vertices create linear segments between points. Although MAX is hiding the Bezier handles from view, these handles are producing the result.

3. Change from the Corner type to the Bezier Corner type. The spline remains the same, but the handles appear. The handles leaving each vertex are pointing directly at the other points. This can be hard to see at first, so select one of the handles and move it. Your screen should look something like Figure 6.15.

Figure 6.15
Spline from Figure 6.14, with all three vertices converted from Corner type to Bezier Corner type. One of the tangent handles is moved to demonstrate its effect.

4. With all the vertices selected, right-click and change them all to the Smooth type. The spline becomes a smooth arc. Even though you don't see the Bezier handles, the curvature is produced by them. To see the handles, change the vertices to the Bezier type. Your screen should look like Figure 6.16.

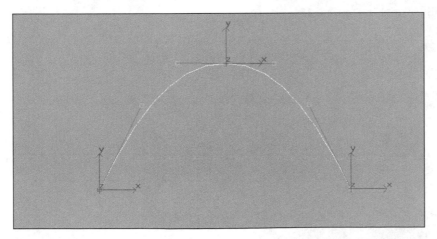

Figure 6.16
Spline from Figure 6.15, with all three vertices converted to Smooth and then converted to Bezier type to reveal the tangent handles.

5. Notice that the tangent handles on the center vertex are equal in length and lie in a straight line. Pull out on one of these handles, and the other pulls out symmetrically. Move one of the handles, and the other one moves to preserve the straight line between them. This relationship between the two handles creates the smooth and equal curvature through the vertex. Your screen might look something like Figure 6.17.

Figure 6.17

Spline from Figure 6.16, with one tangent handle pulled longer and moved downward. The opposite handle automatically extends an equal amount and moves to remain in a straight line.

6. Undo (press Ctrl+Z) until the spline is smooth and symmetrical. Change all of the vertices to the Bezier Corner type, which doesn't change the curve in itself. Instead, it removes the constraints that existed with the Bezier type. Now, you can pull and move each handle separately. Pull one of the handles of the center vertex straight out. The curvature is now different on either side of the vertex, but the curve is still smooth, as illustrated in Figure 6.18.

Figure 6.18

Spline from Figure 6.16, with vertices converted to Bezier Corner type. One handle is pulled out independently in a straight line.

7. If the same handle is moved at an angle with its opposite handle, the curvature through the vertex is broken. As you move the handle to edit the shape, notice that the spline may seem to be broken into linear segments. This is just another aspect of

digital art. If the screen resolution is too low, you can see the individual pixels that produce a color image. When a 3D model does not have a dense enough mesh to define its curvature, the surface does not look smooth. The same principle applies here. The mathematical perfection of a spline can be approximated only by straight-line segments between the vertices. At the default of 6, these segments can become visible.

8. To improve the resolution of the spline, unclick the (yellow) Sub-Object button to return to the object level of the Line object. Look for the Interpolation section of the panel (you may have to open the General rollout). Change the Steps value to see the effect. With a Steps value of 1, there is only a single straight-line segment between the vertices. As you move higher, the curve smooths out. This is precisely the same process, applied to splines, which is used on the polygonal segmentation of 3D parametric primitives. The Optimize option prevents unnecessary segmentation by restricting straight lines between vertices to a single interpolated segment. If you choose the Adaptive option, MAX sets the segmentation automatically to produce a smooth result. Figure 6.19 illustrates the spline with the broken Bezier handle and adaptive interpolation. Nice and smooth!

Figure 6.19
Spline from Figure 6.18, with an angle between handles to break the curvature through the middle vertex. The interpolation has been set to the Adaptive option to increase segmentation for a smooth-looking curve.

9. To make a full circle of this exercise, line up all the tangent handles to re-create the completely linear spline that you started with. Lining up opposing tangent handles to create linear segments is a task that comes up all the time. Bezier splines and their handles are used in Track View's animation graphs, so all of these techniques for managing curvature appear there as well. Your screen should look like Figure 6.20.

Figure 6.20
Tangent handles lined up to create the same linear spline that you began with.

Creating A Wineglass

Use what you've learned thus far, and a little more, to create the profile curve of a wineglass:

1. Use the Line object to draw the spline, clicking to create the essential points. Because you clicked without dragging, you created Corner vertices. Dragging on a vertex changes it to a Smooth one as you draw. I like to draw in linear segments first and then convert vertices, but that's just personal taste. The spline should look like that shown in Figure 6.21.

2. Next, change the third vertex (the one in the middle of the goblet portion) to the Smooth type. With this curvature in place, move other vertices around to improve the proportions—making the stem and goblet slimmer, and the stem shorter. The Smooth vertex is shown as selected in Figure 6.22.

3. There aren't enough vertices in the original spline. In the Vertex Sub-Object mode, add a point near the edge of the base by using the Insert tool. This tool permits you to add a vertex and move it at the same time. The Refine tool simply adds a vertex where you click. Change the new vertex to Bezier Corner type and adjust the handles to get a softer edge. Figure 6.23 is a close-up of this region.

4. Hey, I forgot something! You need the inside wall of the goblet. Use Refine to add two vertices to the first segment at the top. The one near the lip of the goblet must be a Corner vertex to define the sharp edge. The vertex that is moved down to shape the inside wall of the goblet is converted into a Smooth type, just like its partner on the outside. The very first vertex in the spline is moved to the very bottom of the goblet, which is good enough for our purposes. Take a look at Figure 6.24.

5. Finally, apply the Lathe modifier to revolve the spline 360 degrees around the y-axis. The segmentation of the final 3D depends on the segmentation of the spline. Figure 6.25 illustrates this. In the wineglass on the left, the interpolation of the underlying spline is manually set to six segments between each vertex. The glass in the middle is the same, but it uses the Optimize option to eliminate the unnecessary

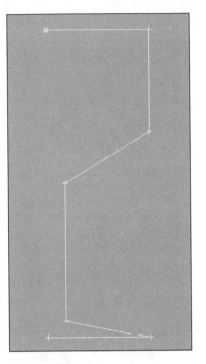

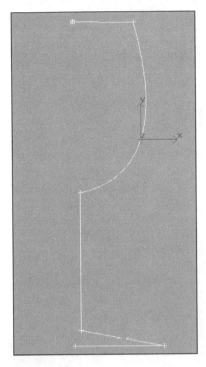

Figure 6.21
Wineglass profile spline, all of corner vertices.

Figure 6.22
Spline from Figure 6.21, with selected vertex converted to Smooth type.

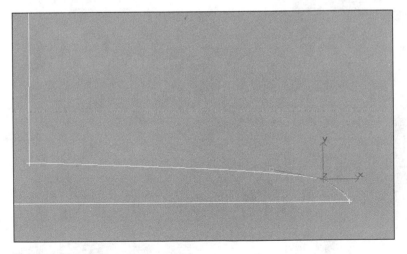

Figure 6.23
Close-up of base, with added vertex converted to Bezier Corner type and handles adjusted.

Figure 6.24
Two more vertices are added, moved, and converted to the correct Bezier types to create the inner profile. Affected vertices are shown as selected.

Figure 6.25
Results of different segmentation options on the profile spline. At left, there are six equal segments between each vertex. The middle wineglass is the same except for the optimization to eliminate linear segments. The right wineglass uses Adaptive interpolation to create denser segmentation in the curved region.

segmentation in the linear stem. The glass on the right uses the Adaptive interpolation option on the spline. Notice that this option creates greater segmentation only where it's needed, on the curving portion at the bottom of the goblet.

Moving On

This chapter explored the objects that are at the root of the modeling process. 3D and 2D primitive objects are important in every 3D application program, but they are even more important in 3D Studio MAX because they are also parametric objects. Once created, they can always be revised and regenerated from scratch by using new parameter values. These primitives are generally far more powerful than their names suggest, and only through a little investigation can you understand their full range and applicability.

MAX's Bezier splines, as you have discovered, are extremely flexible and capable of any type of curvature the user might desire. The key to their use lies in the various vertex types. The vertex types must be understood as an interface to the general powers of Bezier tangent handles.

In the next chapter, you'll move into the guts of hard-core polygonal modeling. Modeling at the mesh level means working directly with the vertices and faces of polygonal objects to sculpt them with precision. Whether used for low-poly, realtime and games work, or for a high-poly, cinematic-quality piece, mesh-level skills are the mark of the professional modeler.

MESH-LEVEL MODELING

The heart of polygonal modeling is in building a mesh by working directly with its components: vertices and polygons. This is true across the modeling spectrum—from the low-polygon count models required for realtime interaction, to the most subtle and organic forms used in film or video.

Althought MAX provides a wide range of modifiers that were designed to bypass direct mesh-level editing, these tools can never fully replace those that allow the user to fashion geometry in a hands-on manner. Mesh-level modeling is not an advanced technique—it's what most professional-level polygonal modeling is all about.

What Is Polygonal Mesh Modeling?

The current 3D modeling universe is divided into two general categories: polygonal modeling and Non-Uniform Rational B-Spline (NURBS) modeling. This division, however practical, is a blurry one for a couple of reasons.

First, all models are polygonal at bottom because the rendering engine doesn't understand anything else. In this respect, NURBS modeling is just a way to create polygonal models. In NURBS modeling, however, the ultimate mesh is hidden from you (unless you choose to look at it), so you can work directly with the NURBS curves and the NURBS surfaces that are created from these curves. Thus, NURBS modeling operates at a step above polygonal mesh modeling, and the tools and concepts for working with NURBS surfaces are fundamentally different from working directly on the mesh.

The second reason for the blurry distinction between polygonal and NURBS modeling is the existence of many non-NURBS spline-modeling tools. MAX used Bezier splines long before it implemented NURBS, and these Bezier curves (which are called *splines* in the MAX interface) are used in most of the same ways that NURBS are. Just like NURBS, the Bezier splines can be extruded into 3D geometry, lathed (revolved), or lofted along a path. In fact, a subtle change in the language of computer graphics recently occurred. A few years ago, it was common to divide modeling into polygonal mesh modeling and spline modeling. *Mesh modeling* is the fashioning of surfaces by direct operations on the faces and vertices of the mesh. *Spline modeling* (regardless of the species of splines used) uses curves in the modeling process—curves that are ultimately broken into linear segments to create polygonal mesh geometry.

Now, due in large part to the special powers and subtleties of the NURBS modeling process, NURBS modeling is seen as a field of its own, distinct from general spline modeling. As a result, most modelers tend to distinguish NURBS and polygonal modeling; non-NURBS spline modeling is, somewhat fuzzily, included under the general heading of *polygonal modeling*. If this sounds confusing to you, join the club. 3D computer graphics is a very new field, and even the most basic concepts are still evolving. It will take awhile for things to sort themselves out. The most accurate view is of a continuum—from pure polygonal mesh-level modeling at one extreme, to non-NURBS spline modeling, and then to true NURBS modeling at the other extreme.

In this chapter, you'll work at the first extreme. Your subject is modeling by creating and editing the vertices and faces of the polygonal mesh. Curvature in the surfaces is achieved by smoothing tools that subdivide the mesh and round it out, not by the use of splines of any kind.

Organic Modeling Vs. Low-Poly Modeling

In modeling, *organic* refers to the kind of smooth and subtle curvature found in the surfaces of living things. Although a rose petal and a human ear are good examples of this kind of fluid geometry, many manufactured objects also have a subtle curvature that requires the same kind of "organic" modeling techniques. Many of today's automobiles have a remarkably fluid curvature that requires the same kind of modeling techniques that truly organic objects do. In short, organic modeling generally refers more to the kind of desired geometry than to the biological status of the object.

Organic curvature requires a high-density mesh with lots of vertices and polygons. A model with many thousands of vertices is difficult to model directly at the mesh level. Thus, the building of an organic mesh is a process in which simpler meshes are modeled and then subdivided by using tools that smooth the object's geometry as the density of the mesh increases. This process can take several steps, in which the model is successively subdivided, edited, and then subdivided further.

The look of organic models is preferable, but models that have many polygons are impractical for realtime applications, such as games. 3D animation is divided between prerendered animation and realtime applications. *Prerendered animation* is just like a video or a motion picture. Each frame in the animation is rendered into a bitmap image; the resulting sequence of bitmaps, if flipped through in order at the proper speed, produces the illusion of motion. Although rendering out the frames may take a longer time, they need only to be viewed after they are rendered. Because the images are fixed, you must rerender out the bitmaps to change the animation.

In contrast, *realtime animation* is rendered as it is viewed. This animation is not stored in bitmaps—it is generated directly on the screen. In a game, the player determines the animation because the process is interactive. Nothing is fixed ahead of time. If the animation is to render out on the screen fast enough to produce a satisfactory sense of motion, the models must be built with the greatest possible economy. The number of polygons in a model must

be as low as possible, even though the smoothness of the objects is greatly compromised. *Low-poly modeling* today is a refined art, in which texture mapping is cleverly used to conceal, as much as possible, the crudeness and angularity of the model.

Low-poly modeling is mostly triangular modeling. In other words, the unit of thought is the individual triangle, and each triangular face (with its edges) is made to count. There can be no waste in realtime modeling. Although there is an increasing trend toward more-powerful game engines that also permit the use of quadrilateral polygons, triangles are still required in most work. Building a satisfactory character figure out of only 400 to 800 triangles is a difficult and demanding task.

On the other hand, organic modeling is generally best handled in quadrangles. A mesh that is built only (or at least overwhelmingly) of four-sided polygons has a regular structure that is readable and, therefore, editable. This point is very important. When a mesh gets dense, it can be very difficult to comprehend visually. If the modeler can't figure out what's going on, he or she can't edit the model. A mesh that looks like a gnarly jumble of points and edges is unmanageable. The use of quadrilateral geometry makes life a lot easier and generally produces a more satisfactory result.

Mesh-Editing Tools Overview

Working at the mesh level in MAX requires access to mesh. This access is achieved either through the Edit Mesh modifier or (most commonly) by creating (or converting to) an Editable Mesh object. Whichever method is used, the toolset is the same—the user can select and edit the mesh by using the vertices, the polygons, or the edges.

The Editable Mesh Object Vs. The Edit Mesh Modifier

To work directly with the polygonal mesh, you need tools to select and edit the individual polygons and their vertices. In every other 3D-modeling program, this raises no special problem. MAX is different, however. If a polygonal object is parametric in nature, the segmentation of its mesh is not fixed. For example, if you create a Box primitive, the segmentation of the mesh in any of the three dimensions can be adjusted at any time. Figure 7.1 shows copies of the same box with the segmentation parameters set to different settings.

If the mesh is not fixed, how can you edit it? One possibility is to fix the mesh and eliminate its parametric nature. If you take a parametric primitive object and convert it to an Editable Mesh object, the parameters disappear. You can no longer change the object's height, length, and width (although you can scale the object); more importantly, you can no longer change its segmentation. In place of these parameters in the Modify panel, you find a set of tools that allows you to select and edit the vertices, faces, and edges that constitute the mesh.

MAX allows you to enter into a parametric object, however, without converting it to an Editable Mesh, and then operate on the mesh. The Edit Mesh modifier, when placed on the stack, is like a permission to edit the object at the mesh level, while still preserving its parametric nature. It's important to understand the limits of this approach.

Figure 7.1
Parametric Box primitives with different segmentation settings.

Figure 7.2
On the left, a parametric Box primitive is edited by using the Edit Mesh modifier to move a row of vertices. In the two copies of this model (on the right), the underlying segmentation parameters are changed. The vertex edits are either lost or distorted.

Figure 7.2 illustrates the problem. The box on the left is a parametric primitive, to which the Edit Mesh modifier was applied. In that modifier, some vertices were translated out to create a sharp edge. So far, so good. Note what happens, however, if you take the model in this state and change the segmentation parameters, as shown in the two examples on the right. The results are completely unpredictable, ranging from the complete loss of the edit to the distortion of the rest of the geometry.

If the mesh is not fixed and the vertices are moved, it is impossible to further adjust the segmentation. Changing the segmentation deletes or creates vertices, so the Edit Mesh modifier can't preserve the shape that was created by translating the vertices. If you use Edit Mesh to edit at the mesh level, you lose the segmentation parameters for the underlying object. In theory, the parameters are still there; in practice, however, they are no longer useful.

This problem is not all that surprising. You can't begin to edit a mesh until you decide what it is—where the vertices of the polygons are located and how many there will be. This is what happens when you convert a parametric object to an Editable Mesh object. I almost never do any serious mesh-level modeling on objects that are not Editable Mesh objects at the bottom of the stack.

There are times when Edit Mesh is important, and it is a clever tool when used well. For example, using Edit Mesh can be a good way to isolate mesh edits under different names to create an edit history. Edit Mesh is applied and certain edits are made. Edit Mesh is applied again and other edits are made, and so on. Each modifier can be renamed to indicate the nature of the edits. By returning to each modifier, you can isolate only the edits made at that particular time, to revise or even delete them.

All experienced MAX users have their own attitudes about the value of the Edit Mesh modifier. My interest in this chapter is the art of mesh modeling; following my own inclinations for the greatest simplicity, I'll stick to the Editable Mesh object.

Mesh Subobject Editing (Vertices, Edges, and Faces)

Whether you reach the mesh through the Edit Mesh modifier or at the Editable Mesh object level (necessarily at the bottom of the stack), your choices are the same. For convenience, I'll refer only to Editable Mesh objects, but the interface for the Edit Mesh modifier is identical.

Prior to MAX 3, the tools for editing mesh subobjects were difficult to use. The user had to move back and forth between completely different panels for operations on vertices, edges, and faces, and each of these panels was long and complex. The new system is streamlined and a pleasure to use. The choices among the various subobjects are arranged as buttons across the top of the Editable Mesh panel, and the same choices are available on the menu that appears when you right-click on an Editable Mesh object. The choices are Vertex, Edge, Face, Polygon, and Element. The last three are just different ways of selecting polygonal faces, so it makes sense to think of them as a group.

As you move from one subobject level to another, the buttons on the panel change, as necessary. Some tools are available for all types of subobjects, others for only a couple, and some for only one. Buttons gray out to indicate that the tools are unavailable for the current type of subobject. In short, the MAX 3 interface tries to organize all the mesh-level tools as a group that crosses over, wherever possible, the different kinds of subobjects. For those who are familiar with MAX 2's method, in which tools are strictly compartmentalized between the different kinds of subobjects, the new interface is something of a fresh start. It's a huge improvement, however, and easy to get used to.

Vertex Sub-Object Level

The Vertex Sub-Object level permits you to select and edit vertices. Most of the time, you select vertices at this level to move them to shape the mesh. You can also weld vertices together, delete vertices, create new vertices, hide vertices, and assign colors to individual

vertices (typically for vertex color rendering). Most of these tools are easy to understand, but some deserve a moment of explanation.

Welding

Welding vertices is a very important process. Two or more vertices are merged together to create a single one. Welding is required in two distinct situations: cleanup and modeling. The most common example of welding as part of a mesh cleanup process is when you join two halves of a mesh object and must weld the centerline vertices together. The mesh-editing process can produce extra vertices as artifacts, however, such that unnecessary vertices sit right on top of necessary ones. In either case, you need to weld a number of vertices to other vertices that are very close to them by using the Weld Selected option. Select the vertices that require welding, typically with a region selection, and then press the Selected button. Selected vertices are welded to other selected vertices that are within the distance indicated in the spinner. By default, the distance is set very low (.1 units) to ensure that only vertices that are exactly or very nearly on top of each other are welded. You may need to increase the distance if the vertices to be welded are farther apart.

Welding can also be used as part of the modeling process, particularly in low-polygon count ("low-poly") work. Individual vertices that span a polygon are merged to eliminate faces and change the geometry. For this kind of welding, use the Target option. Click on the Target button to activate the tool, and drag a vertex on top of another vertex. When the dragged vertex is within the indicated pixel distance from the target vertex, release the mouse button, and the two vertices are welded. Figure 7.3 illustrates the effect. In the mesh on the left, the

Figure 7.3
Target welding of vertices is illustrated. In the model on the left, the highlighted vertex at the top is to be dragged to the highlighted one beneath it. The model on the right shows the result after dragging and welding.

highlighted vertex at the top is to be dragged to the highlighted one beneath it. After welding, triangular faces on three sides are eliminated, as shown in the model on the right.

Chamfering Vertices

Although this Target welding technique is a very important technique for rounding corners on low-poly meshes, MAX 3 introduces a new tool that serves nearly the same purpose in a more flexible way. When you apply the Chamfer tool to a vertex, either by using the spinner or by activating the Chamfer button and dragging from the vertex, the vertex spreads into a face. The vertices of the new face follow the existing edges toward the next set of vertices, where the process stops.

Figure 7.4 illustrates this process. In the mesh on the left, the top corner vertex was chamfered, creating a new triangular face. In the mesh on the right, the same vertex was chamfered as far as it could go, producing the same apparent result as the Target weld shown in Figure 7.3. There is an important difference between the two, however. In the chamfer on the right, there are now duplicate vertices that sit right on top of each other. If you attempt to select a single vertex at one of the newly chamfered corners, the panel informs you that two vertices are selected. (This is a great example of the kind of mesh-cleanup problems that I mentioned previously.) To get rid of the duplicate vertices, select all the vertices (use Select All in the Edit menu) and note that 10 vertices are selected. Press the Selected button in the Weld section, and watch the number of selected vertices drop to seven. The three duplicate vertices are welded.

Soft Selection

MAX 3 improved and renamed the old Affect Region tool. Normally, the selection of vertices is an all-or-nothing proposition—a vertex is either selected or not. The Soft Selection tool permits you to create a graded selection that tails off to create a kind of magnetic field effect.

Figure 7.4
The Chamfer tool is applied to a corner of the mesh. In the model on the right, the chamfer is pulled to its limit, creating duplicate vertices at three corners. Welding cleans up the duplicates.

The prior version of this tool applied only to vertices, but MAX 3 allows you to use it for all of the mesh subobjects. Even so, you probably will use it for vertices.

When the Use Soft Selection box is checked in the Soft Selection rollout, the region around the selected vertices (or other subobjects) is included in the selection, based on a control curve in the panel. This curve determines both the range of the Soft Selection and the manner in which its intensity falls off. This is a critical tool for shaping a fine mesh, in which it would be impossible to move vertices individually to preserve or create surface curvature. Defining the curve was difficult prior to MAX 3, but the new version of the program allows you to work interactively and see the region on the object. If you change the Falloff, Pinch, and Bubble values, the vertices on the object change color to reflect the new shape of the control curve.

Figure 7.5 shows Soft Selection in action. A single vertex is selected, and the Soft Selection region is defined by the curve. The translated vertex pulls the region along with it, creating smooth curvature.

Face, Polygon, and Element Sub-Object Levels

The order of this discussion may seem reversed here, but bear with me. Although the Edge subobject level follows the Vertex level on the interface, it's impossible to understand the Edge tools (or even the concept of edges in MAX) before the polygonal subobject levels are covered.

Faces, Polygons, And Elements As Selection Units

The fundamental unit of polygonal thought in MAX is the triangle, and all polygonal meshes in MAX are constructed of triangles. Although it sometimes makes sense to work directly with triangles (e.g., low-poly modeling for games and realtime use), you need to

Figure 7.5
Soft Selection is applied to create a "magnetic" zone around the selected point. The shape of the region is determined by a control curve.

work with quad (four-sided) polygons for most kinds of modeling. MAX handles this situation by distinguishing between faces and polygons. This language is unique to MAX and can be confusing because faces and polygons generally mean exactly the same thing in 3D computer graphics. In the MAX interface, a *face* is always a triangle. A *polygon* is one or more triangles grouped together to create a quad or N-gon (as polygons with more than four sides are called). To constitute a polygon, the faces must be separated by invisible edges and must be coplanar. Work through the following exercise to get a good handle on this important concept:

1. Create a Box object on the groundplane without any segmentation and convert it to an Editable Mesh object. The easiest way to do this is by right-clicking on the object and selecting Convert To Editable Mesh from the menu that appears. The older method is to use the Edit Stack button in the Modify panel. Figure 7.6 shows the mesh with the Editable Mesh panel. The screen displays the wireframe mesh in quadrangles (polygons).

Figure 7.6
Unsegmented Box primitive converted to an Editable Mesh. The wireframe displays the mesh as quadrangles.

2. Underneath the quad polygons are triangular faces. Go into the Face Sub-Object selection level on the quad on the front of the object. The Editable Mesh panel will inform you that you've selected a face, but it can be hard to see in your viewport. In fact, face selection was always a struggle in MAX before MAX 3. To use the new powers of the program, go to the Rendering Methods tab in the Viewport Configuration dialog box (under the Customize menu) and check the box that reads Shade Selected Faces. Now, the selected face will be clearly visible. I have no idea why this isn't the default. Take a look at Figure 7.7.

3. Deselect the face by clicking outside of the object and change to the Polygon Sub-Object level. Click on the front quad again, and this time the entire polygon, composed of two coplanar triangular faces, is selected. The panel will inform you that two faces are selected. The polygon in MAX is only a grouping concept. The ultimate unit is the triangular face. Take a look at Figure 7.8.

Figure 7.7

Editable Mesh object from Figure 7.6 seen in the Face Sub-Object level. A face is selected and clearly high-lighted because the Shade Selected Faces option has been used.

Figure 7.8

Two faces are selected together in the Polygon Sub-Object level because they are coplanar and separated by an invisible edge.

4. Deselect the faces. The quad polygons are divided by diagonal edges. These are invisible edges. To see these edges, go to the Display panel or bring up the Display Floater from the Tools menu. In the Display Properties section of either of these interfaces, uncheck the box labeled Edges Only. This rather poorly named box refers to visible edges. If it's unchecked, invisible edges will be displayed as dotted lines. This doesn't mean that they have become visible edges within the meaning of the Editable Mesh panel—it just means that you can see them. With the invisible edges displayed, your mesh should look like Figure 7.9.

5. In the Editable Mesh panel, change to the Edge Sub-Object level and select the invisible diagonal edge that divides the front quad polygon. Press the Visible button at the very bottom of the panel and watch it change to a solid line. It is now a visible edge.

Figure 7.9
Invisible edges are displayed as dotted lines when the Edges Only box is unchecked in the Display panel or the Display Floater. This does not convert them into visible edges within the meaning of the Editable Mesh panel, however.

6. Return to the Polygon level and click on the front of the object. This time, only a single triangular face will be selected. The front surface of the object is divided by a visible edge, and therefore each triangle is both a face and a polygon. This takes some thinking to become accustomed to.

7. Go back to the Edge Sub-Object level and select the same edge. Change it back to invisible status using the button at the bottom of the panel. It will become a dotted line again. Now, the front surface is a single polygon again. Let's experiment with the other aspect of the definition of a polygon. Go in the Vertex Sub-Object level and select the bottom-right vertex on the front quadrangle. Translate it forward so the front quadrangle is no longer planar (in other words, not all of its four points are on the same plane).

8. Go back to the Polygon Sub-Object level and set the Planar Threshold to a low value, like 1 degree. Click on the quad and note that only a single face is selected, as you can see in Figure 7.10. This is because, even though the two front triangles are separated by an invisible edge, they are not coplanar within a tolerance of 1 degree.

9. Change the Planar Threshold to 90 degrees. Now, even faces that are at right angles to each other will be grouped into polygons. Click on the surface again, and note that both faces are selected as a polygon. Your result should look like Figure 7.11.

10. So now we understand what a polygon is in MAX. But what is an element? An *element* is a separate unit of mesh in an Editable Mesh object. An Editable Mesh object can contain more than one mesh. Get out of any Sub-Object level and delete the entire object. Create a Sphere primitive. Convert it to an Editable Mesh object and copy it. Place the two copies so that they overlap.

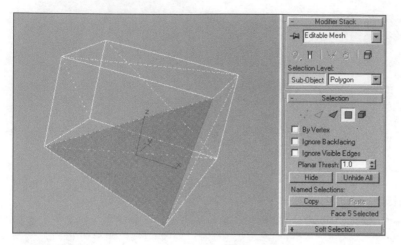

Figure 7.10
At a Planar Threshold of only 1 degree, the two triangles on the front quad do not meet the test of coplanarity. Thus, each one is treated as a separate polygon, regardless of the fact that they are divided by an invisible edge.

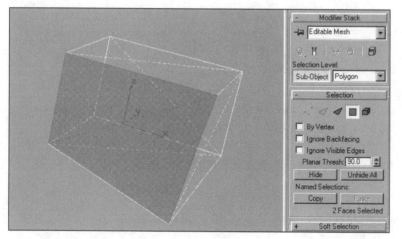

Figure 7.11
After increasing the Planar Threshold to 90 degrees, the two front faces are once again selectable as a single polygon.

11. At this point, you have two separate objects. Confirm this in the Select Objects dialog box (press the H key). Select one of the objects and, without entering any subobject level, click on the Attach button in the Editable Mesh panel. Now, click on the other object. The two objects become two separate mesh Elements in a single Editable Mesh object. Enter the Element Sub-Object level and click on one of the spheres. All of the faces in that sphere are selected. Your screen should look like Figure 7.12.

Extrude And Bevel

Extrusion and beveling are probably the most important operations in modeling because they define the basic architecture of the mesh. They are most important for creating the kind

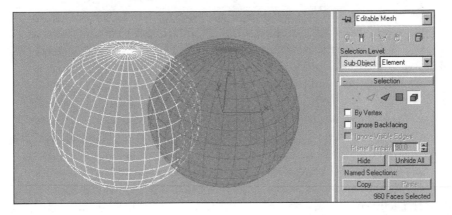

Figure 7.12
Two overlapping mesh elements in a single Editable Mesh object created by attachment. The element on the right is selected.

of branching architecture that is typical of animals and plants. In this regard, polygonal modeling still has significant benefits over NURBS modeling. In polygonal modeling, punching out an arm from a torso or a finger from a hand is as simple as extruding out the appropriate faces. In NURBS modeling, a branching model must be assembled out of separate surfaces to hide the seams between the surfaces—not always an easy task.

The Extrude spinner punches out a selected face in the direction of its normal. Figure 7.13 shows an Editable Mesh object before and after extrusion. The top polygon (quad) is selected and the Extrude spinner is adjusted. Note that the Extrude button on the panel is not activated—only the spinner was used.

It's important to understand the possibilities for extruding adjacent faces or (more often) polygons. When two or more connected faces or polygons are selected, you can extrude them

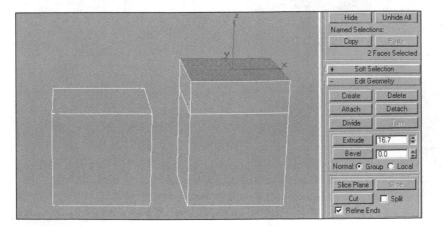

Figure 7.13
Cube-shaped Editable Mesh object, before and after extrusion of the top polygon (quad). Only the Extrude spinner was used—the Extrude button was not activated.

as a group (so that they stay connected after extrusion) or separately. Of course, you can simply select each face or polygon by itself and extrude it, but there's another way. If you move a face ever so slightly before you extrude, it extrudes out separately. If you simply select two or more faces or polygons without moving them first, they extrude out as a connected unit. You can use their group normal or each local normal for the extrusion by selecting the Group or Local radio buttons in the panel. Figure 7.14 illustrates the possibilities. In the mesh on the left, one of the polygons was moved slightly before selecting both and extruding. Each quad extrudes separately. In the mesh in the center, the same two polygons were selected together, without moving one first. They are extruded out as a unit by using the Group normal option. The mesh on the right is the same as that in the center, except that the Local normal option was used. Note that the two polygons fan out in the directions of their respective normals, even though the two polygons remain connected.

The Bevel spinner scales the selected faces or polygons, either inward or outward. In Figure 7.15, the cube-shaped mesh is on the left. At center, the top polygon (quad) is scaled outward using a positive Bevel value. At right, the same polygon is scaled inward using a negative value.

Although I like using the spinners because they give me a good sense of control, a more interactive method is available for both extrusion and beveling. If you activate the Extrude button, you can simply pull out faces or polygons by clicking on them and dragging. If you select multiple polygons prior to activating the Extrude button, dragging extrudes them together. The Bevel button works the same way, but goes a step farther. After you activate it, the first dragging action extrudes. Click and drag again to bevel (scale) the extruded faces or polygons.

Figure 7.14

Extrusion possibilities for connected polygons. On the left, the two polygons extrude separately by moving one of them very slightly prior to selecting both for extrusion. In the center, two polygons are extruded as a unit in a single direction by using the Group normal option. On the right, the same two polygons are extruded as a unit, but each follows the direction of its own normal by using the Local option.

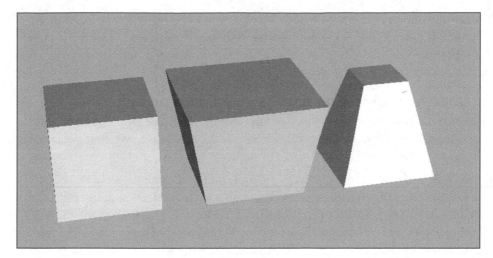

Figure 7.15
Bevel spinner applied to selected polygon. The mesh, prior to beveling, is at left. In the center, the top polygon (quad) was scaled outward by using a positive value in the Bevel spinner. At right, the same polygon is scaled inward by using a negative value.

The Bevel tools are great as far as they go, but they don't really replace true scaling because they necessarily operate uniformly. More often than not, you need the freedom to squeeze quads differently in their two dimensions to create the architecture that you need. Figure 7.16 illustrates the difference. The original cube-shaped mesh is at the left. The next model has the top polygon beveled in—effectively, a uniform scale. In the next model, the same polygon was

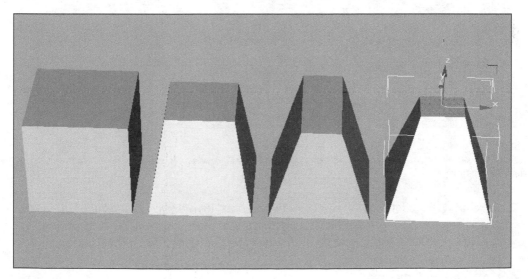

Figure 7.16
Comparison of beveling with nonuniform scaling. The original mesh, for reference, is on the left. On the next mesh, the top polygon is beveled to produce uniform scaling. On the following mesh, the same polygon is scaled in only one dimension by using the regular Non-Uniform Scale tool. At right, the polygon is scaled nonuniformly in both dimensions.

scaled in only one dimension by selecting the polygon and using the regular Non-Uniform Scale tool from the Main Toolbar. The mesh on the right has the same quad scaled in both dimensions, but unequally. MAX 3's new Transform Gizmo, shown in the figure, makes it easy to interactively select the dimension you want to scale.

Deleting, Detaching, And Creating Faces And Polygons

Deleting and creating faces and polygons are important basic tasks. Sometimes, the only way out of a mess is to delete the faces and rebuild the surface. Make sure that you can do this by following these steps:

1. Create a Box primitive on the groundplane and convert it to an Editable Mesh. Go to the Polygon Sub-Object level and select a quad. Delete it by pressing the Delete button. The selected quad disappears, as shown in Figure 7.17. When you look into the box, most of the faces are invisible because the normals of those faces, like those of all faces on the mesh, are pointing outward. Rotate the view to confirm that all of these faces are still there.

Figure 7.17
Editable Mesh object, with its front quad polygon selected and deleted. Three other faces are invisible due to back-facing normals.

2. To rebuild the deleted faces, you have two choices. If you move to the Face Sub-Object level, the Create tool builds only triangular faces (this was the only option in versions of MAX prior to MAX 3). In the Polygon Sub-Object level, the Create tool builds polygons that are composed of one or more triangles. Go to the Face level to try the original method.

3. Click on the Create button to activate it, and then notice the way the vertices appear. To create a face, you "connect the dots," but the operation is a little tricky and you have to be careful. Click on one of the red vertices and drag to another one. The

cursor turns into an arrow as you pass over a vertex. Click and drag to connect three vertices in a counterclockwise direction. Make sure that the dotted line "rubber band" picked up all three points. If you did this successfully, and in the proper counterclockwise direction, a new face appears, as shown in Figure 7.18.

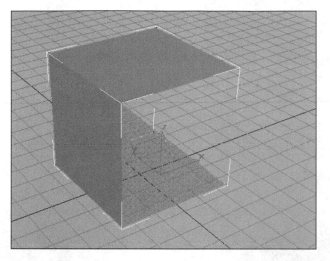

Figure 7.18
A single triangular face is rebuilt by using the Create tool in the Face Sub-Object level.

4. Rebuild the other face, but try to connect the vertices in a clockwise direction. An axis icon appears, which indicates that a face was created, but you can't see it. Creating in the clockwise direction produces a face with normal facing away from you. No problem. Make sure that only the invisible face is selected and right-click to get a context-sensitive menu. Pull down to Normals and select the Flip Selected option. The face appears and the mesh is completely closed again, but a visible edge was created in the process (as shown in Figure 7.19). By creating the faces separately, you fail to produce the quad polygon.

5. Although you can fix this problem by making the diagonal edge invisible in the Edge Sub-Object level, try to rebuild the entire quad polygon in one step. Go to the Polygon Sub-Object level, select both faces, and delete them. You're now back to the state shown in Figure 7.17. Stay in the Polygon level and activate the Create button. Because the create was limited to triangles at the Face level, a face was created the moment you clicked on the third vertex. In Polygon mode, you can create polygons with any number of vertices, so you must click again on the first vertex after clicking on all the others to complete the process. Click and drag around the four vertices in a counterclockwise direction, and return to click on the first one again to create the polygon. This time, the two faces that were necessarily created are divided by an invisible edge, as shown in Figure 7.20.

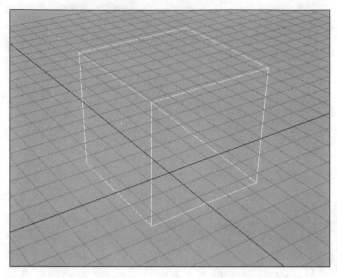

Figure 7.19
After rebuilding both faces separately, the side is divided by a visible edge, so it is not a quad polygon.

Figure 7.20
After creating a quad in the Polygon subobject, the diagonal between the two triangles is an invisible edge. The result is a quad polygon, just like the original.

6. You may want to detach selected faces or polygons instead of deleting them. Detaching faces preserves them, in case you decide to attach them again. Detaching is also an important way to divide a mesh into separate mesh elements, or even separate objects. Select the same polygon in the Polygon Sub-Object level and click on the Detach button. The Detach dialog box appears. The basic choice is whether to detach the selected faces as a separate object or as a mesh element in the existing Editable Mesh object. In either case, you have the option of dividing the original

mesh, or just cloning the selected faces as a mesh element or a separate object—leaving the original mesh as it was. If the Detach To Element box is not checked, you can type in the name of the new object.

7. Check the Detach To Element box and complete the detach. The mesh looks the same on screen. Go to the Element Sub-Object level and click on the mesh. It's now divided into two Elements: the selected quad and the other five quads. Go to the Vertex Sub-Object level and select one of the corners of the detached quad. The panel indicates that two vertices were selected, because two separate mesh elements intersect here. Your screen should look like Figure 7.21.

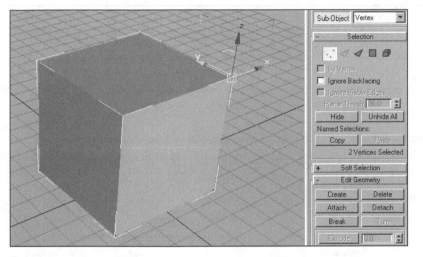

Figure 7.21
After detaching the quad polygon as a mesh Element, there are two vertices (rather than one) at each of the corners, because the two mesh Elements intersect there. The panel reads "2 Vertices Selected."

8. You should now have a good idea about how to put the whole thing back together. Select the vertices around the perimeter of the detached quad. The panel should read "8 Vertices Selected" because there are duplicates at each corner. Weld these duplicates together by using the Selected option and a low Threshold value (such as 0.1) because the duplicate vertices should still be right on top of each other. After the weld is performed, the panel should read "4 Vertices Selected." Return to the Element level and click anywhere on the mesh. The entire mesh should now be selected because there is only one Element again.

Smoothing Groups

The concept of smoothing groups is not easy to grasp. *Smoothing* is a confusing concept, as I repeat often throughout this book. One type of smoothing is geometric smoothing, in which a mesh object is subdivided to create rounder geometry, as when the MeshSmooth modifier is used. The other kind of smoothing—the kind addressed here—is a command to the renderer to blend over polygonal edges, which does not change the geometry at all.

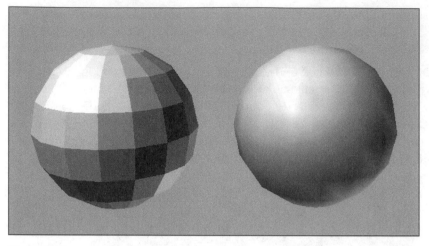

Figure 7.22
Two identical spheres, with and without smoothing. The segmentation that is still visible along the edge of the smoothed object demonstrates that the underlying geometry was not changed.

Figure 7.22 illustrates the concept. The two spheres have identical geometry, but only the one on the right is rendered smooth. Notice that the segmentation of the smoothed version is still visible along the edges.

The smoothing group tools permit you to control the effect of smoothing very precisely. In the vast majority of cases, you need only a single smoothing group for all of the faces. The most common example is when you import a mesh object from another program in a format that causes it to lose its smoothing information. To smooth it, select all of its faces and click on one of the numbers in the panel. All of the faces are assigned to that smoothing group; you can check this by using the Select By Smooth Group tool, which selects faces according to the smoothing group to which you have assigned them.

It is sometimes necessary to preserve a hard crease between two adjacent regions of the mesh, however. For example, Figure 7.23 shows an Editable Mesh object collapsed from a cylinder and edited to bring the top circle of vertices together. The version on the bottom has two smoothing groups—one for the end caps, and one for the entire body. In the version on the top, the body unit was further divided into two smoothing groups to generate a crease. Selected faces are assigned to smoothing groups by clicking on a numbered box in the panel. It's often helpful to clear all existing groups before you start.

Edge Level

MAX's basic mesh-level tools are inherited from the original 3D Studio package. Edges play a unique and central role in this system. For those who are accustomed to polygonal modeling that uses only vertices and faces, the role of the edge-level tools in MAX can take some serious getting used to. Work through the most important concepts with the following exercises.

Figure 7.23
Two identical mesh objects. The one below is divided into smoothing groups for the end caps and the body. The one above has the body unit further divided into two smoothing groups so the angular crease is not smoothed over.

Turning And Dividing Edges

To experiment with turning and dividing edges:

1. Draw out a Rectangle (found under the Shapes tab) in the front view. Using the right-click menu, convert it to an Editable Mesh object. Go to the Edge Sub-Object level. Although a shaded view shows that this is now a 2D surface, not just an outline, keep working in a wireframe view. Bring up the Display Floater and uncheck the Edges Only option to reveal the invisible edges. Your front wireframe view should look like Figure 7.24.

Figure 7.24
Front wireframe view of a Rectangle spline converted to an Editable Mesh. With the Edges Only display option off, the invisible edges are revealed as dotted lines.

2. By now, you are hopefully getting used to the rather confusing idea that "invisible" edges can be seen if you ask to see them in the Display Floater. This is entirely different from making them visible in the Edge subobject panel. Visible edges are always seen on the screen as solid lines, but invisible edges can be seen (as dotted lines) only if the Edges Only display option is off.

3. Start with the Turn tool. Turning an edge is a basic act in MAX mesh modeling, and it is much better demonstrated than explained. Click on the Turn button to activate it (it turns green), and then click on the diagonal edge on the object. The diagonal edge turns to connect the other two vertices of the quadrangle, as shown in Figure 7.25.

Figure 7.25
Mesh from Figure 7.24, with the diagonal edge turned.

4. Notice that you didn't have to select the edge first. The edge-level tools differ among themselves. Some apply only to the selected edge; others, such as the Turn tool, are modes. If the mode is activated, you can jump around the mesh, turning any edge you click on. Turning this edge didn't make any practical difference here because the two triangles are coplanar. In other words, even though there are two triangles, your working unit is a single quadrangle.

5. A huge part of polygonal-mesh modeling is cutting up the mesh. You'll start the old-fashioned way, by using the Divide tool in the Edge panel. Click on the Divide tool to activate it, and then click on the top edge of the quadrangle—looking from a front view. Your screen should look something like Figure 7.26, depending on where you clicked along the edge.

6. Prior to MAX 3, an edge was always divided precisely in the middle, regardless of where you clicked. The current version is a great improvement. A new edge is created, connected to the right-lower vertex. Note that this new edge is an invisible one, preserving the original quad polygon, which is now composed of three triangular faces.

Figure 7.26
Mesh from Figure 7.25, with the top edge divided.

7. The Divide tool should still be active, so click on the bottom edge, directly below the point where the upper edge was divided. It doesn't have to be exact. Now, click on the Divide tool button again (or just right-click anywhere in the viewport) to deactivate it, or else you'll continue to divide edges. With both the top and bottom edges divided, your front wireframe view should look roughly like Figure 7.27. All the diagonal edges are invisible ones, so there's still only one quad polygon.

Figure 7.27
Mesh from Figure 7.26, with both top and bottom edges divided. All the diagonal edges are invisible ones, preserving the original single quad polygon.

8. Activate the Turn tool and click on the original diagonal edge—the one running from corner to corner. Get out of the Turn tool by right-clicking anywhere in the viewport, select this edge, and change it into a visible one. You succeeded in cutting the original quad polygon into two quad polygons—your mesh should now resemble Figure 7.28.

Figure 7.28

Mesh from Figure 7.27, with the middle diagonal turned and converted to a visible edge. The original quad polygon was cut into two quad polygons.

9. Straighten out the cut with an important technique. Go to the Vertex Sub-Object level and select the two vertices at the ends of the visible edge. In the Main Toolbar, get into the Non-Uniform Scale tool and right-click on its icon to bring up the Scale Transform Type-In dialog box. On the right side of this dialog box, type a zero value in the x-dimension (or whatever dimension is the horizontal one, as indicated by the axes on your screen). This action snaps the vertices into a vertical line. The need for this technique comes up all the time. Figure 7.29 illustrates the proper settings and the result.

Figure 7.29

Mesh from Figure 7.28, with the edge made vertical by nonuniform scaling of its two vertices.

Cut And Slice Plane Tools

The traditional method of cutting up a mesh by dividing and turning edges is generally far too tedious for purposes outside of the most painstaking low-poly modeling. Yet, it provides the necessary foundation for MAX's other tools. Walk carefully through the other options to understand their precise consequences for the resulting mesh. Note that all of the tools are not only available at the Edge Sub-Object level, but are best considered in this section because their effect is to divide and rearrange edges. The results are also not nearly so comprehensible when used in the other Sub-Object levels. Follow these steps:

1. Create a cube-shaped Box object on the groundplane and convert it to an Editable Mesh. View it in a perspective window in a shaded version (not wireframe), but with the Edged Faces option on so that you can see all the edges. Open the Display Floater and uncheck the Edges Only option so that you can see the invisible edges. Rotate your view to see both the top and front sides of the box, and note that the diagonal edges are all invisible ones. This makes sense. The cube is composed of six quad polygons. Your screen should resemble Figure 7.30.

Figure 7.30
Editable mesh cube with invisible (diagonal) edges revealed by using the Edges Only display option.

2. There are three tools for cutting up the edges, in addition to the old Divide and Turn method. The first is not even part of the Editable Mesh toolset. It's the Slice modifier, which is placed on the stack above the Editable Mesh. You'll look at it first because it usually produces the ideal result.

3. Before you add the Slice modifier, make sure that you're at the base object level in the Editable Mesh. The yellow Sub-Object button must be off (gray). Now, add the Slice modifier above the Editable Mesh object on the stack. You probably have to press the More button to find it on an extended list of modifiers. Once in the Slice modifier, press on its Sub-Object button to access the slice plane, which appears at the bottom of your object. Rotate the slice plane (by using the regular transform

Figure 7.31

Mesh from Figure 7.30, with a Slice modifier added and rotated to cut vertically through the entire object.

tools) so that it cuts vertically through the object, and then move it back and forth across the mesh. Your screen should look something like Figure 7.31.

4. Make sure that you understand precisely what happened. First, rotate your perspective view to confirm that the cut affected the entire object. The top, front, bottom, and rear sides of the cube were all cut. Second, the cut is a visible edge, automatically creating new quad polygons, without the need to convert edges from invisible to visible status. Third, the Slice modifier added invisible diagonal edges in the new quads that run in the same direction as the original diagonals, which keeps the mesh clean and organized. This ideal result occurred because you used the default Polygons option, which ignores and then rebuilds invisible edges in polygons. If you change to the Operate On: Face button at the bottom of the modifier panel, you see the result if the slice cuts through all the faces in the polygons, as shown in Figure 7.32.

5. This is not a pretty sight, but, although the triangular geometry is more confusing, all of the different diagonals are still invisible ones. The mesh is therefore still divided correctly into quad polygons, even though some of them are now composed of three triangles. You may want to turn the Edges Only display option back on to confirm this. To bring the segmentation produced by the Slice modifier directly into the mesh, choose the Collapse Stack option on the right-click menu. The Slice modifier disappears and the Editable Mesh object includes the new cuts.

6. The Slice modifier is a very valuable tool because you can move it around at will, or otherwise experiment with it before deleting it from the stack or collapsing it into the mesh. Move on to the analogous tool directly within the Editable Mesh toolset: the Slice Plane tool. Return to the original, uncut cube mesh, by deleting the Slice modifier, by undoing, or by creating a new object.

Figure 7.32
Same as Figure 7.31, but with the Slice modifier set to operate on faces rather than polygons.

7. Make sure that you're in the Edge Sub-Object level and activate the Slice Plane tool in the panel by clicking on the button. A slice plane gizmo-like object appears. Rotate it vertically as you did before, and place it into position. This time, you must click on the Slice button to perform the cut. Get out of the Slice Plane tool by clicking on it and look at your result. It's the same as in Figure 7.32, using the Slice modifier to operate on faces. In other words, the slice plane divides all the edges, visible or not. Your screen should look something like Figure 7.33.

Figure 7.33
Using the Slice Plane tool in the Edge Sub-Object level produces the same result as when the Slice modifier was used on faces, as shown in Figure 7.32.

8. Once again, all the diagonals are invisible, so the quad polygon structure is preserved, despite the unnecessary triangles. Thus, it may or may not be necessary to clean things up, depending on what you do later in the modeling process. Even when subsequent processes (such as MeshSmooth) end up reorganizing the mesh anyway, all the unnecessary edges can make the mesh too difficult to visualize (and, therefore, to edit). Edge-turning straightens things out. Activate the Turn button and start clicking on the diagonals. It takes a few minutes to understand the process, but with practice (and a lot of undos), you can quickly eliminate the unnecessary diagonals and get the remaining ones to be slanted in the right directions.

9. Using the Cut tool is closer to the old-fashioned Divide and Turn method. Return to the original undivided mesh by undoing, or create a new mesh, and rotate your view so that the top and sides of the cube are visible (refer back to Figure 7.30).

10. Activate the Cut button on the panel and draw a cut from the top edge to the bottom one, cutting across the top and front sides of the cube. Click on the top edge, drag, and click on the bottom. This result is pretty useful. The invisible diagonal was not cut, so the resulting quad polygons are composed of only two triangular faces, as shown in Figure 7.34.

Figure 7.34
Using the Cut tool across the top and front sides of the cube mesh. No unnecessary triangles are created.

11. The direction of the diagonals is a little peculiar. They are mirrored, so it might make sense to turn one of them so that the polygons are identical on both sides of the cut. (This is a minor point, however.) The Cut tool only divided the three edges that you passed over. Rotate your view around to see the result on the bottom and back sides. The view should look like Figure 7.35.

12. The result on these sides was the same as an old-fashioned divide. If you don't intend to divide the remaining edge, it's probably best to turn the invisible diagonals to create a more organized mesh. Try and make them look like Figure 7.36.

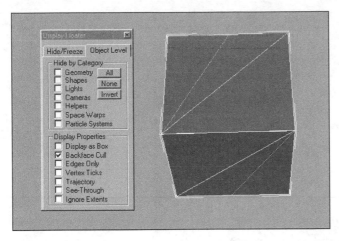

Figure 7.35
Object from Figure 7.34, with the view rotated to see the bottom and back sides.

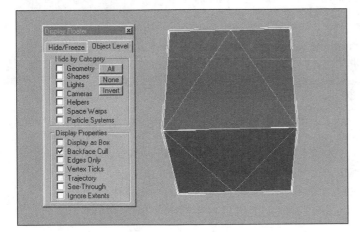

Figure 7.36
Sides seen in Figure 7.35, with the edges turned for a better-organized result.

Chamfering Edges

The Chamfer tool for edges is new to MAX 3 and is extremely valuable, especially for low-poly work. The Chamfer tool creates two edges out of one and spreads them out in the directions of the existing edges. Figure 7.37 shows a cubic mesh with a single edge, beveled, and with all of the top edges beveled together. The latter example produces a result similar to beveling polygons, but it works in the opposite direction—back into the mesh rather than outward from it.

The greatest value of the Chamfer tool is in its power to add curvature to low-poly meshes. A wineglass shape is generally created by lathing a spline, but you can use the Chamfer tool to demonstrate how such curvature is possible, even without splines:

Figure 7.37

Cube-shaped mesh with the edges chamfered. When all edges around a polygon are chamfered together, the result is similar to (although operationally backward from) beveling the polygon.

1. Create a cube on the groundplane (a Box equal in length, width, and height) and convert it to an Editable Mesh. Go to the Edge Sub-Object mode and *carefully* select the four vertical edges. (I stress "carefully" because selecting edges is not always easy work in MAX.)

2. Once the edges are selected, use the Chamfer spinner in the Edge panel to double the number of edges, while rounding the box into an eight-sided cylinder. You'll probably have to view it from the top to get it right. Chamfer the selected edges a second time to produce a 16-sided cylinder. Of course, you can start with a Cylinder primitive, but the purpose is to demonstrate how effectively chamfering edges can be used for rounding. Figure 7.38 shows the original cube and the result after the two successive chamfers.

Figure 7.38

Cube-shaped mesh on the left. On the right, the result after chamfering the vertical edges twice to produce a 16-sided cylinder.

3. Go to the Polygon Sub-Object level and select the polygon that constitutes the bottom cap of the cylinder. Use the Extrude and Bevel tools to build down the stem and base of the wineglass. Use Figure 7.39 as a guide.

Figure 7.39
Cylinder-shaped mesh from Figure 7.38, developed into a crude wineglass by extruding and beveling the bottom cap polygon multiple times.

4. Select the horizontal row of edges running through the lower part of the goblet section. The best way to do this is to choose the Window (rather than the Crossing) selection mode and drag a selection rectangle that closely encloses the desired edges. Once they are selected, use the Chamfer spinner to spread them out and create some simple curvature, as shown in Figure 7.40.

5. By chamfering two or three more rows of edges on the goblet and on the base, you create some pretty respectable curvature while preserving careful control of your polygon count. Using the Bevel tool to scale the top polygon also improves the contour. The mesh in Figure 7.41 has only 284 triangles. Of course, creating an inside surface for the goblet section increases the count, which you can do by extruding and beveling the top polygon down into the glass. Give it a try.

Putting It Together: A Low-Polygon Head

There are about a million ways to build a low-poly human head. In this exercise, the purpose is to explore the MAX mesh-modeling toolset in a practical context. Each artist must develop a unique approach to artistic problems—but only after the available tools are understood:

Figure 7.40
Row of edges in the goblet section from
Figure 7.39 is chamfered to create two rows
and some simple curvature.

Figure 7.41
With a little more edge chamfering, the
profile develops some good curvature, with
careful control of the polygon count.

1. Start with an unsegmented cube that is converted to an Editable Mesh object. You
 will put in all the segmentation yourself.

2. Make a horizontal and a vertical cut all the way through the mesh. Although the
 Slice modifier and the Slice Plane tool both work, try a new way. Go into the Ele-
 ment Sub-Object level and click on the mesh, which selects all the faces. Pull down
 the panel to the Tessellate tool. (*Tessellation* is the process of breaking faces and poly-
 gons into smaller units.) Set the spinner value to 0, and make sure that the Edge
 radio button is selected. Press the Tessellate button. Each of the six quads divides
 into four, with some funny additions of visible edges. Deselect all the faces, and
 choose the Edged Faces option for your Smooth + Highlight view to see things more
 clearly. Use the Display Floater to uncheck the Edges Only option, so that you can
 also see the invisible edges. Your mesh should look like Figure 7.42.

DON'T FORGET TO MERGE VERTICES

MAX has a remarkable tendency to produce duplicate and unnecessary vertices. Make a habit of periodi-
cally selecting all the vertices in a mesh and welding with a small Threshold value (such as 0.1). Check the
vertex count before and after, and you may be surprised how many vertices are eliminated. After welding,
check the model carefully to make sure that it's okay before you continue. Unnecessary vertices give you
an incorrect polygon count, so make sure that you try to clean them up before you check your triangle
count. The number of triangles in a mesh is found in the Object Properties dialog box, which is available
from the right-click menu when you select an object.

Figure 7.42
An unsegmented Editable Mesh cube, after subdivision by using the Tessellate tool. Reveal the invisible edges by unchecking Edges Only in the Display Floater.

3. Turn the edges until all sides of the cube have their edges radiating from the center vertex. This creates one of the most basic contour units in low-poly modeling. All sides of your object should look like Figure 7.43.

Figure 7.43
Mesh from Figure 7.42, after the edges are turned to create sides composed of eight triangles joined at a central vertex.

4. Now that everything is organized, make all the diagonal edges invisible, at least for the next few steps. Check the Edges Only box again, so that only the visible edge can be seen. It is now easier to select them and make them invisible in the Edges panel.

Figure 7.44
With diagonals hidden as invisible edges, two quad polygons are extruded to create a neck.

5. To create a neck, select the two polygons on the rear bottom of the cube and extrude them down, as shown in Figure 7.44.

6. Now, it's time to move the vertices to get the basic shape. Treat the horizontal row of edges through the head as the brow line. You can select and move vertices individually, but if vertices on the opposite side of the head require symmetry, select both together for translation or nonuniform scaling. Every vertex requires attention to create the proper contours. Take a look at the different views in Figure 7.45 for a

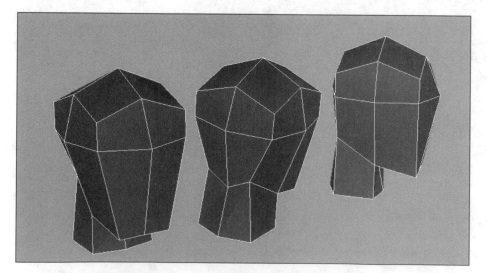

Figure 7.45
Mesh from Figure 7.44, after extensive translation and nonuniform scaling of vertices. Seen from three different views.

possible construction, and take some time to compare my result with yours. It's really quite amazing that you can get from the previous figure to this one by moving only points.

7. After you're satisfied with what you can do with the present number of vertices, add another row of edges midway between the chin and the brow line. Go to the Edge Sub-Object level and use the Cut tool. Set up some snaps so that the cut lines remain connected as you work around the model. Click on the Snap Toggle to activate it and then right-click on it to set the options. You need only the Midpoint and Endpoint options (uncheck anything else). The Cut tool then snaps to the ends and center points of edges. Using the Cut tool is always a little tricky, so be prepared for some practice and a few undos. You have to click on each edge to divide it before you can continue to the next edge. When you finish, however, you connect a new row of edges around most of the head, beginning and ending where the neck touches the jaw. Use Figure 7.46 as a guide.

Figure 7.46
Mesh from Figure 7.45, with a new row of edges added by using the Cut tool. Snaps were activated at the Endpoints and Midpoints of the edges.

8. Straighten out the new vertices so that they are roughly level with each other. Now, it's time to turn edges. From here on, you need to see all triangles, so select all the edges and make them visible. Turning edges creates contours—it involves individual, creative decision-making. I like to organize triangles into contour groups by color. You can easily do this by opening the Material Editor for the Main Toolbar. Select groups of faces that you want to assign a color to, and then drag from one of the material slots onto your selection. The faces are assigned the color in the slot, which helps to keep you visually organized while modeling and does

not prevent you from texturing from scratch when the model is done. After a great deal of edge-turning experimentation, the mesh is divided into contour groups for the brow, the large area beneath it, the top of the head, the back, the two upper sides, the two cheeks, the chin, and the neck. Take some time to consider the organization of edges in Figure 7.47. Consult the color section in the middle of this book for reference images.

Figure 7.47
Mesh from Figure 7.46, with all edges revealed and organized into contours by turning.

9. This is about as far as it makes sense to go by using the entire model. As you turn to the facial features, you will do a lot of detailed work and experimentation, and it doesn't make sense to work on both halves of the model. Select the faces of one half and delete them. Rename the remaining model "right side" or "left side," as the case may be. Bring up the Display Floater for the Tools menu, if it's not already up. You will use it constantly from here. You may now want to uncheck the Backface Cull option to see the inside of the model. While you're at it, you might as well delete the faces from the bottom of the neck. At this point, your screen should look like Figure 7.48.

10. You can still work on both sides of the head together, if you want to. Mirror the model by using the Mirror tool and create an instance. Now, both halves are visible as separate objects. Because they are instances, any edits that you apply to one of the halves automatically apply to the other half. This is an ideal arrangement. For example, with one of the halves selected, move one of the chin vertices inward and watch the opposite one follow to keep the screen image symmetrical (as shown in Figure 7.49).

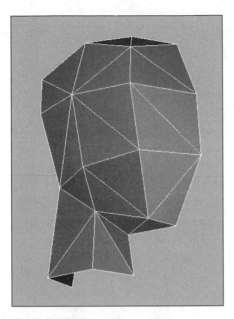

Figure 7.48
Mesh from Figure 7.47, with the faces that constitute the side of the head deleted. The faces at the bottom of the neck are also deleted. The Backface Cull display option was removed to make visible both sides of the remaining surface.

Figure 7.49
Mesh from Figure 7.48, mirrored to create a symmetrical instance across the centerline. Although there are now two models, they act as one. When the selected chin vertex translates inward, the corresponding one on the other side also moves in.

11. It may seem like I'm spending a lot of time on setup, but it's very important. Polygonal modeling (and especially low-poly modeling) is hard work, and it's almost impossible to operate without a good display setup. So, make one further refinement. Because you will work on the character's face from here on, hide all the faces on the back of the object. You do this by selecting the faces in the Face Sub-Object level and clicking on the Hide button in the Faces panel. This action not only makes things easier to see, but it also prevents accidentally selecting the vertices on the back of the object. Note the distinction between hiding subobjects (such as faces and vertices) in the Editable Mesh Sub-Object panels, and hiding entire objects in the Display Floater or the Display panel. To hide the back faces, use the former. To hide and unhide one of the instanced halves of the head, which are entirely separately objects, use the Display Floater. You have tremendous flexibility. Figure 7.50 shows both halves visible, but with the back faces hidden. Note that the adjoining side faces remain unhidden, even though you work only on the front faces. Many edits that you make on the front faces affect the side faces as well, so you need to see them.

12. Add a brow line first. My purpose here is not to show you how to create the ultimate model, which is an artistic process that every creative person handles

Figure 7.50

Mesh from Figure 7.49, with the face on the rear of the head hidden in the Face Sub-Object panel. This is different from hiding one or both of the instanced halves by using the Display Floater, because these instances are separate objects.

differently. Instead, this book is concerned only with learning to use the tools, so that you can exercise your own vision. The key to cutting up a mesh, as you've already learned, is the distinction between visible and invisible edges. If an edge is visible, the Cut tool (in the Edge Sub-Object level) divides it. If the edge is invisible, the Cut tool does not divide it—it reorganizes the invisible edges to accommodate the visible edges. Right now, all edges are visible. (If they are not visible, select them all and press the Visible button.) Thus, if you make a horizontal cut immediately below the existing brow line, you also cut the diagonal edge. With only half of the model visible for clarity, your screen should look like Figure 7.51. Make sure that the Edges Only option is unchecked in the Display Floater to see the new invisible edges add by this cut.

13. Undo until before the cut. Select the diagonal edge and make it invisible. Now, try the same cut again. This time, the diagonal is not cut, which eliminates unnecessary cleanup. Get used to checking and unchecking the Edges Only display option to understand the organization of the visible and invisible edges. Select the two vertices at the end of the new edge and translate (move) them back to create a sharp brow. Low-poly characters need exaggerated features. Figure 7.52 shows the result, with the invisible edges hidden by checking the Edges Only option on the Display Floater.

Figure 7.51
A brow line cut is added in the Edges Sub-Object mode. This action added an undesired cut through the diagonal edge because that edge was visible.

Figure 7.52
The same brow line is added, as in Figure 7.51, but only after making the diagonal edge invisible. The diagonal edge is no longer divided by the cut, which produces a cleaner result. Invisible edges are hidden by checking the Edges Only display option in the Display Floater.

14. Now, add the nose. Begin by cutting downward from the upper brow edge at an outward slant, through the next two horizontal edges. Your cut should look something like the new one in Figure 7.53.

15. To get a sharp shelf under the nose, make a cut to connect the lower corner to a point in the centerline, slightly beneath the tip of the nose. Because it crosses a diagonal, make that diagonal edge invisible before you cut. Turn on the snaps and right-click on the Snaps toggle to set them to snap to vertices. That way, you can start the new cut precisely at the lower corner vertex on the nose. Draw the cut as you see in Figure 7.54.

Figure 7.53
Mesh from Figure 7.52, with a vertical cut added to begin to define the nose. The cut divided three edges.

Figure 7.54
A new cut is added, from the corner vertex of the nose to a point on the centerline slightly below the tip of the nose. Vertex-snapping is used to make sure that the cut begins right at the vertex.

16. Select the new vertex on the centerline and translate (move) it up until there's a distinct ledge in the nostril area. After you are satisfied with the shape, you may want to grab all the vertices at the base of the nose and move them to create better facial proportions, as shown in Figure 7.55.

17. A nose is a pretty complex piece of geometry. Because this is a low-poly version, you have to decide how many triangles to spend on developing it. Right now, the ridge of the nose is a sharp angle. You can improve it with another cut, just inside the previous one. Moving some vertices a bit creates just enough sense of roundness. Take a look at Figure 7.56.

Figure 7.55
The new vertex on the centerline is translated up to create a ledge at the bottom of the nose. All of the verti-
ces at the base of the nose are then translated as a group to improve the proportions.

Figure 7.56
To round out the front of the nose, a second cut is added, just inside the previous one. Vertices were moved
around to create a minimally satisfactory result at both the bridge and tip of the nose.

18. Move down to create the basis of a jaw (or muzzle) effect. Put a horizontal cut across the jaw, roughly where the mouth should be. As you did before, make a cut that connects the corner of the nose to the outside vertex of the new edge by using vertex snaps. Move this vertex up or in (or both) to create a distinct chin, as shown in Figure 7.57.

Figure 7.57
A cut is added across the mouth and a second cut connects it to the corner of the nose. Vertices are then moved to create a distinct chin or jaw.

19. To round out the chin, use the Divide tool rather than the Cut tool. Remember that the Divide tool creates invisible edges, so uncheck the Edges Only option in the Display Floater to see the invisible edges. Activate the Divide tool in the Edge Sub-Object panel and click near the center of the chin edge to divide it. Move the new vertex on the chin upward to round out the jaw, as shown in Figure 7.58.

20. By now, you should be getting plenty of ideas of your own, so I'll add only one other element before leaving you to the freedom of your own imagination. Divide the invisible edge that runs from the top of the nose diagonally to the cheekbone—at about the middle of its length. This creates a vertex for the center of the orbits—the holes in the skull where the eyes are positioned. Move this vertex up and back into the head a bit, so that it's properly positioned for that purpose. Figure 7.59 gives you the idea.

From here on, it's up to you. You need to think a great deal about turning edges, once you get the basic contours that you need. To create more roundness, you need more edges (if your polygon budget permits it). One way is to create more cuts, as I did with the chin in Figure 7.60, and then move the vertices. Another possibility is to select edges and chamfer them, as I did at the top of the face in Figure 7.60. Both of these methods work, but the chamfer method creates additional structures and ends that might require editing. You may have to delete unnecessary faces by target welding the vertices. Just get in there and divide more edges, make more cuts, turn edges, and move points. Once you have the basics, it's all about practice.

Figure 7.58
By using the Divide tool, a vertex is added to the chin edge and then moved upward to round out the jaw line. The Divide tool (unlike the Cut tool) adds invisible edges, so the Edges Only option in the Display Floater is unchecked to see the new edge.

Figure 7.59
The diagonal invisible edge that runs from the top of the nose to the "cheekbone" divides, and the resulting vertex moves up and in, to create the basis of orbits for the eyes.

Figure 7.60
Mesh from Figure 7.59, with some additional rounding. A cut across the chin produced vertices that permitted a basic reshaping of the jaw. At the top of the face, selected horizontal edges were chamfered to create roundness. The chamfering produces additional geometry at the ends, which requires editing or cleanup.

Using MeshSmooth

Every 3D modeling application has its own distinctive tool for subdividing geometry to create curvature. In MAX, it's the MeshSmooth modifier. Mesh modeling is the process of building and modifying meshes, and then smoothing them when necessary. You can't even begin to build an organic mesh without a very strong—even intuitive—sense of how MeshSmooth affects geometry.

There are two traditions in geometric smoothing tools, and both are preserved in MAX's MeshSmooth modifier. The original concept of geometric smoothing for polygonal meshes is that of rounding hard edges. In this approach, a polygonal mesh is essentially completed before the smoothing is applied to clean it up. The other tradition in smoothing is fundamentally different. In this approach, smoothing is applied to change rectilinear geometry into something more ball-shaped. The result of this kind of smoothing is drastic, and is therefore part of the modeling process itself. At an extreme, this kind of smoothing simulates NURBS modeling. The modeler sees the smoothed version on the model as he or she edits the mesh of the unsmoothed version. Thus, the result is very similar to NURBS, in which the modeler transforms control vertices to shape a smoothly curving mesh. Although this second kind of smoothing was less than ideal in previous versions of MAX, MAX 3 perfected this NURBS type of geometric smoothing.

Classic Smoothing

In previous versions of MAX, the edge-rounding method of MeshSmooth was the default, which was overridden by choosing the Quad Output option. In MAX 3, the edge-rounding method is called Classic, and it must be selected. Try a quick exercise to explore this smoothing algorithm:

1. Create a primitive Box on the groundplane. Make sure that it's a perfect cube, either by using the Cube option when you draw it or by setting the length, width, and height parameters to the same values. There should be only one segment in each dimension. Collapse this primitive to an Editable Mesh in the Modify panel.

2. Make a copy of the object and pull it next to the original. Make sure that it's a copy, not an instance. Apply the MeshSmooth modifier to the copy. Change from the default NURMS (Non-Uniform Rational MeshSmooth) type to the Classic type. With the default Strength value of 0.5, your screen should look like Figure 7.61.

Figure 7.61
Identical cubes, with MeshSmooth applied to the one on the right. The Classic type is used with the default Strength value of 0.5.

3. The image shows the result of the smoothing. The edges of the box are all beveled down halfway to the center, and the corners are necessarily chamfered into triangles. Play with the Strength spinner to get the idea. At the maximum value of 1.0, the bevels on all sides meet, and the cube turns into an octahedron. As spinner values approach 0, beveling draws closer to the edges and produces the positive results that this kind of smoothing offers.

4. Put MeshSmooth on the other cube by also using the Classic type. Set the Strength values of both modifiers to 0.1. Compare the results of different numbers of *iterations*, which are repetitions of any process. Thus, setting the Iterations spinner to 2 produces the same result as placing two identical MeshSmooth modifiers right on top of each

Figure 7.62
Classic MeshSmooth is applied to two cubes by using a Strength value of 0.1. The cube on the right uses only one iteration; the cube on the left uses three, resulting in greater segmentation and rounding of the edges.

other, each with an Iterations setting of 1. With the Classic type of smoothing, increasing the number of iterations increases the rounding effect on the edges. In Figure 7.62, the cube on the right uses a single iteration with the Strength value set to 0.1. In the cube on the left, the Iterations spinner is set to 3.

5. The default Relax value is 0.0. When the value increases, the segmentation created by the MeshSmooth modifier is redistributed more evenly across the surface. In practice, the result can often be identical to changing the Strength value. To see this, bring the Iterations number of both models up to 3. On one mesh, leave the Strength value at 0.1, but increase the Relax value to 1.0. On the other mesh, leave the Relax value at 0.0, but increase the Strength back to the default value of 0.5. The two meshes should look very similar, as can be seen in Figure 7.63. They continue to look similar as you reduce the number of iterations for both of them.

Figure 7.63
Balancing the Relax and Strength values produces very similar results with Classic smoothing. The cube on the right uses a Strength value of 0.5 and a Relax value of 0.0. The cube on the left uses a Strength value of 0.1 and Relax value of 1.0. Both use three iterations. The results are very similar.

Quad Output And NURMS Smoothing

As you've learned, the Classic smoothing type achieves the traditional edge-rounding function. The far more important type of smoothing is the one used to create organic geometry during the modeling process, in a manner that is functionally similar to NURBS surface modeling. Prior to MAX 3, this NURBS-type modeling was handled through the Quad Output option. The new version of the program introduces NURMS-type modeling, in addition to Quad Output. To understand the advantages of the new option, start with the older tool.

Figure 7.64 shows an Editable Mesh cube on the left. In the middle, MeshSmooth was applied by using Quad Output and one iteration; all other values remain at their defaults. Notice what happens. Unlike the Classic algorithm that beveled the edges, the Quad Output algorithm divides each quadrangle in the original mesh into four. In effect, it tessellates the mesh and punches out the newly created vertices to bring the cube closer to a ball. Using three iterations, as in the mesh on the right, the rounding of the entire geometry is very pronounced.

The difference between the new NURMS-type and the older Quad Output-type may seem subtle at first. Figure 7.65 compares the two algorithms, as applied to the basic cube. The upper examples use a single iteration, and the lower ones use three. The NURMS examples on the right are distinctly more ball-shaped than the Quad Output examples on the left. In most instances, although not all, this produces a superior result—or at least a result that is more similar to the curvature found in true NURBS surfaces.

A more important advantage of the NURMS type is in the way it handles open edges. As you saw in the low-poly head exercise earlier in the chapter, it is almost always preferable to model bilaterally symmetrical objects in half. With the older Quad Output algorithm, the

Figure 7.64
The effect of the Quad Output type of MeshSmooth is illustrated. The original cube mesh is on the left. In the center, one iteration of MeshSmooth tessellated each quad into four and pushed out the center vertex. On the right, the cube is very rounded after three iterations.

Figure 7.65
Quad Output and NURMS smoothing algorithms are compared. On the right, a cube is smoothed by using the Quad Output type of MeshSmooth, with one and three iterations. On the left, the same cube is smoothed by using the NURMS type, also with one and three iterations. The NURMS result is distinctly rounder.

open edges of half of a model are distorted. With the new NURMS type of MeshSmooth, however, the half-model keeps its shape. This advantage alone makes NURMS the more useful choice in the majority of organic-modeling situations. Figure 7.66 illustrates a situation in which you would use NURMS. A cube mesh has been cut in half and one side has been deleted, so the right side edges are now open. NURMS has been applied to the examples on the left, and there is no distortion at the open edges. In contrast, the Quad Output alternative on the right is unable to keep the smooth shape at the open edges. When the halves are mirrored as instances to create a working view of both sides of the model, the NURMS model (below left) looks perfect, but the Quad Output pair remains distorted.

Another outstanding feature of the new NURMS type is the capability to shape the mesh by using "weights." In true NURBS modeling, control points have adjustable weights that pull or push the corresponding portion of the curve or surface toward or away from the point. This enables the model to shape the mesh by adjusting the weights of the control points rather than by simply moving them. The NURMS MeshSmooth type simulates this important power for polygonal-mesh modeling.

MODELING IN HALVES WITH QUAD OUTPUT

Because the Quad Output algorithm distorts open edges, you can't delete half of a bilaterally symmetrical mesh. Instead, you must hide half of the faces to be able to work efficiently on the other half. This is a clumsy approach because you can't use mirroring and instancing to see both sides, and because the hidden (and therefore unedited) side needs to be periodically deleted and updated by mirroring and welding points.

Figure 7.66
The effect of NURMS and Quad Output on open edges is compared. A cube was cut in half, and the right half was deleted. MeshSmooth is applied to the half-objects. On the left, the NURMS algorithm does not distort at the open edges. On the right, the Quad Output cannot preserve curvature through the open edges. The result is the same when, as below, the halves are mirrored as instances to create a working view of the whole model.

Take an unsegmented cube and convert it to an Editable Mesh. Apply MeshSmooth by using the default NURMS type and set the Iterations spinner to 3. Go down to the section of the panel titled Display/Weighting and check the Display Control Mesh box. This critical addition to MAX's mesh-modeling toolset permits you to see the underlying mesh object as a wireframe surrounding the MeshSmoothed object. The result is very similar to working with a true NURBS surface within a control lattice. Enter the Sub-Object mode at the top of the MeshSmooth panel and go to the Vertex Sub-Object level. Select a vertex, and then return to the Weight spinner toward the bottom of the panel. Change the values in the spinner to see the effect on the smoothed mesh. Values greater than 1.0 pull the mesh toward the selected vertex; values between 1.0 and 0.0 push the mesh away. Figure 7.67 illustrates the effect of a weight value of 4.2 on the selected vertex. Note that edges can be weighted, as well as vertices.

MeshSmooth In Action: A Simple Car

This simple exercise gets you started on organic polygonal modeling with MeshSmooth. You may not think of a car as an "organic" object, but the typical curvature in today's auto body designs is very fluid and subtle. Follow these steps:

1. Create a Box primitive to serve as the main portion of the car body, without the roof. Create three segments along the side and two across the length. Use Figure 7.68 as a

Figure 7.67

The effect of NURMS weighting of a vertex. The NURMS type of MeshSmooth is applied to a cube by using three iterations. The mesh object is displayed as a surrounding wireframe and a vertex is selected. With a weight value of 4.2 applied to the vertex, the nearby portion of the mesh is pulled toward it.

Figure 7.68

Box primitive with proper segmentation, converted to an Editable Mesh object.

guide. Convert the object to an Editable Mesh. Center the Pivot Point in the object, and then center the object in world space by moving it to (0,0,0).

2. Select the two "roof" polygons and extrude them up, as shown in Figure 7.69. Don't try any beveling. We're deliberately starting with a boxy shape.

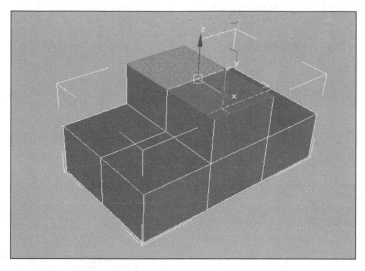

Figure 7.69
Mesh from Figure 7.68, with polygons extruded up to make a roof.

3. You need only half of the model, so select all of the faces on either side of the centerline and delete them. This is a good time to rename the model as "driver's side" or "passenger's side," depending on which half remains. Rotate the model in a perspective view to make sure that it's hollow. Sometimes, internal faces are accidentally created when you extrude faces, as you did for the roof. If the mesh is not completely hollow along the centerline, delete any faces until it is.

4. Mirror the half as an instance and name the mirrored object the opposite of what you named the original side. Put a MeshSmooth modifier on either object—it will appear on both. Use NURMS with two iterations and make sure that the Apply To Whole Mesh box is checked. This ensures that the entire mesh is smoothed, regardless of whether you select a subobject (such as a vertex) at the Editable Mesh level below. Check the box to display the Control Mesh. At this point, your model should look remarkably like a car, as shown in Figure 7.70.

5. From this point, there are three directions to explore. You can return to the Editable Mesh level and move around vertices. You can add more segmentation. And you can try out the effect of the NURMS weights. Try to move the vertices first. Go down to the Editable Mesh level and make sure that you can see the end result by clicking the Show End Result toggle. Select and translate some vertices, and watch the smoothed version of the mesh respond. I pulled out the front vertices and slanted in the rear ones in Figure 7.71.

6. Segmentation has a very important effect on smoothing. Tighter segmentation creates sharper curvature. In MAX, you can experiment with this concept in an interactive way. Add a Slice modifier to the stack below the MeshSmooth modifier—it must be below if the effect is to pass up to MeshSmooth. Make sure that you are not in a Sub-Object mode in Editable Mesh when you add the Slice modifier, or it

Figure 7.70
Mesh from Figure 7.69, with half of the faces deleted, and then mirrored as an instance to restore both sides of the car. MeshSmooth is applied by using NURMS with two iterations, and the Control Mesh displays around the smoothed object.

Figure 7.71
Vertices are translated in the underlying Editable Mesh object to shape the smoothed version interactively. The front vertices, shown selected here, were pulled forward.

won't work. If you make this mistake, delete the Slice modifier, get out of the Sub-Object mode in Editable Mesh, and then put the Slice modifier back on. In the Slice modifier, enter the Sub-Object mode to get the slice plane. Rotate it so that it's running vertically through the mesh, and move it back and forth to see what happens. Figure 7.72 shows how placing the new edges close to the rear sharpens that region.

7. Add more slice planes in different directions to better understand the effect of segmentation on smoothing. When you have a result you like, you can collapse the new segment into the Editable Mesh. Use the Edit Stack button to display the Edit Modifier Stack dialog box, and then select the Slice modifier. Click on the Collapse To button to collapse the Slice modifier into the mesh. When you finish, the new

Figure 7.72
A Slice modifier is added beneath the MeshSmooth modifier on the stack and rotated vertically. Passing the new segmentation through the rear of the car sharpens the curvature.

Figure 7.73
The Slice modifier added in Figure 7.72 is collapsed into the Editable Mesh, creating new vertices for editing.

segment is simply part of the mesh, creating new vertices to edit, as illustrated in Figure 7.73.

8. Finally, try out the weight tools. In the MeshSmooth modifier, enter the Vertex Sub-Object level and select the vertices at the rear of the car. Increase the Weight value at the bottom of the panel to pull the mesh into the corners. You may need to operate separately on the top and bottom vertices. The result should look something like Figure 7.74.

9. After playing around with all these tools, you will reach a basic shape that you like, but it requires more refinement. This might be a good time to reduce your MeshSmooth

Figure 7.74
The Weight values of the rear vertices increase to pull the mesh in more tightly.

Figure 7.75
The mesh from Figure 7.74, with MeshSmooth reduced to a single iteration and the entire stack collapsed. This more-detailed mesh is ready for more editing and another round of MeshSmooth.

Iteration level to 1 and to collapse the entire stack. This action produces a new, more-detailed mesh model for editing, as shown in Figure 7.75. Apply MeshSmooth to this mesh and go on with the process.

Moving On

This chapter discussed all the fundamental tools and principles of polygonal mesh modeling. You learned how MAX provides polygonal editing through a toolset addressed to vertices, edges, and faces. You also learned the importance of visible and invisible edges, and the role they play in organizing triangular faces into coplanar polygons. You explored the MeshSmooth modifier and saw the basic role it plays in interactively fashioning organic curvature.

In the next chapter, you'll learn about the extensive collection of modifiers that can be used in the modeling process.

8

MODELING
WITH MODIFIERS

MAX is like a giant toolbox—it's filled with specialized gadgets that are perfected for specific uses, especially in modeling. But before you can use them, you have to know they exist and how they operate.

Modeling in MAX involves a mixture of mesh-level (or NURBS-level) tools and modifiers. Some of the modifiers are essential—for example, the Lathe and Extrude modifiers create 3D geometry initially, so they do not really "modify" it. Most of the modifiers are narrower tools, however, and the sheer number of them is one of the reasons why MAX is so powerful. To model effectively in MAX, you must have at least a passing knowledge of most of the important modifiers, so that you can identify when they may be called for.

The Modifier Theory Of Modeling

When MAX first arrived on the scene, its signature feature was a new conception of polygonal modeling. Polygonal modeling had long been based on the direct editing of the mesh, and although every program had at least some tools for generally deforming a mesh, these tools were never central features. The MAX programmers decided to introduce a new approach to modeling based on deformation tools for shaping a mesh indirectly. These tools were perfectly suited to another unique feature of MAX—the parametric object. An object can be shaped by using modifiers independently of its geometric resolution. For example, an object can be bent by using a Bend modifier before the modeler determines the amount of segmentation in the object. Thus, the segmentation can always be adjusted to conform to the shape of the object.

However intelligent this approach may be, it did not replace traditional mesh-level modeling, and MAX has acknowledged this by continually improving its mesh modeling features to an extremely high level. Modeling with modifiers is an indirect process, and it takes a great deal of practice to get precisely what you want when you use them. Yet, if you know the modifiers well, they are invaluable.

Note: In general, modeling with modifiers is most useful for creating inorganic and manufactured objects, or structural and architectural elements.

Basic Axial Deformers

The most important modifiers for modeling are those that apply a simple deformation to the object (or some portion of it) based on a directional axis. These modifiers share a common structure. In each case, the panel for each modifier is divided into three parts. The upper section determines the amount or degree of the effect. The second section determines the axis along which the effect is to be applied. The third section of the panel limits the effect to a defined zone.

Bend

The Bend modifier deforms the mesh to create a bend. Bend is the easiest of the modifiers to understand, so let's work through an exercise that reveals features that all of the related modifiers share.

Axis And Direction

To begin the exercise:

1. Create a Box primitive on the groundplane and make it rather tall. Try values such as Length: 15, Width: 15, and Height: 60. Apply the Bend modifier.

2. Note that the default axis in the modifier is z, which is along the height of the object. Try an Angle value of 90 degrees. The Bend gizmo shows the intended deformation, but the mesh can't bend without segmentation. By returning to the parametric Box at the bottom of the stack, you can increase the height segmentation to an amount that is sufficient to hold the bend. Figure 8.1 illustrates the bend before and after the segmentation is added.

Figure 8.1
Box primitive with the Bend modifier applied. The object on the right lacks the segmentation to follow the Bend gizmo. The object on the left is a copy with increased height segmentation.

3. After you determine the correct axis for the bend, you can adjust the direction. Setting the Direction spinner to 90 degrees results in a bend that is perpendicular to the original one. New users of MAX commonly page through the different axis choices,

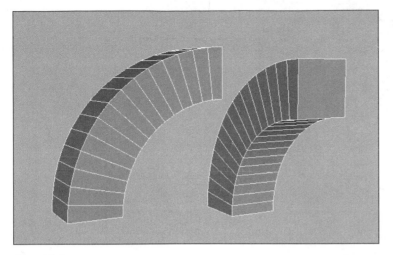

Figure 8.2
Different Direction values are contrasted. Both objects have the Bend modifier applied on the z-axis. The one on the left uses a Direction of 0 degrees; the one on the right uses a Direction of 90 degrees. Neither object was rotated.

when they can get the result they want by changing the direction of the bend. Figure 8.2 shows the same model with the Direction values set to 0 and 90 degrees, respectively. The objects themselves were not rotated.

Using Limits

You can use one of several approaches to isolate the bend effect to a portion of the model. Let's continue our exercise by trying the Limits approach first:

4. Zero out the values for Angle and Direction, so that the object is no longer bent. At the bottom of the Bend modifier panel, check the Limit Effect box. Now, the modifier applies only between the range of the Upper and Lower Limits. Increase the value in the Upper Limit spinner and watch a marker line rise upward on the model. Because the object is 60 units high, set the value to 30; the marker should now be halfway up the object. Increase the Angle value to 90 degrees. The bend is applied only to the lower half of the object, with the upper half remaining rigid. Your object should resemble Figure 8.3.

5. What about the Lower Limit? This spinner works only in the negative direction. Increase its negative value and watch the effect. The marker moves away from the bottom of the object—the effect is not especially useful. The Upper and Lower Limit values are measured from the Center of the gizmo, which is currently at the base of the object.

6. Return all values to 0 (including the Limits) and uncheck the Limit Effect box to start again. Click on the Sub-Object button and choose the Center (not the Gizmo) from the drop-down list. Using the Move tool, move the Center up to roughly the middle of the object. Be careful to move it in only one direction. Set the Angle value

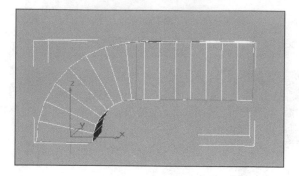

Figure 8.3
Using the Limits options, the bend effect is applied only to the lower half of the object, which leaves the upper half rigid.

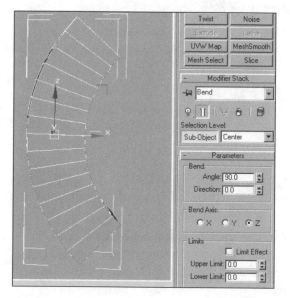

Figure 8.4
With Limit Effect off, the Center of the Bend gizmo was moved up to the vertical center of the object. With an Angle value of 90 degrees, the bend now emanates from the center of the object, rather than from the base.

to 90 degrees and note that the bend now emanates from the center, rather than from the bottom. Your screen should look like Figure 8.4.

7. With the Center of the Bend gizmo in this new position, you can apply both Upper and Lower Limit values. Check the Limit Effects box—don't be surprised to see the object straighten out. At this point, the effect is limited to a range of zero, so there can be no effect. Pull the Lower Limit spinner into negative territory, and then pull the Upper Limit spinner into positive numbers. This action creates a region on either side of the gizmo Center to which the bend applies. Make the positive and negative numbers equal, perhaps 20 and –20. You may need to increase the height segmentation of the Box primitive to follow this tighter bend. Increase the Angle value to 180 degrees

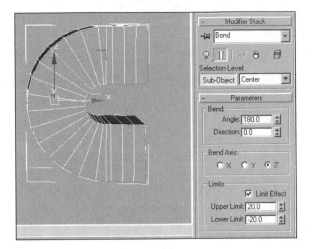

Figure 8.5
Object from Figure 8.4, with Limit Effect turned back on. The Upper and Lower Limits are set to 20 and –20, respectively, and the Angle value is increased to 180 degrees to create a horseshoe magnet shape. The height segmentation in the Box primitive was increased to support the tighter curvature.

to create a horseshoe magnet shape. Move the center up and down to place the bend exactly in the right spot. Your screen should look something like Figure 8.5.

Bending A Subobject Selection

The second approach to applying the Bend modifier to only a portion of an object involves selecting the affected portion and passing it up to the modifier. Continue our ongoing project as follows:

8. Zero out all your values and uncheck Limit Effect to start again. The current stack sends the entire object to the Bend modifier. To pass only a portion of the object up, you must place a Mesh Select modifier beneath the Bend modifier and use it to select the desired portion. Go to the modifier stack and select the line that separates the Box primitive from the Bend modifier. Add a Mesh Select modifier right here—it is placed above the line and between the Box and the Bend.

9. In the Mesh Select modifier, use the Face or Polygon selection mode to select approximately the top one-third of the object. Notice the asterisk that appears next to the Mesh Select modifier name when a subobject selection is made. If you look at the entire stack, you'll see that the Bend modifier also has an asterisk (this means that the Bend modifier applies only to a subobject selection received from below). Figure 8.6 shows the polygons selected in the Mesh Select modifier and the entire stack from the drop-down list.

10. Go up to the Bend modifier and apply a 90-degree Angle value. The Bend applies only to the selected section, but it probably doesn't look quite right. The bend must start at the bottom of the selected faces. Go into the subobject level to get the gizmo Center. Don't use the gizmo—use the gizmo Center. This can be terribly confusing—

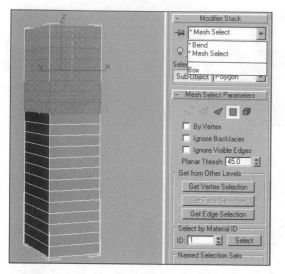

Figure 8.6

Box object, with the Mesh Select modifier added between the Box primitive and the Bend modifier. The top one-third of the Polygons is selected in the Mesh Select modifier, to be passed to the Bend modifier. The asterisks next to the names of the two modifiers indicate that a subobject selection is involved. The Shade Selected Faces option in the Viewport Configuration dialog box is used to help highlight subobject selections.

although moving the gizmo sometimes produces a result similar to moving just the Center, the result is completely different most of the time. Even when the result is similar, moving the gizmo makes the construction on the screen difficult to understand. Once the gizmo Center is moved to the bottom of the selected Polygons, the bend is perfect, as shown in Figure 8.7.

11. A common complaint about working with MAX's deformation modifiers is that they can produce a rigid result. This rigidity may be fine for architectural or other structural objects, but these deformations can look too stiff for a more creative or organic look. The solution is to layer modifiers. For example, a fluid and pleasing curvature is possible when you apply an overall bend to an object with a local bend in it. To put an overall bend in your present object, you have to get out of the subobject selection. You do this the same way you got into it—with Mesh Select. Go to the Bend modifier at the top of the stack (if you aren't already there) and add another Mesh Select modifier. Leave the modifier alone. Don't enter any subobject level; notice that there is no asterisk next to the name of the modifier. The selection of the entire object is recovered, and subsequent modifiers are no longer limited to a subobject selection.

12. Put another Bend modifier on top of the stack and play with the Angle values. The combination of the two Bend modifiers produces a much more fluid curvature, as illustrated in Figure 8.8.

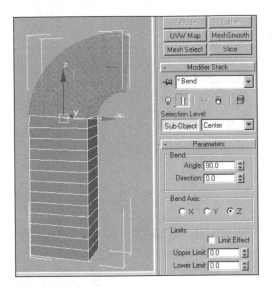

Figure 8.7
Object from Figure 8.6, with the Bend angle set to 90 degrees. The Bend modifier applies only to the subobject selection sent up from the Mesh Select modifier below. The Bend gizmo Center is placed at the bottom of the selected Polygons, so the bend is generated from that point. The Shade Selected Faces option in the Viewport Configuration dialog box is used to help highlight subobject selections.

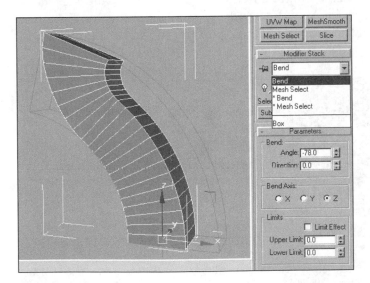

Figure 8.8
Object from Figure 8.7 with a second Bend modifier applied to the entire object. The combination of local and overall bending produces a much more subtle and fluid curvature.

Taper

The Taper modifier is much more powerful than its name might suggest. In common parlance, to *taper* a shape is to narrow it to an edge or a point. But the Taper modifier takes this basic concept much further, enabling you to create many shapes that you might not consider to be tapered.

The following exercise introduces you to the range of this tool and should get you thinking about its many possibilities.

Axis And Effect

To begin the exercise:

1. Create an unsegmented, cube-shaped (equal in Length, Width, and Height) Box primitive on the groundplane. Apply the Taper modifier to the Box. At this point, the local coordinate system of the Box is aligned to world space. Like the Bend modifier and many others, the Taper modifier is applied to a local axis of the affected object. Change the default view coordinates to local on the Main Toolbar so that the governing coordinate system is consistent in all viewports.

2. The default Taper axis is z, which is the vertical one at this point. Change the values in the Amount spinner to see the way the basic Taper works. As the taper acts along the z-axis, its effect is seen in the x and y directions. Positive amount values spread the taper outward; negative ones draw it inward. Figure 8.9 illustrates the original cube in the center, with an inward taper to the left and an outward one to the right. Note that the effect is in the directions perpendicular to the chosen (vertical) axis.

Figure 8.9

Box primitive with the Taper modifier applied by using default z-axis. Original cube is in the center. On the left, a negative amount value draws inward equally in both the x- and y-directions. On the right, a positive amount value spreads outward.

3. The taper doesn't need to be applied in the two directions perpendicular to the axis, however. Change the Effect radio button from xy to either x or y alone, and note that the Box now tapers in only one direction. This is an obvious way to create any wedge-like shape. Figure 8.10 shows the previous tapering action, limited to a single direction. The Box on the left is tapered inward only in the local x-direction; the one

Figure 8.10
Objects from Figure 8.9 that use the z-axis for tapering, but the effect is limited to a single direction. On the left, the Box primitive is tapered inward in the local x-direction only. On the right, the outward taper is limited to the y-direction only.

on the right is tapered outward in the local y-direction. Use the object's axis tripod or Transform Gizmo as a guide to the local directions.

Adding Curvature

Thus far in this exercise, you've been getting what you might expect from the Taper modifier, but the modifier can also be used to create curvature, as you'll see now:

4. Pull the Curve spinner in the Taper panel and watch the shape of the gizmo change. The object cannot follow the curvature because it is unsegmented, so go down to the bottom of the modifier stack and increase the height segmentation to a satisfactory amount. Play with both the Curve and Amount spinners to see how they interact. If the Amount value is reduced to –1.0, the object tapers to an edge or a single point, as illustrated in Figure 8.11. In the object on the left, the Taper Effect is limited to the local x-direction (as before), and the curvature is outward due to a positive Curve

Figure 8.11
Curvature is added to the tapering effect. To the left of the original cube, the Taper Effect is applied to only the x-axis and pulled to a sharp edge. A positive Curve value results in an outward bulge. On the right, both x- and y-dimensions are tapered to a point, and a negative Curve value produces an inward bend. Height segmentation has been increased to support the curvature.

value. In the object on the right, the Taper Effect is applied to both the x- and y-directions, drawing the taper to a single point. A negative Curve value produces an inward curvature.

5. Those astute persons who worked through the exercise on the Bend modifier might be wondering about the location of the Taper gizmo's Center. To test the effect of the Center, make your object look like the one on the right in Figure 8.11, tapering to a point and curving inward. Activate the Taper Sub-Object button and go to the Center level—not the Gizmo level. It is very easy to confuse these levels because the effects can be similar. Make sure that you've got the Center, not the gizmo itself for this purpose. Move the Center vertically through the object to see the effect. The tapering is generated in both directions—upward and downward—from the gizmo Center. Figure 8.12 demonstrates what your screen should show. On the left is the object with the gizmo Center in its original location at the bottom of the object. The middle object shows the effect of translating the Center halfway up the object. On the right, the selected object shows the Center moved to the top of the object. Note that the shape of the gizmo, extending above the object, reveals the entire curvature.

Figure 8.12
The object from the right side of Figure 8.11 illustrates the effect of translating the Taper gizmo Center through the object. On the left is the object with the Center in its default location at the base of the object. At center, it was moved halfway up the object. On the right, the selected object shows the gizmo Center at the top of the object, with the gizmo extending above it, revealing the overall curvature.

6. Thus far, the tapering effect was in only one direction—along the z-axis. Position the gizmo Center halfway up the object and check the Symmetry box. The taper is now mirrored in both directions from the Center. You can already see that the rather sophisticated curved objects can be created entirely using the Taper modifier. Figure 8.13 illustrates the effect of symmetrical tapering. In both objects, the gizmo Center is halfway up in the local z-direction. The object on the right uses the Symmetry checkbox to mirror the taper in opposite directions from the gizmo Center.

Figure 8.13
The effect of symmetrical tapering. In both, the Taper gizmo Center is halfway up the object in the local z-direction (vertical). In the object on the right, the Symmetry option mirrors the tapering effect in both directions from the gizmo Center.

Fancy Touches

Now, we'll add some details as follows:

7. Remove the Taper modifier from your Box object and put it back on to start fresh with the default settings. Move the gizmo Center subobject to one corner of the box. This action "squares off" the result, which is extremely useful for architectural details. Experiment with different Amount and Curve values, and try to apply the effect to either the x- or the y-direction, instead of both. Figure 8.14 illustrates the Box with the Taper gizmo Center placed at a bottom corner. The example on the left is tapered in both local x- and local y-directions, producing a result that is useful for a corner piece. The example on the right is tapered in only one dimension.

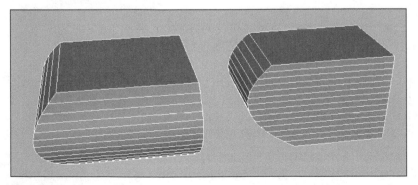

Figure 8.14
The tapered object is "squared off" by moving the Taper gizmo Center to the corner. In the object on the left, the Taper Effect is set to both the x- and y-dimensions. In the object on the right, the Taper Effect applies to only one dimension.

8. Move the Taper gizmo Center so that it's about halfway up in the local z-dimension (vertically), but still along one of the vertical edges of the Box object. This is a good position to try out the Limits option. Check the Limit Effect box and pull the Upper Limit spinner to the top of the object. Play with the Amount and Curve values to see what happens when the Taper is applied only to the upper one-half of the object in this way. In Figure 8.15 (as in Figure 8.14), the object on the left is tapered in two dimensions, whereas the one on the right is tapered in one. Take some time to experiment with different combinations of Limit settings, Curve and Amounts values, and gizmo Center positions. The range of useful shapes is quite remarkable.

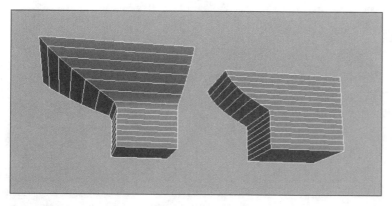

Figure 8.15
Objects from Figure 8.14 with the Taper gizmo Center moved to the center of one of the vertical edges of each Box. Using Limits, the effect is limited to only the upper half of each Box. The object on the left is tapered in both dimensions. The object on the right is tapered in only one dimension.

9. Instead of using Limits, you can make a subobject selection by using Mesh Select and passing only that selection up to the modifier (as you did with the Bend modifier). This time, however, add an interesting new feature. Remove the Taper modifier from your Box to start over and put a Mesh Select modifier on top of the Box. Instead of selecting a precise group of vertices or faces to send up to a Taper modifier, create a *Soft Selection*, which is an expansion of the Affect Region concept from previous versions of MAX. Soft Selection creates a selection gradient. Those vertices that are actually selected are wholly affected by subsequent modifiers. As you move away from the selected vertices within a defined zone, the effect of subsequent modifiers tails off. The Taper modifier is the perfect place to try out Soft Selection.

10. In the Mesh Select modifier, go to the Vertex Sub-Object level and select the four vertices at the top corners of the Box. Make sure that your Box is well segmented in the Height dimension so that there are at least 10 vertical rows of vertices. Create a Soft Selection downward. Open the Soft Selection rollout at the bottom of the Mesh Select panel and check the Use Soft Selection box. Enter a Falloff value equal to the height of your Box—you can get the Height parameter at the bottom of the modifier stack. Use a wireframe view to see the selection clearly. This Soft Selection creates a selection gradient from the top to the bottom of your object. Vertices in the middle

are 50 percent affected by subsequent modifiers; vertices at the very bottom are not affected at all. This selection gradient is displayed as a color gradient. Vertices change from red (wholly selected) to blue (unselected). Note that an asterisk appears next to the Mesh Select modifier name in the stack to indicate that a subobject selection was made.

11. Put a Taper modifier at the top of stack. The asterisk next to the name indicates that that Taper is operating on a subobject selection sent from below. Using the default z-axis, taper the object inward with a negative Amount value. Even though the gizmo shows straight edges, the object is tapered with curved sides because the Taper effect is "tapering off" as it moves through the Soft Selection gradient. The vertices higher on the object are affected more than those lower down. See Figure 8.16. The selected object on the right uses the Soft Selection from top to bottom. The stack and the Taper settings are visible in the panel. A color image would reveal the gradient of vertex colors, from red to blue on the object. Compare the shape of the gizmo with that of the object. For comparison, the object on the left simply uses a Curve amount on the entire object, without any subobject selection. The results are extremely similar.

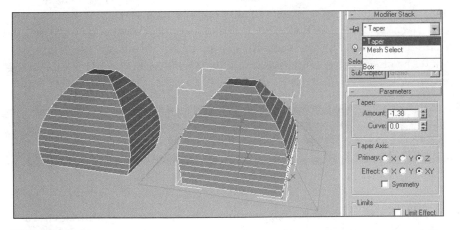

Figure 8.16
Object on the right illustrates Soft Selection. A selection gradient of vertices, from top to bottom, was created in Mesh Select and sent up to a Taper modifier. Although no Curve value is applied, the Soft Selection results in curvature. Compare the shape of the gizmo to the shape of the object. For comparison, the object on the left uses a Curve amount in a Taper, which is applied to the entire object. The results are very similar.

Stretch

The Stretch modifier is a simpler and more specialized version of the Taper modifier. There is always a curvature on a stretch, and the effect is inherently symmetrical. If you already understand the Taper modifier, you'll find the Stretch modifier a handy substitute for many purposes.

The choice of axes and the Limit Effect options are the same as in Bend and Taper, and are obvious enough to require no explanation. The important parameters are the Stretch and Amplify values. A Stretch value of 0 has no effect. Positive values stretch the object along the selected axis; negative values squash it. The stretching and squashing cause the object to

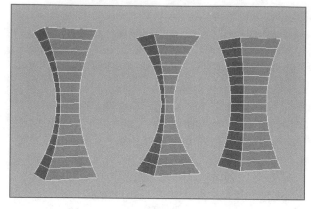

Figure 8.17
The Stretch modifier is applied to a cube. All three versions are stretched vertically (along the local z-axis) by a factor of 1.8. Different Amplify values control the elastic deformation. The object on the left uses a 0 Amplify value. The objects at center and on the right use positive and negative values, respectively.

deform to preserve volume as if it were made of elastic rubber. The Amplify value controls the degree of this deformation. Amplify values greater than 0 increase the deformation; negative values decrease it. See Figure 8.17. The underlying object is a cube, and a Stretch value of 1.8 has been applied to all three versions. The model on the left has the default Amplify value of 0, the object in the center has a positive Amplify value, and the one on the right has a negative value.

> **Note: Although it can certainly be used for modeling, the Stretch modifier is primarily intended for animation. Its parameters can be keyframed to produce the traditional "squash-and-stretch" effect that conveys elasticity in soft-body objects.**

Twist

The Twist modifier is essential. Most of the basic deformation modifiers perform functions that can be duplicated by direct mesh editing (with a great deal more work), but twisting is almost impossible to achieve without a specific tool.

By now, the pattern of these basic deformation modifiers must be familiar. Like the rest of them, the Twist modifier comes with a couple of specialized value spinners to control the degree of the effect, radio buttons to choose the desired axis, and the usual Limits options. As with the other modifiers, with a little practice you can produce much more subtle effects than you might expect at first. Try the following exercise.

Angle And Segmentation

Begin familiarizing yourself with the Twist modifier by following these steps:

1. Create a tall Box primitive on the groundplane, using Length = 15, Width = 15, and Height = 60. Keep it unsegmented for now.

2. Put a Twist modifier on the object. Once again, the default axis is local z, so the Box twists around its Height direction. Pull the Angle spinner to see the effect on the gizmo. Positive values twist in one direction and negative values twist in the opposite direction. Enter an Angle value of 180 and note that the gizmo is twisted around exactly half of a circle from bottom to top.

3. It's obvious that you need segmentation in the underlying Box primitive to express the curvature seen in the gizmo. Twisting deforms an object in all three dimensions, and therefore it requires rather dense geometry. It's often best to use a wireframe view or a shaded view with the Edged Faces option when you adjust the polygonal segmentation. See Figure 8.18. The object on the left is the unsegmented Box with the Twist modifier applied. The second object has been increased to 16 segments in the Height dimension, the axis of the twist. This makes a big difference because it reveals the primary effect of the modifier, but don't forget the other aspects of the curvature. The next two objects show the effect of adding segmentation in the two other dimensions. The final object uses 912 faces (triangles), and it still is not really smooth enough for a quality rendering.

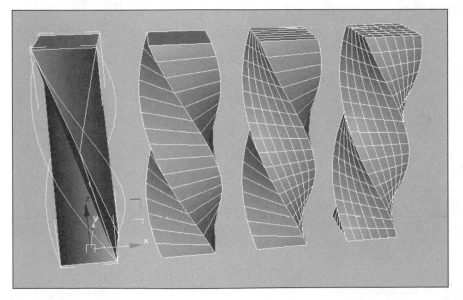

Figure 8.18
The effect of segmentation on a Box with a Twist modifier applied using an Angle of 180 degrees. On the left, the unsegmented object cannot conform to the shape of the gizmo. In the second object, the object is segmented along the axis of the twist. The next two objects illustrate the effect of adding segmentation in the other two dimensions to reveal the full curvature.

4. Experiment with different segmentation values for the underlying Box (at the bottom of the stack). A twisting shape is very demanding of proper segmentation, but you must balance an ideal result with the practical demands of the project. One of MAX's great strengths is its power to keep segmentation fluid. For example, you

may want to bring the segmentation down while you work—to keep the screen interaction from slowing down—and then turn it up at render time.

5. To determine the number of triangular faces in your object as it is currently segmented, select the object and use the right-click menu to bring up the Object Properties dialog box. If you're not already familiar with this tool, take some time to look it over now. In addition to providing you with important information about the selected object, such as the vertex and face count, there are a number of options that you can set. This dialog box is a great place to hide or freeze the selected object or to set any of the display properties for it without having to bring up the Display Floater or the Display panel. Note also that many important render options are found here. Figure 8.19 shows the Object Properties dialog box for the final object in Figure 8.18. When you're done looking it over, close the dialog box.

Figure 8.19
The Object Properties dialog box for the final object in Figure 8.18, obtained from the right-click menu on the selected object. Note the information on the number of faces. Note also the capability to hide or freeze the selected object here or to set any of its display properties.

6. Come up with segmentation for the Box that satisfies you and return to the Twist modifier. Activate the Sub-Object button and go to the Center level. I know how easy it is to make a mistake here, so I'll repeat what I've said before: You want the gizmo Center, not the gizmo itself for this exercise (and, indeed, for most purposes). As with the other general deformation modifiers, the Center of the modifier gizmo is the center of the deformation effect. Translate (move) the Center vertically through the object and watch what happens. The Twist shape remains the same, but it

moves through the object. This produces the same result as rotating the entire object around its local z-axis.

Adding Subtlety With Bias

Now, our exercise continues as you experiment with the Bias value to create a subtle effect:

7. Bring the Center back down to its original position at the bottom of the object. Gradually increase the Bias value on the modifier panel from the default of 0 to the maximum of 100. The twisting effect is pushed away from the gizmo Center (at bottom) toward the top of the object, creating an accelerated (rather than a constant) twist. This subtle effect is very useful, but it comes at a cost. As any twisting effect is increased, the density of the polygonal geometry must also increase to support the tighter curvature. This is true, even if you simply increase the Angle value. Because segmentation is uniform for any given dimension, you must increase it for the entire object to support the portion with the most intense curvature. See Figure 8.20. On the left is the final object in Figure 8.18, using a Twist Angle of 180 degrees and 0 Bias. In the center, Bias is increased to 30, producing less twist at the bottom (near the gizmo Center) and more toward the top. On the right, the Bias is increased to 60, intensifying the effect. To capture the increased curvature at the top, the segmentation for the entire object must be increased. As shown, this object is now composed of 2,484 triangles.

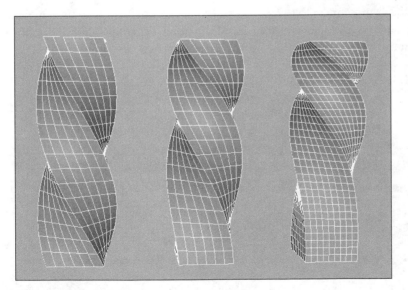

Figure 8.20
The effect of Bias. On the left is the final object from Figure 8.18, using a 180-degree Twist Angle and 0 Bias. In the center, Bias is increased to 30, creating a slightly accelerating curvature. On the left, Bias is increased to 60 for greatly accelerated curvature. The overall segmentation of the object is increased in each dimension to support the region with the tightest curvature.

Skew

The Skew modifier is like the Bend modifier, but without the curvature. It puts a rigid slant through the object (or through some portion of it, if Limits are used or if a subobject selection is sent up from below). The Amount spinner value is measured in distance rather than angle, and increasing it increases the amount of the slant. The Direction spinner, however, is an angular measure, rotating the slant around the selected axis. The idea of direction is precisely the same as in the Bend modifier. The greater the amount of the skew (the slant), the more pronounced the effect of the direction will be. Rotating the direction 360 degrees brings it back to its position at the default value of 0. As a practical matter, you typically use direction in 90-degree increments.

Figure 8.21 shows the Skew modifier in action. A cube has been skewed in the z-axis, which can be confusing at first. The axis of the Skew is the direction that will be tilted. Because the local z-axis of the object is the vertical one here, the vertical direction is slanted. The Direction value determines the direction of the slant in the x- and y-dimensions. In the object at right front, the default Direction value of 0 points the slant in the positive y-direction. In the object at left rear, the Direction value is changed to 90 degrees, pointing the slant in the negative x-direction.

Noise

The Noise modifier adds randomness to the surfaces. At one extreme, it can be used to create large-scale geometry, such as mountainous terrain. At the other extreme, it can add a random roughness to small-scale surfaces that would otherwise appear too smooth.

Figure 8.21

Cube-shaped Box primitive with the Skew modifier applied in the z-axis, which produces a slant in the vertical direction. The Amount of the Skew is the same in both objects. The object at right front uses the default Direction of 0, so it slants in the positive y-direction. The object at left rear uses a 90-degree Direction, slanting in the local negative x-direction. These parameters are similar to those found in the Bend modifier.

Like many tools in MAX, and indeed in all professional-level 3D graphics applications, the Noise modifier can be intimidating to artists because it is a direct implementation of mathematical principles that they may not understand. As a result, many artists simply change values at random and hope for the best. Without pretending to understand (or even wanting to understand) fractals and random seed values, it's possible to secure a practical command of the tool with a little careful experimentation. Try it out in the following exercise.

Nonfractal Noise

Let's begin our exercise by exploring nonfractal noise:

1. Create a cube-shaped Box primitive on the groundplane using values of Length=50, Width = 50, and Height = 50. Set the segmentation to 10 in each dimension. Segmentation is a basic issue when using Noise because the modifier creates a subtle curvature that cannot be expressed in the geometry without a sufficiently dense mesh. Open the Object Properties dialog box (by using the right-click menu) to see the number of triangular faces in the object as currently segmented. The number should be 1,200.

2. Use a wireframe view of the object to best see the deformation process. Add a Noise modifier. Leaving everything else as is, increase the Strength values in the Noise panel for each of the three dimensions (x, y, and z). At the default value of 0, the object is unchanged. As you increase the values, however, notice that the edges of the Noise gizmo change from straight lines to loose curves. You certainly notice how large the Strength value changes need to be to have any visible effect. See Figure 8.22. The object on the left has the default (0) Strength values and is therefore not deformed. The middle object has Strength values of 100 in all three dimensions. The object on the right, with the Noise gizmo visible, uses Strength values of 300 in each dimension.

3. Set all three Strength values to 300 to get the shape on the right side of Figure 8.22. Play with the values in the Scale spinner at the top, which adjusts the effect in all three dimensions at once. As values increase above the default of 100, the deformation decreases as if you had reduced all the Strength values together. Decreasing the scale works in the opposite direction to increase the curvature of the gizmo, and therefore increases the deformation. Figure 8.23 shows the effect. On the right is the object with the original default Scale value of 100.0. In the center, an increased Scale value effectively offsets the Strength values to remove the deformation. On the left, a Scale value below 100.0 increases the effect of the existing Strength values.

Fractal Noise

The nonfractal noise you've used thus far turned a rigid cube into a cube composed of loosely curving edges, making the object look elastic. This is useful as far as it goes, but the primary use of Noise is to add a geometric texture to surfaces. Fractals duplicate patterns at different degrees of scale in the same object. This concept may seem strange at first, but it is not all that hard to understand because you see it so often in nature. To take the best example, the peaks and crags of mountain ranges are found at a smaller scale in the surfaces

Figure 8.22
Effect of nonfractal noise on Box primitive, 50 units in each dimension. On the left, the default Strength value of 0 in each local dimension (x, y, and z) leaves the object unchanged. In the center, the Strength values are increased to 100 in all dimensions. On the right, all Strength values are set to 300. The edges of the gizmo change from straight lines to increasingly looser curves.

Figure 8.23
Effect of adjusting the Scale value on the Noise modifier. On the right is the object from the right side of Figure 8.22, with the Scale set at a default value of 100. In the center, the Scale value is increased to a level that effectively eliminates the deformation. On the left, the Scale value is reduced below 100 and thus increases the effect of the existing Strength settings.

of the rocks of which the mountains are composed. When the Fractal box on the Noise modifier panel is checked, the overall deformation of the object is reapplied at smaller and smaller levels. But enough of theory:

4. Using fractals greatly exaggerates the effect of the Noise strength settings, so set all the Strength values for your Box to 100 (down from 300) before checking the Fractal box. The impact is obvious. Every vertex on the object is jogged, and your 10×10×10 segmentation is not nearly enough to follow the complex curvature of the surface. To experiment with fractals, change your display from Wireframe to Smooth + Highlight, with the Edged Faces option checked to see the mesh.

5. The default value in the Iterations spinner is 6.0. Change the value to 1.0 and note that the object is back to its prefractal form. Increase the value in the Iterations spinner in whole-numbered steps to understand the process. Because increasing this value adds noise at increasingly lower levels of scale, it creates a finer level of detail. The default value of 6.0 is sufficient to create a convincing rocky surface or some choppy seas. Such detail requires dense geometry, however, which Figure 8.24 illustrates. The three Box primitives have Strength values of 100 in all three dimensions, Scale is set to 100, and the Fractal box is checked. On the left, an Iteration value of 1.0 produces the same result as when the Fractal box is unchecked. In the center, the Iterations value is set to 2.0, and the segmentation of the underlying Box primitive is increased from 10 to 20 in all three dimensions to support the complex curvature.

Figure 8.24
The effect of increasing fractal iteration values is illustrated. The three Box primitives have Noise Strength settings of 100 for all three dimensions. Scale is set to 100 and the Fractal box is checked. In the object on the left, an Iterations value of 1.0 produces the same result as not using the Fractal option. In the center, the Iterations value is increased to 2.0, and the segmentation of the Box primitive is set to 20x20x20 to follow the curvature. On the right, the default Iterations value of 6.0 is applied for the characteristic fractal effect. The segmentation on this object is also 20x20x20.

On the right, the default Iteration value of 6.0 really churns up the surface by using the same segmentation values as in the center object.

6. Take a closer look at the segmentation issue. Set the Iterations value to the default of 6.0 and set the segmentation of the underlying Box to 20×20×20. This action produces the result illustrated in the leftmost object in Figure 8.24. Use the right-click menu to bring up the Object Properties dialog box and note that there are 4,800 faces in this object, which makes sense. The underlying object is a Box composed of six sides, each with 400 quadrangles (20×20). This makes a total of 2,400 quads, and therefore of 4,800 triangular faces. Increase the segmentation to 40×40×40 and note how much better the resolution is. This amount is probably the minimum necessary to reveal the detail added by the fractal noise. Check the faces count. 19,200 faces is a huge increase to obtain the desired result. A scene with many of these objects would be a challenge to manage and render. Figure 8.25 shows the difference between varying degrees of geometric resolution. On the left is the object using a resolution of 4,800 faces. On the right, the resolution is increased to 19,200 faces, but the surface reveals the desired fractal effect.

Figure 8.25
Different degrees of geometric resolution are compared. On the left is the object from the left side of Figure 8.24, using (as before) a segmentation of 20x20x20. This resolution of 4,800 faces is not nearly enough to reveal the detail created by the default Fractal Iterations value of 6.0. On the right, the segmentation has been doubled in each dimension to 40x40x40. The resulting resolution of 19,200 faces is probably the minimum necessary to support the fractal effect.

FRACTAL GEOMETRY VS. FRACTAL BUMP MAPPING

I've been stressing the importance of geometric resolution because it's the biggest issue you must face when you use fractal noise. Be advised, however, that you can add fine fractal detail as bump maps. *Bump mapping* creates the appearance of surface texture in the rendering process, without affecting the geometry. The Noise map is a MAX procedural texture that can produce the same kind of fractal patterns as the Noise modifier does, but it applies the patterns as if they were pictures on the surface. The Noise map can be used as a bump map. At a small enough scale, the illusion is satisfactory. Past a certain size, however, viewers notice that the pattern is not really in the geometry. Good fractal effects can be created with a combination of a Noise modifier on the geometry and a Noise map on the renderable surface. In this way, you can use a lower geometric resolution (fewer faces) than might otherwise be necessary and rely on the bump map to create the appearance of finer fractal detail.

7. Even this higher resolution would not be satisfactory for a close-up shot. If you zoom in closer to the object, you have to increase the segmentation to at least 60×60×60 to hold a satisfactory level of detail. This is an astounding 43,200 faces in this single object. Use the Quick Render button on the Main Toolbar to do some test renders because this fine level of detail is lost in a shaded viewport preview.

8. The default Roughness value is 0.0. Although it can be increased as high as 1.0, use it in small increments because its effect can be strong. Roughness may be the only self-explanatory name on the Noise panel. Increasing the value increases the sharpness of the fractal effect. The effect of increased roughness is lost without an increased geometric resolution to support it, however, and nothing sucks up geometry like the Roughness spinner. Try increasing the Roughness value to .3. The object is strikingly more angular, but the effect is blurry unless the segmentation is increased quite a bit. In Figure 8.26, both objects use a Roughness value of .3 with an Iteration value of 6.0. The one on the left has 40×40×40 segmentation, for a resolution of 19,200 faces. However satisfactory this may have been when the Roughness value was set to 0, it's not enough resolution now. The object on the right has its resolution increased to 43,200 faces (60×60×60). Even this huge number of triangles barely reveals the roughness. For close-up shots, a much higher resolution is necessary.

Polygon Optimization

Polygon optimization is a technology that is growing more fashionable. Controlling geometric weight and resolution (that is, mesh density) is important in every aspect of 3D graphics, from low-poly games work to high-end cinematics. No one can afford models with unnecessarily heavy geometry. Perhaps the strongest argument for Non-Uniform Rational B-Spline (NURBS) modeling is its control over mesh density. A NURBS surface is modeled as ideal curvature, and the conversion from this ideal to the ultimate polygon mesh can be made with great precision and flexibility. In this way, a single NURBS model can be used for many different levels of resolution. MAX's NURBS tools are particularly strong in this respect.

Figure 8.26

Adding roughness greatly increases the demands on geometric resolution. Both Box objects are set to 6.0 Fractal Iterations, as shown in Figure 8.24, but Roughness is increased to 0.3. This value produces a more angular effect, but it requires denser segmentation. The object on the left, with 19,200 triangular faces (40x40x40), does not have a fine enough mesh to reveal the roughness. The object on the right, with 43,200 faces (60x60x60) has barely enough resolution to support the present level of detail.

MAX's parametric polygonal primitives have much of this quality of NURBS, in that their segmentation can always be adjusted. But nonparametric polygonal meshes—the Editable Mesh, in MAX terminology—can't be adjusted (or, rather, they can be adjusted only upward). A coarse mesh can easily be subdivided into a finer one, typically by using MeshSmooth, in a regular way. Going in the other direction is much more difficult, and good modeling practice always emphasizes caution when adding additional mesh density.

Polygon optimization tools reduce the geometry of a mesh model by using some kind of mathematical principle. In many—perhaps most—of the cases, this principle is not entirely suitable because the program cannot know what the artist needs out of the model. Two different parts of a model can produce the same kind of optimization because they have a similar geometric structure, but they may require different degrees of detail. In short, no algorithm can replace the artist's judgment. Polygon optimization tools have been getting better and better, however, and are more likely to produce a satisfactory result than ever before. Sometimes, there's just no alternative—a model is finished, but it is simply too heavy for the intended purpose. The danger for the developing modeler is in the practice of modeling without regard to the required geometric weight and having to rely on optimization tools to knock down the polygon count in the end.

Using The Optimize Modifier

The Optimize modifier panel is a little intimidating, but it is much simpler to use than it looks—after you understand the basic concept. Try the following exercise.

Face Threshold

The main optimization control is the Face Threshold spinner, which we'll use in this exercise:

1. Create a Sphere primitive using the default number of segments (the radius of the Sphere doesn't matter). Convert the object to an Editable Mesh.

2. Apply an Optimize modifier on top of the Editable Mesh. You'll immediately notice the polygon reduction at the top and bottom of the sphere. Pull down to the bottom of the panel, to the section titled Last Optimize Status. This section tells you how many faces and vertices are eliminated. When you first apply the modifier, the data is not displayed. To get it to refresh, change the value in any spinner, and then change it back again to its original value. For example, change Face Threshold from 4.0 to 4.1, and then change it back to the original 4.0. Now, the panel indicates that the mesh has been reduced from 960 faces to 692 faces. Using a wireframe view, your screen should look like Figure 8.27.

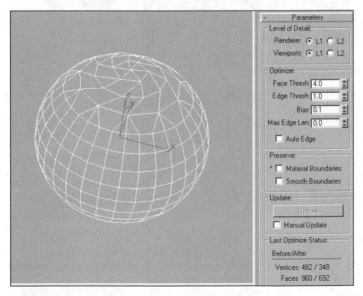

Figure 8.27
Sphere primitive with default segmentation is converted to an Editable Mesh and the Optimize modifier is applied. Using the default parameters, reduction is visible near the poles of the sphere. The panel indicates that the number of faces was reduced from 960 to 692.

3. As the Face Threshold spinner's value is increased, more faces are eliminated. I used a spherical mesh for this example because it demonstrates the logic of the tool most clearly. The Optimize modifier eliminates faces based on their size. Smaller faces necessarily have less effect on the shape of the model than larger ones do, so they are

removed first. Set the Face Threshold value to 0 to see the original sphere. Note that the polygons (and therefore the triangular faces as well) are smaller toward the poles and larger toward the equator. Pull the spinner value up from 0 and note that the optimization grows down from the poles toward the equator. As the Face Threshold value grows larger, the larger polygons fall within its reach, as shown in Figure 8.28. On the left, a Face Threshold value of 2.0 eliminates the small polygons near the poles, reorganizing the mesh in that area and reducing the number of faces from 960 to 870. In the center, the value is increased to 4.0, reducing the face count to 692. The optimization now extends further down toward the equator, but the region near the poles was also reduced from the previous example. On the right, a Face Threshold value of 7.5 brings the optimizations all the way down to the equator and further reduces the polygons nearer the poles. The face count is now down to 468. At each step, larger faces were made subject to optimization, whether they were the previously unaffected ones or ones that were already reorganized. In effect, the Face Threshold determines the minimum permissible size of the faces after optimization. Vertices are eliminated to create larger faces (and therefore polygons) that meet the size threshold.

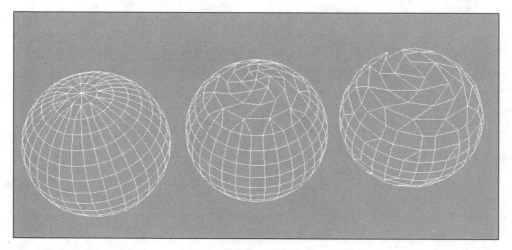

Figure 8.28
As the Face Threshold value is increased, larger polygons are made subject to optimization. On the left, a Face Threshold value of 2.0 affects only the small polygons near the poles. In the center, a value of 4.0 reaches the larger polygons, both those farther "south" and the ones already reorganized near the poles. On the right, a value of 7.5 is sufficient to affect the largest polygons on the equator. The Face Threshold value determines the smallest permissible size of the Faces after optimization.

Adjusting Bias

The Bias parameter makes fine adjustments that may not always be necessary. The values can range from 0 to 1, with a default value of 0.1. Continue the exercise as follows:

4. Increase the value toward 1 and watch the optimization disappear from your object. The purpose of Bias is to adjust the optimization for better organization, and particularly to eliminate skinny or degenerate triangles that are produced as artifacts in

the optimization process. If you discover such flaws (typically, during a render), play with the Bias value to eliminate them.

5. To see how Bias affects the organization of the mesh, set the Face Threshold value on your spherical mesh to 7.5. Reduce the Bias value to 0 and examine the difference. You have to look carefully to see what's going on. Figure 8.29 illustrates the effect. On the left is the mesh with the default Bias value of 0.1. Start at the triangle at the very top of the sphere and notice that the mesh spirals down nicely in a clockwise direction. On the right, the same mesh is shown with the Bias value set to 0. The top triangle is now nested in a closed hexagon, and the spiraling is lost at the top. This is an inferior organization of mesh, both for smoothness and for readability. It's very important to keep meshes as visually comprehensible as possible for subsequent editing in a wireframe view. The overall shape of an object can get lost in a tangle of disorganized edges.

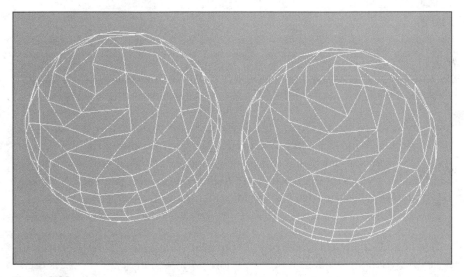

Figure 8.29
The effect of Bias on the organization of the mesh. The spherical mesh on the left uses the default value of 0.1. Starting at the triangle at the very top, the mesh coils downward in a regular spiral in a clockwise direction. This produces a result that is both smooth and visually comprehensible as a wireframe for subsequent editing. The mesh on the right uses a Bias value of 0. The spiraling is lost at the top of the mesh and the top triangle is now nested in a closed hexagon, which makes the mesh irregular and more difficult to read.

6. If decreasing Bias produces a less-desirable result, does increasing the value improve the mesh? Try it. Click repeatedly on the spinner to push the value upward in small increments. Be patient—you won't see much of a change until you get close to a 0.5 value on this mesh; when you do, notice that it affects the organization of only the topmost edges. All of a sudden, at a value of 0.52, a nice alternative appears, as seen in Figure 8.30. On the left, for reference, is the mesh from Figure 8.29 (Face Threshold = 7.5), which uses the default Bias value of 0.1. On the right is the same mesh, with the Bias value increased to 0.52. This is a nice organization that produces

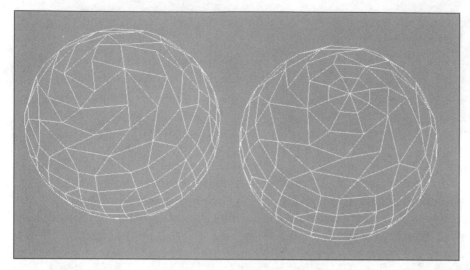

Figure 8.30

The Bias value increases to produce a good alternative mesh. On the left is the mesh from the left side of Figure 8.29 (Face Threshold = 7.5), with the default Bias value of 0.1. On the right, the Bias value increases to 0.52. The mesh is reorganized at the top to produce greater smoothness, yet it is well organized and very readable in wireframe for subsequent editing. The new organization increases the face count only a small amount, from 468 to 484. Note that the region of the mesh near the equator remains unchanged.

greater smoothness at the top. Compare the face counts before and after the Bias change. Although the number of faces increased slightly—from 468 at the Bias value of 0.1 to 484 with the Bias value of 0.52—this small increase is entirely in the area at the pole. The portion of the mesh closer to the equator was unaffected. Thus, Bias can be used to balance the Face Threshold value to produce better results.

Level Of Detail

Level of Detail, often called simply *LOD*, refers to the practice of having different versions of the same model with varying mesh densities. A very low-poly version of the model is used when the object is far away from the camera, so it occupies only a small portion of the screen space. This model then swaps out for higher-density versions as the object moves closer to the camera. MAX makes the process of working with multiple models easier by permitting you to have two different optimizations of the same model in the Optimize modifier. This is just as helpful when you compare different optimization parameters. Try it out on our running project:

7. Switch from the default L1 to L2 for Viewports in the Level Of Detail section of the Optimize panel. Change parameters as you wish, and switch back and forth between the two levels to compare the results.

8. Notice that there are separate radio buttons for the Renderer and the Viewports. The level you select for Viewports is the one you see on the MAX screen, and it is therefore the one that you can adjust the parameters for. In other words, you establish the settings by using the Viewports levels. You can then choose which level to use in

the renderer by using the Renderer levels. Although this process seems confusing at first, experiment with it for a moment. Use the two Viewports levels to set drastically different optimization levels—one of them can be without any optimization at all. Use the Quick Render button at the far right of the Main Toolbar to render the result. Change back and forth between the two levels for the renderer and compare the rendered result. Note that the current Viewports level affects the result in the renderer.

Open Edges

Thus far in our ongoing project, you've worked with a closed mesh. Now, try an open one:

9. Remove the Optimize modifier from your spherical Editable Mesh object for a fresh start. In the Polygon Sub-Object level, select and delete the bottom half of the mesh, which leaves an open mesh with open edges along the original equator. Get out of the Sub-Object level and put the Optimize modifier back on this mesh. Increase the Face Threshold value incrementally until you ultimately reach a high value (more than 20). Notice that the optimization of the region adjacent to the open edges can become very peculiar.

10. The Edge Threshold spinner comes in handy here. If you tested it out on the closed mesh, you probably concluded that it doesn't do anything. The Edge Threshold comes into play with open edges, where an optimization based on face size can no longer make complete sense. Set the Face Threshold value to 20 to get a great deal of optimization. The faces along the open edges are much smaller (and therefore more numerous) than in the rest of the mesh. Increase the value of the Edge Threshold from the default value of 1.0. You don't see much change until you pass a value of about 11. At this point, the procedure begins to encounter open edges that are smaller than the Face Threshold value and begins to optimize them. At a value of 17, the optimization of the entire mesh is roughly uniform. Take a look at Figure 8.31. On the left is the hemispherical mesh, optimized with a Face Threshold value of 20. With the Edge Threshold value set at the default value of 1.0, the portion of the mesh next to the open edges is poorly organized. On the right, the Edge Threshold value is increased to 17. The smaller open edges are reorganized into larger ones to produce a more uniform mesh.

Maximum Edge Length

The Face and Edge Threshold values are minimum values. Increasing these values increases the degree of optimization because ever-longer edges become subject to reorganization. You can also work in the other direction to refine your result. Using the Max Edge Length spinner, you can limit the size of the reorganized edges in our continuing exercise to ensure that too much detail is not lost:

11. Take the hemisphere you are using, with the Face Threshold value of 20 and the Edge Threshold value of 17. The Max Edge Length value is set to the default of 0. At this value, no edge length limit is applied, but the moment you increase it at all, even to

Figure 8.31
The effect of Edge Threshold values on open edges. On the left is a hemisphere created by deleting the bottom half of the Editable Mesh object from Figure 8.30. With a Face Threshold value of 20 applied in the Optimize modifier, and the Edge Threshold spinner set to the default value of 1.0, the region of the mesh adjacent to the open edges is disorganized and inconsistent with the rest. On the right, the same mesh is seen with the Edge Threshold value increased to 17. At this level, the shorter open edges along the rim are reorganized into larger ones to produce a more regular mesh organization overall.

.01, the limits kick in. At a tiny value, all of the edges are longer than the limit, so the optimization is nullified. As you move past a value of 13, however, you begin to recover the optimization. At a value of 55, the result is the same as before the limit was applied because there are no edges (after the initial optimization) that are longer than this value. Values between 13 and 55 refine the optimization by reorganizing excessively long edges. See Figure 8.32. On the left is the mesh without edge length limits applied—the Max Edge Length parameter is set to 0. On the right, the spinner is set to a value of 30.3 so that no edges in the mesh are longer than this value. This causes a reorganization of the mesh into smaller edges (and therefore a higher polygon count), but the result is smoother, clean, and well organized.

Edge Visibility

Optimization typically results in the destruction of any regular polygonal structure that you may have, and the Optimize modifier can generate a lot of invisible edges. Any optimized model is supposed to be composed of triangles, and it's hard to even read the surface of a highly optimized mesh, unless you can see all the edges. Of course, you can always turn off the Edges Only display option for the object, but it often makes sense to collapse the Optimize modifier into the Editable Mesh object, and then convert all the edges in the object to visible ones in the Edge Sub-Object level.

Figure 8.32
Maximum Edge Length limits are applied to refine the optimization. On the left is the optimized mesh from the right side of Figure 8.31. The Face Threshold is 20 and the Edge Threshold is 17. The Max Edge Length spinner is at the default of 0, so no edge length limits are applied. On the right, the Max Edge Length value is set to 30.3. Any edges produced by the optimization that are longer than this value are divided and reorganized. This result is well organized and smooth.

The Auto Edge tool in the Optimize panel goes in the other direction—it makes even more edges invisible. Figure 8.33 illustrates this possibility in terms of the exercise we've been working on. On the left is the original mesh from the left side of Figure 8.32. In the center, the Auto Edge box is checked, which makes the less-significant edges invisible and strips the polygonal structure of the model to the bare bones. On the right, the Optimize modifier is collapsed into the Editable Mesh and all of the edges are made visible. Compare these examples to see which edges are hidden. Regardless of the number and arrangement of hidden edges, however, all of these examples have precisely the same geometry and render identically.

Displacement Mapping And The Displace Modifier

Displacement mapping sits on the borderline between modeling and texturing. Normally, the distinction between modeling and texturing is clear. *Modeling* is the process of creating the geometry of the model, but it does not affect its material attributes (such as color). *Texturing* is part of the process of defining the material attributes by using bitmaps and procedural maps, and it does not affect the geometry of the object. In other words, texturing typically affects only the appearance of the surface, without altering the actual shape of the mesh.

Displacement mapping uses textures to affect the geometry and is typically used to provide textural relief of a surface. Take, for example, a golf ball with its characteristic dimpled surface. At any significant distance from the ball, you can discern this surface quality from the

Figure 8.33
Edge-visibility options are compared. On the left is the optimized mesh from the left side of Figure 8.32. In the center, the same object with the Auto Edge option in the Optimize modifier makes the less-significant edges invisible. On the right, the Optimize modifier is collapsed into the Editable Mesh, with all edges made visible.

dappled color pattern due to the shadowing of the "peaks" onto the "valleys." Only when you bring the object close do you see the actual "terrain." So it is with 3D graphics. A golf ball can successfully be modeled with a smooth sphere and simply be surfaced with a material that includes the appropriate textures. For example, a bitmap with a repeating dot pattern can be mapped to the sphere and used as a bump map. The bump mapping is only a surface effect: It creates the apparent surface shadows that would be produced by actual relief, but it does not create the relief itself. If the camera draws close to the object, it becomes obvious that the shadows are only an illusion—a pattern painted on a smooth ball.

Displacement mapping works the pattern directly into the geometry. If the same bitmap image that was used to bump map the surface material is used as a displacement map instead, the vertices on the object are displaced (upwards and downwards) to conform to the pattern. The relief that was only an illusion as a bump map becomes real. You can now zoom in on the golf ball as close as you want and see the geometric curvature of the dimples. This kind of geometric surface detail necessarily requires very high mesh density, however. Thus, much of the practice of efficient (or even workable) displacement mapping is directed toward controlling the weight of the displaced mesh.

3D Studio MAX handles displacement mapping in two ways. A Displace modifier can be placed on the stack and used to displace the vertices of objects sent up from below. It is a very flexible tool that can even be used without maps, as you will see. You can achieve more powerful displacement mapping by assigning a map to the Displacement slot in the Material

Editor. When this second technique is used, various modifiers can be used to display and even control the resolution of the mesh prior to rendering. Displacement mapping can be an extremely complex subject, and this book covers only the basics.

The Displace Modifier

The Displace Modifier works with the vertices that it gets from the stack below. Let's work with this tool in an exercise:

1. Create a large Rectangle (spline) in a front view and convert it to an Editable Mesh object (this creates only a single quadrangle). Because there are vertices at only the four corners, there's nothing to displace along the surface. You'll fix that as you go along.

2. Put a Displace modifier on the stack. This modifier can use both bitmaps and procedural maps. Bitmaps are added directly in the Image: Bitmap section of the panel; procedural maps (such as noise) are added in the Image: Map section. The Displace modifier can be used without any map at all, however.

Displacement Without Maps

As we continue our exercise, you can create simple displacement effects by using the mapping gizmo without a map:

3. Without adding any map at all, pull down to the Map section of the panel and confirm that it is set for Planar mapping and that the gizmo Alignment is set to the z-axis. The orange gizmo should fit precisely around the rectangular mesh. If it doesn't, press the Fit button. This portion of the panel is similar to that found in the UVW Mapping modifier panel.

4. Use the Length and Width spinners to squeeze down the gizmo so that it covers only a small region in the center of the mesh. Your front view should now look like Figure 8.34.

5. Pull up to the top of the Displace panel and increase the Strength value. This spinner controls the amount of displacement, but nothing happens because there aren't any vertices yet within the gizmo region to be displaced.

6. You can go down to the Editable Mesh level and tessellate the mesh to create vertices, but try a modifier that does the same thing with more flexibility. In the modifier stack, go to the line that separates the Editable Mesh object from the Displace modifier. Add a Tessellate modifier right there. The displacement effect should begin to appear right away, even at the default settings. If it does not, go up to the Displace modifier and adjust its strength. Figure 8.35 shows a perspective view in which the newly created vertex at the center is displaced by the gizmo.

7. Increase the tessellation to 4 Iterations to get a denser mesh. Now, the displacement effect should become clear. Reduce the Tension value to 0 for a perfectly regular mesh. Return to the Displace modifier, play with the Strength value, and adjust the size of the gizmo. Try negative Strength values to displace the mesh in the opposite direction. Figure 8.36 illustrates a couple of alternatives.

Figure 8.34
Rectangular Editable Mesh object, composed of only one quadrangle with the Displace modifier applied. Using a Planar projection aligned to the z-axis, the projection gizmo is squeezed down to cover only a small portion of the center of the mesh.

Figure 8.35
Object from Figure 8.34, with a Tessellate modifier added beneath the Displace modifier. The default values of the Tessellate modifier divided the original quadrangle into four quads, which produces a vertex in the center that is displaced by the Displace modifier gizmo.

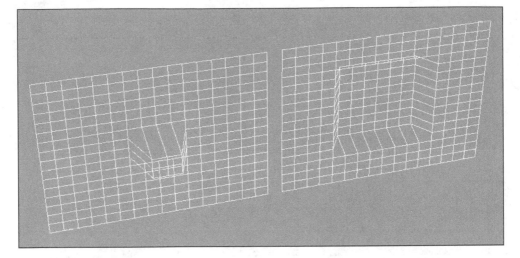

Figure 8.36
Object from Figure 8.35, with the Tessellation modifier set to 4 Iterations and the Tension reduced to 0 to produce a denser, regular mesh. The two examples use different gizmo dimensions and Strength values (both positive and negative).

8. This simple tessellation method produces an inefficient mesh—you didn't need to increase mesh density in the region that was not displaced. To get a better result, decrease the tessellation to 2 Iterations. Place a Mesh Select modifier on top of the Tessellate modifier (and beneath the Displace modifier), and use it to select only the middle columns of faces. Add another Tessellate modifier on top of the Mesh Select to tessellate only the selected faces, using 2 Iterations. Now, the displaced region has a higher mesh density than the surrounding regions, for a more efficient result. Figure 8.37 compares the improved tessellation with the original.

9. Take some time to experiment with the other gizmo shapes. Change from Planar mapping to Spherical mapping in the Displace panel. Enter the Gizmo Sub-Object level to scale the gizmo and move it around. Play with the Strength and Decay values to see the effects. The interaction of all these factors takes awhile to understand. It often makes sense to use Mesh Select to send up a region of selected faces to the Displace modifier. In Figure 8.38, a spherical gizmo is used to create a bulge in the mesh. In the model on the left side, the entire mesh was passed to the Displace modifier, resulting in a distortion of the perimeter. On the right, only the central region of faces was passed to the Displace modifier for a cleaner result.

10. Using Bezier patches instead of polygonal meshes produces a softer result that is sometimes desirable, especially when you use the Displace modifier to create terrain. Hide or delete your objects and create a Quad Patch in a front view. Place an Edit Patch modifier on top of the Quad Patch, and then add a Displace modifier at the top. You'll use the Edit Patch modifier to subdivide the patch, just as you used the Tessellate modifier before.

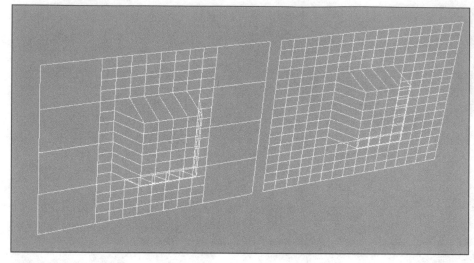

Figure 8.37
Tessellation method is improved for a more efficient mesh. On the right is a single, uniform tessellation of the entire mesh, as in Figure 8.36. On the left, the tessellation is broken into two steps. The first Tessellate modifier uses 2 Iterations on the entire mesh. A Mesh Select modifier is then applied to select only the middle columns of faces, and these are sent to a second Tessellate modifier (using 2 Iterations). The Displace modifier is at the top of the stack.

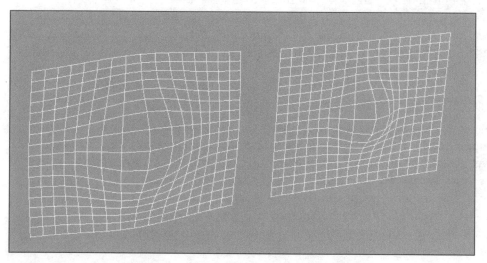

Figure 8.38
A spherical gizmo is used to create a rounded bulge, by using the Decay setting of the Displace modifier, and by scaling and moving the gizmo behind the mesh. On the left, the entire mesh is passed to the Displace modifier, resulting in distortion around the perimeter. On the right, only the central region of faces was passed to the modifier for displacement.

11. Once again, squeeze down the default Planar gizmo to the central region of the patch. Increasing the Strength value of the Displace modifier has no effect because the only vertices are at the corners of the patch. Go down to the Edit Patch

modifier and select the patch in the Patch Sub-Object level. Click on the Subdivide button to divide the patch into four patches. Now, there is a vertex in the center that can be displaced.

12. Get out of the Subobject mode in Edit Patch and go up to the Displace modifier. Play with the Strength value to displace the central vertex and note the soft curvature of the result (because the vertices of patch grids are connected by Bezier curves). The number of steps set in the Edit Patch modifier controls the smoothness of the curvature (and the number of polygons in the resulting mesh). See Figure 8.39. On the right, the Steps value is reduced to 0, producing the same result as using an Editable Mesh. On the left, the default value of 6 Steps produces a smooth curvature between the central vertex and the ones at the four corners.

Figure 8.39
Bezier patch surfaces provide a rounder alternative to polygonal meshes when you use the Displace modifier. A Quad Patch was subdivided into four (by using Edit Patch) to create a vertex in the center. The Displace modifier Planar gizmo is used to displace the central vertex. On the left, the default Steps value of 6 for the patch resolution produces a curved result. On the right, a Steps value of 0 produces the same result as using a polygonal mesh.

Displacement With Maps

Once you understand the operation of the Displace modifier using the gizmo alone, it's easy to move on to using maps. Although the modifier can be used with both bitmaps and procedural maps, you'll experiment with only a bitmap in this exercise:

1. Draw a Rectangle in a front view, making it a square—200 units in Length and 200 units in Width. Convert it to an Editable Mesh to create a single quadrangle. You already understand the importance of flexible control over the mesh density, so place a Tessellate modifier on top of the Editable Mesh, and then put a Displace modifier at the top. Make sure that the Planar gizmo fits the mesh—use the Fit button if it does not.

2. You'll use a bitmap image of a human face (displace.tif) from the MAX Maps directory. As the name suggests, this image was designed specifically for displacement mapping. Displacement mapping uses only grayscale values to displace vertices, so there's no need for color. (Color images can be used, but are effectively converted to grayscale.) The surface relief is determined by the value of the pixels between black and white. Take a look at displace.tif in Figure 8.40. The white areas on the brows, chin, and the tip of the nose are to be displaced outward. The black areas in the eyes and nostrils are to be displaced inward. Painting a map like this is obviously a difficult task—you have to learn to think like a displacement map. This face is an extreme use of displacement mapping that is excellent for demonstration, however. A displacement map to be used to create dimples in a golf ball, for example, is not difficult to create.

Figure 8.40
The bitmap named displace.tif from the MAX Maps directory. When used for displacement, the white areas on the brows, chin, and nose are displaced outward. The black areas in the eyes and nostrils are displaced inward.

3. In the Image: Bitmap section of the Displace panel, click on the button that reads None and select displace.tif from MAX's Maps directory. Pull the Strength value up to 30. There is some small displacement, proving that the map has been applied, but you'll obviously need a much higher mesh density to follow the curvature.

4. Go down to the Tessellate modifier, set the Tension to 0, and use 4 Iterations. This action kicks the density up to the point where you begin to see the face, but it's obvious that this density is not nearly enough. The resolution is good enough to be able to adjust the size of the Displace Planar gizmo. In Figure 8.40, the face is centered in a rectangular bitmap. You are using a square surface, so increase the width of the gizmo to around 300. You can see the displacement expanding in a top view.

5. Because a minimum of four iterations of tessellation is required, you can burn this geometry into the Editable Mesh. Reduce the number of Iterations in the Tessellate modifier to 1 and go down to the Editable Mesh level. In the Polygon Sub-Object level, select the quadrangle and (after setting the Tension to 0 in the unlabeled value box) press the Tessellate button four times.

6. On top of this denser object, return to the Tessellate modifier and begin to increase the number of iterations. With an Iterations value of 2, the face finally begins to become clear. Check Object Properties (from the right-click menu) to see that there are now 8,192 faces. Increase the Iterations to 3, and the pebbly surface of the texture emerges because of the small gradation in grayscale values. The mesh resolution is now 32,768 faces. If you want to try 4 Iterations, make sure to save your scene first because the huge face count may cause the program to lock up. Try some test renders. Figure 8.41 shows a render using 3 Iterations on the Tessellate modifier.

Figure 8.41
The grayscale image from Figure 8.40, applied as a displacement map by using the Displace modifier. The displaced mesh resolution is 32,768 faces.

Displacement Mapping In The Material Editor

Instead of using the Displace modifier, displacement mapping can be achieved by using the Displacement Map slot for an assigned material in the Material Editor. This method is more complex, but it is also more powerful. It often makes sense to apply displacement mapping in this manner simply because the same map is being used to define the Diffuse Color of the object, anyway.

Using Editable Meshes

Let's try using Editable Meshes as the displacement geometry:

1. Create a Rectangle to fill a front view and convert it to an Editable Mesh object.

2. This time, use a procedural texture rather than a bitmap for the displacement. Open the Material Editor from the Main Toolbar. Click on the first (upper-left) material slot to select it. Put this material to your object by using the Assign Material To

Selection button (the third icon from the left in the row beneath the material slots). Your object should now adopt the color on the material slot.

3. Use the Bricks procedural map. Open the Maps rollout in the Material Editor and click on the button that reads "None" for Diffuse Color. Choose Bricks from the Material/Map Browser that now appears. The brick pattern appears in an assigned slot in the Material Editor. To get this image to map to your Editable Mesh object, place a UVW Map modifier on the stack and confirm that it's a Planar projection. To see the map on the object in your shaded viewport, press the Show Map In Viewport icon (the checkered cube) in the Material Editor.

4. Use the same map for displacement. In the Maps rollout for the selected material in the Material Editor, drag the map from the Diffuse channel down to the Displacement channel and set the cloned map as an instance. You won't see any changes in your viewport yet.

5. Add a Displace Mesh modifier to the top of the stack. It's in the World Space Modifiers section of the modifiers list, separate from the Displace modifier. You'll use this modifier to subdivide the mesh to reveal the displacement. Check the Custom Settings box and try the three Subdivision presets. None of these suffice, so choose the Regular Subdivision Method. Increase the number in the Steps spinner. At a value of 6, the pattern starts to sharpen up, but it's backward. The white mortar between the bricks should displace inward. To correct this, return to the Maps rollout in the Material Editor and change the Amount of the Displacement channel from 100 to –100. Click on the Update Mesh button in the Displace Mesh modifier panel to refresh your screen. That's better. If you accomplished all these steps successfully, your shaded object should look like Figure 8.42.

6. You can now burn the desired resolution directly into the Editable Mesh. Remove the Displace Mesh modifier and watch the object flatten out. Go down to the Editable Mesh level of the stack and open the Surface Properties rollout. Check the Subdivision Displacement box and increase the Steps to 6 by using the Regular method. Move up to the UVW Mapping modifier level of the stack and you'll see the image on the flat object. If you do a test render, however, you'll see that the mesh was properly subdivided. Displace Mesh is primarily a tool for working with displacement subdivision in the viewports. The Subdivision Displacement settings at the Editable Mesh level pass through to the renderer.

Using NURBS Surfaces

Displacement mapping with NURBS is a complicated subject, but the results can be so superior that a quick glance is necessary. NURBS surfaces have excellent subdivision properties that are ideal for displacement mapping. To explore these properties, follow these steps:

1. Draw out a NURBS Point Surface in a front view to create a square. Find NURBS Surfaces under Create|Geometry in the Command panel. A NURBS surface, like a NURBS curve, represents an ideal curvature that can be flexibly tessellated into a polygonal mesh for rendering.

Figure 8.42
A Bricks procedural map is applied to a single Editable Mesh quadrangle by using the Displacement Map slot in the assigned material. The same map is applied for the Diffuse Color. The Displace Mesh modifier is used to test different subdivision possibilities.

2. Pick a slot in the Material Editor, assign it to your selected object, and open the Maps rollout. Put a Bitmap in the Diffuse channel and choose displace.tif (from the Maps directory) as the image. Make the image visible on your object in a shaded viewport. Go up to the material level (from the map level) and drag an instance of the Diffuse map to the Displacement map channel.

3. In the Modify panel, open the Surface Approximation rollout. The look of this rollout should be familiar from the previous exercises. All NURBS surfaces (not just those subject to displacement mapping) are tessellated into a mesh with these tools. In the case of displacement mapping, however, the results are seen only in the renderer—not in the viewports. Thus, it makes sense to render out quick wireframe versions. In the Material Editor, check the Wire box in the Shader rollout.

4. Surface Approximation for NURBS is set separately for the renderer and for the viewports. Select the Renderer radio button. Click on each of the three Tessellation Presets in the Surface Approximation rollout and make a quick render of each to compare resolutions. The High preset, which produces an excellent result, can be seen in Figure 8.43.

5. To see the tessellation directly in the viewports, add a Displace NURBS modifier to the stack and use the Renderer option. This action displays the displacement effect by using the tessellation settings for the renderer in the Surface Approximation rollout for the NURBS surface.

Figure 8.43
A NURBS surface, displaced with the displace.tif bitmap, as seen in a wireframe render. The High Tessellation Preset was used in the Surface Approximation rollout.

Free Form Deformation (Lattice Deformation)

Lattice deformation is a well-established (although aging) approach to creating smooth curvature in polygonal meshes. The original idea was undoubtedly to simulate the effect of NURBS control vertices on a NURBS surface. With the arrival of both true NURBS modeling and the NURBS-like NURMS in MeshSmooth in MAX, the lattice deformation tools will undoubtedly become less important. But there will be many instances in which they will remain the easiest or most convenient tools for the job.

The Free Form Deformation (FFD) modifiers are MAX's tools for lattice deformation, and they should not be confused with the Lattice modifier, which does something else entirely. When an FFD modifier is applied to an object or selected subobject, it surrounds the object with a lattice of control points. Moving the control points deforms the object as if each point had a magnetic pull over the adjacent region of the mesh. This action preserves smooth curvature in dense meshes. The modifiers come in two shapes: the FFD(box) is rectilinear in all three dimensions; the FFD(cyl) is cylindrical in shape, consisting of rows of radial patterns of control points. With both of these modifiers, you can freely adjust the number of control points in any dimension. The FFD 2×2×2, FFD 3×3×3, and FFD 4×4×4 are shortcuts to create box lattices of the indicated number of points.

A short exercise introduces the basic features and difficulties of the FFD modifiers:

1. Create a tall Box primitive and give it some segmentation in all three dimensions. The specifics are not important because they can be adjusted later. Place an FFD(box) modifier on the object. A lattice of control points appears around the object.

2. Click on the button that reads Set Number Of Points and change the Dimensions to 3 points in Length and Width, and 4 points in Height. Compare wireframe and shaded views of the object. The shaded view hides the points inside the object. A wireframe view is very often necessary, but it reveals the lattice points inside the object. These points can be terribly confusing and represent the difficulty of working with the FFD modifiers. Figure 8.44 shows a wireframe view of the Box with the 3×3×4 box lattice. It's tough to read. Try unchecking the Display: Lattice box. This result is even worse because it's hard to figure out where the points are without the lines as references. Turn the lattice back on.

Figure 8.44
A segmented Box primitive, with the 3x3x4 FFD lattice applied. In a wireframe view, the interior control points can be visually confusing.

3. Press the Sub-Object button to enter the Control Points level. Now, you can deform the object with the control points. You can select control points in the usual way or use the Selection buttons in the modifier panel. Press the All Z button to activate it and then select a Control Point in the middle of any of the sides of the lattice. The entire vertical row should be selected. Move the selected row outward and inward to see the effect. Go down to the Box level of the stack and increase the segmentation in the affected dimension to capture the rounding effect of the modifier. Your screen should resemble Figure 8.45.

4. Deactivate the All Z button and select only the bottom Control Point in the column that you've displaced. Move it back to the surface of the Box to create a curvature at

Figure 8.45
Object from Figure 8.44 with displaced control points. To reveal the effect of the deformation, the segmentation of the underlying Box primitive was increased in the affected dimension.

the bottom. Now, go to the Lattice Sub-Object level and move the Lattice subobject upward through the object. Scale the Lattice subobject down (by using nonuniform scale in z) to look like Figure 8.46. You have to increase the Height segmentation of the Box to resolve the curvature.

5. Notice the outward bump at the bottom of the deformed region. The FFD modifier works by drawing an invisible spline through the control points and using that spline to deform the mesh. To control the interpolation between the "vertices" of this spline, you can select the control points and adjust their tension and continuity. Select the control point at the offending bump and increase its tension until the deformation straightens out.

Spline-Based Modifiers

The Extrude and Lathe modifiers convert splines into 3D surface geometry. As such, they are closer to the creation tools than to the rest of the modifier. However, in being implemented as modifiers, they take advantage of the stack concept. The spline remains beneath the modifier and can be edited. These edits are then passed up to the modifier, and the surface is reconstructed. For example, a curved spline can be lathed into a wineglass shape. By editing the shape of the spline at the bottom of the stack, the profile of the wineglass can be altered without starting over.

Figure 8.46
Object from Figure 8.45 with the bottom of the displaced control points moved back to the surface of the Box. The Lattice subobject is translated up in the object and then scaled down vertically. Height segmentation was increased to resolve the curvature.

Extrude

The Extrude modifier is so simple that there's almost nothing to say about it. Any spline—open or closed—can be used, and it is extruded perpendicular to the plane that it is created in. The segmentation of the extrusion can be varied at any time, creating a sort of parametric object.

If a closed spline is used, end caps are placed on the spline by default. This means that even a closed spline that is extruded a zero amount is actually two surfaces connected by edges of zero length. For this reason, it is inefficient to create flat surfaces this way. For example, to

WORKING WITH IRREGULARLY SHAPED OBJECTS

The FFD modifiers are best used with objects that are rectilinear or cylindrical. With more irregularly shaped objects, the default shape of the lattice does not conform to the surface of the object. This can make it very confusing to use. MAX provides tools for shaping the lattice so that the control points follow the surface in their default position (before they are used to deform the mesh). The Set Volume subobject level permits you to move control points into the default positions of your choice, nearer the object. You can compare the new positions with the originals by checking and unchecking the Display: Source Volume box. This task can be tedious, though. The Conform to Shape button at the bottom of the panel brings the control points close to the surface, but the result is rarely successful.

create a flat plane, many people apply an Extrude modifier to a Rectangle spline, but this produces only a compressed 3D object. It's better to simply convert the Rectangle to an Editable Mesh.

If capping is used on the extrusion of a closed spline, the default of Morph is almost always preferable. The Grid option creates the caps out of a fine grid that is trimmed to the shape of the closed spline. You can't tell the difference between the two without revealing invisible edges, however. In Figure 8.47, the extrusion on the left uses the Morph option for the caps. The Grid option is used on the right. The Edges Only display property is unchecked for both objects so you can see the invisible edges and the structural difference.

The desired output is generally a polygonal mesh object, although sometimes a patch output makes sense. NURBS extrusions are generally better extruded from NURBS curves by using the specialized NURBS toolset.

Lathe

The Lathe modifier revolves a spline around an axis to create a surface. The revolution can be less than 360 degrees, and the segmentation around the lathe remains parametric.

The panel is straightforward, but a couple of points are worth noting. The first is that the axis of the lathe can be selected as a subobject and moved. Typically, you create a spline, apply the Lathe modifier, make sure that the correct axis direction (x, y, or z) is chosen, and use one of the Align buttons to place the axis in the right position. Sometimes, the right location of the axis is not at the ends or the center of the spline, however. See Figure 8.48. The lathed spline on the right uses an axis aligned to the Minimum of the curve (its innermost point), and therefore comes to a point. In the selected object on the left, the Axis subobject is selected and translated over to the left, increasing the diameter of the lathe.

Figure 8.47
Capping an extruded closed spline. On the left, the Morph option for capping produces the minimal necessary geometry. On the right, the Grid option generates a high-density grid. Invisible edges are revealed to show the difference.

Figure 8.48
Using the Axis subobject. The lathed spline on the right is aligned to the Minimum of the curve, bringing the surface to a point. On the left, the Axis subobject is selected and translated further over to the left, increasing the diameter of the lathe.

Closed splines can be lathed to create a kind of circular extrusion. If the Lathe Degree value is less than 360 degrees, the exposed ends are capped by default. The choice between Morph and Grid is the same as with the Extrude modifier. In Figure 8.49, a circle was lathed, and the Axis subobject was moved out of the circle to create a torus. The version on the left is a full 360-degree lathe. The version on the right is revolved only 180 degrees, and the exposed ends are capped by default.

Figure 8.49
Lathing a closed spline. On the left, a circle is lathed into a torus by moving the Axis subobject out of the spline and revolving 360 degrees. On the right, a 180-degree lathe exposes the end caps.

Moving On

This chapter explored the operation of most of the modifiers used in the modeling process. The axial deformation modifiers (such as Bend, Twist, and Taper) form a logical group with similar interfaces that impose basic shapes on objects and subobject regions. The Noise modifier and the displacement-mapping tools (including the Displace modifier) are more directed toward creating surface detail. In contrast, the Optimize tool is not used to shape geometry, but rather to reduce its polygonal weight. The spline-based modifiers, Extrude and Lathe, create 3D surfaces out of 2D curves.

The next chapter discusses the various compound objects (such as Lofts and Booleans) that use two or more objects to create a result.

COMPOUND OBJECTS

A number of important modeling activities involve the use of two objects to produce a third object. MAX provides Compound Objects as the vehicle for some of these activities.

Loft Objects and Boolean Objects are the most important kinds of Compound Objects. A Loft Object is 3D geometry that is created by extruding one or more splines (as cross-sections) along a spline path. A Boolean Object is used to add two overlapping meshes together or, more commonly, to subtract one out of the other. The Compound Object structure is a flexible way to handle lofting and Boolean operations because the objects that go into the package remain editable. For example, you can change the shape of the lofting path; the Loft Object then updates to reflect it.

ShapeMerge is used to project a 2D shape onto a 3D object. A Connect Object bridges the gap between two open meshes to create a seamless result. The Scatter Object creates random arrays of objects, typically on the surface of another. The Terrain Object converts elevation data, generally from AutoCAD, into models that are suitable for architects and engineers.

Loft Objects

A Loft Object is a kind of extrusion. Just as in a simple extrusion, a 2D spline is drawn out into a 3D object. Unlike simple extrusions, however, a Loft Object does not follow a straight path. Rather, a spline is drawn to serve as the extrusion path. The path can be open or closed, and it can curve smoothly or turn sharp corners. The spline to be extruded, called a *shape* in the MAX interface, is usually called a *cross-section* in standard computer graphic usage. A MAX Loft Object can be composed of multiple cross-sections that are placed at different points along a path.

As a Compound Object, a Loft Object is the result of the path and cross-section splines that are used to make it. As these component splines are edited, the Loft Object updates to reflect the new inputs. The Loft Object is also very much of a parametric object because its segmentation remains adjustable with the turn of a spinner.

Using A Single Cross-Section Shape

You can either put a shape (cross-section) to a path, thereby moving the shape to the path, or put the path to the shape, thereby moving the path to the shape. Most of the time, it makes more sense to determine the position of the lofting path first, and then align one or more shapes along it. To use a single cross-section shape, follow these steps:

1. Create a small Circle in a front view, and draw a straight Line with only two vertices in a top view. The Circle will be lofted along the Line path.

2. Select the path and create a Loft Object. Find the Compound Objects in the Command Panel (Create|Geometry|Compound Objects), and then click on Loft to create the object. A faster method is to find the Loft Object icon in the new Compounds Toolbar. Either way, the path (still called Line) is now part of a Loft Object.

3. Finish this simple loft by putting the Circle to the path. Because the path is already included in the Loft Object, press the Get Shape button to activate it. Click on the Circle on the screen; the loft is created, with the Circle extruded along the path. Click on the Get Shape button to deactivate it, and you're done with this Loft. Press the H key to bring up the Select Objects dialog box, and note that there are now three objects: the Circle, the Line, and the Loft. Convince yourself that the Line object is still a separate object, even though it was used as a path. Select it and move it out of the loft. Your screen should look something like Figure 9.1.

Figure 9.1
A Circle (Bezier spline), lofted along a Line (Bezier spline). The Line was selected at the time that the Loft Object was created. Thus, the Get Shape method was used to put the Circle to the Loft path. Only default settings are used. The Line is still a separate object from the Loft and has been moved outside of the Loft Object.

4. The Line may be a separate object, but its shape continues to control the path of the Loft. With the Line selected, enter the Modify Panel and go into the Vertex subobject level. Select both vertices on the Line and convert them both to Bezier type by using

the right-click menu. Move one of the vertices and adjust its Bezier handles to make a curve. Note that the Loft Object is updated to follow the new path, as shown in Figure 9.2.

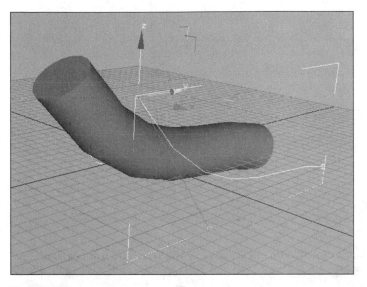

Figure 9.2
Loft Object from Figure 9.1, with the path modified. The Line was selected and its vertices were changed to Bezier type. One of the vertices is translated and its Bezier handles are adjusted to create a curve. The Loft Object updates to reflect the new shape of the path.

5. How about adjusting the cross-section shape as well? Select the Circle and go to the Modify panel. Unlike the Line Object, the Circle's Modify panel does not provide access to the vertices of the spline. Your instincts might suggest converting the parametric Circle to an Editable Spline, but this does not work here. Instead, place an Edit Spline modifier on top of the Circle and use it to select a vertex on the Circle and move it. The shape of the Loft Object updates, as shown in Figure 9.3.

6. Although both of the component objects in the Loft remain editable, there is a significant difference between them. Because you started the Loft with the Line (the path), the Line automatically continues to control the shape of the lofting path. When you selected the Circle to put it to the path, you used the default Instance option. As an instance, the Circle on the Loft remains connected to the original circle for editing purposes, as you saw in Figures 9.1 through 9.3. If you use the Move or Copy options, however, there would be no continuing relationship. Therefore, the Instance option is desirable in almost every case.

7. Get out of the Sub-Object mode for the Circle and move the Circle around. Just as you discovered with the Line, this does not affect the Loft in any way, and it raises a

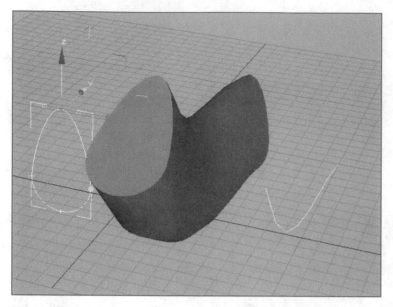

Figure 9.3
Loft Object from Figure 9.2, with cross-section shape modified. An Edit Spline modifier was applied to the Circle object and one of the vertices was translated up. The Loft Object updates to reflect the new shape of the cross-section.

very important point about Loft Objects. The Loft Object does not receive any transform information from its component objects. Thus, if you scale the cross-section shape, the Loft is unaffected. Give this a try by scaling the Circle. In order to get the scaling to affect the Loft, it must be brought into the stack. One approach is to select the Spline subobject in the Edit Spline modifier and scale it. Another way is to place an XForm modifier above the Edit Spline and scale the XForm gizmo. The XForm modifier is used to bring transforms into the stack of an object, and this is a great example of where it can be useful.

Display And Resolution

A Loft Object is a parametric object. It's an abstraction of a perfect shape that must be reduced to a specific mesh resolution. Various display options will help you to manage the object. Let's continue with the object we're working with:

8. To increase the curvature, select the Line, and, in the Editable Spline modifier, adjust the shape of the curve to really turn upward. Return to the Loft Object and open the Skin Parameters rollout. There are many ways to view a Loft. If neither the Skin nor Skin In Shaded box is checked, only the path and cross-sections are displayed in wireframe, as seen in Figure 9.4. If Skin alone is checked, the surface is displayed in the viewports, whether wireframe or shaded. If only Skin In Shaded is checked, the surface is seen only in a shaded viewport.

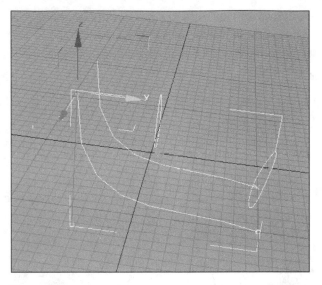

Figure 9.4
Loft Object from Figure 9.3, with curvature of the path increased by adjusting the selected vertex on the Line object. The result in the Loft Object is seen without the skin, with only the path and cross-section shape visible.

9. Make the skin visible, either in a wireframe view or in a Smooth + Highlight (shaded) view with Edged Faces. Play with the Path Steps and Shape Steps spinners in the Skin Parameters rollout to adjust the resolution of the mesh. You can see that the Loft Object is very much like any other parametric object because its segmentation is fully adjustable. The segmentation is adaptive, growing denser in areas of tight curvature, as can be seen in Figure 9.5.

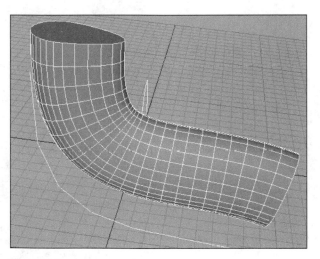

Figure 9.5
Loft Object from Figure 9.4, with skin visible in a viewport. Segmentation was increased by using the Steps spinners to create a smoother mesh result. Note the adaptive segmentation, creating greater mesh density through the tight part of the curve.

10. By default, the cross-section remains aligned to the path, rotating as the spline curves. You can override this by unchecking the Contour box, however. The cross-section now remains unrotated throughout the path. See Figure 9.6. Note that the two end caps of the Loft are now parallel.

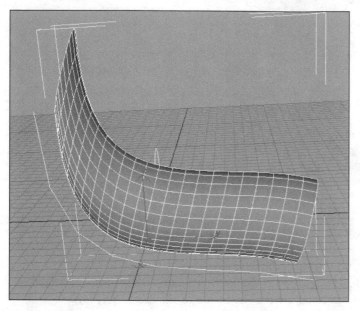

Figure 9.6
Loft Object from Figure 9.5, with the Contour box unchecked. The cross-section shape does not remain aligned to the path, and the two end caps are now parallel to each other.

11. Because you used a closed curve (a Circle) for the cross-section shape, end caps were available and were placed on by default. They can be removed in the Skin Parameters rollout. The Morph and Grid options are the same as found in the Extrude modifier; the default Morph type of cap is almost always preferable. Note also that you can flip normals in the rollout (to reverse the surface direction) and can override the organization of the mesh into quad Polygons by unchecking Quad Sides.

Multiple Shapes On A Path

You can place different shapes (cross-sections) along a single path to create complex shapes that often can be created in no other way. A simple exercise will give you the idea:

1. Create a small Circle and a small Rectangle in a front view. In a top view, draw a straight Line for the lofting path. Make sure that it's absolutely straight, using snaps if you have to, because any curvature along the path affects the segmentation of the Loft Object, as you have seen.

2. With the Line selected, create a Loft Object. Make sure that the Path Parameters rollout is open, and take a look at it. This rollout contains tools for placing shapes (cross-sections) at particular locations along the path. Thus far, you've only placed

one shape at the beginning of the path. That's because the default value in the Path spinner is 0, meaning that the shape is to be positioned at 0 percent of the distance along the path. Activate the Get Shape button and select the Rectangle. The Rectangle lofts along the path, as shown in Figure 9.7. Note the little yellow cross at the start of the path.

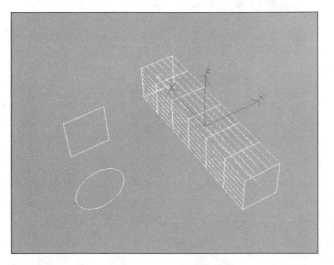

Figure 9.7
Starting a Loft Object with two cross-section shapes: a Circle and a Rectangle. Using Get Shape and a Path value of 0 percent, the Rectangle is placed at the start of the path.

3. Pull the Path spinner and watch the yellow cross move along the path. Move to 40 percent and select the Circle. Move to 60 percent and select the Circle again. Then, move all the way to the end (Path = 100) and select the Rectangle again. Your screen should look something like Figure 9.8.

4. Note the twisting. When multiple splines loft together, they are connected through their respective start points (MAX calls them *first vertices*). It's often necessary to align the start points, either by changing the start point of the curve or by rotating the spline itself. Select the Rectangle and add an Edit Spline modifier to its stack. Enter the Vertex Sub-Object level to see the four vertices, and note that the one in the upper-right corner is marked with a tiny square around the vertex tick. This is the start point of the curve. You could change this to another vertex by using the Make First button lower in the panel, but do the following steps instead.

5. Get out of Sub-Object mode in Edit Spline and select the Circle object. Add an Edit Spline modifier to the Circle and enter the subobject level. Note that the start point of this curve is at 3 o'clock. As you look at the Loft Object, you'll see that the twist is attributable to the curves following a path between the start points of the two shapes. To align the start points, go to the Spline Sub-Object level and click on the Circle object to select the spline. Rotate the spline counterclockwise about 45 degrees, which

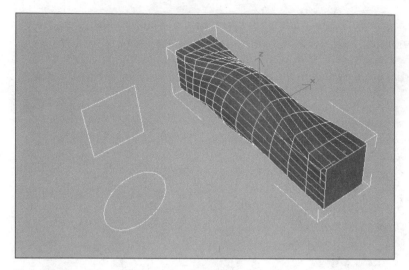

Figure 9.8
Object from Figure 9.7, with other shapes added. The Circle was added to the path at 40 and 60 percent of the distance, and the Rectangle was added again at the end.

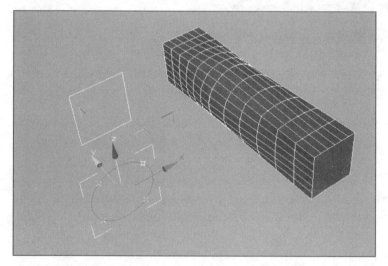

Figure 9.9
The start points of the two splines are aligned to remove the twist from the Loft Object in Figure 9.8. Using the Edit Spline modifier at the Spline Sub-Object level, the circular spline (not the Circle object) is rotated 45 degrees in the counterclockwise direction. This brings the start point of this spline into alignment with the start point of the Rectangle spline.

brings the start points into alignment. Your screen should look like Figure 9.9. (You may want to get out of the subobject level and rotate the Circle object at the object level. This has no effect on the Loft Object because, as discussed previously, the object-level transforms do not pass through to the Loft.)

Open Cross-Sections And Closed Paths

Thus far, you've used closed splines as cross-section shapes and open splines as lofting paths, but both closed and open splines can be used for either purpose. Figure 9.10 illustrates the use of a closed spline to create a picture frame. The open spline cross-section is visible in the center (that spline was lofted around a Rectangle). Note how useful a lofting path with sharp corners can be. Lofting around sharp corners can produce smoothing artifacts in rendering, however. Put a Smooth modifier on the stack of the Loft Object to correct this.

Figure 9.10
An open spline is lofted around a closed one (a Rectangle) to create a picture frame. The open spline is visible in the center. Lofting paths with sharp corners can be very useful, but they may generate smoothing artifacts in rendering. A Smooth modifier on top of the Loft Object corrects this.

Loft Deformation Tools

Once a Loft Object has been created, you can move to the Modify panel and use the Deformations rollout to reshape it. The choices are Scale, Twist, Teeter, Bevel, and Fit. Fit Deformation is a creature all to itself, using cross-sections to create geometry (like that of a car) that one would never think of as the product of lofting. This modeling technique appeals to very few people in my experience, largely because it's not very intuitive, but you may wish to look it over in the MAX documentation or in the online Help.

The other four deformations are easy to understand if you play with them for a moment. They use graphs in x- and y-dimensions that are plotted against the length of the path, from 0 to 100 percent. The Scale deformation is the most useful. In Figure 9.11, it is used on a tubular Loft, created by lofting a Circle along an open spline. Keys were placed along the graph at 5 percent intervals from 0 to 60. The key values alternate between 100 and 50 percent, causing the Loft to scale in and out. The graph shows only the x values, but the y

Figure 9.11
The Scale Deformation tool in the Deformations rollout of the Modify panel of the Loft Object. Keys are created at 5 percent intervals along the path, from 0 to 60. The scaling values alternate between 100 and 50 percent, causing the Loft to scale in and out. The graph shows only the values in the x-dimension, but the y values are identical because of the use of the Make Symmetrical button.

values were made identical by using the Make Symmetrical button. The x- and y-dimensions are always perpendicular to the path.

Boolean Operations

When two objects overlap and therefore share some common volume, three operations are possible. In Boolean subtraction, the shared region is removed from one of the objects. In Boolean union, a single object is created from both. In Boolean intersection, the shared region becomes a new object.

Boolean subtraction is the most important of the three. It's typically used to cut out some distinctive recess in a 3D object, like a cylindrical hole in a pegboard. The object used to make the cut (in this case, the Cylinder) is called the *subtraction object* or the *cut object*. It's placed in position, intersecting the object to be cut, and the operation is performed. Boolean intersection is rarely used because few shapes make sense as the overlap of two others. Boolean union is commonly used, but not to create shapes. Rather, it's used to eliminate internal geometry when two meshes overlap and are intended for use as a single object.

MAX's approach to Boolean operations is unique among 3D packages. In all other programs, the objects used in the Boolean operations have no continuing relationship. MAX, however, has implemented Booleans as Compound Objects. This means that you can always go back to the component objects (called *Operands*) and edit them to produce a new result.

A Boolean Object in MAX preserves the two component objects as subobjects. This is a powerful device, but it comes at a cost in complexity. Take an object that requires three Boolean cuts. A first Compound Object is created to make the first subtraction. That Compound Object then becomes an Operand in a second Compound Object, along with the next cut object. This Compound Object then becomes an Operand in a third. The Compound Object approach creates nested Boolean objects when multiple operations are needed. This is confusing and (even worse) it taxes system resources. When you're sure that you have the result you want and have no further need to edit the Operands, convert the Boolean object to an Editable Mesh.

Perhaps in response to such concerns, MAX has a second method of performing Boolean operations. The Collapse utility works much like the Boolean tools in other programs. Once an operation is performed, only a simple Editable Mesh object remains. Let's look at this tool before turning to the Boolean Compound Object.

BE CAREFUL WITH BOOLEAN SUBTRACTION

The more experience that you have with Boolean subtraction, the more careful you become about using it. In simple situations, subtraction can work well, but it can often produce strange artifacts with more complex meshes. Even when the result is not obviously incorrect, the mesh can become very confused and poorly organized, in a way that makes subsequent editing difficult. A common but easily solvable problem is smoothing artifacts in rendering. If you see funny streaks and shadows in the surface, apply a Smooth modifier, or—even better—collapse the object to an Editable Mesh and correct the smoothing at the Face Sub-Object level.

Using The Collapse Utility

The Boolean tools in the Collapse utility appeared first in MAX 2 and worked well. For some reason, the tools went crazy in MAX Version 2.5, producing such strange results that they were unusable. In MAX 3, they're back to normal; because they are so simple and straightforward, they are often preferable to Boolean Compound Objects. Walk through these tools in the following exercises, which introduce you to general Boolean concepts.

A Simple Subtraction

To perform a simple subtraction:

1. Create two Box objects and position them so that they overlap. Leave one of them unsegmented, and give the other a fair amount of segmentation. Your screen should look something like Figure 9.12.

2. Because you perform a subtraction first, you have to determine which Box will be the cut object. The first object to be selected is the one that is subtracted from, and the second is the subtraction or cut object. The second object is eliminated when the operation is completed. This is the single most important disadvantage of using the Collapse utility for Boolean subtraction. If you'll need the subtraction object later, make a copy before performing the cut.

Figure 9.12
Preparing for Boolean subtraction. Two Box objects are positioned so that their volumes overlap. The mesh of one object was left unsegmented, and the segmentation of the other was increased in all dimensions.

3. Select the unsegmented Box first, and then add the other Box to the selection. Go to the Utilities tab (with the little hammer icon) on the Command panel, and select the Collapse utility. Check the box for Boolean and the radio button for Subtraction. Now, stop! The Collapse utility cannot be undone, so Hold the scene by using the Hold command in the Edit menu. Now, the scene can be recovered in its present state by using the Fetch command in the Edit menu. (The inability to undo Boolean operations is another disadvantage of the Collapse approach.)

4. If you performed the Hold, press the Collapse Selected button to perform the subtraction. The cut object disappears and the other object remains (less the subtracted volume) as an Editable Mesh. Note that the mesh of the subtraction object was impressed into the subtracted region of the remaining object. Figure 9.13 shows the result after subtraction.

5. How about the other way? Use Fetch to recover the two boxes and deselect them. Now, select them in the opposite order, the segmented Box first. Use Hold again to save the scene and then press the Collapse Selected button. Once again, the mesh of the cut object is impressed on the remaining object, even though it eliminates part of the original segmentation in this case (see Figure 9.14). This is an important point. The loss of segmentation in the resulting object confuses the mesh and could make it difficult to edit. The segmentation of the subtraction object must be considered before the cut is made.

Figure 9.13
The segmented Box was subtracted from the unsegmented Box by selecting the unsegmented Box first. Note that the finer mesh of the cut object remains impressed on the resulting object, which is now an Editable Mesh.

Figure 9.14
The unsegmented Box is subtracted from the segmented one. Once again, the segmentation of the cut object is impressed on the remaining one. The loss of segmentation in the region resulted in a poorly organized mesh that could be difficult to edit.

Multiple Subtractions Performed Together

One of the great advantages of the Collapse utility over the Boolean Compound Object is the power to perform multiple operations at once. This is more important than it might seem because, as mentioned previously, multiple operations can create nested Compound Objects if the Boolean object method is used.

1. Create a longish box and position an array of Cylinders through it to make a row of tunnels.

2. As you did in the previous exercise, Hold the scene by using the Hold command in the Edit menu. Then, select the Box first, and then select all the Cylinders.

3. Perform the subtraction with the Collapse utility. Figure 9.15 shows the setup and the result.

Figure 9.15
Multiple Boolean cuts performed in a single step with the Collapse utility. At top is the setup, with an array of cylinders positioned to create a row of tunnels through an unsegmented Box object. The Box is selected first, and then the Cylinders are selected. After the operation, all of the Cylinders are subtracted out, as seen in the object at the bottom.

Cleaning Up With Boolean Union

Boolean union is performed as a cleanup step when creating objects by assembling overlapping units. Let's see how it works:

1. Create three Boxes, each with a fair amount of segmentation, and arrange them so that they overlap each other. Look at a wireframe view and prepare to be confused. Intersecting meshes are impossible to read. By looking at Figure 9.16 alone, it is impossible to understand the geometry.

Figure 9.16
Three segmented Boxes with overlapping volumes. In wireframe view, this geometry is impossible to comprehend, and therefore to edit.

2. Select all the Boxes together. The order of selection doesn't matter for Boolean union.

3. In the Collapse utility panel, change from Subtraction to Union, and press the Collapse Selected button. All of the internal geometry is eliminated and only a single Editable Mesh object remains, as seen in Figure 9.17. Now the surface of the mesh is much easier to understand in wireframe. Equally important, hidden unnecessary geometry is eliminated for smaller file size, better interactive response, and faster rendering.

Figure 9.17
The objects from Figure 9.17 after Boolean union. The internal geometry is eliminated, making the surface of the mesh easier to read in wireframe and creating a more efficient scene.

Boolean Compound Objects

I made a point of introducing the Collapse utility approach to Boolean operations first because relatively few such operations require the editing powers provided by Boolean Compound Objects. Many people are (understandably) unaware of the Collapse utility, so they perform all Boolean operations with the Boolean Compound Object. There are often occasions, however, in which the additional overhead and complexity of Boolean Compound Objects is justified. Walk through the following exercise.

The Basic Setup

To begin the exercise:

1. Create two Box objects and arrange them so that they do not intersect each other. Select one of them and create a Boolean Compound Object. This can be achieved by clicking on the icon in the Compounds Toolbar, or in the more traditional way using the Command panel (Create|Geometry|Compound Objects|Boolean).

2. The Boolean panel appears. Note that the object that was selected when the Boolean object was created appears on the list as Operand A. Activate the Pick Operand B button and click on the other Box by using the default Move option. The Operand B object disappears. Go down to the Display section of the panel and compare the difference between the Results, Operands, and Result + Hidden Ops options. With a shaded view, use the Result + Hidden Ops option to show Operand A in a shaded preview and Operand B in wireframe. Because the default operation subtracts B from A, A is the resulting object. Your screen should look like Figure 9.18.

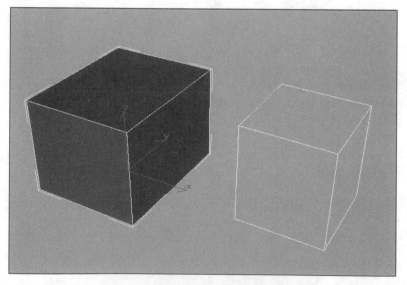

Figure 9.18
Two Box objects were made into Operands A and B of a Boolean Compound Object. The default operation subtracts B from A. Using a shaded view and the Result + Hidden Ops display option, Operand A is shown in shaded view and Operand B (the subtraction object) is shown in wireframe.

3. Click on the Modify tab at the top of the Command panel. The Modify panel for the Boolean looks much the same as the Create panel did, with one important exception. The Modify panel gives you access to the two Operands as subobjects. Enter the Operand Sub-Object level (by clicking on the Sub-Object button), and select Operand B by clicking on the wireframe object. Now, move it so that it intersects Operand A. The subtraction effect is seen in Operand A, permitting interactive subtraction. Your screen should look something like Figure 9.19.

Figure 9.19
In the Modify panel, Operand B is selected as a subobject and moved until it intersects the volume of Operand A. The subtraction effect is seen in Operand A for interactive Boolean subtraction.

4. Unlike the Collapse utility, it doesn't matter which object is selected when you first create the Boolean Compound Object. You can just as easily subtract A from B as you can subtract B from A. And you can also choose a Union or Intersection operation. The Boolean Compound Object is especially useful for the rare times that you'll use Intersection, because it's often very hard to visualize the result. The power to edit the operation on the fly by moving the Operands will really help. Experiment with these operations to see the results.

5. The Cut option is not a true Boolean operation because it doesn't result in new solid geometry. It works only on the surface. Try the Remove Inside and Remove Outside options. Your results should look something like Figure 9.20. The Refine and Split options simply divide the mesh without removing any portion. To see the effect, convert the Boolean object to an Editable Mesh. You'll find that new edges and vertices have been created by the Cut.

6. Hit the H key to bring up the Select Object dialog box.

Figure 9.20
The Cut operation does not result in new solid geometry; it only divides up the mesh. At left, the Remove Outside option eliminates the mesh outside Operand B. At right, the Remove Inside option does just the opposite.

Extracting Operands And Using Instances

In the Select Objects dialog box, note that there is only one object in the scene. When you created the Boolean Compound Object, the two original Box objects became subsumed into the Boolean, which took the name of the first object selected. What if you want your original objects back? The names of the two Operands are listed in the Parameters rollout of the Boolean panel. Let's continue our project:

7. Highlight either one of the objects by clicking and holding down the Extract Operand button, using the Copy option. The Operand is copied out as a separate object and can now be found in the Select Objects dialog box. If both Operands are extracted in this way, the Boolean Compound Object can be deleted, and you are back to where you started.

8. The Instance extraction option also clones the Operand as an object, but the instancing allows you to modify the Boolean by modifying the extracted instance. Delete any copies that you made in the last step so that only the Boolean Compound Object remains. Use the Subtraction A – B operation. Extract Operand B using the Instance option. Select the extracted instance and pull it off to the side. Put a Taper modifier on the instance and play with its values. The deformation of the instance is reflected in the Operand, and it is therefore reflected in the Boolean Object. See Figure 9.21.

Figure 9.21
Using an extracted instance, Operand B is extracted from the Boolean Object using the Instance option. The instance is moved to the side and a Taper modifier is applied. The effect of the modifier on the instance is duplicated in the Operand, and it is therefore reflected in the Boolean Object.

ShapeMerge Objects

ShapeMerge Compound Objects are very similar to Boolean Compound Objects in their setup and operation. ShapeMerge is used to project a 2D spline on a 3D object, and it will remind those who are familiar with NURBS (Non-Uniform Rational B-Spline) modeling of projected NURBS curves. Try the following exercise:

1. Create a short, fat Cylinder object on the groundplane and give it some segmentation. Next, draw an Ellipse object in a front view, so that it fits well inside the Cylinder. The Ellipse is necessarily created on the world xz plane, and it is therefore inside the Cylinder. Change to local coordinates and note that the spline is on its local xy plane and that the local z-axis points perpendicularly toward the front. Move the Ellipse in the positive (local) z-direction so that it's positioned in front of the Cylinder. Your screen should look like Figure 9.22.

2. Select the Cylinder and create a ShapeMerge Compound Object. You can do this either in the Compounds Toolbar or in the Command panel (Create|Geometry| Compound Objects|ShapeMerge). When the ShapeMerge panel appears, activate the Pick Shape button and click on the Ellipse. Using a wireframe or Edged Faces view, you'll see the result of projecting the spline onto the mesh. Your screen should look something like Figure 9.23.

3. Rotate the object around to note that the projection occurred only on one side. The projection is made in the negative (local) z-direction of the spline, and it affects only the faces whose normals face the projection.

4. Pull down the ShapeMerge panel to see the operation choices. The default of Merge simply works the projection of the spline into the mesh. The Cookie Cutter option removes either the area inside the projection or outside of it, depending on whether

Figure 9.22

Preparing to use ShapeMerge. A Cylinder is drawn on the groundplane, and an Ellipse is drawn in the front view. In local coordinates, the z-axis of the Ellipse is perpendicular to the plane on which it was drawn. The Ellipse is translated in local z to sit in front of the Cylinder.

Figure 9.23

The Cylinder from Figure 9.22 is selected and a ShapeMerge Compound Object is created. After picking the Ellipse as the designated shape, that spline is projected onto the mesh of the Cylinder.

Figure 9.24
Object from Figure 9.23, using the Cookie Cutter option. The region either inside or outside the projected curve is eliminated, depending on whether the Invert box is checked.

the Invert box is checked. This is identical to the way MAX uses projected curves for trimming in NURBS modeling. Figure 9.24 shows the two alternatives for the Cookie Cutter option.

5. You may have noticed that the Invert checkbox is available when the Merge option is used. The significance of this is only evident when the Output Sub-Mesh Selection options are used. These options allow you to pass the regions either inside or outside the projected curve and up the modifier stack for subsequent operations. If the Invert box is checked, the region outside the curve is passed upward. You can choose to send up Face, Edge, or Vertex selections. Test this yourself. With the Merge option on, and the Invert box left unchecked, use the Face option in the Output Sub-Mesh Selection group. Put a Mesh Select modifier on the stack above the ShapeMerge Object and go into the Face Sub-Object level. The faces in the region are already selected, as seen in Figure 9.25. Note that the segmentation of the Cylinder object at the bottom of the stack (beneath the ShapeMerge) increased from the previous illustrations, resulting in a more clearly defined shape.

Connect

The Connect Compound Object creates a bridge of edges between the vertices of two open meshes to create a single mesh. It's useful when one object must be seamlessly connected to another (for example, when an ear is connected to a head or a finger to a hand). Connecting vertices by hand can be a very difficult and tedious task, so the Connect Object is often the better alternative. And it's easy to use, as you'll see in this exercise:

1. Create a longish Box object and then pull away a copy of it so that the two Boxes are in a single line. Change the segmentation on each so that they are noticeably different.

Figure 9.25
Creating a mesh sub-selection. The region inside the projected curve is sent up the stack using the Face option in the Output Sub-Mesh Selection section of the ShapeMerge panel. A Mesh Select modifier is applied, and the selected region is immediately visible in the Face Sub-Object level.

2. Convert both Boxes to Editable Mesh objects and delete the Polygons where they face each other. This may take some careful selection work. There are now open regions in the meshes to be bridged. Your screen should look something like Figure 9.26.

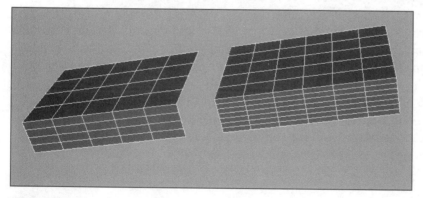

Figure 9.26
Setting up for the creation of a Connect Compound Object. Two Boxes with different segmentations are placed in a line. After converting both of them to Editable Mesh objects, the opposing faces are deleted, leaving open regions in both meshes to be bridged.

3. Select one of the objects and create a Connect Compound Object (either in the Compounds Toolbar or in the Command panel by using Create|Geometry|Compound Objects|Connect). In the Connect panel, press the Pick Operand button and click on the other Editable Mesh object. A bridge of edges now connects the vertices on both objects. Your screen should resemble Figure 9.27.

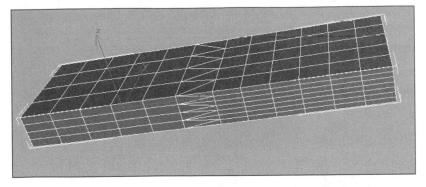

Figure 9.27
Objects from Figure 9.26, after creating the Connect Compound Object. The vertices along the open edges are now bridged with mesh to create a single, seamless mesh.

4. The bridge is still unsegmented. In other words, the vertices of the two original objects (now the Operands of the Compound Object) are directly connected by new edges. Increase the values in the Segments spinner and watch how the bridge region subdivides. The result can be very intelligent. In Figure 9.28, the Segments value is set to 2, and the Connect Object has organized the central area of the bridge region into quadrangles.

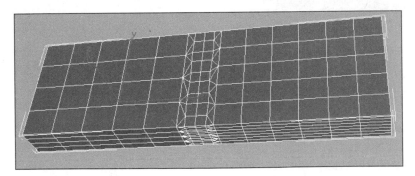

Figure 9.28
Connect Object from Figure 9.27, with the Segments spinner set to 2. Note how the interior area of the bridge region has been organized into quadrangles.

5. Press the H key to bring up the Select Objects dialog box, and note that there is only one object in the scene. As with the other Compound Objects, the two original objects become Operands of the Connect Object. To adjust the position of the Operands without taking the object apart, you can select one at the subobject level. Press the Sub-Object button to get to the Operands and then click on one of them on the screen to select it. Move it away and rotate it so that the two units meet at an angle.

6. The bridge area updates. Add some more segmentation, if necessary. The result may look a little stressed. The default Tension value is 0.5. Increase and decrease the

value (even below 0) to see the results. Notice that the Connect Compound Object is not good for building curved bridge regions. Set the Tension value to 0 to straighten out the bridge region. Your screen should look something like Figure 9.29.

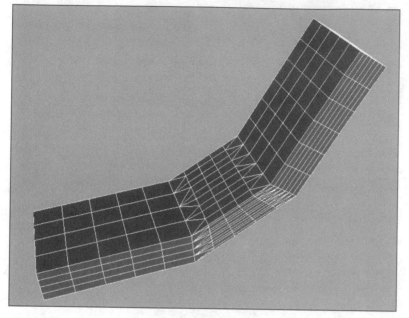

Figure 9.29
Connect Object from Figure 9.28, with one of the Operands rotated and moved so the open sections meet at an angle. The Segments value is increased to 4 and the Tension value is set to 0 to create a straight bridge region.

7. You can extract your Operands out of the Connect Object. The default Instance option permits you to edit the instance away from the Connect Object and watch the corresponding effect on the Operand in the Connect Object. The Copy option gives you an independent copy that is not connected to the Operand. Try extracting both of the Operands as copies. Now you can delete the Connect Object if you wish, and you're back where you started.

Terrain

The Terrain Compound Object is so rarely needed by most MAX users that I'll only introduce it here. Its purpose is to help to visualize elevation data generated in architectural and engineering work, and thus it is designed primarily to use input data from AutoCAD files. Try it with elevation "data" of your own, as follows:

1. Create a few Ellipses of varying sizes in a top view. Arrange them vertically so that they can represent lines of elevation, like you'd find on a topological map. Each higher spline must necessarily fit within the one beneath it. A perspective view might look something like Figure 9.30.

Figure 9.30
A series of closed splines (Ellipses) is arranged vertically to create lines of constant elevation, like you would find on a topological map. The edges of the curves must necessarily not overlap.

2. Select the lowest (and largest) curve and create a Terrain Compound Object. You can do this in the Compounds Toolbar or in the Command panel (Create|Geometry| Compound Objects|Terrain).

3. When the Terrain panel appears, use the Pick Operand button to add successively higher lines of elevation. A surface builds, but note how roughly it is constructed. Select the still-visible spline objects and hide them to see only the Terrain Object. Figure 9.31 shows a wireframe view of the Terrain Object constructed from the splines in Figure 9.30.

4. Go to a shaded preview (such as Smooth + Highlight) if you're not already in one, and move to the Modify panel for the Terrain Object. In the Form section of the panel, compare the default of Graded Surface with Graded Solid. You won't be able to tell the difference until you turn the object over. The Graded Solid option caps the bottom of the Terrain Object.

5. Change to the Layered Solid. The sloping mesh is replaced by the kind of terraces used in architectural models. See Figure 9.32.

6. Our example is artificial because of the simplicity of the curves. Real elevation curves imported from AutoCAD have a huge number of vertices and the resulting curvature of the Terrain Object is much more pronounced. In fact, imported data is likely to be too rich, and the Simplification rollout allows you to simplify it by using only a fraction of the curves or of the vertices on them. Change from No Simplification to Use 1/2 of Points to see the difference, and then return to No Simplification.

7. Color gradients can be added to make the elevations clearer. Open the Color by Elevation rollout and press the Create Defaults button to get the general idea. The surface is assigned colors that change from bottom to top.

Figure 9.31

The splines in Figure 9.30 are used to create a Terrain Compound Object. The mesh is very rough because only a few points on the splines were sampled. The splines are hidden so that the mesh will be more clearly visible in a wireframe view.

Figure 9.32

The Terrain Compound Object from Figure 9.31, viewed as a Layered Solid. This produces the kind of terraced look used in physical architectural models.

Scatter

The Scatter Compound Object creates randomly arranged arrays of objects that would be extremely tedious to produce by hand. This is one of those tools that you have to play with to understand. The Source Object can be arrayed with respect to a Distribution Object, and the single most common use of Scatter is to place numerous hairs or blades of grass on a surface. As you will see, however, many kinds of results are possible with Distribution Objects, including some that are not random at all.

Using Transforms Only

Let's experiment with the Use Transforms Only setting:

1. Create a rather tiny Box object on the groundplane. Make it small enough to leave room for a large random array.

2. With the Box selected, create a Scatter Compound Object. Use either the button in the Compounds Toolbar or the Command panel (Create|Geometry|Compound Objects|Scatter). In the Distribution section of the Scatter panel, change from the default (Use Distribution Object) to Use Transforms Only.

3. Pull down to the Source Object Parameters section and increase the number of Duplicates to 20. Nothing happens on the screen yet because the transform values have not been set.

4. You could continue in the Create panel, but let's explore further into MAX's toolset by switching to the Modify panel. Open the Transforms rollout, if necessary, and pull the spinners for Local Translation. Doing so opens a box in which the duplicates of the Source Object are randomly arrayed. Your screen should look something like Figure 9.33.

5. Add some Rotation and Scale values to the mix, as in Figure 9.34.

6. Open the Display rollout, if necessary, and reduce the Display value in the spinner from the default of 100 percent. Scatter Objects can contain a huge number of duplicates, which can bring screen interaction to a grinding halt. This spinner culls a specified percentage of duplicates for faster processing and display.

7. While you're in the rollout, press the New button in the Uniqueness section to generate a new Seed value. A new random array is generated.

8. Extract the Source Object by picking it in the box in the Objects section of the Scatter Objects rollout and pressing the Extract Operand button. You can now delete the Scatter Object, if you wish, and start over.

Figure 9.33

A small Box is used as the Source Object in a Scatter Compound Object. Twenty duplicates are created and then randomly translated with parameters set by the Local Translation spinners.

Figure 9.34

The Scatter Object from Figure 9.33, with rotation and scale parameters added. The duplicates are now randomly scaled and rotated within the limits set by the spinner values.

Using A Distribution Object

Now, let's play around with some ways you can use a Distribution Object:

1. On a fresh screen, create a small but tallish Box object on the groundplane. Then, create a much larger Sphere to serve as the Distribution Object. Figure 9.35 gives you the idea.

Figure 9.35
A small but tallish Box for the Source Object and a much larger Sphere to serve as the Distribution Object.

2. With the Box selected, create a Scatter Compound Object. When the Scatter panel appears, activate the Pick Distribution Object button and click on the Sphere. The Box jumps to the top of the Sphere.

3. Increase the number of Duplicates and watch the Box object spread out randomly on the surface of the Sphere, like hairs sticking out of a head. Your object should look something like Figure 9.36.

4. Jump to the Modify panel to continue with the same toolset. Reduce the Base Scale value from 100 percent and note that this scales down all the Duplicates together. Increase the Vector Chaos value to randomly jog the vertices of the Duplicates. When you've got the idea, set these values back to their defaults.

5. The most interesting part of the Scatter panel is the Distribution Object Parameters section. Uncheck the Perpendicular checkbox. The Duplicates are no longer rotated so that they stick out of the surface. Check the box again to restore the perpendicularity.

Figure 9.36
The Box is used to create a Scatter Object, and the Sphere is selected as the Distribution Object. As the number of Duplicates is increased, clones of the Box sprout randomly across the surface of the Sphere.

6. Try out the different Distribute Using options. Skip N can be useful; when it's first selected, the Duplicates are clustered at the top of Distribution Object, and increasing the value in the spinner spreads them out. Figure 9.37 shows this option, using a spinner value of 4.

7. The All Vertices, All Edge Midpoints, and All Face Centers options are different from the others because they disregard the specified number of duplicates and create as many as are necessary for their purposes. To improve their effects, hide the Distribution Object in the Display rollout. When you do so, you reveal only the original Sphere object from which the Distribution Object was created, so select this object and hide it by using the Display Floater or the Display panel. The three distribution options mentioned previously create impressively regular patterns that would otherwise be very difficult to construct. Figure 9.38 shows the All Edge Midpoints option with the Sphere hidden.

Morph Objects And Conform Objects

Morphing is a basic technique for deforming the geometry of an object during animation. Multiple versions of the same model are created and then edited, typically by moving the vertices or (in the case of NURBS surfaces) control vertices. The animator may then morph between these different versions by keyframing. The geometry of the model interpolates between the keyframes. For example, a character figure can be modeled with the chest in or the

Figure 9.37
Scatter Object from Figure 9.36, but with the Skip N option applied (spinner value = 4). The duplicates are clustered in a region near the top of the Distribution Object.

Figure 9.38
The All Edge Midpoints distribution option disregards the specified number of Duplicates and places clones at the midpoints of every edge on the Distribution Object. The Distribution Object and the Original sphere are both hidden.

chest out. By morphing between the two versions of the model, the character appears to breathe. Morphing is especially important in facial animation.

The Morph Compound Object is a collection of *morph targets* (as the different versions of the model are called) for keyframing in animation. Morph targets must be edited versions of the single model because the number of vertices and their order in the model file must be the same in each. This is because morphing is essentially an instruction to move specified vertices to new positions. Sometimes, it is too difficult to edit one model into drastically different morph targets. If morph targets are created as separate, independent models, the Conform Compound Object can be used to create workable targets. A Conform Compound Object "shrink-wraps" one mesh to fit another. For example, a single sphere may be conformed to the shape of two different models. This produces morphable results because the spheres were originally identical before their vertices were moved.

Morph Compound Objects have been effectively replaced in MAX 3 by the far more powerful Morpher modifier. All aspects of morphing are covered in detail in Chapter 21.

Moving On

This chapter examined the various Compound Objects in 3D Studio MAX. In each case, two or more objects are used to create a third object. The Compound Object is the result of the operation, but the objects (that is, Operands) that are combined to produce the result remain selectable and editable as subobjects within the Compound Object. The Operands can always be extracted from the Compound Object. Loft Objects and Boolean Objects are, by far, the more important species of Compound Objects for modeling purposes.

In the next chapter, you'll turn to patch modeling. In MAX, *patch modeling* means the use of surfaces created out of Bezier patches. These are triangles and quadrangles, in which the vertices are connected by Bezier curves rather than straight-line segments. Patch modeling has become much more important and exciting in MAX 3, and many longtime MAX users who never felt the need to master the subject will want to take a fresh look.

PATCH MODELING

Bezier patches are something in between NURBS surfaces and polygonal meshes. They have the smooth curvature of the former and the easy, intuitive feel of the latter.

Bezier patches, which appeared in the very first version of MAX, were the program's first essay into true spline modeling. The common attitude was that they were merely a stopgap measure until Kinitex could implement NURBS (Non-Uniform B-Spline) surface modeling. A great many MAX users never took patch modeling seriously—they might use a Bezier patch to simulate mountainous terrain, but they didn't get around to real organic modeling. Bezier patch modeling was perceived of as clumsy, and many thought it would be certainly pushed aside when NURBS arrived.

To the surprise of a great many people, Bezier patch modeling is more alive than ever in MAX 3. With new tools and a better general interface for patch modeling, Bezier patches are attracting serious attention for organic modeling.

Understanding Bezier Patches

The Bezier patch is a funny creature—a centaur mix of splines and polygons. The easiest way to think of a patch is as a kind of flexible polygon. Imagine a triangle or quadrangle with its vertices connected by Bezier curves instead of straight-line segments, and you have the idea. Just as with regular Bezier curves, the shape of the spline is governed by the length and direction of the tangent handles that are associated with each vertex. The MAX interface calls the Bezier tangent handles *vector handles* (or just *vectors*), so I use all these words interchangeably. The vector is tangent to the curve at the location of the vertex.

Familiarize yourself with Bezier patches by working through the following introductory exercises.

The Quad Patch

Let's experiment with one type of Bezier patch—the Quad Patch—now:

1. Create a Quad Patch in a front view. You can do this in the Command panel by using Create|Geometry|Patch Grids|Quad Patch, but it's faster to use the Quad Patch icon in the Objects toolbar. In either case, draw out a rectangular shape in the

viewport; and then adjust the dimensions, if necessary, with the Length and Width spinners in the panel that appears.

2. Your Quad Patch is subdivided into a 6×6 grid. Create another Quad Patch next to the first, with similar dimensions, but increase the Length Segs (Segments) spinner to 2. This grid is now 12×6. Your front view should look like Figure 10.1.

Figure 10.1

Two Quad Patches are created in the front view. At left, the default segmentation values produce a 6x6 grid. At right, the Length Segments value is increased from 1 to 2, and the resulting grid is 12x6.

3. Consider these grids in two ways—as Bezier patches and as polygonal meshes. Select each of the grids in turn and use the right-click menu to access the Object Properties dialog box. Check the face count. The patch on the left is composed of 72 triangular faces, and the one on the right has 144 triangular faces. Because there are two triangles in each quadrangle, it's easy to understand that the patch on the left is ultimately a mesh of 36 quad polygons. The one on the right is likewise a mesh of 72 quad polygons. The grid shows you the quad polygon structure of each patch object.

4. To understand the objects from a Bezier patch perspective, convert each of them to Editable Patch objects by using the right-click menu. The Editable Patch panel allows you to work in three subobject levels: Vertex, Edge, and Patch. This structure is very similar to that found in the Editable Mesh panel. Go to the Patch Sub-Object level by using the Sub-Object button and drop-down box, or by choosing the three icons immediately below them. Click on the grid to determine how many patches it has. The one on the left is only a single patch, but the grid on the right is composed of two patches, arranged vertically. Figure 10.2 shows the upper patch selected in the object on the right.

5. Note that each of the individual patches is a 6×6 grid of quad polygons. There is only one such grid in the object on the left and two in the one on the right. From all

Figure 10.2
The objects from Figure 10.1 are converted to Editable Patch objects to examine them as Bezier patches. In the Patch Sub-Object level, only the upper of two patches is selected in the object on the right. The object on the left is composed of only one patch.

this, you can gather that the Segmentation spinners in the Create panel divide the object into multiple patches, each with a like number of quad polygons.

6. With the upper patch selected, as in Figure 10.2, pull the panel down to the Surface section, where you'll find the Steps spinners. Steps are determined separately for viewport and rendering purposes (an easy thing to forget at render time), and both levels are set to the default of 5. Change the value in the View Steps spinner and watch what happens. The polygonal density of the entire grid changes, and not just within the selected patch. The number of Steps is the number of interior lines dividing the grid; it is therefore always one fewer than the number of rows or columns. That is why the default value of 5 Steps results in a 6×6 grid for each patch. See Figure 10.3.

7. To understand the Steps concept more clearly, uncheck the box titled Show Interior Edges. Only the exterior edges—those bordering each patch—will be visible. Change to the Vertex Sub-Object level and note the vertices at the corners of each patch. Select the bottom-left vertex on the lower patch.

8. Two perpendicular vector (tangent) handles appear. Tilt the one along the bottom edge upward a bit. Change to the Move mode by using the right-click menu. The Transform Gizmo appears on top of the selected vertex. It can be difficult to translate the vector handles if they are covered by one of the axes of the Transform Gizmo. If necessary, use the – (minus) key to shrink the gizmo and get it out of the way. Then, move the vector handle up to put some curvature in the bottom edge.

9. It's now evident that the edges are Bezier curves. Change the Step value again to see how it affects the curve resolution. In Figure 10.4, the Steps value is set to 4. This is too low a resolution for this much curvature, and the five linear segments in the curve are clearly visible.

Figure 10.3

Same as Figure 10.2, but with the Steps value decreased to 1 for the Editable Patch object on the right. There are two patches in this object, and each is now a 2x2 grid of quad polygons. Note how the Steps value affects the whole object, even though only the upper patch was selected. The object on the left uses the default Steps value of 5, producing the default 6x6 grid. The number of Steps is always one unit fewer than the number of rows or columns in the grid.

Figure 10.4

Object from right side of Figure 10.3, with interior edges hidden. Only the edges bordering each patch are visible. The vertex at the bottom-left corner is selected and the vector handle along the bottom edge is translated up to generate some curvature in the Bezier spline. With a Steps value of only 4, the five linear segments in the spline are clearly distinguishable. This is insufficient resolution for a high-quality render.

The Tri Patch

How does a Tri Patch differ from a Quad Patch? Let's find out:

1. Use Reset to start over with a fresh screen, if necessary, and draw out a Tri Patch in a front view. The creation tools for Tri Patches are found in the same place as for Quad Patches. Note that there are still Length and Width creation parameters in the panel, but the segmentation parameters are missing. The object you create is a four-sided grid, but there are a couple of obvious differences from the Quad Patch. First, the grid is composed of triangles rather then quadrangles. Second, the grid lines look a little sloppy and are not precisely parallel. See Figure 10.5.

Figure 10.5
A Tri Patch created in the front view. This object is four-sided, like a Quad Patch, but two differences are evident. The grid is composed of triangles rather than quadrangles, and the edges of these faces are not precisely parallel.

2. Convert the object to an Editable Patch by using the right-click menu. Go to the Patch Sub-Object level and click on the object. You discover that it's made of two triangular patches that meet along a central diagonal edge. Delete one of the patches to understand what a single Tri Patch looks like. Figure 10.6 shows one of the two triangular patches, which is selected and then deleted.

3. Play with the Steps spinner to see how a Tri Patch is tessellated. The concept is the same as with the Quad Patch, in that each of the edges (each Bezier curve) is divided into the specified number of equal segments. The resulting polygonal mesh is much harder to read, however, which makes Tri Patches generally more difficult to work with than Quad Patches. Just as in regular organic polygonal mesh modeling, a quadrangular structure is preferable to triangles whenever possible. Figure 10.7 shows a

Figure 10.6

The Tri Patch object from Figure 10.5 is converted to an Editable Patch object. Using the Patch Sub-Object level, you see that it's composed of two triangular patches that share a common diagonal edge. The upper-right patch is selected in the object on the left, and it is deleted in the object on the right.

Figure 10.7

A single Tri Patch, with different degrees of tessellation. The object on the left uses a Step value of 1. Each edge is divided in half and interior edges connect these vertices. The object on the right illustrates a Step value of 9. Note the curvature of the interior edges. Tri Patch geometry is much more difficult to read than Quad Patches.

Tri Patch with a Step value of 1 (on the left) and with a value of 9 (on the right). Note the confusing curvature of the interior edges in the more tessellated version.

Building With Patches

Now that you have a sense of what Bezier patches are, you can start working with them in the following exercises.

Adding Patches Together

Follow these steps to add patches:

1. Reset your scene if necessary, and create a Quad Patch in a front view and convert it to an Editable Patch. The Editable Patch is a new object in MAX 3. Formerly, it was necessary to apply an Edit Patch modifier to perform patch modeling or to convert polygonal objects into Bezier patch geometry. With the arrival of the Editable Patch object, you rarely need to use Edit patch.

2. Uncheck the Show Interior Edges box so that only the exterior edges are visible. In the Edge Sub-Object level, select the edge on the right. Use the right-click menu to add a Quad Patch. You can use the Add Quad button on the Editable Patch panel as well. A new Quad Patch is added on the right side of the original one. Your screen should look like Figure 10.8.

Figure 10.8
Adding a Quad Patch. A single Quad Patch is created and converted to an Editable Patch object. With the interior edges hidden, the edge on the right side is selected. The Add Quad command in the right-click menu adds an adjoining Quad Patch on the right side of the original.

USE THE RIGHT-CLICK MENUS

The greatly expanded use of right-click menus in MAX 3 is a fantastic time-saver, but these menus are especially valuable with Editable Patch objects. One of the most attractive features of patch modeling is the power of such a small toolset. Just compare the number of buttons on the Editable Patch panel with the number on the Editable Mesh or (even worse!) NURBS, and you'll breathe a sigh of relief. With Bezier patches, you take just a few tools and use them creatively. As a consequence, everything you need fits on the right-click menu and workflow becomes more intuitive. You rarely have to use the Editable Patch panel.

3. Select the two edges on the bottom together and use the Add Quad command on this multiple selection. You now have four patches, arranged in a 2×2 square. Change to the Vertex Sub-Object level and select the vertex in the middle of the bottom row of edges by dragging a small rectangle around it, ensuring that all vertices that occupy the same location are selected. The panel indicates that only one vertex is selected—it indicates the number of the selected vertex—but there can be more than one, as you will see in a moment.

4. Undo to eliminate the lower row of patches and add the lower patches, one at a time. In other words, select one bottom edge and use Add Quad, and then select the other edge and use Add Quad again. Change to the Vertex Sub-Object level and drag a rectangle around the middle vertex on the bottom row of edges. This time, the panel indicates that two vertices are selected. Your screen should look like Figure 10.9.

Figure 10.9
Object from Figure 10.8, with two patches added on the bottom. Each patch was added separately, so there are two separate vertices in the middle of the bottom row of edges. If the two patches were added together, by selecting both edges at once when applying the Add Quad command, there would be only a single vertex at that spot.

5. Click on the spot to select only a single vertex. (Check the panel to make sure that you've got only one.) Move that vertex and, as you'd expect, the two patches rip apart. Undo to get the two vertices back on top of each other. Click on the vertex again to select the other vertex and you'll see the vector handles change direction. Each vertex is associated with only one of the two adjacent patches. Move the upward-pointing vector over to the side. You probably need to shrink the Transform Gizmo (with the minus key) to get it out of the way. As you can see in Figure 10.10, there are two independent edges, and each can have its own curvature.

Figure 10.10
Object from Figure 10.9, with only the vertex for the left patch selected. The upward-pointing tangent handle is translated to demonstrate that the two added patches have independent edges. It was necessary to shrink the Transform Gizmo to get it out of the way of the vector handles.

6. Zip these patches up. Drag a rectangle to select both vertices; you'll see four distinct vectors—two for each patch. Use the Weld command on the right-click menu or the Editable Patch panel. Voila! There is now only one vertex (with three vectors) and only one common edge between the two patches. The object is now seamless. Your screen should look something like Figure 10.11.

Coplanar And Corner Vertices

Let's continue our exercise by exploring the difference between Coplanar and Corner vertices:

7. Move the center vector so that it's pointing straight up and all four patches are square. Drag a rectangle around the vertex in the center of the object, at the point where all four patches meet. Confirm that there is only one vertex here, and note the four vector handles. With the vertex selected, bring up the right-click menu and note the two types of patch vertices: Coplanar and Corner. Coplanar is currently checked. What does this mean?

8. Check the box to display your interior edges again, and use a perspective view. Move any of the vector handles into or away from the mesh. Note that all four handles remained locked together, so moving any one of them will move them all. All four handles are on a single plane, and they remain so when any one of them is moved. In effect, the handles were rotated as a unit around the vertex. When opposing handles for a vertex on a Bezier curve line up in a straight line

Figure 10.11
Object from Figure 10.10, after welding the two vertices in the center of the bottom row of edges. There is now only one vertex (with three vectors) and only one common edge between the two patches. The object is now seamless.

(are *collinear*), the curvature is smooth through that vertex. In the same way, curvature is smooth in all directions when the vector handles of patch vertices are Coplanar. Coplanar vertices are the keys to creating seamless Bezier patch surfaces. Figure 10.12 illustrates the smooth curvature through the center vertex after the handles are moved.

9. You may notice that the vector handles respond to translation in two different ways. If you move a handle in any direction other than in its own line, all four handles effectively rotate around the vertex. If you translate a handle in the direction of its tangent vector, the vector simply becomes longer or shorter, without moving any other handles. These two kinds of control—over both the length and direction of Bezier handles—are the same as for 2D Bezier splines. Figure 10.13 illustrates the effect of pulling out a vector handle.

10. Right-click on the selected vertex and change it to a Corner type. You can move each handle separately; the vectors no longer remain coplanar. See Figure 10.14.

11. Check the Lock Handles box on the Editable Patch panel. If you move any of the handles, they all move as a rigid unit, even though they are no longer Coplanar.

12. Finally, change the vertex back to the Coplanar type. Watch how all the vector handles jump into a single plane.

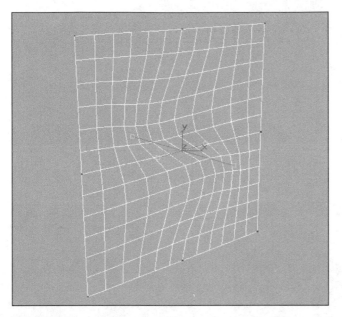

Figure 10.12
The object from Figure 10.11, with its edges straightened out and its interior edges revealed. The vertex in the center is selected and its handles are moved. Because this is a Coplanar vertex, all the handles move together so that they stay in a single plane. By keeping the vectors in a common plane, the curvature through the vertex remains unbroken.

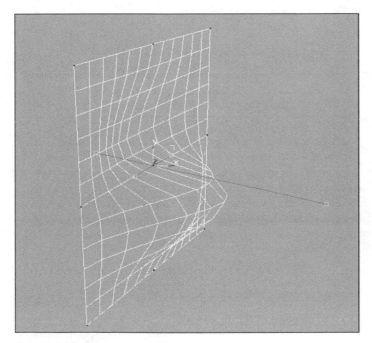

Figure 10.13
Same as Figure 10.12, but with one of the vector handles drawn out in the direction of its own tangent vector. Just as with all Bezier curves, this increases the effect of the curvature in that direction.

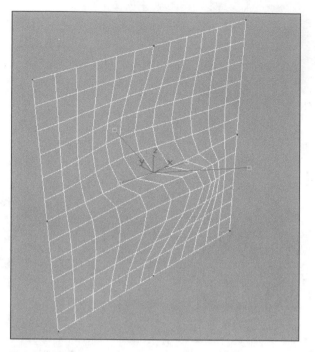

Figure 10.14
Same as Figure 10.13, but with the vertex changed from the Coplanar to the Corner type. One of the handles was moved up, without affecting the others. The handles are no longer constrained to lie on a single plane, allowing sharp changes to the direction.

MANIPULATING VECTOR HANDLES CAN BE TOUGH WORK

The hardest thing to master in Bezier patch modeling is the manipulation of the vector handles. Bezier handles are great on a 2D plane, but can be very difficult to control in 3D space. It's hard to figure out which way they are pointed and how long they are without rotating a perspective view.

The Transform Gizmo, which is such a boon when transforming vertices, is a definite interference when moving vector handles. As I mentioned before, you often have to shrink the Transform Gizmo to get it out of the way. Get used to using the keyboard shortcuts to change the directional constraints when moving vectors. F5, F6, and F7 are x, y, and z, respectively; F8 toggles between xy, yz, and xz. I tend to keep my left hand over these keys while my right hand operates the mouse. Another useful idea is to use the screen coordinate system in a perspective view. That way, you can stay in the xy constraint and move points parallel to the surface of the screen. This requires rotating your view very often, however.

The filters on the Editable Patch panel are very important. If both the Vertices and Vectors boxes are checked, you can transform both vertices and vector handles. If only one is checked, the other type of object is invisible to the mouse cursor. You should often check the Vectors filter to make sure that you don't accidentally move the vertex when you want to move only its handles. Then, when you try to select another vertex, you have to remember to check the Vertices box again.

Subdividing Patches And Binding Vertices To Edges

On a fresh screen:

1. Create a square Quad Patch in a front view, 100 units in Length and 100 in Width. Convert the object to an Editable Patch, and hide the interior edges.

2. Select all four edges in the Edge Sub-Object level by dragging a rectangle around the patch. Use Add Quad to create a "t" of five patches. Your screen should look like Figure 10.15.

Figure 10.15
A square Quad Patch was converted to an Editable Patch object. All four edges are selected and Add Quad is applied to create four surrounding patches. The interior edges are hidden.

3. Go to the Patch Sub-Object level and select the central patch. Press the Subdivide button. The central patch is divided into four patches, but because the Propagate box is checked by default, the new edges continue through the adjacent patches to divide them as well. See Figure 10.16.

4. Undo back to before the Subdivide step, and try Step 3 again with the Propagate box unchecked. The subdivision is now confined to the selected patch, but this creates discontinuities in the geometry. Go to the Vertex Sub-Object level and select one of the new vertices. There are only three handles, and none extend over the edge into the adjoining patch. Move the vertex you've selected to see the discontinuity. Your screen might look like Figure 10.17.

5. Now, get ready for something fantastic—something that gives MAX's patch modeling a real *edge*. (The pun will be obvious in a moment.) One of the biggest issues in

Figure 10.16
Same as Figure 10.15, but with the central patch selected and subdivided. Because the Propagate box is checked by default, the new edges are continued through the adjacent patches, to divide them as well.

Figure 10.17
By unchecking the Propagate box, the subdivision is confined to the selected patch. This creates discontinuities in the geometry, however, because the new vertices are not shared by the adjoining patches. Translating one of these vertices reveals that the geometry is no longer seamless.

modeling is how to create local detail in a restricted area, without increasing the resolution of the entire mesh. In this case, for example, you needed an additional vertex in the center of the central patch, but didn't necessarily want to subdivide the whole object to do it. With vertex binding, you can have it all. Activate the Bind button and drag from the new (translated) vertex to the corresponding edge on the adjacent patch. The gap in the geometry magically closes, as shown in Figure 10.18.

Figure 10.18
The new vertex that was translated in Figure 10.17 is bound to the adjacent edge. The geometry is now seamless.

6. The bound vertex is different from all the others, as you can tell from its black color. First of all, it cannot be moved directly—it moves only when the shape of the edge to which it is bound is changed. Check this out by getting out of Bind mode and selecting one of the vertices on the edge. Translate a vector handle to bulge out the curve. The bound vertex stays on the edge. You screen might look like Figure 10.19.

7. Zoom in on the bulging edge. The segmentation of the adjoining edges doesn't match up. This makes sense. The whole object, as you've learned, uses a single Steps value. On the left side, there are two patches, so each of its two edges is divided into six segments. On the right side, there is only one patch, so its single edge is divided into six segments. There are, therefore, twice as many segments on the right side as on the left. The close-up view in Figure 10.20 shows the problem.

8. If you render this view, however, the result is seamless. A wireframe render (use the Force Wireframe option in the Render Scene dialog box) shows how the two edges are merged into a single one. Take a look at Figure 10.21.

Figure 10.19
The bound vertex from Figure 10.18 is tested. The lower vertex on the edge to which it was bound is selected and its vector handles are translated to put curvature into the edge. The bound vertex sticks to the bulging edge.

Figure 10.20
A close-up view of the object in Figure 10.19 reveals the different segmentation of the adjoining edges. The two edges on the subdivided patch have twice as many total segments as the single edge to which the vertex was bound.

Figure 10.21
The object from Figure 10.20 renders seamlessly. A wireframe render shows that only a single edge is rendered. In a regular shaded render, the result is smooth and without gaps.

9. Try increasing the Render Steps value to get a smoother result. Check it out in a wireframe render.

It's important to understand the reason for this seamless result. A low-end renderer must input a polygonal mesh, so all spline-based objects are tessellated into polygons before they are handed to the renderer. A high-end renderer, such as that found in 3D Studio MAX, can receive spline-based objects directly, however. It both tessellates and reconstructs the mesh in the rendering process. An important part of the geometry work done by the renderer is to rebuild the edges on adjoining curved surfaces so that they are stitched together into a seamless mesh. This process can work only if the adjoining edges are close enough to each other to begin with. The vertex binding tool keeps the edges together so that the renderer can merge their meshes. This subject of the tessellation of curved surfaces and the merging of edges is especially important in NURBS modeling, and will be addressed in greater detail in the next chapter.

Extruding Patches

Patches can be extruded, much like Polygons on an Editable Mesh. There are also differences, however, which are attributable to the fact that the edges of patches are Bezier splines. Explore the possibilities by following these steps:

1. Create a square Quad Patch in a front view by using Length=100 and Width=100. Set the Length Segs to 3 and the Width Segs to 3. This creates a grid of nine patches.

2. Convert the object to an Editable Patch by using the right-click menu and hide the interior edges. You should have a tic-tac-toe board in your front view.

3. Turn the central patch into a circular one. In the Vertex Sub-Object level, select one of its four vertices. Using the right-click menu, convert the vertex from the Coplanar type to the Corner type. Now, you can tilt the vertex handles to create curved edges. Do this with all four vertices and move the appropriate tangent handles until your object looks like Figure 10.22.

Figure 10.22

An Editable Patch object, composed of nine Bezier patches. The vertices around the central patch are converted from the Coplanar to the Corner type, and the tangent handles are translated to create curved edges. The central patch is now circular. Note that the tangent handles defining the curve are collinear.

4. Work in a perspective view so that it's easier to see extrusions into 3D space. Hide the groundplane to make things easier to see. Right-click on the word "Perspective" in the upper-left corner of the viewport and toggle the Show Grid command. (I find it very distracting to work with patch or NURBS objects with a grid in the background.)

5. Go to the Patch Sub-Object level and select the circular patch. You can extrude either by activating the Extrude or Bevel button and dragging on the screen, or by using the Extrusion and Outlining spinners. For now, let's get an idea of how the spinners work. Pull the Extrusion spinner up to a value of 50 to extrude out the selected patch. Note that the spinner value returns to 0 when the extrusion is complete.

6. With the extruded patch still selected, drag the Outlining spinner down (into negative values) to scale the patch inward. Note the curvature in the extruded edges. To see the surface better, show your interior edges and increase the View Steps value. Your object should resemble Figure 10.23.

Figure 10.23
The object from Figure 10.22 with the central patch extruded and then scaled inward with the Outlining spinner. The interior faces are made visible and the View Steps value is increased to see the curvature better.

7. The curvature in the sides of the extruded patch is determined by the options in the Bevel Smoothing section of the panel. By default, both the Start and End are set to Smooth. If you're thinking about using this extrusion for an arm, you might get a better result by changing this setting. Undo to back before the extrusion and change the End option from Smooth to None.

8. This time, work interactively. Activate the Bevel button on the panel. The Bevel mode permits you to extrude and scale together. Drag on the selected patch to extrude it out as before. After you release the mouse button, you can move the mouse

THE MIRACLE OF EXTRUSION IN PATCH MODELING

Anyone with the slightest interest in organic character modeling will take a moment to enjoy the view in Figure 10.23. The debate in organic character work today is between smoothed polygonal cages and NURBS. NURBS are naturally smooth, so they are ideal for organic work, but, by their very nature, it's difficult to create branching architecture. You can't just extrude an arm from a torso or a finger from a hand in a NURBS surface the way that you can with polygons. That's why the use of polygonal mesh cages with MeshSmooth remains such an important organic character-modeling method.

With the addition of extrusion to the Bezier patch modeling toolset, a whole new vista opens up. You can build branching architecture with the simplicity of extrusion, yet work directly with seamless curved surfaces. Bezier patches stand just between polygons and NURBS; for many modelers and for many modeling projects, they are the ideal option.

to scale the patch. Scale the extruded patch slightly inward, and then click to complete the process. Notice the difference in curvature between the start of the extrusion and the end. Figure 10.24 shows the result, with the interior edges visible and with a denser mesh resolution.

Figure 10.24
Same as Figure 10.23, but with the Bevel Smoothing set to None for the end of the extrusion. This result might be useful for building out a character limb, such as an arm.

Creating A Torso

Now that I've laid the groundwork, let's explore the Bezier patch toolset in a practical context. Like all areas of modeling, patch modeling cannot be taught on a "paint-by-numbers" approach. There is no single sequence, and each modeler works in a different way. Use this exercise to help you get started and for basic guidance. Then, start doing things your own way. It takes awhile to get comfortable with the process of the moving patch vertices and vector handles in 3D space, but the effort is well worth it.

The Basic Architecture

All modeling begins with a conception of the basic architecture of the model. An artist must work from the general to the specific or risk getting stuck in a corner. Throughout this exercise, you'll be concerned with creating a basic shape while the structure is still simple and adding geometry only as necessary:

1. You'll model only one-half of the torso and mirror it as you work to see the whole. It makes sense to define the curvature around the side of the torso first. Because you

want the torso to face front, create a 100×100 Quad Patch in the Left view to start the side. Give it 1 segment in Length and 3 segments in Width.

2. Convert the object to an Editable Patch and hide the interior edges. You should see a grid of three patches across. Now, start pulling vertices. Go to the Vertex Sub-Object level and, in a top view, drag a rectangle around the vertex at one end. Check the panel to make sure that two vertices are selected, and note in a left view that you've selected the vertices at the top and bottom of one side of the object. Hold down the Control key and select the two vertices at the top and bottom of the other side. You should now have the four corners of the object selected.

3. Move the selected vertices to the right in a top view to create a curved surface around the side of the torso. At this point, your top view should look something like Figure 10.25.

Figure 10.25
A Quad Patch is drawn in a left view and divided into three Width segments. After conversion to an Editable Patch object, the four vertices at the corners of the object are selected and moved in a top view to create a curved surface for the side of the torso.

4. Now, it's time to correct the curvature by moving the vector handles. Drag a rectangle around the entire object to select all of the vertices. A big part of adjusting vector handles is to keep the Transform Gizmo out of the way. Try the Use Selection Center option to create a single gizmo in the middle of the selected vertices. (This option is the middle of the three drop-down buttons, immediately to the right of the coordinate system drop-down box on the Main Toolbar.) In a top view, move the handles to create a nice curve. Note that there are two sets of handles to align at each location in a top view. Note also that the handles in both directions from a vertex are locked. This is because they are Coplanar vertices. Confirm this in the

Figure 10.26

Object from Figure 10.25, with all vertices selected and Use Selection Center selected on the Main Toolbar to get the Transform Gizmo out of the way. Vector handles are translated in a top view to create the proper curvature for the side of the torso.

right-click menu. Adjust all the handles until your top view looks close to that shown in Figure 10.26.

5. The surfaces you've created thus far are the side of the torso beneath the arm. Add the patches for the shoulder area. In a left view (facing the object), go to the Edge Sub-Object level and select all three edges along the top of the object. Use Add Quad to extend the surface upward. Select the vertices at the top of the object, and then move them down so that the upper row of patches is about one-half as tall as the lower row.

6. Select the middle of the three edges along the top and use Add Quad again. Select all the vertices in the object and check the number indicated in the panel. If this number is greater than 14, you need to look for unwelded vertices and then weld them. Your left view should look like Figure 10.27.

7. The top patch is the top of the shoulder. We need to weld each vertex at the top corner of this "flap" to the vertex at the corner of the row of patches below it. When two vertices are welded in the Editable Patch panel, the new single vertex is positioned midway between them. It may make sense to move the vertices on the flap closer to the vertices on the row beneath before you weld. But why not see how things work out with the vertices in their present location? Use a perspective view and select a pair of vertices to be welded. Your screen should look like Figure 10.28.

8. Pressing the Weld button on the Editable Patch panel probably won't do anything because the default distance threshold value is very small. Increase the value in the spinner next to the Weld button until the welding works. Select the pair of vertices on the other side and weld them together as well.

Figure 10.27
Object from Figure 10.26 in a left view. A second row of Quad Patches is added above the original row, and the height of the new row is adjusted to about one-half that of the lower row. Another patch is added at the top center.

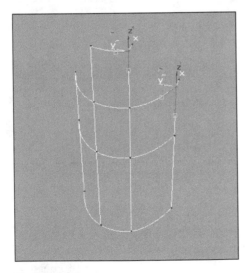

Figure 10.28
A perspective view of the object from Figure 10.27, with a pair of vertices selected for welding. The weld will join the two vertices at a point midway between them.

9. Now, it's time to move vertices and vector handles to clean up the result. Jump back and forth between a wireframe view and a shaded view with Edged Faces to understand what you're doing. I like working in a perspective view, if possible. A great technique is to drag off a clone of the object and make it an instance. Rotate the

instance so that you have two views of the same object. You can work on either one, and both objects remain identical. Take some time getting your object to look like the one in Figure 10.29. Remember to use the Vertices and Vectors filters, and remember to put the Vertex filter back on when you want to select new vertices. This step should take some time to accomplish well.

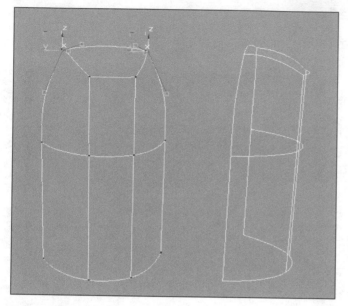

Figure 10.29
After welding both pairs of vertices, the vertices and vector handles around the shoulder area are carefully adjusted to achieve a clean, clear result. An instance of the object is created and rotated to permit two views of the object at once. This makes the effect of vertex and vector adjustments much easier to see without having to constantly rotate the view.

Extruding The Arm

Before you build out the arm, adjust your proportions. It's difficult to gauge proportions when using only one-half of the torso, so you'll mirror it:

10. To set up for mirroring, go to a front view and move the object until the centerline is aligned to the world z-axis. Move the pivot point of the object precisely to the centerline by using the Move Transform Type-In (right-click on the Move button) and setting the x value to 0 in the Absolute World column. It doesn't hurt to get all the centerline vertices lined up, as well. In the Vertex Sub-Object level, select all the vertices on the *centerline*, meaning the vertical column where the two mirrored halves will meet at the spine of the character. You'll be scaling these vertices in the world x-direction to make sure they are all precisely in a vertical line. Select Use Selection Center from the Main Toolbar to set the pivot point correctly between all the selected vertices. Get into Non-Uniform Scale mode. Then, in world coordinates, use the Scale Transform Type-In to scale the vertices to a 0 value. Once the

vertices are lined up, they can be translated to get to x = 0. It's not critical that you achieve all these steps perfectly right now, but give it a try. This scaling technique comes up again and again, so it's worth learning. Your front view should look like Figure 10.30.

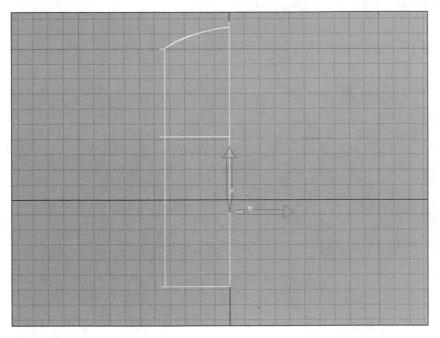

Figure 10.30
The centerline of the object is aligned to the z-axis in a front view. The pivot point is moved to the centerline and all vertices on the centerline are aligned, using a nonuniform scale. This is the ideal setup for mirroring.

11. In a front view, mirror the object on the x-axis, and make the mirrored clone an instance. Now, start making adjustments to get this armless trunk into shape. This is going to take a lot of work, so save your file before you start so you can return to it if necessary. You'll move and scale vertices and moving handles all over the place. You'll quickly notice some of the peculiarity of Bezier surfaces. Moving vertices often create creases because the tangent vector directions don't make sense in the new positions. So, you have to constantly move vertices and then adjust their handles. You may have to bounce back and forth between Coplanar and Corner vertex types to properly manipulate handles. Scaling multiple selected vertices as a group is a useful technique because it tends to keep the surface smooth. If scaling pulls vertices off the centerline, just move them back. It takes a long time to get to something that looks like Figure 10.31, but the skills you're learning are invaluable.

12. Select the four vertices around the patch from which the arm will be extruded and convert them all to the Corner type, if necessary. That way, you can adjust their handles to curve the edges of the patch. Make the patch fairly round and scale it down if the "arm hole" is too big. After you finish, convert the vertices back to Coplanar and see how the surface smoothes out.

Figure 10.31

After the object in Figure 10.30 is mirrored as an instance, all of the vertices and vector handles are carefully edited to produce a trunk with satisfactory proportions. A shaded view with Edged Faces is invaluable for editing Bezier patch surfaces.

13. Select the circular patch and bevel out a short stump, about halfway to the elbow. Experiment with different options for Bevel Smoothing, but end up with None at both Start and End. Once again, get back in there, and start moving vertices and vector handles to improve the contours. Even though you converted the vertices around the extruded patch to Coplanar, they are returned to the Corner type after the extrusion. When you finish adjusting handles around the base of the arm, convert the vertices back to Coplanar, but leave the vertices at the stump of the arm as Corner type. After some editing, your torso might look like Figure 10.32.

Subdivision For Local Detail

This is about as far as you can go with the edges you have. To add a head, you need a place for the neck to be extruded from:

14. Select the edge on top of the shoulder and press the Subdivide button. It doesn't matter whether the Propagate box is checked in this case. Two edges are created across the top of each half of the model.

15. The hole for the neck requires continuity between edges on both halves of the model. So, you have to merge both halves into a single unit before you continue. Use the Attach button to attach the instanced half and get out of the Attach mode. Then, in the Vertex Sub-Object level, select all the vertices on the centerline, except

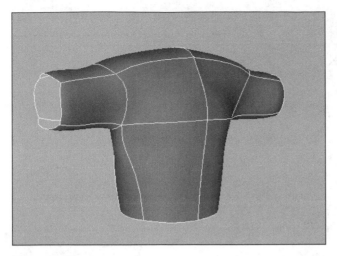

Figure 10.32
After rounding out the edges of the "arm" patch, the patch is beveled out to about mid-forearm. Bevel Smoothing is set to None for both Start and End. After the extrusions, many vertices and vector handles are edited to improve the contours. The patch at the end of the arm stump is hidden for clarity. Don't delete this patch if you want to make further extrusions.

the pair on the very top. The panel should tell you that 12 vertices are selected. Perform a Weld at a small threshold distance to merge the vertices to a total of six.

16. Scale the two unwelded vertices at the top apart, to open a hole for the neck. Start moving vertices and vector handles around the neck hole to create a clean shape. This is tough work, where you earn some spurs in patch modeling. You have to jump back and forth quite a bit between Coplanar and Corner vertex types. You need the Corner type to move the vector handles freely, but you have to return to the Coplanar type periodically to see the result smoothed out. Take advantage of the new vertices on the shoulder to improve the contours there. After a lot of experimentation, you should be able to produce a result similar to the one in Figure 10.33.

17. Once the neck hole is opened up, you can go back to working in halves. In the Patch Sub-Object level, select the patches on one-half of the torso and delete them. Then, mirror the object as an instance, as you did before.

18. Now comes the reward of all your efforts. Save the file in this state so that you can return to it, and then start to carefully add new vertices by selecting edges and using the Subdivide command. These new vertices allow you to craft more subtle contours. All of your developing skills for transforming vertices and tangent handles come into play here. One technique that really helps is to use the Transform Type-In dialog boxes to move and scale selected vertices (this technique doesn't work for vector handles). With one or more vertices selected, call up the required Type-Ins, and click on the spinners to easily and precisely transform them. This is a lot better than dragging the vertices on the screen. After a little while, you have a much better-looking torso. Use Figure 10.34 as a guide.

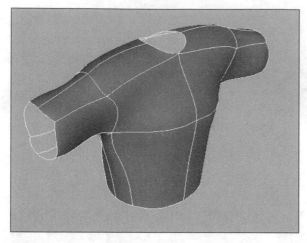

Figure 10.33

A new row of edges is added along the top by selecting the edge across the shoulder and using the Subdivide command. The two instanced halves are attached to create a single patch object, and all of the vertices on the centerline are welded together, except for the pair at the top. This pair is scaled outward to open a hole for the neck. Considerable editing of the vertices and vectors around the neck results in a clean opening.

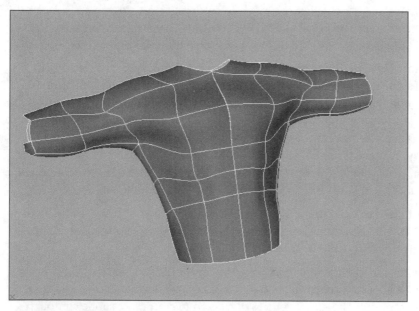

Figure 10.34

By the careful addition of more segmentation, the contours of the model can be defined with much greater precision. The new edges were added by selecting edges and using the Subdivide command. The additional vertices and their tangent handles provide control of localized surface areas.

Modeling With Spline Networks

When you look at a Bezier patch object in a wireframe view with the interior edges hidden, all you see is a spline cage. A *spline cage* is a network of splines that describes a surface. The vertices on the splines intersect, and the web created by these intersections defines the separate patches. MAX 3 added a set of Surface Tools that were formerly available only as plug-ins. These tools allow you to create Bezier patch objects from spline cages built from Bezier splines.

The Surface modifier is placed on top of a spline cage object. Wherever it finds three- or four-sided closed units, it creates a Bezier patch, and it welds coincident vertices between patches. The CrossSection modifier assists in creating spline cages by bridging between splines. There is undoubtedly great flexibility inherent in this approach to patch modeling, but not everyone will find it easy to do. Building and editing spline cages requires a strong understanding of the Editable Spline (or Edit Spline) toolset. In fact, these toolsets were expanded in MAX 3, primarily to provide features appropriate for building spline cages. (There's even vertex binding.) The basic concept is to connect vertices between splines in a single Editable Spline object. You refine existing splines to add additional vertices and use the snap tools to draw new splines that connect these vertices. You can't weld the coincident vertices, however. The process takes a fair amount of practice and experimentation.

The Torso Again

Let's get started with spline cages by using the torso from the previous section:

1. The first curve will be the waist of the object. As usual, you're only modeling one-half of a bilaterally symmetrical object. In a top view, draw a Line object to define this shape, using smooth vertices. Use four vertices. The first and last will be on the centerline and the middle two will define the curvature around the side. The distances between the vertices will determine the size of the patches. After drawing, convert the Line object to an Editable Spline. Use the Move Transform Type-In dialog box to position the first and last vertices exactly on the centerline (x=0). Then, move the pivot point of the object to the centerline, as well. Also, use the Display panel or the Display Floater to turn on Vertex Ticks. When you're finished, your top view should look like Figure 10.35.

2. In the Spline Sub-Object level of the Editable Spline panel, select the spline. Use the Shift key to drag a copy up in a front view, to a height appropriate for the armpit. If you get a message asking you to weld coincident endpoints, say no. Drag a second copy up to the height of the shoulder. The proportions don't need to be perfect—you're just trying to create the basic shape. You should now have three identical splines, stacked on top of each other.

3. Turn on the 3D Snap Toggle at the bottom of the screen and then right-click on the icon to bring up the Grid And Snap Settings dialog box. Remove the check for Grid Points and check Vertex. Then, close the dialog box. Your cursor now snaps to the vertices of the Editable Spline object.

Figure 10.35
A top view of the spline, defining the waist of the torso model. The position of the four vertices will determine the boundaries of the patches.

4. Connect the two middle columns of vertices first—the ones around the bend of the curve. In the Editable Spline panel, activate the Create Line button and then draw lines connecting the vertices. Use a perspective view. The snaps get you right on the vertices. Remember to click on each vertex in a column and to right-click to start a new line for the second column. When you're finished, your spline cage should look like Figure 10.36.

5. Take a moment to understand the nature of the spline cage. In the Spline Sub-Object level, select the different curves to confirm that there are five separate splines. Then, in Vertex Sub-Object mode, drag a rectangle to select all the vertices in the intersecting curves. The panel informs you that there are 12 vertices, two at each intersection.

6. Connecting the other columns of vertices is more problematic because these are endpoints of their respective curves. Try using Create Line to connect them; notice that it extends the existing spine, instead of creating a new one. Undo back and try again, using the Connect tool in the Vertex Sub-Object level. The Connect tool bridges between splines to create a single spline. Connect the bottom and middle vertices on both sides of the object. Notice that you can't connect between the middle and upper vertices. Go to the Spline Sub-Object mode and select one of the lower splines. You'll see that there is a single closed spline. You can only use Connect with endpoints. Your object should look like Figure 10.37.

7. Go back to the Create Line tool and use it to bridge the upper pairs of vertices. Be sure to go from the lower vertex to the upper one, however. The upper vertex is still an endpoint of the upper curve, and Create Line tries to extend the curve if you start there.

Figure 10.36
Editable Spline object from Figure 10.35, with two vertical copies and the two middle columns of vertices connected by new splines. Vertex snapping is used to make sure that the vertices of the new splines are coincident with the vertices on the original curves.

Figure 10.37
The Connect tool is used to bridge the endpoints of the lower pair of curves. This creates a single closed spline, however, so Connect can't be used to complete the bridge to the upper curve.

8. You still need to connect the spline cage across the top. Create Line won't work because there are endpoints involved, so use Connect. Draw a bridge between the first and last vertices on the upper spline. When you finish, the result should look like Figure 10.38.

Figure 10.38
After using the Create Line tool to finish the vertical bridging, the Connect tool is used again to close the top surface of the cage. The two endpoints of the upper curve are bridged. The cage is now complete over the sides and top.

9. At this stage, you have all of the essential features of the cage. Although one possibility is to use the vector handles to shape the curves better before creating the patch object, let's jump ahead and create the surface. Put a Surface modifier on top of the Editable Spline object and flip the normals, if necessary. You should have a patch object.

10. Look at a wireframe view. The mesh may be a little uneven. You can clean it up and reshape the curves by returning the Editable Spline object at the bottom of the stack. By keeping a stack, you can continue to develop the cage by adding new vertices (with Refine) and bridging them. But you may prefer collapsing the stack into an Editable Patch object and using the Editable Patch toolset to go on with your work. Give it a try. Use the Edit Stack button to bring up the Edit Modifier Stack dialog box. Press Collapse All, and you have an Editable Patch object.

11. Hide the interior edges and start adjusting vertices and vectors to get the proper shape. You'll also want to get rid of the Vertex Ticks in the Display panel. Now, you're ready to extrude the arm and open the neck, as in the previous exercise.

Using The CrossSection Modifier

The CrossSection modifier can connect your splines so that you don't have to. It's useful when you are effectively lofting splines, as you might do in NURBS modeling. For example, the body of an airplane might be modeled by creating a series of cross-section splines, using the CrossSection modifier to bridge them into a spline cage, and then applying the Surface modifier to create the Bezier patches.

A simple example gives you the idea:

1. Create an Ellipse in a top view and convert it to an Editable Spline object.

2. Select the spline at the Spline Sub-Object level and drag up a couple of copies so that you have a vertical stack of three identical closed splines.

3. At the Vertex Sub-Object level, edit the splines so that they have somewhat varying shapes. Your stack might look something like Figure 10.39.

Figure 10.39
Three closed splines in a vertical stack. They are all subobjects of a single Editable Spline object.

4. Get out of Sub-Object mode and add a CrossSection modifier to the stack. This modifier connects the vertices to create a spline cage that is suitable for the Surface modifier. See Figure 10.40. Like all lofting or skinning tools, the CrossSection modifier works well only when the cross-sections have the same number of vertices, and those vertices are well-aligned. Think of the CrossSection modifier only as a time saver for simple situations. More complex cages need to be connected by hand.

5. Add the Surface modifier to the top of the stack and flip the normals, if necessary. The Surface modifier creates an internal patch out of the middle ellipse. Eliminate it by checking the Remove Interior Patches box.

6. To preserve your stack, you can add an Edit Patch modifier on top of the Surface modifier. Put one on; in the Patch Sub-Object level, select the patches at the top and bottom, and hide them. With its interior edges hidden, your object might look like Figure 10.41. You can perform the same kind of patch editing in Edit Patch as you do with an Editable Patch object. If you collapse this object, it becomes an Editable Patch.

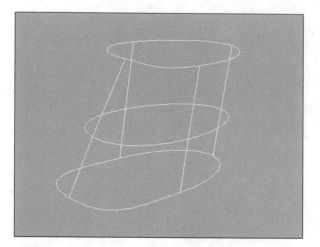

Figure 10.40
Object from Figure 10.39, after the application of the CrossSection modifier. The vertices are connected to create a spline cage that is suitable for the Surface modifier.

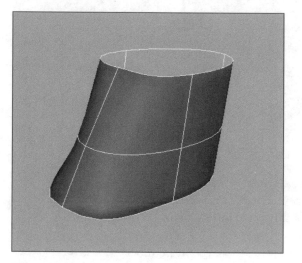

Figure 10.41
Object from Figure 10.40 after application of the Surface modifier. The patches created at the top and bottom have been hidden.

Moving On

In this chapter, you explored the possibilities of Bezier patch modeling. The Bezier patch modeling toolset is relatively simple when compared with NURBS of polygonal meshes, and it is easy to learn. The challenge is less in learning the toolset than in mastering the act of transforming patch vertices and vector handles in 3D space. It takes many hours of work to become comfortable with the process, but the results can be fabulous.

The new Surface Tools have augmented the traditional method of building surfaces directly out of patches. The Surface Tools enable the modeler to build spline cages out of Editable Spline objects and to rely on the Surface modifier to convert this network into Bezier patch surfaces. This is a new approach that requires a new way of thinking, but serious modelers will begin to integrate it into their repertoires.

The next chapter discusses NURBS (Non-Uniform Rational B-Splines) modeling. NURBS surfaces are the most sophisticated form of geometry available to the modeler, and the NURBS toolset in MAX is both impressive and intimidating. This is today's "state-of-the-art" in 3D computer graphics.

NURBS MODELING

NURBS curves and surfaces are the most powerful and sophisticated modeling tools available. There is simply nothing, real or imagined, that cannot be modeled with them.

The acronym NURBS stands for Non-Uniform Rational B-Splines, which means nothing to you unless you're a mathematician. NURBS are the ultimate form of spline (curve) available to the 3D modeler. NURBS curves are used to build NURBS surfaces, which are essentially networks of NURBS curves. To those just beginning NURBS modeling, these tools may seem a mere extension of the familiar Bezier splines modeling tools, using lathes and lofts. True NURBS modeling is a radical departure from previous techniques, however, and must be approached with a humble and inquisitive spirit. If you cannot devote at least 200 serious hours to the study of NURBS modeling, you cannot expect to get over the initial hump. NURBS modeling is only for the serious modeler who wants to be a part of cutting-edge developments in 3D technology.

It would take a book fully as long as this to teach NURBS modeling, so there are serious limits to what can be achieved in a single chapter. My goal is to give those persons with a genuine interest in this important field the necessary grounding for their own exploration. Even a simple NURBS modeling project typically involves hundreds of steps. With this in mind, I have prepared two series of pictures in the color section in the middle of this book that demonstrate important stages in building NURBS models of a piston from an automobile engine and a violin. These projects were specially chosen because they reflect many of the special strategy considerations associated with NURBS modeling, and they make use of many of its unique tools to achieve precise and elegant curvature. These two series of pictures are at least as important to the interested student as the text in this chapter. I highly recommend that you study these images in detail to sense the feel and workflow of modeling in MAX's NURBS implementation.

NURBS And MAX NURBS

The mathematical nature of NURBS curves and surfaces is a subject above and apart from that of any specific implementation. NURBS were first implemented in the highest-tier 3D applications—Alias Power Animator and Softimage 3D—many years ago, and came to

represent the single most important feature that distinguished these more expensive programs from MAX and the rest of the pack. A certain glamour was associated with NURBS modeling, considered to represent the ultimate "high-end" modeling technology.

MAX first introduced a NURBS implementation in MAX 2, undoubtedly driven by a marketing push to equate MAX with its top-tier competitors. This implementation and even its improvements in MAX 2.5 were not technically satisfactory in the view of most users. It was widely believed that MAX NURBS was a promise only to be fully realized in MAX 3. This understanding has turned out to be correct. The NURBS implementation in MAX 3 is only slightly different from the previous version, but it is immeasurably more reliable. Those who tried their hand at MAX NURBS in the past and were disappointed should be ready to try again now.

I stress the distinction between NURBS in general and a given NURBS implementation for an important reason. Those who want to learn NURBS modeling must learn both. On the one hand, there are principles of modeling based on NURBS curves and surfaces that stand above any specific implementation. On the other hand, any specific NURBS implementation is bound to be so complex that a great deal of effort is required to understand the toolset and structure of the individual application. In short, you must learn both NURBS and MAX NURBS.

Overview Of NURBS Modeling

NURBS modeling is characterized by the interdependence of curves and surfaces. You may already be familiar with the use of Bezier splines in MAX to create surfaces by lofting, lathing, and extruding. NURBS curves can be used to create surfaces in just the same way. But splines can be extracted from a NURBS surface, so that the modeling process is not only from splines to surfaces, but also from surfaces to splines. In this basic concept lies most of the unique power of NURBS modeling.

Extracting Curves From Surfaces

Take a look at Figure 11.1. In the object at left, a NURBS curve was drawn and extruded back to create a NURBS surface. A curve is then extracted from the surface—a curve running in the opposite direction as the original extruded curve. In the object on the right, the new curve is extruded upward to create a new surface. This kind of thinking, and the modeling practices that flow from it, require a special kind of vision and strategy.

Trimming Surfaces

Trimming plays an essential role in NURBS modeling. A NURBS curve that is on a NURBS surface can be used to trim that surface. After trimming, all geometry on one side of the curve is hidden. Figure 11.2 illustrates the effect of trimming the first surface by the curve that was used to extrude the second surface. This kind of thinking is basic in NURBS modeling.

NURBS Curves And Control Vertices

NURBS curves are built from control vertices, which are generally called CVs. With NURBS curves, in contrast with Bezier splines, there is no distinction between vertices (which are on

Figure 11.1
The NURBS surface on the left was extruded back from an original NURBS curve. A curve running in the opposite direction is extracted from the surface. At right, the extracted curve is extruded upward to build out a new surface.

Figure 11.2
The curve used to extrude the second surface is used to trim the first surface. The image shows the model before and after the Trim command is applied.

the curve) and tangent handles (which are generally not on the curve). Rather, all of the CVs shape the curve, and only the first and last CVs are always on the curve. Figure 11.3 illustrates a NURBS curve. In the upper curve, the CVs are connected by display lines for better comprehension. In the lower copy of the same curve these lines are hidden.

You can shape the curve by moving the CVs, but you can also adjust the weight of selected CVs. Increased weight pulls the curve closer to the CV and can give the curve a tighter bend. Figure 11.4 illustrates the effect of increasing the weight of the selected CV. The curve is otherwise the same as that in Figure 11.3.

Figure 11.3
A NURBS curve and its control vertices (CVs). In the upper curve, the CVs are connected by display lines for better comprehension.

Figure 11.4
The NURBS curve from Figure 11.3, with increased weight applied to the selected control vertex. The weight pulls the curves toward the CV, creating a tight bend and straightening the adjacent regions.

If you delete CVs from a curve, you necessarily change its shape. If you add a single CV, you also change the shape of the curve, although in many cases the change will have a negligible practical effect. To add a CV without changing the shape of the curve, you must adjust the positions of the CVs on either side of the new CV. All NURBS implementations offer this feature; in MAX, it's called refining the curve. Figure 11.5 illustrates the process. The original curve is below. The refined curve above is exactly the same shape. To add a CV beneath the dip on the right side, the existing CVs were pushed to either side.

Figure 11.5
Refining a NURBS curve adds CVs without changing the shape of the curve. At bottom is the original curve. Above, a new CV is added beneath the dip on the right. Note that the existing CVs have been pushed to either side to compensate.

Figure 11.6
The NURBS curve from Figure 11.3 has been cut in two, but the two curves maintain seamless continuity. Note the straight line of CVs in the highlighted region where the two curves meet.

NURBS curves can be cut without changing shape, creating two curves with continuity across their endpoints. Take a close look at Figure 11.6. The NURBS curve from Figure 11.3 has been cut, yet the two new curves are the same shape as the previous single curve. Look at the highlighted box area. The small circle in the middle is where the two curves meet, and there are CVs from both curves at this spot. Note that this circle and the two CVs on either side of it form a straight line. This should remind you precisely of the collinear Bezier tangent handles on a smooth section of a Bezier curve. Continuity between separate NURBS curves (and surfaces) depends on this straight line of CVs. Because NURBS modeling depends so much on connecting lines and curves in a way that appears seamless, this fact is one of the central "secrets" of NURBS modeling.

Three is the magic number with NURBS curves. Just as three CVs in a line can be used to create continuity between different curves, three CVs in one spot can be used to create a discontinuity in a single curve. In Figure 11.7, two CVs are added (not refined) and placed on top of a third. When the curve passes the three CVs at one location, continuity is broken and the curve can turn a sharp corner. This is another one of the essential "secrets" of NURBS. MAX allows you to fuse the three CVs together to create a group that can be moved as a unit.

Separate NURBS curves can be joined to create a single curve with continuity. The join mechanism closes the gap between the two curves. Figure 11.8 illustrates the join process. Note the straight line of three CVs to create continuity through the join region.

Figure 11.7
Three CVs at a single location break the continuity of the curve, permitting you to turn razor-sharp corners.

Figure 11.8
Two NURBS curves are joined to make one. The gap between the two curves is bridged so as to create continuity. Note the straight line of three CVs through the bridge.

NURBS Surfaces

NURBS surfaces can be created directly as flat grids, but they are generally created from NURBS curves. However they are created, they are ultimately two-dimensional networks of NURBS curves, with CVs running in both directions. Note that I say "ultimately." As you will see, many (if not most) NURBS surfaces remain dependent on the curves that were used to create them. As such, they are edited by editing these curves. In this situation, you are not exposed to the true, underlying NURBS surface composed of surface CVs. One way or another, however, the ultimate network of surface CVs is always there and must be understood.

The main point of this section is to stress the similarities between NURBS curves and NURBS surfaces. Figure 11.9 shows a NURBS surface created by extruding the curve from Figure 11.3 (and converted into an independent surface to show its surface CVs). In effect, the surface is a network of curves running in two directions. There are two curves with five CVs, each running in one direction, and five curves with two CVs, each running in the other direction.

Although these are effectively curves, it's easier to think of them in terms of rows and columns of CVs. To add a row or column of CVs without changing the shape of the surface, you use the same refining process that is used with curves. A new row of CVs was added in Figure 11.10. Compare this image with Figure 11.9 to see that the existing two adjacent rows of CVs were moved to compensate for the effect of the new row.

Just as with curves, NURBS surfaces can be broken without any loss of continuity. In Figure 11.11, the surface from Figure 11.9 is broken into two surfaces, but they remain seamless. Note the three rows of CVs that form a straight line over the break. Just as with NURBS curves, this arrangement creates a continuous tangency.

Figure 11.9
A NURBS surface created by extruding the NURBS curve from Figure 11.3. It is a network of CVs composed of two curves with five CVs in one direction and five curves with two CVs running in the perpendicular direction.

Figure 11.10
A row of CVs is added by refinement to preserve the shape of the surface. Compare with Figure 11.9 to see that two adjacent rows of existing CVs were moved to compensate.

Figure 11.11
Just like a curve, a NURBS surface can be cut in two without loss of continuity. Note the three rows of CVs that form a straight line over the break.

The same principles of discontinuity apply to NURBS surfaces as they do to curves. Three rows of CVs, positioned directly on top of each other, completely break the continuity of the surface, permitting you to fold it as sharply as you wish. And just as with curve CVs, MAX permits you to fuse rows of surface CVs into a functional unit. Take a look at Figure 11.12.

You can adjust the weight of the NURBS surface CVs just as you can with curves. This provides another useful way of tightening up a bend or creating a sharp fold. In Figure 11.13, the weight of a single row of CVs is increased, producing a result that is somewhat similar to that produced with three coincident rows.

Figure 11.12
Just as with NURBS curves, complete discontinuity is achieved for surfaces by placing three rows of CVs directly on top of each other. You can fold the surface as sharply as you wish.

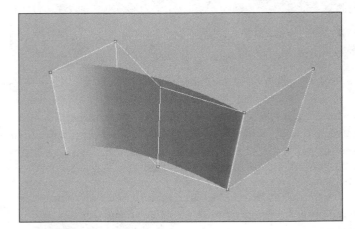

Figure 11.13
NURBS weight is increased for a single row of CVs. This produces a result that is rather similar to that produced by the three coincident rows of CVs shown in Figure 11.12.

Joining separate surfaces into one is an extremely important aspect of NURBS modeling, and, just as with curves, a bridge region must be built between any gaps. Figure 11.14 illustrates the merger of two surfaces. Note that many additional and seemingly unnecessary CVs were created throughout the new surface. It would be wise to clean up this result by deleting many of the excess CVs.

Branching Architecture, Blended Surfaces, And Mesh Tessellation

One of the most important concepts in NURBS modeling—and one of the most difficult to grasp—is the limitations that NURBS surfaces pose on branching architecture. Polygonal models are only as organized as you choose to make them. As long as all the vertices are connected to each other in a mesh, they produce a continuous rendered surface. It's easy to

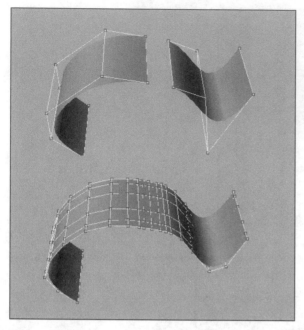

Figure 11.14

Two surfaces are joined by a bridge to make a single continuous surface. Note that many unnecessary CVs were created in this process. It makes sense to carefully delete a number of these.

create sharp changes in the direction of a mesh in polygonal models. You can extrude out faces to push out an arm from a torso or a finger from a hand. This kind of branching architecture is typical in character and animal figures, and it is also typical in many organic and inorganic objects.

Figure 11.15 illustrates the classic approach to branching architecture in a polygonal mesh. A quad polygon has been extruded out from the rest of the mesh. After subdivision using MeshSmooth, a smooth and continuous result is obtained. Note the change in the direction of the mesh between the "torso" and the "arm." This is a clear and logical organization that is easy to edit and to bring to a high level of detail.

MAX's Bezier Patches can be used in the same way as polygons to produce smooth branching architecture, as discussed in Chapter 10, largely because these patches can be treated as groups of polygons with curvature continuity. NURBS surfaces present a different situation, however. NURBS surfaces have inherent structural limitations that make it difficult or (more often) impossible to create branching architecture out of a single surface. Much of NURBS modeling is directed at aligning two surfaces in a way that will give the impression, after rendering, of a single continuous surface. Although the word "blending" is used in NURBS modeling in many ways, in the largest sense, and no matter how it is accomplished, it refers to the practice of creating an apparent merger of different surfaces.

Figure 11.16 illustrates a typical NURBS approach to branching architecture. The "arm" and the "torso" are different surfaces. The arm joins the torso at a curve that is on the surface of

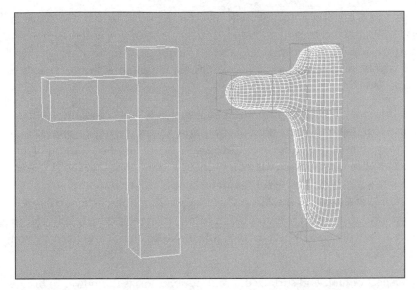

Figure 11.15
Branching architecture with a smoothed polygon mesh. A single quad polygon has been extruded out from the rest of the mesh, and the entire result is subdivided with MeshSmooth. The result is a single, seamless mesh.

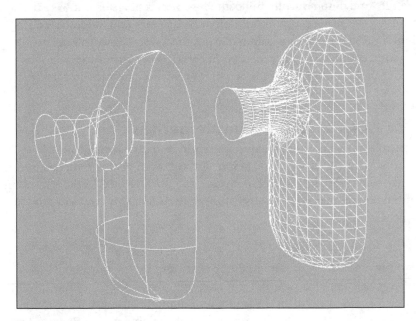

Figure 11.16
Branching architecture with NURBS requires the blending of separate surfaces. The arm surface meets the torso surface at a trim curve on the torso surface and picks up the curvature of the torso. The nature of the blending is seen both in a curves version (at left) and a tessellated mesh version (at right) of the same model.

the torso (and was used to trim out a hole in it). The arm surface picks up the curvature of the torso at this curve, creating a continuous "blended" effect. The image at left shows the basic structure of the two surfaces as networks of curves. The image at right shows the result after tessellation into a polygonal mesh. Compare this tessellated mesh with the tessellated mesh in Figure 11.15.

You have just slipped into one of the most important concepts of NURBS modeling. Although a NURBS surface is an ideal freeform expression of curvature, the rendering engine can understand only a polygonal mesh. Therefore, all NURBS surfaces are tessellated into polygonal meshes to render. This applies just as much to the realtime "render" that you see in a shaded viewport as it does to a true render to create a bitmap for output. Like all digital versions of an analog phenomenon, the tessellated mesh is only an approximation of the ideal, and the greater the tessellation (and the greater the number of faces), the greater the fidelity. Surface approximation tools (as they are called) play a huge role in NURBS modeling because you never render the ideal.

The most impressive aspect of high-end surface approximation tools is the power to bridge small gaps to create a seamless mesh. This power is called "edge merging," and it is the ultimate reason why blending of NURBS surfaces is possible. Look at Figure 11.17, which is a wireframe render of the blended region from Figure 11.17. Note that the mesh between the two surfaces was carefully and automatically bridged. The object renders as if it were a single seamless surface because, after surface approximation and edge merging, it really is a single seamless polygonal mesh. It's impossible to gain real command over NURBS modeling without the understanding and control over the process that converts freeform surfaces to the renderable polygonal mesh. In this way, you can see that NURBS are ultimately vehicles to create a polygonal mesh.

Overview Of The MAX 3 NURBS Implementation

MAX's NURBS implementation is powerful, unique, complex, and often frustrating. There are a lot of basic things you have to understand before you can even begin. You need a lot of patience to master these concepts. Like the modifier stack, the MAX NURBS implementation is based on certain principles that cannot be satisfactorily "hacked out" by raw experimentation, no matter how persistent.

The Basket Concept

The term "basket" is mine, not MAX's, although it's the best word for the purpose. NURBS models are necessarily a collection of curves and surfaces, and they often contain a substantial number of both. MAX could have taken the traditional approach (found, for example, in Softimage) of treating each curve and surface as a separate object, and giving the user the responsibility of organizing these objects into functional groups by using parent-child hierarchies. MAX did something very different, however, and very typical of MAX—it created a basket object in which the component curves and surfaces are subobjects.

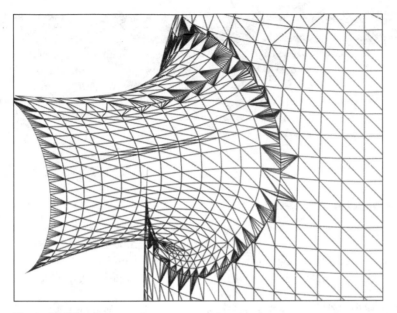

Figure 11.17
A wireframe render shows how, in the tessellation process, the two NURBS surfaces are merged into a single contiguous polygonal mesh. The object renders seamlessly precisely because, after surface approximation and edge merging, it really is seamless.

Bear with me, and consider the following material slowly and carefully, because your sanity depends on it. MAX provides two kinds of objects: the NURBS Curve object and the NURBS Surface object. Don't take these names at face value—each of these objects is a basket. A NURBS Surface object can contain any number of NURBS surfaces and NURBS curves as subobjects. Prior to MAX 3, a NURBS Curve object could contain only curves, so you had to convert a NURBS Curve object to a NURBS Surface object before you could build any surfaces. MAX 3 permits you to build and include surfaces in a NURBS Curve object, and thus there is no longer any practical distinction between NURBS Curve objects and NURBS Surface objects. In effect, there is only a single NURBS basket object, under either name, in which curves and surfaces are collected. Thus, you can be faced with such confusing ideas as "There are three NURBS surfaces and six NURBS curves in this NURBS Curve object." You've just got to get used to this kind of thinking.

Learn to distinguish between the creation of curves within a NURBS basket object and outside of it. NURBS curves that are created directly by selecting Create|Shapes|NURBS Curves become completely new NURBS Curve objects, being the only objects in the basket. You can then create more curves in this same way, but they will be separate baskets. More commonly, you add more curves to an existing basket by using the curve-creation tools within the basket. New curves thus created become additional subobject curves within the basket. You can bring curves from outside the basket into the basket by using the Attach tools in the top-level NURBS Surface panel. One way or another, all of the curves that will be used together to build or trim surfaces must be in the same basket.

MAX 3 OFFERS AUTOMATIC ATTACHMENT

Prior to MAX 3, the Attach tool was the only way to collect curves and surfaces from different baskets together in a single basket. This caused a great deal of confusion for the vast majority of users who didn't understand the basket concept. For example, the average user would simply create two NURBS curves from the Create panel, and then become frustrated by the inability to loft between them to create a surface. To alleviate this frustration, MAX 3 now automatically attaches curves from different baskets when you try to loft between them. The sophisticated user, however, should understand the process better and deliberately collect all necessary curves in a common basket, typically by creating all of the curves (except the first) from within the basket itself.

Dependent And Independent Subobjects

Due to the interdependence of NURBS curves and surfaces that characterizes the NURBS modeling process, all NURBS implementations offer a "modeling relation" concept by which a subobject curve or surface remain functionally related to the subobjects from which it was created. In MAX, this is achieved by the distinction between dependent and independent objects.

Take the simplest example. A NURBS CV curve is created from the Create panel. (Note that I will be using only CV curves in this chapter. MAX offers Point curves, which are supposed to be a simplification of CV curves. You should explore their merits only after you are fully grounded in CV curves, which are the true NURBS curves.) The curve is then extruded to create a surface. By default, this surface is a dependent subobject. It is dependent on the curve from which it was created, and if that curve is edited, the surface will be computed accordingly (see Figure 11.18). Note how the extruded surface updates when the curve is edited by moving the selected curve CV. This may remind you of similar mechanisms elsewhere in MAX. For example, you can change the shape of a lathed object by editing the spline underneath the Lathe modifier. Instancing can also be used in Loft Objects to the same effect. But dependency in NURBS is a much more general and uniform concept that is applied throughout the NURBS toolset.

At this point, the CVs that define the surface definitely exist, but are unavailable. Because the shape of the surface is dependent entirely upon the shape of the curve, there is no reason to access the surface CVs, so they remain hidden. You can break the dependency, however, by selecting the surface at the Surface Sub-Object level and pressing the Make Independent button; then, the surface is no longer connected to the curve and edits to the curve no longer affect the surface. Moreover, the surface CVs for the surface become available and can be edited to change the shape of the surface directly (see Figure 11.19).

BE CAREFUL ABOUT BREAKING DEPENDENCIES

Dependencies are an extremely important factor in NURBS modeling. It takes a great deal of experience to determine whether subobjects should be dependent and at what point it is safe to break a dependency. Often, the consequences of a broken dependency appear much later in the modeling process, to your great surprise. You can always break a dependency, but you can't re-create one (except by undoing). Get used to thinking far ahead about the consequences of broken dependencies. You'll often be forced to break them, but don't break them otherwise.

Figure 11.18
An extruded surface remains dependent on the curve from which it was extruded. The surface is effectively re-extruded when the curve is edited by moving the selected point.

Figure 11.19
After making the extruded surface from Figure 11.18 independent of the curve, edits to the curve no longer affect the surface, as seen at the top. Once independent, the surface's own CV network can be revealed and edited directly to shape the surface, as shown at the bottom.

Object And Subobject Levels

The basket concept forces the user to move constantly between the object level (top level) and the various subobject levels. You can do this from the drop-down list at the top of the NURBS Surface panel, from the right-click menu, or by using hotkeys. However you get around, there is a huge amount of interface to learn, even in a general way.

Figure 11.20 shows the top-level panel with only the General rollout open. Here, you can attach (and import, which is a variation of attachment) NURBS subobjects from other baskets to add them to the selected basket. The Display options, which are critical, are also available from the right-click menu. NURBS models can become an overwhelming mess of curves and surfaces, and you often need a quick way of hiding entire classes of subobjects. Note that this is different from hiding selected subobjects from within a given subobject panel.

Figure 11.20
The top-level (object level) NURBS Surface object panel, with the General rollout open.

The Display Line Parameters rollout is used to set the numbers of curves displayed on a surface in a wireframe view. It's important to understand that these are for display purposes only, to help you grasp the contours of a surface. The number and position of the curves does not necessarily indicate the position of the rows and columns of CVs on the surface. The Surface Approximation rollout contains the tools for tessellating NURBS surfaces into polygons. You'll consider this important toolset later, but for now, note that (because it is at the object level) it applies to all of the surfaces in the basket. The three subobject creation

rollouts permit you to create subobjects within the basket. All of these tools are generally much more easily reached through the NURBS Toolbox or the right-click menu.

Within each of the subobject levels (Curve, Curve CV, Surface, and Surface CV), the panel provides the tools appropriate for the job. In each case, you will often (but not always) have to select the specific subobjects that you intend to edit. When you have a number of subobjects in a class, this can be tough work. Be sure to name each of your subobjects with a good, descriptive title in the Name box. As is typical throughout MAX, the program generates a generic name when you first create a subobject. There is nothing more frustrating than trying to find a surface or curve from a huge list without the help of a distinctive name. The situation can be especially difficult because the original name assigned by MAX often no longer makes sense after a number of operations (especially after dependencies are broken).

To find subobjects on a list, you need to activate the little button at the bottom center of the MAX screen (with the flyout that reads Plug-In Keyboard Shortcut Toggle). If this button is activated, you can press the H key to bring up the Select Sub-Objects dialog box (rather than the regular Select Objects dialog box).

Hiding subobjects is another task that is essential for sanity and productive workflow. It is especially important due to the necessary consequences of the basket approach to organization. For example, when you move to the Curve CV subobject level to edit a given curve, you see all the curve CVs of every curve in the basket. This can become impossibly confusing. A typical NURBS model is filled with all kinds of construction curves that you dare not delete, but don't want cluttering the screen. If you develop strict practices for hiding subobjects, you'll thank me one day.

The NURBS Creation Toolbox

The centerpiece of MAX's NURBS modeling interface is the NURBS Creation Toolbox. To edit existing NURBS curves and surfaces, you must go to the appropriate subobject level and select from the panel. You can also create curves and surfaces at any time, regardless of your current selection level, by using the NURBS Creation Toolbox.

The NURBS Creation Toolbox is shown in Figure 11.21. The Toolbox generally appears by default as a floating toolbar on the screen, but it can be toggled on and off through its icon in the object level (top-level) panels of the basket objects. The Toolbox is divided into three sections: Points, Curves, and Surfaces. These icons are nothing more than macro buttons that call the subobject creation tools found in the bottom three rollouts of the top-level panels. Creating points independently of curves is a rare occurrence, so let's ignore the point creation tools. Figure 11.22 shows the Create Curves and Create Surfaces rollouts. Although you'll almost always use the Toolbox instead of the rollouts, take a look at the names of the available objects and see how they are organized into independent and dependent objects.

Some of the creation tools are much more important than others. Note first that you can create new CV curves within the basket by selecting the tool and drawing. Because the curve is drawn from scratch, it is necessarily an independent object. The dependent curves are all

Figure 11.21
The NURBS Creation Toolbox.

Figure 11.22
The Create Curves and Create Surfaces rollouts from the top-level panels of the NURBS Curve object and NURBS Surface objects. These are the tools that are called by pressing the Curve and Surface icons on the NURBS Creation Toolbox.

created, in one way or another, from existing curves or surfaces, and are therefore made dependent on those subobjects. You can always break the dependence. A Transform curve is a dependent copy of an existing curve. Because this is considered curve creation, rather than curve copying, you can create a Transform curve without being in the Curve Sub-Object level. By contrast, you can formally copy a curve by selecting it at the Curve Sub-Object level and performing the conventional "Shift—drag." After the curve is copied, you can decide whether the copy should be a dependent or independent object.

An Offset curve is also a dependent copy of an existing curve, but one that is automatically scaled as you move it away from the original. Sometimes, this is easier than scaling the curve after copying it, but not often. Mirroring curves is extremely important in NURBS modeling to create bilaterally symmetrical objects. The Mirror curve can be a little clumsy to use, however, and it is often easier to use the regular MAX mirror tool to mirror the entire object (basket) and then perform an attachment to merge the baskets.

The most important class of curves that can be created within a basket is that which consists of curves on surfaces. These curves can be used for trimming or building additional surfaces. The Vector Projected curve is a curve that is projected onto a surface in a single direction. The Normal Projected curve, which makes a projection in the direction of the normals of the surface, is much less useful. The other curves are taken directly from the intended surface. The U Iso curve and V Iso curve are curves that are extracted anywhere along the surface in either the u- or v-direction. These are *isoparametric curves*, meaning that they represent a constant value in either u or v across the surface, and they reveal the structure of the NURBS surface. A Surface Edge curve is just an easy way of getting the isoparametric curves at the very start or end of the surface in either the u- or v-direction.

So much for the essential curves. You can create new CV grids (called *CV Surfaces*), and you can make dependent copies of surfaces by using the Transform Surface. The most important surface creation tools, however, are those that fashion surfaces out of curves. The Loft Surface is central; it is a surface created by "skinning" (lofting) NURBS curves. It comes in two flavors, permitting you to skin curves in either one or two directions. The Lathe and Extrude Surfaces create surfaces from a single curve and require no explanation to any MAX user. The Sweeps (1-Rail and 2-Rail) are guided extrusions. Instead of extruding a curve in a straight line, it is extruded along a path defined by one or two other NURBS curves.

The Blend Surface is used for blending surfaces, as described earlier. The Blend Surface can be created between the edges of two surfaces, between curves on surfaces, and between either of these and a curve off of the surface.

When you select a creation tool from the NURBS Creation Toolbox, the appropriate creation rollout appears in the panel. You'll often need to set values on this panel to get the result you want; by picking the direction of an extrusion or the axis of a lathe, for example. When creating all dependent subobjects, the objects available to create the new object turn blue under the cursor. Once a subobject is finally created, its parameters can be changed only by selecting it at the curve or surface subobject level.

NURBS Surface Primitives

Most NURBS modeling involves creating surfaces from curves, but it is often useful to work from NURBS surface primitives. A NURBS CV Surface is simply a flat NURBS grid that can be created by choosing Create|Geometry|NURBS Surfaces. The primary value of this approach, as opposed to extruding a straight NURBS curve, is that you can specify the number of rows and columns of CVs. The same kind of CV Surface can be created with an existing basket from the NURBS Creation Toolbox.

All of the Standard Primitives can be converted from polygons to NURBS by using the right-click menu, including (believe it or not!) the Teapot. The use of a NURBS Sphere primitive is essential in NURBS modeling, but I have mixed feelings about the other primitives. To some extent, you can save time by converting basic shapes to collections of NURBS surfaces, but for the serious student, this approach takes you off the track of true NURBS modeling strategy and techniques.

Lofting Surfaces

Lofting curves into surfaces is the most essential concept in NURBS modeling. Lofting is often called *skinning* among NURBS modelers, and I'll use these terms interchangeably here. MAX sticks with the word Loft, which at least prevents confusion with the new Skin modifier that has nothing to do with skinning curves.

A Loft Surface is dependent on its component curves, at least in the first instance. Any changes made to these curves causes the surface to reloft. You can, of course, convert the lofted surface to an independent CV Surface, after which it will be editable only by its surface CVs. MAX has the unusual power of being able to reloft from any surface, however, and effectively exact curves from the surface and skin them. Work through an exercise that will get you started with lofting while introducing a number of general concepts.

Creating A Loft

You start by creating curves and skinning them, as follows:

1. Draw a wavy NURBS curve in a front view, using five CVs. Use Create|Shapes|NURBS Curves|CV Curve. Draw the curve as you would a regular Bezier spline, clicking to lay down control vertices (CVs) and right-clicking to end the process. Pay careful attention to the way the curve takes shape and notice how each additional CV affects the shape of previously drawn sections. It takes a lot of practice to become skilled at drawing with NURBS. Get used to hiding your screen grids if you don't need them, to see things more clearly. Switch to the Modify panel and look at your curve at the Curve CV Sub-Object level. You can select CVs and edit the shape of the curve. This gives you a feeling of how translating CVs affects the curve. When you finish, your front view should look something like Figure 11.23.

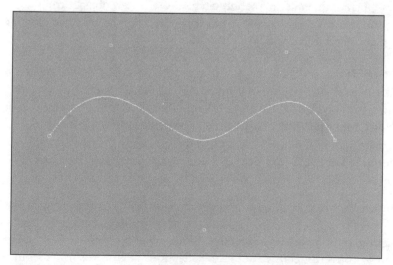

Figure 11.23

A NURBS curve composed of five CVs drawn in a front view and viewed at the Curve CV Sub-Object level. The Display Lattice option is turned off.

2. You can now make a copy of this curve and skin between both. Do so in a perspective view to get a good feeling of depth. Rotate your perspective view to get an angle on the curve. One way to copy the curve is as a Transform curve. Give this a try by activating the Create Transform Curve button in the NURBS Creation Toolbox. If the Toolbox is hidden, you can unhide it by using the button in the top-level panel. Place your cursor over the curve; it will turn blue. When you start dragging, however, you'll notice that the Transform Gizmo is not available, making it difficult to position the copy precisely. Right-click to get out of the creation tool and undo to get rid of the Transform curve.

3. Go to the Curve Sub-Object level and select the curve by clicking on it. It turns red and its name ("CV Curve 01") appears in the panel. Get into Move mode if you're not already there and note the Transform Gizmo. Hold down the Shift key as you drag off a copy in the world y-direction. When you release the mouse, you'll see a dialog box. Press the OK button to accept the default option of an Independent Copy. Your perspective view should now look something like Figure 11.24.

Figure 11.24
The NURBS curve from Figure 11.23 is copied as an independent subobject and moved behind the original.

4. Now, you can skin the curves. Select the U Loft Surface tool from the NURBS Creation Toolbox. Click on one curve, click on the other, and then right-click to end the process. If your surface seems to be missing, rotate your perspective viewport to see whether it's visible from underneath. The surface is visible in only one direction—the direction of its normals. Go to the Surface Sub-Object level, select the surface (named U Loft Surf 01), and check the Flip Normals box to reverse the direction, if necessary. Your surface should be facing up. After you know that it's facing in the correct direction, change your display to show both sides of the surface. (You can do this by unchecking the Backface Cull option in the Display panel, which affects only the selected object.) It's impossible to work with NURBS surfaces when you can't see both sides. Your surface should look like Figure 11.25.

Figure 11.25
The two curves are lofted (skinned) into a surface. After making sure that the surface normals face upward, both sides of the surface are revealed in the viewport for better comprehension.

Editing The Loft

You could have created this surface more easily by just extruding the original curve, so you can continue our exercise by making some adjustments that represent the typical modeling process:

5. Switch to the Curve CV Sub-Object level and note that the CVs of both curves are available for editing. Move the middle CV in the back curve straight up. The Loft Surface is dependent on its curves, so the surface is automatically reskinned to reflect the new condition of its curves. Your surface should look something like Figure 11.26.

Figure 11.26
The lofted surface is dependent on its component curves. Editing the shape of these curves at the Curve CV Sub-Object level causes the surface to reloft accordingly.

6. There's only so much you can do with two curves, so let's pull a curve off the surface and add it to the loft. Press the Create U Iso Curve button in the NURBS Creation Toolbox and pull the cursor over the surface. You can see that the surface can be understood as a continuum of isoparametric curves in the u-direction. When you create a U Loft Surface in MAX, the u-direction is the direction of the loft—the direction connecting the selected curves. Find a curve right in the middle and click on it to accept it. The curve turns green, indicating that it is a dependent subobject. Right-click to get out of the tool (or you'll go on creating Iso curves).

7. The Iso curve is dependent on the surface. You can test this by moving one of the Curve CVs to change the shape of the surface. The Iso curve remains stuck to the surface. Go to the Curve Sub-Object level and select the Iso curve. Pull the Position spinner in the Iso curve rollout and note that you can move the curve across the surface, effectively creating a different isoparametric curve than the one you began with. You can find this kind of flexibility with dependent objects throughout the toolset.

8. Break the dependency by pressing the Make Independent button. When this button is gray for a selected subobject, it means that the object is independent. Go back to the Curve CV level and note that CVs are now available for the Iso curve. There is a huge number of them, however, which is typical of curves that have been computed to follow a curving surface. Your screen should now look something like Figure 11.27.

Figure 11.27
An Iso curve is created from the middle of the surface and converted into an independent object. Note the large number of CVs typical of surface curves on curving surfaces.

9. There are two ways to add the middle curve to the loft: Simply delete the surface and reloft by using all three curves instead of just the original two, or add curves directly to an exiting loft. Let's try out the second method by going to the Surface Sub-Object level and selecting the Loft Surface, if necessary. Pull down to the U Loft Surface rollout at the bottom of the panel. The U Curves window lists the component curves in order. To insert the additional curve into the loft, select the second curve on the list

and activate the Insert button. Click on the Iso curve, and after a moment, you'll see it added into the middle of the list. Now, check to see whether it worked.

10. If you just go back to the Curve CV level to edit the curve, you'll find that the sheer number of CVs is unworkable. So, to clean things up, select the middle curve in the Curve Sub-Object level. The curve can now be rebuilt with a lesser number of CVs. Press the Convert Curve button to bring up the Convert Curve dialog box. Change to the Number option and enter the number 5. If the Preview box is checked, you'll see the curve after it's been resampled down to only five CVs, which is the same number as the other curves in the loft. The shape of the curve changes, of course, so that it no longer follows the surface; the more points you use, the closer it will remain to its original shape. Press the OK button to accept the resampled version of the curve. The surface is automatically relofted and interpolates all three curves. Figure 11.28 shows the result. Now, you can move CVs on the middle curve to shape the surface.

Figure 11.28
The middle curve is resampled down to only five CVs by using the Convert Curve dialog box. After accepting the new curve, the surface is automatically reskinned through the middle curve. Image is seen at the Curve CV level.

11. Actually, there is a much simpler way to add a surface curve to the loft. Go back to the Surface Sub-Object level and press the Refine button in the U Loft Surface rollout. Pull the cursor over the surface to select an isoparametric curve that is very close to the current middle curve. Click there to see the new curve added to the list. Now, select the previously added Iso curve from the list and press the Remove button. The Iso curve disappears from the list, but the curve is still visible on the screen. The curve still exists in the basket, even though it's not in the Loft Object. Go to the Curve Sub-Object level, and then select and delete the curve (Iso Curve 01).

12. Go to the Curve CV Sub-Object level and note the relatively reasonable number of CVs that were created on the refined curve. With only nine CVs, the curve managed to follow the original surface very closely. Figure 11.29 illustrates the refined surface.

Figure 11.29
A new curve is added to the loft by using the Refine tool, and the inserted curve is removed and deleted. The curve added by refinement has the minimum number of CVs needed to preserve the shape of the surface.

Note that MAX's NURBS implementation is remarkably good at skinning between curves with different numbers of CVs. Often, however, you will need to add or delete CVs from curves in a loft to get a smooth result.

Relofting The Surface

One of the most interesting features of the MAX NURBS toolset is the power to automatically reloft a surface. The typical use of any kind of relofting is to change the direction of the lofting curves, but it is also used to create curves in new positions on the surface that are in the same direction as the original curves. In both cases, the purpose is to position editable curve CVs in more useful locations as more detail is added to the surface. Let's see how relofting works with the surface we've been working with as we continue our exercise:

13. Select the surface at the Surface Sub-Object level and press the Make Loft button on the panel. The Make Loft dialog box appears, as illustrated in Figure 11.30. The Make Loft tool samples out isoparametric curves from the surface, in either the u- or v-direction. (It can also sample in both directions to create MAX's unique UV Loft Surface.) Make sure that the Preview button is checked and play with different numbers of curves in either direction. By default, the tool provides you with the minimum number of samples that preserve the shape of the surface. As you try numbers below the default, you'll see that the surface loses fidelity to the original contours.

14. Use the default number of samples in the direction opposite to your original curve. Before relofting, you must decide whether you want to delete the curves that currently support the loft. Sometimes, these curves are particularly important and should be preserved, even if they are not used in the loft. In this case, however, it would be easy to use the Make Loft tool again (in the other direction) to recover the

Figure 11.30
The Make Loft dialog box, which allows you to reloft a surface by sampling a given number of curves from the surface in a given direction.

edge curves. Check the Delete Original Curves box and press OK. Take a look at the Loft Surface rollout to confirm that a new list of curves is supporting the loft.

15. As a general proposition, breaking a dependency is an irrevocable act, but the Make Loft tool also works on independent CV Surfaces. Press the Make Independent button to convert the surface to a CV Surface. Go to the Curve Sub-Object level, select all the curves, and delete them—noting in the process that the original curves are already gone. The surface is unaffected because the dependency on the curves is broken. Move on to the Surface CV Sub-Object level and move some surface CVs to change the shape.

16. Now, convert the surface back into a Loft Surface. With the surface selected in the Surface Sub-Object level, press the Make Loft button. Once again, an adjustable number of isoparametric curves can be sampled off the surface in a chosen direction. Note that the Delete Original Curves option is grayed out because you're not sampling from an existing Loft Surface. Set a sampling that appeals to you and press the OK button. You again have a Loft Surface that is edited from the CVs of its component curves.

Surface Curves And Trimming

The whole concept of a curve being confined to a surface is unique to NURBS, and it takes a long time to become accustomed to. The curve is dependent on the surface, so that if the surface changes, the curve changes to stay aligned with the surface. In the loft exercise, you saw how isoparametric curves can be sampled from a surface. Isoparametric curves constitute the very structure of a NURBS surface. You can also extract such curves individually as U Iso Curves and V Iso Curves from the NURBS Creation Toolbox.

But isoparametric curves are not often useful for trimming purposes. Trimming is a pillar of NURBS modeling. The shape of a surface is defined not only by its structure, but by surface curves that are not part of that structure. These curves are used to hide portions of the sur-

face or to connect with other surfaces. Trim curves are generally created by projecting a curve onto a surface to create a surface curve. You'll learn the basics in the following exercise.

Projecting A Surface Curve

You project a curve onto a surface in a chosen direction to create a surface curve for trimming. The concept is very similar to that of a Planar projection in texture mapping. Follow these steps:

1. Reset your scene if you're continuing from the previous exercise. Draw a straight, horizontal CV curve in a front view, using five CVs. Switch to the Modify panel and choose the Create Extrude Surface tool from the NURBS Creation Toolbox. Drag down from the curve to extrude a surface. If nothing seems to be happening, try a different Direction option in the Extrude Surface rollout. Note that you can use the spinner in the rollout to set the length of the extrusion. Check in a shaded perspective viewport to see which way the surface is facing. Flip the surface normals in the rollout, if necessary, to get the surface to face toward you. Right-click, as usual, to end the creation process.

Using An Open Curve

An open curve can be used to trim a surface if it both enters and leaves the surface. Neither endpoint can be on the surface. You'll see how this works with the surface you're working with in this exercise:

2. Create a CV curve from the NURBS Creation Toolbox so that the curve is part of the current basket. After activating the icon, draw a curve in a front view so that it begins to the left of the surface and ends to the right of it. Your front view should look something like Figure 11.31.

Figure 11.31
A surface is extruded downward from a horizontal curve in a front view. A separate curve is drawn that crosses the surface and extends out on either side.

3. Due to the way you created the curve, it happens to be located precisely on the surface, but it is not a surface curve. To create a surface curve, you need to project the current curve onto the surface. Projection is a funny concept here because you can "project" the curve, even though it is already on top of the surface. To make things clearer, select the curve in the Curve Sub-Object level and move it toward you (in the world y-direction) in a perspective view. Figure 11.32 shows a rotated perspective view with the curve moved back as directed.

Figure 11.32
A rotated perspective view shows the curve moved back, in the world y-direction, ready for projection.

4. You will project the curve in the direction that you are looking in the viewport. This is a very important concept that takes a moment to grasp. To get the proper result, you need to perform the projection from a front viewport. Select the Create Vector Projected Curve button from the Toolbox and place your cursor over the curve in a front viewport. When the curve turns blue, click and drag to the extruded surface. When the surface turns blue, release the mouse button. Look at your perspective view to see the Vector Projected curve on the surface, as illustrated in Figure 11.33. Do not right-click to end the creation process yet.

5. Because you didn't right-click to end the creation process, the Vector Projected Curve rollout is visible. (If you did right-click, just undo.) Check the Trim box to hide all of the surface on one side of the projected curve. Then, check the Flip Trim box to hide the opposite side. End with the top portion of the surface hidden, as shown in Figure 11.34. Now, you can right-click out of the creation tool.

6. There are multiple dependencies here. Although the Vector Projected curve (the surface curve) is dependent on the curve from which it was projected, it is also dependent on the surface. To test this, go to the Curve CV level and change the shape of the projecting curve. Watch both the surface curve (and the trim effect) update.

Figure 11.33
After projecting the curve from a front viewport, a Vector Projected curve is created on the surface. The horizontal line indicates the direction of the projection.

Figure 11.34
The surface curve is used to trim the surface, hiding everything on one side of the surface curve.

Then, move the CVs on the curve from which the surface was extruded to put some waves in the surface. The projection is automatically updated. See Figure 11.35.

7. Go back to a front view and move one of the endpoints of the projecting curve so that the curve no longer extends off the end of the surface. Note that the surface turns orange and the trim disappears. This is an error state. Trimming can make sense only if a surface curve divides a surface into two distinct portions—one to be hidden and one to be displayed. If an open curve does not leave the surface at both of its endpoints, it cannot serve as a trimming curve. This is the cause of the vast majority of trim errors.

Figure 11.35

Multiple dependencies are tested. The projecting curve is edited, changing the shape of the projected surface curve. The curve from which the extrusion was made is edited, which changes the shape of the surface and therefore the shape of the dependent surface curve.

Cutting Holes With A Closed Curve

You can use a closed curve to cut a hole through two surfaces and create the typical NURBS version of Boolean subtraction. Follow these steps:

1. Create a CV Surface in a front view (Create|Geometry|NURBS Surfaces|CV Surf). Draw it out to make an approximately square grid.

2. Create a Circle object (a Bezier spline) in a front view that fits well inside the NURBS grid. Use the right-click menu to convert it to a NURBS curve in a NURBS basket. When the NURBS panel appears, use the Attach command to add the grid to the current basket.

3. Select the grid (the CV Surface) at the Surface Sub-Object level and, in a top view, move it in the world y-direction, so that it's a little in front of the circle. Then, use Shift-drag to make an independent copy of the grid behind the circle, in the world y-direction. A rotated perspective view should look like Figure 11.36.

4. Now, you project the same curve on both surfaces to cut out a hole. If you used the regular Vector Projected curve method (in a front view), you'd need to hide one surface to be able to project onto the other one without interference. However, when you use a flat grid, it's possible to use the Normal Projected curve method. This method projects in the direction of the surface normals, which is a very confusing idea in any case other than a flat surface. Rotate your perspective view to get an angle that gives cursor access to all three objects. Activate the Create Normal Projected Curve button on the NURBS Creation Toolbar. Click and drag from the circle to one grid. When the surface curve appears, check the Trim box in the

Figure 11.36
A circular NURBS curve is sandwiched between two flat NURBS surfaces. All are subobjects in a single NURBS basket.

Normal Projected Curve rollout to cut out a hole. Now, do the same thing for the other surface, and then right-click to get out of the creation tool. Select the curve in the middle in the Curve Sub-Object level and hide it with the Hide button. Your perspective view should now look like Figure 11.37.

5. To bridge the holes, create a U Loft Surface between the two surface curves. When you finish, you have a tunnel. Figure 11.38 illustrates this in wireframe.

6. Check your model in a shaded perspective view to get the normals right. The back grid may need to have its normals flipped. Whether the loft needs flipping depends on the direction in which you connected the curves.

7. The loft created a sharp hole—the one that was drilled out. To create a softer hole, you need a method that maintains some curvature continuity with the flat surfaces. Select the Loft Surface in the Surface Sub-Object level and delete it. Use the NURBS Creation Toolbox to create a Blend Surface between the two surface curves. Drag from one curve to the other, just as with a loft. Right-click when you're done. A wireframe view, as shown in Figure 11.39, reveals the result.

8. Select the Blend Surface and pull down in the panel to see the Blend Surface rollout. You can change the direction of the continuity at either end of the surface by flipping the tangents. Check the Flip Tangents boxes to understand the concept, and then return to the correct result. A Blend Surface is much like a loft, and as in all

Figure 11.37
The circle from Figure 11.36 is projected on both surfaces and used to trim out a hole. The circle is then hidden.

Figure 11.38
The two surface curves are bridged with a U Loft Surface to create a tunnel.

Figure 11.39
The two surface curves are bridged with a Blend Surface to create continuity of curvature and a softer result at the edge of the holes.

lofts (NURBS and otherwise), the component curves must all be running in the same direction and their start points must be aligned. The Flip End options allow you to reverse the curves without going back to the Curve Sub-Object level. Select these options to see the effect of reserved curves. There are also spinners here to align the positions of the start points, which are connected by a dotted blue line in the viewports. These curve-alignments tools are also available for Loft Surfaces.

9. The primary control for Blend Surfaces is Tension, which is set separately for each end. Reducing both values to zero completely eliminates the tangency, producing the same sharp result as the loft approach did. Experiment with values, both less and greater than the default of 1.0. The higher the value, the greater the curvature. Figure 11.40 illustrates a Tension value of 2.0 at both ends.

Surface Approximation

It's impossible to stress strongly enough that using NURBS is ultimately a way of generating a polygonal mesh. NURBS surfaces are freeform abstractions that must be reduced to a mesh for rendering. The process of surface approximation, as this tessellation is called, is an essential part of the NURBS modeling process. This is not merely because NURBS models can generate an excessive number of polygons and slow rendering to a halt. Again and again, you'll discover that NURBS surfaces are not rendering correctly and that the answer to these problems lies in the surface approximation tools.

Figure 11.40
The Tension spinner determines the degree of curvature continuity going into the blend. At a value of 2.0, twice the default, the curvature is extreme and organic.

Surface approximation, like everything in NURBS, is a deep subject, but the serious student has got to get started somewhere. The main Surface Approximation rollout is at the object (basket) level, so it applies to all of the surfaces in the basket. You can override these settings with respect to selected surfaces by using the Surface Approximation rollouts at the Surface Sub-Object level, but this is rarely necessary.

Figure 11.41 illustrates the Surface Approximation rollout at the object level. The two radio buttons at the top determine whether the present settings are to be applied to the shaded viewports or to the renderer. (Remember that a shaded viewport is a rendering, and therefore requires a polygonal mesh.) In the interest of interactive speed, it obviously makes sense to use a lower degree of tessellation for the viewports than should be used for a finished rendered image. The viewport tessellation is very important, however. You'll very often need to use an Edged Faces view to see the tessellated polygonal mesh in the viewports. Even when this tessellation is not as fine as that intended for the final render, it indicates the flow of the mesh and highlights obvious problems of irregularity.

The settings for the renderer require serious consideration. MAX provides three preset values—Low, Medium, and High—that all use the Spatial and Curvature tessellation options. These are adaptive options that generally produce the most intelligent result. The Curvature method uses a maximum angle set by the user. This is effectively the largest possible angle between adjacent polygonal edges after tessellation. The smaller the angle, the finer the mesh must be to meet the test. The Curvature method also uses a Distance measure that determines the maximum distance that the mesh can vary from the ideal NURBS

Figure 11.41
The top-level Surface Approximation rollout.

surface being approximated. Once again, the smaller the number, the finer the mesh and the better the approximation. The Spatial method fixes the maximum length of an edge in the resulting polygonal mesh and, again, the smaller the number, the smoother the result. The default Spatial and Curvature method uses both techniques together. The Regular and Parametric methods are nonadaptive and are rarely needed. Make a practice of using wireframe renders (use Force Wireframe in the Render Scene dialog box) to test your surface approximation results.

The Merge spinner at the bottom of the panel is one of the most important tools in the entire NURBS implementation. It determines how far the surface approximation tools reach to bridge the mesh between adjacent surfaces. The default value of .01 is often far too small. When your renders display small cracks between surfaces, especially when they meet at surface curves, kick this number up to 1.0 or more.

Moving On

In this chapter, you were exposed to only a small amount of the information needed to use MAX's NURBS implementation. Yet there are weeks of study in these pages alone. NURBS modeling is a subject of such depth and difficulty that it could easily fill an entire book all by itself. This chapter sought only to provide the basic grounding for the serious student.

You learned some of the essential properties of NURBS curves and surfaces, and then moved on to the major features of MAX's NURBS implementation. You learned about the basket concept for NURBS objects in MAX, and you saw how the program handles dependencies (modeling relations) between subobject curves and surfaces in a basket. You worked with a

basic Loft Surface—building it, editing it, and relofting it from sampled curves. You learned the basics of trimming surfaces with projected surface curves, both open and closed, and saw how a Blend Surface can be used to create continuity between surfaces. Finally, you took a short look at the important issue of surface approximation.

In the next chapter, you'll move on from modeling topics to explore materials definitions and the use of MAX's powerful Material Editor.

3D STUDIO MAX
R3 STUDIO

3D Studio MAX provides unparalleled opportunities for creative expression to meet a wide range of professional demands, from entertainment to commercial visualization and beyond. In the following series of color images, you'll see MAX applied in many of these directions, both in finished renders and works-in-progress.

Building an organic character figure with MeshSmooth NURMS begins with a basic cage. (MeshSmooth modeling is covered in Chapter 7.) In the first of four images showing this process, a Box object is converted to an Editable Mesh, and quad polygons are extruded in stages to create the head, arms, legs and feet with their most basic segmentation. Only half of the model is built. The polygons along the centerline are eliminated so that the mesh is open from the top of the head to the crotch.

Applying MeshSmooth NURMS to the initial mesh produces a rounded and subdivided model visible within the cage. Using only a single iteration of MeshSmooth, each quad in the original mesh becomes four in the NURMS version.

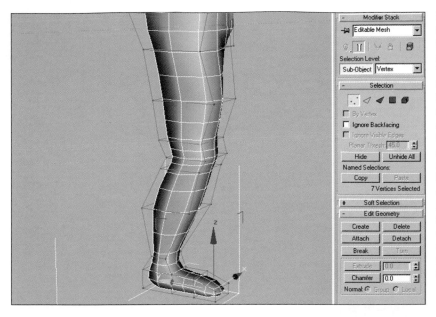

In the Editable Mesh level, the vertices are edited on the cage to shape the smoothed object within. The effect is much like using control vertices with true NURBS, but is easier and more intuitive. Additional segmentation was added to the leg and foot using the Slice modifier and collapsing it into the mesh. Unlike most other methods of creating localized subdivision in a mesh, the Slice modifier does not damage the quadrilateral structure of the model or generate undesired vertices.

As the model takes shape, the half of the figure that has already been built is mirrored to assess the overall proportions. If the mirrored object is made an instance (rather than just a copy), it will update as the other half is edited. The hard crease along the centerline indicates that the two halves are not yet a single mesh. In the end, both halves are joined into a single object and the points on the centerline are welded together to create a seamless mesh.

Three images showing the building of a low-polygon head are shown here. (This exercise is shown in its entirety in Chapter 7.) In this image, the low-polygon head is begun by collapsing a Box into an Editable Mesh and performing some simple subdivision. The neck is extruded down from two quad polygons on the bottom. The mesh is still organized in quads, with the exception of the triangles that join the jaw to the neck.

Further along in the process, a brow and a nose have been built out of new edges, created either by dividing existing edges or by drawing new edges with the Cut tool. Different colors have been assigned to logical contour groups to keep the model organized while building. Much of the mesh was hidden to make it easier to work on the face. The mesh is no longer organized in quads, but the less-significant edges have been made invisible to keep the model readable.

With all the faces visible, the mesh was refined for greater roundness. An additional row of edges was added to the top of the blue brow region, and a similar addition was made to fill out the chin. An additional edge was added to the cheek, and turning was used to reorganize all the edges in the area. At this point, the mesh is composed of 64 triangles.

NURBS surfaces are excellent for displacement mapping, producing subtle organic curvature. Here, a NURBS patch is displaced with the displace.tif bitmap from the MAX Maps directory and rendered in wireframe to demonstrate the effect on the ultimate mesh. Displacement mapping is covered in Chapter 8.

MAX is a close relative to AutoCAD and is therefore an ideal platform for architectural visualization. Steve Smith, an architect and architectural modeler, shows how it's done in this and the next four images. The subject is a burial crypt in a famous German cathedral, constructed of barrel-vaulted ceilings supported by columns. Steve starts with a single unit of clean mesh that can be readily duplicated—built primarily from a loft object.

An axonometric (user) projection in wireframe shows the structure, assembled almost entirely from duplicates of the original unit. A central courtyard is open to light from above and is surrounded on three sides by closed rooms. Only the room to the rear, with the ornamental wash basin, has been fully completed. Note how the clean, simple mesh makes it possible to easily visualize the space in a wireframe render.

Architectural visualization is an art of lighting. And high-quality rendered illumination requires the use of the radiosity method. The model has been textured and exported to Lightscape, now a sibling to MAX in the Discreet product line. A radiosity mesh is then generated that computes the effect of lighting, including bounced light, on all of the surfaces. This mesh stores the lighting information, but is completely separate from (and denser than) the polygonal mesh of the underlying model.

With the mesh hidden, we see the radiosity solution. The effect of bounced light is beautifully captured in soft shadows and gentle gradients. A radiosity solution is camera-independent. All of the surfaces have been lit and rendered, regardless of whether they are currently visible from the camera. As a result, this scene can be used as an interactive walk-through. The downside of the radiosity solution is the lack of general sharpness and poorly rendered shadows from direct (as opposed to bounced) light.

The ultimate result is achieved by applying a ray-traced render on top of the radiosity solution. This sharpens the image and corrects the direct shadows without losing the beautiful atmosphere of the indirect lighting. Lightscape is an essential tool for those interested in creating convincing interiors, especially those that mix contributions of indoor lighting with daylight.

Dave Russell, an artist from Cogswell College, demonstrates convincing interior lighting using tools entirely within MAX. The sense of global illumination is generated by ray-traced and mapped reflections on the various glass surfaces. Note the extraordinary variety of materials and the painterly sense of composition reminiscent of an old European master. Materials and texturing are covered in Chapters 12 and 13.

This and the following 11 images show how you can build a piston from an automobile engine out of NURBS surfaces. (NURBS modeling is covered in Chapter 11.) Dino Giannini, a student at Cogswell College, and I collaborated on this effort. In this image, the first three surfaces are built by vertically extruding curves. The surfaces are then all trimmed using projections of a single profile curve. This provides the basic definition of one-quarter of the final model.

MAX's NURBS can support multiple trims. Surfaces that were already trimmed in the previous step are trimmed with projections of a second curve. This is a powerful way of creating complex edges and contours. After the surfaces are trimmed, a connecting (green) surface is created as a loft between the trim curves.

Two more connecting surfaces (yellow and blue) are lofted between the trim curves. A new surface, in dark green, has been extruded down from a new curve to create an overhanging lip. The small pink surface is then lofted between curves to close the exposed "ledge." Even at this early stage, there are quite a few separate NURBS surfaces.

Another profile curve is projected on the bottom of the major surfaces and used to trim them. Note how the same curve (in red) is used to trim three different surfaces. This angle also exposes the blue loft surface used to create the underside of the lip. Color-coding your surfaces helps keep you organized.

Closing up the bottom beneath the new trim curves required a lot of attention. Such a complex surface cannot generally be lofted in a single unit. The purple surface was originally lofted in two stretches, and the resulting surfaces were then joined into a single one. Because the pinkish surface meets the purple one at a sharp corner, there was no need to join the two.

To cut a hole through the object, the front and rear surfaces are trimmed with a single curve, which is not seen in this image. To create a rounded hub on both sides of the hole, curves are copied and scaled (using the Offset Curve tool) in preparation for building the necessary surfaces.

The new surfaces are built in two parts. The surface that meets the existing flat surface is created as a Blend Surface and colored dark orange. The Blend Surface preserves surface tangency, creating the impression that the curved surface is a seamless extension of the flat one. The second surface, seen here in red, is a simple loft.

The edge in the previous image is much too hard. To soften it, the two surfaces are joined, producing a single independent CV surface. By deleting a couple of circular "rows" of CVs (control vertices) around the edge, a much softer lip is fashioned. The model is also simpler because there are fewer separate surfaces to manage.

A similar hub, in blue, is created from the inside surface. The inner curves of both hubs are then connected by lofting to produce the yellow surface. Note that both sides of all of the NURBS surfaces are made visible during modeling for better comprehension.

The one-quarter model is mirrored twice to create the complete piston. There are four instanced NURBS objects, each composed of 14 different surfaces. By carefully crafting the shape of the surfaces, they appear perfectly seamless where they meet.

NURBS surfaces are ideal, freeform curvatures that must be tessellated into polygonal meshes for rendering—a process called *surface approximation*. A wireframe render is an excellent way to test surface approximation options. This tessellation preserves smooth curvature without burdening the renderer with unnecessarily heavy geometry.

The final render after the application of materials. The primary surface texture was derived from a photograph of a real piston and was mapped using the intrinsic coordinate space of the surface. The other surfaces employ simple bitmaps and procedural textures. Careful observers will note the two notches added to the hub by trimming and lofting—a final realistic touch.

A violin is a subtle and difficult model that makes another excellent test of the MAX NURBS implementation, which is introduced in Chapter 11. For this first of 11 images in the process, I began by creating half of the top of the body of the instrument as a flat NURBS surface and projecting a profile curve from above to trim out the basic shape. I then projected a second trim curve to cut out the distinctive f-hole.

After curving the front surface to create a swollen "belly," the front surface was mirrored to create the back surface. I extracted a trim curve from the border and extruded it to create the side surface. With the careful use of blend surfaces, the front and back surfaces were connected to the side surfaces with smooth, overhanging lips. The view is from the bottom.

The scroll was the hardest part of the project. I drew a NURBS spline in the shape of the desired spiral. Then, I created a straight NURBS surface with the characteristic edges and an exaggerated central ridge. Path deformation was used to "roll" the surface up along the spiral curve, much the same way that you'd roll up a carpet.

The spiral was completed by creating a separate surface as a "plug." I used a projected curve to trim out a hole in the top for the peg box, and extruded down the sides. The pegs were lathed curves, trimmed on both sides, and filled with matching curved trimmed surfaces. The visible white cracks between these surfaces were eliminated by edge merging in the final render.

The neck took some serious planning because it required a combination of smooth bends and sharp edges. I created a single loft surface to define the bend by drawing the component curves. Trim curves were then projected to create the sharp borders. I could get by with "only" four trims because some of the bulging curvature would end up being hidden inside the body of the violin. The image shows the underlying surface (with all its CVs) and the results of the trimming.

To build the fingerboard, I used the two trim curves that defined the top edge of the neck as guides along which to extrude a curve. Of course, the fingerboard needed to be much longer than the neck, but once I had the basic surface, I could extract curves from it, elongate them, and then rebuild the surface from the longer version. To close up the top of the fingerboard, I extracted a curve off the end of the surface and used it to loft a little separate capping surface.

The bridge was a huge trimming challenge. I found that slight changes in the complexity of the outer profile curve greatly affected the accuracy of the projection onto the surface for trimming. A second curve was projected to cut out the hole in the middle. After creating one finished surface, I mirrored it to create the back and connected all the trim curves with loft surfaces to close up the object. Note the guideline showing where the bridge meets the surface of the body. The bulge below this line is hidden inside the instrument and could be ignored.

The tailpiece was another serious trimming exercise. Like the violin body, it required both inner and outer trims on a slightly bowed surface. But unlike the body, none of the curves was extremely complex, so I was able to apply multiple trims without resorting to working in halves. I used two separate curves for the outer profile, to prevent having to turn any sharp corners with a single curve. Then, I trimmed out four identical holes for the strings. This meant a total of six trims, but it worked because none of these were especially complex.

The strings were tedious work, but the concept was easy. I extruded a tiny circular NURBS curve along a path defined by another NURBS curve in a rail sweep. This method provided considerable flexibility. I could change the gauge of the strings by scaling the size of the circle. And I could edit the path curve to carefully fit the strings through the holes in the tailpiece, over the bridge and the nut on the fingerboard, and finally wrap each one around a peg in the peg box.

I had organized the major pieces into separate files for clarity and faster interactive response, and I periodically brought them together to assess the bigger picture. Even with all my care, they did not all match up perfectly in the end, so I made a variety of scaling adjustments. When all was done, the finished geometry looked like this, ready for materials and textures. Note how functional units are color-coded for easy identification.

The finished model was pleasingly smooth and convincing proof that the MAX 3 NURBS implementation is ready for prime time. The surface approximation into polygons was excellent, completely eliminating cracks and gaps between adjacent surface edges. A bit of wood grain texture and some careful experimentation with specularity was enough to produce a satisfactory finish. The serious modeler will be jumping into MAX NURBS with both feet.

The images on these two pages show MAX in a fine art, avant-garde role. Mark Haren, motion graphics designer and Cogswell College alumnus, created an experimental short film from a combination of hand-drawn, scanimation, and 3D techniques. "Sleepless" won a first-place award in the 1998 NextFrame International Student Film and Video Competition and was screened at the 1999 Cannes Film Festival.

Says Mark, "The one element that holds the composition together is the type, which was completely animated in MAX. The organic, random feel was actually carefully orchestrated to fit compositionally with the imagery. It was interesting to use 3D to create something completely the opposite of the usual smooth, polished look. I wanted to exploit the power of MAX, but give the animation a crude, handmade feel."

3D graphics plays an enormous role in scientific and medical imaging. This model of the human spine (shown in front view and side view) by James Yamaoka reflects the precision and careful detail required for this kind of work.

Curtis Egan, a Cogswell College graduate, is currently with ImagineEngine in San Francisco, California. This image is his very creative take on a warrior robot. Note the clever use of Boolean subtraction throughout the object to create detail. This rendering exploits the Mitchell-Netravali fliter, one of the new antialiasing options in MAX 3, for improved clarity and "pop."

MAX is the dominant player in the games development industry, in part due to tradition dating to its 3D Studio predecessors, and in part due to its special strengths in texture mapping. Here we look over the shoulder of Derek Jenson of Dynamix, Inc., as he works on texturing models for the Desert Fighters product. Low-poly models require outstanding texturing. Note how multiple textures are arranged on a single bitmap. MAX's Unwrap UVW modifier (discussed in Chapter 13) provides an Edit UVWs dialog box that is used here to precisely assign mapping coordinates. In both of these screenshots, the selected texture vertices in the dialog box correspond to vertices on the model. This makes it easy to do detailed texturing work and divide up a single bitmap for use over an entire model.

One of the most important commercial uses of 3D graphics is to enable viewers to understand the hidden interiors of complex objects. There are many approaches to this fascinating problem. James Yamaoka, a Cogswell College graduate and independent 3D artist, uses a wireframe rendering approach to reveal the interior mysteries of a hard disk. This model is not only extremely precise, it is also remarkably pleasing in its use of color—cutting a fine line between drafting and visualization.

Hank Gatewood uses MAX professionally to visualize large commericial and industrial signage projects. Usually, this means a rendering of the finished project on site, but he also uses MAX to demonstrate assembly using an exploded view. With animation, you could actually see this whole image come together.

Steve Smith developed a cutaway view into the interior of the Hiryu, a Second World War aircraft carrier. Not only does this model reveal the structure of the ship, but color-coding is used to identify different systems. For example, the light blue color indicates a driveshaft connecting an engine to a propeller.

Mondo Media, in San Francisco's Multimedia Gulch, is one of the premier MAX shops in the world, especially noteworthy for imaginative use of the program. In this piece, designed and produced by Mondo Media for The Locomotion Channel, a beautiful painterly effect blurs the distinction between traditional 2D cel animation and 3D computer graphics. The look is at once rough and charming. 3D animation is crying for fresh ideas like this.

Opposite page: With MAX 3's major push into character animation, the program will become an especially exciting place to be for those with an eye on the entertainment industry. Mike McReynolds, a student at Cogswell College, has a fantastic touch for creating (and animating) attractive and original characters in MAX. These two were created by direct editing of polygonal meshes, with strong texturing and materials. But more importantly, these two characters have, well, character! The character animation toolset is covered in Chapter 21.

Greg Lima is a Cogswell College graduate, currently with Quantum 3D. Here is a logo image he created for the company that makes strong use the kinds of atmospheric and render effects discussed in Chapter 17, including glows and volumetric lights. Clean lines and good design sense give this image the kind of "pop" that is essential to positive business identity. Business graphics is moving into 3D very rapidly, encouraged by the style of video flying logos, film effects, and the Internet.

Another image by Greg Lima is the interior of a computer case. The detailed work here is impressive, both in the geometry and the texture mapping. The business world is hungry for attractive and highly realistic imagery of manufactured products—or of products yet to be manufactured. Due to its ties to AutoCAD and 3D Studio VIZ, MAX is a favored platform for industrial and commercial visualization.

MAX's Patch (Bezier patch) modeling toolset is far simpler than NURBS and more intuitive than polygons. Bezier patches can provide a remarkable degree of subtle curvature with a minimum of defining curves. In this first of three images taken from the Torso Project in Chapter 10, a simple half of a torso is built from only seven patches, and the entire unit is then mirrored to create the other half.

The most amazing part of the Patch modeling toolset is the ability to extrude out branches, just as you would do with polygons. Here, an arm has been simply pulled out of the shoulder. Seamless continuity between the patches is easy to achieve by making the tangent handles of vertices coplanar.

Here's something else you can't do with polygons. A hole is opened for the neck by simply shaping the curves. Note the new segment (dividing the patches) running along the shoulder. It's easy to make such subdivisions to add more vertices, and therefore more local detail, just where you need it. After only a few more subdivisions, there are more than enough vertices to create a very satisfactory level of detail. Bezier curves take some getting used to when you're working in a 3D environment, but they have the advantage of easily producing a muscular look. And you can go back and forth between smooth curvature and sharp discontinuities with ease.

Outdoor vegetation is a real challenge in any 3D scene. There's a lot to learn from the way that Mike Macias handled it here. Note the studied randomness, using repeated elements with small variations. But what really sells the image are the tiny colored flowers that dot the scene, not only lending beauty, but also suggesting depth as they appear from within the foliage.

Mike Macias is a Cogswell College graduate and 3D artist with a great sense of imagery and considerable command over MAX. This bug-inspired tank is a truly original idea in a badly overworked genre, one that blurs the line between organic and inorganic modeling. Note the extent to which the yellow specular reflections on the tank's "scales" and on its wheels contribute to the impact of the image.

You can't have a collection of MAX images without a couple of space scenes. Mike Macias puts his own creative take on the subject, with some unusual and imaginative geometry.

Vertex weighting is the key to getting pleasing bends in a character model that is animated with bones. MAX 3's new Skin modifier, discussed in Chapter 21, has outstanding vertex-weighting tools. The influence of a selected bone over vertices is indicated by color coding. In the images on these two pages, the lower bone is selected. The red and yellow vertices are weighted heavily to follow this bone, but the influence of the bone falls off upward toward the knee, as indicated by the cooler-colored vertices. This happens because the influence of the upper bone becomes a larger factor for these vertices.

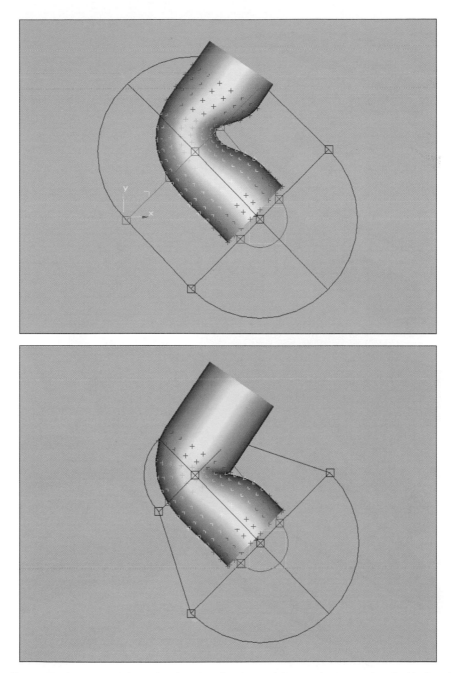

It's easy to adjust general vertex weighting by changing the shape of the envelope associated with the selected bone. Note how such a simple adjustment changes a rubbery bend into one that more resembles a human knee. The color coding is visible in a shaded view as well as a wireframe one, so you can readily see the results of envelope adjustments.

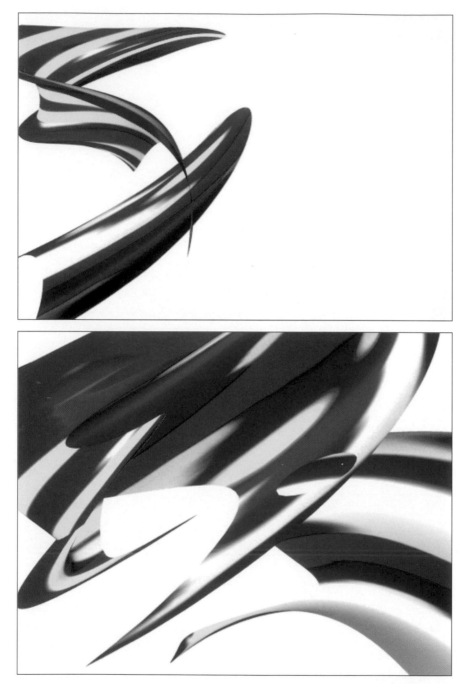

3D graphics and animation is a major development in the visual arts, and its aesthetics are only just beginning to form. Its special beauty is the ability to suggest space and freedom of movement—not just that of the physical world, but the space and energy of the human mind. In these two frames from a small animation, which show the initial "brush stroke" and the final "painting," I used NURBS surfaces to create a free and gestural feeling, seeking the pleasure of a moving paintbrush unconfined by the limits of a canvas.

PART IV

MATERIALS
AND
TEXTURES

MATERIALS AND THE MATERIAL EDITOR

Once you have geometry—the shape or form of your object—you must determine the surface appearance. What colors will render, and what real-world materials should be suggested?

Defining the surface qualities of a 3D model is essentially a question of how it should respond to the lights in the scene. The subject is a mix of quasi-physical principles taken from the real world and practices born out of the peculiar needs of the virtual world.

What Is A Material?

The word "material" is familiar from everyday usage, and this causes confusion to those entering the arcane world of 3D computer graphics. The meaning of the word in computer graphics is technical, and every serious student of 3D graphics must understand this concept. But the word also has a meaning unique to 3D Studio MAX, which overlaps the general computer graphics (CG) meaning. To keep things clear, I'll capitalize the word "Material" to refer to the material object in 3D Studio MAX, and use "material" in lowercase when discussing the general concept in computer graphics.

Materials In 3D Computer Graphics

The precise CG meaning of the word "material" originated in the common meaning of the word. The computer graphics pioneers in the 1970s developed methods for controlling the colors of rendered 3D models to convey the illusion that an object is composed of recognizable substances. For example, a cup-shaped object might be rendered to look like it was made out of glass, ceramic, metal, or plastic. Because the purpose was to create the convincing impression of real-world objects, it was natural to think in terms of simulating real-world materials, and so the word "material" was adopted into the emerging language of computer graphics.

Even from the start, however, the word "material" meant something broader. The features of a physical material that give it characteristic visual qualities can be abstracted into the way it reflects light. In computer graphics, a material is a collection of parameters that determine how the surface of a 3D model responds to the light sources in the scene, and therefore determine the colors of the pixels representing that object in a rendering. These parameters are

designed to produce workable results for rendering purposes, and therefore may not correspond to physical reality. But a CG material need not be designed to simulate a real-world substance. Any combination of the parameters that determine how a surface responds to the light sources in a CG scene, and, therefore, what pixel colors are produced in a render, is called a *material*.

Material Parameters

Consider the parameters of a given material to be its visual elements. The most important is diffuse color. This is close to the common meaning of the "color" of an object. When light strikes a physical surface, certain wavelengths of the light are emitted back into space in all directions. This is a base color—the orange in the skin of an orange or the yellow of a lemon. If you look carefully at either of these fruits, however, you notice other colors that the eye and brain interpret to conceive of the surface. There are white regions that are produced by the light source reflecting off the surface. These are the highlights that characterize shiny substances. The brightness of such highlights can vary, as can their spread. A billiard ball is very shiny—with small, tight, and very bright highlights. A waxy crayon has duller highlights that are more spread out.

A close look at the orange or lemon reveals small patterns of darker color that you interpret as the small shadows created by the surface terrain. Thus, variation in the diffuse color over the surface is likely to be understood as physical texture (relief) rather than just irregularities in the "true" color of the object.

An orange may be shiny, but not in the same way as a mirror. A mirror reflects the colors of other objects in the room, and not just the light sources. The shininess of the orange or the billiard ball is called *specularity* (or specular reflection) in computer graphics. The term *reflection* (all by itself) is reserved for mirror-like surfaces, in which the colors of other objects in the scene are visible. This is a great example of the difference between the CG material concept and reality. In physical reality, there is no distinction between specularity and reflection. A reflective surface reflects light from all origins—whether it is the direct light from light sources or the light emitted from objects as diffuse color. If you look carefully at a shiny billiard ball, you see the highlights caused by the reflection of light from lamps and also the reflection of your own face (diffuse color). The same is true of a shiny piece of fruit, except that object reflections are much less intense than highlights from light sources and are more likely to be obscured by the diffuse colors of the fruit itself.

Computer graphics distinguishes between highlights (specularity) and reflections for important practical reasons. Highlights can be correctly rendered with only the information relating the direction of the light source to that of the surface. Because this operation is fast enough to perform in realtime, specular highlights are visible in your shaded preview. Reflections require information relating the directions of light paths connecting objects in the scene. This is most correctly obtained through ray tracing—a powerful, but very time-consuming, rendering method. Because object reflections are noticeable only on mirror-like surfaces, it makes sense to ignore them when rendering materials that are intended to reflect

only highlights. Highlights are extremely important in conveying a 3D effect. They not only suggest the shininess of the material, but also the contours of curved surfaces. Even a small amount of specularity helps communicate the shape of curved geometry.

In Figure 12.1, the ball on the left has no specularity, and its curvature is conveyed only through the gradation of the diffuse color. The ball in the center has a small degree of specularity. The surface does not look shiny, yet the faint highlights help to communicate the shape. The ball on the right has even more pronounced highlights, but they are spread to avoid a shiny appearance. The curvature of the sphere is even more apparent with these increased visual clues. Specular highlights also help to tie objects together in a 3D scene, by suggesting their relative positions to the light sources.

Transparency (or its inverse, *opacity*) is another essential material parameter. If a material is completely transparent, it is invisible. Thus, glass-like surfaces must rely on specular highlights and object reflections to reveal themselves. Transparent objects generally refract light passing through them, so objects appear distorted or shifted as seen through such surfaces. Refraction is therefore a necessary material parameter, but one that is available only if the material contains at least some transparency.

Shaders And Material Parameters

Materials exist within shading models (often called shaders). A *shading model*, or *shader*, determines what information the material definition must contain in order to render the surface. The classic Phong or Blinn shaders are the most important and contain all of the best known material parameters, such as the following:

- Ambient color
- Diffuse color
- Specular color
- Specular intensity
- Specular spread

Figure 12.1
Specular highlights contribute visual clues that help the viewer read the curvature in 3D objects. The sphere on the left is without specularity. Its curvature is revealed only by the gradation of its diffuse color. Even the small amount of specularity in the middle sphere does a lot to reveal the contours. In the sphere on the right, the intensity of the highlight is increased, but the broad spread keeps the object from appearing shiny.

- Self-illumination (or luminosity)
- Transparency (or opacity)
- Reflection
- Refraction

Some features of these shading models take a moment to understand. Note the three different kinds of color. The diffuse color is revealed only to standard light sources in the scene. Ambient light is a kind of general, completely nondirectional lighting that is used to fill out shadow areas. Standard computer graphics lighting does not provide for reflected light. Regions that are shadowed from direct light rays are therefore completely black, without ambient light. In the real world, light reflected off of surfaces typically provides a huge percentage of the total illumination, especially indoors. The radiosity rendering technique uses reflected light, and therefore can produce extremely realistic interior scenes. In absence of radiosity, ambient light is used as a fix to simulate the all-over illumination that results from light bouncing off of surfaces. In the Phong and Blinn shaders, the color revealed by the ambient lighting can be different from that revealed by the direct lighting (in the diffuse color parameter). Once again, this is something that could not occur in the physical world.

Specular color is the color of the specular highlight. Normally, it makes sense to make this color the same as that of the light sources. But colored (or slightly colored) highlights can be used for both realistic and fantasy purposes.

Self-illumination, or luminosity, is a parameter that controls the brightness of diffuse color independently of the light sources. A surface with a self-luminous material value is visible in a scene without any lights at all. Luminosity is used to make objects such as neon signs appear self-illuminated, but it's also useful to simply add a little brightness to objects that are lit by light sources. The luminosity parameter does not cause the surface to emit light; thus, nearby objects are not affected.

Shading models other than Phong or Blinn differ in their material parameters. The Lambert shading model (not found in MAX) has no specular components. Other shading models handle specular highlights in more specific ways than the Phong and Blinn shaders do. And some, such as the Strauss shader, are organized much differently from the Phong and Blinn standards.

Materials Distinguished From Textures

One sure sign of the 3D professional is that he or she knows the difference between materials and textures, and doesn't confuse the two. The material is the complete definition of all the parameters required by the shader. Each material parameter, by default, has only a single value. For example, a single diffuse color applies to the entire material.

By "mapping" a material parameter, you can vary the value of the parameter over the surface. The most important example is the use of a bitmap image to provide the color values for the diffuse color parameter of a material. Instead of having just one diffuse color in the

SHADING MODEL OPTIONS ARE GREATLY EXPANDED IN MAX 3

Shading models have taken on increased importance in MAX 3. The list of available shaders used to be small. The Phong and Blinn options generally produce very similar results, and the only really important decision used to be whether to use the Metal shader for metallic surfaces.

MAX 3 places new emphasis on shader choices with seven options. The different shaders can produce strikingly different results. Phong and Blinn remain the most important options, but the new shaders can provide more precise tools for high-end materials work. For the materials professional, the materials-building process begins with the choice of shader.

material, the colors of all the pixels in the bitmap are used. (I'll leave the issue of the way the bitmap is applied to the surface of the model to the next chapter.) The use of a bitmap (or a procedure) to vary the diffuse color parameter of a material over a surface is often called texture mapping, or texturing. This is because the technique was developed to create the illusion of surface texture, such as the pebbly surface of a basketball. But, like the word *material*, the term *texture mapping* has a broader meaning than its origin might suggest. To *texture map* a surface is to map its diffuse color parameter, regardless of whether the color variations suggest surface relief. The MAX interface does not use the word *texture*, and a texture map in MAX is simply a map that is applied to the diffuse color parameter of a material. By contrast, a bump map, which always creates the illusion of surface texture, is never called a texture map.

A material is required, but a map is optional. Each parameter of a material has only a single value unless a map is applied. Thus, there can be many maps associated with a material—one (or even more than one) for different material parameters.

Materials In 3D Studio MAX

Materials in MAX are a specific implementation of the material concept in 3D computer graphics. A *Material* in MAX is a MAX object. (Remember that I'll be capitalizing the word when referring to the object in MAX, as opposed to the general concept.) A MAX Material is the entire package necessary to define the colors that are rendered to pixels when a surface is rendered.

Think of Materials hierarchically, as a sequence of decisions to be made from the general to the specific.

Material Types

At the top of the hierarchy is the Material type. The basic Material type is the Standard Material, but there are also Raytrace and Matte/Shadow Materials. There are also a number of Compound Materials, which are containers for combining more than one Material on an object. The Compound Materials use the Standard, Raytrace, and Matte/Shadow Materials as Sub-Materials. If a Compound Material is used, each Sub-Material is defined independently.

Shaders

For the Standard and Raytrace Materials, you have a choice of shaders (shading models). The number of alternatives is larger for the Standard Material. The Matte/Shadow Material does not have shader choices because its function is to hide a surface rather than reveal it.

Material Parameters

The choice of shader for a material determines the parameters of the material. So the next step is to set all these parameter values.

Maps

If a given parameter cannot be satisfied with only a single value for the entire surface, a Map object is applied to that parameter. The Map uses either a bitmap image or a *procedure* (a small program that receives user input) to create the variation in the parameter. The Map object overrides the parameter values entered in the Material Editor.

Using The Material Editor

The only way to understand MAX Materials is to work with them. Fortunately, you can learn a great deal by using only the Material Editor. In this section, you'll get a handle on MAX's powerful but rather complex Material Editor:

1. Create a Sphere object and open up the Material Editor. The Material Editor can be reached through the Main Toolbar or the Rendering Toolbar, but most conveniently through the Ctrl+right-click menu (hold down the Ctrl key and right-click on the mouse). The upper and static portion of the Material Editor is illustrated in Figure 12.2.

Figure 12.2
The upper and static portion of the Material Editor with the default six Material slots.

2. By default, six slots are visible in the Material Editor, but there are actually 24 slots available. Place your cursor over the space between the slots and drag the window, both horizontally and vertically. You'll see that there are four rows with six slots in each.

3. Right-click on any of the slots and note that you can choose to see more, but smaller, samples at one time. Try the 6×4 option. All 24 slots are visible at once, although they are pretty tiny. Right-click on any slot again and try the Magnify option. A larger separate window appears, apart from Material Editor (see Figure 12.3).

Figure 12.3
The Material Editor, with the display changed to fit all 24 samples in the visible window. The size of each of these samples is very small, so the selected slot is magnified. The magnified version can be moved around the screen, independently of the Material Editor.

Moving Materials Between Slots And Objects

It's very important to understand the relationship between Materials in the slots in the Material Editor and Materials on objects. When an object is first created, it doesn't have a Material; instead, it has an Object Color. Object Colors are assigned to help distinguish objects on the screen. Let's continue our exercise by learning how to move materials between slots and objects:

4. Select your Sphere and go to the Modify Panel. At the top of the panel is the name of the object, and to the right is a color box with the Object Color. Click on that color box and use the Object Color dialog box to change the color. This does not, however, assign a Material.

5. Open a Track View window from the Main Toolbar or from the menu bar. Notice that there are 24 Materials listed under Medit Materials (the Material Editor), but none under Scene Materials. Put a Material in one of the slots onto the Sphere object. With the Sphere object selected, click on the upper-left slot in the Material Editor. The Material Editor indicates that "Material #1" is selected. Beneath the sample slots is a row of icons. The third icon from the right is Assign Material To Selection. Press this button and watch your Sphere assume the color of Material #1.

6. Look at Track View again. A little plus sign has appeared next to the Scene Materials label. Click on it to open up the track. Notice that Material #1 is now in two places at once: in a slot in the Material Editor and on an object in the scene. The

Figure 12.4
After Material #1 (in the first slot of the Material Editor) is assigned to the Sphere, that Material is stored in the MAX file in two separate places: on the object and in the slot. A Track View window shows Material #1 in the Material Editor, in the list of Scene Materials, and on the Sphere object itself.

Material is in a third place, as well. Open up the Objects label and the Sphere within it to find the Material once again. Figure 12.4 shows the current state of the Track View window.

7. Look at a wireframe view and notice that the Object Color is still used for the wireframe (when the object is unselected), despite the Material assignment. Only a shaded preview shows the color of the Material.

8. Drag Material #1 from its current slot in the Material Editor to the slot next to it. Even though both of these slots now have the same name (Material #1), only the first slot is connected to the Sphere. With the second slot selected, click on the Diffuse color box in the Material Editor. Change the diffuse color and notice that the change is reflected in the slot sample, but not the object. Go to the first slot and change the diffuse color there. This time, the object color changes along with the slot sample.

The Material/Map Browser

You could continue creating objects and connecting them to slots in the Material Editor, but what happens when you need more than 24 Materials? Even though there is room for only 24 Materials in the Material Editor, there can be as many Materials in the scene as can be assigned to objects, as we'll see as we progress with our exercise:

Figure 12.5
The Material/Map Browser.

9. To recover the first slot, click on it to select it, and press the Get Material button—the first one on the left in the row beneath the slots. The Material/Map Browser appears, as seen in Figure 12.5.

10. Take a moment to look over this important dialog box. On the right is a list of all of the possible Material and Map objects. The Materials are listed first and bulleted with a blue ball. The Maps follow with a green parallelogram. The Show section of the dialog box allows you to filter out either category. The dialog box displays options for new Materials and Maps. Page through the options in the Browse From section of the panel to see other alternatives. The Material Library contains a broad range of stock Materials that are supplied with MAX. If you select one of these, it will be loaded into the slot. The Selected option provides the Material assigned to the selected object if an object is selected. The other Browse From options are easy to understand. Return to the New option and choose a Standard material by double-clicking on that item on the list. A new Standard Material appears in the first slot, in the default gray color.

11. This slot is now free to define a new Material however you wish, and assign it to an object in the scene. But what if you need to edit the Material on the Sphere again? Just pick a slot that you're not using right now and pull the Material off the object. Give it a try. Select the Sphere; then, select a slot and press the Get Material button. Use the Selected option in the Material/Map Browser and double-click on the only Material that appears in the list (it indicates the name of the selected object). Note that Material #1 is now in the selected slot, ready for editing.

A Couple Of Shortcuts

Another way to get a Material off an object is even faster than the process we used in the previous few steps of this exercise:

12. With the desired slot selected, use the eyedropper tool to the left of the Material name to click on the object. The object doesn't have to be selected. Try this in another slot.

13. There's also a quicker way of freeing up a slot. Select the slot you just used to pick up the Material from the object. Press the Make Material Copy button in the middle of the row beneath the sample slots. The Material in the slot does not change, but the white triangles in the corners of the slot disappear. This means that the slot is no longer connected to the object. Change the diffuse color of the Material in the slot and note that the object remains unaffected. If you wish to put the revised Material back on the object, either select the object and assign the Material in the usual way or just press the Put Material To Scene button (second from left). This button assigns the Material to the object because the names of the Material in the slot and the Material on the object are still the same.

Using The Material Library

Sometimes, you want to save Materials to disk. You may have developed a number of variations of a Material, but you don't want to waste valuable space in the Material Editor. Or, you may want to save a useful Material for use in other scenes. Just as you can get a Material from the Material Library, you can save a Material as well. Let's see how this applies to the exercise at hand:

14. Select any slot you want. The current name of the Material is not sufficiently descriptive to be useful in a library. You can change it in the Material Editor, or you can change it when you save it. Press the Put To Library icon in the middle of the row beneath the sample slots and change the name if you haven't already.

15. To call up the Material from the Material Library, pick a different slot and press the Get Material button. When the Material/Map Browser appears, use the Material Library option. The name of your Material appears in the list. Check out the viewing options represented by the first four buttons above the list. These options are available, whatever the source of the Materials in the list. The three buttons to the right are available only when browsing a Material Library. You can delete a Material from the library, clear the entire library, or update the scene with Materials from the library that have identical names. Double-click on your saved Material to load it into the Material Editor.

The Standard Material

The Standard Material type is used in the majority of cases, either by itself or as a Sub-Material in a Compound Material. Indeed, the other two primary Material types, Raytrace and Shadow/Matte, are not really materials in the conventional computer graphics sense.

The Standard Material implements the full range of shaders (shading models) that are available in 3D Studio MAX. The choice of shading model determines the parameters that must be defined for the Material. As you will see, the primary significance in the choice of shader is in the treatment of specular highlights.

Phong And Blinn Shaders

The Phong and Blinn shaders are the most important and most suitable for the broadest range of uses. Their parameters are identical; the only difference is the appearance of specular highlights. Follow these steps:

1. Open the Material Editor and select a sample slot. Right-click on the slot and select Magnify to create a magnified window. Right-click again and choose Options to call up the Material Editor Options dialog box, as illustrated in Figure 12.6. (This dialog box can also be called from a button in the column to the right of the sample slots.)

Figure 12.6
The Material Editor Options dialog box, with its default values.

2. Take a moment to look over these options. Note that each sample is rendered by using two lights—one from the top and one from the back. The color and intensity (Multiplier value) can be adjusted in this panel. Increase the Multiplier value for the top light and press the Apply button. The top light becomes brighter for all the samples in the Material Editor, including the magnified copy. Click on the Default button to return the Multiplier to the default value. Now, increase the Ambient Light Intensity value and press Apply. All the samples become generally lighter.

Note: The default value for ambient light is a low but significant value in the Material Editor. However, the default level of ambient light in a MAX scene is very low. This can account for a confusing difference between the appearance of a Material in the Material Editor and its appearance on an object in the scene. Ambient light for a MAX scene is set in the Environment dialog box, which is reached through the Rendering menu.

Specular Highlights

Now, let's continue by adding specular highlights:

3. Return the Ambient Light Intensity to its default value and close the Material Editor Options dialog box. Compare the specular highlights in the Blinn and Phong shaders. Drag the Material from your magnified slot into another slot to create an identical copy, and magnify the second slot. Place the two magnified windows side-by-side for comparison. Both samples will use the Blinn shader because this is the default. Select one of the samples and change it to the Phong shader by using the drop-down list.

4. Increase the Specular Level parameter to 100 for both samples to create a strong highlight. Play with the Glossiness parameter to see how this adjusts the spread of the highlight and then return it to the default value of 25. Leave the Soften parameter at its low default value. Compare the two magnified samples. The top-lit highlight is tighter and a bit softer in the Blinn sample than in the Phong one. The backlit highlight is much broader in the Phong sample. In both samples, the backlit highlight is a glancing one, whereas the top-lit one is direct. Your samples should look like those shown in Figure 12.7.

Figure 12.7
Specular highlights in Blinn and Phong shaders, compared in a Standard Material. Both samples use a Specular Level of 100, and Glossiness is set to the default of 25. The top-lit highlight is tighter in the Blinn sample on the left than on the Phong sample on the right. The glancing backlit highlight is much broader in the Phong sample.

5. Increase the Soften parameter to 1.0 (the maximum) for both samples and compare. As you can see in Figure 12.8, softening has a much greater effect on the glancing highlights than the direct ones. Even so, the Phong highlights remain broader than the Blinn ones.

Figure 12.8
Same as Figure 12.7, but with the Soften parameter increased to its maximum value. Softening has a much greater effect on the glancing highlights than on the direct ones, but the Phong highlights remain broader than the Blinn ones.

6. Note that the default specular color is white. This effectively means that the high-lights will be the color of the light sources that create them, without any tint. Leave the specular color at its default and change the color of the top light to a strong yellow in the Material Editor Options dialog box. Press Apply. The top highlight is now yellow because the light is yellow. But the entire sphere is yellowed also because the light affects the diffuse color response, as well as the specular highlights.

7. Try it the other way. Return the light color to its default white and change the specular color of the Material to yellow. This time, only the highlights are yellow and the diffuse color region is unaffected. Most shiny objects reflect back only the color of the light; therefore, most highlights are white if the light source is white. Some substances, most notably metals, have tinted highlights, however. Notice that you can lock the diffuse and specular colors on the Material Editor. If you lock them, the specular color always remains the same as the diffuse, so the color of the highlights are tinted with the diffuse color of the surface.

Ambient Color

Ambient lighting is a computer graphics shortcut that is not based in physical reality. In the real world, surfaces have only a diffuse color, which responds equally to direct or indirect light. In computer graphics shading models, an object can use a color in response to indirect (ambient) light that's different from the color that responds to direct light (the diffuse color). This concept is, admittedly, quite confusing, and it takes a while to become accustomed to it. Continue your experimentation as follows:

8. Click on various samples in the Material Editor and notice that, by default, the ambient color is a darker shade of the diffuse color. To maintain this relationship as you change diffuse color, lock the ambient and diffuse values together. This keeps them precisely the same, so if you decide that the ambient color should be darker, open up the Color Selector dialog box and lower the Value slider.

The ambient color is necessarily most noticeable in areas that are not exposed to direct light. The rendered color is the result of the color of the ambient light in the scene and the ambient color of the material. Unlike most direct light sources, the ambient light is often a color other

than white because ambient color is used to approximate the effect of light bouncing off surfaces in a room. This indirect light takes on a mix of the colors of the surfaces. Unfortunately, the Material Editor is not capable of applying colored ambient light in the slots, and thus any real testing must be done by rendering MAX scenes.

Opacity And Advanced Transparency

Opacity and transparency are inverses of each other. A surface that is 0 percent opaque is 100 percent transparent. MAX uses both terms in the Material Editor. The overall value is set in the Basic Parameters rollout as Opacity, and the Extended Parameters rollout contains Advanced Transparency controls. All of these are identical in both the Blinn and Phong shaders. Let's continue our exercise by seeing how opacity and advanced transparency work:

9. Select a fresh sample slot and press the checkerboard icon to the right of the samples to get a colored background image. Play with the Opacity spinner to see the effect.

10. Open up the Extended Parameters rollout to look at the Extended Transparency controls. Note the three Type options. The default of Filter allows you to tint or intensify the color of the transparent object to simulate the effect of light passing through colored glass. To test it out, change the diffuse color of the Material to a bright yellow and set the Opacity spinner to 40 percent. The effect is merely washed out. Then, set the Filter color to the same yellow and notice how the sample brightens up.

11. The Falloff controls are also very useful. Set the Opacity of your sample back to 100 percent. Choose the In option for Falloff and increase the Amount spinner to 100. The sample sphere is now 100 percent transparent in the center and opaque around the edges. This is excellent for simulating the walls of glass vessels. Flip to the Out option, and the effect reverses. The increasing transparency toward the edges is just right for smoke and clouds. To see these effects better, toggle off the background pattern. Then, open up the Material Editor Options dialog box and increase the Background intensity to 1.0, which makes the background white. Finally, check the Anti-Alias box. Antialiasing increases the refresh time for the samples, but displays much sharper edges. See Figure 12.9.

Figure 12.9
Falloff transparency options are compared. In the sample on the right, the In option causes transparency to increase toward the center of an object, leaving the opaque edges typical of glass vessels. The sample on the right used the Out option, and its transparency increases toward the edges.

Metal Shader

The Metal shader generates its specular color from the diffuse and ambient colors. The distinguishing characteristic of metals is that they reflect mostly specular highlights. Take a gold ring into the shade and it's very dull—only in direct light does it reveals its characteristic color. Let's try out the Metal shader:

1. Select a slot in the Material Editor and change to the Metal shader. Notice that there is no specular color parameter. Magnify the sample.

2. Set the diffuse color to a brownish yellow and lock the ambient color to the diffuse. Once the two colors are the same, unlock them and reduce the Value slider for the ambient color until it is a very dark version of the diffuse color. Note the effect of moving the slider in your sample.

3. Set the Glossiness parameter to 60 to create a fairly tight highlight. Now, try increasing the Specular Level. Note that increasing this value increases the contrast between the specular region and the diffuse region of the surface. The area within the highlight grows brighter using the diffuse color of the surface. The remaining area grows darker. At high Specular Level values (above 100), the area outside the highlights is black. In Figure 12.10, the Specular Level values are 50, 100, and 200 from left to right.

Figure 12.10
The Metal shader produces increased contrast between the highlights and the nonspecular areas of the surface as the Specular Level value is increased. All three samples use a Glossiness value of 60, but the Specular Level values are 50, 100, and 200 from left to right.

4. Return to the ambient color and experiment a bit. First, try increasing the value of the color back closer to the diffuse color. Then, try different hues. The impact of ambient color is much stronger when the Specular Level values are lower. Tinting the material with a contrasting ambient color can produce a very exciting effect.

5. Note that all of the other parameters in the Metal shader are identical to those found in the Blinn and Phong shaders.

Anisotropic Shader

The Anisotropic shader differs from the Blinn and Phong shaders in that it is able to create the elliptical highlights that are characteristic of glass and brushed metal surfaces. To use the Anisotropic shader:

1. Select a slot in the Material Editor and change to the Anisotropic shader. (You may want to use the Reset Map/Material button (with the "X" icon) to restore default parameters before you do.) Increase the Specular Level parameter to a high value, such as 75, to get a strong highlight.

2. Play with the Anisotropy spinner. At a value of 0, the specular region is circular, like a regular Blinn highlight. As you increase the value, it narrows in one dimension and becomes elliptical. You can see the effect, both in the sample slot and in the clever 3D graph on the panel. Change the Orientation value to rotate the highlight. Figure 12.11 illustrates this. On the left, the Anisotropy value is 0. In the center, the value is increased to 50. On the right, the highlight is rotated.

Figure 12.11
The Anisotropic shaders permit elliptical highlights that are characteristic of many shiny materials. On the left, an Anisotropy value of 0 produces the same circular highlight as the Blinn or Phong shaders. In the center, a value of 50 creates an elliptical highlight. On the right, the elliptical highlight is rotated using the Orientation parameter.

3. All other parameters of the Anisotropic shader are the same as those found in the Blinn and Phong shaders, except for Diffuse Level. Reducing the Diffuse Level from its default value of 100 reduces the value of the diffuse color—in short, it darkens it. The same result can be achieved by reducing the value of the diffuse color with the Color Selector dialog box, but the separate Diffuse Level is mappable. This makes it easy to create grayscale maps to vary a single diffuse color, or even to vary a color texture map.

Other Shaders

The Multi-Layer shader is identical to the Anisotropic shader, but it permits you to superimpose two layers of specular highlights on a surface, each with its own values. The Oren-Nayar-Blinn shader is a Blinn shader with additional diffuse parameters. One is the Diffuse Level parameter found in the Anisotropic shader (and discussed previously). The other, Roughness, is unique to the Oren-Nayar-Blinn shader. Increasing Roughness narrows the range of diffuse color values over a surface, producing a matte effect. The word "roughness" should not be understood to suggest a textured surface. Rather, the physical cause of a matte appearance is a very fine surface roughness (just as specularity is ultimately attributable to surface smoothness). Run your finger over the surface of a terra cotta pot and you'll feel the very fine texture that breaks up reflected light.

The Strauss shader is a simpler alternative to the Metal shader. There is only a single Color parameter, and therefore no distinction between ambient and diffuse color. The Specular Level and Glossiness parameters of the other shaders are merged into a single Glossiness parameter. When a high specularity is added to a surface using this parameter, the Metalness parameter darkens the contrasting diffuse color to give the characteristic metal effect.

Other Material Types

The MAX Materials, other than the Standard Material, fall into two classes. The Raytrace and Matte/Shadow Materials can be used as alternatives to the Standard Material. The various Compound Materials are combinations built from two or more Standard or Raytrace Materials as Sub-Materials. Although theoretically possible, it is not likely that a Matte/Shadow Material would be used as a Sub-Material in a Compound Material. The most important Compound Material is the Multi/Sub-Object Material, which is used to assign different Materials to different regions of an object.

Raytrace And Matte/Shadow Materials

Ray tracing is a rendering method for producing accurate shadows, reflections, and refractive effects through transparent objects. MAX implements ray tracing in a rather unique way. MAX has always offered raytraced shadows as an option available for lights. The ray tracing of reflections and refractions appeared first in MAX 2, and it is offered as an option for the specific surfaces that are intended to be reflective or refractive. Although ray tracing is not a material in the computer graphics sense, if you want a surface to render with raytraced reflections or refractions, you can assign it a Raytrace Material. You can also use a Standard Material and assign a Raytrace Map to the Reflection or Refraction Map channels. Ray tracing is no more a map than it is a material, but this is the way the MAX interface allows you to instruct the renderer to ray trace a surface. The Raytrace Material, together with the Raytrace Map types, will be discussed in the next chapter.

The Matte/Shadow Material is used for compositing. A surface that is assigned a Matte/Shadow Material becomes invisible, but it blocks any geometry behind it, revealing only the background image (if there is one). The Matte/Shadow is typically used on flat silhouette objects that are used to mask out geometry. In the most common example, a scene contains a background image of buildings or trees. A 3D object is added to the scene, but it must appear as if it is behind the background "objects." Masking surfaces are modeled and placed in front of the 3D object. If a Matte/Shadow Material is assigned to a masking object, the region of the 3D object directly behind it disappears, revealing the background. The effect is as if the 3D object is partially obscured by the background "objects," and is therefore behind them. A *matte* is a background image, in motion picture parlance, so the Material effectively turns a masking object into a part of the background. Objects with Matte/Shadow Materials can both cast and receive shadows.

Multi/Sub-Object Material

The Multi/Sub-Object Material is an absolutely essential tool that every MAX user must understand completely. Every application has its own approach to assigning different materials to different regions of a single object. In MAX, the entire object is assigned a Multi/Sub-Object Material that contains two or more Sub-Materials. Each Sub-Material (which is almost always a Standard Material) is assigned to regions of the objects on the basis of Material IDs. Thus, the process is divided into two steps:

1. You must divide the object into the appropriate Material IDs.

2. You define the Materials for each Material ID as a Sub-Material in a Multi/Sub-Object Material.

Assigning Material IDs is accomplished differently for different objects. For polygonal mesh objects, Material IDs are assigned to faces. For Patch objects, they are assigned to patches, and for NURBS (Non-Uniform Rational B-Spline) Surface objects they are assigned to surfaces. Thus, you may have to divide NURBS and Patch surfaces to create regions to be assigned separate Materials.

This exercise uses an Editable Mesh. You can assign Material IDs in Edit Mesh on a parametric object, but it almost always makes more sense to convert to an Editable Mesh object before you start assigning and defining Materials. The Materials process is typically begun only after modeling is completely finished.

The Traditional Method

To assign and define Materials using the traditional method:

1. Create a Box object of any size and convert it to an Editable Mesh. In the Face Sub-Object level, pull the panel down to the tiny section titled Material in the Surface Properties rollout.

2. When you create the primitive object, MAX typically has already divided the surface into Material IDs, which can be convenient. To see which Material IDs are already assigned, press the Select By ID button. If you page through the numbers 1 through 6 in the Select By Material ID dialog box, you find that all six quad sides of the mesh have been assigned different Material IDs.

3. You can assign your own. Assigning Material IDs is a subtractive process. You start by assigning all of the faces to one ID, and then pull faces from the group to assign to other IDs. Use Select All in the Edit Menu to select all of the faces. Enter the number 1 in the ID spinner on the Editable Mesh panel and press Enter. Click on the screen to clear your selection.

4. Now, test to see whether the assignment was successful. Bring up the Select By Material ID dialog box and try the number 1. All of the faces should be selected. Try some other numbers and note that these are now clear.

5. Create three Material IDs, as follows: Select the faces on the top and bottom of the mesh. (Changing from the Face to the Polygon Sub-Object level makes this easier.) Enter the number 2 in the ID spinner and press Enter. Then, select the front and back of the mesh and assign them Material ID number 3. Use the Select By Material ID dialog box to confirm that the assignments worked. Don't be surprised if they didn't—this can be a tricky task. Keep trying until you get it right.

6. Now that the Material IDs are assigned, line them up with a Multi/Sub-Object Material. Open the Material Editor and pick a sample slot. Change the Material Type from Standard to Multi/Sub-Object. (Click on the Type button that reads "Standard" and select Multi/Sub-Object from the Material/Map Browser.)

7. You are asked whether to include the current Material as a Sub-Material, or whether to start with all default Materials. The choice does not matter for your present purposes. When you complete these steps, you see a list of Standard Sub-Materials. You need only three materials, so set that number at the top of the panel.

8. Enter each of the three Standard Sub-Materials and give them different diffuse colors. You can navigate between the Sub-Materials in a couple of ways. Use the Go To Parent button (the up arrow) to return to the Multi/Sub-Object level, and then select another Sub-Material from the list. Or, move directly from one Sub-Material to another using the Go Forward To Sibling Button (the right-pointing arrow). A very direct way to assign only diffuse colors is to click on the color boxes next to each entry on the Sub-Materials list. Note that the sample sphere displays all three Sub-Materials.

9. Finally, the moment of truth. Get out of any subobject level, so the Editable Mesh is selected at the object level. Now, put the Multi/Sub-Object Material to the selected object. If everything works out, mesh is appropriately divided into three different Materials.

A Faster Method For Editable Meshes

Now that you know how to do it the hard way, try a streamlined method that works only for Editable Mesh objects:

1. As before, create a Box object and convert it to an Editable Mesh. In the Polygon Sub-Object level, select all the faces and assign them to Material ID #1. Use the Select By Material ID dialog box to confirm that this worked.

2. With all the faces selected (and assigned to Material ID #1), drag from a slot in the Material Editor that contains a simple Standard Material onto the mesh. All the faces will adopt this Material. Select the faces on top and bottom, and drag from a second slot onto these. Repeat this again with the front and back. In the end, you should have three different Materials on the mesh, each in a separate slot.

3. Even though you created this collection from separate slots in the Material Editor, MAX already created a Multi/Sub-Object Material for you. Pick a new slot and use the Get Material to grab the Material off the selected object. Now, there's a Multi/Sub-Object Material ready to go, with all the Material IDs assigned for you.

NURBS And Bezier Patches

NURBS Surface objects can be composed of multiple Surface subobjects. Material IDs can be assigned to a selected Surface subobject in its Material Properties rollout. For Bezier Patch objects, selected Patch subobjects are assigned their Material IDs in the Surface Properties rollout in the Edit Patch or Editable Patch panels.

Composite, Blend, And Shellac Materials

The Composite, Blend, and Shellac Materials are used to layer different Materials on top of each other. The Blend Material is limited to two Sub-Materials. The Mix Amount spinner determines their combination. At 0, only the first Sub-Material is visible; at 100, the second Sub-Material completely takes over. A Map object can be used as a Mask between the Materials.

The Composite Material has no masking, but can layer up to 10 materials. This can be a superior alternative to nesting Blend Materials inside each other. The Shellac Material is, once again, limited to two Materials, but it performs a distinctive color-blending effect that is more sophisticated than simple color compositing.

Top/Bottom Material And Double-Sided Materials

The Top/Bottom Material and Double-Sided Materials position Materials on opposing sides of an object. The Top/Bottom Material can save a lot of the effort that would be spent selecting Faces to assign Material IDs. The Double-Sided Material places different Materials on opposite sides of a single surface, which is something that can be achieved in no other way. The obvious application is pages in a book. There's even a translucency feature that allows the two Materials to blend together.

Moving On

In this chapter, you explored both the basic principles of materials in computer graphics and their particular implementations in MAX. You saw that MAX relies primarily on a Standard Material type, but that type is available in many different shading models (shaders). The choice of shader determines the parameters that must be defined to create the Material. You also examined the various Compound Materials that are used to combine multiple materials on a single object or surface. The most important of these is the Multi/Sub-Object type, which relies on Material IDs to assign different Materials to different regions of an object.

The next chapter covers maps and mapping. As I explained in this chapter, each Material parameter can be mapped so that its values can vary over the surface of the object. Mapping is essential to creating subtle and realistic Materials effects.

MAPS AND MAPPING

Simple material definitions are often insufficient for creating rich and convincing surfaces. Bitmaps and procedural textures provide the necessary detail and realism.

Mapping is perhaps MAX's greatest strength. No application has as complete and powerful a toolset for applying bitmap images to surfaces, and this is one of the reasons for MAX's high status in the games-development world. Where the geometry must be simple, texture mapping becomes critical; but mapping is also important in high-end work. MAX offers an outstanding collection of procedural textures that are often more useful than bitmaps. This is a big subject, so let's get started.

Mapping Material Parameters

For most of the parameters within a selected material type, you choose between using a single overall value and a map type that varies the values over the affected surface. The most obvious and important example is when the pixel colors of a bitmap image are used in place of a single color in the diffuse color parameter. This is the technique called (rather confusingly) "texture mapping," although the color pattern need not necessarily suggest a surface texture. The concept is much more general, however. Any time different values are to be distributed over a surface for a given material channel, a MAX Map object is used.

Mapping is the process of determining what values are assigned to what regions of the surface. Think of real-world maps. If you have a map of the United States set before you, you know that each point on the map corresponds to a spot on the Earth. There may be issues of scale and distortion, but you can at least be certain that the locations that are next to each other on the map are also next to each other on the surface of the Earth. You are accustomed to starting with real-world terrain, and then drawing a mapped representation—going from the 3D world to a 2D (or even 3D) representation. In computer graphics, however, you generally go in the other direction—placing colors or other values from the representation onto the virtual 3D object. For example, you map from a bitmap image to the surface of the 3D model. It takes awhile to get used to thinking like this.

Figure 13.1
The Maps rollout of the Material Editor for a Standard Material, using the Blinn or Phong shaders.

The Map channels are available in the Maps rollout in the Material Editor. Figure 13.1 shows the Map channels available for the Blinn (and Phong) shaders in a Standard Material. This is the list you'll work with most of the time.

Maps For Standard Material Parameters

Take a moment to compare this list with the Material parameters. The following channels are the same as parameters in the material:

- Ambient Color
- Diffuse Color
- Specular Color
- Glossiness
- Specular Level
- Self-Illumination
- Opacity
- Filter Color

This relationship is confirmed by the little gray squares next to each of these parameters' Material Editor. These squares can be used to assign a Map object to the parameter, just as you can do in the Maps rollout. If a map is assigned, an "M" appears in the box. Figure 13.2 shows the Basic and Extended Parameters rollouts in the Material Editor. The gray squares are on the right of each of the parameters listed previously. A map was assigned to the Diffuse Color parameter.

The Ambient Color mapping is locked to the Diffuse Color mapping, by default. This almost always is desirable, but if you deactivate the little lock icon in either the Basic Parameters rollout or the Maps rollout, a mapping channel becomes available for Ambient Color.

Mapping the Diffuse Color channel to create the traditional texture map is basic. This is the primary way to create convincing real-world surfaces, but mapping is also useful for

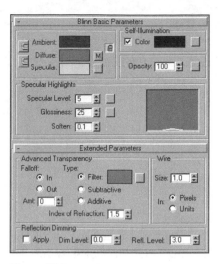

Figure 13.2

The Basic and Extended Parameters rollout for the Standard Material used in Figure 13.1. Small gray boxes on the right of certain parameters indicate that they can be mapped. The "M" next to the Diffuse Color parameter means that a Map object has been assigned to that parameter.

Specular Level. On the human face, the nose and forehead are much shinier than the cheeks, and the lips are often very specular. A Specular Level map is necessary to create these variations. Opacity mapping is useful for suggesting the small irregularities in the transparency of glass objects.

Other Map Channels

This leaves four Map channels that do not correspond with the Material Parameters:

- Bump
- Reflection
- Refraction
- Displacement

Bump And Displacement Mapping

Bump mapping is a tool for creating the illusion of texture. The illumination of a point on the surface of a model is determined by the angle between the surface normal at that point and the direction of the light. (The normal is a vector pointing in a direction perpendicular to the surface.) Think about this for a moment. At noon, the rays of the sun are directly perpendicular to the surface of the ground. To put it another way, they are aligned with the normal vector of the surface of the ground. Under these circumstances, the illumination of the ground is at its maximum.

A few hours later, the sun is setting, and an angle opens up between the rays of sunlight and the normal vector of the ground. Illumination intensity decreases until, when the angle is 90 degrees at sunset, there is no longer any illumination on the surface.

The eye interprets the surface relief (texture) in two ways. If the relief is great enough or if you are very close, you actually see the surface geometry that causes the relief. But even when your vision cannot resolve the actual surface geometry, you interpret fine-dappled lighting patterns on the surface as shadows cast by the surface relief. Bump mapping creates these patterns, which are interpreted as shadows (and therefore as relief) without changing the surface geometry. It does so by jogging the normals used to compute the illumination at rendered points. Instead of the normals pointing perpendicular to the surface, they point at various angles. These create illumination patterns that the viewer reads as shadows.

To get the idea, try this exercise:

1. Pick a slot in the Material Editor and open the Maps rollout.

2. Click on the button to the right of the Diffuse Color channel (it currently reads "None") to get the Material/Map Browser. Look for the Map type called Marble. If you don't see it on the list, make sure that either All or 3D Maps is selected as the filter. Double-click on the Marble type to put a Marble Map object in the Diffuse Color channel.

3. The default settings for this map type produce a pattern in dark brown and tan, as you can see in the sample slot. After assigning the Map, MAX automatically brings you into the panel for the Map. You don't need to make any changes, so return to the Material level by using the Go To Parent button (with the up arrow), immediately above the word "Marble" in the Type box.

4. Back in the Maps rollout of the Material Editor, you see the Marble map applied to the Diffuse Color channel. Drag the Marble map down to the Bump channel to clone it. Choose the Instance option from the dialog box that appears. This option ensures that any changes made to the Map object in either channel are reflected in both. Look at your sample slot and notice the Bump effect. There are sharp differences in relief between the areas that are mapped with darker and lighter colors. Increase the Amount from the default of 30 to about 50 and notice the suggestion of illumination and shadow at the edges of the color regions. To see this clearly, drag your sample into an adjacent slot and turn off the Bump channel for the copy by unchecking the box to the left of the word "Bump" in the Maps rollout. Figure 13.3 shows two magnified samples, with the Bump channel turned off for one. Notice that the Bump channel is unchecked in the Maps rollout below.

Note: This is a good time to reflect on the term texture map. *Both samples share the same texture map (meaning the Diffuse Color map). But this "texture" map does not suggest surface texture at all. Rather, it's the bump mapping that creates the impression of surface relief.*

5. Using the same texture map and bump map is often desirable, but not necessary. Disable the Diffuse Color channel in the original version by unchecking it to see the effect of the bump map alone. Increase the amount of the Bump to very high levels

Figure 13.3

Comparing magnified samples with and without bump mapping. Both samples share the same default Marble map in both the Diffuse Color and Bump channels, but the Bump channel is disabled in the version on the left. Note the illumination and shadow effects on the borders of the color change in the version on the right.

and note that the effect degenerates. Bump mapping is an illusion created by illumination patterns. At high levels of relief, the viewer begins to expect to see the contours of the actual geometry. This requires displacement mapping.

6. Drag a copy of your material to another slot. Using the copied sample, drag the Marble map from the Bump slot to the Displacement slot, and use the Instance option to clone it. Play with the Amount spinner for the Displacement slot. Note that the actual geometry is affected because the surface is displaced in and out, based on the color values in the map. Disable the Bump channel to see the displacement effect alone. Samples in the Material Editor cannot give an accurate impression of the way that displacement mapping works on a real model. In a high-quality render, the displacement mapping resolves the terrain very accurately. In Figure 13.4, the sample on the right uses bump mapping alone. Note that the sample ball is round. With the same Map used for displacement mapping as well, the geometric contours are affected. On the left, the bump mapping is disabled to show only the displacement, but the sample does not convey the accuracy of a true

> *Note: It should be clear now why the Bump and Displacement channels do not correspond to any Material parameters. Bump and displacement effects require variation over the surface, so any single value for the entire material would not make sense. The variations are based on the grayscale values of a map. If a color map is used, as in our exercise, the colors are effectively converted to grayscale.*

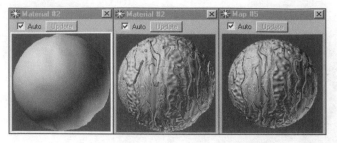

Figure 13.4
Bump mapping and displacement mapping are compared using Material Editor samples. On the right, bump mapping alone does not affect the geometry. The ball is still round. In the center, displacement mapping is added by using the same Marble map, and the contours are visibly affected. On the left, the bump mapping is disabled to reveal only the displacement effect.

render, which would resolve the details quite closely. Displacement mapping is ultimately a method of modeling surfaces and is more fully discussed in Chapter 8.

Reflection And Refraction

MAX is unique among 3D packages in handling reflection and refraction effects through Map objects. This subject can be very confusing and is based in the history of the program. See the "Reflections, Refractions, And Ray Tracing" section later in this chapter.

Using Bitmaps

Bitmap images are the primary vehicles for mapping Material parameters. When most people use the term "texture map," they mean a diffuse color map achieved by applying a bitmap to the surface. But how do you get a flat bitmap image to wrap correctly around a 3D surface? This is a very big and often difficult subject that requires both an understanding of mapping coordinates generally and of MAX's specific tools for creating them. The mapping of bitmap images will always remain a mystery to those who are unwilling to master some rather subtle concepts. This chapter will try to make the subject as simple as possible.

Creating Mapping Coordinates

If you look at a text version of a MAX scene and find a polygonal model to which a bitmap has been applied as a texture, you see mapping coordinates (also called *texture coordinates*) for each vertex. The mapping coordinate tells the application what location on the bitmap corresponds to that vertex. The color at that spot on the bitmap becomes the color of the object at the vertex when it is rendered.

Texture Space In UV Coordinates

Become accustomed to the concept of *texture space*. A 3D object is in 3D Cartesian space, and each point in that space is designated by the coordinates x, y, and z. The texture space of a bitmap is only 2D, however, so rather than using the coordinates x and y, you use the coordinates u and v to designate locations in that space. (The use of u and v as coordinates on a

surface should be familiar to those accustomed to NURBS (Non-Uniform Rational B-Splines) modeling, and this correspondence gives NURBS special mapping advantages, as you'll see.)

UV texture space is always between 0 and 1 in each dimension. The u-direction is horizontal, from left to right. The v-direction is vertical, from bottom to top. The four corners are therefore at the coordinates (0,0), (0,1), (1,1), and (1,0). The point (.5,.5) is exactly in the center of the rectangle (u = .5 and v = .5). Take a look at Figure 13.5 to get the idea.

The texture space must be rectangular, but it need not be square. If the u- and v-dimensions are unequal in length, they are still measured between 0 and 1. Think of mapping coordinates as percentages of the distance across the texture space, not as fixed units of measurement. Figure 13.6 illustrates a texture space that is not square. The corners are still at (0,0), (0,1), (1,1), and (1,0). (.5,.5) is still in the center of the rectangle.

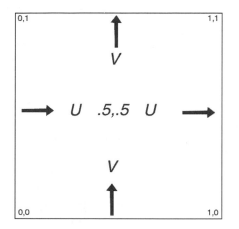

Figure 13.5
Texture space in uv coordinates. The origin (u = 0, v = 0) is in the lower-left corner. The u-direction is horizontal and the v-direction is vertical. The u and v coordinates are always in the range between 0 and 1. Thus, the four corners are at (0,0), (0,1), (1,1), and (1,0). (.5,.5) is right in the middle.

Figure 13.6
The texture space must be a rectangle, but it need not be square. The uv coordinates measure the percentage of the distance across the map in the horizontal and vertical directions. Thus, the upper-right corner is still at (1,1).

When mapping (texture) coordinates are assigned to a 3D model, each vertex on the model is given a corresponding uv location in texture space. A triangular face on the model therefore corresponds to a triangular region in the uv texture space. Take a good long look at Figure 13.7 to understand this most basic concept. A triangular face on the mesh is highlighted in white. Its three vertices are numbered 1, 2, and 3. Each of these vertices is assigned a corresponding point in the texture space, creating a triangle in texture space (shown in black). Thus, the black triangular region of the texture space will be applied to the white face on the mesh. Note that the shapes of the two triangles need not be the same—the region on the map will be squeezed or stretched to fit the face. The texture vertex labeled 1 is roughly at (.15, .2) in uv coordinates. These uv coordinates will be assigned to vertex 1 on the mesh as its mapping or texture coordinates. Whatever way it's achieved, the mapping process produces these assignments for every vertex that requires mapping.

Note that you haven't begun to deal with an image yet. Imagine the 2D texture space as empty. If you slide a picture into the space, the mapping assigns specific pixel colors at the uv coordinates to the textured object. But the mapping process does not necessarily require an image—mapping coordinates can be generated before any specific image is applied, and the image can be changed without changing the mapping coordinates. This will become clearer as we go along.

Figure 13.7
The meaning of mapping (or texture) coordinates. A triangular face on the mesh object is highlighted and its vertices are numbered 1, 2, and 3. In the mapping process, a triangular region of the uv texture space (in black) is assigned to the face. The uv coordinates of the corners of the triangle in texture space are specifically assigned to the corresponding vertex on the mesh.

Projecting Mapping Coordinates—The UVW Mapping Modifier

So, now that we know what it means to generate mapping coordinates for a model, how do we do it?

There are two fundamentally different approaches. One uses the inherent topology of the object to automatically create mapping coordinates. Where this is possible, it will generally be the preferred method because the mapping follows the surface in a logical way. In most applications, only NURBS surfaces can be mapped in this way, but MAX offers this method for a surprisingly wide array of geometry. You'll learn this mapping approach in a bit.

The other method of generating mapping coordinates is by projection. Imagine shining a slide projector on a white object. You turn off the projector, turn on the lights, and discover that the image is burned into the surface of the object, just as if it were photosensitive. Although this gives you the general idea of projecting mapping coordinates, the only way to understand the process is by hands-on experience, so let's get started with an exercise:

1. Create a Box object. The dimensions are not particularly important. Open the Material Editor and pick a slot. Assign the Material to the selected object.

2. You will generate mapping coordinates before you actually apply a map. Put a UVW Mapping modifier on your object. Why is it called UVW instead of just UV? Unlike any other application, MAX provides a third dimension for texture space. You can comfortably ignore the w-dimension in the overwhelming majority of situations.

3. The default projection is the Planar type. This is the most important type of projection, by far. In a Planar projection, the image is mapped to a face of the bounding box of the geometry. Because you're using a Box object, the model is the same shape as its bounding box. The projection goes right through the object. Play with the x, y, and z alignment options. For each of these, use the Fit button to snap the size of the projection gizmo to the dimensions of the bounding box. Use the Length and Width spinners to adjust the dimensions of the gizmo, and then use Fit to snap back to the natural defaults. In the vast majority of situations, you will use Fit this way.

4. Now, see the results with a test bitmap. You'll use the image in Figure 13.5 because this helps you understand the mapping process better. Select your Material in the Material Editor. In the Maps rollout, click on the None button in the Diffuse Color channel. When the Material/Map Browser appears, double-click on the Bitmap type. (If you don't see it, make sure that the 2D Map types are visible.)

5. The Select Bitmap Image File dialog box appears. Find the bitmap image named uvtest.tif in the Chapter 13 directory on this book's companion CD-ROM. After opening the image, you'll see it in the sample slot. To see it on the object, click on the button with the blue and white checkered box (called Show Map In Viewport) in the row beneath the sample slots. Depending on the dimensions of your Box and the direction of your projection, your screen should look something like Figure 13.8.

Figure 13.8

A Planar projection is made on a Box object, fitted to the dimensions of the object's bounding box. The bitmap image from Figure 13.5 is used to help you understand the projection. In this basic type of projection, the corners of the texture space map to the corners of the face of the bounding box.

6. Rotate the object to see the projection on the opposite side. The other sides of the object are white. To understand the situation better, increase the Length and Width parameters of the projection gizmo until the arrows and letters fall over the side, as shown in Figure 13.9. A sliver of the map is dragged over other faces because they are perpendicular to the direction of the projection. A tiny fraction of uv texture space is being applied to large areas, creating extreme distortion. A Planar projection therefore makes sense only where surfaces are relatively flat. That often means dividing an object into many regions and applying separate Planar projections to each. You'll learn about this shortly.

7. Hide or delete your Box and make a Cylinder object. Put a UVW Mapping modifier on it and project a Planar projection along the length of the object. Use Fit to align the projection gizmo to the bounding box of the Cylinder. Unlike the Box object, the Cylinder is distinct from its bounding box, and it's therefore easier to see a natural relationship between a Planar projection and a bounding box. In the Material Editor, put the Material you used before to the new object, and make sure that the bitmap is visible on the surface. Rotate the view to see the result. As you can see in Figure 13.10, there is a general distortion—minor in the center but more extreme toward the edges of the projection where the cylinder turns sharply away. The numbers at the corners are quite stretched. Try to imagine the bitmap placed on the surface of the bounding box and then projected onto the curved object. This ex-

Figure 13.9
Increasing the size of the Planar projection gizmo brings some of the black areas of the bitmap over the edge of the object's bounding box. Because the projection is perpendicular to the sides of the Box object, only a sliver of texture space is mapped to these faces. This kind of distortion is a major issue when you use Planar projections.

Figure 13.10
A Planar projection on a Cylinder shows mild distortion in the center and more extreme stretching at the ends. A Cylinder is typical of the gently curving surfaces on the faces and bodies of character figures, where Planar mapping is very often used. The bounding box of the object is now distinct, and it's easy to see how the Planar projection is fitted to a face of the bounding box.

ample gives a good sense of the way Planar projections work (and distort) on the body and faces of character figures.

8. The second most important kind of projection is the Cylindrical type. In the Mapping UVW modifier panel, change to a Cylindrical projection. Find the appropriate alignment and use Fit. The Cylindrical projection gizmo should fit closely to the object.

9. Rotate the object to see the result. The bitmap is now wrapped around the Cylinder. There is no distortion because the projection and the object are exactly the same shape. There must be a line where the two edges of the map meet, however. This is not a problem with the image that you're using because both edges are white. But if there was a pattern, and the pattern did not coincide at both edges, you'd see a visible seam. Figure 13.11 shows the Cylindrical projection in the region where the two edges of the bitmap meet.

Figure 13.11
A Cylindrical projection is applied to the Cylinder object. The Cylindrical projection gizmo shows an exact fit to the geometry of the object, and thus there is no distortion. The two edges of the bitmap meet in a line, however, as if a piece of paper were wrapped around the surface. If this were a patterned bitmap, and the pattern was not the same at both edges, a troubling seam would be visible.

10. It makes a great deal of difference when you project mapping coordinates in the modeling process. Although you'll mostly deal with a finished Editable Mesh object, whose stack (if any) was collapsed before the entire texturing and materials process began, it pays to think ahead. Put a Bend modifier on top of your stack and give your stack some bend. Because the Cylindrical projection was applied before the object was bent, the mapping follows the deformation correctly. Delete

both the Bend and UVW Mapping modifiers and try the other way. Put the Bend modifier on first, bend it, and then put the UVW Mapping modifier on top. Once again, use a Cylindrical projection with Fit. The result does not make sense because the Cylindrical projection is applied after the object is no longer really cylindrical. See Figure 13.12. This issue comes up very often. For example, when texture mapping a curved surface, it may make sense to start with a flat surface that can be easily mapped with a Planar projection. Apply the UVW Mapping modifier and then deform the surface. The mapping correctly follows the surface.

Figure 13.12
Establishing mapping coordinates, before and after deformation. At left, a Cylindrical projection was used to establish texture coordinates before the object is bent. The map sticks to the surface as it deforms because the vertices were already assigned their uv coordinates. At right, the Cylindrical projection is applied after the object is bent. The mapping no longer makes sense because the shape of the object is no longer cylindrical. Note that the Cylindrical projection gizmo was fitted to the bounding box of the object.

11. The other mapping projections are much less important. Create a Sphere and use the uvtest.tif bitmap to get the basic idea. The Planar and Cylindrical projections do not distort the image if the surface being mapped is flat or cylindrical. There's no way to wrap a flat rectangle (the bitmap) around a Sphere without some distortion, however. The Spherical projection wraps around the object in the horizontal (u) direction, but closes up at the vertical (v) poles. The Shrink Wrap projection creates intense distortion by pulling all four corners of the map to a single point. This projection is very rarely useful. The Box projection is simply six Planar projections from the six perpendicular directions. This is sometimes a better alternative than a Spherical projection for getting a finely patterned bitmap wrapped all around an

object. The mapping doesn't close up at the poles; however, because there are multiple projections, seams are likely to be visible where the separate Planar projections meet. The Spherical, Shrink Wrap, and Box projections are illustrated in Figure 13.13.

Figure 13.13
A Sphere object with Spherical, Shrink Wrap, and Box projections. The Spherical projection on the left wraps around the object in the horizontal (u) direction, just like the Cylindrical projection. Unlike the Cylindrical projection, however, it closes up at the vertical (v) poles. In the center, the rarely used Shrink Wrap projection pulls all four corners of the bitmap to a single point, at the cost of considerable distortion. On the right, the Box projection is simply six perpendicular Planar projections.

12. Try the Face map option, which projects the same map separately to every polygon and sometimes make sense with fine texture patterns. The XYZ To UVW option applies to 3D procedural maps, as you'll see later in this chapter.

Editing Mapping Coordinates—The Unwrap UVW Modifier

For many texturing jobs, a simple projection isn't good enough. The Unwrap UVW modifier is an extremely powerful tool for editing mapping coordinates that were obtained in the first instance by projection with the UVW Mapping modifier. If nothing else, a little experimentation with this modifier will greatly clarify the very meaning of mapping coordinates. This basic exercise will get you started:

1. Create a Rectangle in a front viewport and convert it to an Editable Mesh. In the Edge Sub-Object level, select the invisible diagonal edge and convert it to a visible one. This creates two separate triangles for purposes of selection in the Unwrap UVW modifier.

2. Apply a UVW Mapping modifier and fit a Planar projection to it. In the Material Editor, pick a slot and assign a bitmap to the Diffuse Color. Use the uvtest.tif file from this book's companion CD-ROM and put the Material to the object. Make sure that the bitmap is visible in a front shaded viewport. Your screen should resemble Figure 13.14.

Figure 13.14
A Rectangle spline is converted to an Editable Mesh object and mapped with a Planar projection.

3. Put an Unwrap UVW Modifier on top of the stack. Press the Edit button to get the editing interface. This is a direct look at your uv texture space. To see it better, hide the bitmap with the blue and white checkered button (Show Map) at the top of the Edit UVWs dialog box. As you may expect, your projection mapped the four vertices of the mesh object to the four corners of texture space. Move these vertices in texture space so that they enclose only the lower-left quarter. Use the type-in spinners at the bottom to set the u and v coordinates for each vertex exactly: (0,0), (0,.5), (.5,.5), and (.5,0). Leave the w value alone. Look back at your front view to see the new mapping. As you can see in Figure 13.15, the object is now mapped with only a quarter of the bitmap.

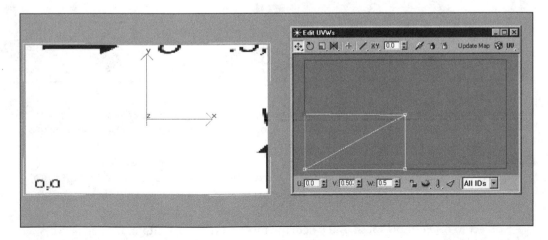

Figure 13.15
The Unwrap UVW modifier is used to move the vertices of the Editable Mesh object in texture space. The four corners of the mesh are assigned the texture coordinates of (0,0), (0,.5), (.5,.5), and (.5,0). Thus, only the lower-right quarter of the bitmap is mapped to the surface.

4. Your Mesh object has only two triangles and four vertices, so it's obvious which vertices in the Edit UVWs dialog box correspond to the specific vertices on the object. But with any reasonably complex mesh, things can get quite confusing. In the Unwrap UVW panel (not the Edit UVWs dialog box), press the Sub-Object button to enter the Select Face mode. Click on a corner of your object in a viewport to select one of the two triangular faces. You may want to glance at a wireframe view to confirm this selection. Things won't look any different in the Edit UVWs dialog box until you press the triangle icon (Filter Selected Faces) at the bottom. Once you do, only the single selected triangle for the mesh will be visible in the texture space.

5. To edit the texture space of the triangle, you want to see the bitmap image. Make it visible. Now, you can't see the lines and vertices because they are white against the white bitmap. Press the Unwrap Options button at the top of the dialog box and change the Line Color to dark blue. Press OK, and the selected triangle is clearly visible in texture space. Move the vertices to define a region within the triangle and note that the same portion of the map appears in the corresponding triangle on the mesh object. See Figure 13.16.

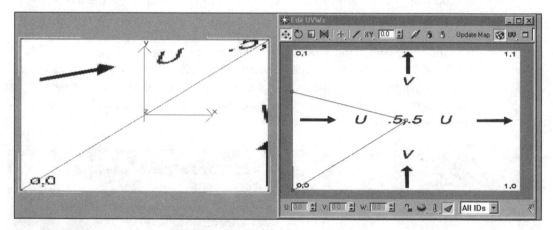

Figure 13.16
The Select Faces Sub-Object level is used to isolate the upper-left triangle on the Editable Mesh object for editing in texture space. Note that the region of the map inside this triangle in the Edit UVWs dialog box appears on the corresponding triangle on the Mesh object.

6. Put all this to some very practical use by straightening out a Planar projection on a curved surface. Create a short and rather fat Cylinder object. Make it half of a Cylinder by using the Slice parameter and setting Slice To at 180 degrees. Convert the object to an Editable Mesh and delete the faces on the top, bottom, and back. This leaves only the curved surface.

7. Put a UVW Mapping modifier on the stack and fit a Planar projection to the object from the front. Assign the object a Material in the Material Editor and put the uvtest.tif bitmap in the Diffuse Color map channel.

8. As you saw earlier in this chapter, this projection stretches the map around the edges. Add an Unwrap UVW modifier and open the Edit UVWs dialog box to understand why. (Change the Line Color, if necessary, to see the lines against the white bitmap.) All of the faces on the Mesh are exactly the same size, but they are not assigned equal amounts of texture space. Due to the direction of the projection, the faces at the edge of the object have only a sliver of the texture space. Figure 13.17 illustrates the problem. Note the stretching of the numbers at the edges of the mesh.

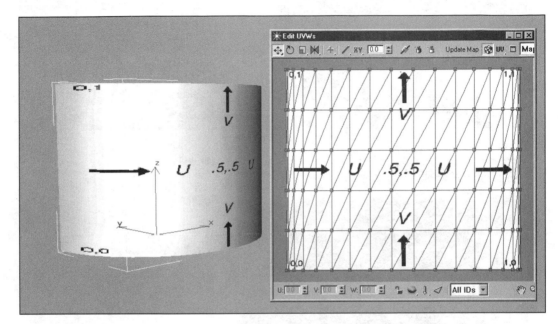

Figure 13.17
A Planar projection is fitted to the front of a curved Editable Mesh made from half of a Cylinder object. The Edit UVWs dialog box shows that the faces, although equal in size, have been allocated unequal amounts of the texture space. The faces near the receding edges are allocated only a sliver of the map. This accounts for the stretching of the numbers on the bitmap.

9. You can fix the problem by moving the columns of vertices in the u-direction (horizontally) in texture space until they are fairly even. Select all the vertices in a column by carefully dragging a rectangle around them; then, use the u-direction spinner at the bottom to translate them. Figure 13.18 shows half of the vertices corrected. Note that the distortion has now been eliminated.

Mapping Multiple Surfaces

Maps must often be applied separately to different regions of the same mesh. The process can be tedious, but if you don't work carefully and systematically, you'll make a mess of things. The following exercise demonstrates a reliable method for this kind of work:

1. Create a longish Box object and convert it to an Editable Mesh. Move a couple of edges and scale some pairs of vertices to create angles. Your object might look something like Figure 13.19.

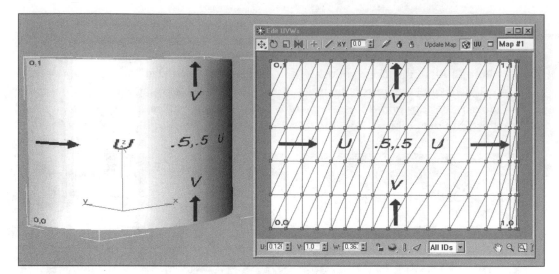

Figure 13.18
Same as Figure 13.17, but with half of the columns of vertices translated in texture space to even out the distribution of the map over the mesh. Note that the distortion has been eliminated.

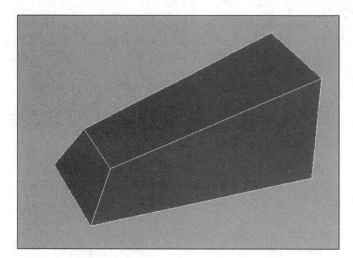

Figure 13.19
A Box object is converted to an Editable Mesh, which is then edited to create angular surfaces.

2. You will apply a texture map of an aluminum surface to all sides of this object, which requires dividing the object into six different Material IDs for use in a Multi/Sub-Object Material. This subject was covered (without maps) in Chapter 12, so refer to it, if necessary. MAX automatically created six Material IDs for the Box, but it's good practice to assign them yourself. Start by entering the Polygon Sub-Object level, selecting all the Polygons, and assigning them to Material ID #1. Test with the Select By ID button to make sure that the entire mesh is assigned to a single ID.

3. Leave only one of the quad Polygons as Material ID #1 and assign all the others to IDs #2 through #6. This can be frustrating work unless you've had a lot of practice. Select a Polygon and enter a number in the Material ID spinner (or click on the spinner). Test after each assignment using the Select By ID button. Make sure that all sides have been properly assigned before you go on.

4. You need a separate projection for each surface; you'll create them by using Mesh Select to select the affected faces and then applying a UVW Mapping modifier for each group of faces. Add a Mesh Select to the stack and then add a UVW Mapping modifier. Repeat this until you have six pairs of these modifiers. Use the Edit Stack button (in the Edit Modifier Stack dialog box) to look at your stack and to rename each pair to add an identifying number (e.g., Mesh Select 1, UVW Mapping 1; Mesh Select 2, UVW Mapping 2; and so on). This step is critical to your sanity, so don't omit it. Your stack should look like Figure 13.20.

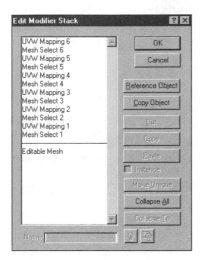

Figure 13.20
After assigning a different Material ID to each side of the object, a stack is built of pairs of Mesh Select and UVW Mapping modifiers. The Edit Modifier Stack dialog box is used to add an identifying number to each pair.

5. Next, you create a separate mapping projection for each of the Material IDs. At the bottom of the stack, enter Mesh Select 1. Go into the Faces or Polygon Sub-Object level and find the Select By Material ID section. Enter the number 1 in the spinner and press the Select button. The quad (two triangular faces) that you selected should now be assigned to Material ID #1. Only these faces will pass up to the first UVW Mapping modifier.

6. Don't turn off the Sub-Object button on Mesh Select before moving up to UVW Mapping 1. Get the Planar projection gizmo aligned in the direction for the chosen side. If that side is slanted, align the gizmo by activating the Normal Align button. As you drag across the sides of the object, notice how the gizmo aligns to the surfaces.

When you're aligned to the appropriate surface, choose Fit to get the proportions right. Figure 13.21 shows the Planar projection gizmo aligned to the Polygon that I had designated as Material ID #1. Note that the projection is fitted to the bounding box for only the selected faces, not for the bounding box as a whole.

Figure 13.21
The faces in Material ID #1 are selected in the Mesh Select 1 modifier and sent up the stack to UVW Mapping 1 modifier. The Normal Align tool is used to align the Planar projection gizmo to the slanted surface, and Fit is then used to snap its dimensions to the bounding box of the selected faces (not the entire object). Texture coordinates have now been established for only the single surface.

7. Repeat this process for the five other sides, working very carefully. Use the Mesh Select modifier to select the faces within the designated Material ID, and then use the corresponding UVW Mapping modifier to align and fit the Planar projection gizmo to the surface.

8. All of the mapping coordinates are established, so it's time to try a bitmap. Pick a slot in the Material Editor and change it from a Standard Material type to Multi/Sub-Object Material. Put the Material to the selected object. Set the number of Sub-Materials to 6. Enter the first one (which will be assigned to the faces with Material ID #1) and enter a Bitmap Map type in the Diffuse Color channel. For the bitmap itself, choose Aluminm3.gif (the "u" is missing) from this book's companion CD-ROM. Make sure that the bitmap is made visible on the surface and notice that it's properly mapped to the faces that you designated as Material ID #1. Your screen might look like Figure 13.22.

9. Back in the list of Sub-Materials, drag a copy of the first material into each of the other slots (use either "copy" or "instance") and watch how the bitmap appears on all of the surfaces. There's a problem, however. The pattern is uneven because the same bitmap was mapped to surfaces of different sizes. To correct this, go to the

Figure 13.22
A Multi/Sub-Object Material is created and assigned to the object. The Multi/Sub-Object is given six Sub-Materials. The Sub-Material assigned to Material ID #1 is given a bitmap in the Diffuse Color channel (a texture map). The pattern is now visible on the affected faces.

UVW Mapping modifier for one of the small faces and use the Length and Width spinners to scale the Planar projection gizmo larger. At some point, the pattern will match the scale of the larger faces. See Figure 13.23.

Map Channels

Map channels are a very sophisticated subject, but it's so important that you must have at least some basic understanding. Up until now, we've assumed that there can be only a single set of mapping coordinates for an object. After an object is mapped, each affected vertex is assigned a uv coordinate in texture space that tells it where to get its color (or other) values from a map. But what if a vertex could have more than one such number? If multiple maps were used on a single surface, each map could be applied using different mapping coordinates. Multiple maps might apply where different bitmaps were used for different parameters. For example, a texture map (Diffuse Color) might be different from a Bump map or a Specular Level map. This is not the most important use of multiple mapping coordinates, however.

The most important use of multiple texture coordinates is when maps of the same type (typically, texture maps) are layered on top of each other to create complex texture effects, and above all, to hide seams. Consider this fundamental problem: You're texturing a character figure that necessarily requires an assemblage of different maps. If each is assigned to a different Material ID, there will be obvious seams where the borders meet. Although careful work in Photoshop on the edges of both images may help soften the effect, a better alterna-

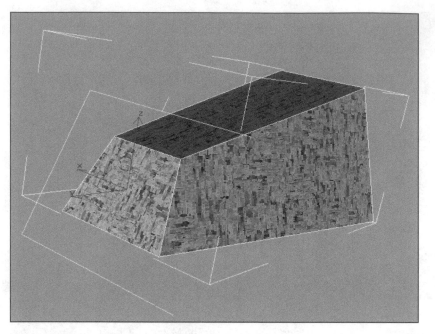

Figure 13.23
After the Material with the bitmap is copied to all of the other Sub-Materials, the mapping alignments are corrected, but the scales are wrong. The pattern is much denser on the smaller sides, and the longer sections may feel stretched. To equal things out, the Length and Width spinners for each of the UVW Mapping modifiers are used to adjust the dimensions of the projection gizmos. In this example, the pattern on the small region in the front is stretched out to better resemble the rest of the object.

tive is to allow maps to overlap lightly and to use a transparency effect to disguise the overlap. Try this simple (yet challenging) exercise:

1. Create the same kind of half-cylindrical Editable Mesh that you made earlier in this chapter (in the "Editing Mapping Coordinates—The Unwrap UVW Modifier" section) and fit a Planar projection to the front. Refer back to Figure 13.17; your object should look like the one in that figure. Note that the Map Channel in your UVW Mapping modifier panel is set to the default of 1.

2. Now, add a second UVW Mapping modifier directly on top. Set this Channel to 2. Use the Normal Align tool to align the Planar gizmo with the Polygons about halfway around the side. Go into the Sub-Object mode and move the gizmo outside the surface so that the sense of the projection is evident. This Channel 2 projection should look like Figure 13.24.

3. Before you go on, rename your modifiers as UVW Mapping Ch 1 and UVW Mapping Ch 2 in the Edit Modifier Stack dialog box. (Do not skip this step, or it will cause you frustration later on.)

4. To put two overlapping bitmaps to a single surface, you need to use the Composite Map type. Pick a slot in the Material Editor and put the Material to the object. In the

Figure 13.24
A second Planar projection for a single surface is aligned with the sides of the object. This is Channel 2. An earlier Planar projection (Channel 1) was made directly from the front.

Diffuse Color channel, use a Composite Map type. (This is not the same thing as a Composite Material.) This gives you two slots to put Bitmap Map types in. Put a Bitmap type in the first slot and select uvtest.tif from this book's companion CD-ROM. Make sure that it's the first slot because the first slot is the lowest layer on the blending stack. Make sure that the image is visible on your surface. Note in the Material Editor that Map Channel 1 is specified by default as the Explicit Map Channel. This means that the map is using the projection coordinates established with the first UVW Mapping modifier.

5. Now, try the second channel. Navigate up though the Material Editor (using the up arrow to get to the two Composite channels). Drag the Bitmap in the Map 1 slot down to Map 2 to create a copy. Click on the Map 2 button to get to the Map 2 panel and change the Map Channel number from 1 to 2. Click on the blue and white checkered box to refresh your screen; after doing so, you'll notice the new projection on your object. The preview can support only one map at a time.

6. This is going to be some sophisticated stuff, so take your time with it and use the reference files from this book's companion CD-ROM (but they're designed to be used only after you've worked on the exercises yourself). The Composite Map type will completely hide Map 1 with Map 2 because both maps were assigned to the entire surface (although in different directions). Do a Quick Render (from the Main Toolbar), and you'll see the Channel 2 projection duplicated around the surface, as shown in Figure 13.25. The projection is obviously distorted in the region for which it was not intended.

7. To let Map 1 (with Channel 1 coordinates) show through, go into the Material Editor panel for Map 2, where you'll see Map Channel 2 designated in the spinner.

Figure 13.25
A render shows that only the Channel 2 projection is visible because Map 1 is completely covered. Most of this mapping is distorted because the projection was only aligned to the side.

Uncheck the Tile box in the u-direction. The Map is no longer repeated beyond the range of its projection. Render again: Map 1 is now revealed, but there is a visible seam where the Channel 2 projection ends. Take a look at Figure 13.26.

Figure 13.26
Tiling is turned off for Map 2 (using the Channel 1 projection) so that it doesn't cover areas beyond its projection. Map 1 is now visible, but there is a troubling seam.

8. To eliminate the seam, you need an Alpha (transparency) channel in the bitmap. Back in Photoshop, I added a thin masking strip along the right edge of the bitmap and saved it as an Alpha channel. The new file was named uvtest_alpha.tif (it appears on this book's companion CD-ROM). Take a look at Figure 13.27.

Figure 13.27
The uvtext.tif map with an Alpha channel mask is added as a strip along the right side. This makes this region of Map 2 transparent and eliminates the seam shown in Figure 13.26.

9. To replace the bitmap in Map 2 with the updated version, go down into the Bitmap level for this map in the Material Editor and click on the long button with the name of the current map. A dialog box opens; use it to select uvtest_alpha.tif from the CD-ROM. Render again with the new bitmap, and the seam is gone. Your result should look like Figure 13.28.

Note: For most purposes, you'll use a gradient rather than a solid mask in the Alpha channel so that the upper image fades gently into the adjoining lower one. Sophisticated mapping techniques, such as the one addressed here, are extremely difficult to master and take a great deal of practice. Most of all, they demand a firm understanding of principles. The reason that two maps could overlap is because the affected vertices could be assigned more than a single set of texture coordinates. Understanding these subtle ideas does not come easily, so don't expect it to.

Using Implicit Mapping Coordinates

Earlier in this chapter, I noted that there are two methods for establishing mapping coordinates on a surface. We've just covered one of them—using the UVW Mapping modifier to project texture coordinates onto vertices. The other method is very important, and, where possible, is often preferable.

Figure 13.28

Same as Figure 13.26, but using the revised bitmap with the transparency (Alpha) channel along the edge (seen in Figure 13.27). The seam at the overlap between the maps is now eliminated.

A NURBS surface is inherently defined in its own two-dimensional uv space. In other words, every location on a NURBS surface can be specified by a (u,v) pair of values. These can then be used directly for the texture space. One of the strongest arguments for NURBS modeling is in this direct correspondence between surface and texture coordinates. Maps, therefore, naturally follow a curved NURBS surface without the distortion inherent in most projection techniques. Take a look at some of the possibilities with NURBS surfaces and then touch on the use of implicit coordinates in non-NURBS surfaces.

Figure 13.29 shows a gently curving NURBS surface with the uvtest.tif bitmap applied. No UVW Mapping modifier is used because the surface's inherent uv coordinate space is used for mapping coordinates. The image follows the surface perfectly, although it is uniformly stretched because the surface does not have the same dimensions as the bitmap.

Because of the connection between the coordinates on the geometry and the mapping coordinates, changes to the geometry change the mapping. For example, if the surface is relofted in the opposite direction—so that the former u-direction is now the v-direction—the mapping reflects the new direction. Figure 13.30 shows the same surface after relofting.

This reversal of directions could be a problem, but MAX has a very complete set of tools for adjusting the mapping coordinates with respect to the surface coordinates. These tools are all found in the Material Properties rollout for the selected Surface subobject in the NURBS Surface object. To get the map turned back around without changing the underlying surface coordinates again, you can set the Rotation Angle to 90 degrees. To get only a portion of the map applied to the surface, you can choose each of the four corners of the surface and change the corresponding texture coordinates. In Figure 13.31, the corners are set to (.5,0),

Figure 13.29
The uvtest.tif bitmap is applied to a curved NURBS surface using the inherent uv coordinates as the mapping coordinates. The map follows the curvature perfectly.

Figure 13.30
The NURBS surface from Figure 13.29 is relofted in the opposite direction, so that the u- and v-directions are reversed. The mapping coordinates reflect this change in the underlying geometry.

(1,0), (.5,1), and (1,1). As a result, only the right half of the map (from u = .5 to u = 1) is mapped to the surface.

The mapping can be offset and tiled on the NURBS surface. In Figure 13.32, the mapping is offset in one direction to center the image, and then it is tiled in the other direction.

Detailed editing of NURBS surface mapping is easier and more powerful than using the Unwrap UVW. A Texture Surface is slipped between the true texture space and the geometry of the object. You can get access to this Texture Surface by selecting the User Defined option in

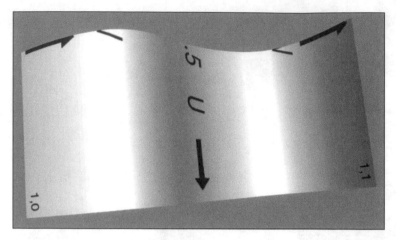

Figure 13.31

The NURBS surface from Figure 13.30 with the corners of the surface assigned to (.5,0), (1,0), (5.,1), and (1,1) in texture space. Thus, only the right half of the bitmap is mapped to the surface.

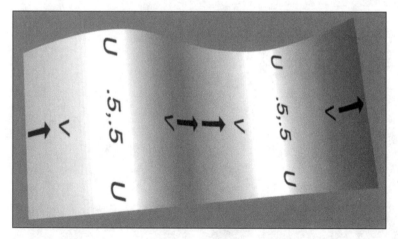

Figure 13.32

Same as Figure 13.31, but with an offset applied to center the image in the u-direction. Tiling is applied in the v-direction to fit two vertical units on the surface.

the Material Properties rollover. Once you have done so, you can edit the Texture Surface directly by using a dialog box that is very similar to that used in the Unwrap UVW modifier. Or, you can edit Texture Points directly on the object surface. Both of these methods give you extremely refined control over mapping. In Figure 13.33, the Texture Surface was edited on the right side of the surface.

This kind of mapping makes perfect sense for NURBS surfaces because they necessarily have their own 2D coordinate spaces. However, MAX is unique among 3D applications because it has analogous tools for a wide range of other objects. Most primitives automatically assign mapping coordinates, consistent with their structure. Loft Objects can generate mapping

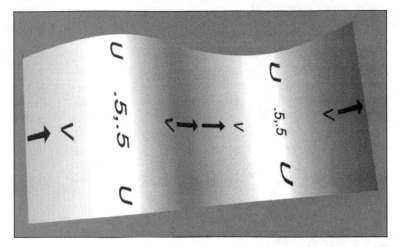

Figure 13.33
Same as Figure 13.32, but with the Texture Surface edited slightly on the right side of the NURBS surface.

coordinates that automatically follow the surface without need for projections. If you think ahead, the right approach to modeling automatically produces the mapping coordinates that you need. Every time you see the Generate Mapping Coordinates checkbox, take note and think of how that object might serve in the mapping process.

For example, suppose that you want to wrap an image continuously around a sharp corner. With most modeling methods, it is necessary to use projections to get the image properly aligned, and the result might never look perfect. If the surface is generated from an extruded spline, however, the Extrude modifier has a Generate Mapping Coordinates checkbox. When mapping coordinates are established this way, rather than with a UVW Mapping projection, the mapping follows the polygonal surface in a manner similar to what you just saw with NURBS. See Figure 13.34.

The Bitmap Panel

When a Bitmap Map type is assigned to a mapping channel, the Material Editor makes available a wide range of controls. The Coordinates rollout is shown in Figure 13.35.

The primary controls are for offset and tiling of the bitmap. As a rule, you should do your tiling here rather than in the similar tiling spinners in the UVW Mapping modifier. Tiling makes sense only with bitmaps designed to line up seamlessly. The Mirror option is a way of making tiling less noticeable with images that do not have perfectly tilable edges. Figure 13.36 illustrates the effect of mirroring in both directions. When using a bitmap with a fine pattern, the repeating pattern of edges is slightly less noticeable.

Now, you can finally consider the meaning of the w-dimension. If u and v are the directions on the 2D plane of texture space, w is perpendicular to that plane. By dragging the w spinner above the Rotate button, the plane is rotated like a wheel on an axle. This is sometimes a valuable adjustment. Figure 13.37 shows previous images rotated in w.

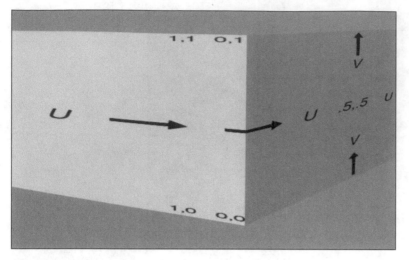

Figure 13.34
A polygonal surface is created with a spline to which an Extrude modifier is applied. By checking the Generate Mapping Coordinates box in the Extrude modifier, texture coordinates are created that follow the surface. Note how the image flows perfectly around the corner.

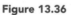

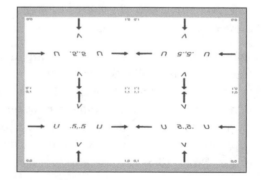

Figure 13.35
The Coordinates rollout in the Material Editor for a Bitmap Map type.

Figure 13.36
Mirroring a bitmap in both directions. With a fine image pattern, this arrangement makes tiling slightly less noticeable.

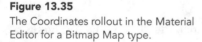

In the Bitmap Parameters rollout, the Cropping tool allows you to use only a portion of a bitmap without having to go into a separate bitmap-editing application (such as Photoshop). The Placement tool allows you to scale down the bitmap to fit over only a portion of the affected surface. The remaining region reveals the underlying Material in a render.

If a bitmap contains an Alpha channel, the Alpha channel is used for transparency. By default, Image Alpha is selected as the Alpha Source. By changing to None, the Alpha channel in the image is disregarded. For some reason, the Premultiplied Alpha option is checked, by default (at the bottom of the Bitmap Parameters rollout). In the overwhelming majority of

Figure 13.37
Mapping for Figure 13.36, rotated in the w-dimension.

cases, it should not be checked. This is the standard way of putting "decals" on surfaces. On the right side of Figure 13.38, the bitmap appears with the Alpha channel as overlay. Everything covered by the mask is made transparent. When applied to the object and rendered, the underlying material shows through where Alpha channel masked out the image (see the left side of Figure 13.38). You may want to try out the image named uvtest_alpha2.tif on this book's companion CD-ROM to duplicate the result in this figure.

Figure 13.38
Using an Alpha channel. On the right is the bitmap image, with the masked area in the Alpha channel indicated. The effect on the rendered surface is on the left. The masked region is made transparent, revealing the underlying Material.

Procedural Maps

A *procedural map* (also called a *procedural texture* or *procedural shader*) is a small program. By setting the parameters of the procedure, you change the color, pattern, and general appearance of the output. You used a Marble procedure earlier in this chapter (in the "Bump And Displacement Mapping" section) to create a pattern without resorting to a bitmap image.

It's hard to talk about procedural mapping in general terms because each procedure is a different program. And MAX's procedures are especially sophisticated, with a very wide range of input parameters for each. The only way to learn what you can do with procedure textures is to experiment with them, making numerous tests with different parameter values. The interaction of the various parameters can make results hard to predict. Even when I use a procedural shader that I've used many times before, I feel like I'm starting over.

Procedural mapping is extremely important, however, and it is becoming more important as shaders improve. The most important procedures are 3D, but MAX has a small range of 2D procedures that are very handy.

DON'T JUDGE A PROCEDURE BY ITS NAME

The range of possibilities hiding under a name like Wood or Marble is simply astounding. Most procedural shaders are given a name that reflects their primary purpose, but vast new possibilities open up once you start playing with the parameters. You simply can't understand what a shader is capable of without a lot of experimentation.

2D Maps

Figure 13.39 shows the Material/Map Browser filtered to show only 2D Map types. Not all of these map types are procedures. The Bitmap type is the opposite of a procedure, and it is what you've been using to map bitmap images to surfaces. The two Adobe filter types are tools for applying third-party Photoshop and Premiere filters. The Paint Map type is an interface that connects Discreet Logic's *paint application with MAX. Only Bricks, Checker, Gradient, Gradient Ramp, and Swirl are procedures, as this term is used here.

The 2D procedures are simply ways to create bitmap images directly within MAX. This can be a great convenience. Why go into Photoshop to create a checkered pattern or a color gradient if you can do it in MAX? Remember, though, that you are creating a bitmap, so you'll face all the same mapping issues as when you use a bitmap from outside the program. To understand your 2D procedural output as a bitmap, change the Sample Type in the Material Editor slots that you're using from a sphere to a cube. Each face of the cube will display a copy of the bitmap.

The Gradient Ramp Map type is a particularly valuable tool. The color gradient can be adjusted to any degree of complexity and then projected in a variety of ways. Noise can be added for greater subtlety or for a fractal look. Figure 13.40 shows six possibilities for a single color gradient.

Figure 13.39
The Material/Map Browser, filtered to show only the 2D Map types.

Figure 13.40
Six variations of a single color gradient, using the Gradient Ramp Map type. The Linear, Diagonal, Radial, and Sweep gradient types are shown, followed by a couple of examples of noise applied to the Linear sample.

3D Maps

3D maps are the most important kind of procedural shaders. Like the 2D versions, they permit you to define the characteristics of the map by setting parameter values. Unlike the 2D versions, however, these procedures do not create bitmaps—they create patterns in 3D space. The mapped object picks up these patterns as its surfaces intersect this 3D texture space. This has two very important consequences. First, you don't need to trouble with mapping coordinates. You are not wrapping a flat image around a 3D surface, so you don't need to use the UVW Mapping modifier to project anything. There's no image to project. There's no question of ugly seams at the edges of bitmaps.

The second consequence is that patterns can flow through the 3D space of an object in a natural way. The patterns that you see on the surface of a wood or marble object are just the

Figure 13.41
Wood and Perlin Marble 3D procedural shaders are applied to a Cylinder. Note the continuity of the pattern over the edge from the top and down the sides. This effect of an internal pattern running through material is nearly impossible to achieve with bitmaps.

intersection of patterns that run in all directions through the substance. Figure 13.41 shows a Wood and a Perlin Marble shader applied to a Cylinder. They look as if they were cut out of a single larger piece of material. It is nearly impossible to create bitmaps for the sides and top to produce this effect of internal continuity.

> Note: 3D maps are not visible in the shaded viewports. Use the sample slots in the Material Editor to get some rough bearings, and then make test renders to see the result on your geometry.

3D maps are applied, by default, in the local space of the object. That way, the map stays in place as the object is transformed. The map isn't actually stuck to the vertices on the geometry, however, and this can be a problem when vertices are deformed in animation. For example, if a Noise map is used on the surface of a character that is being deformed with bones, you need to be sure that the pattern stays with the surface in the same way that a bitmap would. To create hard texture coordinates on vertices for 3D maps, use the UVW Mapping modifier with the XYZ To UVW option. Then, make sure that your 3D map is using the Explicit Map Channel option in the Material Editor. See Figure 13.42. On the left is a Cylinder with a Noise map applied. In the center, the top row of vertices was translated upward, but the object simply expanded into a new region of the 3D texture space. At right, the UVW Mapping modifier is used to create mapping coordinates on the vertices before the vertices are translated in an Edit Mesh modifier. Now, the top of the map stretches to follow the translated vertices.

Figure 13.43 shows the list of 3D Maps from the Material/Map Browser.

Figure 13.42
Using the UVW Mapping modifier to create hard texture coordinates for a 3D Map. On the left is a cylinder with a Noise map applied. In the center, the top row of vertices extends the object into a new region of the 3D texture space. On the right, the UVW Mapping modifier is used to pin the map to the vertices. The map now stretches as the top row of vertices is translated upward.

Figure 13.43
MAX's 3D Maps listed in the Material/Map Browser.

Reflections, Refractions, And Ray Tracing

A reflective material reveals other objects in the scene on its surface. If a material is completely or partially transparent, it reveals other objects through it. Most transparent materials are at least somewhat refractive—that is, they bend the light passing through them, distorting objects seen from behind.

True Object Reflections And Refractions

The most important method of creating accurate reflection and refraction effects is ray tracing. *Ray tracing* is a rendering technique that follows a ray of light through the scene, bouncing from one reflective object to another or passing through transparent objects to find objects behind. MAX has always offered ray tracing for shadows, but it did not offer ray-traced reflections and refractions until MAX 2. The older program filled the gap with some makeshift alternatives in the Map channels for reflection and refraction. Some of these are still useful because they can produce a satisfactory result without the enormous rendering times that ray tracing often requires.

When MAX introduced ray tracing for reflections and refractions, it did so in a very confusing way. You can apply ray tracing at the Material level by using a Raytrace Material. Or, you can use the Raytrace Map type in the reflection or refraction Map channels. The Raytrace Material offers some more advanced parameters, but the panels for both the Map and Material types are extremely complex and intimidating. There is nothing about ray tracing that should require so many parameters for the general user. Fortunately, the default settings are almost always satisfactory for anyone who is not a professional rendering specialist. Make sure that Antialiasing is checked in the Raytrace Options dialog box (available from the Options button of both of the Raytrace panels).

As alternatives to ray tracing, the Flat Mirror Map type can be applied only to flat (coplanar) regions of an object. The Reflect/Refract Map type generates a six-sided box map of the environment, as seen from pivot point of the object, which is then applied as a spherical projection to the object. With curved objects, the inherent inaccuracies of this technique may not be noticeable, and it's much faster to render than ray tracing. The Thin Wall Refraction Map type gives a good impression of refraction when used with thin, flat surfaces such as window glass.

Using Reflection Maps

Often, you don't need to produce reflections of true geometry in the scene. For example, a reflective surface may be blurry enough that the reflections are not identifiable, and all you need is vague reflected patterns. In other cases, you need reflections of discernible objects, but don't need (or want) to model them directly. In either case, you can use bitmaps or procedural textures to get a satisfactory effect. Putting such a map in the reflections Map channel creates a Spherical Environment Map that is reflected off the surface of the object. A Spherical Environment Map is a map projected on the inside of an infinite sphere enclosing the scene. Using a reflection map of a cloudy sky (such as sky.jpg in the MAX Maps directory) is a very standard practice.

Moving On

In this chapter, you learned that mapping is the process by which a material parameter (such as Diffuse Color) can be made to vary over a surface. You learned how bitmap images are used for mapping, and particularly how texture coordinates are established on a surface, either by projection or through the use of a surface's intrinsic coordinates. You explored the vast possibilities of MAX's procedural mapping tools that permit you to create patterns without the use of bitmaps. And you took a brief look at object reflections and the use of ray tracing.

In the next chapter, we'll turn to lighting in 3D Studio MAX. You'll learn the important ways in which lighting in computer graphics differs from real-world lighting, and you'll explore the full-scope of MAX's lighting toolset.

PART V

LIGHTS, CAMERA, RENDER!

LIGHTS

Just as in the theater or a motion picture, lighting is the life of a 3D scene. Your models are only geometry until they are properly illuminated.

3D computer graphics (CG) is closely analogous to real-world filmmaking. Objects are constructed and placed in space. Lights are used to illuminate the scene, and the action is photographed with a virtual camera. But a CG scene is not merely a virtual version of a physical one. There are many important differences between CG and the physical world, and your real-world instincts are often inappropriate for the computer-imaging environment.

The area that most readily comes to mind in this regard is lighting.

Lighting In Computer Graphics

CG lighting differs from real-world lighting in the most fundamental way. You cannot light a scene correctly, nor can you take advantage of CG's lighting advantages, if you do not understand these differences.

Diffuse Reflection And Global Illumination

In the real world, and especially indoors, most illumination is attributable to reflections off of surfaces. As I look around my workspace right now, light is entering the room only from a window at the side. Yet all the walls are illuminated—at least softly—even though very little surface area is in the direct path of the window light. The window light bounces off the walls, it hits onto other surfaces, and then hits onto others until all of the surfaces share in the illumination. The paint on the walls is matte, but if it were glossier, the overall illumination would be stronger.

Note the way in which I use the word "reflective" here. In standard computer graphics, *specular reflection* refers to the highlights on shiny objects attributable to light sources. True reflections in standard computer graphics are reflections of other objects in the scene in a mirror-like surface. In the real world, however, the most important kind of reflection is diffuse reflection—reflection of the diffuse color of a surface. When light hits a surface, the light that characterizes the diffuse color of the object is emitted back. That's how you see the surface with your eyes and identify its color. This colored light is passed on to other surfaces, illuminating them. The

characteristic unity or quality of beautiful indoor lighting is attributable to the mixing of the colors of the light generated by diffuse reflection from colored surfaces. Painting a wall a different color changes the mix of colored lighting in the room and affects all surfaces.

Diffuse reflection is the primary feature of what is called *global illumination*. In a global illumination model, there can be no sharp line between objects and light sources. All are responsible for the illumination of the scene. In MAX, ray tracing of object reflections is a type of global illumination, but it is limited to effects on mirror-like surfaces.

The absence of diffuse reflection is the single biggest issue when lighting a scene in MAX. Light does not bounce off of the surfaces in the scene, so the results are generally very different from an analogous real-world lighting setup. Objects that are in shadow or otherwise out of the path of direct illumination may be very dark, or even black. The color of the illumination is generally incorrect because it does not incorporate the influences of colored surfaces in the scene. Much of the art of computer graphics lighting is in figuring out how to address these problems.

Figure 14.1 illustrates the essential problems. A sphere in a room is lit by only a single Directional Light. The back side of the sphere is completely black. The back wall is also completely black because it is not in the direct path of the light, and the side wall is much lighter than the floor. The shadow on the floor is solid black, as well. In a real-world environment, light would reflect off the floor to light the back of the sphere and the other walls. And light reflecting off of these walls would bounce back to the floor, washing out the shadow

Figure 14.1
The absence of global illumination creates harsh and unrealistic contrasts. The sphere is lit only by a single Directional Light. The back of the sphere is completely black, as are the back wall and the shadow. In the real world, light would reflect off the floor to illuminate the walls and rear of the sphere. Secondary reflection off the walls would wash out the shadow a bit.

USING RADIOSITY FOR BEAUTIFUL GLOBAL ILLUMINATION

The radiosity rendering technique produces magnificent results by using diffuse reflection. The surfaces in the scene transmit the light they receive back onto all other surfaces in a way that closely resembles real-world illumination. The results can be startlingly realistic and are essential for visualization projects in architecture and interior design. The premiere product in this area is Lightscape from Discreet. Lightscape works seamlessly with MAX. You can model objects or even complete scenes in MAX, light and render the radiosity solution in Lightscape, and then import the radiosity solution back into MAX for rendering. You can even add additional objects and animation back in MAX. Radiosity rendering takes some study, but the results are unparalleled.

somewhat. The absence of the global illumination produces the stark contrasts that are suitable only for fantasy environments.

Ambient Light

Ambient light is a technique that is used to create the illusion of global illumination, but it is not a light at all—it's really only the self-illumination of surfaces. When ambient light is present in the scene, its color is multiplied by the ambient color of the object (in its material definition) to produce a surface color. That color is added to the color produced by the interaction of the true light sources with the diffuse color of the surface to get a total. The idea is to add a kind of general overall lightening to the illumination generated by the light source. Ambient lighting is often called an "ambient factor" to suggest that it's just an illumination adjustment rather than a light source. In the vast majority of cases, the ambient color of the object should be the same as (or a darker version of) the diffuse color because the whole idea is to suggest global illumination of the object's diffuse color.

In MAX, the default ambient level is very low, and almost every scene will require a greater ambient factor. As an indication that ambient light is not really a light, MAX puts it in the Environment dialog box, which is reached through the Rendering menu on the menu bar. The problem with ambient light is its very generality. Adding a little ambient light to the scene from Figure 14.1 decreases the contrasts, but it lightens the floor too much. Take a look at Figure 14.2.

A better result can be achieved with some careful balancing. First, you can lower the intensity of the Directional Light and rely more on the ambient light. Then, you can divide the room object into separate Materials as a Multi/Sub-Object Material. Darkening the ambient color for the floor brings its value back down. The very dark back wall can be lightened by using a little Self-Illumination in the Material definition because the ambient color is already at its maximum. (This demonstrates the fundamental resemblance between the ambient factor and self-illumination.) Finally, the ambient color of the sphere is lightened, both to compensate for the decreased direct lighting and to fill out the back side. The result in Figure 14.3 looks much better, especially considering that there is only one true light source in the scene—which might be a window.

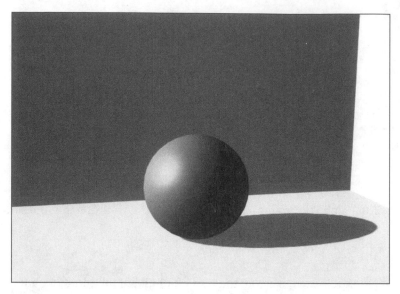

Figure 14.2
Adding some ambient light softens the contrasts, but the floor is now overlit.

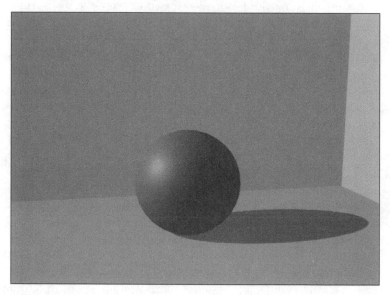

Figure 14.3
Careful balancing greatly improves the result from Figure 14.2. The intensity of the Directional Light is reduced to rely more on the ambient factor. The ambient color of the sphere has been lightened to fill out the shadow and adjust for the decreased Directional Light. The room object is divided into different Materials using a Multi/Sub-Object Material. The faces on the floor are given a darker ambient color. The faces on the back wall already have the lightest possible ambient color, so a self-illumination color is used to lighten them further.

Shadow Casting

In the real world, all lights produce shadows if their paths are blocked by surfaces. In computer graphics, however, shadow casting is optional. You can decide whether a light will cast shadows generally, and you can also decide whether a particular object in the path of a light will cast shadows on other objects. You can further decide whether an object will receive shadows from other objects. These options are available in the Modify panel for the selected light or in the Object Properties dialog box for the selected object.

These shadow-casting options are important for optimizing rendering time, but they also give the 3D artist a kind of flexibility that is unknown to the photographer. Undesirable shadows can be eliminated without moving the lights. But more importantly, lighting can be designed so that certain lights cast shadows and others serve only to illuminate the scene. Shadows are extremely important to establish depth and substance in a 3D image. Shadow placement can be handled with great independence of overall illumination by using a combination of shadow casting and non–shadow-casting lights.

Figure 14.4 demonstrates the concept in an extreme that is the opposite of realism. The specular highlight shows the direction of the main source of illumination, but the only shadow in the scene is cast by a light in the opposite direction.

This extreme example is used only to make a point. If you eliminate the specular component from the front Directional Light, as in Figure 14.5, the troubling highlight disappears. The light thus serves only to fill out what would otherwise be the dark areas of the sphere and to

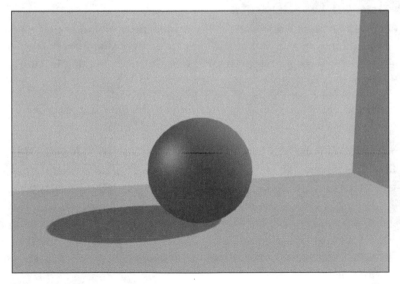

Figure 14.4
Different lights are used for general illumination and for shadow casting. The specular highlight shows the direction of one Directional Light. The shadow is cast only by a second Directional Light from behind. This is the opposite of realism.

Figure 14.5
Same as Figure 14.4, but with the specular component eliminated from the front Directional Light. Without the confusing highlight, this light now serves to fill out the general illumination without creating cross-shadows.

generally even out the illumination of the scene. This result can replace or be balanced with the ambient factor in building the illusion of global illumination.

Inclusion And Exclusion Of Objects

Another striking difference between real-world and CG lighting is the power to exclude specific objects from the illumination of specific lights. In Figure 14.6, the scene from Figure 14.5 is altered to exclude the sphere from the illumination by the front Directional Light. That light still illuminates the room (Box) object.

Note the difference between this exclusion and simply turning off the light in the scene, as shown in Figure 14.7.

MAX provides an Exclude/Include dialog box for every type of light. Figure 14.8 shows this dialog box, as used in the current scene. The left side begins with a list of all objects in the scene. Selected objects can then be moved to the panel on the right side. These objects are excluded or included in the illumination of the light, depending on the choice made at the top. Sometimes, it's easier to organize the objects that you wish to include in the illumination than to list those that you wish to exclude. Generally, you'll exclude objects from both illumination and shadow casting, but this dialog box can also be used as a method for sorting out your shadow-casting decisions alone.

Another way to include or exclude objects from lights is with the Light Include/Exclude utility, available in the Lights & Cameras toolbar. The panel is shown in Figure 14.9. Select the desired geometry and choose either the Include or Exclude option. Then, activate the Assign

Figure 14.6
Same as Figure 14.5, but with the sphere excluded from illumination by the front Directional Light. The room (Box) object remains lit by that light.

Figure 14.7
Same as Figure 14.6, but with the front Directional Light simply turned off in the scene. Its fill illumination effect is now lost.

To Light button and click on a light in any viewport. The selected objects are included or excluded for that light. The bottom half of the panel displays the complete include or exclude list for the light you clicked on, and you can also look at the lists for other lights with the Choose Light option.

Figure 14.8
The Exclude/Include dialog box for the front light in the scene rendered in Figure 14.6. The Sphere object was moved from the left panel to the right panel for exclusion.

Figure 14.9
The Light Include/Exclude utility panel, which is available from the Lights & Cameras toolbar. This flexible tool allows you to exclude or include any object in the scene from any light.

Light Types And Their Parameters

MAX offers the three standard light types that are common to all 3D graphics applications. A Directional Light is best conceived of as a plane generating light rays perpendicular to that plane. Thus, all of the rays are parallel. In the real world, this most closely simulates sunlight. Of course, the rays of sunlight received on Earth are not exactly parallel, but our distance from the sun is so great that they may be treated as parallel, for all practical purposes. MAX offers a Sunlight System that uses a Directional Light, and information about

time and location to get a correct angle for sunlight on the scene. This kind of precision is typically necessary only in scientific or commercial visualizations. The Sunlight System is available from the Lights & Cameras toolbar or from Create|Systems in the Command Panel. MAX's Directional Lights can use either an infinite plane of rays or some defined region of a plane, either rectangular or circular.

An Omni Light is the same type that is called a bulb light or a point light in other applications. The Omni Light is located at a single point in world space and generates light rays in all directions, radiating out like a sphere. This simulates the way the light is distributed from a conventional light bulb, and is therefore extremely useful in enclosed spaces.

The Spot Light is like a conic region of an Omni Light. Like the Omni Light, the Spot Light generates light from a single point, but the distribution is limited to a cone.

DON'T TRUST YOUR SHADED PREVIEW

When working with lights, the rule is "render, render, render!" The realtime shaded previews in your viewports are often very different from your rendered results. Even the rough effects of light placement and basic parameter changes cannot be assessed without rendering. And, of course, the preview can't show you your shadows.

Creating Lights

You can create lights by selecting Create|Lights in the Command panel or from the Lights & Cameras toolbar. Both the Directional Light and the Spot Light have Free and Target options. Because these lights must be pointed in some appropriate direction, it generally makes sense to use a Target object. When you create a Target Direct or Target Spot, and drag on the screen, you create both the light and the Target object (a nonrendering null object). The light is given a Look At controller that keeps it directed at the Target object. Moving the Target object in the scene rotates the light, and to point a light at a renderable object, you simply align the Target with the object. If you create a Free Direct or Spot Light, no Target object is created, and the light is pointed by rotating it directly. Use the Views menu in the right-click viewport menu to look directly through the light when rotating it.

An Omni Light is completely nondirectional, so there is no need to rotate it. There is no choice of Free or Direct. Create the light by simply clicking on a location in a viewport and moving the light, as necessary.

Setting General Parameters

After a light is created, its parameters are freely adjustable in the Modify panel. In fact, you can even change the light to another type from the drop-down list. If you do this, remember to change the name of the light to reflect the new type. Figure 14.10 shows the General Parameters rollout from the Modify panel. Although the selected light is a Free Direct type, this rollout is the same for all of the light types.

USING THE DEFAULT LIGHTS

MAX always starts a scene with one of two kinds of Default Lighting. The "default" Default Lighting is a single Directional Light that remains aligned with your view, so that objects remain illuminated at every viewing angle. However, you can change from this 1 Light option to a 2 Lights option in the Viewport Configuration dialog box (under the Rendering Tab). The 2 Lights option uses two Omni lights. A "Key" light is positioned above-front-left. A "Fill" light is positioned diagonally opposite—below-rear-right. You can easily compare the two Default Lighting options by creating a Sphere in the center of world space and flipping between them.

The default lights are unselectable and uneditable. To make them into true lights that may be transformed and otherwise edited, use the Add Default Lights To Scene command in the Views menu. This applies only to the 2 Lights option, and you can choose to convert either one or both of them.

Figure 14.10

The General Parameters rollout for a Free Directional Light. This rollout is the same for all light types.

The On checkbox toggles the light on and off. The square to the right of this checkbox indicates the color of the light, and clicking on it brings up the Color Selector dialog box. If you change the color in the Color Selector dialog box, the values in the RGB (Red, Green, Blue) and HSV (Hue, Saturation, Value) spinners change accordingly. You can also work in the opposite direction, changing the values in the spinners and seeing the effect in the Color Selector and the color swatch.

The Exclude button brings up the Exclude/Include dialog box, discussed earlier in this chapter, for limiting the illumination of the light only to specified objects. The Multiplier spinner adjusts the intensity of the light.

The options in the Affect Surfaces section of the rollout are for specialized purposes. By default, a light generates both diffuse and specular illumination. In other words, a light illuminates the diffuse color of the object and generates highlights if the object's material is defined to include specularity. On the other hand, the light should have no impact on the ambient illumination. You can disable the diffuse or specular elements for a light, so that a light either does not produce highlights or only produces highlights. By checking the Ambient Only option, the light is used only to illuminate the ambient color of the material.

Figure 14.11
The Contrast spinner increases the contrast between diffuse and ambient regions. The sphere is lit with only a single Directional Light from above, and the bottom of the object is filled out with an ambient factor. The render at left uses the default Contrast value. The render on the right uses a high value of 60.

The Contrast spinner increases the contrast between the diffuse and ambient regions of a surface. In Figure 14.11, a sphere is lit from above with only a single Directional Light. A small but significant ambient factor was added to fill out the bottom-half of the object. (The ambient factor is, as explained earlier, a combination of the ambient color of the material and the color of the ambient light set for the scene.) The render on the left side uses the default Contrast values. The render on the right uses a high Contrast value of 60. Note that the area lit by the light (the diffuse illumination region) is relatively brighter and the ambient region below is relatively darker.

The Directional Lights and Spot Lights have special rollouts to set additional parameters. The Directional Parameters rollout for the Directional Lights determines whether the light extends in an infinite plane or whether it is limited to a defined region. By limiting the light to a defined region, these lights become a kind of cylindrical or rectangular spotlight—something that doesn't exist in the real world. The Overshoot box is unchecked by default, but I've never quite understood this. The vast majority of uses for Directional Lights require an infinite plane, and MAX users are often confused when they add a Directional Light that appears to do little or nothing. If you do not intend to use a Directional Light as a sort of spotlight, make sure that the Overshoot box is checked.

The whole idea of "Overshoot" assumes some defined region to which the light is restricted, and which is optionally ignored (or "overshot"). This defined region is either cylindrical or rectangular. The Circle option creates the cylindrical region. Figure 14.12 illustrates the effect of a cylindrical Directional Light. A Plane object is illuminated by only a single Directional Light, pointing down on the surface. On the left is a wireframe top view. Two concentric circles represent the Directional Light. The outer circle is the limit of the cylinder of light and is controlled by the Falloff spinner in the rollout. The inner circle is the area of constant

Figure 14.12

Using the Directional Light to create a cylindrical "spotlight." A single Directional Light is pointing down on a flat surface. In the top wireframe view on the left, the outer concentric circle defines the limits of the cylinder of light. The inner circle defines the region of maximum intensity. The render on the right shows how the light intensity falls off between the inner and outer circles.

maximum intensity, and it is controlled by the Hot Spot spinner. As you can see in the rendered image on the right, the light intensity falls off between the inner and the outer circles.

The Spotlight Parameters rollout for Spot Lights provides precisely the same functions as the Directional Parameters rollout does for Directional Lights. Both of these rollouts permit you to use the light to project a Map. Oddly enough, an Omni Light can also be used as a projector, but this function is in a separate rollout.

Attenuation

Lights in computer graphics differ from real-world lights because a light continues at full intensity for an infinite distance, unless you instruct it otherwise. Objects that are far away from the light source are illuminated with the same intensity as those close by. The tools in the Attenuation Parameters rollout cause light intensity to decrease. Figure 14.13 shows the Attenuation Parameters rollout with some values set.

Figure 14.13

The Attenuation Parameters rollout, with some values set for use.

There are two approaches to the problem. First, the Near and Far Attenuation sections of the rollout give you precise control. Everyone is confused by these controls at first because the whole idea of Near Attenuation seems so peculiar. If Near Attenuation is used, the light actually increases in intensity as it leaves the light source. I must confess that I've never had cause to use it. Far Attenuation is what you would naturally understand as light attenuation. The viewports display the Start and End limits that you set by using the spinners in the rollout, in a form appropriate to the type of light. Attenuation begins at the Start distance, meaning that the light begins to fall off. At the End distance, the light is completely attenuated.

Figure 14.14 illustrates a Far Attenuation setup. A top wireframe view shows five Cone objects, arranged in a diagonal. A single Directional Light is placed right in front, at the base of the arrow icon, and there is no ambient illumination in the scene. The first line is the Start distance and the second is the End distance. Thus, the light is at full intensity prior to the Start line and then falls off to the End line. A perspective render in Figure 14.15 shows the result. The first two Cones are at full intensity, and the attenuation at the third Cone is not significant. The fourth Cone receives much less illumination, and the last Cone is beyond the End line, so it is in the dark.

An easier and more physically correct way to obtain attenuation is with the Decay tools at the bottom of the rollout. By default, the Decay type is set to None, and there is no attenuation. The Inverse option causes the light to fall off gradually (the inverse of the distance), and the Inverse Square option is a more accelerated decay. The Start spinner controls where the Decay begins. Use the Show option to see the Start distance in a viewport. Figure 14.16 illustrates the Inverse Square type used on your same scene.

Figure 14.14
A Far Attenuation setup seen in a top wireframe view. Five Cones are arranged in a diagonal and a single Directional Light is placed in front. The first line is the Start distance and the second is the End distance. Thus, the light will lose intensity beginning at the Start line and will fade out entirely by the End line.

Figure 14.15
A perspective render of the setup in Figure 14.14. The first two Cones are fully illuminated and the attenuation on the third is minor. The fourth Cone receives significantly less illumination. The fifth Cone is beyond the End line and is therefore invisible. There is no ambient illumination in this scene.

Figure 14.16
Same as Figure 14.15, but with Inverse Square Decay used in place of the Far Attenuation controls.

Shadows

Shadows are the absence of light. I know this sounds obvious, but it's very easy to forget. Computer graphics always refers to "shadow-casting," whether with respect to lights or objects, and this makes it sound like the shadow is being projected as a dark region. Rather, it's the light that is being projected and the shadows occur where the light is occluded. You don't create shadows—you create light and then obstruct its path in the scene. If a surface is already highly illuminated, a shadow cast on it is barely visible. Shadows don't make surfaces darker—they prevent them from getting lighter than they would otherwise be.

As discussed earlier in this chapter, MAX has controls for determining whether a light casts shadows and whether each individual object casts or receives shadows. You can turn shadows off for the entire scene in the Render Scene dialog box, which speeds up the renders made to test elements other than shadows.

Basic Shadow Parameters

The toolset for shadows is not very complex. For the selected light in the Modify panel, the Shadow Parameters rollout allows you to choose between Shadow Map and Ray Traced Shadows. If the Shadow Map type is used, a Shadow Map Parameters rollout appears below, providing specialized parameters. If the Ray Traced Shadows option is used, a Ray Traced

Figure 14.17
The rollouts for Shadow Map and Ray Traced Shadows, with shadows and the default values.

Shadows Parameters rollout appears. Figure 14.17 shows the rollouts for both shadow types, with shadows on and the default values.

The Use Global Settings option is a kind of instancing. Every light in the scene for which this box is checked shares some of the same settings, and changing any of these settings for any one of the lights changes it for all of them. This can be a great convenience when there are many lights in the scene. All of the lights that share Global Settings share the same type (Shadow Map or Ray Traced Shadows), and they will share all of the values in the Shadow Map or Ray Traced Shadows rollouts. For example, they will all share the same Bias. They will not share parameters in the Shadow Parameters rollout (except for the Shadow type), and thus can have different settings for color and density. When you uncheck the Use Global Settings box, independent control of the light returns for all parameters.

OVERSHOOT DOESN'T AFFECT SHADOWS

Spot Lights and Directional Lights are confined to their Falloff region, unless the Overshoot box is checked. Overshoot turns a Directional Light into an infinite plane of light and turns a Spot Light into the equivalent of an Omni Light. Not for shadows, however. Even if the Overshoot box is checked, shadows are not cast for regions outside the Falloff. This can be very confusing, especially for Directional Lights. You often have to expand the Falloff to cast the necessary shadows, even if Overshoot is checked.

The color of a shadow should nearly always be black, but you can change it for special effects. The color of the light can also be used to influence the color of the shadow. The Density control is extremely important. When the value is at the default of 1.0, the light is completely occluded. Lesser values make the shadow more transparent, softening its effect. A separate and independent section of the rollout provides for shadows to be cast by atmospheric effects, such as fog.

Choosing Between Ray Traced Shadows And Shadow Maps

Ray tracing produces extremely accurate shadows that are very sharp-edged. Shadow maps can produce shadows with much softer edges, but can also produce undesirable artifacts. In interior scenes, the large amount of global illumination reflecting off the wall softens shadows. In outdoor scenes, the sun is usually the only light source, and reflected illumination that might soften shadows is typically absent. Thus, as a general rule, the Ray Traced Shadows type is used outdoors, and the Shadow Map type is used indoors.

Shadow Map Parameters

Working with shadow maps can be very frustrating. Every time you try to correct one thing, something else goes wrong. The logic of the situation runs like this: A shadow map is computed at a certain resolution. The default map size is 512 x 512 pixels, as you can see in the Size spinner. Increasing the size of the map increases its resolution. The main purpose of a shadow map is to create soft shadows, however, and increasing the resolution makes the map sharper. A low-resolution map is softer, but it can generate flaws. A higher-resolution map reduces these artifacts, but it may make the shadow too sharp. The Sample Range affects the softness of the shadows, but increasing this value can produce artifacts in the same way as an insufficient map size.

Walk through a series of images to demonstrate the kind of balancing act that is typical when you use shadow maps. The scene is the same room used earlier in this chapter, with a slightly different sphere and a tall, thin cylinder. A single Directional Light is used. Figure 14.18 shows

Figure 14.18

An interior scene, with a single Directional Light using the default Shadow Map parameters. Thin, dark shadow lines appear where the walls meet. The shadow cast by the ball is not soft enough for the environment. The shadow cast by the cylinder is unrealistically hard, and it does not touch the base of the object on the floor.

the results of using the shadow map default values. Thin, dark lines appear where the walls meet—lines that did not exist before the shadow map was turned on. The shadow cast by the sphere is soft, but not soft enough for the environment. The shadow cast by the cylinder is unrealistically hard, and does not meet the base of the object on the floor.

Increasing the Sample Range from 4 to 10 softens the shadow from the ball quite well, but the shadows where the walls meet grow far worse. The shadow from the cylinder broadens without blurring, producing an even worse result than the previous version. Figure 14.19 illustrates this poor result.

To get rid of those horrible artifacts on the walls, I detached the floor polygons from the rest of the room to create a separate object. That way, the walls (but not the floor) could be turned off to shadows by using the Object Properties dialog box. Adjusting the Bias to 0 brings the shadow from the cylinder back in contact with the object itself. Take a look at Figure 14.20.

In Figure 14.21, the Map Size is increased from 512 to 1024. The increased resolution essentially offsets the softening quality that is achieved by increasing the Sample Size. The result is better for the cylinder because even a sharper shadow is preferable to the unrealistically broad one.

Figure 14.19
Same as Figure 14.18, but with the Sample Range increased from 4 to 10. The shadow cast by the sphere is pleasingly softer, but the shadow lines where the walls meet have grown much darker and more noticeable. The shadow from the cylinder broadens without blurring.

Figure 14.20
Same as Figure 14.19, but with the walls separated from the floor at the object level to eliminate shadows from the walls alone. This eliminates the shadow artifacts at the edges. The Bias is adjusted to bring the shadow of the cylinder into contact with the object on the floor.

Figure 14.21
Same as Figure 14.20, but with the Map Size increased from 512 to 1024. The increased resolution effectively cancels out the softening achieved by increasing the Sample Range, but the shadow from the cylinder is more acceptable.

Figure 14.22
Same as Figure 14.21, but with the shadow Density decreased from 1.0 to 0.7. The paler shadows feel softer and the flaws are less noticeable.

A possible compromise might be to decrease the Density of the shadows from 1.0 to 0.7. The paler shadow seems softer and the flaws are less noticeable. Figure 14.22 shows the result.

Ray Tracing Parameters

There's much room to play with Ray Traced Shadows. Increasing the Max Quadtree Depth above the default value of 7 produces greater accuracy (and longer render times), but you'll rarely need to do this. On the other hand, you'll often have to play with the Bias spinner. Bias is typically used as it was earlier in this chapter—to move the shadow into alignment with the shadow-casting object—but Bias adjustment also solves some other problems.

Figure 14.23 shows the scene you've been using, but with Ray Traced Shadows used instead of Shadow Map. The shadows are very precise. They are much too sharp for most indoor illumination, and this is especially noticeable with the ball. The ray tracing generated some small artifacts where the walls meet. They are not as extreme as in the Shadow Map versions, but they are still noticeable.

Adjusting the Bias up to 0.5 eliminates these artifacts, as you can see in Figure 14.24. Luckily, this increase in Bias was not great enough to pull the shadows away from the objects on the floor.

Using The Light Lister

If you have more than a couple of lights in a scene, managing the lighting can become a nightmare. MAX 3 introduced a fantastic tool to help you keep your sanity. The Light Lister panel is available from the Lights & Cameras toolbar. Figure 14.25 shows the panel for a scene in which there are four lights.

Figure 14.23
Using Ray Traced Shadows produces very sharp and accurate shadows—much too sharp for this indoor scene. Note the small artifacts where the walls meet. These are not nearly as extreme as in the Shadow Map example, but they are still irritating.

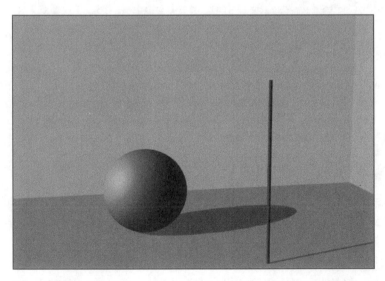

Figure 14.24
Same as Figure 14.23, but with Bias increased to 0.5 to eliminate the artifacts. This adjustment was not enough to pull the shadows away from the objects on the floor.

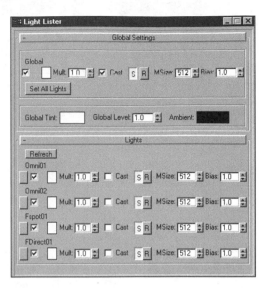

Figure 14.25
The Light Lister panel for a scene with four lights.

The Lights rollout lists all of the lights and permits you to change the most important parameters without using the Modify panel. The checkbox for each light turns it on and off. Clicking on the gray box on the left selects the light and brings it up in the Modify panel. The Global Settings rollout is divided into two sections. The upper section allows you to define parameters to apply to all the lights in the scene. Once they are set, use the Set All Lights button to transfer the values to the individual lights. The lower section is of much more general value. You can apply a color tint and a Level to all the lights in the scene. This does not replace the existing values; it is a separate adjustment layer. You can also set the ambient light for the scene in this section. These three controls are also available in the Environment dialog box from the Rendering menu.

Moving On

In this chapter, you learned about lighting in computer graphics and about MAX's particular lighting toolset. Lighting in 3D applications such as MAX differs fundamentally from real-world lighting. Most important is the lack of global illumination. Illumination in MAX is not reflected off of walls and other surfaces, so it is necessary to work creatively to create the illusion of such reflected light.

You learned about the three light types in MAX and their specific parameters. You also learned about shadows, particularly about the choice between shadow mapping and ray tracing of shadows.

The next chapter turns to cameras and compares the two types of cameras and their parameters. You'll work through exercises that will teach you how to manipulate cameras, either by transforming them directly or by using special camera-navigation tools.

15

CAMERAS

You don't have to create a camera in MAX. If a single viewpoint is all that is needed, and the viewpoint won't be animated, you can simply render through a perspective viewport. You can even render through an orthographic viewport, although this is rarely useful.

If the viewpoint is to be animated, you need to create a camera. And if you wish to work with multiple viewpoints in the scene to cut from one to another, you need more than one camera. Even where you don't absolutely need a camera, it can be useful. For example, you can set up camera locations, and then use a Perspective Window (or another camera) to navigate freely through the scene.

There are two kinds of cameras: Free Cameras and Target Cameras. Just as with the lights, a Target Camera automatically comes with a nonrendering Target object that is used to rotate the camera. The Target Camera is given a Look At controller that keeps it pointed toward the Target object, and thus you rotate the camera by moving the target. In contrast, a Free Camera comes without a Target object and is rotated directly. In the vast majority of cases, it's much easier to manage a camera with a Look At target. And the Target object is separately animatable.

When you create a camera, it becomes available as a viewport option. When you activate a camera viewport, special navigation options replace the standard ones at the bottom-right corner of the MAX screen. You also have a collection of parameters for each camera in the Modify panel. As you'll see in this chaper, there's some overlap between these parameters and the camera navigation tools.

The best way to understand the MAX camera toolset is to walk though an exercise.

Creating And Transforming Target Cameras

Begin our chapter-long exercise as follows:

1. Create a Sphere object in the center of world space. Create a Target Camera by using either Create|Cameras in the Command panel or the button in the Lights & Cameras Toolbar. In a top view, click and drag to create and direct the camera. First, click in front of the object to place the camera, and then drag toward the Sphere to lay down the Target object right in the middle of the Sphere. With the camera selected, go in the local coordinate system. Your top view should look something like Figure 15.1.

Figure 15.1
A top view showing a Sphere at the center of world space and a Target Camera pointing at it. The camera is created and directed by clicking to establish the location of the camera, and then dragging to establish the location of the Target. The Target Camera is selected and is using the local coordinate system. Note that it is pointing in its local z-direction.

2. Take a moment to examine your top view or Figure 15.1. The small square in the middle of the sphere is the Target. The line connecting the Target to the Target Camera is called the Target Line, and the angular structure defining the field of view is called the Camera Cone. With the Target Camera selected and using local coordinates, you can see that the Target Camera is looking down its local z-axis.

3. Move the Target Camera to understand the Look At concept. No matter where you move it, the local z-axis is always pointed at the Target object. In effect, moving the Target Camera causes it to orbit the Target, although you can also move the Target Camera closer to (or farther away from) the Target. Figure 15.2 shows the Target Camera moved around the Target and closer to it.

4. Select the Target object and move it to rotate the Target Camera away from the Sphere. You'll probably need to use the Select Objects dialog box (press the H key) to select the Target. Notice that the distance of Target object from the Target Camera is irrelevant. Only the direction of the Target matters. Your top view should look something like Figure 15.3.

5. With the Target still selected, use the Ctrl key to add the Target Camera to the selection. Moving the Target Camera and its Target together translates the Target Camera without affecting its rotation. Move the two objects so that the Sphere is back within the Camera Cone, as in Figure 15.4.

Figure 15.2
Same as Figure 15.1, but with the Target Camera moved around the Target and closer to it. Note how the
local z-axis remains pointed toward the Target object.

Figure 15.3
Same as Figure 15.2, but with the Target object moved to rotate the Target Camera off of the Sphere. The
distance between the Target and the Target Camera doesn't matter.

Creating And Transforming Free Cameras

You can add a Free Camera to the scene and compare it to the Target Camera. A Free Camera
is not only harder to transform—it's harder to position and direct in the first place. Just like the
Target Camera, the Free Camera points down its local z-axis. To continue our exercise:

Figure 15.4

Moving the Target Camera and its Target as a single unit translates the camera without rotating it. This figure shows the Target Camera and Target from the previous figure translated together until the Sphere is back within the Camera Cone.

6. Hide the Target Camera and Target object in your scene and create a Free Camera from the Lights & Cameras Toolbar. Before you click in a viewport to place the Free Camera in the scene, take a moment to think. The Free Camera's local z-axis will look into the direction of the viewport in which you click. This can be confusing, so try to position the Free Camera just as you did the Target Camera—in front of the Sphere and pointing toward the center of world space. If you use a top view and click on the right location, the Free Camera is pointing downward, in the negative z-direction in world space. That means you have to rotate it. On the other hand, if you click in a front view, the Free Camera is pointed in the correct direction, but it is located in the wrong place. It's generally easier to translate an object than to rotate it, so this second choice is preferable. Figure 15.5 shows a top view of a Free Camera created in a front view and then translated to the desired location.

7. Take a moment to look at Figure 15.5 in more detail. Note that there is no Target object or Target Line. The Target Line is a great help in seeing where a camera is pointed, especially in a complex scene. The Camera Cone remains, however, to indicate the field of view.

8. Orbiting the Free Camera around the object takes two steps. First you move it, and then you rotate it. This can be hard to do in a way that keeps the focus on a constant point. Give it a try. When you finish, your top view might look like Figure 15.6. This was much easier to do with the Target Camera.

9. Translate the Free Camera without rotating it and you get the same result as when you translate a Target Camera along with its Target. This is the only thing that's easier to do with a Free Camera than with a Target Camera. Rotating a Free Camera is like moving the Target with a Target Camera, but it can be more difficult because you typically are trying to point the camera at an object. By aligning a Target to an object, you automatically cause a Target Camera to rotate correctly.

Figure 15.5
A top view showing a Free Camera pointed toward a Sphere at the center of world space. The selected Free Camera is shown in local coordinates, so you can see that (like the Target Camera) it points in its local z-direction. There is no Target object and no Target Line, but there still is a Camera Cone.

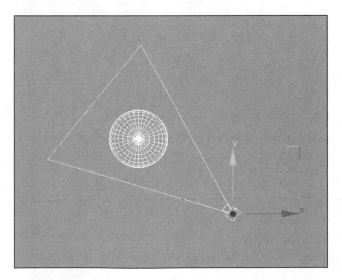

Figure 15.6
Same as Figure 15.5, but the Free Camera is orbited around the Sphere. This requires separate translation and rotation steps, which can be difficult to do precisely. With a Target Camera, this result is achieved easily in a single intuitive step by simply moving the camera.

Camera Parameters

You can set camera parameters when you create a camera, but you'll generally work in the Modify panel with the camera selected. Figure 15.7 shows the parameters for the Free Camera in Figure 15.6.

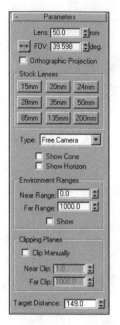

Figure 15.7
The parameters for the Free Camera in Figure 15.6 (from the Modify panel).

Converting Between Camera Types

Note the Target Distance spinner at the bottom of the panel in Figure 15.7. To figure out what this setting means, let's pick up our exercise where we left off:

10. Play with the spinner and watch the Camera Cone expand outward or contract inward.

11. Adjust the value so that the line marking the end of the Camera Cone cuts right through the center of the Sphere.

12. Convert the Free Camera to a Target Camera by changing the Type in the selection box.

Voila! You now have a Target Camera with the Target at the distance you set in the spinner—meaning at the end of the Camera Cone. This is a fantastic convenience. Of course, you can always change a Target Camera to a Free Camera as well.

Adjusting Field-Of-View

All of the parameters on the panel above the Type choice affect a single thing. With a real camera, the length of the lens (measured in millimeters) determines the angle constituting the field-of-view (FOV). Shorter lenses produce wider fields, and longer ones produce narrower ones. Let's see how this works in relation to our ongoing exercise:

13. Thus, in the Modify panel, you can change the length of the lens and watch the FOV spinner change value, or you can change the FOV value and watch the Lens spinner change—it's all the same thing. The buttons allow you to grab stock lens lengths without bothering with the spinners. Experiment with the lens length and FOV parameters. As you change values, the angle of the Camera Cone changes on the screen. Figure 15.8 shows the camera from Figure 15.6 (converted to a Target Camera) using the stock 24mm lens. This corresponds to a 73.74-degree horizontal angle for the field-of-view.

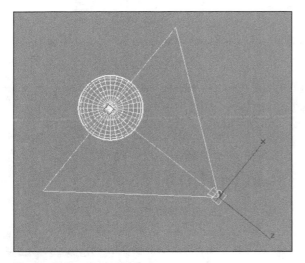

Figure 15.8
The Free Camera from Figure 15.6 is converted into a Target Camera and given a 24mm lens. This creates a very wide field-of-view angle, as can be seen from the shape of the Camera Cone.

Clipping Planes

Clipping planes define the depth for which the camera is active. In most cases, you want the camera to capture everything in its field-of-view, no matter how close or far away. Sometimes, however, it makes sense to narrow the clipping region—typically, when you don't want the renderer to waste time with distant objects that are too small to be seen. Let's adjust our exercise's clipping planes now:

14. Check the Clip Manually box and adjust the spinners for the clipping planes. The planes are visible in the viewports. Set them so that the Near Clip plane is just in front of the Sphere and the Far Clip plane is just behind it. A top view should look like Figure 15.9. In a view through this camera, any objects created in front of or

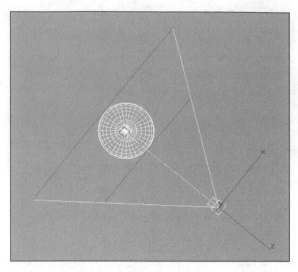

Figure 15.9
Same as Figure 15.8, but with clipping planes set just before and behind the Sphere. In a view through this camera, objects created in front of or behind the Sphere are not visible.

behind the Sphere would not be visible. The Environment Ranges controls are just like the Clipping Planes controls, except that they apply to atmospheric effects rather than to geometry. Uncheck the Clip Manually button before you go on with this exercise.

Camera Viewports And Navigation

Now, let's look through the camera we've been creating settings for:

15. Pick a viewport and right-click on the name of the viewport to get to the Views menu. The cameras in the scene are listed. Make sure that you pick the right one. If you have followed this exercise and created two cameras (one hidden), the visible one is named Camera02. Pick this camera for the viewport.

16. If the camera viewport is active, you'll notice some new navigation tools in the bottom-right corner of the MAX screen. Sometimes, it's easier to adjust a camera from a viewport in which you can see the camera object, and sometimes it's easier to work while looking directly through the camera. You already explored the former approach, so try navigating though camera view. Make sure that you have a top viewport next to your camera viewport for easy comparison. And make sure that the Show Cone box has been checked in the camera panel. That way, the cone remains visible if you lose the selection of the camera.

Dollying The Camera

In filmmaking, moving a camera toward the object on which it's focused is called *dollying* the camera. To see the effect of using the dollying feature in MAX on our running exercise:

17. Make sure that you're in the camera viewport. The navigation icon with the up and down arrows is the Dolly Camera button. Click on this button to activate it and drag in the camera viewport. The object grows bigger or smaller, and you can see the camera moving the top viewport. Take a look at Figure 15.10.

Figure 15.10
Same as Figure 15.9, but with the camera moved away from the object using the Dolly Camera tool, which is available when a camera viewport is active. The top view shows the new position of the camera, and the camera view shows the effect.

18. Hold down on the button again to see the other options. You can dolly only the target, or dolly both the camera and the target. If you use a Free Camera instead of a Target Camera, you get only the Dolly Camera option. Because there's no target with a Free Camera, the Dolly Camera tool moves the Free Camera in its local z-direction.

The Field-Of-View Tool

The Field-Of-View tool does the same thing for the camera viewport as it does with a perspective view. Let's see how it applies to our current exercise:

19. Activate the Field-Of-View button (with the angle icon) and drag in the camera viewport to narrow down the field-of-view quite a bit. You see the Camera Cone contract in the top view, and, if the camera is selected, you can see the Lens and FOV values change in the Modify panel. Your screen should look something like Figure 15.11. This is the true zoom, as opposed to the dolly.

The Perspective Tool

Dollying the camera and zooming a lens (changing the field-of-view angle) have very different effects on perspective, as you'll see as you continue the exercise:

20. Activate the Perspective button (with the distorted box icon). As you drag in the camera viewport, look at the top view and at the values in the Modify panel. Notice that the camera is being dollied and the field-of view angle is changing at the same time. Back in the camera view, notice that the sphere isn't getting any bigger or

Figure 15.11

Same as Figure 15.10, but with the field-of-view angle decreased to zoom in on the object. Compare the Camera Cone in the top view with the image through the camera viewport. The values in the Modify panel indicate that you have the equivalent of about an 85mm lens. This is a true zoom, as opposed to dollying the camera.

smaller. Why would you want to do this? A wide field-of view creates a strong perspective distortion, called *perspective flare*. A fish-eye lens provides the most extreme example. The narrow angle associated with a telephoto lens has minimal distortion. In order to correct (or sometime increase) perspective flare, you often have to change your field-of-view angle and then dolly the camera to compensate while maintaining your scene composition. The Perspective tool does this automatically. As you drag with it, watch the lines on the Sphere surface carefully. Figure 15.12 illustrates a change in perspective using this tool. The camera is moved much closer to the Sphere, but the field-of-view angle is correspondingly increased. The Sphere takes up the same amount of space in the camera view, but the perspective flare is very strong.

Figure 15.12

Same as Figure 15.11, but with the Perspective tool used to increase perspective flare. The field-of-view angle is greatly increased, but the camera is automatically dollied in to compensate. The result in the camera view is a change in the amount of perspective distortion without changing the composition of the frame.

Rolling The Camera

Let's try out the Roll Camera tool and Dolly and Roll spinners on our sphere:

21. Adjust the perspective to something less distorted than what you saw in Figure 15.12. The Roll Camera tool is immediately to the right of the Perspective icon.

Dragging in the camera viewport rotates the camera around its local z-axis. Take a look at Figure 15.13. The rotation of the viewing axis results in a slanted horizon line in the camera viewport and is evident from the Camera Cone seen in a front view. Rolling a camera generally makes sense only if the camera is animated and is more commonly achieved by banking the camera as it follows a curved animation path.

Figure 15.13
Rolling the camera causes it to rotate around its local z-axis. The rotation of the viewing axis results in a slanted horizon line in the camera viewport at left. The front viewport at right shows the rotation of the Camera Cone.

22. To eliminate the roll, take a moment to check out a precision alternative to dragging in the viewport. In the Main Toolbar (and with the Target Camera selected), activate the Rotate button, and then right-click on that button to bring up the Rotate Transform Type-In. Notice that there are Dolly and Roll spinners. Play with these spinners to see how easy they are to use, and then set the Roll value to 0. The Dolly and Roll controls are available from the Move and Scale Type-Ins as well.

Trucking The Camera

The button with the hand icon is called the Pan tool when used with any viewport other than a camera viewport. With a camera viewport, this same button becomes the Truck Camera tool, which performs the same function as the Pan tool in a regular perspective window. Trucking is moving a camera in its local xy plane. Dragging vertically in the camera viewport trucks in the camera's local y-direction. Dragging horizontally trucks in the local x-direction. With a Target Camera, this means moving the Target Camera and the Target object together. To experiment with trucking the camera in our current exercise:

23. Make sure that the camera viewport is active in order to get the camera navigation tools. Figure 15.14 shows a pan that moved the Target away from the Sphere and moved the Target Camera along a parallel path. Compare the camera view with the top view at left. As you truck the camera, notice how it moves in the direction parallel to the endline of the Camera Cone. With a Free Camera, the Truck tool moves the camera alone in the plane perpendicular to its local z-axis (the local xy plane),

Figure 15.14
Trucking a camera translates it in its local xy plane—the plane perpendicular to its viewing axis. In this figure, trucking the Target Camera moves both the Target Camera and its Target object along parallel paths. The Target object is no longer in the center of the Sphere, as you can see in the top view at left.

producing the same result. Experiment with all these concepts before moving on. Mastering this kind of thinking brings you closer to the mentality and practice of conventional filmmaking.

Orbiting The Camera

The final pair of camera navigation tools is in the button to the right of the Truck Camera tool. The default icon looks like a tiny version of the planet Saturn. This is the Orbit Camera tool. Let's experiment with this tool in our ongoing exercise:

24. Truck the Target Camera back until the Target object is in the center of the Sphere. Activate the Orbit Camera tool and drag in the camera viewport. Keep an eye on the other viewport to see what the camera is doing. The Target Camera orbits its Target object while remaining pointed toward it. The Target Camera moves and the Target object stays fixed. Note that Target Distance (the distance between the Target Camera and the Target object) at the bottom of the camera panel remains constant. Figure 15.15 shows your scene with the Target Camera orbited, so that it points downward on the Sphere and from the opposite direction. The perspective view at left helps in understanding the new location and orientation of the Target Camera.

25. Orbit to get the Target Camera back straight in front of the Sphere and level with the groundplane. You should be looking at the Sphere dead-on from the front. Hold down on the Orbit Camera button to select the alternative choice. This is the Pan Camera tool.

Panning The Camera

The hand icon is the Pan tool—a completely different creature—when not used with a camera view. Yeah, I know—this is pretty confusing. The Pan Camera tool is closer to what a filmmaker means by "panning"—rotating the camera from a fixed position. Specifically, the

Figure 15.15
Orbiting a Target Camera moves it around its Target object while maintaining a fixed distance. The Target object does not move. The Target Camera is now orbited so that it points at the Target (and therefore the Sphere) from above and from the opposite direction. The perspective view at left helps to visualize the new location and orientation of the Target Camera.

Pan Camera tool rotates a camera around its local x- and y-axes. (The Roll tool, as you have seen, rotates the camera around its local z-axis.) Let's try out the panning tool on the sphere:

26. Drag in the camera viewport and keep an eye on the other viewports for reference. The Target Camera stays in its place, but the Target orbits the Target Camera. This causes the Target Camera to rotate, much as when a person stands in one spot and turns his or her head to look around. Figure 15.16 shows the Target Camera panned horizontally a bit from a straight-on front view. Note in the top view that the Target object is not in the center of the Sphere.

Figure 15.16
Panning a camera rotates it without moving it. In this figure, the Target Camera was originally directed straight at the center of the Sphere. By panning horizontally a bit, the Target object orbits the Target Camera, causing the Target Camera to rotate.

27. Convert your Target Camera to a Free Camera. The Pan Camera tool works the same way it did before, except that there is no Target object to orbit. The Free Camera simply rotates around its local x- and y-axes. This makes sense. But you may be surprised to find that the Orbit Camera tool also works the same way as it did with

the Target Camera. Doesn't the Orbit Camera necessarily require a Target object to orbit the Camera around? Yes, it does. But a Free Camera has an implicit Target object, which is why you can convert freely between the two camera types. This implicit Target is located where the local z-axis of the camera intersects the endline of the Camera Cone, and it is the location used at the center of rotation when orbiting the Free Camera.

Moving On

In this chapter, you learned about the two camera types in MAX and how easily you can convert between them. You saw how to create and transform cameras in your scene by operating on them directly. You passed through the important camera parameters, including the field-of-view and clipping plane controls. Finally, you learned to use the camera navigation tools to manipulate a camera when working in a camera viewport.

In the next chapter, you'll turn to MAX's rendering toolset to learn how the scene or animation can be output to bitmap images or video files.

RENDERING TOOLS

The results of all your labors are images, either single or in sequences to be run as animations. All your audience sees are pictures, so they'd better be good.

Although you may think of rendering 3D scenes into bitmapped images as just the last thing you do, in fact, you're always rendering, at every stage of the process, to test the current state of your efforts. Many aspects of your work cannot be judged adequately, or at all, without rendering. In any case, rendering takes time—often an enormous amount of time. You need a good command of the rendering toolset to work efficiently and with minimum time lost to errors.

Rendering Essentials

The following exercises will make you comfortable with all of the essentials for rendering in MAX.

Production And Draft Rendering Configurations

In this exercise, you'll explore the relationship between Production and Draft renders:

1. Create a Box object in the center of the groundplane. Make sure that the Main Toolbar is visible. Pull the Main Toolbar over to the left, if necessary, to make sure that the render tools (the three buttons with the teapot icons) are visible.

2. In the middle of the three teapot buttons is the Quick Render tool. Don't let this name confuse you. There's no difference between a Quick Render and a render made from the Render Scene dialog box (which I'll cover shortly). The only thing that's quicker about a Quick Render is that you don't have to open the dialog box to make it. Rest your cursor over the Quick Render icon to bring up the label. Note that it says Quick Render (Production).

3. Click on the Quick Render button to render the scene. Note that you are rendering the active viewport. If the perspective view is active, you render a perspective view. If a top view is active, you render a top view (in an orthographic projection). A screen appears, called the Virtual Frame Buffer, with the rendered image in it. Unless you've changed from the defaults, your image will be at a resolution of 640×480 pixels.

4. Hold down the Quick Render button to reveal your options. The upper icon is the same blue teapot that you just used for a Production render. The gray teapot below it is the Draft render option. Drag to this button and release it to perform a Draft render. You see that the Virtual Frame Buffer is being redrawn, but with exactly the same image. What gives?

5. MAX permits you to keep two rendering configurations active at once. By default, the Production configuration and the Draft configuration are exactly the same. That's why you saw no difference when you moved from one to the other. Change the settings for the Draft configuration so that you can understand how this system works. Click on the Render Scene button immediately to the left of the Quick Render button. This brings up the Render Scene dialog box, as seen in Figure 16.1. You can also access this dialog box from the Rendering menu.

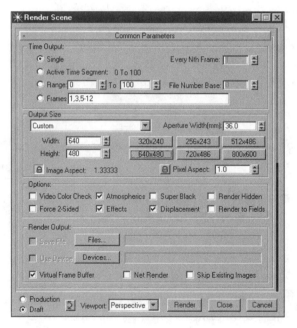

Figure 16.1
The Render Scene dialog box, available from the Main Toolbar and Rendering menu.

6. At the very bottom of the panel, you see radio button options for Production and Draft configurations. Click from one to the other, and notice that none of the settings in the panel changes. The main purpose for providing two alternative configurations is to allow you to jump back and forth between a faster Draft mode and a slower (but finished quality) Production mode. Try this out. Go into the Draft mode and change the output size from 640×480 pixels to 320×240 pixels by clicking on the button for this option. The values in the Width and Height spinners change accordingly. Flip back and forth between the Draft and Production configurations to make sure that they now have different resolution settings. Click on the Render

button at the bottom of the dialog box for each of these configurations. When you render with the Draft option selected, the image in the Virtual Frame Buffer is now 320×240 pixels, and the Production render is still at 640×480 pixels.

7. Notice that the Render Scene dialog box, being modeless, persists on the screen. It might get hidden behind the Virtual Frame Buffer, but it's still there. Close the dialog box by pressing the Close button. The Virtual Frame Buffer remains on screen.

8. Go back to the Quick Render button on the Main Toolbar and render by using the Production and Draft options (the blue and gray teapot icons). You get the same results as rendering from the Render Scene dialog box.

9. Switch from the Main Toolbar to the Rendering Toolbar by clicking on the Rendering tab at the top of the screen. Notice what appear to be the same three teapot buttons that you found on the Main Toolbar. The Quick Render button (the middle one) here is not exactly the same, however. You can't choose between blue and gray options. Pressing the Quick Render button on the Rendering Toolbar renders in the current configuration. The current configuration is the last one used (either Draft or Production) in the Quick Render on the Main Toolbar or in the Render Scene dialog box. Change from Production to Draft—or vice versa—in either of these places and note that whichever one is selected becomes the mode used for Quick Render in the Rendering Toolbar. I have no idea why they made the Quick Render button different in the two toolbars.

The Virtual Frame Buffer

This is a good moment to consider the Virtual Frame Buffer. The renderer produces a bitmap, which it can output to different places. The main purpose of a renderer, of course, is to create saved bitmap files to be used (and viewed) outside 3D Studio MAX. Thus, rendered images can be saved to disk in standard image and video file formats. Rendered images can also be sent directly to external devices, such as a video recorder. Prior to rendering your final output, however, you'll typically need to see the current test renderings of single images from within MAX. The Virtual Frame Buffer displays rendered images that are stored temporarily in RAM. You'll become familiar with the Virtual Frame Buffer in this exercise:

1. Create a Box object on the center of the groundplane and render the perspective view. The Virtual Frame Buffer appears with the rendered image, reflecting the current Draft or Production settings. It may seem funny to think of the Virtual Frame Buffer as receiving output from the renderer, so open the Render Scene dialog box and look at the Render Output section of the Common Parameters rollout. This section is obviously intended to direct render output to files for disk storage or to external devices. The Virtual Frame Buffer is also shown as an output option, however. It is active by default, so uncheck the box and render again. Although the Rendering panel appears, and the action along its progress bar indicates that rendering is occurring, the output of the renderer has no place to be stored, even in RAM. Check the Virtual Frame Buffer box again to output to RAM.

Note: A frame buffer is a region in memory that holds pixel data for screen display. The entire image that you see on your computer monitor is a reflection of the frame buffer of the display at that moment. High-end video cards have high-speed memory on the card dedicated for use as a frame buffer. This makes for faster display update speed than is possible by using system RAM on the motherboard.

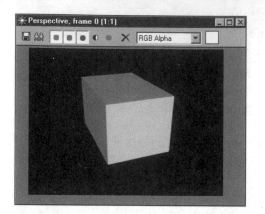

Figure 16.2
The Virtual Frame Buffer displaying the render of a Box object.

2. Render your scene again. Your Virtual Frame buffer should look like Figure 16.2.

3. The Virtual Frame Buffer is not just a picture. There's a lot of important functionality here. Click on the leftmost button (with the disk icon) to see the options for saving the rendered image to disk. In the dialog box that appears, check out the wide range of file types from the drop-down list. It's often easier to render to the Virtual Frame Buffer and save the image than it is to set up file saving in the Render Scene dialog box.

4. Next to the Save Bitmap button is an icon with twins, which permits you to clone the Virtual Frame Buffer. This is a critical tool. Click on the button to produce a copy of the Virtual Frame Buffer that you can minimize if you want. Move the Box in your scene a bit and re-render. Note that the original Virtual Frame Buffer is overwritten with the new image, but the clone is unaffected. This way, you can compare different render results (reflecting changes in lights, materials, and so on) side by side.

5. The rendered bitmap is a 32-bit image, meaning that there are separate 8-bit (one byte) channels for red, green, blue, and alpha. You'll rarely need to isolate the separate color channels, as the panel lets you do, but it's great to be able to see (and even save) the alpha channel. Click on the Display Alpha Channel button. As you can see in Figure 16.3, MAX generates an alpha channel for rendered images, in which opaque objects receive white pixels and the background is black. This allows rendered images to be used in compositing because the background is masked (treated as transparent) when layered with other images. If the Box were made semi-transparent, its pixels in the alpha channel would be gray.

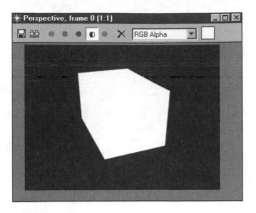

Figure 16.3
The Virtual Frame Buffer from Figure 16.2 , showing only the alpha channel. The pixels for the opaque Box object are white and the background is black. This bitmap can be used as a mask when compositing with other images, so that the region outside the Box is treated as transparent.

Outputting To Disk

To send an image (or sequence of images) directly from the renderer to a file on disk, open the Render Scene dialog box and go to the Render Output section. Click on the Files button, and you see a dialog box that asks you to name or choose a file for saving. A very complete list of file formats is available. In my experience, the Targa (.tga) format is the most universally useful format for individual bitmaps or bitmap sequences, but there's a good argument to be made for TIFF files, as well. For animation files intended to be run only on a computer, AVI and QuickTime formats are the obvious options. You have to think about your needs. If you need to preserve the alpha channel of the rendered images, you have to use a 32-bit (four-channel) format like Targa or TIFF. If image-file size is a big issue (as for Web graphics), JPEG images may be the best. The new PNG format has great compression and an alpha channel as well. Whatever format you pick, you'll be given the options (typically, compression options) that are appropriate to that format.

Figure 16.4 shows the Render Scene dialog box, set up to save only the current frame as a single image. Note the Single option chosen at the top. The rendered frame will be saved in JPEG format under the name mytest.jpg. Even after the file name is entered, saving can be disabled by unchecking the Save File box.

Rendering Animation

When you render out animation, you are saving a sequence of bitmap images for consecutive frames, either as separate images or collected into a single video file. Create a simple animation, as follows:

1. On a fresh screen, place a Sphere object near the left side of the perspective view, as seen from the front. Drag the Time Slider to Frame 100 and turn on the Animate button at the bottom of the MAX screen. Now, move the Sphere in the world x=direction to the right edge of the viewport. Turn off the Animate button and pull

Figure 16.4
The Render Scene dialog box set up to save only the current frame as a single image. The rendered frame will be saved in JPEG format under the name mytest.jpg. Saving can be disabled at any time by unchecking the Save File box.

the Time Slider back and forth. You should have a simple animation of the Sphere moving across the screen. Hit the Play Animation button to watch it run, if you wish.

2. To save this animation, open the Render Scene dialog box. Change from Production to Draft mode at the bottom of this dialog box and choose the 320×240 resolution option to make things go more quickly. Press the Render button; you get a render of only the single current frame. Move the Time Slider and render again. The image in the Virtual Frame Buffer will be replaced with a render of the new current frame.

3. To save a sequence, rather than a single frame, you'll need to change the settings at the top of the panel. The Active Time Segment option is the most commonly used. It renders the range of frames set in the Time Configuration dialog box, which can be reached from a button on the bottom-right of the MAX screen. By default, the Active Time Segment is from Frame 0 to Frame 100. The other options permit you to select a specific range of frames or even specific individual frames. Choose the Active Time Segment option and note how the Every Nth Frame spinner becomes active.

4. At the default value of 1, every frame from 0 to 100 is rendered. You don't need such smooth animation for your current purposes, so save time by rendering only every fifth frame. Change the spinner value to 5.

5. Now, you have to save the animation. With single images, you can render to the Virtual Frame Buffer if you want and then save to disk from there. But with an animation, you have to save directly from the renderer. Click on the Files button and

look at the different format options in the drop-down box. There are a lot of choices here, but the basic choice is between saving as a bitmap sequence or as a video file.

Saving As A Bitmap Sequence

Saving to bitmap sequences is the safest method for saving finished production-rendered animation. When you choose any of the bitmap files formats (such as Targa, TIFF, or JPEG), the render outputs a sequence of numbered files—each one a still image of a rendered frame. This kind of output has important advantages. It can be loaded into any digital video-editing environment for finishing and output to tape. And each frame can be separately loaded into a bitmap editor (such as Photoshop) for retouching and correction. It's also easy to divide up a rendering job over time or on different machines. Using the moving-ball animation file from the last section:

1. Choose the Targa format and name the file "ball." When you save, you are presented with Targa options. Accept the defaults.

2. Press the Render button to render the sequence. You see each frame rendered, one after the other, in the Virtual Frame Buffer. Note that the frame numbers increment in units of 5. When the animation finishes, only the final frame (100) is visible in the Virtual Frame Buffer.

3. Open the View File dialog box from the File menu in the MAX menu bar. Go to the directory in which you saved the sequence; you should find a list of 21 Targa files from ball0000.tga to ball0100.tga. MAX has added a four-digit extension to the name you chose, which allows you to save sequences as long as 10,000 frames.

4. Click on a number of different file names and watch the image appear in the Preview box. Open any one of the files. The image will appear, full-size, in a window that resembles the Virtual Frame Buffer. Click on the right and left arrows to move forward and backward through the bitmap sequence. Of course, you can also view these files in Photoshop or any other application that can read Targa files.

5. You probably noticed the Rendering panel, which is displayed during the rendering process. The render was completed so quickly that you probably didn't have a good chance to look it over, but you will have a chance to examine it (with interest and a bit of impatience) during longer renders. Figure 16.5 shows the panel as it stood when Frame 25 was being rendered. The upper progress bar (for Total Animation) indicates that a quarter of the job is rendered, and the lower progress bar (for Current Task: Rendering Image) indicates that most of the current frame is rendered. In the Rendering Progress section, you can see that the previous frame took only one second to render and that the rendering process has gone on for only six seconds. This panel shows you the settings you set (or accepted by default) in the Render Scene dialog box, and it also provides information about the scene.

6. The buttons at the top of the Rendering panel permit you to pause or cancel a render. Canceling a render simply cancels it; pausing a render stops it, which gives you the option to resume from where you left off or to cancel it for good. You can experiment with this. In the Render Scene dialog box, click on the Files button to save the

Figure 16.5
The Rendering panel, as it stood as Frame 25 was being rendered. The progress bars indicate progress through the entire animation and through the current frame.

animation again under a new name. Use the file name "newball.tga." Before you hit the Render button, prepare to hit the Cancel button in the Rendering panel when Frame 20 (the fifth frame) is about half-rendered. Go ahead and render, and then cancel when you are in Frame 20.

7. Open the View File dialog box and note that there are only four Targa files, ending with newball0015.tga. Frame 20 was not saved because it was not finished. To complete the job without re-rendering what you already finished, check the Skip Existing Images box in the Render Scene dialog box. Hit the Render button again and notice that the rendering starts at Frame 20.

USE THE NEW RAM PLAYER TO RUN A BITMAP SEQUENCE

The new RAM Player in MAX 3 is available from the Rendering Toolbar. This fantastic tool permits you to run bitmap sequences at true frame rate, although you're necessarily limited by the amount of your system RAM. The results are far superior to AVI video files that run in the Windows Media Player.

Saving A Video File

To play an animation on a computer, you need to package it in a video file format. Unlike a bitmap sequence, a video file is a single file that contains all of the images in order. The

QuickTime MOV format is very important, but stick to the AVI format for this exercise because it's universal on all Windows systems:

1. Use the moving-ball animation file from the previous exercise, and this time save it under the name "ball" using the AVI format. You'll get a list of compression options. The Full Frames option at the bottom of the list is completely uncompressed, giving you the same quality as the uncompressed Targa files you created earlier. Video files generally require compression to keep the size manageable, however. Everyone prefers different values for compression options, which are called *codecs* (meaning compression-decompression algorithms). In my experience, the Cinepak codec at a value between 90 and 100 is a safe place to start. Go ahead and render with the codec of your choice or use Full Frames.

2. After rendering, bring up the View File dialog box from the File menu on the MAX menu bar. Select the file named ball.avi. The animation will run in the Windows Media Player—it will probably run fairly well because this is a tiny file. In general, AVI playback is slow and disappointing even on today's most powerful systems if they do not have special video hardware.

3. Try to cancel the render in midstream again. Change the file name to "ball2.avi," and, after starting the render, cancel it after a few frames. Run the file from the Media Player and note that it stops where you canceled. If you want to start it up again, do you have to re-render from the very beginning? Make sure that the Skip Existing Images box is checked in the Render Scene dialog box and render again. Note that, unlike the case with the Targa sequence, rendering starts all over again from Frame 0, regardless of the instruction to Skip Existing Images.

PLANNING FOR RENDER SHUTDOWNS

Rendering animations of any significant size or complexity takes a huge amount of time. There is always a possibility that your render will terminate before it's complete, either intentionally or by accident. Rendering to bitmap sequences rather than video files ensures that you'll never lose whatever is already rendered. Any standard video-editing package, such as Adobe Premiere, permits you to save out a bitmap sequence as a video file. In fact, you can do it in MAX's own Video Post by inputting the bitmap sequence and outputting to an AVI or MOV.

Output Size And Other Options

One of the most important decisions that you must make in the rendering process concerns the resolution and aspect ratio of the image. These words have overlapping meanings. *Resolution* is simply the total number of pixels in the image. More pixels mean higher resolution, and there is thus greater detail (but also longer rendering time). A resolution of 640×480 is a total of 307,200 pixels. A resolution of 320×240 is 76,800 pixels—exactly one-quarter as many. Note that the resolution of an image is always defined in terms of the number of pixels in width, multiplied by the number of pixels in height. Thus, the resolution necessarily defines the relative dimensions in the width and height. This relative dimension is called the

aspect ratio. A 640×480 image and a 320×240 image have different resolutions, but the same aspect ratio. The aspect ratio is determined by dividing the width by the height. In both cases, the aspect ratio is 4/3, or 1.333. In other words, both images are one-third wider than they are high.

Open the Render Scene dialog box and (using the default Custom Output Size option) click on any of the resolution choice buttons. Notice that the 1.333 value in the Image Aspect spinner does not change because all the resolution choices share the same standard aspect ratio. If you pull the Height or Width spinners, however, the Image Aspect ratio changes. You can lock the aspect ratio by pressing the little lock icon, after which both spinners move together to maintain a constant ratio.

Pixel Aspect ratios are something different. On a computer monitor, the pixels are square. Because the width and height are equal, the aspect ratio of each pixel is 1/1, or 1.00. Some display devices, namely standard video monitors meeting NTSC or PAL standards, do not have square pixels, however. If you select the NTSC option from the drop-down list, you see that the Pixel Aspect ratio is .90000, meaning that the pixels are slightly taller than they are wide. Also notice that the Image Aspect ratio buttons have changed to provide standard units that preserve the 1.333 ratio. For example, the standard resolution is 720×486 instead of 640×480. Let's think this through. Because the pixels are taller than they are wide, you need more pixels in the horizontal direction to preserve the 4/3 aspect ratio. If you render an image for NTSC video in 720×486 with the .9 Pixel Aspect value, it appears a little squashed on your square pixel computer monitor, but it looks correct on a screen with NTSC pixels.

The checkbox options in the Common Parameters Rollout of the Render Scene dialog box are straightforward. Atmospheric effects, render effects, and displacement mapping are all enabled by default. Because these are all time-consuming processes, however, it's helpful to be able to disable them when making test renders. Video Color Check, Super Black, and Render To Fields are all for video output purposes. In particular, field rendering produces two frames for every one—each having only odd- or even-numbered horizontal scan lines. The Force 2-Sided option results in rendering both sides of all faces in the scene, rather than only the sides in the direction of the normals. Don't use this option rashly. If you really need to render both sides of a surface (with a flag, for example), it makes more sense to define the Material for that surface as 2-Sided in the Material Editor.

Rendering Regions And Selections

Test renderings are essential, but they can be very time-consuming. It's important to be able to render only a portion of a frame to speed things up. The following exercise demonstrates the options:

1. Create a Box and a Sphere on the groundplane. Make sure that you can see the rendering tools at the right end of the Main Toolbar. The Render Type drop-down box shows the default of the View option, which means that the entire active viewport will be rendered. But don't render yet!

2. Open the Render Scene dialog box and make sure that the Single frame option is selected and that any file saving is disabled. Then, close the dialog box. Select the Box object and change the Render Type to Selected. Press the Quick Render button. Only the Box renders. That makes sense, and it's obviously very useful to be able to render only a single object if necessary.

3. Select the Sphere and render again. Although you may be surprised to see that the Box remains while the Sphere is rendered, this is also a good idea. By keeping the existing image in the Virtual Frame Buffer and rewriting only the pixels for the selected object, you don't have to re-render everything when only the selected objects change.

4. To clear the Virtual Frame Buffer, click on the X button ("Clear") on its toolbar. Now, try rendering the selected Sphere again; note that it appears all by itself.

5. To get a close-up render of the selected Sphere, change to the Box Selected option. This option renders only within the region defined by the bounding box of the selected object. When you render, you get a panel that permits you to adjust the dimensions of the image. Set the size you want and continue with the render. Note an important difference between this option and the previous one—the Selected option renders only the selected object. The Box Selected option renders the region of the viewport bordered by the bounding box. Objects in front or behind the selected object are rendered with this option if they intersect this region.

6. Another way to render a region is with the Blowup option. Switch to this option and press the Quick Render button. You see a cropping frame appear in the active window. You can move this window and size it, but you can't change its aspect ratio because it keeps the same aspect ratio as your full-size image. When you have it where you want it, press the OK button that appears in the corner of your active viewport. The defined region is blown up to fill the full image space. Figure 16.6 shows the cropping frame and the resulting enlarged render of the selected region.

7. In contrast, the Crop option does not change the resolution of the selected region. Select the Crop option and press the Quick Render button. Once again, you get a cropping frame in the active viewport, but this time you can adjust its dimensions however you want. Press the OK button to see the result. As is illustrated in Figure 16.7, the defined region is isolated in its own image.

8. Switch to the Region option and render the same defined region. This time, you see the entire frame space, with the selected region rendered in its proper place. Figure 16.8 gives you the idea. This approach has the same value as the Selected option—if you first render the entire scene (using the View option), you can re-render selected regions without losing the other pixels already in the Virtual Frame Buffer.

Figure 16.6
A Blowup render that shows the region within the cropping frame (below) and the rendered result (above).

Figure 16.7
A Crop render that shows the region within the cropping frame (below) and the rendered result (above). Unlike the Blowup render in Figure 16.6, the resolution of the selected region is not changed.

MAX Scanline Rendering Options

Thus far, you've paid attention to only the upper rollout in the Render Scene dialog box—the one named Common Parameters. It's called this because the included parameters are the kind that would be the same, regardless of the renderer used. MAX is not wedded to a single renderer, however. The standard MAX package comes with two. The Default Scanline Renderer is probably the only one of the two that you'll need to know about. It's the renderer you've been using all along, unless you took the trouble to change it. MAX also offers the VUE File Renderer, which outputs an ASCII-rendering script that can be edited before rendering to pixels from the command line. It's safe to say that very few people need the VUE File Renderer, but it's available to replace the Default Scanline Renderer under the Rendering tab in the Preference Settings dialog box.

All of the parameters for the Default Scanline Renderer are in the lower rollout in the Render Scene dialog box. Pull down to reach this rollout, which is shown in Figure 16.9.

Figure 16.8
A Region render that shows the region within the cropping frame (below) and the rendered result (above). Unlike the Crop render, the entire frame space is preserved with the selected region in its place. If the entire viewport were rendered to the Virtual Frame Buffer first, the selected region could be updated without losing the rest of the image.

Figure 16.9
The Default Scanline Renderer rollout in the Render Scene dialog box.

You can add other renderers as plug-ins. The most important plug-in is the Mental Ray renderer, which has long been available for Softimage. As of this writing, Mental Ray for MAX has been announced for release in 1999.

Motion Blur

Motion blur is essential for creating convincing animation. Although the virtual camera in a 3D animation package records each frame at a mathematical instant in time, a real camera has its shutter open for some duration of time, however short. Objects necessarily blur as they move across the field of view during that duration. A faster shutter speed (a shorter duration) can decrease the blur to the point that it is unnoticeable, but the blur is always there. Nor is the blur always attributable to the movement of the objects in the scene. If the camera is moving during the exposure, all objects in the scene are inherently blurred.

Blur is not just a flaw or limitation to be tolerated or minimized. Human vision operates much faster than a camera, but high-speed objects like a propeller are blurred to human sight. You can sense their speed from the extent of the smear.

Motion blur in MAX can be a little confusing. There are two methods: Object Motion Blur creates copies of the object during the rendering process, and Image Motion Blur produces a generally superior result by smearing the image after rendering is complete. You need to use two different dialog boxes when using either type of blur.

Object Motion Blur

Follow these steps to see how Object Motion Blur works:

1. Place a Sphere object near the left side of the perspective view, as seen from the front. Drag the Time Slider to Frame 100 and turn on the Animate button at the bottom of the MAX screen. Move the Sphere in the world x-direction to the right edge of the viewport. Turn off the Animate button and pull the Time Slider back and forth to see the Sphere moving across the screen.

MOTION BLUR AND ROTATIONS

Motion blur is especially critical for animated rotations. Video runs at 30 frames per second, and film runs at 24 frames per second. These speeds are not nearly fast enough to capture enough samples of quickly rotating objects. For example, assume that a wheel or propeller is rotating 15 times per second. At 30 frames per second, there are only two samples (frames) for each rotation. This is far too few to convey continuous rotation—as a result, the viewer sees only a kind of random strobing or a movement that seems to alternate back and forth. In early motion pictures, directors struggled with the same problem when wagon wheels appeared to suddenly rotate backward.

Animating the rotation of propellers and rapidly turning wheels depends almost entirely on motion blur. Typically, the rotation is animated just fast enough to give a satisfactory number of samples for each rotation, even though this is far slower than the rotation should be. The effect is then "accelerated" with motion blur.

2. Pull the Time Slider to Frame 50, right in the middle of the animation. You'll test motion blur effects by rendering single frames. Thus, to make the effect clearer, open the Environment dialog box (from the Rendering menu) and change the Background Color from the default black to white. Close the Environment dialog box when you're done.

3. Both kinds of motion blur require the use of two separate panels. First, the blur must be turned on for the selected objects in the Object Properties dialog box. Then, the blur parameters are adjusted in the Render Scene dialog box. Right-click on the Sphere object and ask for the Object Properties dialog box. The Motion Blur section is in the lower-left corner. Figure 16.10 shows the Object Properties dialog box in its default state.

Figure 16.10
The Object Properties dialog box for the selected object, with default settings. The Motion Blur section is in the lower-left corner.

4. The choice between Object and Image is obvious enough, but why do we need both a None option and an Enabled checkbox? The Enabled checkbox can be animated to turn blurring on and off, as necessary. You definitely don't want to waste rendering time computing motion blur when you don't need it. For now, just leave the Enabled box checked, and choose the Object option.

5. Object Motion Blur is now enabled at the object level. The next step is to adjust the parameters in the Render Scene dialog box. Open it and drag down to the MAX Default Scanline rollout. If you refer back to Figure 16.9, you see that both Object

and Image Motion Blur are enabled by default. This two-layer structure allows you to turn either (or both) off for the entire scene, even if they are enabled for individual objects—a valuable option when making test renders.

6. The basic parameter for both kinds of motion blur is Duration. By default, the blur is computed on the basis of the "shutter" being open for half of the time (0.5) between successive frames. The longer the Duration, the greater the blur. Try a test render with the default settings. The result will be only slightly blurred.

7. To increase the blur, increase the Duration to a much larger number, such as 10, and render again. With this extreme value, you can see what happened. Ten copies of the Sphere were rendered over the distance that the object would cover in 10 frames. This does not look much like true motion blur in a still image, but the effect is much more satisfactory when run in an animation. Your render should look much like Figure 16.11.

Figure 16.11
Object Motion Blur on an animated sphere, using an extremely long Duration setting and the default value of 10 for both the Samples and Duration Subdivision spinners. Ten overlapping copies of the Sphere are rendered.

8. Play with the Samples and Duration Subdivision spinners a moment, and you certainly notice something peculiar. Both of these values top out at 16. The Samples value can be less than or equal to the Duration Subdivision value, but not more. The Duration Subdivision is the number of copies rendered in each frame. If the number of Samples is the same as the Duration Subdivision, you get the clean copies similar to Figure 16.11. If the number of Samples is reduced below the Duration Subdivision value, however, you'll get a grainy smear in which the separate copies

are less discernible. Try a render by using a Duration Subdivision value of 16, but a Samples value of 8. This effect will sometimes produce a more convincing result.

9. Try turning the blur off for part of the animation. Bring the Time Slider to Frame 51 and turn on the Animate button. Right-click on the Sphere to find the Object Properties dialog box. Uncheck the Enabled box and press the OK button. Before you do anything else, turn off the Animate button. Notice that a key symbol appears in the Track Bar, immediately beneath the Time Slider. Move the Time Slider back to Frame 50 and bring up the Object Properties dialog box for the Sphere. Note that the Enabled box is checked. Move the Time Slider past Frame 51 and look again. The Enabled box is unchecked. Try rendering frames before and after Frame 51 to see the difference.

10. Although the term Object Motion Blur might suggest that the blur doesn't work if the camera—and not the object—is animated, it actually works in either case. To test this out, delete your Sphere and create another in the center of the groundplane. Create a camera that points toward the new Sphere and use the Animate button to keyframe the camera so that it passes across the object. Select the Sphere and enable Object Motion Blur in the Object Properties dialog box. Change a viewport to a camera view and render a frame. The result looks the same as when the object, and not the camera, was animated. Remember something important, however: Even though the camera was animated, the blur is applied only to objects for which the blur was enabled. If you put another object in the scene and don't give it motion blur, it looks oddly sharp. When you animate a camera, you usually need to turn on motion blur for all the objects in the scene. This can be easily accomplished by selecting them all together and using the Object Properties dialog box for the multiple selection.

Image Motion Blur

In my experience, Image Motion Blur produces a much better result than Object Motion Blur. Object Motion Blur is typically preferable only where the quality is good enough, and the rendering time is much faster than with Image Motion Blur. Object Motion Blur renders multiple copies of the same object, and is therefore fastest when the geometry is simple. Image Motion Blur smears pixels after the object is rendered and is therefore independent of geometry.

Image Motion Blur also has the important advantage of having an animatable Multiplier parameter. (The Multiplier spinner applies only to Image Motion Blur.) To get a spinning wheel or propeller to look like it's speeding up or slowing down, you need to be able to animate to amount of blur. And, just as with Object Motion Blur, animating the camera will blur any objects for which Object Motion Blur has been enabled. Unlike Object Motion Blur, Image Motion Blur also can blur an Environment Map, like a starry sky. To test Image Motion Blur:

1. Use either the animated camera or the animated sphere scenes from the previous exercise. Select the Sphere and use the Object Properties dialog box to enable Image Motion Blur. Note the default Multiplier value of 1.0.

2. Open the Render Scene dialog box and find the Image Motion Blur section, or refer to Figure 16.9. The parameters are few and simple to understand. The Duration spinner performs the same function as with Object Motion Blur. The longer the Duration, the greater the blur. Render a frame using the default values. Note that the object is completely rendered before the blur passes are applied to smear the pixels.

3. The blur is rather small, but go back and animate the Multiplier instead of increasing the Duration value. Drag the Time Slider to Frame 100 and press the Animate button. Select the Sphere and bring up the Object Properties dialog box. Enter the number 10.0 in the Multiplier spinner and turn off the Animate button. Move the Time Slider to different frames and look back at the Multiplier values; note that they increase between Frame 0 and Frame 100. Render different frames to see the result. Figure 16.12 shows the Sphere with a moderate amount of blur. Note how much more realistic this looks than with Object Motion Blur in Figure 16.11.

Figure 16.12
Image Motion Blur generally produces a more realistic blur than Object Motion Blur. Compare this image with Figure 16.11.

Anti-Aliasing

Anti-aliasing is the process that reduces or eliminates contrasts between adjacent pixels. Without good anti-aliasing, objects appear to have rough edges and the image looks obviously (and crudely) digital.

Anti-aliasing in MAX is always on by default, so you may be taking it for granted. To understand it, you have to turn it off. Figure 16.13 shows a portion of a Sphere rendered with

Figure 16.13
A portion of a Sphere rendered with anti-aliasing disabled. The color contrast at the edge of the object makes the pixel network visible.

anti-aliasing disabled in the Render Scene dialog box. The roughness around the edges is due to the fact the digital images have limited resolution—that is, they are divided into just so many pixels. Pixel color typically changes very suddenly at the edges of rendered objects, and this contrast tends to make the pixel network visible.

The answer to this problem is a process that tests the color of each pixel against the color of its adjacent pixels. If the color contrast is above a certain threshold, it's likely that it represents an edge. The colors of adjacent pixels are then blended to smooth out the transition of the edge. As you can see in Figure 16.14, anti-aliasing eliminates the roughness very effectively.

MAX traditionally suffered from a lack of anti-aliasing power. MAX 3 eliminates this weakness with a huge range of anti-aliasing options. There is now a long list of filters, and many of these have adjustable parameters. They may strike you as needless overkill at first, or perhaps as just another complex feature to learn, but they are actually very important. Experiment with these options whenever you render—you'll discover that different choices result in striking differences in render quality. As a general rule, you are trading off sharpness for smoothness because anti-aliasing is inherently a blurring technique. The right choice of filter and settings keeps your image sharp while blending only the edges. And you can also use the anti-aliasing options to soften an image. Note that Filter Size refers to the range of adjacent pixels used in the process. The wider the range (the wider the pixel area considered), the softer or blurrier the result is likely to be. Figure 16.15 shows the list of anti-aliasing filters.

Figure 16.14
Same as Figure 16.13, but with MAX's default anti-aliasing turned back on. The colors of the pixels along the edge are blended for a smooth transition.

Figure 16.15
The list of anti-aliasing filters that are now available in MAX 3. Many of these have adjustable parameters. The right choice of anti-aliasing options can make a great deal of difference in render quality. MAX's default settings are rarely the best choice.

Rendering Previews

To test only the motion and composition of an animation, it often makes sense to render out a preview. This is only a render in the strict technical sense because previews are nothing more than a sequence of screenshots. In other words, they store frames only in the display formats in which they are available in the viewports (wireframe, Smooth + Highlight, and so on). Because they are pre-rendered and stored in a video file, they run faster than when you simply use the Play button. They can also be saved for reference and later viewing.

Figure 16.16
The Make Preview dialog box, available from the Rendering menu or the Rendering Toolbar.

The Make Preview dialog box, shown in Figure 16.16, is available from the Rendering menu and from the Rendering Toolbar. The controls are self explanatory. After making a preview in the default AVI video format, the Windows Media Player immediately appears and runs the preview. If the preview looks unacceptably rough, change the codec (compression) settings.

The preview is saved in the Previews directory in your MAX folder. Use the View Preview command on the Rendering menu to review the current preview. You can also rename the current preview so that it won't be overwritten when a new preview is made.

Moving On

In this chapter, you covered all of the essential tools for rendering MAX scenes into bitmapped images. You learned how to use the Production and Draft rendering modes, how to save single images and animations, and how to use the Virtual Frame Buffer. You learned about the methods for controlling your output and how to render only fractions of a frame. You explored the main features of MAX's Default Scanline Renderer, compared Object Motion Blur and Image Motion Blur, and learned the importance of anti-aliasing. Finally, you took a look at the process of creating animation previews.

In the next chapter, I'll cover MAX's powerful Environment and Render Effects. You'll see how the new Render Effects toolset permits you to interactively develop post-processing effects, such as glows and contrast adjustments, within the regular render process. You'll also learn about Environment Maps and about the various atmospheric effects, such as fog and volumetric lights.

17

ENVIRONMENT AND RENDER EFFECTS

The term "visual phenomena" has recently become popular in 3D computer graphics. It suggests that the artist is creating imagery in the most general sense, not just rendering models.

Indeed, geometry is hardly the only means for creating visual elements in your scene. Atmospheric effects—such as fog, water, clouds, and fire—are not produced from geometry. These are all created as Environment Effects in 3D Studio MAX. Most of these are confined, however, to a defined volume, so they are therefore often called "volumetric effects." The volume is defined by a nonrendering geometric object, or in the case of the volume lights, by the light cone.

Another aspect of a MAX Environment is the Background. Although not a geometric object, it can hold a color or an image that is placed behind all the rendered objects in the scene. An Environment Map can be projected as if on an infinite sphere or cylinder surrounding the scene.

After rendering is complete, the finished bitmap can be subjected to post-processing of the pixels. Prior to MAX 3, post-processing was confined to Video Post, but the current release includes a wide range of post-processing tools as Render Effects. Render Effects are added immediately after rendering, but without the need of Video Post. This makes it much easier to experiment with them in the regular course of workflow. Render Effects include the Lens Effects to create visual "objects" such as glows and flares, and the standard image-adjustment tools for blurs and contrast adjustments.

Because the Render Effects toolset is new to MAX 3, let's turn to it first.

Render Effects

The subject of Render Effects is narrow, but very deep. Many people make little or no use of any post-processing tools in their work; others use Render Effects very extensively and become experts in this niche. In this chapter, I don't attempt to cover the full scope of this fascinating field, but you'll still get a good general sense of the toolset.

MAX packages two distinct classes of tools under the name of Render Effects. One is the collection of Lens Effects, which are creative tools for producing visual effects such as glows and flares. The other class consists of correction or adjustment tools, which are not designed to produce visual "objects," but rather to balance color or blur the image, among other things. These correction tools generally perform the kinds of functions that you can perform in Photoshop with your rendered images, but it's obviously a great convenience to be able to do them in MAX. In any case, all of the Render Effects are post-processing effects. You fully render the image to pixels before you apply the Render Effects. Render Effects operate on pixels in a bitmap, rather than on objects in the underlying 3D scene.

The Rendering Effects dialog box seems confusing at first, but once you learn your way, you'll find it a pleasure to experiment with. I emphasize the word "experiment" because experimentation is at the very heart of using Render Effects. This is particularly true of the Lens Effects group. The more trials and comparisons you can make, the better your result is likely to be. And until you experiment extensively with the toolset, you won't even understand the remarkable range of possibilities.

When you bring up the Rendering Effects dialog box (from the Rendering menu or the Rendering Toolbar), the list of Effects in the Effects rollout is empty. To add Effects to the scene, press the Add button. This brings up the Add Effect dialog box, with a list of all of the available Effects. Figure 17.1 shows the Effects rollout and the Add Effect dialog box. In this example, two Effects have been added to the list.

You can have multiple instances of the same Effect. If you do, use the Name type-in box to rename the Effect with a distinguishing title. You can delete Effects from the scene or simply disable them by unchecking the Active checkbox. You can even incorporate Effects from other scenes.

Figure 17.1
The Effects rollout of the Rendering Effects dialog box and the Add Effect dialog box. Two Effects were already added to the list.

The Preview section of the Effects rollout is the key to the most powerful feature in the toolset. As I've already stressed, you have to make render after render after render when experimenting with constructing Render Effects. Instead of rendering in the usual way, however, you can make your test renders directly from this panel. Any objects in the scene are rendered first to the Virtual Frame Buffer. Then, the Render Effects are applied as post-processing. When you change a Render Effect and press the Update Effect button, only the post-processing is updated, which generally saves a considerable amount of time. If the Interactive checkbox is checked, the Effect updates automatically every time a parameter is changed. You can always refresh the underlying render by pressing the Update Scene button. You'll use these tools extensively in the following sections.

Lens Effects

Lens Effects, unlike all of the other Effects, is a collection rather than a single Effect. When you add a Lens Effects package to the scene, you must choose one or more effects within the package to use. The logic of this system makes sense, but it definitely takes some getting used to. Each effect within a Lens Effects package is called a Parameter in one of the rollouts and an Element in another rollout. The name Parameter is terribly confusing because each of these "Parameters" has numerous adjustable parameters (like everything else in MAX). To keep this discussion as clear as possible, I'll refer to the collection of Lens Effects as Elements.

Figure 17.2 shows the Rendering Effects dialog box with a Lens Effects package added and selected at the top of the panel. In the Lens Effects Parameters rollout below, the list on the left contains all of the available effects. The box on the right contains the Elements from that list that are being applied in the current Lens Effects package. In this case, Glow and Star Elements are being used. The left and right arrows are used to add and remove Elements.

Lens Effects are applied to specific objects and lights in the scene. This is why you need to be able to have multiple instances of each Element. For example, you might need three glowing objects, each with its own Glow parameters. This means adding three separate Glow Elements to the list, each one directed to a different object. But you can also have multiple Elements directed to a single object, and the same Elements for multiple objects.

The following exercise introduces you to most of the Elements in the Lens Effects package.

Glow

Glow is the most important and generally useful Element in the Lens Effects package. Its inclusion in the Lens Effects group is not entirely logical. All of the other Elements in the Lens Effects group are related to or derived from the effects that occur when using a lens on a real camera. Although they are used for a broad range of visual purposes, they are essentially variations of the basic lens flare that appears when a lens looks directly into a light source. On the other hand, a Glow is simply a region of colored pixels around an object that creates the sensation that the object is self-illuminated. As such, a Glow can be applied to the entire surface of an object. The other Elements can emanate only from a point. Let's experiment with applying Glow:

Figure 17.2
The Rendering Effects dialog box with a single Lens Effects package added and selected at the top of the panel. In the Lens Effects Parameters rollout below, Glow and Star have been selected from the list of available Elements for the current Lens Effects package. The left and right arrows are used to add and remove the Elements.

1. Create a Cylinder in the middle of the groundplane. You can adjust its size as you go along.

2. Open the Material Editor and assign the Cylinder a Material. Give the Material a bright yellow Diffuse Color value. This will be the Source Color of the object when applying Render Effects.

3. Open the Rendering Effects dialog box from the Rendering menu or the Rendering Toolbar. Add a Lens Effects package to the scene at the top of this panel. Then, use the arrow buttons in the Lens Effects Parameters rollout to add a single Glow Element to the empty package.

4. As you pull down through the rest of this long dialog box, you'll come to the Lens Effects Globals rollout. The two tabs in this rollout provide parameters that affect all components in the Lens Effects package together. Because you are using only a single Element (the Glow), you can ignore this panel for now.

5. Move down to the Glow Element rollout. This is the meat of the business. The rollout is divided into two tabs: the Parameters tab provides all of the parameters that control the appearance of the Glow, and the Options tab determines where the Glow will be applied in the scene. Take a moment to look these controls over. Both tabs are illustrated in Figure 17.3.

Figure 17.3
The two tabs in the Glow Element rollout. The Parameters tab provides all of the parameters that control the appearance of the Glow. The Options tab determines where the Glow will be applied in the scene.

6. Start with the Options tab. A Glow can be applied to a light or to geometry. If it is applied to geometry, it can be applied to the surface of the object or it can simply radiate from a point in the center of the object. In the Apply Element To section, the Lights and Image options are active, by default. There are no lights in the scene—the default lights do not count for this purpose. The Image option uses the pixels attributable to specified objects. There are two ways to make this assignment. If the entire surface of the object is to be used for the Glow, you can use the Object ID. If the Glow is to be applied only to specified regions of the surface, you can use the Effects ID. An object can have only a single Object ID, although multiple objects can share one Object ID. An Effects ID is assigned to Material in the Material Editor (by using the Material Effects Channel button). Any portion of an object (or multiple objects) with that Material will receive the Glow.

7. Use the Object ID approach. Select and right-click on the Cylinder and bring up the Object Properties dialog box from the menu. Look for the G-Buffer section and change the Object Channel number to 1. (A G-Buffer stores information for each pixel in a rendered image that designates the object in the scene that generated the

pixel.) Press the OK button to close the Object Properties dialog box and return to the Glow Element panel. Check the Object ID option and make sure that the value is set to 1. At this point, the application knows to use the pixels rendered from the Cylinder when generating the Glow. Note that the All box is checked in the Image Filters section. That means that all of the pixels from the Cylinder will be used.

8. Now, it's time to see what you've got. Pull up to the top of the Rendering Effects dialog box and press the Update Effect button. The scene will render in the Virtual Frame Buffer, as usual; after a short while, the Glow will be applied. But whoa! The whole frame filled up with white. What happened?

9. First, you need to get the size under control. The size of the Glow is a function of the Global Size for the entire Lens Effects package and the Size parameter for the single Glow element. Reduce the Size value drastically in the Glow Element rollout: reduce it from the default of 30 to 3 or 4. Press the Update Effect button again to recompute the Glow without rerendering the scene. You may need to adjust your perspective view to get the object better centered. If you do, use the Update Scene button to rerender everything. Figure 17.4 shows the result of using a Size value of 3.

Figure 17.4
An upright Cylinder with a Glow applied to all of its pixels. Except for Size, all of the parameters are at their defaults.

10. It still looks like a white burnspot rather than a glow. You can start experimenting to get a softer effect, and the Intensity spinner looks like a good place to start. The default value is 110. You can try lowering it drastically, even below 1.0, but this will not make much difference. The problem is the color. Like all of the Lens Effects, a Glow can use three different color effects: Source Color, Radial Color, and Circular

Color. By default, the Source Color parameter is set to zero, and thus is not a factor in your current glow. The Circular Color Mix value is also set at zero. Thus, only the Radial Color is being used. The default white color is much too hot. Click on the white color box for Radial Color and bring the color down to a medium gray. Make test after test, changing the Intensity and the Size values until you can clearly see the Cylinder through a soft white glow. Be prepared to be surprised by the interaction of all these parameters. Figure 17.5 shows an acceptable result.

Figure 17.5
Same as Figure 17.4, but with the Radial Color darkened from white to gray to reduce intensity. The Size and Intensity values have been adjusted to see the "illuminated" Cylinder from within the Glow.

11. You probably picked up on the biggest single problem with Glows—it's very easy to make them too hot. You can use the Source Color of the object rather than the Radial Color—increase the Source Color value to 100 percent and start experimenting. You'll soon discover that decreasing Intensity alone is not enough. Just as with the Radial Color, you'll probably need to darken the yellow Diffuse Color of the Material in the Material Editor. After you do, remember to use Update Scene to rerender from scratch because the Glow must start with the color of the pixels in the rendered image. After a lot of experimenting with Size and Intensity values, you'll probably get something that looks okay, but the Glow on the surface of the object will remain uneven. Why is that?

12. Remember that you are using the rendered pixel colors, not the diffuse color of the Material. Even though the Material is a single hue, the color of the pixels on the object varies due to shading. In particular, the caps of the Cylinder are probably darker than the front of the object. To even out the color of the pixels, increase the

Self-Illumination factor for the Material in the Material Editor (uncheck the Color box first). Use Update Scene to rerender from scratch. This time, the Glow is more evenly distributed over the Cylinder, which finally looks like a glowing yellow tube. A black-and-white picture is not really adequate, but Figure 17.6 should give you the general idea.

Figure 17.6
Same as Figure 17.5, but with the Source Color used and parameters adjusted. To get the even glow that suggests a self-illuminated object, the Material was given some self-illumination. This creates a more consistent color for the pixels rendered from the object, which is then passed on to the Glow.

13. Before you move on to using lights, return to the Options tab of the Glow Element rollout. You've been using the All option in the Image Filters section to generate the Glow from all of the pixels in the Cylinder. Sometimes, it makes sense to restrict the Glow to the region outside of the object. To make the effect clearer, go back to the Material Editor and remove the Self-Illumination factor. Then, try the Perimeter Alpha option in the Image Filters section. You changed the underlying color of the object, so remember to rerender from scratch. Play with other parameters, as needed, to get a good result. As you can see from Figure 17.7, the object no longer appears to be glowing itself, but is highlighted by a background glow.

14. Let's take a look at using Glows with lights. You can apply a Glow to any type of light, but the effect is always the same: The Glow radiates out spherically from the location of the light. Delete your Cylinder and create an Omni Light in the center of world space. In the Rendering Effects dialog box, reset all of the Options for the Glow Element to their default values. Use Figure 17.3 for reference. This includes eliminating the Use Source Color factor and returning the Radial Color to white.

Figure 17.7
Using the Perimeter Alpha option in the Image Filters section restricts the glow to only the region surrounding the object. The Cylinder no longer appears to be self-illuminated, but is highlighted by a background glow.

15. Before anything can happen, you have to include the light in the Lens Effect. In the Parameters tab of the Lens Effects Globals rollout, press the Pick Light button, and then click on your light in a viewport. The name of the light will appear in the panel.

16. Press the Update Scene button to render. An empty scene renders first, and then the Glow is applied in post-processing. Unlike the situation in which you rendered the Cylinder, your initial Glow trial should look pretty good—something like Figure 17.8. Be sure you're in a perspective (or camera) viewport.

17. If you look carefully at your own image (not at the black-and-white figure), you'll notice a slight reddening around the perimeter of the Glow. This is the second of the two Radial Colors. Press the Falloff Curve button in the Radial Color section to bring up the graph in the Radial Falloff dialog box. The default curve tails off swiftly toward a zero value, which is why the red color is so faint. Drag the last point on this curve up to 1.0 and use its Bezier handle to create a straight line, if necessary. Press the Update Effect button. This time, the red color remains at full intensity all the way to the end of the Glow. The result is like a solid sphere—white at the center and changing to red toward the edges. Your result should look like Figure 17.9.

18. To get a Glow that falls off at a constant rate, adjust the curve in the Radial Falloff dialog box so that it falls from 1 to 0 in a straight line. Play with different Radial Colors to see what's possible. Change other parameters, such as Size and Intensity. The possibilities are endless.

Figure 17.8
A Glow is applied to a single Omni Light, using default settings.

Figure 17.9
Same as Figure 17.8, but with the falloff eliminated. The Glow remains at constant intensity all the way to the perimeter. Without the falloff, the color gradient from white to red is clearly evident, even in this black-and-white image. The apparent gray in the image is actually bright red.

19. Although you can mix in the Source Color of the light, just as you did with the Cylinder, let's look at the Circular Color option. The default Mix value for Circular Color is 0. Increase it to the maximum of 100 and update. Your Glow turns completely red.

20. The four color boxes are currently red. Change them to four different colors and update. The Glow is now a circular color gradient, passing through all four colors. Press the Falloff Curve button in the Circular Color section to get a graph like the one you just used for Radial Color. By default, it's a constant value of 1. Play with different curves to see the result. Decreasing values along the graph decreases the intensity of the glow. Figure 17.10 shows the effect of Circular Fallout. In contrast, the Radial Size graph decreases the size of the glow as it circles the light.

Figure 17.10
Illustration of Circular Falloff for a Glow around an Omni Light.

Other Lens Effects

Once you have the Glow Element pretty well figured out, the other Lens Effects Elements are easy—they have similar parameters for Size, Intensity, and the color options. The primary difference between Glow and the other Lens Effects Elements (as mentioned previously) is that whereas the Glow can be applied across the surface of an object, the other Elements necessarily radiate from a single point. You can apply them to any light, but if applied to a geometric object, they operate only from a point in the center of the object.

Take a quick run through these Elements and add them on top of each other:

1. Reset your screen, if necessary, to start afresh. Create a Box object in the center of the groundplane.

2. Open the Rendering Effects dialog box and add a Lens Effects package. In the Lens Effects Parameters rollout, bring a Ring Element over to the right side. Just as with the Glow, the Ring Element rollout has Parameters and Options tabs. In the Options tab, note that the Image checkbox is grayed out. Check the Image Centers option.

3. To let the application know what object you want the Ring applied to, check the Object ID option. Then, bring up the Object Properties dialog box for the Box and set its G-Buffer Object Channel to 1. Now, you can try a render from the Render Effects panel. The Box renders first, and then the Ring is applied. But the Ring knows nothing about the size of the Box. It's just centered on the Box, and therefore can simply look like it was pasted on it. See Figure 17.11.

Figure 17.11
A Ring Element is applied to the Image Center of a Box. The Ring has no relationship to the size of the Box and looks like it was pasted on top.

4. Of course, you can adjust the Size of the Ring, but all of the Lens Effects Elements (other than Glow) are more typically applied to lights. That's because they create reflection-like effects that are derived from the basic lens flare that occurs when intense light reflects off the surface of a lens (as when light rings appear on photographs). Delete the Box and create an Omni Light in the center of world space. By default, all Lens Effects apply to lights, but you have to use the Pick Light tool in the Lens Effects Globals rollout to include the specific lights. Once you set everything up, remember to press Update Scene to rerender in a perspective viewport from the ground up.

5. Now, you have a very satisfactory Ring by using the white and red default Radial Colors. To adjust the size of the Ring, try changing the Size in the Lens Effects Globals rollout. Your render should resemble Figure 17.12.

Figure 17.12
A Ring Element is applied to an Omni Light.

6. Add a Ray Element to the package in the Lens Effects Parameters and update your render. The Ray sends out rays radially around the light (see Figure 17.13). The Number of rays is set in the Parameters tab of the Ray Element rollout, along with all of the other standard parameters, such as Size and Intensity. Change the Size in the Lens Effects Globals rollout and update. Note that the Ring and the Ray Elements are scaled together.

Figure 17.13
Same as Figure 17.12, but with a Ray Element added, using default parameters.

7. Remove the Ray Element with the arrow buttons and add a Star Element in its place. Update again (or check the Interactive box for automatic updates) and you'll see that the Star is very similar to the Ray. Unlike the Ray, the Star pattern is regular and the tapering of its rays can be adjusted. Increase the Intensity of the Star alone (not globally) to get it to stand out against the Ring. Figure 17.14 shows a Star Element with its Taper adjusted.

Figure 17.14
Same as Figure 17.13, but with a Star Element in place of the Ray. The Star's rays have been tapered outward and its Intensity has been increased to make it stand out against the Ring.

8. You don't need to remove an Element to disable it. Uncheck the On box in the Star Elements Parameters panel. Now, add a Streak and update. The Streak is pretty tiny, by default. Its intended function is to simulate scratches on the surface of a lens. In Figure 17.15, the Width of the Streak has been increased to its maximum of 20.

Other Render Effects

As already discussed, all of the Render Effects other than Lens Effects provide batch image processing of rendered images.

Brightness And Contrast

Nothing could be simpler than this panel. You can adjust the Brightness and Contrast of your frames as they are output from the renderer, which can be a lot easier than adjusting the lighting in the scene.

Blur

You can go crazy with this panel if you want to, but the settings will be simple most of the time. Generally, you'll want a Uniform blur, but you can create a Directional or even a Radial

Figure 17.15
Same as Figure 17.14, but with a Streak Element added and the Star Element disabled. The Streak is seen at its maximum Width value of 20.

blur. You can blur the entire image or only a portion, such as the background or a selection defined by luminance or with a mask.

Blurring shows up so many places in MAX that you may never need this tool. Try using the new selection of anti-aliasing filters in the Render Scene dialog box to create blurring during, rather than after, the render process.

Color Balance

Like Brightness and Contrast, the Color Balance tool is right out of Photoshop. You can shift hues from red to cyan (green-blue), from green to magenta (red-blue), and from blue to yellow (red-green). Anyone familiar with basic bitmap-editing techniques already understands this tool.

Film Grain

Film Grain applies a look that you can get in Photoshop or any bitmap editor with Gaussian Noise. A grainy look is an interesting touch in itself, but the main purpose of this tool is to blend a MAX scene nicely with Background images that were scanned from photographs. A checkbox allows you to exclude the Background image from the Film Grain effect.

File Output

File Output is a way of saving a frame before some or all of the Render Effects are applied. The placement of the File Output effect on the list determines the stage at which saving occurs.

Depth Of Field

Depth of Field is an important effect. A real-life camera has a range of focus in depth. If a large aperture setting is used on the lens, objects in front of and behind the object being focused on will be out of focus. As the aperture closes down, the Depth of Field increases, and foreground and background objects remain in focus. Limiting the depth of field is an essential tool in photography and filmmaking because it focuses viewer attention on an object or character. Computer graphics uses an ideal "pinhole" camera, in which everything is in focus. This strikes many viewers as unrealistic.

The simplest way to use the Depth of Field effect is to pick an object as the Focal Node. This will be the center of the range of focus. The Focal Range spinner controls the distance in front and back of this point that will remain in focus. The Focal Limit defines the depth over which the blurring will reach its maximum. The maximum degree of blur is defined in the Horizontal and Vertical Focal Loss spinners. Because these last two values should generally be the same, there is a spinner lock that can keep them identical.

Environment

Three separate toolsets are grouped under the heading Environment. Figure 17.16 shows the Environment dialog box with its default settings. This panel can be reached through the Rendering menu or the Rendering Toolbar.

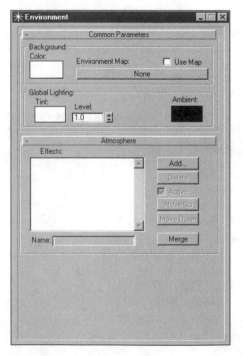

Figure 17.16
The Environment dialog box, with its default settings.

The Common Parameters rollout contains two of these toolsets. The Global Lighting section sets the Ambient light for the scene and allows the user to globally adjust the tint and intensity of all of the light sources in the scene. It's a great convenience to be able to adjust all of the lights together. These same controls are also in the Light Lister, but (unlike the Light Lister) they operate even on the default lighting.

The Background section of the Common Parameters rollout allows you to choose the Background Color and to apply an Environment Map. The Background Color is the color of all pixels that are not attributable to rendered objects. The Background Color is completely independent of the lighting in the scene. If you raise or lower the intensity of the lights (or change their colors), the Background Color does not change at all. It can therefore look very artificial unless carefully adjusted. Sometimes, it makes sense to enclose your scene in a large sphere or to put a flat plane in the rear of the scene, in order to get a background that responds to scene lighting. The Environment Map option allows you to replace the Background Color with a Map.

The Atmosphere rollout provides MAX's atmospheric effects. Like the Render Effects, these are post-processing effects that are applied to a bitmap after the frame is rendered. These include Fog, Volume Fog, Volume Light, and Combustion.

Environment Maps

You can apply Maps to your Background for greater realism or stronger visual effect than is possible with a single color. These Environment Maps can be applied in a number of ways. The following exercise will get you up to speed.

The Basic Screen Projection

Let's see how to work with a screen projection:

1. Start a new scene without any objects. Open the Environment dialog box and press the Environment Map button (labeled "NONE"). The Material/Map Browser will appear. Choose the Bitmap map type. A dialog box will appear, enabling you to choose a specific bitmap.

2. To understand the process, use the same uvtest.tif bitmap that you used in Chapter 13. (You can find it on the CD.) This is a square bitmap, illustrating uv coordinate space. The u-direction is horizontal and the v-direction is vertical. The bottom-left corner is at 0,0 in uv coordinates, and the top-right corner is at 1,1. Figure 17.17 illustrates this bitmap. Make sure that you understand this image before you go on.

3. Render from a perspective view. By default, the Environment Map is applied as a Screen projection, meaning that it's fitted to the screen. Because the default render output uses a 1.333 aspect ratio, the screen is wider than it is tall. The bitmap is stretched horizontally to fit, as can be seen in Figure 17.18. Generally, you need a bitmap with the same aspect ratio as your rendered output to use a Screen projection.

Figure 17.17

The uvtest.tif bitmap from the CD, illustrating uv coordinate space. The u-direction is horizontal and the v-direction is vertical. The bottom-left corner is at 0,0 in uv coordinates, and the top-right corner is at 1,1.

Figure 17.18

The bitmap shown in Figure 17.17 is applied as an Environment Map in an empty scene and rendered. The default Screen projection fits the image to the dimensions of the screen. Because the default output aspect ratio is 1.333, the Environment Map has been stretched horizontally.

4. Open the Material Editor and pick a slot. Press the Get Material button to bring up the Material/Map Browser. You want to get the current Environment Map into the slot, so choose Scene from the Browse From list. Double-click on the Environment Map when it appears. The Environment Map should now be assigned to the slot.

5. Take a look at the Coordinates Rollout in the Material Editor. Note that the current Mapping projection is Screen. You can try some other options in a moment. Experiment with Offset and Tiling values to see what they do. As a rule, a map that was designed for a Screen projection will not tile or offset correctly. Play with the Blur Offset spinner. Sometimes, an image mapped directly to the Background will be distractingly sharp. A little blur applied only to the Environment Map can help. Reset the parameters to their defaults before you go on (Offset = 0, Tiling = 1).

USING AN ANIMATED BACKGROUND

You can use a video file instead of a still image. The subject of compositing live-action backgrounds into MAX scenes is beyond the scope of this book, but is an extremely important professional technique. You will find, however, that it often makes sense to composite MAX animations together. For example, you might want to render out an animated sky background with moving clouds. You can then use this animation as an Environment Map (using a Screen projection) behind an animated model of a fighter plane. The tools for using animated Maps are found in the Time rollout in the Material Editor.

6. Unless you are using an animated Map, a Screen projection doesn't make sense if the camera will be animated. And a Screen projection seems sometimes unconvincingly flat, in any event. Change from a Screen projection to a Spherical Environment projection in the Mapping drop-down list. This projection maps the image to the inside of a virtual infinite sphere surrounding your scene. This is generally preferable to creating your own giant sphere because it adds no geometry to clutter your scene. Render the perspective view again. Only a tiny fraction of the image is blown up to fill the screen. This is because your field-of-view is only a tiny fraction of the circumference of the sphere.

7. This necessarily produces a very grainy background image, even with a pretty large bitmap. Very few background bitmaps can be designed to be tilable. A starry sky is the only example that comes to mind of a pattern that can be seamlessly repeated without attracting attention—and even this is tough. For the most part, you need to be able to tile and offset the image so that a single tile fits within the frame (or covers the entire range of camera angles). This is not an easy task, so take some time here to give it a try. You'll need to try many renders to make it work, so reduce your image size to 320×240 to speed up the process. Adjust the Offset and Tiling values incrementally in both u and v until you have a single instance of the image to fit within a frame, with the corners of the bitmap over the edge to leave room for a little camera movement. Be prepared for some frustration. When you finish, a rendered image should look something like Figure 17.19.

8. A Cylindrical Environment projection differs from a Spherical one in that it doesn't curve in the vertical direction. This is sometimes easier to use if the camera does not point very much above or below the horizon. Change to a Cylindrical Environment, and once again try to get a single instance of the image to fill the screen. This is a tough job, and the primary reason for addressing the problem here is to stress the difficulty of working with Spherical and Cylindrical Environment projections. The Shrink-Wrap option is even more difficult to use and is only rarely useful.

Atmospheric Effects

Atmospheric effects are used to give substance to space. Even on a relatively clear day, mist or particulate matter in the air causes objects to become blurrier with distance from the viewer. And many scenes require fog, smoke, or even the sense that they are underwater. MAX provides Fog as an atmosphere that pervades the entire scene. In contrast, Volume Fog

Figure 17.19
Same as Figure 17.18, but using a Spherical Environment projection. The image has been mapped to the inside of an infinite sphere. After a great deal of experimentation with Offset and Tiling, only a single instance of the bitmap fills the frame (with the edges hanging over to leave room for a little camera rotation). The image is backward in the horizontal direction.

is confined to defined volumes and is therefore useful for clouds and similar effects. Volume Lights likewise confine the atmospheric haze to the volume of a light cone, to create the effect that is typical of theatrical and outdoor spotlights. Combustion is a completely different kind of effect. To create the impression of fire and explosions, bright but ragged volumetric atmospheres can be animated. You can add any number of atmospheric effects together in a single scene.

Fog

The standard MAX Fog is not confined to a precise volume, and it is therefore appropriate for large-scale atmospheres, whether of airborne mist or underwater. The following exercise covers all the basics for both Standard and Layered Fog:

1. With a fresh scene, create a Box in the center of the groundplane. Make it 30 units in both Width and Length, and 60 units in Height. Make sure that the Box is a strongly saturated color to test its visibility through Fog. Open the Environment dialog box and use the Add button in the Atmosphere rollout to add a Fog to the list of Effects. Carefully examine the Fog Parameters rollout that appears below it. The panel is shown in Figure 17.20.

2. Fog is available in two flavors: Standard and Layered. The default is Standard Fog, with the Layered section of the rollout grayed out. Unlike Layered Fog, Standard Fog fills the entire scene. Render your perspective view to take your first look at Standard Fog. The entire Background should be bright white, and the Box should be softened by a white haze.

3. Uncheck the box titled Fog Background and render again. This time, the Background is solid black, although the Box is still hazed. Note that black is the default Background color at the top of the Environment panel. When the Fog Background box is checked, the Fog Color is used for the Background. When it is not checked,

Figure 17.20
The Atmosphere and Fog Parameters rollouts in the Environment dialog box. A Fog Effect has been added to the list of Effects at top. Any number of Effects can be included in a single scene.

the Background color is used. There's no middle ground, but this is generally okay. In most scenes, the Fog Color naturally consumes the far distance. Check the Fog Background box again before continuing.

4. The Near and Far percentages are easy to understand. By default, the Near percentage is 0 and the Far percentage is 100. That means that the Fog density is 0 immediately in front of the viewer, and it reaches full density at a long distance away. I'll clarify this point in a moment. Increase the Near value to 100 percent and rerender. The scene is completely white because the Fog density is 100 percent immediately in front of the viewer. Return the Near value to 0 and reduce the Far value to 50 percent. Render again. The Background is now gray because the white fog has only 50 percent density when applied to the black Background Color. The Box is also brighter because the density is less at every point in depth. Reset your Far percentage to 100 before continuing.

5. Because you have not created a camera and are rendering from a perspective view, you do not have control over our Environment Range. The Environment Range defines the Near and Far distances from a camera over which the Fog will be applied. Create a camera (either Free or Target) with a view on your scene that is similar to the one in your perspective view and assign the camera to a viewport. Adjust your top view so that you have a good view of the Camera Cone.

6. In the panel for the camera (either Create or Modify), find the Environment Ranges section. Note that, by default, the Near Range is 0 and the Far Range is 1,000. This means that (as when rendering from a perspective view) the Fog begins immediately in front of the camera and reaches its maximum intensity at 1,000 MAX units. Check the Show box to see these ranges in the Camera Cone. This feature works the same as the Clipping Planes. Change the Near and Far Range spinner values and watch the indicator lines move back and forth. You'll probably have to type in the Far value with a much lower number because a distance of 1,000 units is very far away from the camera to begin with.

7. To test the Environment Ranges, copy your Box object a couple of times and arrange the three Boxes in increasing depths from the camera. Adjust the Near and Far Range values until the Near Range begins after the nearest box and the Far Range begins before the farthest box. Your top view should look something like Figure 17.21.

Figure 17.21
A top view showing Environment Ranges set for a camera. The camera faces three Box objects at increasing distances. The Near Range is set between the first and second Boxes, and the Far Range is set between the second and third boxes. Fog will be applied only within these limits.

8. Activate your camera viewport, and then render. As you can see in Figure 17.22, the closest box is completely unobscured by the Fog. The middle Box is partially obscured because it's in the middle of the Environment Range. The most distant Box disappeared because, like the Background, it is completely obscured by the Fog Color.

9. By default, Fog density increases linearly at a constant rate from Near to Far. Check the Exponential box in the Fog Parameters rollout to make the density increase

Figure 17.22
A render through the camera from Figure 17.21. The closest box is completely unobscured by the Fog. The middle Box is partially obscured because it's in the middle of the Environment Range. The most distant Box disappeared because, like the Background, it is completely obscured by the Fog Color.

Figure 17.23
Same as Figure 17.22, but with the Exponential box checked. The Fog density increases much more quickly from Near to Far across the Environment Range, causing the Box in the center to be more fog-obscured than in the previous figure. The Box at left is outside the Environment Range, so is therefore unaffected.

much more quickly across the Environment Range. When you render again, notice how much denser the fog becomes on the Box within the Environment Range. Take a look at Figure 17.23.

10. Now that you understand the basics of Standard Fog, let's move on to Layered Fog. Switch your Fog Type from Standard to Layered and note that the Layered section of the Fog Parameters rollout becomes active. Take a good look at the parameters, illustrated in Figure 17.24. Standard Fog operates in a range of depth from the camera. In contrast, Layered Fog operates vertically in world space. The basic parameters are therefore Top and Bottom instead of Near and Far. By default, the Layered Fog starts on the groundplane (z = 0) and continues to the z = 100. Fog density is set to 50 percent.

Figure 17.24
The Environment dialog box, showing a Layered Fog effect with default values. A vertical layer of Fog begins at the groundplane (z = 0) and ends at z = 100. Fog Density is set to 50 percent.

11. Layered Fog sounds easy in principle, but it can be confusing to use. You should know that it makes a great deal of difference whether the camera itself is in the fog layer. Assuming the default settings, the camera will be in the Fog if its position is between 0 and 100 in the world z-dimension. If the camera is located above the plane z = 100, it will be above the Fog and looking down on it. Right now, your Boxes stand 60 units high on the groundplane. Set the Top of the Fog to 30 so that the Fog layer is limited to only the bottom half of the Boxes. Then, position your camera vertically at z = 20 in world coordinates. Make sure that you're in the world coordinate system for the rest of this exercise.

12. Point the camera in a straight horizontal line toward the Boxes. If you're using a Free Camera, just rotate it. If you're using a Target Camera, move the Target object. Figure 17.25 shows a left view of this setup and the resulting view through the camera. Because the Fog is between 0 and 30, the camera is in the Fog. Environment Ranges (in depth) have no significance for Layered Fog, so hide them by unchecking the Show box in the Camera panel.

Figure 17.25
The Camera is 20 units above the groundplane and pointing horizontally at the Boxes, as seen in a left view. The resulting view is seen through a camera viewport. Because the Fog Top has been set to 30, the camera itself is in the Fog.

13. Activate your camera viewport, and then render. (It's easy to forget to activate the camera viewport after adjusting the camera in an orthographic viewport.) Your result should look much like Figure 17.26. The Fog density is greatest in the band constituting the lower half of the Boxes. This is the defined layer. But the regions above and below show a Fog gradient, from white to dark gray. Think this through. The region above the upper Fog line is nonetheless seen through the Fog because the camera is in the Fog. As you move higher in the frame, the camera view necessarily intersects a smaller region of Fog. Beneath the lower Fog line is much the same thing. The Camera is looking through the Fog and through a decreasing amount of it as you move lower in the frame. This definitely takes a moment to grasp. But note the same idea at work, even in the Fog layer. The more distant Boxes are more obscured because you're looking through more Fog.

14. Move your camera up above the Fog line to z = 50. In the Camera panel, check the box to Show Horizon. Notice the line in your Camera viewport that cuts across the scene at z = 50. (It passes through the tops of the Boxes.) This is the Horizon. Now, render again from your camera viewport—you should get a result similar to Figure 17.27. The view is now from above the Fog. The Boxes are completely unobscured above z = 30, and the Fog extends all the way to the Horizon line. This makes sense, but the Horizon line is too sharp.

Figure 17.26

A rendering of the scene from Figure 17.25. The defined layer of Fog from the bottom to the middle of the Boxes is evident. But the region above the upper Fog line is nonetheless seen through the Fog, because the camera itself is in the Fog. The region below (and in front of) the Boxes is also seen through the Fog, producing a similar gradient.

Figure 17.27

Same as Figure 17.26, except that the camera has been moved above the Fog, to z = 50. As the camera is no longer looking through the Fog, the Boxes are completely unobscured above the Fog layer. The Fog is applied to the Background as high as the Horizon. The Horizon is defined by the plane z = 50, the vertical position of the camera.

15. Check the Horizon Noise box in the Fog Parameters rollout and render again by using the default values. As you can see in Figure 17.28, this creates a noisy region of Fog at the Horizon. The Size spinner does not affect the size of the region, but it affects the size of the noise. It's the Angle parameter that determines the size of the region. For example, reducing the Angle value to 1 degree results in a very narrow band of Horizon Noise.

Figure 17.28
Same as Figure 17.27, but with the default values for Horizon Noise applied. The Angle parameter determines the width of the Horizon Noise band.

16. By default, the Fog layer is computed at a constant density. The Falloff option is set to None. By changing it to Top, the Fog density decreases exponentially from bottom to top. The Bottom option does the reverse. Choose the Top option and rerender. As you can see in Figure 17.29, the Fog layer fades out as it rises toward the plane z = 30.

Volume Fog

Volume Fog produces a cloud or smokelike effect within a defined volume. The volume is defined by an Atmospheric Apparatus. These come in three shapes: the BoxGizmo, the SphereGizmo, and the CylGizmo (a cylinder). You must create one of these gizmos first, and then assign a Volume Fog effect to it. The Volume Fog then renders only within the space of the gizmo. If you create a Volume Fog without an Atmospheric Apparatus, the Volume Fog will fill the entire scene.

Volume Fog is a highly animatable effect. For example, you can animate the position of the gizmo to move a cloud through a scene. You can also animate the shape or form of

Figure 17.29
Same as Figure 17.28, but with the Top Falloff option used. The Fog density decreases exponentially as it rises toward z = 30.

the effect by using various parameters to produce the characteristic evolutions c^f a cloud or smoke.

Like most volumetric effects, Volume Fog can be a science. The panel contains a large number of parameters with cryptic names, which can be rather intimidating to someone seeking to create only a simple effect. Even worse, many of the parameters are interdependent in many ways, so that the significance of one value depends on the other values. I won't be able to address all aspects of this powerful feature in this book, but let's work through the following exercise to get you started:

1. To create a gizmo that will contain the Volume Fog, go to Create|Helpers in the Command panel (the tab showing the tape measure icon). In the drop-down list, change from Standard to Atmospheric Apparatus. Three gizmo choices appear. Create a BoxGizmo on the groundplane, which is big enough to take up a significant portion of the perspective view. Your perspective view should look something like Figure 17.30.

2. At this point, there are two ways to get a Volume Fog bound to the BoxGizmo. With the BoxGizmo still selected, change to the Modify panel. Open the Atmospheres rollout and press the Add button. You can create a Volume Fog effect by selecting it from the list. But don't do it right now. Instead, open the Environment dialog box and add the Volume Fog in the Atmosphere rollout.

Figure 17.30
A BoxGizmo is created to hold a Volume Fog effect.

3. Had you added the Volume Fog to the gizmo from the Modify panel, you would have both created the Volume Fog and bound it to the gizmo. Because you created the Volume Fog in the Environment dialog box, you must bind it to the gizmo in a separate step. Activate the Pick Gizmo button and click on the BoxGizmo in a viewport. The name of the BoxGizmo appears on the panel. The lower portion of your Environment dialog box should now look like Figure 17.31.

4. Rendering time for volumetric effects can be astronomical, and many of the decisions you make are less about appearance than about rendering speed. Render your perspective view at the default 640×480 size. Unless you have a very fast system, you're likely to be surprised by how long it takes to render this scene with only a single object and the default lighting. To speed things up during this exercise, you may want to change your output size to 320×240. In any case, your render should look something like Figure 17.32.

5. The reason this looks like a cloud is because, unlike regular Fog, Volume Fog necessarily contains noise. Switch from Regular to Fractal noise, and then rerender. It takes a little longer, but the result is better, as you can see in Figure 17.33. The Fractal noise produces a crisper, more intricate result. When you changed from Regular to Fractal noise, the Levels spinner became active. Like all fractal effects in MAX, you can control the number of iterations. A higher Levels value produces a more detailed result, but at the cost of increased rendering time.

Figure 17.31
The Atmosphere and Volume Fog Parameters rollouts of the Environment dialog box. A Volume Fog is created and bound to a BoxGizmo. All other settings are at their default values.

Figure 17.32
A render of the perspective view from Figure 17.30, using the default settings seen in Figure 17.31.

Figure 17.33
Same as Figure 17.32, but with Fractal noise instead of the default Regular noise. The result is much more detailed and cloudlike, but the render time is longer.

6. Switch to the Turbulence option, and then render again. Turbulence typically produces very high-contrast results that are better suited to a starry nebula or a galaxy than a cloud. Take a look at Figure 17.34.

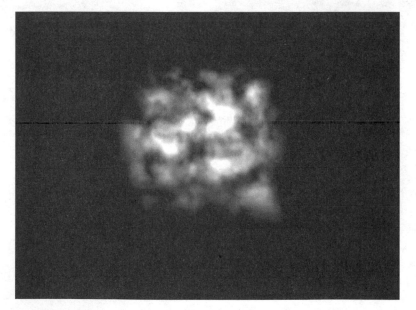

Figure 17.34
Same as Figure 17.33, but with Turbulence used instead of Fractal noise. This high-contrast result looks more like a starry nebula than a cloud.

7. Because render times are so long, perhaps the most important parameter on the panel is Max Steps. This is a fairly straightforward trade-off between render speed and quality. Change back to Fractal noise and render at the default Max Steps value of 100. While rendering, take a look at the rendering panel, and note that it informs you of the time consumed rendering the last frame. Clone the Virtual Frame Buffer. Lower the Max Steps value to 75, render again, and write down the render time of the previous render. Continue in this way, cloning the Virtual Frame Buffer and lowering the Max Steps value, and then compare the quality of your results against render time. You'll probably find that you can cut your render time substantially before you see a noticeable degradation in results.

8. Play around with some animation possibilities. Animate the gizmo's size or move it through space. To make the cloud churn in place, animate Phase by going to Frame 100 and activating the Animate button, and then change the Phase value to something like 100. Make test renders at different frames and note how the cloud changes shape. As you pull the Time Slider, you'll see the Phase value change in the spinner. Render out an animation to see the result.

Combustion

Combustion can be thought of as a type of Volume Fog, using multiple colors and other specialized parameters that are designed to create the impression of flames and explosions. Combustions generally look much better when animated than they do in individual frames because it's the movement of the flames that sells the effect.

USE THE ONLINE HELP FOR COMBUSTION

MAX's Online Help is an excellent resource at any time, but particularly when using Combustion. The Combustion page contains many color examples of different parameter settings that provide an invaluable reference.

Let's take a brief look at Combustion with an exercise:

1. Just as with Volume Fog, a Combustion effect must be bound to an Atmospheric Apparatus that defines its volume and location. Use Create|Helpers|Atmospheric Apparatus to create a CylGizmo on the groundplane. Make the CylGizmo 60 units high with a 30-unit radius.

2. For reference, create a small Box (not a BoxGizmo!), about 10 units high, at the bottom of the CylGizmo. This represents the fuel at the base of the fire—symbolic logs, if you will.

3. Select the CylGizmo again and go to the Atmospheres rollout in the Modify panel. Add a Combustion effect right here. You could do this in the Environment dialog box as well, but this method is faster. At this point, your screen should look something like Figure 17.35.

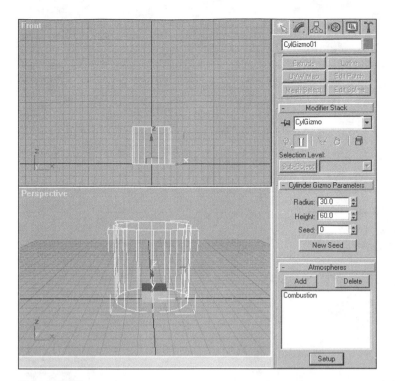

Figure 17.35

A CylGizmo with a Combustion effect added in the Modify panel. A Box object is placed at the bottom of the gizmo in place of "fuel" for the fire.

4. With Combustion selected in the Atmospheres rollout, press the Setup button at the bottom of the Atmospheres rollout; the Environment dialog box appears with the Combustion Parameters rollout open, as seen in Figure 17.36. Take a good look at this panel. The Colors section provides for Inner, Outer, and Smoke Colors. The Smoke Color applies only if an Explosion is used. The other sections are Shape, Characteristics, Motion, and Explosion. Motion and Explosion apply only to animation.

5. The default Flame Type is Fire Ball, which is good for explosions. Because you are creating a burning fire, switch to the Tendril type. Render your perspective view. The result is probably much different from what you might have expected. A small reddish cloud is floating well above your "log." There are two ways to change this: within the Combustion Parameters or by changing the shape of the CylGizmo (see the next two steps).

6. Within the Combustion Parameters, your first instinct might be to increase the Stretch value, but this only makes the flames more vertical in shape without increasing the volume. It's the Regularity parameter that you need. Regularity determines the amount of the gizmo volume that is used for the effect. At the default level of 0.2, only the middle fifth of the CylGizmo is being used. Try increasing this value closer to 1.0, and then render. You probably won't be too happy with the result, however, because the effect will begin to look too cylindrical.

Figure 17.36
The Combustion Parameters rollout in the Environment dialog box, with default values.

7. To keep the result diffuse, return to the 0.2 value for Regularity and change the shape of the CylGizmo. Make it twice as high, either by doubling the Height parameter or by using a non-uniform scale in the z-dimension (you can ignore the warning box). Either way, you have to move the gizmo down until it's roughly centered on the "log." Render again to see your result, and continue to adjust the gizmo to get the correct size and position.

8. Now, it's time to improve the look of your flames. Try reducing the Regularity to 0.1 or below for a more diffuse look. Increase the Stretch to 2.0 for more vertical tendrils. Move down to the Characteristics section and reduce the Flame Size for more delicate tendrils. Reduce or increase Density to adjust the transparency of the fire. You have to experiment with many parameters to get the result you want.

9. To animate your fire, you need to set keyframes for Phase. Activate the Animate button and move the Time Slider to Frame 100. Set the Phase value to 100 and turn off the Animate button. Pull the Time Slider and watch the Phase value change in the panel. Render out at different frames to see the result, or render out an animation at 320×240 size. Because the Phase is changing at a constant rate, the fire churns at a constant rate. (To produce more intensified burning, you can change the slope of the curve in Track View so that it's not linear.) Try animating the Height of the gizmo to make the flames scale up and down.

Let's see what else Combustion can do by trying a quick explosion:

1. Reset your screen and create a SphereGizmo. Add a Combustion effect to the gizmo and press the Setup button to bring up the Combustion Parameters. Check the Explosion box. When the Explosion box is checked, the animation of Phase produces a specific result. Between the values of 0 and 100, the explosion builds from nothing to full intensity. From 100 to 200, the explosion burns and turns to smoke (using the Smoke Color) if the Smoke box is checked. From 200 to 300, the explosion clears. You can create your own Explosion Phase curve in Track View, but you can also produce a default one automatically. Press the Setup Explosion button and accept the defaults, which generate a curve from Frame 0 to Frame 100.

2. To find the curve, open Track View, find the Combustion effect under the Environment heading, and click on the Phase parameter. To see the curve, click on the Function Curves button in the Track View. Examine the curve on your screen or in Figure 17.37. Note that Phase value reaches 100 by Frame 18, about half a second at video frame rate (30 fps). This is the height of the explosion. It burns until Frame 44 (Phase = 200) and then dies out over the remaining frames.

Figure 17.37
The Phase Curve for a default explosion, as seen in Track View. The explosion grows from zero to its maximum in the first 18 frames (from Phase = 0 to Phase = 100). It burns and turns to smoke until Phase = 200 is reached at Frame 42. The effect then dissipates until it completely terminates at Phase = 300.

3. It's hard to see the dark smoke against a black Background, so change the Background Color to white at the top of the Environment dialog box. Use a 320×240 output size for faster rendering. Keep your eye on the current frame number as you watch the rendering. Note how quickly the explosion builds, how it turns completely to smoke by Frame 42, and how long it takes for the smoke to dissipate. If you saved this animation to a file, you can run it from View File in the File menu.

Volume Lights

Volume Lights create a volumetric glow within a region defined by a light. You can create a glowing cylinder with a Direct Light or a glowing sphere around an Omni Light, but the most common use is to illuminate the cone of a Spot Light. Try the following exercise:

1. Create a Sphere in the center of world space. Then, create a Target Spot Light, pointing at the Sphere from above-right in a front view. Use a fairly tight light cone around the object. Your front view should resemble Figure 17.38.

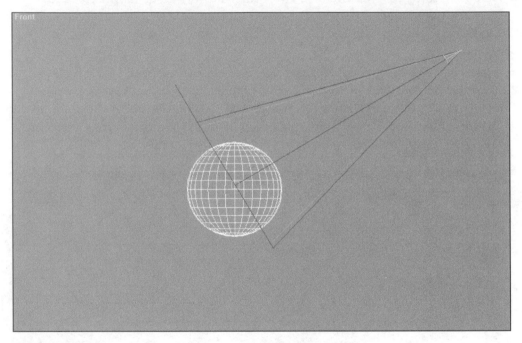

Figure 17.38
Setup for testing a Volume Light. A Target Spot Light is pointed at a Sphere.

2. With the light selected, go to the Atmospheres & Effects rollout at the bottom of the Modify panel. Add a Volume Light effect here, and use the Setup button to open the Environment dialog box with the Volume Light Parameters rollout displayed. Figure 17.39 shows this panel with its default settings.

3. As with other volumetric effects, rendering can be very slow. Use a 320×240 output size and render your perspective view against a black background. It should look something like Figure 17.40. Note that the light gets unrealistically hot past a certain point. That's because the cone is getting wider and the effect is being multiplied. To correct this, reduce the Max Light % from 90 to about 50. This ensures that the glow will never get brighter than 50 percent of the Fog Color (the default is white). Render again to see the result.

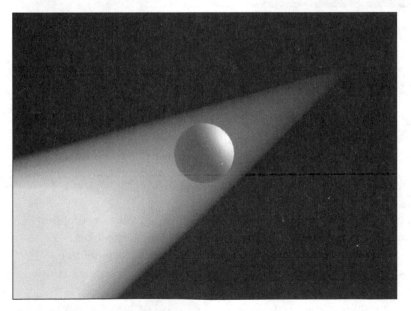

Figure 17.39

The Volume Light Parameters rollout in the Environment dialog box, with default settings.

Figure 17.40

Render of a perspective view of the scene in Figure 17.38, using the default settings in Figure 17.39. The glow gets too hot past the Sphere. Reducing the Max Light % prevents this.

4. The image is not realistic because the Sphere should cut the cone with a volumetric shadow. Adding a Shadow Map shadow to the light itself corrects this. With the light selected, turn on Cast Shadows in the Modify panel. Render again. Your result should now look like Figure 17.41.

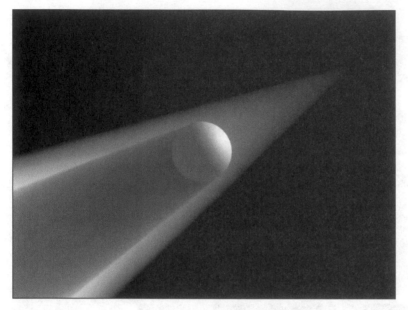

Figure 17.41
Same as Figure 17.40, but with Cast Shadows turned on for the Spot Light. The Sphere now cuts a volumetric shadow through the light cone.

5. Set some attenuation so that the glow falls off with distance. With the light selected, turn on Far Attenuation in the Attenuation Parameters in the Modify panel. Adjust the Start and End Spinners so that attenuation begins a little before the Sphere and ends a little after it. Check the Show box so that the ranges remain visible, even when the light is not selected. Your front view should look something like Figure 17.42.

6. Render your perspective view again. As you can see in Figure 17.43, the glow tails off by the end of the attenuation range.

7. The Fog Color is the color of the volumetric glow. Actually, the glow is a combination of the Fog Color and the color of the light itself, but it generally makes sense to make these two colors the same. You can add another color to the attenuation range only. The Attenuation Color is blue by default, and if you check the box titled Use Attenuation Color, you might expect to see it. But the default value for the Atten. Mult. (Attenuation Multiplier) spinner is too low. Change it to a much higher value, such as 30, and render again. This time you'll see a bright blue color in the attenuation range. The Attenuation Multiplier controls the impact of the Attenuation Color, and not the effect of attenuation generally.

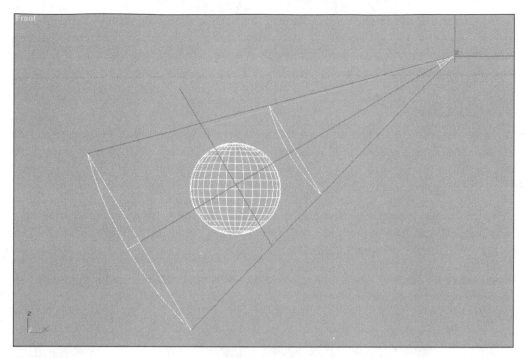

Figure 17.42
Adding Far Attenuation. The light begins to decay at the line in front of the Sphere, and it is completely attenuated when it reaches the line behind the Sphere.

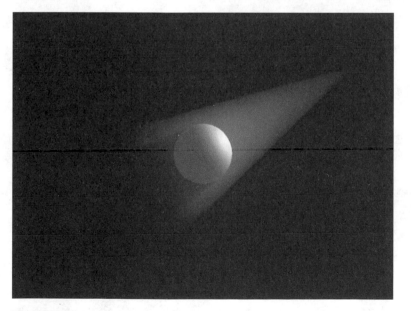

Figure 17.43
A render of the scene from Figure 17.42, showing the attenuation of the volume glow.

The Noise parameters are essentially identical to those found in Volume Fog. Remember that the glow in a Volume Light is typically intended to convey the effect of illuminating airborne mist or particulate matter. In an animation, the viewer expects this material to be moving, and even a small amount of animated noise is convincing.

Moving On

In this chapter, you learned about the tools used to create visual phenomena by means other than the rendering of geometry. You saw how the Render Effects toolset permits you to add post-processing in the normal workflow. You explored the possibilities of the various Lens Effects and experimented with the image-adjustment post-processing tools.

You learned about how to map an image to the Background by using the Environmental Mapping tools. You then investigated the broad range of Atmospheric Effects, including Fog, Volume Fog, Combustion, and Volume Light.

The next chapter discusses Video Post, a powerful utility that can be used for video editing, compositing, and post-processing effects.

USING VIDEO POST

MAX's Video Post is a remarkably useful and powerful tool for performing simple video editing and compositing. You can use it to cut or transition between cameras within a single animated scene and to add post-processing effects such as glows and flares.

Video Post is much simpler to use than it looks. You can edit together different rendered video sequences, or you can combine such sequences with your current scene. It's not a replacement for a true video editing or compositing package, but it's handy and effective for a lot of simple, routine tasks.

The Video Post Queue

The Video Post process entails setting up a Queue (list) of Events to be processed in order. You must decide what Events are in the Queue and in what sequence they are to be executed. "Events" is a general and undescriptive term. The best way to understand an Event is as a step in the Video Post Process.

Video Post Events

There are seven types of Events that you can place in the Queue:

- Scene Events
- Image Input Events
- Image Filter Events
- Image Layer Events
- Image Output Events
- External Events
- Loop Events

The first two Event types are inputs. A Scene Event adds the rendering of the current MAX scene to the Queue from a specified camera or viewport. By using multiple Scene Events, you can use Video Post to cut or transition between different cameras or viewports in the course of your video. An Image Input Event is the other source of input. The input is from bitmap images rather than from the current scene, whether single or in sequence.

A Filter Event applies image processing to the image it receives from Events above it in the Queue. The Image Layer Event is used to composite or transition between two images.

The Image Output Event is used to send the output of the Video Post Queue to a file. Without an Image Output Event, the results are displayed in the Virtual Frame Buffer frame by frame, but are not saved. An External Event sends the output of the Queue to an external device, such as a video tape recorder (VTR).

A Loop Event is a convenient way of generating repeated frame sequences.

The Video Post Panel

The Video Post interface is reached from the Rendering menu. Strictly speaking, it's a modeless dialog box, but it more closely resembles Track View with its adjustable range bars. Most people I know call it the Video Post panel, and I'll use that term here. Figure 18.1 shows the Video Post panel with an empty Queue, just as you see it when you first bring it up in a scene.

Across the bottom of the panel (from left to right) is a prompt line, a status bar with information about frame ranges for the selected track, and navigation tools. The Start frame (S) is 0 and the End frame (E) is 29, for a total of 30 frames (F). This is the range of the Queue because there are as yet no other tracks. The current output is at 640×480. The hand icon pans the range window and other buttons zoom it. These tools are very easy to figure out.

The top of the panel is also rather simple. The first three buttons create a new sequence by deleting the current Queue, load (open) a saved sequence, and save the current sequence. The Video Post Queue is always saved with your scene file, but you can save it independently as a VPX file and load it into any scene.

The next three buttons are grayed out because they apply to Events, and there are as yet no Events in the Queue. The first button allows you to edit the parameters for the selected Event. The second deletes the selected Event. The third swaps the positions in the Queue of two Events that are selected together.

Figure 18.1
The Video Post panel with default settings.

The next button, a running man icon, is also grayed out. Pressing this button executes the Video Post Queue, once you have one to run. The following five buttons are used to edit the range bars. Only the first is active right now because the others are used to align multiple range bars for different Events.

The final seven buttons are used to create the various Event types. Only the Add Scene Event, Add Image Input Event, and Add Image Filter Event options are available at this point because the other Event types are dependent on the existence of these Events.

Video Post Essentials

Video Post is a remarkably powerful tool for performing video editing, compositing, and post-processing within 3D Studio MAX. It is not, however, used by many MAX users, for a couple of reasons. One reason is that it can be somewhat confusing and intimidating. Although it's rather simple once you understand it, Video Post can be daunting at first exposure.

A second reason is more important, however. When MAX first appeared, access to video editing and compositing software was not nearly as common as it is today. The professional-level packages were quite expensive and were often far too sophisticated for people seeking to accomplish only basic editing tasks. But the situation is much different today—Adobe Corporation's Premiere and After Effects packages have grown into serious professional-level tools for video editing and finishing. They are very affordable and have become ubiquitous among serious and professional 3D animators. Anyone who truly needs a video-editing toolset for use with MAX is better advised to buy and learn Premiere and After Effects, instead of making do with Video Post. Like Photoshop, these products (or at least Premiere) are essential auxiliary tools for the 3D artist.

With the arrival of MAX 3, Video Post has become somewhat less essential. Formerly, all of MAX's post-processing functions could be accomplished only through Video Post. For example, Lens Effects such as glows and flares were available only if you set up a Video Post Queue. This made post-processing effects difficult to access and use. As discussed in Chapter 17, MAX 3 has introduced a wide range of important post-processing tools (including the Lens Effects) under a new Render Effects interface. This permits them to be used without recourse to Video Post, and allows you to easily experiment with them.

For all these reasons, I will limit my discussion of Video Post only to the most basic and routine tasks for which it makes the most sense. The following exercises introduce you to the workings of the Video Post queue and leave you with the most important skills in this area of MAX. These exercises are cumulative, building directly from each other using a single file.

First Steps In Video Post

Let's begin by setting up the simplest possible Queue:

1. Open a fresh scene and create any kind of very simple animation. For example, cause a Sphere to move diagonally across your perspective view over 100 frames. The nature

of the animation doesn't really matter here, and you can change it later if you want. Don't render it out, but save the scene.

2. Open the Video Post panel from the Rendering menu. (Refer back to Figure 18.1.) Note that the range bar in the Video Post panel extends from Frame 0 to Frame 29, and that the End frame is 29 at the bottom of the panel. However, the Active Time Segment of your scene runs from Frame 0 to Frame 100.

3. Click on the teapot icon on the Video Post Toolbar to create a Scene Event. This adds the current scene to the Video Post Queue. The Add Scene Event dialog box will appear, as seen in Figure 18.2.

Figure 18.2
The Add Scene Event dialog box that appears when you add a Scene Event to the Video Post Queue.

4. The Perspective viewport option is chosen by default. Press the down arrow on the drop-down box to see the other choices. Because you have not created any cameras, your only choices are the currently available viewports. Leave the Perspective option. This means that you will be adding a render of the current scene through your perspective viewport to the Video Post Queue.

5. Press the Render Options button. This brings up a Render Options dialog box, which is really the Render Scene dialog box without the output options. Anything you change here changes in the Render Scene dialog box as well and will therefore affect the result if you render in the usual way (outside of Video Post). Output options, including both time and frame size, are set independently within Video Post. Close the Render Options dialog box by pressing the Cancel button.

6. Back in the Add Scene Event dialog box, note that Scene Motion Blur is available. Check the box and the parameters will activate. This is the third form of motion blur in MAX. Object and Image Motion Blur, discussed in Chapter 16, are more

commonly used because they do not require the use of Video Post. It's usually not wise to add Scene Motion Blur to a scene that is already using another kind of motion blur, but you may want to try Scene Motion Blur in Video Post if you are not satisfied with the results from the other kinds. As usual, increasing the Duration of the virtual shutter increases the blur, and the Duration Subdivisions determines the number of samples used. The greater the number, the better the result, but there is longer processing time. Scene Motion Blur necessarily applies to the entire frame, rather than to selected objects.

7. Accept the defaults, which lock the Scene Range to the Video Post Range. After pressing the OK button, take a look at your Video Post panel. As you can see in Figure 18.3, a Scene Event name, Perspective, was added as the first (and only) Event in the Video Post Queue. To edit the parameters of this Event, select it by clicking on its name or on its range bar. When these are highlighted, press the Edit Current Event button on the toolbar. The Edit Scene Event dialog box is exactly the same as the Add Scene Event Dialog box that you've already explored. Close this dialog box without changing anything.

Figure 18.3
The Video Post Queue from Figure 18.1 after a Scene Event has been added using the parameters in Figure 18.2. The Scene Event is named Perspective, because it renders the scene from the perspective viewport.

8. Right now, the only thing in the Video Post Queue is the perspective view of the current scene. If you press the Execute button, it renders out the frame sequence, but it isn't saved anywhere. To save it to a file, you need to create an Image Output Event at the bottom of the Queue. (This is not so odd as it may first appear. You have to name an output file when rendering outside of Video Post, or you'll lose your render.) Click in some empty space in the panel to deselect the Scene Event (Perspective). If the Scene Event is selected when you add the Image Output Event, the Image Output Event is added as a child of the Scene Event, rather than simply at the bottom of the Queue. Now, add the Image Output Event from the toolbar. The Add Image Output Event dialog box appears, as shown in Figure 18.4. These same parameters are available if you edit the Event after creating it.

Figure 18.4
The Add Image Output Event dialog box that appears when you add an Image Output Event to the Video Post Queue. The same parameters remain available for editing after you create the Event.

9. Press the Files button to save the output as you do in ordinary rendering. Choose the AVI format and name the file "test1.avi." You can accept the default codec settings or change to something you like better. It's not important for your present purposes. When you're done, your Video Post Queue will contain two Events: the Scene Event (Perspective) and the Image Output Event (test1.avi). Take a look at Figure 18.5.

Figure 18.5
The Video Post Queue from Figure 18.3 with an Image Output Event added, as in Figure 18.4. The Image Output Event is named test1.avi—the name of the output file.

10. Now, it's time to render. Press the Execute button on the Video Post Toolbar (the running man), and you get the Execute Video Post dialog box seen in Figure 18.6. This dialog box contains the same output options that you're familiar with from the top of the Render Scene dialog box, except that these are used only for outputting from Video Post. To speed things up, render only every fourth frame and use a 320×240 output size.

Figure 18.6
The Execute Video Post dialog box contains the same output options as the Render Scene dialog box, but applies only to output from Video Post.

11. Press the Render button and watch it render. In this simplest setup, it renders exactly as it would in the usual way, outside of Video Post. Use View File in the File menu to view your animation in the Windows Media Player.

Adding A Fade

Thus far, you haven't done anything different than you do in a regular render, so make things more interesting by adding an Image Filter Event to fade out the scene. Fading to black is a very important method for closing an animated sequence, either at the end of an entire piece or as a transition:

1. Before adding the Fade, make sure that no Events in your Queue are currently selected. Press the Add Image Filter Event button, and the Add Image Filter Event dialog box appears. Open the drop-down list box and look at the long list of options. Note that the Lens Effects are available for this kind of Event. Figure 18.7 shows the Add Image Filter dialog box with most of the options displayed in the open drop-down list.

2. Select the Fade option and close the dialog box. The Image Filter Event (Fade) will appear at the very bottom of the Queue. This won't work because the Fade must be applied before the Image Output Event, so drag the Fade up above the Image Output Event (test1.avi) in the sequence. Another way to do this is to select both of the last two Events (by using the Shift key) and use the Swap Events button on the Video Post Toolbar to reverse their positions. Now, with only the Fade selected, drag the start point of its range from 0 to 50. Use the S: number in the status bar at the bottom of the panel to confirm. This creates a Fade that begins halfway through the animation and finishes at the very end. Your Video Post Queue should now look like Figure 18.8.

3. Do a couple of things before rendering. First, with the Fade selected, press the Edit Current Event button on the Video Post Toolbar. Once again, you see a dialog box,

Figure 18.7
The Add Image Filter Event dialog box, with most of the options displayed in the open drop-down list. The Fade option is selected.

Figure 18.8
The Video Post Queue from Figure 18.5 with a Fade (an Image Filter Event) added beneath the Perspective (Scene Event). The Fade range has been set to begin at Frame 50 and end at Frame 100.

offering the same parameters that you saw when the Event was first created. You can change the Fade to any one of the other Image Filter Event types, if you wish. Close the panel without changing anything.

4. A Fade dissolves the entire frame to black. This effect is less than clear if you are already starting with a black background, so open the Environment panel and change the Background Color to white.

5. Execute the Video Post Queue, using the same output parameters as before (320×420 and every fourth frame). Keep a close eye on the rendering process, particularly when the Fade begins. For every frame, the image is rendered as usual, and then a Fade is applied as a post-process effect. There are two obvious and distinct steps that correspond to the two Events (Perspective and Fade) in the Video Post Queue.

6. Take a look at your finished AVI file by using the Windows Media Player and confirm the Fade.

Cutting Between Views Or Cameras

The most valuable use of Video Post is probably to switch views within the course of an animation. You'll rarely render from an orthographic window, so you'll either use multiple cameras or a combination of one or more cameras with the perspective view. Without Video Post, you'd either have to animate a single camera to jump sharply between frames or render out separate sequences to be edited together outside of MAX.

Continue your exercise by creating a couple of cameras and making a straight cut between them:

1. Select the Fade (Image Input Event) on the Video Post Queue and delete it using the Delete Current Event button on the Video Post Toolbar. Your Queue should now contain only the Scene Event (Perspective) and the Image Output Event (test1.avi).

2. Create a couple of cameras to view your simple animation from different directions. For example, make Camera01 look down from above and set up Camera02 for a front view. Create viewports for each of these cameras and pull the Time Slider to see how the animation is framed in both cameras. Adjust your camera views to get something that pleases you.

3. Select the Perspective (Scene Event) in the Video Post Queue and press the Edit Current Event button. Choose Camera01 and close the dialog box. The Scene Event on your Video Post Queue should now be named Camera01 instead of Perspective.

4. While the Camera01 Event is still selected, notice that the button for Create Scene Event is grayed out. To create a Scene Event for the other camera, you must first deselect any Events on the Queue by clicking in an empty region. Now, add another Scene Event and assign it to Camera02. The new Scene Event appears at the bottom of the Queue, so either drag it up above the Image Output Event or swap their positions.

5. To save this animation under a new name, select the Image Output Event (test1.avi) and press the Edit Current Event button. When the Edit Image Output Event dialog box appears, press the Files button to enter a new file name. Enter "test2.avi." When you finish, your Video Post Queue will look like the one shown in Figure 18.9.

6. At this point, both Scene Events (Camera01 and Camera02) have range bars that extend the entire length of the Queue range—from Frame 0 to Frame 100. Before rendering, guess what's likely to happen. Then, press the Execute button and use the same output settings that you've been using all along. Watch the frames as they render to see the process.

7. For each frame, the Camera01 view renders first and then the Camera02 view renders right on top of it, completely erasing the Camera01 image. This is the Video Post Queue concept in action. For each frame, each Event is executed in order from top to bottom. In this case, it means that the second Scene Event completely obscures

Figure 18.9
Video Post Queue with two Scene Events for two cameras and an Image Output Event (test2.avi). The range bars for both of the Scene Events (Camera01 and Camera02) extend the entire length of the Video Post Range.

the first before being sent to the Image Output Event. Run the animation "test2.avi" in the Windows Media player to confirm that only the Camera02 view survived in the output.

8. Select the range bar for Camera02 and drag its start to Frame 50. The range bars of the two Scene Events now overlap only between Frame 50 and Frame 100. From Frame 0 to Frame 49, Camera01 is not obscured. Your Video Post Queue should look like Figure 18.10.

Figure 18.10
Video Post Queue from Figure 18.9, but with the range bar for Camera02 adjusted to extend only between Frame 50 and Frame 100. The two Scene Events overlap between these frames, but Camera01 is unobscured for the first 50 frames in the Video Post Range.

9. Execute this Queue and watch the process. (If you get a warning box about the output file, make sure that the Windows Media Player is closed before you Execute again.) For the first half of the range, only the Camera01 view renders. During the second half, Camera01 renders first, but it is then overwritten by the rendering of

the Camera02 view. Look at the result in the Windows Media Player to confirm a cut from Camera01 to Camera02, halfway through the sequence.

10. This method works to create a jump cut between cameras, but the Video Post Queue is not as clear is it might be. With such a simple setup, it hardly matters, but if you're working with multiple cuts or more than two cameras, the arrangement of the range bars must be readable. Move the end of the Camera01 range bar to Frame 49. As you can see in Figure 18.11, it is much more evident where one Scene Event ends and the next one begins.

Figure 18.11
Video Post Queue from Figure 18.10, but with the range bar for Camera01 adjusted to extend only between Frames 0 and 49. Without the overlap, it's much clearer that a straight cut was created between the two cameras at Frame 50, and the needless rendering of the Camera01 view is eliminated.

11. Execute again and watch the process. This time, only Camera02 renders from Frame 50 to Frame 100, eliminating the needless rendering from Camera01. This speeds up the process quite a bit, and with a complex scene would be absolutely essential. As you can see by viewing the AVI file, however, the final result is no different.

12. To cut back to Camera01, you must add another Scene Event for that camera. Add a new Scene Event, assign it to Camera01, and position it in the Queue immediately beneath the Camera02 Event. In a more complex scene, it might make sense to give this Event a distinctive name, as it amounts to a camera shot in an editing sequence. Try this by using the Edit Scene Event dialog box to enter the name Camera01_Shot B in the Label box. After closing the dialog box, this name will appear in the Video Post Queue.

13. Adjust the range bars so that Camera01 extends from Frame 0 to Frame 40, Camera02 extends from Frame 41 to Frame 69, and Camera01_ShotB extends from Frame 70 to Frame 100. Use the display at the bottom of the panel to confirm these ranges. When you finish, your Video Post Queue should look like Figure 18.12.

14. Execute the Video Post Queue and watch the process. There should be no overlapping, and the final animation should cut back and forth between the two cameras.

Figure 18.12
Video Post Queue from Figure 18.11 with a third Scene Event added. The new Scene Event renders Camera01 again, and so it has been given a distinguishing name. The range bars for all three Events have been adjusted to cut from Camera01 to Camera02 at Frame 40, and then back to Camera01 at Frame 70.

Adding A Cross Fade

Thus far, you've learned how to dissolve to black by using a Fade—an Image Filter Event. You've also learned how to cut between cameras. A cross-dissolve between sequences is an essential film and video-editing technique that fades one sequence out as it fades another in. Now, add a cross fade to your scene:

1. Adjust the range bar for the Camera02 Event so that it extends from Frame 41 to Frame 80. Adjust the range bar for the Camera01_ShotB Event so that it extends from Frame 60 to Frame 100. Thus, these two Events will overlap from Frame 60 to Frame 80. Select the Image Output Event and change the output file name to test3.avi.

2. If you execute the Video Post Queue right now, the Camera01_ShotB Event overwrites the Camera02 Event where their ranges overlap. This effectively creates a cut from Camera02 to Camera01_ShotB at Frame 60. To create a cross-dissolve, select both of these Events together, using the Shift key. Look at the Video Post Toolbar and notice that all of the Add Event buttons are disabled, except for Add Image Layer Event.

3. Press the Add Image Layer Event button to bring up the Add Image Layer Event dialog box. Take a look at the list of options in the drop-down list box, as illustrated in Figure 18.13. As you can see, an Image Layer Event provides tools for simple compositing and transitions between image sequences.

4. Select the Cross Fade Transition option and close the dialog box. Your Video Post Queue should now look like Figure 18.14. Note how the two Scene Events have become hierarchical children of the Image Layer Event (Cross Fade Transition). Take a look at the default range of the Cross Fade Transition. It extends from the beginning of the Camera02 range to the end of the Camera01_ShotB range. If you execute the Queue right now, you'll get an undesired result. The Camera02 view will begin to

Figure 18.13
The Add Image Layer Event dialog box with the drop-down list revealed. All of these options provide simple compositing and transitioning between image sequences.

Figure 18.14
Video Post Queue from Figure 18.12 with an Image Layer Event (Cross Fade Transition) added as a parent to two overlapping Scene Events. The default range of the Cross Fade Transition covers the combined ranges of the two Events, rather than just where they overlap.

dissolve to black at Frame 40, well before the Camera01_Shot B Event begins. On the other side, Camera01_Shot B will fade in from Frame 60 all the way to Frame 100.

5. Adjust the range of the Cross Fade Transition so that it covers only the overlapping ranges of the Scene Events (Frame 60 to Frame 80). Your Video Post Queue should look like Figure 18.15.

6. You're interested only in the Cross Fade, so there's no need to render out the whole thing. After pressing the Execute button, set the Range to operate from Frame 55 to Frame 85 and bring the frame interval back to 1 (from 4) so that each frame will render. Let 'er rip and watch the process. You should get a nice cross-dissolve between the two camera views.

Figure 18.15
Video Post Queue from Figure 18.14 with the Cross Fade Transition range adjusted to cover only the overlapping region of its children Scene Events.

Using Prerendered Sequences

Video Post is a valuable tool for the quick editing and compositing of image sequences that you've already rendered out—either by themselves or in combination with the current scene, as we'll see here:

1. In your current scene, create a fresh Video Post Queue by pressing the New Sequence button. Add a Scene Event for one of your cameras. Then, use the Add Image Input Event to add one of the test.avi animations you made in this chapter. Use the Files button on the Add Image Input Event dialog box to find the file. Unless you rendered out the full 101 frames for the AVI file, it should be much shorter than the 100-frame Scene Event. Adjust the Scene Event to begin one frame after the Image Input Event ends. Your Video Post Queue should look something like Figure 18.16.

Figure 18.16
Video Post Queue with a Scene Event (Camera01) and an Image Input Event (test1.avi). The Image Input Event is a 26-frame AVI file rendered out earlier in this exercise. The range of the Scene Event has been set to start one frame after the Image Input Event ends.

2. Add another Image Input Event to the bottom of the Queue, using another test animation for this exercise. Click on its range bar (not on the ends) and drag it until it ends at Frame 100. Dragging in this way keeps the length of the range constant as you move it. Adjust the end of the Scene Event back from Frame 100 so that it overlaps some, but not all, of the new Image Input Event.

3. Create a Cross Fade where the Scene Event and the Image Input Event overlap by selecting both of the overlapping Events and using the Add Image Layer Event button to create a Cross Fade Transition. Notice how the order of the Queue is rearranged to group the two child Events together. Adjust the length of the Cross Fade range bar to cover only the overlapping region of its children. Add an Image Output Event at the bottom of the Queue to save the output to a file named test4.avi. Your Video Post Queue should look like Figure 18.17.

Figure 18.17
Video Post Queue from Figure 18.16 with a second Image Input Event added (test2.avi) and moved to the end of the Queue range. The Camera01 Event has been adjusted to overlap only part of test2.avi. Both Camera01 and test2.avi have been made the children of an Image Layer Event (Cross Fade Transition).

4. The Queue in Figure 18.17 should work as follows: First, the prerendered "test1.avi" sequence will be copied into "test4.avi." Then, the current scene renders from Frame 26, using the view from Camera01. Between Frames 75 and 85, there will be a Cross Fade between the current scene and the prerendered sequence in test2.avi. The files will finish at Frame 100 with test2.avi alone. Your own example should be very similar. Execute the Queue and see how it works out. Remember that you already have cuts and fades in the prerendered sequences, so don't be confused by them. Compare the prerendered sequences with the final result in Media Player to confirm that everything worked as planned.

Moving On

In this chapter, you learned the essential skills needed to use MAX's Video Post utility for its most common functions. You began by learning to simply render a scene through Video Post

by setting up a Queue involving only a Scene Event and Image Output Event. You learned how to dissolve the scene by using an Image Filter Event—the Fade. You then learned how to include multiple camera views in your animation, first by simply cutting between them, and then by using an Image Layer Event to create a Cross Fade Transition. Finally, you learned how prerendered sequences can be used in place of, and in addition to, the rendering of the current scene in the Video Post Queue.

The next chapter begins an examination of MAX's powerful animation toolset.

PART VI

ANIMATION

ANIMATION ESSENTIALS

In the opinion of many people, MAX's strongest suit is animation. Its animation toolset is unrivaled for strength and versatility. And nearly everything in MAX is animatable.

There's a lot to learn and understand before you can make use of MAX's strong animation toolset. Animation is a challenging subject in any case, and the very size and power of MAX's toolset can be rather intimidating. In this chapter, I'll make sure that you are well grounded in the fundamentals. Although I call them fundamentals, this material isn't simple—you have to be willing to think deeply and explore the possibilities at every step. I'm always returning to these fundamentals, and I'm always learning new things about them.

What Is Animation In 3D Studio MAX?

This is not a naïve question, and it deserves a precise answer: Animation is the variation of one or more parameter values in a scene over time.

The next sections discuss this central idea. You are probably already familiar with the term *parameter*. In computer programming, a parameter is an input value sent to a function that determines the output of that function. Every object in MAX (not just geometric objects) can be understood as a function that receives input parameters and outputs some result. A Sphere object has a Radius parameter, a Material has a Diffuse Color parameter, and a Bend modifier has an Angle parameter. The Environment has a Background Color parameter. A light has a Multiplier parameter. All objects that have locations in a scene have transform parameters for Position, Rotation, and Scale. The list is endless.

Each of these parameters is assigned some specific value. When that value is made to change over time, the parameter is said to be *animated*. Although not all parameters can be varied over time, MAX is remarkable among 3D applications for the number of its parameters that can be animated.

HOW DO I KNOW WHETHER A PARAMETER CAN BE ANIMATED?

Every animatable parameter in your scene is given an animation track in Track View. To determine whether a parameter can be animated, open Track View and find the desired parameter within its object. A green arrow indicates that a parameter can receive an animation controller and can therefore be animated.

Understanding Function Curves

The idea of function curves is basic to computer animation. A *function curve* describes the way a parameter changes over time. It's not an overstatement to say that a function curve *is* the animation.

In traditional 2D cel animation, the extremes of motion are drawn first as *key frames*. Then, the intermediate frames are filled in the process called *inbetweening*. This approach is essential to cel animation. When many people begin working in 3D computer animation, they adopt the 2D approach instinctively. They pose a character or adjust other scene parameters at key frames, and then they allow the application to do the inbetweening. It's very important to get past this approach as soon as possible.

3D computer animation allows you to understand animation as continuous change, not just as the linking together of still poses. The animation is the function curve that describes the changing parameters. The keys are used only to create the curve. (Note that I use the term *keys* to designate the fixed values set directly on the curve in 3D animation. In contrast, I use the term *key frames* to designate the primary frames drawn in 2D cel animation. These ideas are closely connected, but ultimately different, as you shall see.)

To understand this idea, take a look at a couple of function curves from Track View. It doesn't matter which parameters are involved right now. In Figure 19.1, an animation is achieved with five keys. The parameter values at Frames 0, 50, and 100 are all set to 0. At Frame 25, the value decreases to a minimum of –20; at Frame 75, it rises to a maximum of 20. The keys were used to define the curve, but it is the curve, not the keys in themselves, that de.ine the animation. Imagine the flow of this animation just from looking at the curve. If this curve were applied to a position transform in the world z-dimension, an object would be moving up and down. If applied in the world x-direction, it would be shifting back and forth. The serious 3D animator can read function curves the way a musician can read music. Function curves are the language of computer animation.

Figure 19.1
A simple function, a curve, is created from five keys at Frames 0, 25, 50, 75, and 100. The interpolation between these keys determines the shape of the curve and therefore determines the value of the parameter at every frame.

Figure 19.2
A function curve nearly identical to Figure 19.1 is created with fewer keys by adjusting the interpolation between them with tangent handles. MAX's function curves are the same Bezier splines as are found in the rest of the program, and the keys amount to the same thing as spline vertices. The curve appears slightly different than the one in Figure 19.1 due to the vertical stretching of the display, but its values at any given frame are very close to those found in Figure 19.1.

The very same animation can be created with a different number of keys if you change the interpolation, however. In Figure 19.2, there are keys at only 0, 50, and 100. MAX's function curves are the same Bezier splines as are found in the rest of the program. By adjusting the tangent handles for these keys (which amount to the same thing as vertices on a regular spline), you can create the same curve shape as in Figure 19.1. If it looks a bit different to you, examine it carefully. The display in Figure 19.2 is vertically stretched compared to Figure 19.1, but the curves are nearly identical in terms of their values at any given frame.

This comparison can be used to make two points. One is that keys need not represent extremes of motion as key frames do in 2D cel animation. In cel animation, key frames would have been drawn at 0, 25, 75, and 100 (but not necessarily at 50), because these are the extremes of motion to define the limits of the inbetweening. The curve in Figure 19.1 adopts this approach, although it uses a key at Frame 50 to help shape the interpolation between the extremes. The curve in Figure 19.2 has all three keys at a single value, and there are no keys at the extremes. The shape of the curve, and therefore the progress of the animation, is defined by the interpolation tools.

Why would you prefer one curve over another? The answer should be a familiar one to the experienced 3D modeler. Curves with fewer keys (vertices) are generally easier to edit than curves with many. And it will often make more sense to edit a curve by using Bezier handles than by adding and positioning more keys.

Working With Keys

You should now understand how keys are used to create the function curves that actually define the animation of a parameter. MAX has always had two approaches to creating keys. The Animate button can be used to create keys interactively by transforming objects or

changing parameters. And all key-related operations can be handled in Track View, including creation, deletion, and editing. MAX 3 has added a new Track Bar beneath the Time Slider and the key-creation tools that are available from the Time Slider itself. You can create, delete, and move keys by using these important new tools.

Experienced MAX animators develop their own work styles, incorporating all of the various tools. The serious student must learn to master Track View from the very start, however. Beginners often think of Track View as an advanced feature that they need not address until they have developed skills using the Animate button. At most, they think that Track View is something to use in editing, but not creating, an animation. This mindset is a severe impediment to the development of any serious animation skills. Track View is a fantastic tool—probably the strongest competitive feature in MAX. Every animation tool is available here and nearly every animation question can be answered by reference to it. And most importantly, a student animator needs constant exposure to function curves to develop a feel for the control of timing and movement.

To understand the integration of all the available tools for key creation and management, let's work through a series of instructional exercises.

Managing Keys In Track View

We'll start right off with Track View, the control center for animation in 3D Studio MAX:

1. The most useful screen configuration for animation uses only two viewports extending the width of the screen. This setup allows the full length of Track View to be visible above a scene viewport that is big enough to see motion. To get this configuration, right-click on any of the viewport labels and choose Configure from the menu. Choose the Layout tab from the Viewport Configuration dialog box that appears and select the fourth option on the top row, as shown in Figure 19.3.

2. Open Track View from the Track View menu or from the Main Toolbar, and position it in the upper viewport. Depending on the size of your monitor, you may want to allow it to extend over the lower viewport (which is a front view, by default).

3. Create a Box in the middle of your front view. Because you don't have multiple viewports to see it, use the Modify panel to set the size of the Box to 50 units in all three dimensions. Use the Move Transform Type-In (right-click on the Move button) to place it precisely at the world origin (0,0,0). Note that the Box object appears in Track View. Expand the Box tracks by clicking on the plus sign next to the title of the object, and then expand the tracks under Object (Box). Adjust the view so that you can see all the tracks together. Your Track View panel should look like Figure 19.4. The three transforms are obviously all animatable, but note that all of the underlying parameters of the primitive object can be animated, as well. The little green triangle to the left of each parameter name indicates that it is animatable. There are no keys in any of the tracks yet, but the current static value of each parameter is displayed.

Figure 19.3
The Layout tab of the Viewport Configuration dialog box with a useful layout option selected for animation work. The upper viewport can hold Track View and the lower one provides a large view of the scene. The reverse layout option immediately to the right is just as suitable.

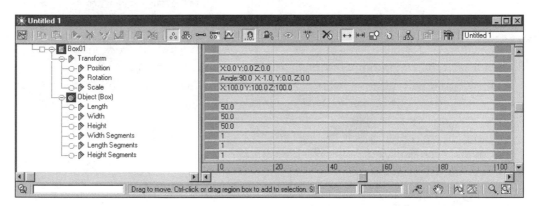

Figure 19.4
The Track View panel for an unanimated Box object, with all tracks expanded. The three transforms are all animatable parameters, of course, but note how all of the underlying parameters of the Box object are also animatable. The little green triangle to the left of each parameter name indicates that it is animatable. There are no keys in any of the tracks yet, but the current static value of each parameter is displayed.

4. Before you set a single key, you have to know what controllers you are working with. The concept of controllers is powerful and unique to MAX. Each animatable track is assigned a controller. There are many different types of controllers available for each track, and each one determines how the function curve is created and what it means to the affected object. Controllers are covered in depth in the next chapter, but you must understand at least the basics right from the start. Unfortunately, Track View does not show you your controller names by default. To determine what controllers are currently being used, click on the Filters button at the far left end of the Track View toolbar. The Filters dialog box will appear, as shown in Figure 19.5.

Figure 19.5
The Filters dialog box is critical to the effective use of Track View because a complex scene will contain much data. Filters are used to hide unnecessary tracks and information. Note the long list (only partially displayed) of controller types.

5. The Filters dialog box is critical to the effective use of Track View. Track View's great value is in the fact that it is comprehensive—it contains everything in one place. The downside is that it can get pretty complicated. With a scene of any complexity, you need to be able to hide unnecessary tracks and information, and the Filter dialog box allows you to do this. Considering all of the information that is displayed by default, I've never been able to understand why you need to ask to see your all-important controller types. In the Show section of the dialog box, select the Controller Types checkbox.

6. Before closing the dialog box, take a quick look at the huge list of the controller types in the center section. They are divided into Float Controllers, Point3 Controllers, Position Controllers, Rotation Controllers, Scale Controllers, and Transform Controllers. Keep this organization in mind. When you change an animatable parameter from one controller type to another, the available choices will depend on the nature of the parameter. Close the dialog box and look again at your Track View panel. The controller types are now visible for each track.

Note that Position is animated by default using a Bezier Position controller. This kind of controller has two distinguishing features. First, the values defined by its function curves are the positions of the object in x,y,z coordinates. Thus, the Bezier Position controller generates a separate curve for each of the three dimensions. Second, the function curves are Bezier splines. The keys are effectively Bezier spline vertices, and the interpolation between them can be controlled, if desired, by Bezier tangent handles. When you create keys using a Bezier Position controller, you are fixing a location in space at the specified frame. Then, you can interpolate between different locations using Bezier-type controls.

7. Let's start creating keys. Press the Add Keys button on the Track View toolbar to activate it. Click in the Position track to set a key. The key is selected (white) and its current frame location is indicated in a box in the status bar at the bottom of Track View. Type "0" in the box to move the key precisely to Frame 0. Create a second key at Frame 100. Get out of the Add Key mode by right-clicking (or else you'll create more keys every time you click in the panel). Close the Object level tracks to simplify the display. At this point, your Track View should look like Figure 19.6.

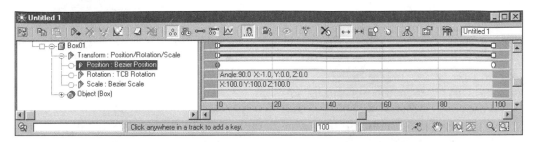

Figure 19.6
Keys have been created directly in Track View in the Position track at Frames 0 and 100. The controller type is Bezier Position. This is an Edit Keys view, showing the location of the keys and the range of the animation, but not the actual function curves.

8. Right now, you are looking at the tracks in the Edit Keys mode. You see only the location of the keys and the range of the animation. The range is an important idea. By default, the range extends from the first key in a track to the last key. Select either of your keys and move it to a different frame. Notice how the ranges expand and contract accordingly. Reset back to 0 and 100, and use the Add Keys button to create a third key at 50. Right-click to get out of the Add Key mode, and now try moving the endpoints of the range bars above the animated track. Note how this shortens or lengthens the animation by scaling the distance between the keys. This is just one of many fantastic features of Track View.

9. You've set three keys, but what do they mean? Because the track uses the Bezier Position controller, each key contains a location in x,y,z coordinates. Click on the key at Frame 0 to select it. It turns white. Now, right-click on the same key to bring up a small dialog box. As you can see in Figure 19.7, the dialog box tells you a number of important things about the key. The title "Box01\Position" indicates that the parameter being keyed is the Position transform of the object Box01. The number 1 at the top means that this is the first key in the track. The Time box indicates that this key is currently at Frame 0. And, finally, the x, y, and z values tell you that, at this key, the Box is located at (0,0,0) in world space. Use the little arrows at the top to page through all three keys. (This is an easier way to select them than by clicking on the keys themselves.)

10. All three keys have precisely the same values. By "values," I refer specifically to the information stored in the key, not information about the key. The information

Figure 19.7
The dialog box for the first key in the track illustrated in Figure 19.6. The dialog box indicates the object and its affected parameter (Box01\Position), the number of the key in the track (1), and the time at which the key is set (Frame 0). It also tells you the value of the parameter at this key—a location of (0,0,0) in world space.

stored in the key—its value—is the position in x,y,z coordinates. This idea will become clearer when you look at the function curves. All three keys have the position values (0,0,0). Animation is the variation in the value of a parameter. So, right now there is no animation, even though there are keys. Pull the Time Slider to confirm that nothing is moving. Switch to a Function Curve view in Track View by clicking on the button on the Track View toolbar with the curve icon. You see a straight line running through three keys (now squares instead of circles). The straight line means that the Box is maintaining a position of (0,0,0) throughout the 100-frame range.

11. Now, you can animate this. Select the second key at Frame 50, either by using the arrows in the dialog box or by clicking on the key on the function curve. Move the Time Slider to Frame 50. Now, increase the z value in the dialog box to 50. Two things happen at once. The key moves up in the window, creating a rounded blue curve. And because the Time Slider is at Frame 50, you can see the new position of the Box in the viewport at this frame. Pull the Time Slider back and forth to see the animation, and watch the time line move across the function curve in the Track View panel. Your screen should look like Figure 19.8 when the Time Slider is at Frame 50.

12. Some controllers produce only one curve, and some produce three. Bezier Position produces three curves: for x, y, and z. In all applications that I'm familiar with, curves affecting the x-dimension or axis are displayed in red, curves for y are always green, and curves for z are blue. It's easy to remember "xyz—rgb." Only the blue curve is animated, and the two others can still be seen as straight lines. It can be difficult to work with the multiple curves in a single controller. The best approach is often to use the value spinners in the dialog box to make sure that only a single curve is affected at a time. Another approach is to filter out all but a single curve. You can use a filter to animate the translation in the x-direction. Open the Filters dialog box and find the section titled Function Curve Display. By default, all three dimensions are checked for all three transforms. Uncheck the y and z options for Position. After you press the OK button, only the red curve will be visible in Track View.

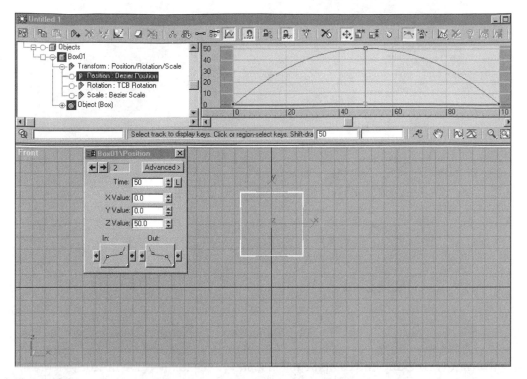

Figure 19.8
The z value for key 2, which is currently at Frame 50, has been increased to 50 in the dialog box. This creates a rounded function curve in which the z value rises from 0 to 50 and back down again over a range of 100 frames. Because the Time Slider (not seen) is currently at Frame 50, the Box is located at z=50 in the front viewport.

13. Pull the Time Slider to Frame 100. Select the third key in Track View, at Frame 100. Increase the x value of this key until the Box has moved some significant distance to the right of the screen. You can do this in a number of ways. One method is to drag the key upward in Track View, although you'll probably have to zoom or pan the window to give yourself enough room. Another way is to increase the x value in the spinner in the dialog box, just as you did before. And yet another way is to type a value directly into the box in the Track View status bar. Experiment with all these methods, but finally set the x value to 100. Use Zoom Value Extents at the bottom of the Track View panel to get a good view of the curve, which should now look like Figure 19.9.

Take a good look at the x curve on your screen or in Figure 19.9, because we have come to something very important. You have three successive keys with x values of 0, 0, and 100. Without a view of the function curves, you might expect that the Box would remain still between Frames 0 and 50, and then move 100 units in the x-direction during the remaining 50 frames. But this is not what happens. By default, the interpolation between keys is spline interpolation, not linear interpolation. That means that the keys are treated as the vertices of Bezier splines. If you create Smooth vertices (the default) when drawing Bezier splines in

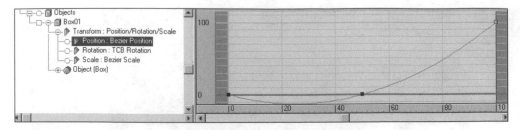

Figure 19.9
The y and z curves have been filtered out, leaving only the (red) x curve. The value of the key at Frame 100 has been increased from 0 to 100. Note how the interpolation dips the curve below zero between the first two frames.

MAX's regular viewports, you expect to see them connected by curving lines. It's just the same with the function curves that are used to control animation. Due to spline interpolation, MAX fits a smooth curve between the keys. As a result, two things are noticeable. First, the curve dips below 0 between the first two frames. Second, the function curve is not a straight line between the second two keys. Rather, it's a curve whose slope increases as it approaches Frame 100. This means that the motion accelerates between Frame 50 and 100.

14. Unhide the z curve by using the Filters dialog box to see both curves, and use the Play Animation button at the bottom-right of the MAX screen to run the animation. Watch very carefully and compare the motion you see to the curve in Track View, both for position and speed. Note that the Box drifts backward in the x-direction at the start, and that it accelerates in the z-direction toward the end. Press the Play Animation button to stop the animation when you finish.

HOW TO TELL IF YOU ARE A COMPUTER ANIMATOR

Even if you've done little or no computer animation before, you can learn a lot about yourself right here. A person with serious interest in mastering this difficult field will be fascinated by the relationship between the shape of the function curves and the motion of the animated object. He or she will not move on to the next step in the current exercise without understanding everything about the motion of the Box in this simple setup. Computer animation is only for those who love it, because this love gives them the energy and persistence to learn to read and edit function curves. These are brand-new tools that traditional animators never dreamed of.

15. If you set your keys outside of Track View without looking at the curves, you probably would be very surprised at the animated result. Suppose that what you want is for the x value to remain constant for the first 51 frames (remember that Frame 0 is included). To make things as simple as possible, eliminate the z animation to isolate only the x animation. Select the Frame 50 key on the z curve and set the value to zero. The z (blue) curve now becomes a straight line again. Hide the z curve to get it out of the way and pull the Time Slider to confirm that the only animation is back and forth in the x-direction. Now, select the Frame 50 key (#2) on the x (red) curve and right-click, if necessary, to bring up its dialog box. At the bottom of the dialog box are buttons under the headings In and Out. These control the spline interpola-

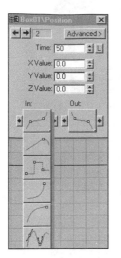

Figure 19.10
The spline-interpolation options for a curve heading into the selected key. The same options are available heading out of the same key.

tion in and out of the key. Click and hold down the In button to see your choices, as shown in Figure 19.10.

16. Select the bottommost option to make your Bezier tangent handles visible. Notice that the handles appear on both sides (in and out), even though you only used the In button. The new icons for both In and Out on the dialog box confirm this. Note also that the shape of the curve is completely unaffected. The handles are locked together to keep them collinear. As you know from MAX's regular Bezier splines, collinear handles keep the curve smooth through the selected vertex. Move either of the handles to test this. But you need a sharp change—a discontinuity. Click on the Advanced button in the dialog box for the selected key to reveal additional parameters. Click on the little lock icon for the x-dimension to unlock the handles. Now, you can move each handle separately.

17. Move to Key #1 and display its Bezier handle. Because this is the start point of the function curve, there will only be a single handle. Adjust the outgoing handle of Key #1 and the incoming handle of Key #2 to point at each other in a straight line. Your curve should look like Figure 19.11. The straight linear segment between the first two keys means that x will maintain a constant value between Frames 0 and 50. Play the animation to confirm that you have eliminated the backward drift.

18. Turn to the second 50 frames. Right now, the Box will accelerate constantly until it reaches Frame 100, where it will come to a sudden stop. For most objects, this is not realistic or pleasing. Physical objects have inertia. It takes energy to speed them up and slow them down. In the language of traditional animation, you usually need to "ease in" to motion and "ease out" of it. In other words, there should be acceleration at the start and a deceleration at the end. Acceleration or deceleration is achieved by changes in the slope of the curve. If the slope is changing so that it

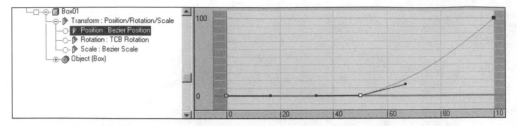

Figure 19.11
The function curve from Figure 19.9 with the Bezier handles of the first two keys revealed. By adjusting the outgoing handle from the first key into a straight line with the incoming handle for the second key, the value remains constant for the first 50 frames. This eliminates the backward drift at the start of the animation.

grows more vertical with time, the rate of speed is increasing. If the slope is changing so that the curve grows flatter with time, the rate of speed is decreasing. These concepts, right out of high-school physics, are the meat and potatoes of 3D computer animation. You already have a constant acceleration, so you need to add a deceleration at the end. You could do this with a Bezier handle, but let's try another way. Select the third key and look at the interpolation options in the dialog box for In. Select the one just above the Bezier handle option (with the flattening curve icon). This creates an automatic ease-out. Go back to Key #2 and adjust its outgoing handle downward to create an ease-out that mirrors the ease-in. Your curve should look like Figure 19.12. Play the animation to see the result.

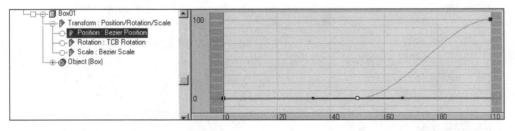

Figure 19.12
The function curve from Figure 19.11, with an ease-out applied to the end and the outgoing Bezier handle for the second key adjusted to provide a matching ease-in. This creates a slight acceleration into the motion (from a dead stop) and a slight deceleration out of the motion.

Using The Animate Button

Now that you understand how keys are used to create function curves, you are in a position to understand the Animate button.

Here's a confession: I don't like the Animate button very much, so I use it for only very simple operations. I almost always work in Track View to set keys because I want to see and edit my function curves at every stage. I also find the Animate button a bit confusing. In all other animation applications that I'm familiar with, the user transforms the selected object at a given frame and then creates a key if he or she wants to. In MAX, you turn the Animate

button on before you change anything, and any change that you then make to an object automatically creates a key at the current frame. This forces you to constantly test and undo. Another problem is forgetting to turn the Animate button off. If you leave it on, you create keys unintentionally every time you do almost anything. I know, however, that many other people don't share my irritation with this tool, especially those who work exclusively with MAX and are not used to any other approach. And the Animate button makes special sense when animating rotations with MAX's default TCB Rotation controller because that uses no function curves, in any case.

The following exercise shows you how the use of the Animate button ties into the larger picture:

1. Set up a scene, as was done in the first seven steps in the previous exercise. If you completed the previous exercise, you can simply eliminate the animation by changing to an Edit Keys view in Track View, selecting the three keys by dragging a rectangle around them, and pressing the Delete Keys button on the Track View toolbar. But be careful what frame you are on when you do this. When you delete all of the keys in a track, the new static value is taken from the curve at the current frame. Put the Time Slider at Frame 0 (or at least between Frames 0 and 50) to position the unanimated Box at the center of world space. Make sure that Track View stays open.

2. Press the red Animate button to activate it. Drag the Time Slider to Frame 100. Select the Box and move it 100 units in the positive world x-direction. Turn off the Animate button and take a look at Track View. A key was created in the Position track at Frame 100, but another one was also created at Frame 0. Switch to a Function Curve view in Track View to see the curve shown in Figure 19.13. Note the linear curve between a value of 0 at Frame 0 and a value of 100 at Frame 100. Before you even run the animation, you should be able to determine that the Box will move at a constant rate in the x-direction, without any acceleration or deceleration.

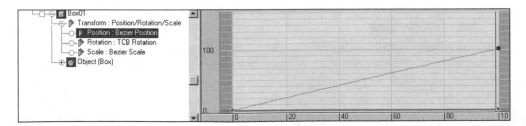

Figure 19.13
The function curve, created from keys set by using the Animate button. The unanimated Box was located at (0,0,0) in world space. The Animate button was turned on, and the Time Slider was set at Frame 100. Moving the box to (100,0,0) created keys at Frame 0 and Frame 100 to produce an animation.

3. Now that you have a very simple animation, what would happen if we moved the object with the Animate button off? Put the Time Slider at any Frame you want and move the object forward in the x-direction. What happens to the curve in Track

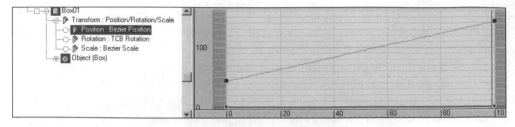

Figure 19.14

The function curve from Figure 19.13 after the object has been translated farther in the x-direction with the Animate button off. This translates the entire animation as a rigid unit to a new position in space.

View? As you can see from Figure 19.14, moving the object with the Animate button off has translated the entire animation, so that it starts and ends farther forward in the x-direction. Pull the Time Slider to confirm this result in the viewport. Try moving the Box again with the Time Slider on a different frame. As you'll see, the result is the same no matter which frame you are on—an important feature of MAX animation that comes up in many contexts.

4. Any animation can be rigidly translated or rotated in a scene as a single unit. This step clarifies exactly what the Animate button does. When the Animate button is on, only the value at the current frame is affected by any change. When it is off, all existing keys are affected together. Test this idea by moving the Time Slider to Frame 100. With the Animate button still off, translate the Box up in the world z-direction. The blue linear curve in Track view rises as a rigid unit, with both of its keys moving in parallel. Undo to return to z=0. Now, turn on the Animate button and translate the Box up in the z-direction. Notice that only a single key moves up in the function curve. Because there was already a key at this point, turning on the Animate button permitted you to change its value by moving the object. The same result can be achieved in just the opposite way by editing the key in Track View and watching the object move in the viewport.

Using The Track Bar

The Animate button is too simple and general a tool for much of your animation work, but Track View may sometimes present too complex an interface for basic key creation and editing. MAX 3 introduces some important new tools that provide a happy medium. You can now create keys by using a dialog box available from the Time Slider, and you can edit keys with the new Track Bar located immediately beneath the Time Slider. The following exercise introduces you to this new toolset.

Using The Create Key Dialog Box

Let's start the exercise by experimenting with the Create Key dialog box:

1. Create an animation of a Box using the settings shown in Figure 19.13. You can create the keys using the Animate button or, preferably, directly in Track View. The Box is animated only in its X Position transform, moving from the world origin to

(100,0,0) over 101 frames from Frame 0 to Frame 100. Make sure that Track View is open and displaying the function curve.

2. Drag the Time Slider to Frame 50 and make sure that the Box is selected. It's probably a good idea to lock your selection (by using the spacebar) to make sure that you don't lose it. When you create and edit keys in Track View, it doesn't matter whether the affected object is selected, but it does matter when using the new toolset. Right-click on the Time Slider to bring up the new Create Key dialog box. As you can see in Figure 19.15, the Source Time and Destination Time spinners both display the current frame. By default, all three of the transforms are checked (Position, Rotation, and Scale).

Create Key ? ☒

Source Time: 50

Destination Time: 50

OK

Cancel

☑ Position ☑ Rotation ☑ Scale

Figure 19.15
The new Create Key dialog box, reached by right-clicking on the Time Slider. The Source Time and Destination Time spinners both display the current frame. All three of the transforms are checked by default.

3. As you can deduce from the three checkboxes, you can set keys only for transforms—not for any other parameters from this dialog box. You want to create keys only for the Position transform, so uncheck the Rotation and Scale boxes. Press the OK button and take a look at your function curve in Track View. It should now look like Figure 19.16.

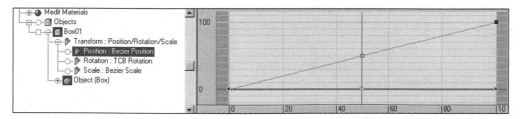

Figure 19.16
The function curve from Figure 19.13 with a Position key added by using the Source Time and Destination Time settings from Figure 19.16. The key is placed at Frame 50 because that is its Destination Time. It is placed exactly on the existing curve because it uses the value of its Source Time (also Frame 50).

4. As you can see from Figure 19.16, a key was added at Frame 50 by using a value of x=50. This did not change the shape of the curve at all. Make sure that you understand exactly what happened. The new key was placed at Frame 50 because the Destination Time was set to 50. The value of the new key is determined from the Source Time, which was also set to 50. Prior to the addition of the key, the value of the parameter at Frame 50 was x=50. Therefore, this value is used for the new key. Select the new key in Track View and delete it to try something different.

5. With only the two original keys remaining, bring up the Create Key dialog box. This time, use 0 as your Source Time and 60 as your Destination Time. Press OK and look at the function curve in Track View, as shown in Figure 19.17. You have created a new key at Frame 60 (the Destination Time). The value of that key was taken from Frame 0 (the Source Time). As a result, the new key at Frame 60 has a value of x=0. Note the spline interpolation that brings the curve below zero, causing the Box to move backward before it moves forward. You learned how to correct this with Bezier handles earlier in this chapter, but don't bother to do so here.

Figure 19.17
The function curve from Figure 19.13 with a Position key added using a Source Time of 0 and Destination Time of 60. The new key at Frame 60 uses the value of the parameter at Frame 0, effectively copying it to a new location on the graph. Note the spline interpolation that dips the curve below 0.

Editing From The Track Bar

Let's continue our exercise by moving on to explore the possibilities of the Track Bar:

6. Look at the thin horizontal window immediately beneath the Time Slider. This is the new Track Bar. You see the same circular key symbols that you'd find in an Edit Keys view in Track View, and they are used in much the same way. There are currently keys at 0, 60, and 100. Select the second key in the Track Bar and move it from Frame 60 to Frame 50. Check the result on your function curve in Track View.

7. Right-click on the second key in the Track Bar to bring up a tiny menu. At the top is the name of the animated parameter—Box 01: Position. If you don't get this option, be sure to right-click exactly on the key. Click on this option to bring up the same key-editing dialog box that you get when right-clicking on a key in Track View. You can use it to change the values for the keys, or their interpolation options, in the standard way.

8. There are two options for deleting keys. Make sure that the second key is selected and then right-click in the Track Bar, although not on a key. You'll get a stripped-down version of the menu. Try the Delete Selected Keys option to delete the second key. This is a good way to delete many keys at once.

9. With only two keys remaining, right-click directly on the last one (at Frame 100) without selecting it first. This time, the menu will allow you to delete the specific key by selecting the Delete Key option. Delete it to see that it works and then undo to get the key back.

10. Right-click anywhere in the Track Bar to bring up the menu and look at the Filter options. This is where you determine what keys are visible in the Track Bar. The options are All Keys, All Transform Keys, Current Transform, Object, and Material. Experiment with these filters. Your present Position keys will always remain visible when using All Keys and All Transform Keys, and they will always be hidden when using Object and Material. If you use the Current Transform option, they will be visible only if you are in Move mode. The Object filter displays keys set for the underlying parameters of an object or the parameters of its modifiers.

Ranges And Out-Of-Range Types

The *range* is a central and extremely useful concept in MAX animation. The animation of any parameter extends over a time range, which is generally specified in Frames. For example, all the animations you have been working with in this chapter occupy a range of 101 frames, from Frame 0 to Frame 100. The ranges are displayed as black bars in Track View and are adjustable so as to scale the animation or to move them.

Ranges are hierarchical. There are ranges for each animated parameter and ranges for the parents of related parameters. This setup permits you to scale or move related ranges as a unit by adjusting their common parent. But ranges are independent of the Active Time Segment, which is the unit of frames available to the Time Slider. This means that the Active Time Segment can be longer than the ranges within in it. At first, this may seem rather confusing, but, in fact, it is very important. The animation may be made to continue outside of its ranges using some very powerful controls.

The following exercise introduces all these tools and concepts.

Using Child And Parent Ranges

Let's begin the exercise by becoming familiar with different types of ranges:

1. Use the same viewport layout you've been using all along, with Track View above and a front view below. Create a Box and position it at the world origin. Using any method you want, create Position keys at Frames 0 and 50. The value at Frame 0 should be (0,0,0), and the value at Frame 100 should be (100,0,0). Thus, the Box should move 100 units in the world x-direction over 50 frames.

2. Look at the ranges in Track View using an Edit Keys view, as illustrated in Figure 19.18. The Edit Keys view shows only Parent ranges. There are black range bars at the Box level and at the Transform level. These are composite ranges of all the ranges beneath them. In this case, there is only one animated track, Position, with keys at 0 and 50. Thus, both of the Parent range bars extend from 0 to 50.

3. To understand the concept of Parent ranges, create keys in the Scale track at Frames 0 and 70. Set the x value of the key at 70 to 200, so that the Box both moves and "grows." As you can see in Figure 19.19, the Parent ranges now extend from Frame

Figure 19.18
An Edit Keys view of an animation created with two keys in the Position track. Only the Parent ranges are shown as range bars.

Figure 19.19
Keys are added to the Scale track at Frames 0 and 70. The Parent ranges expand to include the full extent of any of their Child ranges.

0 to Frame 70. In other words, they cover the full extent of any of their Child ranges. The value of this system is obvious if you move the end of either of the Parent range bars. Notice how all the keys in the Child ranges scale together, allowing you to slow down or speed up animated tracks as a unit.

4. So, what if you wanted to scale only the Scale track by itself? Switch to an Edit Ranges view on the Track View toolbar. All of the keys disappear and all the Child tracks display their range bars. Drag the end of the Scale range back to Frame 50 so that both animated tracks have identical ranges. The Parent ranges will contract as well. See Figure 19.20.

Figure 19.20
Using an Edit Ranges view allows you to see all of the Child ranges, instead of their keys. Here, the Scale range is adjusted to end at 50, the same as the Position range. Note that the Parent ranges contracted as well.

5. To get the full picture of the relationship between Child and Parent ranges, go back to an Edit Keys view and open the Object (Box) tracks. Create keys at Frames 0 and 80 for the Width parameter. Change back to an Edit Ranges view. Your Track View panel should look like Figure 19.21. Start adjusting the lengths of the ranges. Adjusting the length of the Box range at the top of the hierarchy scales all of its Child ranges. Adjusting the Transform range scales its children, the Position and Scale

Figure 19.21
Same as Figure 19.20, but with a range created for the Width parameter at the Object level using keys at Frames 0 and 80. Adjusting the Box range scales all of the Child ranges together. Adjusting the Transform range or the Object range scales only its respective Child ranges.

ranges. Adjusting the Object range scales only its child, the Width range. Adjusting the keyed ranges—Position, Scale, or Width—affects only its parents if it changes the end of those ranges. It takes a while to get used to these tools, but their flexibility is one of the reasons why Track View is so highly respected.

Out-Of-Range Parameters

Let's continue the exercise by working with out-of-range parameters:

6. In an Edit Keys view, delete the keys in the Width and Scale tracks, leaving only the Position track with an animated range. You can do this in the standard MAX way by dragging a rectangle around the desired keys to select them all at once, and then delete by using the Delete Keys button on the Track View toolbar. Your panel should again look as it did in Figure 19.18. Note that the keys extend only to Frame 50, but the light-gray region of the panel extends between Frames 0 and 100. This region is the Active Time Segment.

7. Open the Time Configuration dialog box using the Time Configuration button in the bottom-right corner of the MAX screen. As you can see in Figure 19.22, this panel permits you to set the frame rate of the animation and the time units used for display. It also determines playback speeds used when running animation in the viewports. The Real Time option drops frames, if necessary, to keep the display speed at frame rate. Focus, however, on the Animation section. The Active Time Segment is the unit of time beginning at the Start Time and ending with the End Time. Change these values and note the corresponding changes in the light-gray region in Track View. Note also how the Active Time Segment is indicated on the Time Slider. Once you have the idea, cancel out or otherwise return to an Active Time Segment of 0 to 100.

8. The Position range ends at 50. What happens after that? Switch to a Function Curves view and see, or look at Figure 19.23. The curve is a solid color during its range, from Frame 0 to Frame 50. After Frame 50, the curve continues as a dotted line, indicating that this is beyond the end of range of the keys. However, the out-of-range portion is every bit as important as the in-range portion. Pull the Time Slider or play the animation to see that the Box remains still from Frames 50 to 100.

Figure 19.22
The Time Configuration dialog box. The Start Time and End Time parameters determine the Active Time Segment.

Figure 19.23
A Function Curve view of Figure 19.18. The region within the range (from 0 to 50) is displayed as solid color with its keys. Beyond the end of the range, it becomes a dotted line.

9. This is no big surprise, of course, but why did it happen? Click on the button on the Track View toolbar titled Parameter Curve Out-Of-Range Types. You'll get the dialog box seen in Figure 19.24. These important options determine what happens when the animation extends outside of a range. Each option has two arrows: The left arrow applies the option to the frames prior to the beginning of a range, and the right arrow applies the option to the frames after the end of the range. For the most part, you'll rarely be creating ranges that don't begin at the start of the animation, so consider only the right arrow for now.

10. Note that the Constant out-of-range type is currently active. This means that the final value in the range is simply continued unchanged. Click on the right arrow under Loop and press the OK button. The function curve now shows the animation in the range being repeated after the end of the range, as illustrated in Figure 19.25. Run the animation to test this. Then, select the second key on the curve and move it around. Notice how the repeating pattern in the out-of-range region adjusts accordingly.

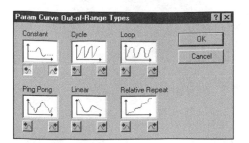

Figure 19.24

The Parameter Curve Out-Of-Range Types dialog box. These options control the shape of the function curve before and after the keyed range. The default out-of-range type is Constant.

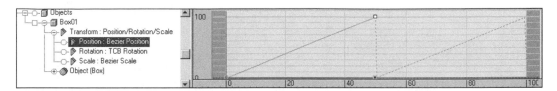

Figure 19.25

The function curve from Figure 19.23 with the outgoing out-of-range type changed from Constant to Loop. The animation in the range is repeated in the region beyond the end of the range.

11. Experiment with all of the other out-of-range types, particularly the Relative Repeat. A Loop repeats the exact animation in the range, always jumping back to the beginning. By contrast, Relative Repeat adjusts the repeat to begin where the previous unit left off. In our example, this means only that the Box just keeps going in the same direction. This is not a particularly valuable use, but Relative Repeat can be used to keep a character walking forward or climbing steps.

Moving On

In this chapter, you learned the essential tools of MAX animation—the features on which all your animation work will rest. You learned that animation is the variation of parameters over time, and how such variation is both described and controlled by function curves in Track View. You explored the basic toolsets for creating and editing keys, including Track View, the Animate button, and the new MAX 3 Track Bar. You learned about the use of ranges and how animation can be made to continue beyond the limits of its ranges.

The next chapter looks into the animation of the transforms—translation, rotation, and scale. You'll learn how the different animation controllers are used for each of these transforms, and you'll take a look at the special powers of inverse kinematics.

ANIMATING THE TRANSFORMS

Computer animation is a much more difficult subject, even at a basic level, than most people are prepared for when they first approach it. The tools and concepts are technical, even mathematical, but they are also powerful and exciting.

3D animation can be divided into two aspects. The first is the animation of an object's transforms. You move and rotate objects in space, but do not change their shape. This is the topic of this chapter. The second aspect of animation is the deformation of an object's geometry so that it changes shape during animation. The two subjects overlap in many important ways, and the animation of scale (although clearly a transform) could be understood as a kind of deformation. Deformation is covered in Chapter 21.

Transforms And Controllers

Controllers are pure MAX. Like modifiers and space warps, they implement concepts that are both central and unique to this very powerful application. Controllers are MAX's way of organizing the varied possibilities for animation. When you first begin animating, you may not be aware of the importance of choosing the right controller, but this choice is always a critical one.

Controllers apply to all animated parameters, not just to transforms. For other animated parameters, you'll typically stick with whatever default controller MAX offers. Not so with the transforms, or rather with position and rotation, because the animation of scale is a minor issue. The differences between the possible controller choices are drastic. For rotations in particular, the choice may mean the difference between having editable function curve control of your motion and not having it. Nor can you simply trust the defaults until you run into a problem. It's not always easy to change controllers in midstream.

People who work in building trades live by the rule that calls for the "right tool for the job." You can't drive a nail with a screwdriver or plane a board with a saw. So it is with MAX's animation controllers—but it's impossible to understand the relative strengths and weaknesses of the competing controllers without a good general exposure to all of them. Some animation problems absolutely demand a given controller. In other situations, the choice of controllers depends on personal preferences and work styles. In all cases, however, understanding the

animation process means understanding the underlying tools, and the most important animation tools are the controllers.

Animating Position

When animating translations, you have many controller choices—perhaps too many—but some of the controllers are far more important than others. The default Bezier Position controller and the Position XYZ controller are basically the same because they set positional values in space for selected moments in time and then interpolate between these positions. In contrast, the Path controller puts an object on a path defined by a previously created spline. You can control an object's speed and direction along the spline, but you cannot position it off of this path.

The Bezier Position And Position XYZ Controllers

The Bezier Position controller is poorly named. Although it correctly suggests that it uses Bezier splines as function curves to describe changes in position over time, this controller might be better called an "explicit XYZ" controller (a term used in Softimage) because its function curves store changing values in space (in x,y,z coordinates). When you create a key with the Bezier Position controller, you are storing the x,y,z location of the object at the indicated frame, and are therefore shaping the function curve.

The Position XYZ controller does precisely the same thing, so its name is therefore more apt. The difference between the two controllers is in their tracks. The Bezier Position controller has only a single track, with all three function curves within it. This means that whenever you set a key, it appears on all three graphs. This can produce a lot of meaningless keys. Take a look at the function curves in Figure 20.1. The object was only animated in the z-dimension. The x and y values remain constant. However, keys were automatically created on the x and y tracks.

Unnecessary keys can become very confusing when you edit the curves, but a bigger problem arises when you animate a different curve. Take a look at Figure 20.2. When one of the keys

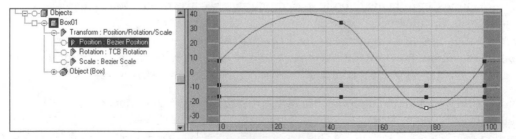

Figure 20.1
The function curves of an animated translation, using the Bezier Position controller. All the curves (x,y,z) are included in a single track, and all three curves are keyed together. The object is animated in only the z-dimension, but unnecessary keys were automatically created on the nonanimated curves.

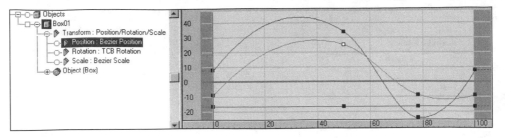

Figure 20.2
The curves from Figure 20.1, with a key added for the purpose of animating a second dimension (x). Any adjustments to the x graph are complicated by the presence of the other keys, which necessarily pin the graph to values. Instead of a single soft bend, the interpolation among all of the keys produces a complex wave.

is adjusted upward in value, all of the existing keys on the graph create all kinds of complications. The curve is pinned at undesired frames; instead of a single soft bend, we get wavy interpolations.

The answer here is editing. By adding a key and adjusting the values of a couple of existing keys, a curve can be created that follows the simple, intended path. The curve is unnecessarily complex, but is at least shaped correctly; see Figure 20.3. Another minor nightmare is moving keys in time. If you move a key to a new frame on any one graph, it moves all three keys together.

There are other problems to the single-track approach. With all three curves occupying the screen at once, it's often necessary to use the Filters dialog box to hide the ones you don't need to see. All the hiding and unhiding can quickly become tedious. Key selection can be difficult, especially when different curves lie right on top of each other. It's very easy to select unintended keys on multiple curves together.

The Position XYZ controller, by contrast, arranges the three curves on independent tracks. If you place a key on the x curve, it does not also appear on y and z. If you move a key in time, it changes only in a single dimension. Figure 20.4 shows the same animation as in Figure 20.1, but using the Position XYZ controller instead of Bezier Position. Note that the Position

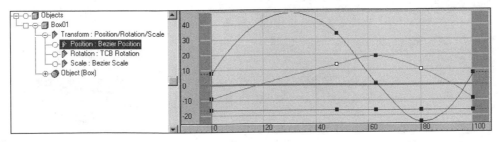

Figure 20.3
The curves from Figure 20.2, with a key added and the shape of the x curve adjusted. The resulting curve is the simple back-and-forth movement originally intended.

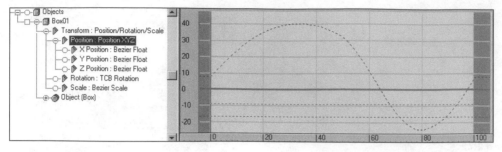

Figure 20.4

The animation from Figure 20.1, implemented by using the Position XYZ controller instead of Bezier Position. The Position XYZ track is the parent to three separate tracks: X Position, Y Position, and Z Position. The parent track is selected, and all three child curves are displayed together as dotted lines without keys.

XYZ track is the parent to three separate tracks: X Position, Y Position, and Z Position. In Figure 20.4, the Position XYZ (parent) track is selected, and all three curves are displayed together as dotted lines. This is for information only. No keys are displayed, and the curves cannot be edited.

The three individual tracks have their own controllers. Each one is of the Bezier Float type. This has nothing to do with floating. In computer programming, a *float* is a floating-point number—that is, a number that may contain decimal values (such as 37.9215 or –.0036). In contrast, an integer is a number without a decimal point—a whole number such as 598,825 or –3. Floating-point values are obviously essential for continuous motion. If your animation tools could only jump rigidly between whole number values, they wouldn't be very useful. Thus, the Bezier Float controller generates a single continuous Bezier spline.

Figure 20.5 shows the Z Position track with its keyframed function curve. These keys are independent to this track alone, and any edits made to this track—adding or deleting keys, moving keys in time or changing their values—have no impact on the other dimensions. If you looked at the other two tracks, you'd find no keys at all.

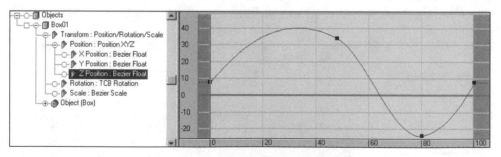

Figure 20.5

The Z Position track from Figure 20.4 is selected. Only a single function curve is displayed, and all keys in this track are completely independent of any keys placed in the X Position or Y Position tracks.

The downside of the Position XYZ controller is essentially the same as the upside. The independence of the tracks necessarily means jumping between them during editing. You can't see all three curves at once (with their keys) as you can with Bezier Position. In short, the Position XYZ controller can be more difficult to use than Bezier Position, where an object is being translated three dimensions at once, typically as the result of arbitrary movement from location to location. I find, however, that many animation tasks tend to involve translations that can be easily isolated into separate dimensions. A much stronger argument for the Bezier Position controller is that it permits you to use Trajectory keys, a process that you'll explore shortly. In the end, the decision to use one controller rather than the other turns on personal predilections as much as anything else.

CONVERTING EXISTING ANIMATION BETWEEN CONTROLLER TYPES

You can convert one controller to another, even after keys have been set. For example, you may have started out with the default Bezier Position controller and then discovered that things would be much easier with the separate tracks available in the Position XYZ controller. In my experience, conversion between such closely related controllers works reliably. Not all conversions work well, and many don't work at all because the nature of the two controllers may be fundamentally different.

Getting Started

The tools for animating explicit positions with either of the two controllers are remarkably powerful and flexible—I never stop discovering new possibilities in them. Once you develop a sense of how well integrated they are, you are in good position to establish your own working style.

The following exercise introduces you to most of the tools available in the Bezier Position and Position XYZ controllers. You'll start with the Position XYZ controller for clarity, and then move to the Bezier Position controller along the way:

1. Configure your viewports as you did in the previous chapter, as follows: Open the Viewport Configuration Panel from the Configure menu and go to the Layout Tab. Select the option in the middle of the top row of icons, with a smaller viewport above and a larger one below. Create a Sphere in the lower viewport (it doesn't matter where you put it for now). Open a Track View panel and fit it over the upper viewport. Open the tracks for the object and center them in the visible portion of the panel. Your viewports should resemble Figure 20.6.

2. You will animate the position (translation) of the Sphere. Before you set a single key, ask two questions: What controller is currently being used? What controller is the best choice? As mentioned in the previous chapter, MAX doesn't show you your controller types in Track View unless you ask it to in the Filters dialog box. Always choose to see your controller types. When you do, you'll see that the Bezier Position controller was applied by default. That answers the first question. You've already decided the answer to the second question for the purposes of this exercise—to change from the Bezier Position controller to the Position XYZ controller, click on the

Figure 20.6

A front view and Track View, set up to begin the present exercise.

Figure 20.7

The Assign Position Controller dialog box with its list of available controller types. The little arrow indicates that Bezier Position is the current controller. Bezier Position is also the default controller.

Assign Controller button on the Track View toolbar. The Assign Position Controller dialog box appears, as shown in Figure 20.7.

3. The dialog box contains a list of all of the controller types available for animating translations. Bezier Position is indicated as the current controller and also as the default controller. Select Position XYZ from the list. The Make Default button activates, allowing you to make this the default controller. Ignore this button and click on OK to change the controller.

Using The Motion Panel

You're all ready to animate with the new controller. Rather than using Track View or the Animate button to create keys, however, let's try a completely different approach by using the tools in the Motion panel. The Motion panel can get lost in the shuffle of animation tools. To some extent, it duplicates tools that are available elsewhere in the MAX interface, but these are well organized in a single panel to the right of the viewport, in a way that will often make them more convenient. Other tools are found only in the Motion panel, and these will be our focus here:

4. With the Sphere selected, click on the Motion tab on the Command panel (the one with the little wheel on it). The Motion panel is divided into the Parameters and Trajectories subpanels. When you first open the Motion panel, you'll be in the long Parameters subpanel. The topmost rollout is called the Assign Controller. Just as in Track View, you select a track in the little window and use the Assign Controller button to access the Assign Controller dialog box. There's nothing new here. The PRS Parameter rollout immediately below contains tools for creating and deleting keys at the current frame in the Time Slider for Position, Rotation, and Scale. These tools work very much like the new Track Bar tools discussed in Chapter 19. The final two rollouts provide precisely the same controls for individual keys as are found in the little dialog boxes that appear when you right-click on a key in Track View or the new Track Bar. In short, the Parameters subpanel provides an alternative route to existing tools. Figure 20.8 shows this very long subpanel in two pieces.

Figure 20.8
The Parameters subpanel of the Motion panel, seen in two parts.

Creating Trajectories From Splines

Your real business is the Trajectories subpanel. Before you go there, let's think about a different approach to animating translations that doesn't involve setting your own keyframes, at least to start. It often makes sense to draw a curve to represent the motion path of an object and then cause the object to follow that path. True path animation using the Path controller will be discussed later in this chapter, and will be contrasted with what you're doing here. Right now, you are concerned with continuing our exercise by simply setting Position XYZ keys, using a spline as a guide:

5. Draw a straight Line object across the length of your front view, below your Sphere. Use only two vertices and make sure that the Line is precisely level by setting both vertices to the same world z value. (Or, use Grid Snaps when drawing it in the first place.) Your front view should look something like Figure 20.9.

Figure 20.9

Setting up to create a straight Trajectory from a spline. A straight Line object (Bezier spline) is drawn in the front view below the Sphere from Figure 20.6.

6. Select the Sphere, go to the Motion panel, and press the Trajectories button. Stop right here and look at the object name at the top of the panel. It should be the name of the Sphere and not the name of the Line object. I stress this because it's very easy to create a Trajectory for the wrong object—I do it all the time. If you have the right object, start looking over this important subpanel, which is shown in Figure 20.10.

7. Two buttons—Convert From and Convert To—permit you to convert from a spline to a Trajectory and to convert to a spline from a Trajectory. Use the Convert From button because you want to convert the existing spline object into a Trajectory for the Sphere. This is accomplished by sampling along the curve—that is, by picking points along the spline and using them as the locations for keyframes. Look at the Sample Range section of the panel. Here, you determine when you want the animation to start and end. Leave these values at Frames 0 and 100. Then, you must determine how many keys will be sampled along the curve. Use the default of 10.

Figure 20.10
The Trajectories subpanel of the Motion panel.

Click on the Convert From button and then click on the Line. Voila! The Sphere should have jumped onto the Line, and a blue dotted line indicates that an animated Trajectory has been created. Ten keys appear across the Track Bar. Your screen should resemble Figure 20.11. To see the Trajectory clearly, move your Line object out of the way, and notice that the Trajectory stays where it is. The spline was used only to create the keys. Once they are created, the spline has no continuing relation with the Sphere or its Trajectory.

Figure 20.11
The result of creating a Trajectory from the spline in Figure 20.9, using default parameters. The Sphere jumped down to the Line object, and a dotted blue line indicates its animated Trajectory. The Track Bar immediately below indicates 10 keys, set at equal time intervals.

8. Save your scene just as it is now, so that you can easily return to it as necessary. To figure out exactly what you have, go to an Edit Keys view in Track View and look at the keys in the three position tracks. Click on each one to determine what Frames they are on. You might have expected that, by using 10 samples over 100, keys would have been created at 10-frame intervals. But because the keys must begin on the first frame and end on the last, the frames are placed at 11-frame intervals. The last frame is automatically rounded up from 99 to 100.

9. The spline-conversion method places keys in all three dimensions, as it must because the motion path might need to move in all three. In this case, the object is moving only in the x-direction. Should you delete the unnecessary keys? That depends on where you want to go from here. As discussed earlier, if you're going to animate only in one dimension or need the freedom to manage each dimension separately, you may want to delete the unnecessary keys. To delete, drag a selection rectangle around all of the Y Position and Z Position keys in Track View and press the Delete button in the Track View toolbar. Switch to a Function Curves view and look at each one of the curves. Only the X Position curve should have keys. Now that you know how to delete these keys, let's back up and try to work with them. Undo (or reload the saved scene) to get back the keys on all three tracks.

Adding An Acceleration

The essence of the skilled animator is the ability to control timing and acceleration. Although you really don't need 10 keys to make the Sphere move in a straight line (two keys are enough), use these keys to cause the object to accelerate along the path. Look at a Function Curves view of your X Position track, as shown in Figure 20.12. Unlike an Edit Keys view (or the Track Bar), the curve directly illustrates both the time location of the keys and their values in the x-dimension. You already know that the keys are equally spaced in time, and the graph shows that they are equally spaced in distance. In other words, between every two adjacent keys, the Sphere moves the same distance in the same amount of time. The curve is a straight line and the Sphere is moving at a constant speed from start to finish. You can confirm this by playing the animation.

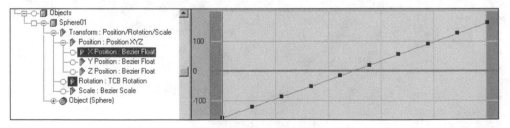

Figure 20.12
The X Position curve directly illustrates both the time location of the keys and their x-dimension values. The object is translated an equal distance in space for each equal distance in time. It moves at a constant speed, and its function curve is a straight line.

10. To make the Sphere move faster, you could bunch the keys closer together so they move the prescribed distance in a shorter amount of time. Before you start moving anything, however, think about the keys for the Y and Z Position tracks. Things can get very confusing indeed if these do not remain aligned with the X Position keys. One way to make sure that they all move together is to switch to an Edit Keys view and select a column of three keys together when moving. A new and powerful way to do so uses the new Track Bar. Each key that you see on your Track Bar is actually all three keys located at that frame. As you drag a key, all three move together as a grouped unit. (To move only one of the three, right-click on the key and select the track you want from the menu.) Move all of these keys until they bunch increasingly together toward the end of the animation. This takes some practice to get right. Use the function curve as a guide. An acceleration is described by a curve with a constantly increasing slope. When you finish, your screen should look something like Figure 20.13. Note how the Trajectory indicates the distance covered between frames. The distances get longer toward the right. This is a fantastic way to read the timing without running the animation.

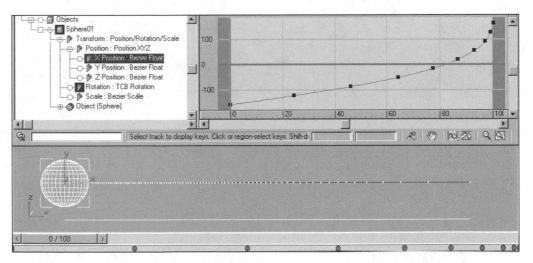

Figure 20.13
The keys are dragged in the Track Bar to create an acceleration. Because the distance values between the keys are constant, bunching them closer in time causes the object to move faster. The function curve now has a constantly increasing slope. Note how the Trajectory indicates the distance covered between frames. The distances grow longer toward the right.

Using Trajectory Keys

Trajectory keys allow you to edit the animation directly on the motion path. You can add this useful tool to your skillset by continuing our exercise as follows:

11. Reload the saved scene to return to the original, unaccelerated animation. You just accelerated the animation by moving the keys in time. A different approach is to move the keys in space. MAX allows you to view and edit the keys directly on the

Trajectory, but where are these keys? Trajectory keys don't make sense if you use the Position XYZ controller, because each key must represent a complete position in x-, y-, and z-dimensions at once. Therefore, Trajectory keys are available only when the Bezier Position controller is used. You can change controllers from the Assign Controller buttons in Track View or the Motion Panel, but you can also use the Collapse Transform section at the end of the Trajectories subpanel. Check only the Position box and press the Collapse button. The controller changes to Bezier Position, and the keys on the Trajectory appear, as shown in Figure 20.14.

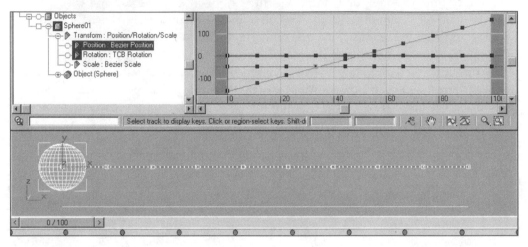

Figure 20.14
After converting from the Position XYZ controller to the Bezier Position controller, Trajectory keys appear.

12. Save this scene so that you can return to it, as necessary. You can now try to achieve the same acceleration as before, but by moving the keys in space rather than in time. Press the Sub-Object button in the Motion panel to get access to the Trajectory keys. As you click on a key on the Trajectory, notice that the corresponding key is highlighted in Track View and in the Track Bar. As you move the keys in the x-direction (along the path), the corresponding keys in the Track Bar do not move. You are changing their values in the x-dimension without changing their positions in time. This idea definitely takes some time to get comfortable with. In which direction should the keys be bunched? Think about it. They remain at equal intervals in time, and the Sphere moves faster if it covers more distance within a given time interval. Thus, the Trajectory keys must be spread farther apart as the Sphere moves along the path. Adjust the Trajectory keys to get a smooth acceleration. Use the shape of the x-dimension function curve as a guide. Note how moving the Trajectory keys stretches out or compresses the frames, as displayed on the Trajectory itself. When you finish, your screen will look something like Figure 20.15.

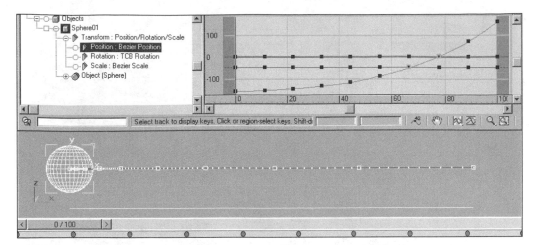

Figure 20.15
To create an acceleration, the Trajectory keys are positioned so that the distances between keys increase toward the right. As you can see in the Track Bar, the keys remain at equal distances in time, and the Sphere accelerates as it covers more ground between keys. Note the accelerated shape of the x-dimension function curve in Track View.

A Bouncing Ball

You are now in a position to put a lot of things together. The idea is to learn to see the interdependence of all of the tools, so that you can develop a style that is suited to your own inclinations. As you continue this exercise to create a bouncing ball, take time to explore for yourself:

13. You can start with the accelerated Sphere or reload the unaccelerated one. Although you can just start moving the Trajectory keys to create peaks and valleys, make things easier by deleting most of the keys first. Do this by selecting them on the Trajectory and pressing the Delete Key button in the Motion panel. Delete all but the first three keys and the final one at Frame 100. The first key is the highest point of the path, the second key is at the ground, and the third is back up, although slightly lower than the first. You can use your Line object as a guide for the bottom of the bounce. It's not really the floor level, because the Sphere's pivot point is positioned at the center of the object (rather than at the bottom), and the pivot point is what follows the Trajectory. Your screen should look like Figure 20.16.

14. Take a good, long look at your screen or at Figure 20.16 to see what's right and what's wrong with it. A couple of things are obviously wrong. The Trajectory continues upward in a long arc after the third key, to finally arrive at the last one. This is inherent in the default spline interpolation between keys that was already discussed. You can see the same problem in the shape of the z function curve in the Track View panel. Also wrong is the rounded path around the second key, where the ball hits the ground, which is also due to spline interpolation (on the other hand, that same rounding is perfect for the top of the bounce). And take a good look at the timing.

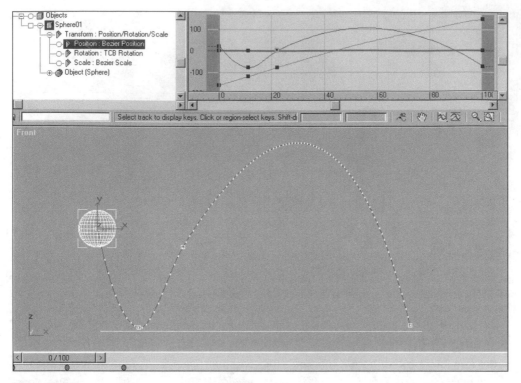

Figure 20.16

After deleting all but the first three keys and the last one, a single bounce is created by moving the Trajectory keys into position. Note the rounded path through all of the keys, and the accelerations and decelerations indicated by the compression of the frame ticks on the Trajectory.

Notice how the ball decelerates into a curve and accelerates as its path straightens out. You can see this in the relative compression of the frame ticks in the Trajectory. They are much closer together around a curve and are wider apart elsewhere. Play the animation to check the accelerations and decelerations, and try to see how they correspond to the shape of the z function curve and to the spacing of the frame ticks on the Trajectory. These are the basic skills of the MAX animator, which take considerable effort and innumerable hours to polish.

15. Correct the actual bounce first. When a ball falls toward the ground, it accelerates until impact, and then it immediately changes direction. To create this discontinuity, you must break the spline interpolation. Select all of the keys in the animation in Track View and right-click. The dialog box for the multiple key selection is blank, but click on one of the two boxes at the bottom and choose the Bezier handle option at the bottom of the menu. Although you need them for all of these keys, you also need to unlock the handles for the keys at the floor level. Choose the second key. Bring up its dialog box and use the Advanced button to unlock the handles for the z curve, as you learned to do in the previous chapter. Clean up your Track View by hiding the x and y curves with the Filters dialog box.

16. Adjust the handles for the first two keys on the z curve to get the correct shape and timing. Notice that the shape of the Trajectory changes as you change the shape of the function curve. You need a sharp v-shaped discontinuity through the second key and a nice clean drop from the first key. Play with the Bezier handles until you get the correct acceleration. The ball should speed up as it approaches the ground. Use the frame ticks on the Trajectory to assess this—they should spread out as the ball moves downward. On the other side of the second key, do your best to duplicate the same path and acceleration, only in reverse. You can only go so far with this because the interpolation through the remainder of the spline interferes. Take time to develop a feeling of the way that the function curves control the shape and timing of the Trajectory. When you finish, your animation should look similar to Figure 20.17.

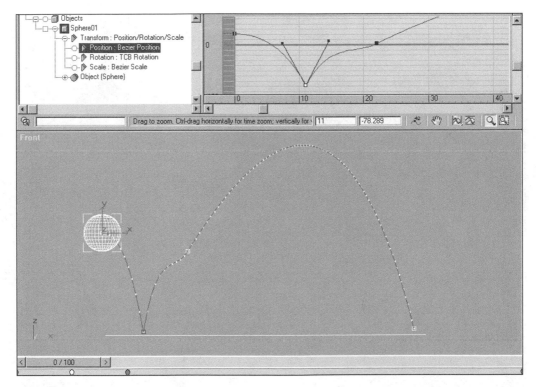

Figure 20.17
Editing the start of the z function curve with Bezier handles changes the shape and timing of the Trajectory. The Bezier handles on the second key were unlocked to create a sudden discontinuity in the Trajectory where the ball hits the floor. Adjustment of the shape of the function curves has also produced an acceleration as the ball falls toward the floor and a deceleration as it rises after the bounce. The shape of the curve between the second and third keys is complicated by the interpolation of the remainder of the spline.

17. Add more keys directly to the Trajectory. Make sure that you're in Sub-Object mode in the Motion panel. Press the Add Key button to activate it and then click on the Trajectory a little way past the third key. Add another key somewhat further on, and then deactivate the Add Key button by clicking on it again.

18. Move these keys into position to describe a second bounce. The curve will probably behave wildly because of the spline interpolation, but you can tame it quickly. There's a lot to do. First, level out the locked Bezier handles on the third key. Then, adjust the outgoing handle on the previous key to create a clean, rounded path between the two keys. Move on to the fourth key. Display its Bezier handles and unlock them as you did previously. Adjust the handles to fashion a sharp bounce. The next key is probably OK as is. There's no need to display its Bezier handles. Set the z values for the two keys at the "floor" to precisely the same amount. You can do this in all the usual ways, but also by right-clicking on the Trajectory key and choosing Key Info from the menu. Your screen should now look something like Figure 20.18.

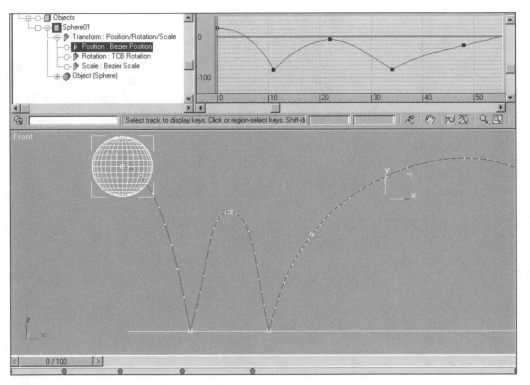

Figure 20.18
Two more keys are added to the animation from Figure 20.17 and adjusted to fashion the second bounce. The locked Bezier handles at the third key are positioned horizontally to create a smooth and equal interpolation into and out of the key. The fourth key's Bezier handles are unlocked and adjusted similarly to those for the second key to create a sharp discontinuity.

19. Add some more keys further down the Trajectory and make all the adjustments that you've learned thus far. Display and unlock the Bezier handles on the "floor" keys and adjust them. You also need to display the handles on the keys at the top of the arc. See how making these handles horizontal keeps the key at the very top of the

interpolation curve. You'll generally need to level these handles out before you can work effectively with the "floor" vertices.

20. Pay attention to the x distance between bounces. Just as each successive bounce should be smaller in z, so should each cover a shorter horizontal distance. The ball is losing energy as it bounces. As you position the keys in the x-dimension, you'll no doubt need to rework your spline interpolation using the Bezier handles. Take some time with this process. Your screen should end up looking something like Figure 20.19.

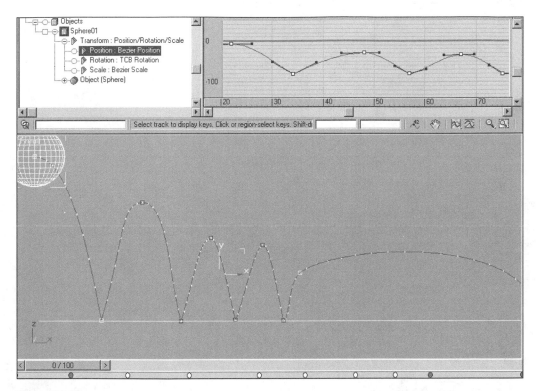

Figure 20.19
More keys are added and positioned for additional smaller bounces. Locked Bezier handles on the upper keys are made horizontal to position the key at the very top of the arc. Unlocked handles on the lower vertices are used to create sudden changes of direction (discontinuity). The horizontal (x) distance between successive bounces has been decreased, reflecting the loss of energy as the ball bounces along.

21. From here on, you've got a lot of serious balancing to do. Add as many further keys as you wish to finish the remaining bounces. Timing should now become an important issue. For one thing, you should have about the same number of frames on each side of the key at the top of each arc. If there are seven frames going up, there should be about seven going down. This involves moving the keys in time. The most effective way to adjust the key location is with the Time spinner in any of the dialog boxes that provide key information. As you increment or decrement the frame number, watch the number of frame ticks change on the adjacent segments of the

Trajectory. This is a fantastic way of getting precise timing. Play the animation often to test the timing. You need to make a lot of Bezier handle adjustments at all stages. A special consideration is getting your x-direction movement correct. Unhide the x function curve and try to get this curve into a fairly straight line by adjusting values and Bezier tangent handles. Take your time and learn, because there's a lot going on here, even with such a "simple" project. Try to get your result to look something close to (or even better than) Figure 20.20. The purpose is not to make the perfect bouncing ball; it is to learn the complex interaction of function curves, Trajectories, and keys.

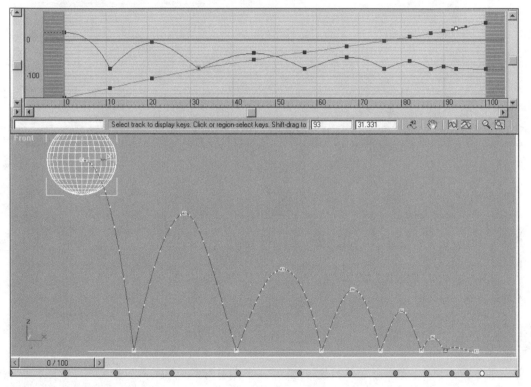

Figure 20.20
The finished bounce Trajectory requires a great deal of careful balancing. Note that the timing of the bounces is equalized—the number of frames on each side of an apex is the same or very close to it. The x-dimension function curve is adjusted into a fairly straight line.

The Path Controller

The Path controller implements what is generally called *path animation* in computer graphics. The path in space that an object will follow is defined first, with a spline. Then, the object is put to the path and follows it over the course of the animation. Any changes made to the underlying spline are automatically reflected in the path animation. Path animation is extremely important because an animation is often most easily understood as a motion path.

A jet fighter in flight and a racing car moving around a track are only the most obvious examples. A camera is often best animated by putting it to a predefined path.

The 3D animator is often faced with the choice between explicit XYZ animation (using the Bezier Position or Position XYZ controller) and path animation (using the Path controller). The choice can be a difficult one, so it's important to understand the differences between these two approaches. When using the Bezier Position or Position XYZ controllers, you create function curves that determine the locations of objects in 3D space over a period of time. The keys that you set designate values in x, y, and z. In contrast, when you use a Path controller, you create a function curve that defines the motion of an object along a previously defined path. The shape of the function curve controls the speed and direction of the object along the path; in setting a key, you fix the object's percentage distance along the path at the specified frame. Nothing that you can do in a Path controller can move the object to a location that is not on the path.

Someone once called the Path controller a "gas pedal," and I like this metaphor. With the Path controller, you can speed up or slow down with ease. The metaphor, however, must be expanded to include the brakes, and the forward and reverse gears, because you can both stop and go backwards on the path, if desired. As a general proposition, the Path controller is preferable to an explicit xyz controller when the motion path of an object can be defined in advance and control or speed and timing is more important than control over location. For example, the Path controller would make no sense in the bouncing ball exercise in the previous section, because you need to constantly edit the location of the object over the course of the animation.

SPLINE CONVERSION VS. PATH ANIMATION

In the previous section, you saw how the spline-conversion tools in the Motion panel can be used to translate an object along a previously existing spline when using the Bezier Position and Position XYZ controllers. How does this differ from path animation using a Path controller?

The spline-conversion method places explicit x,y,z position keys along the spline. It simply samples along the length of the spline to find positions in space. After this is done, the animation has no continuing relationship with the spline. You can move or delete the spline without affecting the animation. In other words, the spline is used as a template for placing points in space. If the spline has lots of subtle curvature and an insufficient number of samples are used, the motion path will not follow the spline accurately. In contrast, the Path controller locks the object exactly to the spline. The animation follows the spline exactly, and any changes to the spline affect the animation.

Spline conversion for the explicit xyz controllers is often preferable to path animation. You may have a good general idea of an object's motion path, but you need the precise location control that you get from the Bezier Position and Position XYZ controllers. Far too few people are familiar with MAX's spline-conversion powers.

The following exercise introduces you to most of the important aspects of the Path controller.

Putting An Object To A Path

You'll start this exercise with the basics: creating an object, drawing a spline path, and putting the object to the path:

1. Start with a fresh scene, using the Reset command in the File menu if necessary. Use the same two-viewport layout that you've used throughout this chapter (refer to Figure 20.6 for an example), but don't open Track View yet. The upper viewport will be a top view, and you need this top view to create the object.

2. A Cone object is good for understanding Path animation because it has a directional "nose" like an airplane. Create a small Cone by drawing its first radius in the top view. This will place it on the groundplane and orient it vertically. Pull it up and draw it to a point. It doesn't matter precisely where it's located because you'll be putting it to a path in any case.

3. Draw an Ellipse object in your front view. This will be the motion path, so make it large enough to fill much of the viewport. At this point, your viewports should look like Figure 20.21.

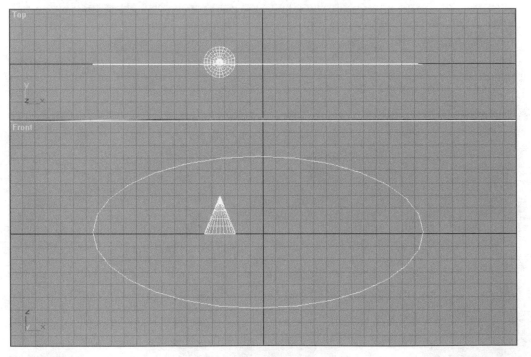

Figure 20.21
Setting up for the Path controller exercise. A Cone is created in a top view to orient it vertically, and an Ellipse (Bezier spline) is drawn as a motion path.

4. Open Track View to cover the upper viewport and open the Transform tracks for the Cone. If you're a step ahead of me, you've already used the Filters dialog box (from the Track View toolbar) to display your controller types. You see that your current controller in the Position track is not Path (it's almost certainly Bezier Position), so you're ready to change it by using the Assign Controller button. This will work, but let's do it in the Motion panel instead for practice. Make sure that the Cone (and not the Ellipse) is selected when you open the Motion panel.

5. Open the Assign Controller rollout at the top of the Motion panel and select the Position track. Press the button with the green triangle and select the Path controller from the list in the Assign Position Controller dialog box. Press OK to confirm and note that the word Path appears in the Position tracks in Track View and the Motion panel. But notice something striking: An animation range has suddenly appeared in Track View. Expand the Position track in Track View, and you'll see that keys were created in the Percent track at Frames 0 and 100. With the Percent track selected, switch to a Function Curves view, as shown in Figure 20.22.

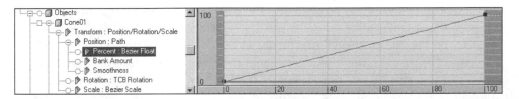

Figure 20.22
Converting the Position track to Path controller immediately produces a function curve.

6. Nothing has changed in the viewports, and if you pull the Time Slider, you'll see that nothing has been animated. The function curve for the Percent parameter shows the value increasing from 0 percent at the start to 100 percent at the end. The curve is a straight line, meaning that the parameter is increasing at a constant rate. The Percent parameter is the percentage of the distance along the path. Because you have not yet put the object to a path, this percentage has no meaning. To put the object to the path, look at the Path Parameters rollout that now appears in the Motion panel. Press the Pick Path button to activate it and then click on the Ellipse in the viewport. The Cone will jump to a point on the Ellipse.

7. The cone points straight up, just as it did before putting it to the path. Play the animation or just pull the Time Slider to see the motion. The pivot point of the object follows the path, and the Cone does not rotate at all. Figure 20.23 uses the Snapshot tool in the MAX Main Toolbar to illustrate the Cone at a number of positions on the path.

Returning To The Spline

The Cone jumped to the spot it did because that point was the start point (first vertex) of the Ellipse. Remember that the Ellipse is just a Bezier spline and can be edited in the same way as a spline drawn using the Line object. See what happens when you edit the Ellipse:

Figure 20.23

After the Cone is put to the path, it follows a circuit around the Ellipse. The pivot point of the object, presently at the base of the Cone, is placed directly on the path. The Cone was not rotated from its original orientation when it was put to the path, and it does not rotate as it follows the path.

8. To edit the Ellipse, select it and go to the Modify panel. You can simply convert the object to an Editable Spline using the Edit Stack button, but place an Edit Spline modifier on the stack instead. Go to the Vertex Sub-Object level and select one of the vertices on the spline other than the present first vertex (where the animation began). The first vertex is distinguished from the others by a tiny square icon. After another vertex is selected, press the Make First button in the Geometry rollout. The animation now begins at the new location.

> *Note: The first vertex position is only an issue with closed splines. When an open spline is used, the end points are obviously a given. The Make First button can then be used only to switch the first vertex (the start point) from one end to the other, which is the same thing as reversing the spline at the Spline Sub-Object level. If you do this, the path animation proceeds in the opposite direction.*

9. Undo or otherwise change the first vertex back to its original location. Edit a vertex or two to change the shape of the spline. For example, tilt some Bezier handles. Pull the Time Slider to see how the animation follows the revised path. Undo back to the original shape and delete the Edit Spline modifier. Move and rotate the Ellipse, noting how the Cone translates with it. It doesn't change its orientation with the spline, however, as you can see in Figure 20.24.

Aligning Rotations To The Path

Most objects that are put to a path need to rotate as they move. Your Cone looks funny because it doesn't appear to be following its nose around the path. To align an object's rotation to a curved path means keeping a local coordinate axis of the object constantly aligned with the changing tangent to the curve. MAX permits such alignment using the Follow checkbox in the Motion panel. Apply this tool to your Cone as follows:

Figure 20.24
If the spline is moved or rotated, the Cone translates to stay on the path, but it doesn't change its orientation with the spline.

10. Undo from the last step in this exercise to eliminate any translation or rotation of the Ellipse. Select the Cone (not the Ellipse) and change to its local coordinate system in the Main Toolbar. The local z-axis should be pointing vertically though the Cone, from base to tip. This axis is the one to be aligned with the path.

11. Look in the Path Parameters rollout in the Motion panel for the Follow checkbox. Check this box. The default alignment axis is x, which is wrong for the Cone, so change it to z in the Axis section at the bottom of the rollout. (Note the Flip checkbox, which reverses the direction of the selected axis.) Pull the Time Slider to see that the Cone now rotates to remain aligned to the path. But there's something wrong. As you can see in Figure 20.25, the nose of the Cone is not on the path.

Figure 20.25
The local z-axis of the Cone is aligned to the path by using the Follow checkbox in the Motion panel, but the nose of the Cone is not on the path. This is a Snapshot view of the animation.

12. To correct this, you'll need to move the pivot point to the very tip of the Cone. Click on the Hierarchy tab on the Command Panel to get the Pivot tools. Press the button to Affect Pivot Only and try and move the pivot point. It won't move because it's locked to its position on the path. Switch to Affect Object Only and move the Cone such that its tip is exactly on the pivot point, and therefore on the curve. You'll probably have to zoom in to get it right. Click on the Affect Object Only button again to deactivate it. Test the animation. As you can see in Figure 20.26, the Cone is now properly aligned to the path.

Figure 20.26
Same as Figure 20.25, but with the pivot point located at the tip of the cone. As the pivot point stays on the curve, the object is now properly aligned to the path.

ALIGNMENT TO A MOTION PATH IS NOT LIMITED TO THE PATH CONTROLLER

You can do the kind of rotational alignment you do with the Follow command in the Path controller with a motion path that was created using the Bezier Position or Position XYZ controllers. Find the Follow/Bank utility under the Utilities tab in the Command panel (you'll need to use the More button). Unlike the Path controller, however, this tool creates explicit keys in rotation tracks. You must determine how many samples along the motion path you'll need to set a reasonable number of keys. Winding paths will need more samples to capture all the rotations. Many users assume that they must use a Path controller if they need rotational alignments, but this is not so. I'm not sure why such an important tool has been buried so deeply in the interface.

Adjusting Rotations

Rotations are covered in the "Animating Rotations" section later in this chapter, but let's look now at their effect on path animation. A quick glance at Track View confirms that there is no animation range in the Rotation track. Yet the Cone is constantly rotating, which means that the basic alignment rotation for the Path controller is applied beneath any direct rotations. The alignment rotation becomes a baseline against any direct rotations. You can see how rotations can be applied to cause the cone to tail out as it moves into a tight bend:

13. Before you can add rotations, you have to consider your controller. As you can see in Track View or the Motion panel, the current rotation controller is TCB Rotation. As you will see later in this chapter, this controller does not display a function curve. Although it could be used for your simple purposes here, it's important to work with function curves wherever possible, so change the rotation controller to Euler XYZ.

14. Select the Cone, if it's not already selected. In local coordinates (or in world coordinates, for that matter) you can see that the y-axis is the right one for creating a tail-out rotation. Expand the Euler XYZ track in Track View and create two keys in the Y Rotation track—one at Frame 0 and one at Frame 100—to bookend the animation. Switch to a Function Curves view, if you're not already using it. The function curve is a straight line with a constant value of zero.

15. Think carefully about where the keys belong in time. You need three of them: at the moment where the tail-out rotation begins, where it reaches its maximum, and where it ends. Drag the Time Slider to identify these three points around the bend opposite the start point and create keys for them on the function curve. They will be located where the Cone begins to enter the bend, at the apex of the bend, and where it leaves the bend. The exact positions are not important.

16. Place the Time Slider at the point where the Cone goes through the apex of the bend. Drag the key that was placed at this frame up to a value of about 20 degrees. Watch how the Cone rotates to create the tail-out effect. But look at the graph—spline interpolation has animated the rotation all along the curve. Take a look at Figure 20.27.

17. Before you correct the interpolation, take a look at another problem. Pull the Time Slider slowly around the bend, moving frame by frame if necessary. The first thing you may notice is a funny rotational twitch in the Cone on the frame on which it reaches the apex. If this occurs, just ignore it. It's due to a bug, and is unnoticeable when running the animation at true frame rate. Something else is not a bug, however. Notice that the Cone flips its rotational direction as it passes through the bend. The Cone was rotated 20 degrees outside the Ellipse path, but it jumps to 20 degrees inside after passing the apex. The meaning of the rotation angle changes with the direction of the spline.

18. To fix this, you need to make the rotation change from 20 degrees to –20 degrees as it passes through the apex. Create a key on the frame immediately next to the key currently at the apex of the curve. (It doesn't matter whether you place the new key before or after the key currently at the apex.) Set the first of these two keys to exactly 20 degrees. Set the second one to –20 degrees. The default spline interpolation results in some very extreme-looking curves. Select the first of the two adjacent keys and change its interpolation by using the right-click dialog box (Cone01/Y Rotation). Go to the Out interpolation options and, in the drop-down list of icons, choose the third one from the top—the one with the square interpolation lines. This option, which keeps an interpolation at a constant value until the next key is reached, is

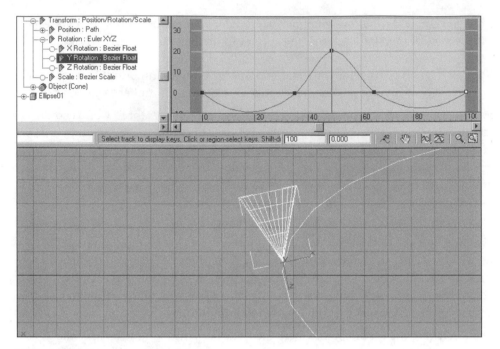

Figure 20.27
The key set at the apex of the bend is adjusted to a value of 20 degrees. The tail-out rotation in the viewport looks fine, but spline interpolation has caused the function curve to bend outside of the intended region.

used for sudden changes in value. Check your graph to see that the interpolation problem is fixed and run the animation to see whether the Cone is now rotating properly. If it is, go on and use the same interpolation option on the keys at Frame 0 (Out) and Frame 100 (In). This is a great way to create linear segments between keys with identical values, without having to deal with Bezier handles. Use Figure 20.28 for reference. Note that the function curve is flat at the beginning and end and that it jumps suddenly between Frames 49 and 50. The key at Frame 49 is selected; note the Out interpolation in its dialog box. Finally, note that the Time Slider is set to Frame 54 on the outbound side of the bend and that the Cone is rotated correctly. This is careful, tedious work—in other words, it's real 3D animation practice.

Controlling Speed

You have the Cone rotating nicely along its path, but there's still the issue of its velocity. Let's finish this exercise by exploring the ways in which the object's speed can be modified:

19. You should be able to see the object slowing down into the bends from just playing the animation. To understand things better, select the Cone, if necessary, and click on the Trajectories button in the Motion panel. You can now see the frame ticks, as shown in Figure 20.29. (You'll probably want to hide the Ellipse to see the Trajectory better.) Note that the frames get compressed through the bends, which slows down

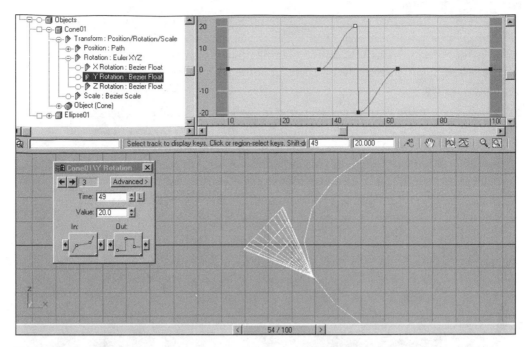

Figure 20.28

Final rotation adjustments are made. The rotation switches suddenly from 20 degrees to –20 degrees as the Cone passes the apex of the curve. This counters the flipping of rotational direction as the Ellipse spline changes direction. Note the Out interpolation option, used for the selected key. The Cone now remains rotated to the outside of the Ellipse after it passes the apex of the bend.

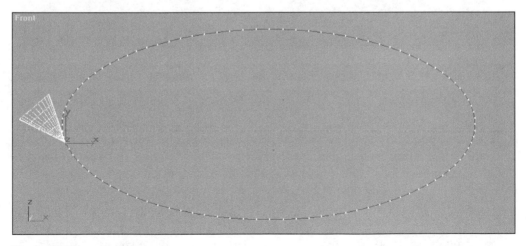

Figure 20.29

A Trajectory view shows how the Cone's velocity slows down into the bends and speeds up out of them. The frame ticks are compressed through the bends.

the velocity. You already saw the same thing earlier in this chapter in the bouncing ball exercise, using the Bezier Position controller. But it's rather strange here, if you think about it. It's as if MAX uses an elastic ruler to measure percentage. The distance covered by increments of 1 percent of the path differs, depending where you are on the path.

20. Switch back to the Parameters subpanel in the Motion panel and check the Constant Velocity box in the Path Parameters rollout. Go back again to Trajectories to see the frame ticks. As you can see in Figure 20.30, the frames are now spaced evenly in distance. Try playing the animation and jump back and forth between the default acceleration and Constant Velocity. Can you see the difference? It takes a lot of practice to read motion from a computer monitor. The default acceleration is clearly more appropriate, so uncheck the Constant Velocity box before continuing.

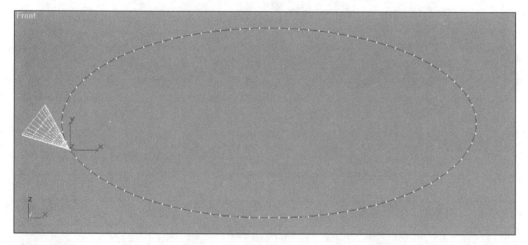

Figure 20.30
Same as Figure 20.29, but with the Constant Velocity option used in place of the default acceleration. The distance covered between frames is equal (disregarding minor flaws in the display), and the Cone does not accelerate and decelerate around bends.

21. The most important control over velocity (and direction) is the Percent function curve in the Path controller. Open this function curve in Track View and add a key at Frame 30, right on the curve. Add a second one at Frame 40. You will make the Cone slow to a stop at Frame 30, stay still for 10 Frames, and then accelerate away. Change the value of the key at Frame 40 to 30 percent. This is the same distance along the path as at Frame 30. The function curve should look pretty good. It rises and then flattens out through Frame 30. After Frame 40, it accelerates again, but if you move the Time Slider slowly, you'll see some small irritating wavering during the time that the Cone should be stopped. This is a tiny amount of spline interpolation, too small to be visible on the graph. Change the interpolation between the keys as you did in Step 18 to get a perfectly linear segment. Check the animation again. It should be completely still during the linear segment. Your function curve should look like Figure 20.31.

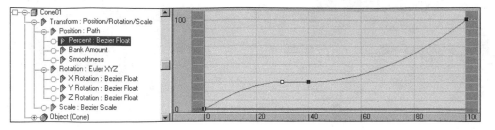

Figure 20.31
The Cone is made to slow down, stop for 10 frames, and accelerate again. The interpolation during the stopped segment is made perfectly linear to eliminate a slight wavering.

22. If you examine things carefully, you'll find new problems. The rotations that you set for the tail-out are now incorrect, and the object is no longer going through the bend at the same frames as it was before. This is easy to fix in Track View. Pull the Time Slider to find the frame that is now at the apex of the curve. In the Y Rotation track in Track View, select the four keys that comprise the rotation and move them so that the second key in this group is set directly on the current frame. Use Figure 20.32 as a guide. Run the animation to see that it's working.

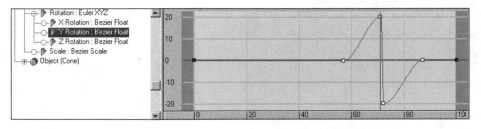

Figure 20.32
The tail-out rotation is moved to its proper location. The stop that was added in Figure 20.31 changed the time at which the Cone passed through the bend. Compare with the graph in Figure 20.28.

23. Try adjusting the Percent function curve to bend downward and make the Cone move backward, either by moving keys or by adjusting Bezier handles. This helps you to understand the meaning of this function curve as it controls both velocity and direction. Any changes you make here require another adjustment of the tail-out rotation, as you did in the previous step. Figure 20.33 shows a simple adjustment to make the Cone drift back and forth, instead of stopping.

Other Position Controllers

The remaining position controllers are much less important in everyday use than Bezier Position, Position XYZ, and Path. Some are more significant than others, however, and deserve a brief introduction.

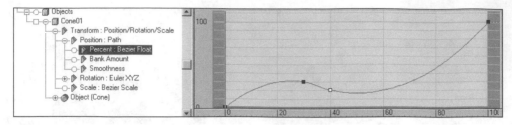

Figure 20.33
The Percent curve is adjusted to cause the Cone to drift backward and forward on the path.

Position Expression And Position Script

Much sophisticated animation is not created by using keys to shape a function curve. A considerable range of motion can be more accurately and flexibly specified in programming code. Expressions are relatively simple units of code that can be constructed by people with no prior programming experience at all. Expressions are used in Expression controllers, of which Position Expression is the one dedicated to position animation. MAXScript is a much more complex coding language than that used in expressions, and it is much more powerful. The use of code to control animations will be discussed in Chapter 22.

List Position And Noise Position

The List controller is available in Position, Rotation, and Scale versions. It allows you to group multiple controllers together. Extremely sophisticated results are possible in this manner, but the most common use of List controllers is to add noise to an existing transform with a Noise controller.

The Noise controller need not be an element of a List Controller, but is rarely used by itself. Instead, you'll typically have an object on a motion path that requires periodic rattling or vibration. When you assign a List Position controller to a position track, it automatically includes whatever position controller was already there. For example, if you've already created keys in a Bezier Position controller, you won't lose them. The Bezier Position controller with all of its keys intact becomes the first item in the list, as illustrated in Figure 20.34.

Figure 20.34
A motion path was already created using the Bezier Position controller. To add Noise, the controller is converted to a List Controller. The Bezier Position track is included as the first item in the list—its keys are unaffected.

The track named Available can then be assigned a Noise Position controller. A new Available track then appears to add other controllers to the list, if desired. The Noise Position controller is keyed in its Noise Strength track. This track uses a Bezier Point3 controller, meaning that it contains x,y,z function curves in a single track, just like the Bezier Position controller. By default, all three curves have a constant value of 50. That means that the object will move randomly in all three dimensions to a maximum of 50 units. You can apply noise differently in different dimensions if you want. For example, Figure 20.35 shows noise added only in the z-dimension. The Noise Strength function curve for z rises quickly from zero to 100 units and then tails off. The x and y curves hold a constant value of zero.

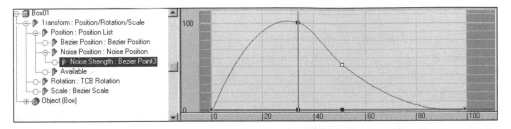

Figure 20.35
The Available track in Figure 20.34 has been assigned a Noise Position controller. Noise Strength is animated only in the z-direction. The x and y function curves maintain a constant level of zero.

The effect of the Noise Strength function curve is seen in a function curve view when its parent track, Noise Position, is selected; see Figure 20.36. The erratic curve is positional movement in the z-dimension only. Note that the amplitude of the curve tracks the shape of the Noise Strength function curve. If noise were animated in all three dimensions, three such curves would be visible.

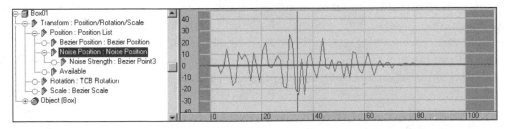

Figure 20.36
The function curve for the Noise Position track (the parent of Noise Strength) shows the positional animation of the object. The amplitude of this erratic curve tracks the shape of the Noise Strength curve in Figure 20.35.

The composite picture of all the animation in the List controller can be seen in Track View as well, as shown in Figure 20.37. With the Position List track selected, the function curve shows the object moving at a constant rate in the x-direction while it rattles up and down in the z-dimension.

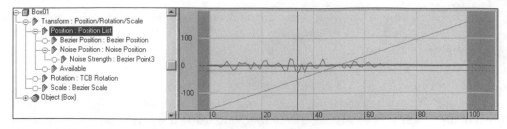

Figure 20.37

With the Position List track selected, the composite result of both controllers is visible. The object is moving at a constant rate in the x-direction, as set in the Bezier Position controller. But it's also rattling up and down in the z-direction, due to the Position Noise controller.

Attachment And Surface Controllers

The Attachment and Surface controllers align an object to the surface of another object. The Attachment controller is used where the surface to be aligned with is a polygonal mesh. You take the object to be attached to the mesh surface and assign it an Attachment controller in the Position track. The controls in the Motion panel allow you to choose the surface object and even to create keys at different locations on the surface, but this kind of animation across the surface of an object is clumsy and unreliable with polygonal meshes. A better use of the Attachment controller is to keep an object stuck to a surface that is being deformed.

Unlike polygonal meshes, NURBS surfaces are inherently parameterized. In other words, NURBS surfaces can be continuously measured in two dimensions. Every point on a NURBS surface has an exact location in the uv coordinate system of the surface. This makes NURBS surfaces far more appropriate for animations in which objects must travel along geometric surfaces. The Surface controller allows you to do just this. After applying a Surface controller to the Position track of the object to be animated, you choose a NURBS surface. The object can then be positioned and keyed in the uv coordinates of the surface using spinners. Figure 20.38 illustrates such an animation (using the Snapshot tool to record multiple frames). Keys were set for the Box object for positions at the top and bottom of the sloping NURBS surface. The box follows the surface continuously between the two keyed positions. If the surface itself is deformed in animation, the Box remains aligned to it.

Animating Rotations

Animating rotations is hard. I think it's the single most difficult aspect of animation in MAX or any other program. The problem is largely rooted in the mathematics of rotations. The order in which the three axial rotations (around x, around y, and around z) are performed makes a considerable difference in the result. At an extreme, the order of rotations can produce the phenomenon known as *gimbal lock*, in which rotations around two different axes become identical.

MAX's approach to rotations is highly controversial, and I don't pretend to be on both sides of the issue. In fact, I believe that MAX took the wrong tack with this difficult subject, making it even more difficult in an attempt to simplify it. Much of this section will be devoted to

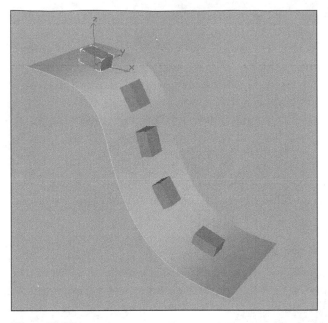

Figure 20.38
The Surface controller is used to animate a Box object along a NURBS surface. This Snapshot view of the animation shows the Box following the surface between its keyed positions at the top and bottom of the slope.

making clear the problems with MAX's special approach and the need to turn to a more conventional one in the vast majority of cases. This view is not shared by everyone, however. Each practitioner must make up his or her own mind on this central issue, but the decision must be made through careful investigation and experience.

The conventional method applies three rotations, in a prescribed order, around the three coordinate axes. As already mentioned, this method creates occasional problems due to the order of rotations. These problems can almost always be resolved by parenting (linking) a null object (a Point or Dummy in MAX) to the misbehaving object. The null object can be rotated to rotate the child object. By dividing the rotations around the three axes between the two objects, you can control the order of the rotations because the parent's rotations are necessarily applied first.

The designers of MAX decided, however, to avoid the entire problem of order of rotations by implementing a radically different approach. This approach uses quaternion mathematics—hardly intuitive to the vast majority of users. The main problem with this implementation is that it does not produce an editable function curve, which is a fatal compromise, in my opinion. To offer this approach as an optional controller would have been unobjectionable, but MAX's designers decided to make it the default in the TCB Rotation controller. Most people who learn MAX naturally work with the default controllers until they learn that there are other options, and those who stick with the TCB Rotation controller are unaware that it is such a big departure from the rest of the industry. I feel that if quaternion rotations made

good practical sense, they would be quickly adopted by MAX's competitors. They were not adopted, however, and all 3D animation applications that I'm familiar with use only the conventional approach applied previously. It's very important to understand the larger picture: The purpose is not to learn to use MAX for its own sake, but rather to learn 3D graphics and animation using MAX. As a result, the following material introduces you to the TCB Rotation controller, primarily to understand its nature and limitations. You then quickly move on to MAX's Euler controllers, which implement the conventional approach to rotations.

The other rotational controllers require little attention. There is an Expression controller for rotations, and the Noise and List controllers here perform the same way as they did in their position versions. Refer to the section on "Other Position Controllers" earlier in this chapter for information.

The TCB Rotation Controller

The TCB Rotation controller (like the Bezier Position controller discussed at the start of this chapter) is poorly named. TCB stands for Tension, Continuity, and Bias—which are three parameters used to control the interpolation between vertices on a cardinal spline. The cardinal spline, sometimes called the natural spline, does not use Bezier-type tangent handles for interpolation, and TCB controls are the only way to shape spline segments between vertices. MAX doesn't use natural splines in its modeling interface, so you may not be familiar with them if you haven't used them with other applications.

Thus, the TCB element in the controller name tells us two important things: Spline interpolation is implemented, and this interpolation is controlled by Tension, Continuity, and Bias parameters. By itself, this would be only a relatively minor change from the regular Bezier splines used in function curves. What the name TCB Rotation doesn't tell you, however, is the most important thing about the controller—that it implements a quaternion approach to rotations.

Now, let's start an exercise to get some hands-on experience with the TCB Rotation controller:

1. Using a fresh screen, switch to the two-viewport layout that you've been using throughout this chapter, with a narrow top view above and a large front view below. Create a small Box object in the top view. You can always adjust its size later. Be sure that you create it in the top view so that it's built on the groundplane. This ensures that the Box will have a local coordinate system aligned to world space. In other words, the local z-direction will be up in a front view, y will extend toward the back, and x will run to the right. Confirm that this is so by switching back and forth between local and world coordinate systems. The pivot point (or Transform Gizmo) should remain unchanged as you do so.

2. Note that the pivot point is currently at the base of the Box. You want the Box to rotate around a point in the center. Center the pivot point in the object, and move the Box precisely to the center of world space by using the Move Transform Type-In dialog box. At this point, your screen should look like Figure 20.39.

Figure 20.39
Setting up for the TCB Rotation exercise. A Box object is created in the top view to align its local coordinate system with world space. The pivot point is centered, and the object is translated to the world origin (0,0,0). This view is in local coordinates.

3. Open up a Track View panel to cover the upper viewport, and find the Box's Rotation track. Show your controller types by using the Filters dialog box, and you'll see that you've got a TCB Rotation controller. Stay in the Edit Keys view in Track View and create a key precisely at Frame 0. Right-click on the key to bring up the key information dialog box. Then, with the Box selected, activate the Rotate tool on the Main Toolbar. Get into local coordinates if you're not there already, and open the Rotate Transform Type-In dialog box. Your screen should look like Figure 20.40.

4. You're looking at two approaches to rotation at the same time. The world x, y, and z values on both sides of the Rotate Transform Type-In dialog box reflect the conventional approach. They rotate the object around each of the three axes independently. The key information uses the quaternion approach. The x, y, and z values are used to point a vector in an arbitrary direction from the pivot point, and the Angle value represents a rotation around that vector. The x, y, and z values vary between 0 and 1 because they are angular measures using trigonometric functions. You can play with the values in both dialog boxes, if you're so inclined. If you do, you'll certainly notice that rotation values that are easy to understand in the Rotate Transform Type-In dialog box are incomprehensible as quaternions, unless they are around only a single axis.

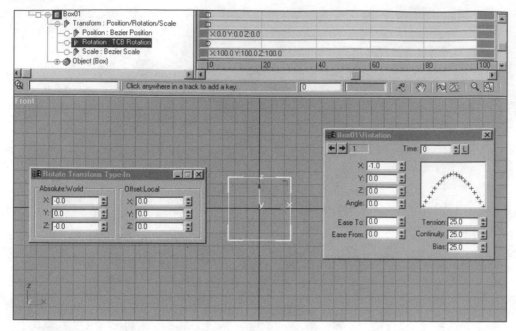

Figure 20.40

In the Rotation track, and using the default TCB Rotation controller, a key is created at Frame 0. The informational dialog box for that key is displayed. The Rotate Transform Type-In dialog box is also displayed.

5. Animate a rotation around the local y-axis. Set the quaternion values to x=0, y=1, and z=0. This aligns the axis of rotation with the y-axis. Play with the Angle value to confirm that the Box is rotating around the local y-axis, and then reset the Angle value to zero. Create a second key at Frame 50. Give this key the same values as the first one, except change the Angle value to 45. Pull the Time Slider to make sure that the Box is rotating 45 degrees. See Figure 20.41.

6. So far, things are understandable, at least if you rotate around only a single axis. Create a third key at Frame 100, and give it the same values as the second key. Before you pull the Time Slider to check the results, think about what should happen. Your three keys have Angle values of 0, 45, and 45, respectively. Thus, you're likely to conclude that the Box will rotate 45 degrees between Frames 0 and 50, and then remain still through Frame 100. This is not what happens, however. Pull the Time Slider and see that the Box rotates 45 degrees and then a second 45 degrees, ending up with a 90-degree rotation. In other words, the angle values are not absolute, but only relative to the previous key. That makes it very difficult to understand an animated parameter directly from its data.

7. Switch to a function curve view in Track View. No curve appears. Function curves can make sense only with absolute values. This fact is the root of the single biggest problem with the TCB controller.

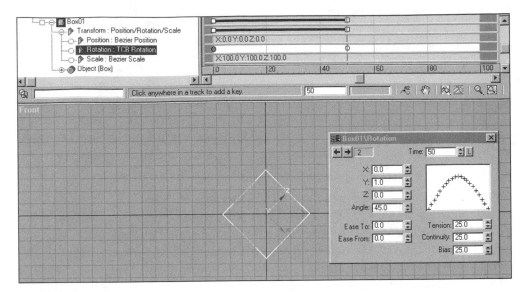

Figure 20.41
An animation, rotating the Box 45 degrees around the y-axis. Note the y quaternion value of 1, which aligns the axis of rotation with the y-axis. The Angle value rotates the object around the axis of rotation.

8. Just because you don't have function curves, it doesn't mean you don't need to control interpolations. To get the result that you originally intended, change the Angle value of the third key to 0. The Box should therefore not rotate after Frame 50. If you pull the Time Slider you'll see it wiggle, however, due to the interpolation of a spline that you cannot see or directly edit. To edit the interpolation, change the Continuity setting of the second key to 0. The display indicates a linear interpolation. Test to see whether the waver is gone. A lot can be done with these TCB tools, but they are extremely unintuitive compared with Bezier handles on splines you can see.

IS THE TCB ROTATION CONTROLLER EVER PREFERABLE?

The TCB Rotation controller can make special sense in situations in which an object is tumbling in an arbitrary manner (e.g., down a flight of stairs). Very complex rotations such as these are sometimes too difficult to understand as function curves, and the quaternion approach prevents complications due to order-of-rotation problems. The obvious purpose of this controller is to allow you to set keys interactively with the Animate button, rotating your object freely as you go, without worrying about problems due to order of rotations. This makes it easy to do simple character animation, for example. But the loss of function curve control is too high a cost, in my opinion, unless order-of-rotation problems become unmanageable.

The Euler XYZ Controllers

MAX has always offered a conventional rotational controller, named Euler XYZ. (Euler was a famous mathematician.) The operation of this controller is easy to understand. It contains three children tracks for X Rotation, Y Rotation, and Z Rotation, and thus should remind you

of the Position XYZ controller. Each of these tracks can be keyed separately, and each has an editable function curve. If you create a key in the parent track in Track View, all three children tracks will receive keys together.

The Euler XYZ controller sets x,y,z rotation values in the parent coordinate space of the object. If an object has no parent, the world coordinate system is used. MAX 3 has added a Local Euler XYZ Controller that uses the local coordinate system of the object. For users like myself, with long experience with the original Euler controller, it takes some time to measure the comparative merits of the Local version. The two controllers are otherwise identical, however.

As mentioned previously, the disadvantage of the conventional rotational approach used in the Euler controllers is in the peculiarities introduced by the order in which the three rotations are applied. You can change this order in the Motion panel. When you click on the Rotation button in the PRS Parameters rollout, a drop-down list list appears, containing all possible arrangements (xyz, yxz, xzy, and so on). But I find that few people, including myself, can think this way. It makes more sense to deal with order-of-rotation problems by parenting (linking) an object to a null object (Point or Dummy) and moving one of the rotations to the null object. This technique was demonstrated on an animated rotation at the end of Chapter 3 (in the section "Using Null Objects To Create Coordinate Systems").

Another problem with the Euler controllers is a lack of correspondence between the named rotation tracks and the object's pivot point. Sometimes, you adjust the Y Rotation function curve, only to see that object rotate around z. Rather than sweat the complex reasons for this when it happens, just find the track that works.

Because you already know how to set keys in Track View and adjust function curves, the following introductory exercise is short:

1. Create the same Box and viewport layout as you did in the first two steps of the previous exercise. Your screen should look like Figure 20.39. If you're continuing from the previous exercise, you can just select your keys in Track View and delete them.

2. Make sure that your controller type names are showing in Track View and change the Rotation controller to Euler XYZ. In the Y Rotation track, create keys at Frames 0 and 100. Set the value of the second key to 720 degrees. Run the animation to confirm that the Box makes two complete rotations at a constant speed. Your Y Position function curve should look like Figure 20.42.

3. Bring up the Bezier handles for both keys and adjust them to get a nice ease in and ease out. Run the animation to see how much more convincing it is with these small accelerations and decelerations. It suggests that your Box has physical mass. Your function curve should look like Figure 20.43.

4. Try making the Box spin back and forth. Bring the key at Frame 100 down to a value of 0 degrees and add a new key at Frame 50. Set the value of the new key to

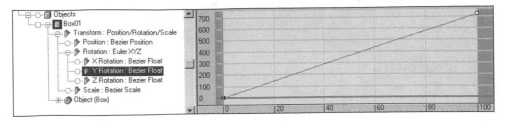

Figure 20.42

The function curve for rotation around the y-axis. The rotation runs at a constant speed, turning 720 degrees (two complete rotations) over the course of the animation.

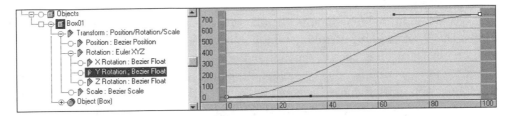

Figure 20.43

Same as Figure 20.42, but with Bezier handles used to create an ease in and ease out. These small accelerations and decelerations suggest that the object has physical mass.

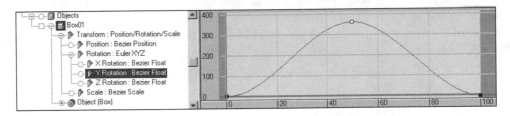

Figure 20.44

The Box spins forward 360 degrees and then backward the same amount. The curve shows natural and pleasing changes in velocity.

360 degrees. Your function curve should look like the one in Figure 20.44. Run the animation—you might be surprised to see how pleasing and convincing such simple movement might be.

5. For a final touch, cause the Box to stop for 10 frames. Move the second key to Frame 45 and create a new key at Frame 55. Set the new key to 360 degrees, the same value as the previous one. The curve will look pretty good, but there will be a little spline interpolation problem. Pull the Time Slider and note the slight drifting in the object when it's supposed to be stopped. Make the interpolation between the two keys linear, as you have been doing throughout this chapter, and the problem will be solved. Your function curve should look like Figure 20.45.

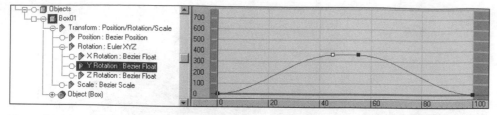

Figure 20.45

Same as Figure 20.44, except that the Box comes to a stop for 10 frames before it starts turning forward.

Inverse Kinematics

When objects are organized into parent-child hierarchies, child objects share their parents' transforms. This is exceedingly useful in animation because it allows you to mimic real-world hierarchical structures, such as the human body. If you rotate your right upper arm, you expect the forearm and hand to go along for the ride. However, rotating your hand at the wrist should not, in itself, move the bones back up the chain.

This leads naturally to a certain approach to animating hierarchical chains, and particularly the character figure. For example, consider a character leg assembled from a thigh, a calf, and a foot, all properly parented in a chain, and with the pivot points located at the location of the joints (hip, knee, and heel). To animate a step, you have to start at the top of the chain and rotate the thigh, which rotates the entire unit. Then, you continue down to the calf and rotate it at the knee to give it a bend. Finally, you may wish to continue to the foot to rotate it a little at the heel. You have to work from top to bottom. This method is often called *forward kinematics*, suggesting movement down the parent-child chain. It is always the default.

Forward kinematics can be very tedious and is somewhat unintuitive. Especially in character animation, it is useful to have a method in which transforms move backward up the chain. The most important example is the step just discussed. Using *inverse kinematics (IK)*, you can simply lift the foot (at the heel), and the thigh and calf will rotate accordingly. Inverse kinematics is not limited to character animation—interactive mechanical parts often require this method. Character animation is, by far, the most important application for inverse kinematics, however.

Inverse Kinematics In MAX

Inverse kinematics in MAX can be intimidating. New users are completely baffled by it, and users migrating from other applications are surprised at the complexity of the implementation. The irony is that MAX's IK is really quite workable and reliable—it's just buried in the most confusing and frustrating array of options and parameters. I'll spend only a few words on background here and then proceed to a hands-on practical use of IK that will put you on the road to confidence.

There are three different kinds of IK in MAX. By activating the IK on/off toggle on the Main Toolbar, you activate interactive IK. If you move a child object, the parent objects up the chain rotate. The IK panel under the Hierarchy tab in the Command panel contains a startling array of options and parameters that affect interactive IK (and all other types of IK, as well). In the Rotational Joints rollout, you can constrain rotations to specific axes and to specific angular ranges. And in the Object Parameters rollout, you can designate an object in a chain as a *Terminator*, meaning that it does not respond to IK that is generated further down the chain—for example, a hip object should not rotate when a foot is lifted.

Many long-time MAX animators are used to working with interactive IK and have figured out its many peculiarities. The main disadvantage of this method in animation is that it produces separate keys for every rotated object in the chain, making editing difficult.

Applied IK is a method apparently designed to provide more reliable results than interactive IK could produce, at least in the earlier versions of MAX. It involves binding the object at the end of the chain to another object, animating this second object, and then generating a result. This clumsy approach is of little interest today.

The only IK method that we will address in any detail uses Bones and the IK controller. This method is very similar to that used in other major applications. In the early versions of MAX, Bones were only display tools, but with MAX 2 they became a vehicle for inverse kinematics through the IK controller. Bones can be used by themselves to create a skeleton to deform a mesh in Character Studio or by using the Skin modifier. They can also be applied directly to a hierarchy of objects, such as the segments of a robot, by using the Auto Boning tools when the Bones system is created.

In order to give you a practical perspective, the rest of this section is devoted to an exercise in which you use a Bones system to create a stepping motion.

Animating A Step With Bones

The walk or stepping action is the most basic unit in character animation. You'll work with only a single leg unit and use IK to take a single step forward. This unit can be repeated to create further steps and applied in reverse for another leg. My purpose here is to get you into the very challenging workflow of character animation:

1. Set up a two-viewport layout as you've been doing throughout this chapter, with a narrow top view above and a large front view below. Go to Create|Systems in the Command panel and activate the Bones button to draw Bones. Before you draw, look at the panel, shown in Figure 20.46. The IK controller section contains three checkboxes. Assign To Children applies the IK controller to all of the Bones in the system except the first one, the root. This box is checked by default, and you should leave it checked here. Assign To Root applies the IK controller to the root Bone as well. Check this box, because you want your first bone (the hip) to be part of the IK chain. The last box creates an End Effector. You'll see what this means in a moment.

Figure 20.46

The Bones creation panel with default settings. (The Assign To Root box should be checked in our exercise to make the root Bone in the chain—the thigh—part of the IK system.)

2. Before drawing the Bones, pan your front view down until the dark groundplane line (z=0) is close to the bottom. Use this line as a reference. The Bones should be drawn so the foot is on or very near this line. At the left side of your front view, draw three Bones vertically to create the thigh and calf. This may sound peculiar, but the Bones are actually the joints—not what are normally called bones. Thus, you create three Bones at the hip, the knee, and the heel to effectively create the thigh and calf. This kind of thinking takes some getting used to. Click three times to create the Bones, and then right-click to stop creating them. Draw your Bones with a slight bend at the knee. This helps IK to know the proper direction of rotation and is a huge help later on. Your front view should look like Figure 20.47. Note the End Effector (the cross) at the end of the chain.

3. Rename Bones 01, 02, and 03 as hip, thigh, and calf, respectively. It's very important to name Bones correctly, or you're sure to become totally confused. Press the H key to bring up the Select Objects dialog box, and check the Display Subtree box to show the hierarchy. The Bones should be arranged in a parent-child hierarchy—hip, thigh, and calf.

4. Select the calf Bone (the last one) and move it up and down. You'll see IK in action, bending the knee. Notice that you are really translating the End Effector, which is connected by a kind of string to the Bone. However, if you open the Select Objects dialog box, you won't find the End Effector. To improve your setup, parent the End Effector to a Dummy object. Create a small Dummy object right on top of the End Effector. It makes good sense to keep all your coordinate systems aligned, so align the pivot point of the Dummy to world space in the Pivot panel under the Hierarchy tab by using the Align To World button. In local coordinates, the Dummy should have the same pivot point orientation as the Bones. Now, select the calf Bone and

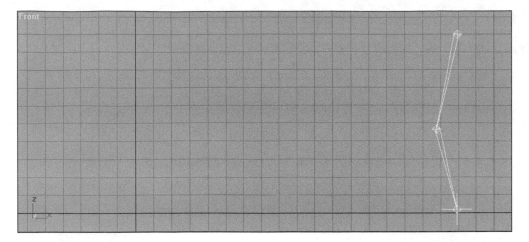

Figure 20.47
The three Bones are created at the hip, knee, and heel to effectively create a thigh and calf. A slight angle at the knee helps IK understand the proper direction to bend. Note the End Effector (the cross) at the end of the chain.

enter the Motion panel, where you'll find the parameters for the IK controller that govern the Bones. Click the Link button in the End Effectors section and then click on the Dummy. Select and move the Dummy to make sure that it controls the End Effector. Rename the Dummy as Heel Dummy before you go on. Your Bones system should now look like Figure 20.48.

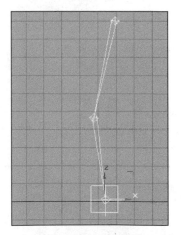

Figure 20.48
The End Effector is linked (parented) to a Dummy object. Animating the Dummy now animates the End Effector. The pivot point of the object is aligned with world space to be consistent with the Bones.

5. Add a foot Bone by clicking on the heel, and then click again some distance to the left. Right-click to stop creating Bones. Press the H button to bring up the Select Objects dialog box and notice two things. First, there's only one new Bone, even though

you clicked twice. Second, the Bone has automatically been added to the hierarchical chain as the child of the calf Bone. This second fact explains the first. Rename the Bone as foot.

6. Select the Heel Dummy and move it around. Due to the End Effector at the end of the foot Bone, that Bone remains pointing at the ground. This can be useful for a sophisticated setup with a flexible foot, but it would create too many problems in this simple setup. With the foot Bone selected, go to the Motion panel and return to the End Effectors section of the IK controller Parameters rollout. Under the heading Position, press the Delete button. The End Effector disappears. Now, try moving the Heel Dummy again. The foot stays rigid, maintaining a constant angle with the calf, as shown in Figure 20.49.

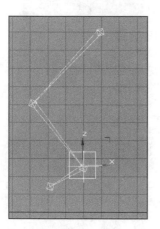

Figure 20.49
A foot Bone is added to the end of the chain, but its End Effector is eliminated. The foot follows the rest of the chain but stays rigid, maintaining a constant angle with the calf.

7. IK is not just a one-way street: It's used not only to rotate from the end of the chain, but also to keep the end fixed when the start of the chain is moved. For example, when you squat from the waist, your knees bend and your feet stay on the ground. Select the hip Bone and move it down to create a squat. Everything works except for the foot. It stays rigid because you made it so in the previous step, and therefore rotates into the floor. To correct this, select the calf Bone and return to the End Effectors section of the Motion panel. Under the Rotation heading, press the Create button. The foot Bone's rotations are now controlled by the calf Bone's End Effector. This End Effector is in turn controlled by the Heel Dummy. This means two things. First, you can now bend the knee by moving the hip and the foot will remain flat on the ground, as shown in Figure 20.50. Second, it means that you can rotate the foot up and down by rotating the Heel Dummy. Play around a bit with these possibilities before going on.

8. Now, you can create all of the necessary poses with just the Heel Dummy and the hip. For a cleaner setup, create a second Dummy to control the hip. Create a small Dummy object right on top of the hip Bone and, as you did with the Heel Dummy,

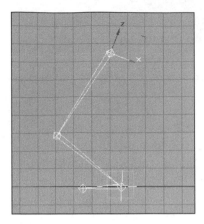

Figure 20.50
Same as Figure 20.49, but with a Rotation End Effector created for the calf Bone. This locks the foot Bone's rotation to the orientation of the calf Bone, and therefore to the Heel Dummy. One consequence is that the foot does not rotate when the knees bend in a squat.

align its pivot point to world space. Change its name to Hip Dummy and link (parent) the hip Bone to the Hip Dummy using the Link button on the Main Toolbar. This makes the Hip Dummy the root object of the entire hierarchy, as you can see in the Select Objects dialog box. Note that this is conventional linking, unlike the special linking of the End Effector.

9. The step is composed of three poses, as shown in Figure 20.51, from right to left. First, the leg is extended behind the hip. Then, the foot moves forward until it is about even with the hip. The foot is lifted, bending the knee, and rotated to dip the

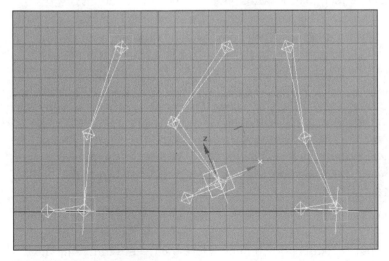

Figure 20.51
The step begins with the leg extended behind the hip. The foot moves forward until it is about even with the hip. The foot is lifted, bending the knee, and rotated to dip the toe. Finally, the foot is planted on the floor in front of the hip.

toe towards the floor. Finally, the foot is planted on the floor in front of the hip. Practice making these poses before starting to animate, by moving and rotating the Heel Dummy alone. You'll move the Hip Dummy when you animate.

10. It's time to animate. Open Track View to cover the top viewport and make sure that your controller type names are displayed (by using the Filters dialog box). All of the animation will be achieved by using only the Heel Dummy and the Hip Dummy. The Hip Dummy will be translated by using the default Bezier Position controller. The Heel Dummy will be both translated and rotated. The Bezier Position controller will be fine here, but convert the TCB Rotation controller to Euler XYZ. Because there is no need to expand the tracks below the Hip Dummy, your Track View should look like Figure 20.52.

Figure 20.52
Track View ready for animating the Hip Dummy and Heel Dummy. Both objects will be translated by using the default Bezier Position controller. The Heel Dummy will also be rotated by using the Euler XYZ controller. There is no need to expand the tracks below the Hip Dummy.

11. Think through the process carefully. You'll begin with the foot at its extreme backward position and then bring it to its forward position. One-half second is a reasonable time for this, so it will occur over 15 frames when using the standard 30 fps video frame rate. The complete cycle will bring the foot back to where it began, behind the hip. You don't slide your feet backward when you walk. The forward foot becomes the backward foot because the hips move forward while the front foot remains planted—the other foot is stepping forward to accomplish this. Thus, your leg animation will step from back to front from Frame 0 to Frame 15. This is actually 16 frames, but the extra frame can be ignored here. Then, the Heel Dummy will remain planted while the Hip Dummy moves forward to its final position at Frame 30. Make sure that you understand these ideas by taking some steps with your own body. Then, move the Heel Dummy into position to create the backward pose on the right side of Figure 20.51.

12. Turn on the Animate button and move to Frame 8, halfway through the step. With the Heel Dummy selected, go to the Motion panel and press the Trajectories button. Now, you can see the motion path as you build it. Move the Heel Dummy into the lifted position in the center of Figure 20.51. Be sure to rotate the Heel Dummy as

well to get the proper dip in the toe. Drag the Time Slider to Frame 15 and create the forward pose in Figure 20.51 by moving and rotating. Turn the Animate button off. Pull the Time Slider to check the animation and take a look at the keys in Track View. Note that the Animate button creates rotation keys in all three dimensions, even though they are only needed in y. This is not a big problem here. Also, note that the Trajectory allows you to see the motion path with key placement. Your screen should look like Figure 20.53 when in local coordinates.

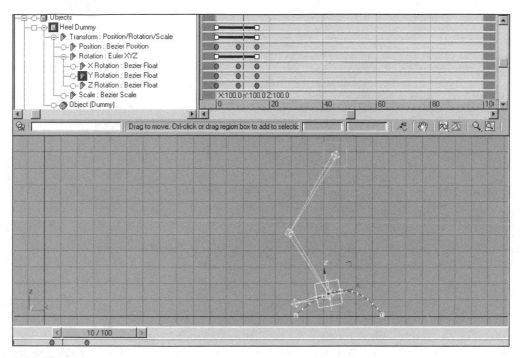

Figure 20.53

Keys are created for the Heel Dummy with the Animate button to define the step. The Trajectory shows the motion path. Note that rotation keys were automatically created in all three dimensions even though they are only needed in y.

13. You can now edit the shape of the step with the Trajectory keys. Press the Sub-Object button in the Motion panel and then move the keys a bit. For example, lower the height of the step on the second key and move it forward a bit. Run the animation to test your results as you edit. Pay attention to the frame ticks in the Trajectory. Note in Figure 20.54 that they indicate a slowing down as the foot is planted. (A much better step can be created by rotating to place the toe down before the heel, but I'll leave this refinement to the more ambitious reader.) You need to adjust the rotation at the top of the step to accommodate the new height. Do this by right-clicking on the key at Frame 8 in the Track Bar and bringing up the Y Rotation dialog box. Bring the Time Slider to Frame 8 and adjust the Value spinner. Watch the Dummy rotate as you do this.

Figure 20.54
The step is adjusted by using Trajectory keys to reduce the height. Note from the frame ticks that the animation slows down as the foot is planted.

14. You need to add another key at Frame 30 to complete the cycle. Right-click on the Time Slider to bring up the new Create Key dialog box. Uncheck the Scale box so that keys are created only for position and rotation. Set the Source Time to 15 and the Destination Time to 30, which creates keys at Frame 30 with the same values that they had at Frame 15. After you finish, you'll see a new key symbol appear at Frame 30 in the Track Bar. But you'll also see a funny tail appear at the end of the Trajectory. Pull the Time Slider to see the drifting effect of spline interpolation between Frames 15 and 30.

15. To correct this problem, select the Position track in Track View and switch to a Function Curves view. You'll see a bend in both the x and z function curves between the last two keys. Make the interpolation linear between these two segments by selecting either key and using the constant interpolation option. (Refer to Step 18 of the Path controller exercise earlier in this chapter, if necessary.) The function curves should now be perfectly straight between the two last keys. Do the same thing with the Y Rotation function curve. Test the animation to make sure that it's completely still between Frames 15 and 30.

16. Let's add the hip movement. In mid-stride, the hips move forward at a fairly constant rate. Select the Hip Dummy and turn on the Animate Button. Set the Time Slider to Frame 30. Move the Hip Dummy forward until you duplicate the original pose at Frame 0, with the foot extended behind the hips. Your screen should look like Figure 20.55 when the Trajectory is visible.

17. This should work pretty well. Further adjustments are necessary, but I'll leave them to you. For one thing, the Hip Dummy is now in a different position at Frames 8 and 15 than it was when you posed the Heel Dummy. Try repositioning the Heel Dummy at these frames to accommodate this. If you do, you'll need to rekey Frame 30 as well. Then, create a second leg chain and parent its hip Bone to the Hip Dummy. Create the opposing step. You have to keep the second foot (the front one) on the ground until Frame 16 or so, after the back foot is planted.

Figure 20.55
The Hip Dummy is animated to translate forward between Frame 0 and Frame 30. At Frame 30 (pictured here), it's positioned in front of the foot to duplicate the original pose at Frame 0.

Animating Scale

Animating scale raises no significant issues, nor does it come up very often in animation projects. Most of the time, when an object is changing size, it's also changing shape, and is therefore animated by using the morphing techniques discussed in Chapter 21. The default scale controller is Bezier Scale. Like Bezier Position, all three function curves (x, y, and z) are included in a single track and keyed together. The Scale XYZ controller corresponds to Position XYZ in that the three dimensions are placed on separate tracks and can be keyed separately. A List and a Noise Controller are available for scale, as is an Expression controller.

USING RELATIVE REPEAT AND THE NEW BLOCK CONTROLLERS

Once you create a single step for one or both legs, experiment with the Relative Repeat (in the Parameter Curve Out-Of-Range Types) to keep the character walking forward. You need to use it on every animated track. You can even convert these repeats to editable keys using the Create Out of Range Keys utility, found under the Track View Utilities button when you're not in a Function Curves view.

The more advanced animator will want to try out the new Block controller in MAX 3. The Block controller allows you to collect ranges in many animated tracks together as a single, repeatable unit. For example, all of the animated tracks for the Hip Dummy and Heel Dummy in the previous exercise can be made into a block named "step." The coordinated step can be repeated any number of times. Look in MAX 3 online help for instructions on how to use the Block controller. It's remarkably easy to use.

Moving On

In this chapter, you took on the exciting challenge of animating object transforms. You learned the central role that MAX's animation controllers play in this kind of work. You compared the most important controllers for animating position—Bezier Position, Position XYZ, and Path—to assess their relative strengths. You also learned how the choice between the two most important types of rotation controllers, TCB Rotation and Euler XYZ, determines your access to function curves. You finished with a look at how inverse kinematics can be used to create a character-stepping motion.

In the next chapter, you'll learn about animation tools that deform object geometry. I'll emphasize those that are most central to basic character animation: skeletal deformation and morphing.

Deforming The Geometry

MAX provides many powerful tools for deforming object geometry that make this challenging task workable and even fun.

Although inorganic or manufactured objects transform rigidly, living things change shape as they move. To animate living things, you need to be able to deform the geometry of your objects. In the final analysis, this amounts to the translation of the individual vertices of the polygonal mesh over time.

Introduction To 3D Character Animation

Character animation is, without question, the most difficult and demanding application of 3D computer graphics. 3D tools are easily suited to animating rigid objects in space, but the animation of subtle deformations in organic objects pushes existing toolsets to their extremes. The situation is complicated by the standards for character animation that have long been established in Disney-tradition cel animation. The viewing public expects high production values for this kind of entertainment.

Character animation is not just a visual art—it is, even more, a dramatic art. Character animation is animation in the service of storytelling and moviemaking, and its ultimate skills are in the refinement of timing in character movement and facial expression. Unlike in cel animation, however, the 3D animator cannot simply draw a smile or a character pose directly. Rather, he or she must obtain subtle control of the shape of the mesh—control powerful enough to permit continuous animation of the surfaces. Character animation in 3D computer graphics is a subject that requires a book fully as long as this one, and thus my goals in this chapter are very narrow. Character animation rests on the power to control mesh deformation. Only after you understand the available tools and have mastered them in the simplest situations can you begin to think about their creative application in character animation. In this chapter, I'll lay the groundwork for those who are interested in moving further.

A clarifying point is in order here. Not all mesh deformation is character animation. Many inorganic objects are flexible or fluid in motion, water being the most obvious example. However, in this chapter, you'll focus almost exclusively on the application of mesh deformation in the character animation context because this is such an important direction for 3D

animators. In MAX 3, Kinetix is staking its largest claim ever to a place in the character animation world, precisely because this is where so much of the paying work in 3D graphics is found.

Mesh deformation in all 3D packages can be divided into two basic approaches—skeletal deformation and morphing. I'll cover these concepts next.

Skeletal Deformation

Skeletal deformation involves the creation of a hierarchy of nonrendering objects called Bones. The Bones (generally a complete character skeleton) are positioned inside the character model and are then attached to the mesh. Transforming the Bones causes the mesh to deform because the vertices on the model are rigidly associated with specific Bones. Although the concept is similar to the way in which real Bones are attached to muscles, the similarity is a very thin one. There are no "muscles" in the character model, which is simply a hollow shell. It takes an enormous amount of practice to create skeletal deformations that suggest solid flesh. Note that skeletal deformation is mesh deformation, not object transformation. The Bones (as objects) are moved and rotated, but the character model is deformed by these transforms. It takes a while to grasp this concept clearly.

MAX 3 introduces new skeletal-deformation tools that greatly change the status of the package as a character-animation environment. Prior to MAX 3, true skeletal deformation was available only if you bought the Character Studio plug-in. Character Studio is a very powerful tool, but it is also rather complex and forbidding compared to implementations in competing packages. And, of course, it costs additional dollars for those who've already spent money on MAX. In contrast, all of the competing professional-level applications (and some nonprofessional ones, as well) contain skeletal deformation as part of their standard packages. I've never understood the marketing strategy that left these tools out of the standard MAX, but Kinetix has reversed field on this issue in MAX 3. MAX 3 includes a new Skin modifier that implements a very impressive skeletal-deformation system. It does not contain all the bells and whistles of Character Studio, but neither is it so complex. The Skin modifier will get the job done for the vast majority of your skeletal-deformation needs, so I will focus on this modifier, rather than on Character Studio, in this chapter.

Morphing

Skeletal deformation is the preferred approach to bending limbs and extremities. It's used to make a character walk, move its arms and hands, and rotate the torso and head. But there's a large range of mesh deformation for which Bones are unsuitable. For example, a character breathes by moving the chest in and out. Muscles in the arms and legs bulge as they are flexed. Most importantly, the face (and especially the mouth) changes shape while speaking or shifting emotion. All of these kinds of deformations require morphing.

Morphing is a big word in 3D computer graphics. In the broadest sense, it includes all geometric deformations by whatever means, including Bones. It's generally used, however, to refer to a specific method in which various versions of a single model (called *targets*) are

interpolated in the course of animation. This method is called *target morphing*, and it is implemented in MAX 3 with the Morpher modifier (which effectively replaces the older Morph Compound Object). As with all implementations, you must generally create all your morph targets from a single model. For example, a face model is created with the mouth in a neutral position. Then, copying the original model and editing the vertices creates a smiling version. You can then morph between the two targets in time by setting keys. Morphing moves the vertices from their positions in one target to their positions in the next target. Each vertex has a motion path. That's why you have to work with copies of a single model. If your targets have different numbers of vertices or if the vertices are not in the same order in the model file, it's impossible to specify the motion of each vertex.

As morphing amounts to animating vertices, it can be achieved by other means than interpolating between complete versions of the mesh. At an extreme, you can animate individual vertices or control vertices on an Editable Mesh object by using the Animate button. Once they've been animated to any degree, they'll appear as tracks in Track View for further editing. This method is more workable, however, if some refinements are made. For example, you can animate vertices on a low-poly cage object, which is then subdivided with MeshSmooth. That way, you work with a more manageable number of vertices and the deformations are smoother because they are applied before subdivision. NURBS surfaces provide an analogous approach. You can select and animate NURBS control vertices (CVs) and get a smooth result.

This brings you to the concept generally known as cluster animation, in which a selection of vertices or CVs is animated as a named unit with its own pivot point. MAX achieves this with the XForm modifier. Multiple vertices or CVs can be passed to an XForm modifier, and that modifier's gizmo can then be animated. This keeps things organized, and it is especially suited to the control of facial features, such as eyebrows. A Linked XForm modifier goes further, allowing you to control the selected vertices by transforming a Dummy or other independent object.

Modifiers And Space Warps

Thus far, you've seen techniques that are common to most 3D packages in one form or another, but MAX has some unique powers attributable to its modifier stack concept. Most of MAX's modifiers deform geometry and can be used in modeling. But the parameters of these modifiers are typically animatable. You can animate the amount of a bend produced by a Bend modifier or the degree of twist applied by a Twist modifier. When MAX was first introduced, these tools were touted as replacements for "old-fashioned" morph targeting. The problem with using modifiers, however, is that the results tend not to look "organic" enough. The modifiers implement mathematical principles that are often too "perfect" to be convincing in the character animation context. Use them with caution.

The FFD (Free Form Deformation) modifier, however, stands apart from the other deformation modifiers. As a lattice-deformation tool, it's a flexible interface for animating vertices fluidly, and is very well suited to localized morphing. For example, it can be fitted around an upper arm to animate a muscle bulge.

Space warps are the flip side of modifiers. If a modifier can deform an object directly, space warps do so indirectly. Strictly speaking, space warps deform the space, which is then reflected in the deformation of the object. The geometry is deformed as it moves through the affected space. Although they are very useful, it's safe to say that space warps are peripheral to most character animation work. They are more applicable to the geometric deformation of inorganic surfaces—for example, to animate waves or ripples in water. You'll take a look at space warps in Chapter 22.

The Skin Modifier

The Skin modifier is a wonderful tool. So much in MAX is overly complex, and many of its powerful tools are difficult and frustrating for creative people to master. Character animators, in particular, need to worry about their art and not about their tools. The Skin modifier is remarkably intuitive. There's a lot of power there if you care to explore it, but you can also go an enormous distance with only a basic understanding. This tool is actually fun to use.

Let's cover the basics in an exercise.

Getting Started

The Skin modifier requires a mesh to be deformed, and objects to control the deformation. The latter can be any kind of objects, such as Boxes. They can even be splines, in which case the mesh deforms to the curvature of the spline. The most important objects to control deformation are Bones, however, because they are easily assembled into a skeletal hierarchy, do not render, and implement inverse kinematics. You can deform a mesh with Bones by following these steps:

1. Draw a Cylinder object in the center of the groundplane. Make it 100 units in height with a radius of 20. Segmentation is a very important issue because the mesh must deform smoothly. Use a setting of 20 height segments and use the default of 18 sides. This should provide a dense enough mesh for deformation.

2. To draw the Bones, activate the Bones button in the Create|Systems panel. Before drawing, make sure that the Assign To Root box is checked in the Bone Parameters rollout. This ensures that the entire Bones chain will be subject to inverse kinematics. Now, draw the Bones. Click three times in a vertical line—just above the top of the Cylinder, right in the center, and just below the bottom. Right-click to stop creating Bones. At this point, your front view should look like Figure 21.1. Check in multiple views to make sure that the Bones are running through the middle of the Cylinder. If they are not, move them there.

3. Note the End Effector at the end of the Bone chain. Make it a rule to always link the End Effector to a Dummy object. This will make your life much easier because the End Effector is not, by itself, a selectable object. Create a small Dummy and position it over the End Effector. Then, select the last Bone in the chain (Bone03) and go to the Motion panel. In the IK Controller Parameters rollout, find the End Effectors section. Press the Link button there to activate it, and then click on the Dummy. The

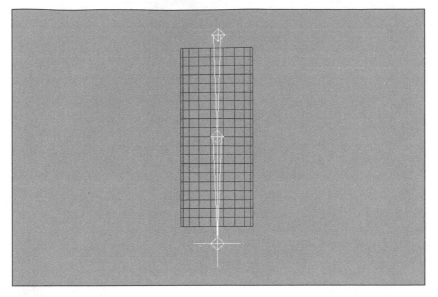

Figure 21.1
A Cylinder object with Bones running down the center in preparation for skeletal deformation, as seen from a front view.

box above the Link button should now inform you that the Dummy is the parent of the End Effector.

4. Move the Dummy to test the inverse kinematics. The IK should rotate the Bones correctly, but nothing happens to the Cylinder. Your front view should look like Figure 21.2.

5. Undo or otherwise make your Bones chain perfectly straight again before continuing. A skeleton must always be in its default position when you attach it to an object. To attach the Bones to the Cylinder, select the Cylinder and put a Skin modifier on its stack. Click on the Add Bone button beneath the empty window. A dialog box appears, containing all of the objects that can be used to deform the mesh. Note that it contains the Dummy, but it does not contain the first of the three Bones. Bone01 (the one at the top) has no length and is effectively only a joint rather than a true Bone. Pick the two available Bones from the list (Bone02 and Bone03) and click on the Select button to close the dialog box.

6. Go back and select the Dummy object. Move it to flex the skeleton and watch the mesh deform. Pretty cool, huh? Your screen should look like Figure 21.3.

Vertex Weighting

It's important to have a good basic understanding of the way skeletal deformation operates. When you attach Bones to a mesh (or vice versa—both ways of speaking are correct), each individual vertex in the mesh becomes associated with one or more Bones. Each such vertex is said to be weighted with respect to each Bone. The weighting is always between 0 and 100

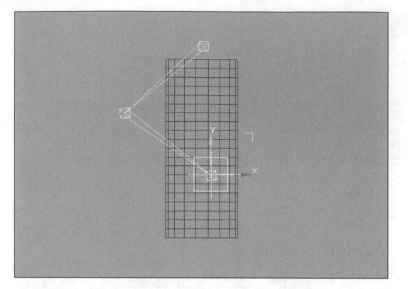

Figure 21.2
A Dummy object is created to be a parent of the End Effector of the Bones chain. Translating the Dummy moves the End Effector, thereby rotating the Bones in the chain. However, the Cylinder object is as yet unaffected.

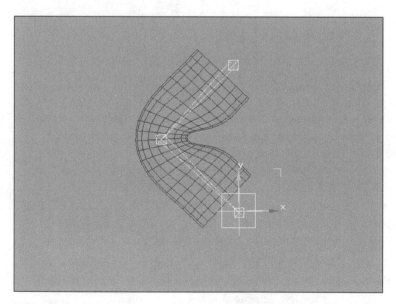

Figure 21.3
A Skin modifier is applied to the Cylinder object and the Bones are added to the modifier. Now, the rotations of the Bones deform the mesh.

percent. If a vertex has a zero weight, it is completely unaffected by a Bone. If it has a 100 percent weight, it moves rigidly along with the Bone as the Bone is rotated or translated. Values between 0 and 100 cause a vertex to move only proportionally to the transformation

of a Bone. For example, a vertex weighted 50 percent to a Bone moves only half the distance it would move if the weight were 100 percent. The concept is very similar to that found in the Soft Selection tools in MAX.

Dividing vertex weights between two Bones is the key to effective deformation at joints. Vertices at a knee or elbow region may be weighted 50 percent to the upper Bone and 50 percent to the lower one. This overlapping influence of two Bones on the same vertices is called *joint blending.*

Let's continue with our exercise to explore how vertex weighting is controlled:

7. Straighten out your Bones again to make them vertical and then select the Cylinder object. Note that most of the Skin modifier panel is grayed out. Almost all of these controls pertain to vertex weighting, but are only available in the Envelope SubObject level. An Envelope is a region around a Bone that is used to determine vertex weighting. As a general proposition and starting point, only vertices within a Bone's Envelope can be attached to that Bone. Press the Sub-Object button to get into the Envelope SubObject level. You'll see an Envelope appear around whichever of the two Bones is highlighted in the panel. You'll also see colored tick marks at all of the vertices that are weighted more than zero for that Bone. Black-and-white images are not really adequate here, but with the upper Bone selected, your screen should look like Figure 21.4.

8. The ultimate issue is always the weight of the vertices, and Envelopes are only a convenient way of assigning weights. The color of a vertex tick indicates the weight of the vertex with respect to the selected Bone. A red tick means that the weight is 100 percent. A blue tick is close to zero percent. To test this out, and to see that vertex weight can be set independently of Envelopes, check the Vertices box in the Filters section. This allows you to select individual vertices for weighting. Click on the vertex at the bottom-left corner of the mesh to select it. This vertex is completely outside the Envelope, so it has zero weight with respect to the selected Bone. Go to the Absolute Effect spinner and play with it. Notice how the tick changes color as you set the vertex weight directly. At 10 percent (.1), the tick is blue. At 30 percent (.3), it's green. Increasing the weight moves it through yellow (a very broad range that includes 80 percent) until it's finally red at 100 percent (1.0). Note also that the vertex moves a tiny bit as you change the weight, because it's falling under the influence of the upper Bone. This should give you a good sense of the meaning of the colored ticks within the Envelope. Those at the very top, in red, are completely controlled by the upper Bone. Those in the middle are only partially influenced by that Bone, and those near the bottom of the Envelope receive little or no control from the upper Bone. Use the Reset Selected Vertices button to return the vertex to its original unweighted state. Deselect the vertex and uncheck the Vertices box in the Filters section.

9. Click on the lower Bone (Bone03) in the selection box to see its Envelope and vertex weighting effect. The situation is the exact reverse of that for the upper Bone. The

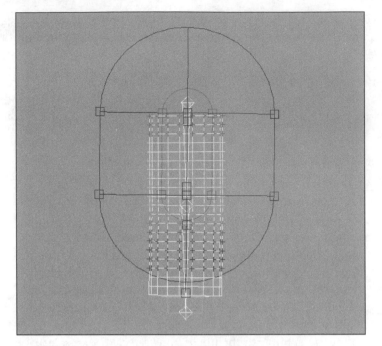

Figure 21.4
In the Envelope Sub-Object level, the Envelope for the upper Bone is displayed. Note the inner and outer bounding regions. Note also the tick marks for vertices that are weighted to the Bone. These vertex ticks are color-coded in a spectrum from red to blue to indicate weight percentages. In this black-and-white image, the yellow and light green ticks in the center of the Envelope cannot be seen, but are nonetheless present.

red vertices with full weight are at the bottom, and weighting decreases as you go upward. This makes perfect sense. At the very top and bottom of the mesh, the vertices should be controlled only by a single Bone. Toward the middle, however, vertices should be influenced by both Bones, and their weights should be divided between them. This division of weights is achieved by the overlapping of Envelopes. Check the box titled Draw All Envelopes to see both Envelopes together, although only the vertex weights for the selected Bone are visible. Your screen should look like Figure 21.5.

Adjusting The Envelopes

If you're anything like me, you gag when you first see something as cluttered and confusing as the overlapping Envelopes in Figure 21.5. It looks more like a NASA control panel than an artist's environment. The great thing about the Skin modifier, however, is that you can work interactively to adjust your Envelopes (and therefore your vertex weights), seeing the result as you work. After a short time, the Envelopes begin to make good practical sense. You can prove it here in our current exercise by changing vertex weights to get a better deformation at the bend point:

Figure 21.5
With the lower Bone selected, the vertex tick colors are reversed from those of the upper Bone. The fully weighted (red) vertices are at the very bottom, and their weights decrease as they go up. The vertices in the middle of the object are about equally weighted to each Bone to create a smooth blend. By showing the upper Envelope at the same time, you can see how this blending is attributable to the overlap of the upper and lower Envelopes.

10. Get out of the subobject mode and select the Dummy object. Move it to create a bend in the "knee" like the one in Figure 21.3. This deformation is not very convincing. Due to the symmetrical weighting of the vertices, it looks more like an elastic object than human flesh.

11. Go back to the Cylinder object and enter the Envelope Sub-Object level again. Choose the lower Bone if it's not already selected and uncheck the Draw All Envelopes box if it's still checked. Uncheck the Color Vertices Weights box, as well, to kill the vertex ticks. You will now adjust the deformation at the knee interactively by changing the shapes of the Envelope.

12. Note that the Envelope is actually two envelopes. The larger, brown one is the outer bound. The smaller, red one is the inner bound. Technically, the falloff in vertex weights attributable to overlapping Envelopes occurs between the outer and inner boundaries. Don't spend much time worrying about this principle in the abstract, however—it's more important to understand how to control the shape of the Envelopes. This is achieved by scaling the cross-sections that run through both the inner and outer bounds. You should see two such cross-sections, marked by brown and red diamonds. Select the upper cross-section for the outer bound by dragging a rect-

Figure 21.6
Preparing to correct a deformation by adjusting vertex weights through Envelope shape. The upper cross-section on the outer bound (brown) has been selected and is about to be scaled.

angle across one of its diamonds. The cross-section turns purple and a Transform gizmo appears over the selected diamond. Your screen should look like Figure 21.6.

13. You can scale the cross-section in one of two ways: you can either drag the Transform Gizmo or use the Radius spinner on the panel. However you do it, play with the Envelope shape in this way until you've got a convincing crease on the inside of the bend. Don't worry about the mesh looking crunched in this crease. Try to get it to look like Figure 21.7.

14. Now, you can refine the weighting with the red inner bound. Select one of the red diamonds on the same cross-section and scale it out a bit. This brings the outside of the knee down until it's aligned with the crease in the back. Use Figure 21.8 as a guide. These are pretty impressive tools for controlling skeletal deformations.

15. Before you do anything else, you've got to render to see what things really look like. Change your background color to white and give the object a light color so that the shadows in the crease are clearly visible. Figure 21.9 shows a test render. The crease at the "knee" is pretty good, but the segmentation around the outside of the bend is crude. The Cylinder is a parametric object, so you can increase its segmentation if you wish. But because almost all polygonal character models are Editable Mesh objects, this approach is not generally useful. As I mentioned previously, smooth geometry is a major issue in skeletal deformation.

Figure 21.7
Same as Figure 21.6, but with the outer bound of the Envelope scaled down to create a tight crease in the deformation behind the bend. This looks a lot more like a real knee. The Bones have been hidden for clarity.

Figure 21.8
Same as Figure 21.7, but with the inner bound of the Envelope scaled out to refine the result and bring the outside of the knee into line with the inside.

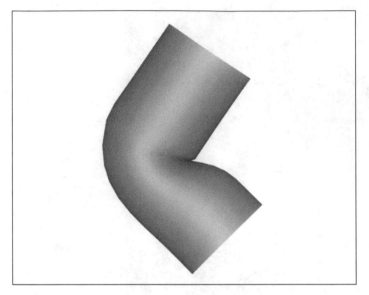

Figure 21.9
Test render of Figure 21.8. The deformation at the crease looks pretty good, but the mesh density is not high enough to keep the bend around the knee smooth. Remember to test render constantly when making deformation adjustments.

Using Editable Mesh Cages

Character models are generally either Editable Mesh objects or NURBS objects that are collections of separate NURBS surfaces. With the enormous improvements in Bezier patch modeling in MAX 3, Bezier patch character models will undoubtedly become more common as well. In the case of both Bezier patch and NURBS models, the Skin modifier operates on control vertices rather than the true vertices of the final renderable polygonal mesh. This method provides two significant advantages over polygonal mesh character models. First, there are far fewer vertices to clutter the screen and to consider in the weighting process. Second, and more importantly, it produces a smoother result because the surface is tessellated into polygons from curved surfaces using adaptive methods as the mesh is deformed.

These same advantages can be obtained for Editable Mesh models if they are built by applying MeshSmooth to a coarser "cage" version of the model. The cage version is boned and deformed with the Skin modifier, and MeshSmooth is applied only after deformation, frame by frame. The results are very similar to those achieved with NURBS models because the animated vertices of the cage are the practical equivalent of NURBS control vertices. MAX 3's new MeshSmooth tools (discussed in Chapter 7) provide outstanding methods for interactively building organic models by smoothing a cage. Take a look at the images in the color section in the middle of this book that illustrate the process. It is easy to build the kinds of polygonal cages appropriate for use with the Skin modifier and MeshSmooth.

The following exercise introduces you to the basics.

Building The Legs

Start by creating a couple of legs. Unlike in the previous exercise, however, they are created as most organic polygonal character models are—by smoothing a cage:

1. Create a tall, thin Box in the center of the groundplane using Length = 20, Width = 20, and Height = 100. Position the Box so that it sits precisely on the world origin (0,0,0).

2. Convert the Box to an Editable Mesh. You're going to use the Slice modifier to create vertices for the knee. (Don't use the Slice Plane tool in the Editable Mesh panel, because this will create unwanted vertices.) Make sure that you're not in a subobject mode in the Editable Mesh, and then put a Slice modifier on the stack. Press the Sub-Object button to access the Slice plane and then move it halfway up the object. Burn the new segmentation into the mesh by collapsing the Slice modifier. Press the Edit Stack button on the Slice panel and press the Collapse All button on the dialog box that appears. After navigating through the warning box (press Yes), the Editable Mesh will be divided at the "knee." Perform this task two more times to create segments slightly above and below the middle. When you're done, your Editable Mesh cage will look something like Figure 21.10 in a front view.

Figure 21.10
An Editable Mesh cage to serve as a basic leg, as seen in a front view. An unsegmented Box object was converted to an Editable Mesh, and the Slice modifier was used three times to create segmentation at the "knee." The Slice modifiers are collapsed into the Editable Mesh.

3. Apply a MeshSmooth modifier to the Editable Mesh cage. Stick with the default NURMS type of smoothing and increase your iterations to 2. Note the denser segmentation in the middle of the object, which will be perfect for a bending knee. Check the box that reads Display Control Mesh to see the underlying cage along

with the smoothed version. (The two ends of the object are quite rounded because there is no segmentation to tighten things up. This would not be an issue on a real character model, which would have a foot and a pelvis.) At this point, your model should look like Figure 21.11.

Figure 21.11
A MeshSmooth modifier is applied to the Editable Mesh cage from Figure 21.10. The default NURMS type of smoothing is used, with two iterations. Note the denser segmentation in the middle of the object, perfect for bending the knee. The underlying cage remains visible as a guide.

4. Let's add some Bones. To make things clearer, disable the MeshSmooth modifier (by clicking on the light bulb icon) so that only the underlying cage remains visible. Create the Bones as you did in the previous exercise, by clicking at the top, middle, and bottom of the object. Don't forget to check the Assign To Root box before drawing the Bones. It's extremely important that the Bone chain be centered in the object in all three dimensions. It's very easy to draw Bones in a front view and only discover much later that they were not properly positioned from a side or top view. Correct vertex weighting becomes impossible if a Bone is not properly positioned between the vertices that it's supposed to control. Take time to do it right, even if it means selecting and moving individual Bones after drawing them.

5. Select everything (the mesh and all its Bones) and Shift-move to create a copy immediately to the right in a front view. Something funny happens, though. As you can see in Figure 21.12, the End Effector in the copy gets left behind in the original location. Fix this by selecting the final Bone in the chain and moving it into a vertical position.

Figure 21.12
The entire assembly in Figure 21.11 is copied as a unit to create a second leg. The End Effector in the copy is left behind in the original location. You can fix this by simply moving the last Bone in the new chain into a vertical position.

6. Don't forget a final, but important step when creating Bone chains using inverse kinematics. Create a Dummy object on top of each End Effector and link the End Effector to the Dummy in the Motion panel. (To make it perfect, use the Align tool to get each Dummy centered on its End Effector before you link.) Name the Dummy objects "left dummy" and "right dummy," respectively. You've got to be strict about naming objects in character animation setups because things get complicated very fast. When you're done, your front view should look like Figure 21.13.

7. There's one more thing to do before you start deforming. This model is completely artificial. A true character model would include both legs (and probably the entire body) in a single seamless mesh object. Select one of the two legs and attach the other leg to it in the Editable Mesh panel. Check the Select Objects dialog box (press the H key) to confirm that there is only one mesh object remaining (the other objects will be Bones and Dummies). Rename the single Editable Mesh "legs."

Applying The Skin Modifier

Now, you're ready to attach the Bones to the mesh. To do this, you need to place the Skin modifier between the Editable Mesh object and the MeshSmooth modifier on the modifier stack. The idea is to apply the Skin modifier to the cage and then apply MeshSmooth to the cage only after it has been deformed by the Skin modifier. Let's continue our exercise:

Figure 21.13
Two cage "legs," ready to be animated. Dummy objects are positioned over the End Effectors at the end of the Bones chains, and the End Effectors are parented to the Dummies. The Dummy objects are named "left dummy" and "right dummy" for clarity.

8. Select the mesh object and, in its modifier stack, select the line that separates the Editable Mesh from the MeshSmooth modifier. Add a Skin Modifier right here and note its position on the modifier stack. It should be above the line and beneath MeshSmooth.

9. Press the Add Bone button and select all the Bones to attach them to the mesh. Now, test it. Select the right dummy and move it to the right. As you can see in Figure 21.14, the Bones in the right leg are pulling on the vertices on the left leg. Undo the move to straighten out the leg.

10. If you go back to the Skin modifier and enter the Envelope Sub-Object mode, you'll quickly see what's wrong. The default Envelopes for all of the Bones are large enough to include vertices in the other legs. This point is illustrated in Figure 21.15.

11. To clean up the problem, scale the outer bound of each Envelope to fit snugly around its limb. This takes a great deal of practice to get right. A lot of confusion is generated by the fact that changing the vertex weighting of the selected Bone affects the vertex weightings of all other Bones, because the system attempts to divide the total weight of each vertex between all available Bones. You'll probably find that you need to get all of the Envelopes scaled down in a basic way before you can make sense of the vertex colors. Keep making small adjustments, using the inner bounds also if necessary, until you get vertex tick colors that make sense. There should be no affected vertices on the opposing leg. On the selected leg, try to

Figure 21.14

The default Envelopes created undesirable vertex weighting. The Bones in the right leg are exercising an influence over the vertices of the left leg.

Figure 21.15

A view of the default Envelope for a Bone in Figure 21.14. This Envelope (like all of the others) is large enough to include vertices on the opposite leg.

Figure 21.16

To correct the problem in Figure 21.15, the outer bound of the Envelope is scaled down using its two cross-sections. After scaling, the vertex ticks on the right leg disappear, indicating that no vertices on that leg are weighted for the selected Bone.

achieve a good color gradient from red at one end to yellow, green, and blue across the knee. This is the sign of a smooth falloff of influence. Figure 21.16 shows a workable Envelope.

12. Test this by moving the Dummies. If it isn't working out, get back in there and play with your Envelopes some more. Make sure that both legs have identical Envelopes. This is easily achieved by copying a finished Envelope on one Bone to the corresponding Bone in the other leg. With the desired Envelope selected, press the C icon in the Envelope Properties section. Move to the other Bone and press P to paste.

Putting On The MeshSmooth

The final part of this exercise is activating the MeshSmooth to see how it looks when the knee is bent:

13. Thus far, we've only been pulling the legs outward in a front view. To bend the knees, you need to go to a side view. In a left view, select the left dummy and try to move it. The Bones don't move. That's because the Bones are constrained to rotate only around the axis perpendicular to the plane in which they were drawn.

14. Select a Bone and go into local coordinates to see the governing axes. In your left view, you can see that the x-axis is the desired axis of rotation. Go to the IK panel under the Hierarchy tab in the Command panel. Open the Rotational Joints rollout (if it's not already open) and note that only the y-axis is active (the Active box is

checked). Deactivate the y-axis and make the x-axis active for this Bone, and then do the same thing for all the Bones. When you're done, move the Dummy objects to create a "running" pose with bent knees, as in Figure 21.17.

Figure 21.17
After changing the rotational axis of all the Bones in the IK panel, the Dummies are used to bend the knees in a left view. Note the overlapping of the mesh in the forward knee.

15. Note the way that the mesh overlaps in the forward knee. This may seem to be a problem, but it's not. With the mesh object selected, turn the MeshSmooth back on. You may want to kick the Iterations level up to 3 to see a nicely smoothed version. Try turning the display of the cage (the Control Mesh) on and off to understand the smoothing process. In any case, you'll see the kind of crease behind the knee that you achieved in the previous exercise with vertex weighting. Your screen should look something like Figure 21.18. Note the fine segmentation around the kneecap.

16. The proof of the pudding is in the rendering, so get a close-up view of the bent knee and make a test render. The bend and crease should look smooth and convincing, as in Figure 21.19.

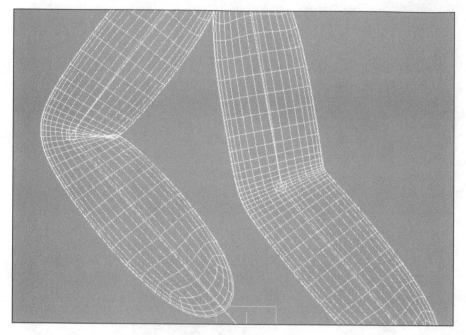

Figure 21.18
Same as Figure 21.17, but with MeshSmooth turned back on and set to three iterations. The crumpled area in the cage generated a pleasing crease in the smoothed version. Note also the fine segmentation around the kneecap.

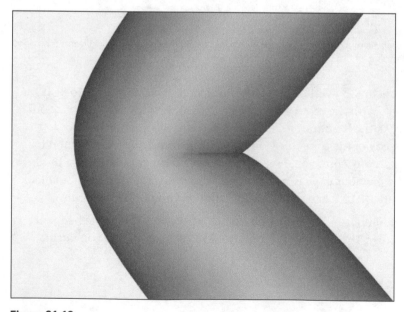

Figure 21.19
A close-up render of the forward knee, showing the smoothness of the bend and the crease.

IDEAS FOR WORKING WITH MESHSMOOTHED CAGES

Animating with MeshSmoothed cages has many advantages beyond smoothness and easy vertex weighting. One of the most important is previewing speed. By disabling MeshSmooth, you can play animation in the viewports using only the low-poly cage. This kind of view will run much faster than using a finished mesh. It can also be easier to recognize motion and timing issues when previewing the animated cage, instead of the high-density mesh.

MAX also allows you to use a different number of MeshSmooth iterations in the viewports than are used for rendering. That makes it easy to use a fast, low-iteration version in the viewport while using the fully smoothed version in your test renders.

The Morpher Modifier

Prior to MAX 3, morphing between morph targets was possible only through the Morph Compound Object. A Morph Compound Object contains all of the morph targets associated with a single object, and you can morph between these targets by setting keyframes associated with individual targets. This tool is very simple and workable, but is far less powerful than those offered by the most important competing packages. As part of the move to make MAX a serious player in the character animation world, MAX 3 has introduced the Morpher modifier. This new tool is fantastic—a remarkable combination of power and ease of use. The Morph Compound Object is still in the program, undoubtedly for purposes of backward compatibility. It has been functionally replaced by the Morpher modifier, however, so only this new toolset is discussed here.

The best way to understand the Morpher modifier is to work with it. The exercise in this section will introduce you to all of the basics.

Creating Morph Targets

Morphing requires morph targets. As explained earlier in this chapter, all morph targets for a single model must be created by editing the original geometry. This means that you start with a base version of the model (often called an "anchor object" in 3D animation parlance) and move vertices or control vertices to create the various targets. There will be occasions in which this will be too difficult to do because the intended morph target is very different from the anchor object (e.g., a box morphing into a sphere). MAX's Conform Compound Object provides a method by which a mesh can be "shrink-wrapped" to fit another object. This method can be used to create multiple morph targets from a single mesh without editing vertices. But the "shrink-wrap" method is only rarely useful, and the results are not always very good. In this exercise, you stick to the basic method, which is at the very heart of the character animator's skill set:

1. In a perspective view, create a Sphere object on the groundplane. Convert the object to an Editable Mesh and copy it a couple of times to the right to create three identical models along the world x-axis.

2. Maximize your front viewport to get a good view of the three objects in a line. Leave the one on the left as the base or anchor object. This is the default version that will be morphed by its targets. Select the middle sphere and rename it "up target." Select some rows of vertices on the top of this object and translate them sharply upward. Now, go to the rightmost object and rename it "down target." Move some rows on the bottom of the object downward. When you're done, your front view should look like Figure 21.20.

Figure 21.20
The base (or anchor) object at left is the original Editable Mesh that will be morphed. The two targets at center and right are created by selecting and translating vertices.

Applying The Morpher Modifier

Once the morph targets are created, you're ready to morph by applying the Morpher modifier to the base object and selecting the targets:

3. Select the base object (Sphere01) and apply a Morpher modifier to its stack. The Morpher panel appears. The Channel List rollout indicates all of the current morph targets. Because you haven't selected any yet, all the channels read "empty."

4. Pull down to the Channel Parameters rollout and open it, if necessary. Channel 1 is currently selected. Click on the button that reads Pick Object From Scene and then click on the up target object in the viewport. Now, test the result by dragging the Channel 1 spinner in the Channel List. As you increase the value between 0 and 100, the anchor object morphs into the up target. Figure 21.21 illustrates with a value of 50 percent.

5. Click on the second channel in the Channel List to activate it and apply the down target object to this channel. Play with the spinner of both channels to see how both morphs are added together. Because the edited vertices in each target are different, both targets can be used together. Imagine the first target as controlling the shape

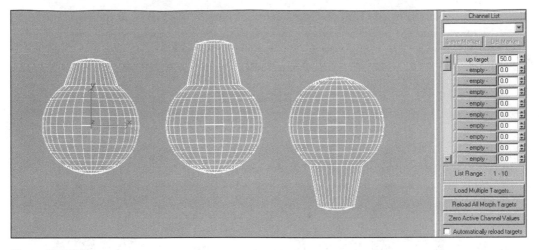

Figure 21.21
The up target model (center) has been used as a morph target for the anchor object in Channel 1. With the value in the Channel 1 spinner set to 50 percent, the anchor object is morphed halfway into the target.

of the eyebrows on a head and the second as controlling the mouth. The power to add morph targets together permits you to create specialized targets affecting only narrow areas and blend them together in animation. Figure 21.22 illustrates both targets applied together.

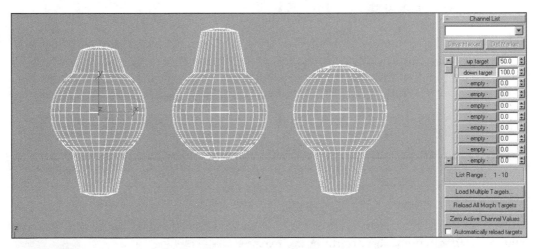

Figure 21.22
The down target model is added to the Channel List in the second channel. Because the edited regions of the two targets are different, they can be used together to create an additive result.

6. After you create an additive result, it may make sense to save it out as an independent morph target of its own so that you can grab it whenever you need it. Adjust your channels to produce some combination of both targets, as shown in Figure 21.22. Then, activate the empty Channel 3. In the Channel Parameters rollout,

press the button titled Capture Current State. In the dialog box that appears, name the new target as "both" and press the Accept button. The new target appears in the third channel. To test it, reduce the first two channels to 0 and then increase the third channel to 100. Your result should look the same as when you created the new target. See Figure 21.23.

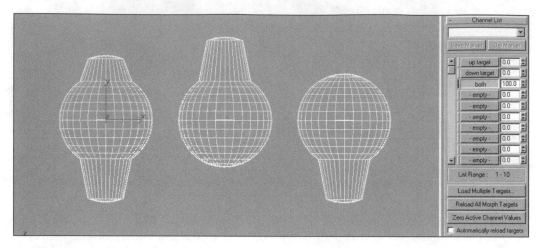

Figure 21.23
The blended result in Figure 21.22 was made into a new morph target in the third channel under the name "both". With this channel set to 100 percent, and the others set to zero, the result is the same as when the first two channels were blended.

7. There are some excellent tools for managing the Channel List. Delete the first two channels by right-clicking on each. Now, there's empty space above the third channel. Open up the Advanced Parameters rollout and press the button titled Compact Channel List. Note how this moves the third channel to the top of the list.

8. Delete the first channel to create an empty list. This time, load both targets at once. Press the button titled Load Multiple Targets and select the two target models from the list. When you finish, down target and up target will be loaded into the first two channels.

Making The Most Of Targets

Once your targets have been loaded into channels, you have more flexibility with them than you might first imagine. Let's continue our exercise:

9. Open the Global Parameters rollout and note the spinner that limits the range of percentage values. By default, you are confined to values between 0 and 100 percent. Uncheck the Use Limits box and set a value for the down target channel that is greater than 100 percent. Note how this extrapolates the target beyond its original limits, saving you the trouble of having to re-edit your morph targets on many occasions. Now, set the up target channel to a negative value and watch how the morph is extrapolated in the opposite direction. You can use this to turn a smile into a frown. Your screen should look something like Figure 21.24.

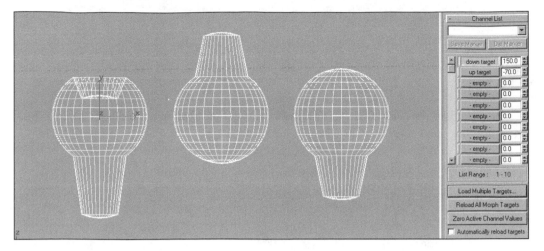

Figure 21.24
With the percentage limits off, you can morph to values greater than 100 percent and less than zero (producing a negative morph).

10. Click on the button titled Zero Active Channel Values to return all the channels to a zero value. Now, try editing the morph targets. Select the up target object (the Editable Mesh, not the channel in the Morpher modifier). Move the previously edited vertices over to the right to create a slanted top. Return to the base object and increase the up target channel. The object will morph as it did before. To use the newly edited version, right-click on the channel to reload the target. Now, the morph will use the slanted version, as illustrated in Figure 21.25. Note that if the box titled Automatically Reload Targets is checked, you don't need to reload after editing a target.

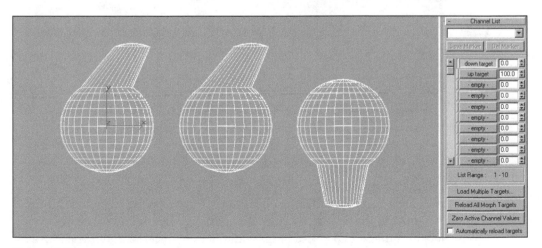

Figure 21.25
The up target model has been re-edited to create a slanted top. After reloading the target into its channel, the morph incorporates the new version.

Animating The Morphs

Now that you know how to set up morph targets, let's continue our exercise by animating with them:

11. Reset all channel values to zero and then turn on the Animate button. The plan is to pull out the top in the first 26 frames and then pull out the bottom in the next 25 frames. Pull the Time Slider to Frame 25 and set the up target value to 100 percent. Note that keys appear in the Track Bar at Frames 0 and 25. Pull the Time Slider to confirm that the top of the object morphs up over these 26 frames.

12. Move to Frame 50 and set the down target value to 100 (leaving the up target also at 100). Turn off the Animate button and drag the Time Slider to see the result. This is not what you want—the bottom starts morphing at Frame 0, not at Frame 25, as you expected. Confirm this by watching the down target spinner values as you pull the Time Slider.

13. To understand and correct this problem, open Track View and pan your front viewport down so that you can see everything at once. In Track View, open the tracks for the base object (Sphere01) until you find the tracks for the morph targets under the Morpher modifier. Select the down target track and change to a function curve view. As you can see in Figure 21.26, the down target track is changing values continuously between Frame 0 and Frame 50. The key you set at Frame 25 did not affect this track.

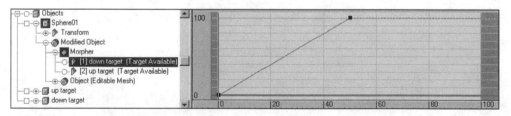

Figure 21.26
The function curve for the down target track shows the morph building continuously between Frames 0 and 50.

14. To fix this, create a key at Frame 25 and set it to a zero value. The default spline interpolation will create an extreme curve, so correct the interpolation to get a straight line between the first two keys and a smooth, rising curve between the second and third keys. (Methods for adjusting interpolation are discussed in Chapters 19 and 20.) When you finish, your function curve should look like Figure 21.27.

15. Pull the Time Slider to confirm that the animation is now working as intended. As a final step, try moving the keys in the Track Bar to change the timing of the two morphs. Note that the second key contains both tracks at once, so that if you move it forward, the first morph slows down and the second speeds up. It takes quite a while to master the animation of additive (overlapping) morphs. Take some serious time to explore this subject.

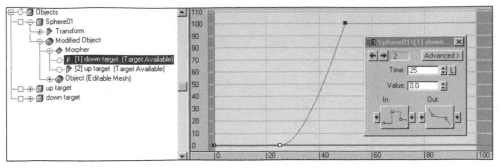

Figure 21.27
The function curve shown in Figure 21.26 is corrected by the addition of a key at Frame 25. After adjusting the interpolation, the morph holds a constant zero value until Frame 25, and only then begins to build.

Morphing Materials

Morphing geometry is often associated with animated materials. For example, a character's cheeks might change color when it morphs into an angry scowl. MAX 3 has introduced a new material type that automatically ties material definitions to morph targets. You can try it out on the animation we've been working with:

16. Change to a Smooth + Highlight view. Open the Global Parameters rollout in the Morpher panel and press the button titled Assign New Material. You'll see your base object assume the default gray material.

17. Open the Material Editor and pick a slot. Press the Get Material button to bring up the Material/Map Browser. Use the Selected option to find the Material on the selected object and double-click on its name to load it into the slot. When this is accomplished, the panel for the Morpher Material type will appear in the Material Editor, as shown in Figure 21.28.

18. Open the Base Material (Default Material) by clicking on the button and set its Diffuse Color parameter to red. Go back up to the top level for the Morpher Material; then, click on the Mat 1 slot and assign it a Standard Material. Set the Diffuse Color of this Material to green. Finally, put a Standard Material in Mat 2 and make its Diffuse Color blue. Pull the Time Slider and watch your viewports. If nothing happens, don't be surprised. Check the bottom of the Morpher Material panel to make sure that the Always radio button is selected under Mixing Calculation Options. In theory, this should show the color morphing in a shaded viewport, but it was not functioning in my developmental version of MAX 3. This may be fixed in the final release of the program. In any case, such calculations are very processor-intensive, and if your display slows down too much, switch to the When Rendering option.

19. Render out the animation to a file and view the result.

Figure 21.28
The panel for the Morpher Material type in the Material Editor. The numbered material slots correspond to the channels in the Morpher modifier.

The XForm And Linked XForm Modifiers

The XForm modifier is used to bring the transforms (Move, Rotate, and Scale) into the modifier stack, overriding the general operation of MAX, in which transforms are only applied to objects after they have emerged from the end of the modifier pipeline. The XForm modifier is of considerable general importance in MAX, but one of its most valuable applications is to implement cluster animation. As mentioned earlier in this chapter, *cluster animation* is the animation of groups of vertices or control vertices as defined units. For example, the vertices at the corners of a mouth can be defined as a cluster and then animated. Raising the cluster causes the character to smile and lowering the cluster causes it to frown. Cluster animation can be a very useful alternative to morphing because translating vertex selection sets is often a more intuitive concept than interpolating between morph targets.

You can animate the XForm gizmo that contains the selected vertices, but a cleaner approach involves parenting that gizmo to another object, typically a Dummy, by using the Linked XForm modifier. That way, you can transform the XForm gizmo (and therefore the cluster) by transforming the object. A short exercise will be enough to get you started.

Cluster Animation With A MeshSmoothed Cage

In the following exercise, you make a simple mouth and animate the corners of the lips with the XForm modifier:

1. Create a Box object on the groundplane to serve as the mouth. It should be short and wide, and divided into three segments across. Use Figure 21.29 as a guide from a front view.

Figure 21.29
A Box object in a front view to serve as an animated mouth.

2. Collapse the Box to an Editable Mesh. Put a Mesh Select modifier on the stack and use it to select all the vertices at the right and left ends of the object. The panel indicates that eight vertices have been selected.

3. Add an XForm modifier on top of the Mesh Select. The XForm will be passed only the selected vertices, which are now under the control of the XForm gizmo. Move the XForm gizmo upward to raise the cluster. Your front view should look like Figure 21.30.

Figure 21.30
The vertices at the ends of the mouth are selected in a Mesh Select modifier and then passed to an XForm modifier. Translating the XForm gizmo translates the cluster.

4. This doesn't look much like a mouth, so give it some organic subdivision. Place a MeshSmooth modifier at the top of the stack and kick the iterations up to 2. Now, your mouth should look like Figure 21.31. Go back to the XForm modifier and move it up and down to test the result. You can always increase the number of iterations of MeshSmooth to achieve a smoother end product.

Figure 21.31
Same as Figure 21.30, but with a MeshSmooth modifier applied above the XForm.

Using A Finished Mesh

To get a smooth result, you used XForm on a cage and applied MeshSmooth at the top of the stack. What happens if you start with a finished mesh? Let's continue our exercise to find out:

5. Delete the Mesh Select and XForm modifiers from the stack. Increase the iterations of MeshSmooth to 3 and then collapse that modifier into the Editable Mesh. This results in a dense Editable Mesh object without any modifiers in its stack.

6. Put a Mesh Select modifier on the stack and use it to select only the single vertices at the very ends of the mouth. You have to zoom in a bit to get these. The panel should indicate that only two vertices are selected.

7. Go to the Soft Selection rollout at the bottom of the Mesh Select panel and check the Use Soft Selection box. You'll now see a gradient of colored vertices that extend inward from the selected ones. You are creating, in effect, a "soft cluster."

8. Place an XForm modifier on the stack and move its gizmo up to create a smile. You may not be happy with the shape of the mouth right now, so go back down to the Mesh Select modifier and make sure that you can see all the way up the stack (using the Show End Result toggle). Play with the spinners in the Soft Selection rollout to get a pleasing result, as shown in Figure 21.32. There's a remarkable amount of flexibility here, especially when you consider that the Soft Selection parameters can be animated to produce subtle changes in expression.

Animating The Cluster With Linked XForm

Now that you can deform the mouth, you can animate the deformations by keyframing the XForm gizmo in different positions. Grabbing the gizmo means having to enter the modifier stack of the object. In a full character, it generally makes more sense to link the gizmo to a Dummy object using Linked XForm. Finish the exercise by creating this kind of setup:

Figure 21.32
A high-density finished mesh is deformed smoothly by using a Soft Selection, which is passed an XForm modifier. This produces a kind of "soft cluster."

9. Create a Dummy object some distance above the mouth. This will be the controller that "pulls the strings" of the selected cluster. Check from different views to make sure that the Dummy is in the same vertical plane as the mouth and is above the very center of that object.

10. Delete the XForm modifier from the stack of the mouth object and replace it with a Linked XForm modifier. Press the button titled Pick Control Object and then click on the Dummy.

11. Select the Dummy and move it up and down to move the cluster. Your screen should look like Figure 21.33 when it's been moved down to create a frown.

12. Turn on the Animate button and try setting some keyframes by moving the Dummy. After you do, you can adjust the timing by moving the keys in the Track Bar. On a real model, you could name the Dummy "mouth cluster" and edit its function curves in Track View.

Other Deformation Tools

Skeletal deformation, morphing, and cluster animation are, by far, the most important tools in character animation. But the character animator must also be aware of some other tools for animating deformations that MAX 3 offers.

Path And Surface Deformation

Path and surface deformation are often the only ways to get the result that you want in 3D animation. *Path deformation* deforms an object along a spline path (either Bezier splines or NURBS curves). The object assumes the shape of the path as it moves along it; thus, a long cylinder will slither like a snake if animated along a wavy deformation path. *Surface deformation* conforms

Figure 21.33
A Dummy object positioned above the mouth is used to control the cluster via a Linked XForm modifier.

the shape of an object to a surface. The classic example is a tear dripping down a cheek, but the possibilities are endless. Some fantastic results are possible with surface deformation when the deforming surface is hidden, and therefore invisible in the final render.

In MAX 3, path deformation is handled through two PathDeform modifiers. Surface deformation is divided between the SurfDeform modifiers and the PatchDeform modifiers. The SurfDeform modifiers are used when the deforming surface is a NURBS surface, and the PatchDeform versions are used when the deforming surface is a Bezier patch. All three types of modifiers come in two "flavors": Object Space modifier and World Space modifier (WSM). Without getting into the confusing details, it's enough to say that the World Space versions are superior for most applications because they bring the deformed object to the deforming object, rather than vice versa.

Figure 21.34 illustrates the use of PathDeform. A NURBS curve was drawn as a path (although I could have used a Bezier spline). An extruded text object was given a PathDeform(WSM) modifier and then put to the path. It's necessary both to select the path and to instruct the object to move to that path. Once on the path, you need to select the correct local axis of the deformed object and rotate the object around that axis, as necessary. You can then move the object along the path (as a percentage distance) and set keyframes to animate this movement. The image shows a small amount of stretch applied to the deformation.

Figure 21.35 illustrates surface deformation using the SurfDeform(WSM). The text object is deformed by a NURBS sphere. The parameters and methods are essentially the same as those of the PathDeform modifier, except that they are applied in two dimensions instead of one. Translating the deformed object moves it away from (or closer to) the surface.

Figure 21.34
An extruded text object with a PathDeform(WSM) modifier applied. The object is positioned midway along the path and a small amount of stretch has been applied.

Figure 21.35
The extruded text object is deformed by a NURBS sphere using the SurfDeform(WSM) modifier. The object has been translated a bit off the surface for greater impact.

Flex

The Flex modifier, new to MAX 3, adds elasticity to objects. It's very easy to use. Once a Flex modifier is added to the stack, an animated object deforms in a flexible, springlike way. The object stretches as if resisting the motion and then swings back into position after the motion stops. Three parameters—Flex, Strength, and Sway—control the character of the effect, essentially controlling the elasticity of the object.

The axis of the flex is determined by the position of the subobject center. This is the point that remains rigid and follows the underlying motion exactly. Color-coded vertices, similar to those found in the Skin modifier or the Soft Selection tools, indicate the flexibility gradient across the object. The weighting of these vertices can be edited to get very precise results. You can also apply space warps, such as gravity and wind, to a Flex modifier, causing it to behave elastically under these forces.

Figure 21.36 shows a Flex modifier in action. A Box object is animated to rotate from lying flat to standing straight. The center of flex is at the object's pivot point. The other end flexes backwards as if resisting the rotation.

Figure 21.36
The Flex modifier in action. A Box object is animated to rotate from lying flat to standing up straight. The center of flex is at the object's pivot point. The other end flexes backward as if resisting the rotation.

Moving On

In this chapter, you learned about the tools used to deform geometry, primarily for the purposes of organic character animation. You explored the process of skeletal deformation with the Skin modifier, learning how Envelopes are used to control vertex weighting. You then examined target morphing with the Morpher modifier. You moved on to learn about how the cluster animation of vertices is achieved with the XForm and Linked XForm modifiers. Finally, you took a brief look at the path and surface deformation and the new Flex modifier.

In the next, and final, chapter, you'll explore some specialized animation toolsets, including space warps, expressions, particle systems, and dynamics.

SPECIAL ANIMATION TOPICS

MAX boasts a few powerful animation features that you probably won't be using every day. The MAX animator still must be aware of these tools and be able to call on them when the need arises.

This chapter touches on some special animation tools that every MAX animator must understand in at least a basic way. Space warps are like modifiers that operate in world space, rather than in the local space of individual objects. Thus, objects with binding to space warps change shape as they move through space. Space warps also provide the motive forces for dynamic simulations, which are animations that are computed by applying physical principles to objects and forces.

Particle systems are used to manage the animation of large numbers of objects that share a common behavior or that are meant to be perceived as fluids. Falling snow and water fountains are characteristic uses of particle systems.

Expressions are simple units of programming code used in expression controllers to precisely define animated movement. They are often used to create interdependent systems in which the animation of one object automatically controls the animation of other objects.

Space Warps

It's hard to characterize space warps because a number of related but distinct ideas are clustered under this title. The term *space warps* implies the curved space of relativistic physics. Einstein introduced the notion that the motion of objects in the universe could be better understood as expressing a curvature of the space in which they moved. This is undoubtedly a very subtle idea that is comfortable only for mathematicians and physicists, but it takes on practical meaning in MAX.

Visualize MAX's world space system as a 3D network of points connected by lines. In a pure Cartesian system (such as the default world space), all of the points are at equal distances from their neighbors, and the lines connecting them are rectilinear. Now, imagine this network of points and connecting lines being subjected to heat so that it begins to melt and sag. The points are no longer at equal intervals (measured in the conventional way) and the network of connecting lines is no longer strictly rectilinear. (A similar idea can be visualized

in 2D by comparing a fishing net pulled taut with a net that's allowed to hang loosely.) If, despite the distortion, the points continue to be used for measurement of other objects, the objects subject to such "measurement" will appear deformed in comparison to those defined by the metric of a purely rectilinear space.

Space warps in MAX are created and then bound to specific objects. If you create a space warp and fail to bind it to any objects, it will have no effect. If you bind it to some objects and not others, only those that are bound will express the space warp. Thus, unlike Einstein's space warps, which affect all matter and energy, MAX's space warps are selective.

Space warps can be used for modeling purposes, but play a much more significant role in animation. In some cases, the space warp provides the "force" that generates or shapes a motion path. In others, a space warp is used to deform an object as it moves through the deformed space generated by the space warp. Space warps are not tools that most people pick up readily, nor are their creative applications always obvious. But the general MAX practitioner must have a good basic grasp of their organization and potential.

Two Classes Of Space Warps

To best understand the organization of the space warps, take a look at the drop-down list in Create|Space Warps from the Command panel shown in Figure 22.1.

The space warps can be generally divided into two classes. First, they can be used to deform the geometry of standard objects as these are moved though the deformed space. These kinds of space warps are included under the Geometric/Deformable and Modifier-Based headings:

- Geometric/Deformable
 - FFD(box)
 - FFD(cyl)
 - Wave
 - Ripple
 - Displace

Figure 22.1
The drop-down list of space warps under the Create tab of the Command panel.

- Conform
- Bomb
- Modifier-Based
 - Bend
 - Noise
 - Skew
 - Taper
 - Twist
 - Stretch

The names of all these space warps may already be familiar to you from other parts of MAX. There is a Conform Compound Object, and all of the other names (except Bomb) are those of modifiers. Only the Bomb is completely unique to the space warps. Thus, in almost every case, these space warps are world space deformation versions of other tools that operate only in the local space of the model.

The space warps in the first class apply to objects that are not necessarily animated. Of course, they almost certainly are animated, but the space warp does not depend on existing animation. The space warps in the second class apply to certain objects that are necessarily animated, and the purpose of the space warp is to influence or control their motion paths. These objects are either particle systems or objects that are included in a dynamic simulation. In the case of dynamic simulations, space warps provide the forces (such as gravity) that drive the simulation. Dynamic simulations can be created using any kinds of objects. Particle systems are inherently animated by the action of their particle emitters, and space warps are used to shape the path of the animated particles. Thus, the second class of space warps includes those that can be used either on particle systems or dynamic simulations:

- Particles & Dynamics
 - Gravity
 - Push
 - Wind
 - Motor
 - PBomb
- Particles Only
 - POmniFlect
 - UOmniFlect
 - SOmniFlect
 - Deflector
 - SDeflector

- UDeflector
- Path Follow
- Dynamics Interface
 - PDynaFlect
 - UDynaFlect
 - SDynaFlect

The second class of space will be considered later in this chapter, in the context of dynamics and particle systems. For the present, look at the space warps of the first class.

Space Warps For Geometric Deformation

The grouping of the space warps of the first class into two headings is not especially helpful. All of the ones in the Modifier-Based group are space warp (world space) versions of regular modifiers, but the same is true of almost all of the space warps in the Geometric/Deformable group. In any case, all of them deform object geometry as it moves through the deformed space created by the space warp.

A First Example

Let's try a simple example that demonstrates the difference between modifiers and space warps, as follows:

1. Create a thin, tall Box object on the groundplane, and give it enough segmentation so that it is capable of bending smoothly. Drag a copy of the Box a little way off to either side. Place a Bend modifier on one of the two copies and give the object a noticeable bend.

2. Create a Bend space warp on the groundplane, about the same size as the Box (choose Create|Space Warps|Modifier-Based in the Command panel). Bend the space warp and note that it has no effect on either object. A front view should look something like Figure 22.2.

3. To give the space warp effect, you must bind it to the object. Click on the Bind To Space Warp button on the Main Toolbar to activate it. Now, click on the unmodified Box and drag it to the space warp. When you release the button, the Space Warp gizmo should briefly light up, indicating that the binding has occurred. A second later, the Box will assume the bend. Check the modifier stack of this Box to confirm that a Bend Binding is placed on the stack. Your screen should now look like Figure 22.3.

4. Press the select arrow on the Main Toolbar to get out of the binding mode (this is easy to forget). Move the two Boxes in different directions, and notice the difference between the modifier bend and the space warp bend. The modifier bend is local to the object and moves with it. Moving the object doesn't change the bend. This is a reflection of a basic fact about MAX—that transforms are applied after the object is output from the modifier stack. In contrast, the space warp version changes shape

Figure 22.2
Setting up for a space warp. At left, a segmented Box object with the Bend modifier applied. At right, a copy of the same Box without any modifier. At center, a Bend space warp that has not yet been bound to an object.

Figure 22.3
After binding the space warp to the Box on the right, that object assumes the bend of the Space Warp gizmo. Note that this bend is a projection of the bend in the gizmo.

as you move it. It's as if the Space Warp gizmo is being used to deform the entire world space for any object bound to it. Your screen should look something like Figure 22.4. For this system to work, space warps must be applied after object transforms. Open up Track View and expand the tracks to see that a Space Warps track appears on top of the Transform track for the affected box.

Figure 22.4
Moving the Box on the left with the Bend modifier does not affect its shape because transforms are applied after modifiers. In contrast, moving the Box with the space warp changes its shape because space warps are applied after object transforms. The position of the Box in the deformed space determines its shape.

5. Using the Animate button, cause the space-warped Box to move between frames 0 and 100. Note the effect of the space warp on the animated object. When you're done, delete the Bend Binding from the modifier stack. The Box is no longer deformed by the space warp.

Some Useful Space Warps

In my experience, only a few of the space warps that deform geometry have practical significance.

The Wave and Ripple space warps have modifier versions, but often make more sense as space warps in animation because you move the object through the space warp rather than the modifier gizmo through the object. Figure 22.5 shows a Wave space warp bound to a polygonal grid. Note that the pattern established by the Space Warp gizmo extrapolates out into world space in all directions, invisibly repeating the same pattern. The gizmo shows only two wave crests, but the longer grid contains three. This is a great illustration of the way space warps deform all of world space.

The Conform space warp shares the basic concept of the Conform Compound Object in that it "shrink-wraps" one surface to another. Although the Conform Compound Object is used primarily to create morph target models, however, the Conform space warp is best used to animate surfaces to follow other surfaces. This may remind you of the SurfDeform(WSM) discussed in Chapter 21, but there are important differences. For one, the deforming surface

Figure 22.5

A Wave space warp is used to deform a polygonal grid. The pattern established by the Space Warp gizmo extrapolates out into world space in all directions, invisibly repeating the same pattern.

need not be a NURBS surfaces. Second, the deformation in the Conform space warp uses a kind of "gravity" concept, in which the deformed object is projected in a linear direction on the deforming object. In Figure 22.6, a polygonal grid bound to a Conform space warp is projected onto a Cylinder object.

The Bomb space warp is unlike any of the others in that it has no parallel modifier or compound object elsewhere in the program. It also differs because it creates its own animation, somewhat analogous to the explosion in a Combustion effect. In any case, the explosion involves breaking the object up into its individual faces and scattering them. The minimum and maximum number of faces in each fragment can be set with spinners. Note that the Bomb is called the MeshBomb in its Modify panel, presumably to distinguish it from the PBomb for particle systems.

The location of the Bomb gizmo determines the center of the explosion. Figure 22.7 illustrates an exploding sphere with the gizmo placed in the center of the object. A small amount of Spin and Chaos in the parameters gives the result a more random look that helps disguise the obvious regularity of the fragment sizes. The detonation can be set to occur at any desired frame. A Gravity parameter causes the fragments to settle down to earth.

Figure 22.6
A polygonal grid, bound to a Conform space warp, is projected vertically onto a Cylinder object.

Figure 22.7
A polygonal sphere is exploded by a Bomb space warp placed in the center of the object. A small amount of Spin and Chaos in the parameters creates a more random look that helps to disguise the regularity of the fragments.

Dynamic Simulations

A *dynamic simulation* is an animation created entirely by the application. The user provides all of the necessary physical information about the objects and the forces acting on them, and the computer figures out the consequences. The results are function curves that can either be used as is or edited.

Dynamic simulations tend to be useful in three instances:

- In scientific, commercial, and forensic visualizations in which the user relies on the physical accuracy of the animation

- In entertainment contexts in which a realistic behavior of an object might be hard to imagine

- In any case in which multiple objects interact with each other (e.g., balls on a billiard table)

Dynamic simulations in MAX always involve space warps, because space warps are used to provide the motive forces. The Gravity space warp applies a constant acceleration in a specified direction. The Wind space warp is similar to Gravity, but it introduces an element of turbulence. The Push space warp creates a directional force at a specified point. The Motor space warp applies a rotating force to the objects in the dynamic simulation.

A Basic Simulation

Dynamic simulations can be very complex and can consume extraordinary amounts of processing power. MAX also provides extremely sophisticated tools for specifying the physical parameters of the objects involved in the simulation. In this book, I'll introduce you to the toolset, but any serious use of the full power of dynamic simulations requires considerable experimentation and a firm grounding in physical principles. (This is a kind of education that relatively few 3D animators have.)

A dynamic simulation consists of objects and forces. The objects can be either standard geometric objects or particles systems. Although this chapter sticks to standard geometric objects, note that the DynaFlect series of space warps allows particle streams to "push" an object in a dynamic simulation. To create a dynamic simulation, you must determine which objects in the scene are included in a given simulation and assign forces (called *effects*) to these objects. You must also determine the physical properties of the objects.

The following exercise gets you started:

1. Create a smallish Sphere object on the groundplane. Pan your front view vertically so that you have room to watch the object fall downward.

2. In a top view, create a Gravity space warp (choose Create|Space Warps|Particles & Dynamics). It doesn't matter where you create it as long as you do so in the top view. Check the other viewports to confirm that the arrow in the Space Warp icon is pointing down (in the world z-direction).

3. To create the simulation, go to the Utilities tab in the Command panel and click on the Dynamics button. This utility panel consists of two rollouts: one named Dynamics and one named Timing & Simulation. Because there is no current simulation, almost all of the controls are grayed out. Press the New button to create a simulation with the default title Dynamics00.

4. To put objects into the simulation, press the button titled Edit Object List. The Edit Object List dialog box appears, as shown in Figure 22.8. The left window contains all of the objects that are available for inclusion in the simulation. Use the right arrow key to move the Sphere01 object to the left window. The object is now included in the simulation.

Figure 22.8
The Edit Object List dialog box. On the left side are all of the objects available for inclusion in the simulation. Moving the Sphere01 object to the right side causes it to be included in the simulation.

5. The next step is to assign the space warp as an effect in the simulation. Press the Edit Object button to bring up the Edit Object dialog box. As you can see in Figure 22.9, this is a complex panel. The Sphere01 object is specified in the OBJECT: drop-down list in the upper-left corner. If there were more objects in the simulation, they could be chosen from a drop-down list. Note that the density of the object is assigned a value of 1g/cc (one gram per cubic centimeter), which necessarily determines the object's mass in grams. Because the acceleration of objects under gravity is independent of mass, the mass or density of the object does not matter in this simple simulation. (Think of the fictitious story of Galileo dropping balls from the Leaning Tower of Pisa, in which balls of different weights [masses] fell at the same rate.)

6. You can assign effects globally to all objects in a simulation, or you can assign effects individually to objects. Note that Effects By Object is the default in the Effects

Figure 22.9

The Edit Object dialog box, showing the parameters for Sphere01. The density of the object is assigned a default value of 1 gram per cubic centimeter, which produces a mass (weight) in grams, based on the volume of the Sphere. The mass or density is irrelevant to the acceleration of an object falling due to gravity.

section of the Dynamics rollout. Click on the Assign Object Effects button at the top of the Edit Object dialog box. The Assign Object Effects dialog box appears, as shown in Figure 22.10. All available effects (the space warps) are listed in the left window. Use the right arrow button to move the Gravity effect to the right window.

7. To solve the simulation, first consult the default values in the Timing & Simulation rollout. The simulation will be computed from Frame 0 to Frame 100. Keys will be created at every single frame. There will be no air resistance because the Density spinner is at 0. Return to the Dynamics rollout and look at the Solve section. Check the box titled Update Display w/ Solve in order to see your solution develop in the viewport. This slows down the process quite a bit and is only useful for simple simulations. Now, press the Solve button and watch what happens.

8. You should see the Sphere moving downward, accelerating as it goes along. If the Sphere is selected, you'll see the Track Bar fill up with keys at every frame. Play the animation to see the result. You may have to zoom out for the entire animation to be visible in a front view.

9. To figure out what happened, open Track View and expand all the Transform tracks for the Sphere object. Make the controller types visible by using the Filters dialog box. As you can see in Figure 22.11, the Position and Rotation tracks have been automatically assigned a Dynamic Position controller and a Dynamic Rotation controller. Each of these is the parent of two children. The first child controller con-

Figure 22.10

The Assign Object Effects dialog box for the Sphere object in the simulation. All available effects (the space warps) are listed in the left window. Moving the Gravity effect to the right window causes it to be applied to the Sphere in the simulation.

tains the keys set by the simulation, using the controller types already in place (Bezier Position and TCB Rotation, if you have not changed the defaults). The second child contains the animation (if any) prior to solving the simulation. Select the first child controller for Position and change to a Function Curves view. As illustrated in Figure 22.11, you see a pretty crowded picture. A function curve with keys on every frame is called a "raw function curve," and it is the typical result of input from simulations or motion capture. Even so, you can see that the z-function curve is bending downward at a constantly accelerating rate.

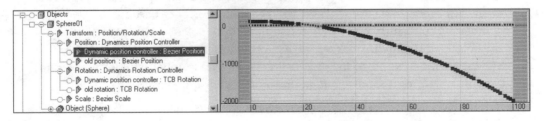

Figure 22.11

The position function curves generated by the simulation are "raw" curves with keys at every frame. The z-function curve is bending downward at a constantly accelerating rate.

10. This function curve is editable, but editing it could be hard work because it has so many keys. One approach is to resolve the simulation with the Keys Every N Frames spinner set to a higher value than 1. For example, at a value of 5, keys are created only at every fifth frame. Although this is fine for such a simple animation, a safer practice is to compute a solution with the maximum amount of samples (one per

frame) and then optimize the resulting function curve in Track View. To do this, enter the Edit Time mode in Track View and select the complete time segment by dragging across the position track with the 101 keys. With all frames from 0 to 100 selected, press the Reduce Keys button on the right side of the Track View toolbar. The Reduce Keys dialog box appears. Accept the default Threshold value of 0.5 and press OK. You'll see almost all of the keys disappear. Switch to a function curve view to see the result. As shown in Figure 22.12, almost all of the keys have been eliminated, but the shape of the curve is almost unchanged. This is now a highly editable function curve.

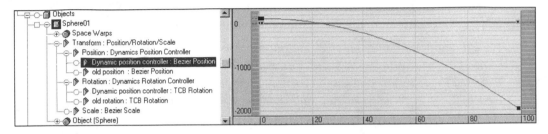

Figure 22.12
The raw function curve from Figure 22.11, after optimization by using the Reduce Keys tool. The shape of the curve is essentially unchanged, but it is now highly readable and editable.

11. The parent-child controller structure preserves any animation you had before solving the simulation. To restore the original animation, you copy and paste the "old position" and "old rotation" controllers. Your scene was unanimated, but let's use the same technique to restore the state of the scene prior to the simulation. In Track View, click on the "old position" controller to select it, and then press the Copy Controller button on the left side of the Track View toolbar. Select the parent position controller and press the Paste Controller button. Accept the default Copy option and note that you're back to your default Bezier Position controller. Do the same thing with the rotation controllers.

Adding Collisions

The real power of dynamic simulations is in collisions; at this point, however, the subject gets extremely complex. The following is a simple exercise to introduce you to the basic concepts and methods (this is a mere beginning to any serious exploration):

1. Create a Sphere with a radius of 10 and position of 100 units above the center of the groundplane, at (0,0,100) in world coordinates.

2. Create a thin Box object on the groundplane directly beneath the Sphere. Make it about 100 units in width and length, and only 1 or 2 units high. You may wonder why you are not creating a flat 2D surface, such as a plane object. The collision-detection tools do not produce reliable results with such surfaces, so it's advisable to stick with 3D objects in dynamic simulation.

3. Create a Gravity space warp in a top view to create a downward force on the Sphere.

4. Everything is now in position. Open the Dynamics utility and create a new simulation. Open the Edit Object List dialog box and move both objects (the Box and the Sphere) into the simulation.

5. The next steps require a bit more thought. The Sphere is to fall under the influence of gravity and bounce when it collides with the Box. The Box, on the other hand, will remain fixed and rigid throughout the entire simulation. Open the Edit Object dialog box and select the Sphere from the OBJECT: drop-down list, if it's not already selected. Press the Assign Object Effects button and assign the Gravity effect to the Sphere. This causes it to fall, as it did in the previous exercise.

6. Press the button titled Assign Object Collisions. You see the Assign Object Collisions dialog box, shown in Figure 22.13. Its purpose is to determine which objects should be tested for collisions against the currently selected object. Move the Box object over to the right window so that the Sphere recognizes collisions with the Box. Press OK to close the dialog box.

Figure 22.13
The Assign Object Collisions dialog box for the currently selected (Sphere) object. After the Box object is moved to the right window, the simulation tests for collisions between the Sphere and the Box.

7. The Collision Test section of the Edit Object dialog box is very important. Collision testing between objects is extremely processor intensive. The Mesh option here provides the most accurate test, but its computations can be unreasonably time consuming. Whenever possible, it makes sense to use a simplification of the geometry. Because your current object is already a Sphere, it makes sense to use a sphere for collision testing. Choose the Sphere option in the Collision Test section.

8. Select the Box in the OBJECT: drop-down list. The Box does not move, and thus is not assigned any effect. Moreover, the Box should remain rigid upon collision with the Sphere. In the Dynamic Controls section of the dialog box, check the box titled This Object Is Unyielding. Note that most of the other parameters in the dialog box are now grayed-out. The Collision Test section is still active, so make sure that the Box option is set here. Note that it's unnecessary to add the Sphere to the Box's collision list.

9. Press the Solve button to compute the solution, but don't check the box that displays the process. The solution should compute quickly. Now, play the animation. The Sphere should bounce convincingly.

10. Go into Track View and, as you did in the previous exercise, optimize the raw function curves in the position track by using the Reduce Keys tool. When you're done, you should have nice clean function curves, as shown in Figure 22.14.

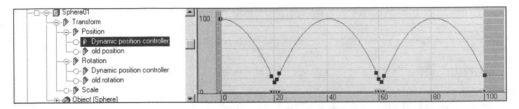

Figure 22.14
After applying the Reduce Keys tool in Track View, the function curves describe a nice, clean bounce.

Particle Systems

Water, fire, snow, and smoke are all examples of phenomena that are often best simulated by the coordinated animation of a large number of small particles. In all of these cases (and many others), the individual particles respond to common forces and thus have many of the qualities of a single object. For example, a school of fish is composed of discrete creatures, yet the school behaves largely as a single unit.

MAX particle systems are inherently animated. Particles are emitted from a source and flow in a regular path. More sophisticated control of particle behavior is possible through the use of space warps. Indeed, these phenomena are cases in which space warps make the most obvious sense, and there are a number of space warps that are especially directed at the control of particle streams.

Choosing A Particle System

There are six types of particle systems available when you choose Create|Geometry|Particle Systems:

- Spray
- Snow
- Blizzard
- PArray

- PCloud
- Super Spray

Spray and Snow are of the previous generation of MAX particle systems. Although they are part of MAX 3, they need not be learned because the newer tools are better. The parameters of Spray and Snow are extremely limited, and although these particle systems are easy to use, Super Spray and Blizzard have effectively superseded them.

The current generation of particle systems, however sophisticated, is not difficult to master, primarily because its members share most of the same parameters. You'll quickly notice that the panels for Blizzard, PArray, PCloud, and Super Spray differ only in their respective Basic Parameters and Particle Generation rollouts. The Particle Type, Rotation And Collision, Object Motion Inheritance, Bubble Motion, Particle Spawn, and Load/Save Presets rollouts are identical for all four of these particle systems. Thus, most of the skills you obtain with respect to any of these particle systems can be applied to all of them.

The four "new generation" particle systems differ in the manner in which they emit particles.

Super Spray

Super Spray is the classic particle emitter—something of a fountain. Particles are generated from a single point. Figure 22.15 shows the Super Spray icon emitting particles at default values. The stream is a single line of particles flowing in the direction of the axis indicated by the arrow.

Figure 22.15
A Super Spray particle system, using default values. The stream is a single line of particles flowing in the direction of the axis indicated by the arrow.

This spray can be spread out (fanned out) along the indicated plane, and it can be further spread out on either side of the plane to produce the standard particle fountain, as illustrated in Figure 22.16.

Figure 22.16
The Super Spray emitter from Figure 22.15 is adjusted to spread out the particle stream into the standard particle fountain.

Blizzard

The Blizzard particle emitter is simple—the emitter icon is a plane and the particles are emitted randomly from the surface, in a direction perpendicular to that surface. This is perfect for falling rain or snow. Figure 22.17 illustrates the Blizzard particle emitter.

PArray

The PArray particle system emits particles from the surface of a selected object. The emitter object can be visible or hidden. The PArray is created (as all of the other particle systems are) by drawing out an icon. The size and location of the icon are irrelevant, however. After the PArray is created, the user must pick an object to use as the emitting surface. There are a number of emission options, including emission from a set number of distinct points and emission from selected faces. Figure 22.18 illustrates emission from the entire surface of a selected sphere. The PArray icon is visible on the left.

PCloud

The PCloud particle system is a little confusing. It can be used much like the Parray system to emit particles from a volume, and it has the advantage of being able to create box, sphere, and cylindrical emitters as icon choices. The PCloud can also be used to randomly

Figure 22.17
The Blizzard particle emitter releases particles randomly from a plane icon, in a direction perpendicular to the plane.

Figure 22.18
The PArray particle system is used to emit particles from the surface of a selected sphere. The PArray icon is visible on the left.

confine particles (typically, instanced objects) inside a volume. In this use, the particles are not animated, although the icon may be animated as a means of moving all the particles together as a group. In order to keep the particles confined to the volume, the Speed parameter in the Particle Generation rollout must be kept at 0. At values greater than 0, the PCloud emits the particles.

Figure 22.19 illustrates a box-shaped PCloud, used to confine random instances of a sphere inside a volume.

Figure 22.19
The PCloud is used to confine random instances of a sphere inside a box-shaped volume. The original sphere is shown outside the volume.

Particle Generation And Rendering

The Particle Generation rollouts for each of the "new generation" particle systems differ only in minor ways. In each case, there are parameters governing Particle Quantity, Particle Motion, Particle Timing, and Particle Size. After these factors are determined, the user must determine what type of particle will render. A short exercise using the Super Spray emitter will get you oriented.

Speed And Timing

First, get control over the speed and timing of particle emission by following these steps:

1. Create a Super Spray emitter in the center of the groundplane (choose Create|Geometry|Particle Systems|Super Spray). By default, the particles are displayed as ticks. Pull the Time Slider and watch the particle stream flow in a straight line. Note that new particles cease to be emitted after Frame 30.

2. Increase the two Spread parameters in the Basic Parameters rollout to 30 degrees. Pull the slider to see a fountain effect. By default, only 10 percent of the true (renderable) number of particles is made visible in the viewport. Increase this percentage if you wish in the Basic Parameters rollout.

3. Open the Particle Generation rollout, shown in Figure 22.20. The default Use Rate option for Particle Quantity determines the rate of particle emission in particles per frame. By default, 10 new particles are emitted every second. Experiment with this spinner to get the idea, and then return to the default value.

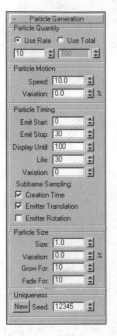

Figure 22.20
The Particle Generation rollout for the Super Spray emitter. The parameters are extremely similar to those found in Blizzard, PArray, and PCloud.

4. The Particle Timing parameters inform you that particles are being emitted between Frame 0 and 30, and that each particle has a life of 30 frames. It follows that all particles should disappear after Frame 60. Pull the Time Slider to confirm this. Particle speed is measured in units per frame. Increase the Speed parameter in the Particle Motion section to 20 and pull the Time Slider. The particles travel twice the distance over their lives.

Rendering Particles

The particles that actually render can be Standard Particles, MetaParticles, or instances of selected geometry. You can try all three on your particle stream by continuing the exercise as follows:

Figure 22.21
The Particle Type rollout for the Super Spray emitter. The default settings cause the particles to render as triangles.

5. Open the Particle Type rollout, shown in Figure 22.21 (without the Material Mapping and Source section). The default settings will render your particles as triangles, one of the Standard Particles options. Set your Time Slider to Frame 25 and adjust your perspective view to get a good view of the particle stream. Before you render, set the background color to white in the Environment dialog box. Now, render. Depending on your view, the triangles may be very small. Go back to the Particle Generation rollout and increase the Size parameter in the Particle Size section. Render again to see the difference.

6. In the Particle Type rollout, switch from the Triangle to the Facing option and render again. Notice that the particles are much denser. The Facing option creates squares that always face the camera. By texture mapping these particles and using an opacity map to create transparent edges, you can create convincing leaves and snowflakes.

7. Change your particle type to MetaParticles. MetaParticles are a species of the common metaball technology that merges adjacent objects into larger units to create organic and fluid forms. At its best, MetaParticles can produce excellent simulations of liquids and viscous fluids, but the process is extremely taxing on anything but the

most powerful systems. The Tension parameter controls the tendency of particles to blend. Set it to a low value such as .1, and render. After a little while, you get a result like Figure 22.22.

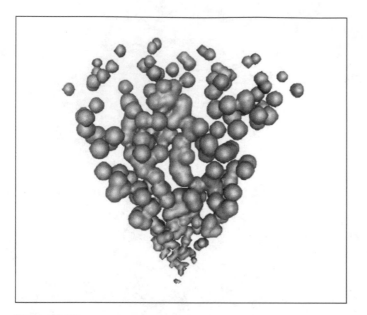

Figure 22.22
MetaParticles applied to a Super Spray particle stream. A Tension value of .1 was used to increase the blending of the particles.

8. Create a small Teapot object somewhere in your scene to be used as a particle. With the Super Spray object selected again, go to the Particle Type rollout in the Modify panel. Switch to Instanced Geometry. In the Instancing Parameters section, press the Pick Object button to activate it and then click on the Teapot in your viewport. Go back to the Particle Generation rollout and set the Size parameter to 1 if you changed it before. Now, render. You should see a fountain of teapots, as illustrated in Figure 22.23.

9. Go back to the Particle Size section of the Particle Generation rollout and set the Variation parameter to 50 percent. When you re-render, notice that the teapots are now in varying sizes.

Controlling Particle Streams With Space Warps

Space warps are ideal tools for shaping particle streams in useful ways. The following exercises explore some of the possibilities.

Wind And Gravity

Let's experiment with wind and gravity:

1. Create a Super Spray emitter on the groundplane and set its two Spread parameters to 40 degrees. This creates a simple fountain.

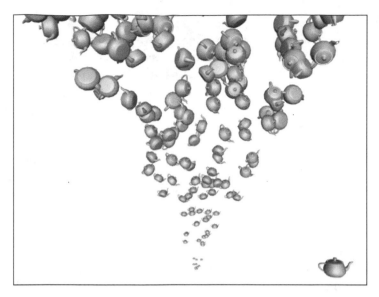

Figure 22.23
A small teapot (seen apart at bottom right) is used as instanced geometry in the Super Spray particle system.

2. Create a Wind space warp in a left view and bind it to the Super Spray. Pull the Time Slider and note that the particles are now being pulled in the direction of the Wind icon, as in Figure 22.24.

Figure 22.24
A Super Spray particle system is bound to a Wind space warp. The particle stream is being turned in the direction of the Wind arrow icon.

3. Add a Gravity space warp in a top view so that its arrow is pointing down; then, bind it to the Super Spray. Now, the particle stream is being dragged down by gravity in addition to being pushed by the wind. Play with the Force parameters for both the Wind and Gravity space warps to adjust the effect. Try adding some turbulence to the wind.

Deflecting Particle Streams

In the Create panel, you'll find a class of space warps named Particles Only (choose Create|Space Warps|Particles Only). The Deflector, SDeflector, and UDeflector space warps can be ignored because they have been replaced by the superior OmniFlect versions. These space warps deflect a particle stream off of a surface. The POmniFlect deflects off of a plane and the SOmniFlect deflects off of a sphere. These Warps can be aligned with renderable objects in the scene. The UOmniFlect uses the mesh of a renderable object directly. Continue our exercise as follows:

4. Create a POmniFlect space warp and position it so that it intersects the particle stream. Bind the POmniFlect to the Super Spray and pull the Time Slider. The particle stream will bounce off the plane.

Using A Spline Path

Let's continue our exercise by creating a spline path:

5. Delete all three of the space warps and set the two Spread parameters of your Super Spray to 5 degrees. This generates a fairly narrow vertical spray.

6. In a front view, draw a curving Bezier spline (a Line object) to direct the flow of the particles. Your screen should look something like Figure 22.25.

Figure 22.25
A spline path is drawn to shape the flow of the particle stream from a Super Spray emitter.

7. Create a Path Follow space warp (from the Particles Only group) by drawing an icon anywhere in your scene. Press the button titled Pick Shape Object and then click on your spline. Bind the warp to the Super Spray.

8. Pull the Time Slider to see how the particle stream follows the path. In the space warp's Modify panel, compare the two Particle Motion options: Along Offset Splines and Along Parallel Splines. Figure 22.26 illustrates the Along Offset Splines option.

Figure 22.26
Same as Figure 22.25, but with a Path Follow space warp added and bound to the Super Spray. The Path Follow icon is at bottom right. The spline was assigned to the Path Follow space warp, causing the particle stream to follow the spline. The Along Offset Spline option for particle motion was used in this image.

Animating With Expressions

Expressions are small units of programming code that define animatable parameters by referencing them to the other parameters or to the current time in the scene. At each frame, the expression is evaluated to produce a new value.

Most persons entering 3D graphics have little or no programming experience and readily conclude that expressions are something that they don't need to understand. This view could not be more incorrect. Anyone capable of handling the enormous technical complexities of 3D Studio MAX has the ability to write and understand simple expressions. Once you understand how powerful they can be, 3D artists quickly learn to love them.

MAX actually has two ways of producing "programmed" animation. Expressions are relatively simple and can be mastered by nearly anyone. In contrast, MAXScript is a full-strength object-oriented scripting language that can be used to write instructions of almost infinite complexity.

Every animatable parameter has both an expression controller and a script controller. Although the expression "language" is easy enough for any serious user to master, MAXScript requires considerable effort to learn and is most useful to those who are familiar with object-oriented programming languages. We'll stick to expressions here. (For more information on MAXScripts, see Chapter 2.)

Expressions For Interdependent Animation

The most important use of expressions is to create interdependent animation, in which the animation of one object or parameter automatically controls the animation of another object or parameter. The range of applications for this concept is unlimited. For example, you can write an expression that rotates the wheels of a car the correct amount for the distance that the car travels down the road. You can cause the front wheels to rotate as the steering wheel is turned. You can even create a character setup in which the hips move as the feet are moved. Expression controllers can be combined with regular keyframe controllers under a List controller, so that you can always tweak the results of the expression.

In the following exercise, you'll create a network of turning gears. As you animate the first gear, all the others will rotate along, producing a virtual machine.

Modeling The Gears

To correctly model a network of interlocking gears, you must make the number of teeth proportional to the radius of the gear. If a gear is twice as big as another, it must have twice as many teeth. The size of the teeth must be the same for all of the gears, however, or they won't mesh together properly. Follow these steps:

1. Create a Cylinder in a front view with a radius of 20 and a height of –10. Set the Height Segments to 1 and the number of Sides to 20. Convert this object to an Editable Mesh.

2. Select every other quad polygon around the rim of the object (a total of 10) and extrude these out 5 units. Then, use a slight negative bevel to slant them in. Your result should look like Figure 22.27.

3. Create a second gear in the same way, except use a radius of 30 and 30 sides. Extrude out the 15 alternate quads 5 units and bevel them as before. Position the second gear so that it meshes with the first, as shown in Figure 22.28. Do not rotate the second gear when aligning it.

4. Create a third, much smaller gear with a radius of 10 and 10 sides. Extrude out the 5 alternate teeth, and bevel as in the previous steps. Rotate this gear 90 degrees so that it's parallel to the groundplane. Then, align it carefully to mesh with the bottom of the second gear. This will almost certainly require some rotation of the gear around its own axis. When you're done, your finished gear system should look like Figure 22.29 in a perspective view.

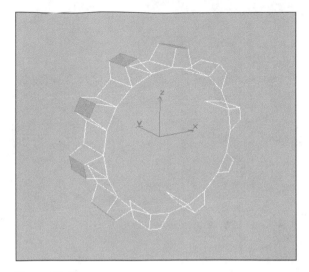

Figure 22.27
A gear with 10 teeth is modeled from a Cylinder object that has been converted to an Editable Mesh. Alternate quad polygons were selected and then extruded and slightly beveled.

Figure 22.28
A second gear is added that is 50 percent bigger than the first, with 50 percent more teeth. The second gear is positioned to mesh with the first gear.

Setting Up The Expressions

As we continue our exercise, the first gear will be animated in the conventional way, and the other two gears will be assigned expressions to cause them to rotate in coordination with the first gear:

5. The first step is to set up the rotation controller for the first gear. Open Track View and use the Filters dialog box to show your controller types. Open the tracks for the Cylinder01 object and change the rotation controller to Euler XYZ (if you have not already made this the default rotation controller).

Figure 22.29
A third, much smaller gear is added and rotated to mesh at a right angle with the second gear.

6. Open the tracks for the second gear, Cylinder02, and once again change the rotation controller to Euler XYZ. This gear will be rotating around the world y-direction, so open the Y Rotation track and change the controller from Bezier Float to Float Expression. This track will now use an expression to produce an animated value.

7. Right-click on the range bar to bring up the Expression Controller dialog box, shown in Figure 22.30. Take a good look at this panel. The expression that is evaluated at every frame is written in the Expression window. The simplest possible

Figure 22.30
The Expression Controller dialog box. The expression that is evaluated at every frame is written in the Expression window. Variables are created on the left side of the panel.

expression is just a literal value. If you typed a number in the box, it would set the y-rotation value for the object. This is not a useful approach, however. To produce an animated result, in which the value of the expression can change from frame to frame, you need to create a variable in the expression. As the value of the variable changes, the value of the expression changes accordingly.

8. The variable you need is the current y-rotation value of the first gear. As this value changes, the expression governing the y-rotation of the second gear will change as well. To create a variable, type the name "yrot" (for y-rotation) in the variable Name box. Before you press the Create button to confirm this, you must decide whether the variable is to be a vector or a scalar. A vector is a three-coordinate value; a scalar is a single number. Because the y-rotation is a single number, choose the Scalar option. If you were creating a position variable from a Bezier Position controller, which uses an (x,y,z) value, you would use the Vector option. Press the Create button to create the variable and note that its name appears in the list of scalar variables.

9. At this point, you have a named variable, but it doesn't know where to get its value. To connect it to the y-rotation value of the first gear, press the Assign To Controller button. A dialog box appears, which is like a miniature version of Track View. Open up the tracks for Cylinder01 and select its Y Rotation track. Press the OK button. When you're done, the Expression Controller dialog box will indicate that the yrot variable has been assigned to Cylinder01/Y Rotation. Take a look at Figure 22.31.

Figure 22.31
A scalar variable named yrot (for y rotation) is created and assigned to the y-rotation controller for the first gear (Cylinder01). This variable now contains the current y-rotation value of the first gear.

10. Now, you can use the variable in the expression. Type the word "yrot" in the expression window (overwrite the zero). The y-rotation value of the second gear is now determined by the y-rotation value of the first gear. Press the Close button to close the dialog box.

11. Test this by animating the first gear. Open the Y Rotation track for Cylinder01 in Track View and create two keys, one at Frame 0 and the other at Frame 100. The value of the first key should remain at 0, but change the value of the second key to 360 degrees. This causes the first gear to make one full rotation.

12. Pull the Time Slider to see the result. The first gear is rotating correctly, and the second gear is also rotating, but not correctly. For one thing, it's rotating in the same direction as the first gear when it should be rotating in the opposite direction. Second, it's rotating at the same speed as the first gear. Because the second gear is 50 percent larger than the first, it must rotate proportionately slower. Specifically, it should rotate two-thirds of a turn for every full rotation of the first gear. Open the Expression Controller dialog box and change the expression to read "-.666*yrot". Doing so tells the controller to multiply the current value of yrot by negative two-thirds. The result therefore rotates more slowly and in the opposite direction. Your dialog box should look like Figure 22.32. Close the dialog box and pull the Time Slider again. The gears now mesh correctly as they turn.

Figure 22.32
The expression for the second gear must account for the fact that the second gear is 50 percent larger than the first gear, so it rotates only two-thirds as fast. Using a negative multiplier causes the second gear to rotate in the opposite direction.

Adding The Third Gear

The third gear rotates in a different direction than the other two; otherwise, the concepts remain the same:

13. Open the tracks for Cylinder03, the third gear, and assign a Euler XYZ controller to the rotation track. This time, you want the Z Rotation track of the third gear to be controlled by the Y Rotation track of the first gear. Assign a Float Expression Controller to the Z Rotation track of Cylinder03.

14. Open the Expression Controller dialog box and create a scalar variable called yrot. Use the same name as you did previously because it's precisely the same variable—

the y-rotation value of the first gear—even though it's being used to control the z-rotation of the affected gear. Assign the variable to the Y Rotation track of Cylinder01, just as you did with the second gear.

15. Now, it's time to write the expression. If you rotate this gear around the world z-direction to position it in the first place, you'll see a peculiar number already in the Expression window (rather than just 0). This is the current angle value, but expressed in radians rather than degrees. A radian, which equals approximately 57 degrees, is a basic and useful unit of measure in trigonometry. The expression controller often uses radians instead of degrees, so you sometimes have to use one of the built-in functions on the Function List to convert from one unit of measurement to the other. Type the expression (–2*yrot)+(whatever rotation value is already present). For example, in my case, the current rotation value in the Expression window was 0.628319 radians. Therefore, my expression was (–2*yrot)+0.628319, as illustrated in Figure 22.33. This expression tells the controller to multiply the y-rotation value of the first gear by 2 (because the third gear is half the size of the first gear) and to rotate in the opposite direction. Then, the expression adds the rotational adjustment to it so the gears remain in the same alignment as in the original setup.

Figure 22.33
The expression for the third gear also uses the y-rotation value of the first gear as its primary input. The rotation amount is multiplied by 2 because the third gear is half the size of the first one. The original rotational adjustment that is required to make the gears mesh is added to the expression. This number is in radians, and it is equivalent to about 36 degrees.

16. Close the dialog box and pull the Time Slider to test the result. Everything should be working. What's great is that this is a working machine. Go back to the Y Rotation track for the first gear. Look at the function curve and edit it. Add keys and make the gear turn forward and backward. When you run the animation, all the other gears follow automatically.

Expressions Based On Time

Expressions produce animated results because the input value of a variable in the expression can change with each frame. The most important type of variable is one that tracks the current value of another animated parameter, as you saw in the previous exercise. But the current time, typically expressed as a frame number, can also be used as a variable.

In the simplest example, an object is assigned a Position Expression controller with the expression [0,0,F]. F is a built-in variable that inputs the current frame number. Using this expression, the object will move from (0,0,0) to (0,0,100) in world space as the Time Slider moves between Frame 0 and Frame 100.

Things get a lot more interesting (and useful) when trigonometric functions are involved. The expression [0,0, 100*sin(4*F)] causes the object to rise from 0 to 100 in world z, fall to –100, and return to 0—all over 90 frames. Anyone who remembers his or her high-school trigonometry will be able to figure out why. A sine function rises from 0 at 0 degrees to 1 at 90 degrees. It falls back to 0 at 180 degrees and falls further to –1 at 270, before circling back to 0 at 360 degrees. The multiplier of 4 causes the F value to increase from 0 to 360 over 90 frames. The sine value therefore follows the sine wave, multiplied by 100, over the course of the animation. The resulting function curve is illustrated in Figure 22.34.

Figure 22.34
The z position function curve for an object using the Position Expression [0,0, 100*sin(4*F)]. A sine function is applied to the current frame number, resulting in a sine wave.

Moving On

In this final chapter, you took a brief look at some of the important, but specialized, animation tools that may not be a part of your everyday work. You examined how space warps can be used to deform geometry in world space, so that the object's shape changes as its position is animated. You worked through some basic dynamic simulations to understand how MAX can create animation, based on physical forces and principles. You learned the essentials of MAX's particle systems and how space warps can be used to control the behavior of a particle stream. Finally, you learned how expressions can be used to create systems of interdependent animation, in which the animation of one object automatically controls the animation of another.

3D graphics and animation is an art and a way of life for those who love it. No book, no matter how large, can pretend to do it justice. 3D Studio MAX, in particular, is a monumental work of programming whose depths cannot be sounded after years of experience. But it is precisely this constantly receding horizon that makes 3D computer graphics so exciting. I hope I've been able to share my excitement with you.

INDEX

2D maps, 412–413
2D primitives, 140–143
2D splines, projecting on 3D objects, 273–275
3D character animation. *See also* Skin modifier.
 Bones, 610
 elasticity, 641–642
 introduction, 609–610
 modifiers, definition, 611–612
 morphing, 610–611
 muscle bulges, 611–612
 path deformation, 639–641
 skeletal deformation, 610
 space warps, definition, 611–612
 surface deformation, 639–641
3D maps, 413–415
3D primitives, 134–140

A

Acceleration, 568–569, 577
Affect Region tool, 159–160
Aligning objects, 124–126
Alignment tool, 124–126
Ambient color. *See also* Shaders.
 Ambient Color, Map channel, 382–383
 ambient color material parameter, 363–364
Ambient Color, Map channel, 382–383
Ambient color material parameter, 363–364
Ambient lighting, 373–374, 423–424, 495
Angles between objects, measuring, 127
Animate button, 548–550
Animating
 clusters, 636–639
 parent-child hierarchies. *See* Inverse kinematics.
 scale, 607
Animating position
 acceleration, 568–569, 577
 Attachment controller, 590
 Bezier Position controller, 560–576
 bouncing ball example, 571–576
 definition, 559–560

editing on the motion path, 569–571
List Position controller, 588–590
Noise Position controller, 588–590
Path controller, 576–587
Position Expression controller, 588
Position Script controller, 588
Position XYZ controller, 560–576
rattle, 588–590
speed, 584–587
spline conversion vs. path animation, 577
splines, drawing, 578–579
Surface controller, 590
trajectories, creating from splines, 566–568
trajectory keys, 569–571
vibration, 588–590
Animating position, objects
 aligning to other objects, 590
 creating, 578–579
 putting to a path, 578–579
Animating rotation
 aligning to the path, 580–584
 Euler XYZ, 595–598
 gimbal lock, 590
 overview, 590–592
 TCB Rotation controller, 592–595
Animating the human body. *See also* 3D character animation, Inverse kinematics.
 lips, 636–639
 muscle bulges, 611–612
 skeletal deformation, 610
Animating the human body, legs
 applying Skin modifier, 623–626
 bending the knee, 626–629
 building, 621–623
 MeshSmooth, 626–629
Animation. *See also* Controllers, Particle systems, Space warps.
 along a path. *See* Animating position.
 converting between controllers, 563
 coordinate systems, 57–58
 Create Key dialog box, 550–553
 definition, 537
 editing, 552–553

with expressions, 667–674
inbetweening, 538
interdependent, 667–674
key frames, 538–539
prerendered, 154
realtime, 154
rendering. *See* Rendering.
smoothing edges. *See* Anti-aliasing.
Track Bar, 550–553
turning gears, example, 667–674
Animation, keys
creating, 550–553
definition, 538
in Track View, 540–548
Animation, parameters
definition, 537
out-of-range, 555–557
Animation, ranges
child and parent, 553–555
definition, 553
Anisotropic shader, 375–376
Anti-aliasing, 474–476
Approximation, surfaces, 355–357
Arc Rotate tool, 86–87
Arms, modeling, 310–312
Array tool
circular arrays, 96–97, 103–109
one-dimensional arrays, 97–100
three-dimensional arrays, 103
two-dimensional arrays, 100–102
Arrays
circular, 96–97, 103–109
one-dimensional, 97–100
three-dimensional, 103
two-dimensional, 100–102
Aspect ratio, 466
Atmospheric effects
combustion, 510–513
explosions, 510–513
flames, 510–513
Layered Fog, 502–505
Standard Fog, 498–501
Volume Fog, 505–510
Volume Lights, 514–518
Attachment controller, 590
Attenuating lighting, 432–434

B

Background colors, 495
Background section, 495

Basket concept, 334–336
Bend modifier, 208–213
Bending, 208–213
Bevel spinner, 166–168
Beveling
boxes, 139
cylinders, 139
meshes, 164–168
Bezier patches. *See* Patch modeling.
Bezier Position controller, 560–576
Bezier splines
creating, 144–148
definition, 143
editing, 144–148
shaping, 144–148
vs. NURBS, 143–144
wineglass example, 148–151
Bias, adjusting, 232–234
Bias value, 223
Bitmap panel, 409–411
Bitmaps, saving animation as, 463–464
Bitmaps, wrapping a 3D surface
Bitmap panel, 409–411
cropping, 410
map channels, 401–405
mapping coordinates, creating, 386–388
mapping coordinates, editing, 394–397
mapping coordinates, implicit, 405–409
mapping coordinates, projecting, 389–394
mapping multiple surfaces, 397–401
offsets, 409–411
scaling, 410
texture space, 386–388
textures, layering, 401–405
tiling, 409–411
transparency, 410–411
Unwrap UVW modifier, 394–397
UVW Mapping modifier, 389–394
Blend Material, 380
Blend Surface, 341
Blended surfaces, 331–334
Blinn shader, 371–374
Blizzard particle system, 659
Block controller, 607
Blur effect, 492–493
Bodies, animating. *See* Animating the human body.
Bomb space warp, 649–650
Bones
definition, 610
deforming a mesh, 612–613
joint blending, 615

vertex weighting, 613–616
walking/stepping action, 599–607
Bones, human legs
applying Skin modifier, 623–626
bending the knee, 626–629
building, 621–623
MeshSmooth, 626–629
Boolean Compound Objects, 270–273
Boolean operations
Boolean Compound Objects, 270–273. *See also* ShapeMerge Objects.
subtraction, 264–268
union, 268–269
Bouncing ball example, 571–576
Bounding boxes, resetting, 68–72
Boxes
beveling, 139
creating, 134
Branching architecture, 331–334
Brightness and Contrast effect, 492
Brushed metal, 375–376
Bulb lights, 429
Bump, Map channel, 383–386

C

Camera tools
Field-Of-View, 451
Orbit Camera, 454
Pan, 454–456
Perspective, 451–452
Roll Camera, 452–453
Truck Camera, 453–454
Cameras
clipping planes, 449–450
converting types, 448
cutting between, 527–530
depth of field, 449–450
dollying, 450–451
field-of-view, 449
fish-eye view, 451–452
Free Cameras, 445–447
navigation, 450–456
orbiting, 454
panning, 454–456
parameters, 448–450
perspective flare, 451–452
rolling, 452–453
Target Cameras, 443–445
trucking, 453–454
viewports, 450–456

Capsule option, 139–140
Chamfer tool, 159, 181–183
ChamferBox option, 139
ChamferCyl option, 139
Circular arrays, 96–97, 103–109
Clipping planes, 449–450
Cloning objects
along a path, 109–115
circular arrays, 96–97, 103–109
definition, 93
multiple copies, 95–96
one-dimensional arrays, 97–100
renaming the new object, 94–95
single copy, 94–95
three-dimensional arrays, 103
two-dimensional arrays, 100–102
vs. copying, 93
vs. instancing, 93–94
vs. referencing, 93
Clouds. *See* Environment Effects.
Clusters, animating, 636–639
Collapse utility, 265–269
Collisions, 655–657
Color, ambient. *See also* Shaders.
Ambient Color Map channel, 382–383
ambient color material parameter, 363–364
Color Balance effect, 493
Color gradients, 89, 412–413
Colors
ambient lighting, 373–374
background, 495
diffuse. *See* Shaders.
materials, 362
specular color material parameter, 363–364
specular highlights, 371–374, 376
specular intensity. *See* Shaders.
specular intensity material parameter, 363–364
specular reflection, 362, 421–423
specular spread. *See* Shaders.
specular spread material parameter, 363–364
specularity, 362
Combustion, 510–513
Common Parameters section, 495
Composite Material, 380
Compositing, 377
Compositing video. *See* Video, editing and compositing.
Compound objects
Boolean operations, 264–273
Conform Objects, 284–286

Connect Object, 275–278
Distribution Object, 283–284
Loft Object, 255–264
Morph Object, 284–286
Scatter Object, 281–282
ShapeMerge Object, 273–275
Terrain Object, 278–280
Cones, 137–139
Conform Objects, 284–286
Conform space warp, 648
Connect Object, 275–278
Constraints, 52–53
Contrast, lighting, 431, 492
Contrast spinner, 431
Control vertices, 324
Controllers
 Attachment, 590
 Bezier Position, 560–576
 Block, 607
 definition, 559–560
 Euler XYZ, 595–598
 grouping, 588
 List Position, 588–590
 Motion panel, 565
 Noise Position, 588–590
 Path, 576–587
 Position Expression, 588
 Position Script, 588
 Position XYZ, 560–576
 Surface, 590
 TCB Rotation, 592–595
Coordinate space, 50–52
Coordinate systems
 for animation, 57–58
 creating with null objects, 76–79
 grid, 56
 local, 54–56
 parent, 56
 pick, 56
 rotation, 57–58
 scaling objects, 50–52
 screen, 53–54
 view, 53
 world, 54–56
Coplanar vertices, 295–298
Corner vertices, 295–298
Creases, preserving, 172
Create Key dialog box, 550–553
Cropping bitmaps, 410
Cross fades, 530–532

Cross-sections, 255–264
CrossSection modifier, 318–320
Culling back faces, 88–89
Curves. *See* Bezier splines, Deformation,
 MeshSmooth tool, NURBS.
Customizing the MAX 3 interface, 22–27
Cutting a recess. *See* Boolean operations,
 Collapse utility.
Cutting between views or cameras, 527–530
CV Surfaces, 341
CVs (control vertices), 324
Cylinders
 beveling, 139
 creating, 137–139
 pointed caps, 139–140
 rounded caps, 139–140

D

Decal effect, 411
Default Scanline renderer, 468–470
Deformation
 axial, 208–224
 bending, 208–213
 elasticity, 225–229
 free form, 248–250
 lattice, 248–250
 path, 639–641
 skeletal, 610
 skewing, 224
 slanting, 224
 stretching, 219–220
 surface, 639–641
 tapering, 214–219
 twisting, 220–223
Deforming
 a mesh, 612–613
 object geometry. *See* 3D character animation.
 objects along a path, 639–641
Dependencies, breaking, 336
Depth of field, camera, 449–450
Depth of Field effect, 494
Dialog boxes, creating, 34–35
Diffuse Color, Map channel, 382–383
Diffuse color material parameter, 363–364
Diffuse reflection, 421–423
Directional Light, 428–429
Displace modifier
 displacement with maps, 243–245
 displacement without maps, 239–243
Displacement, Map channel, 383–386

Displacement mapping
 definition, 237–239
 with Displace modifier, 239–245
 in Material Editor, 245–248
 with NURBS surfaces, 246–248
Display Properties, 88–89
Distance between objects, measuring, 127
Distribution Object, 283–284
Dollying a camera, 450–451
Don't Affect Children option, 75–76
Double-Sided Material, 380
Dummy objects, 76–79
Duplicating objects. *See* Cloning objects.
Dynamic simulations, 651–657

E

Edge length, maximum, 235–236
Edge level, 172–183
Edge visibility, 236–237
Edges
 chamfering, 181–183
 dividing, 173–176
 open, 235
 rounding. *See* MeshSmooth tool.
 smoothing. *See* Anti-aliasing.
 turning, 173–176
Edges Only option, 89
Edit Mesh modifier vs. Editable Mesh object, 155–157
Editable Mesh objects
 Affect Region tool, 159–160
 Bevel spinner, 166–168
 Chamfer tool, 159, 181–183
 definition, 7
 Edge level, 172–183
 Extrude spinner, 165–166
 Face Sub-Object level, 160–172
 materials, assigning to objects, 379–380
 Vertex Sub-Object level, 157–160
 vs. Edit Mesh modifier, 155–157
Editing
 animations, 552–553
 Bezier splines, 144–148
 lofts, 344–347
 on the motion path, 569–571
 NURBS curves, 339–341
 NURBS surfaces, 339–341
 subobjects, 48, 157
 toolbars, 24–25
 video. *See* Video, editing and compositing.
Elasticity, 225 229, 641–642

Elements, as selection units, 160–164
Elevations, architectural and engineering, 278–280
Environment Effects
 background colors, 495
 Background section, 495
 Common Parameters section, 495
 Environment Maps, 495–497
 Global Lighting section, 495
 light, 495
 screen projections, 495–497
Environment Effects, atmospheric effects
 combustion, 510–513
 explosions, 510–513
 flames, 510–513
 Layered Fog, 502–505
 Standard Fog, 498–501
 Volume Fog, 505–510
 Volume Lights, 514–518
Environment Maps, 495–497
Euler XYZ controller, 595–598
Explosions, 510–513
Extended primitives, 139–140
External Events, 519–520
Extrude modifier, 251–252
Extrude spinner, 165–166
Extrude Surface, 341
Extruding patches, 303–306
Extrusion, 164–168, 251–252. *See also* Loft Object.

F

Face Sub-Object level, 160–172
Face Threshold, 231–232
Faces (of objects)
 creating, 168–171
 deleting, 168–171
 detaching, 168–171
 as selection units, 160–164
Fading
 to black, 525–527
 cross fades, 530–532
Field-of-view, camera, 449
Field-Of-View tool, 451
File Output tool, 493
Film Grain effect, 493
Filter Color, Map channel, 382–383
Fire. *See* Environment Effects.
Fish-eye view, camera, 451–452
Fit Deformation tool, 263–264
Flames, 510–513
Flex modifier, 641–642

Fog effects. *See also* Environment Effects.
Layered Fog, 502–505
Standard Fog, 498–501
Volume Fog, 505–510
Forward kinematics, 598
Fountain effects, 658–659
Fractal bump mapping vs. fractal geometry, 229
Fractal geometry vs. fractal bump mapping, 229
Fractal noise, 225–229, 412–413
Frames, saving, 493
Free Cameras, 445–447
Free form deformation, 248–250
Free Form Deformation modifier, 248–250
Freezing objects, 89–90

G

Gears, animation example, 667–674
Generate Mapping Coordinates option, 134
Geometric deformation, 646–650
Geometric shapes. *See* 3D primitives.
Geometric texture, 225–229
Geospheres, 134–137
Gimbal lock, 590
Glass, 375–376
Global illumination, 421–423
Global Lighting section, 495
Glossiness, Map channel, 382–383
Glow Element, 481–489
Gravity effects, 664–666
Grid coordinate system, 56
Grids, 88, 90–92
Grouping controllers, 588
Groups
adding objects, 49
smoothing, 171–172
and temporary pivot points, 62
vs. linking, 48–49
vs. selection sets, 49

H

Heads, modeling, 183–196
Hiding objects, 89–90
Holes, cutting in surfaces, 352–355
Home grid, 90
Hotkeys. *See* Keyboard shortcuts.
Human arms, modeling, 310–312
Human bodies, animating. *See* Animating the human body.
Human heads, modeling, 183–196

Human knee, bending, 626–629
Human legs, animating
applying Skin modifier, 623–626
bending the knee, 626–629
building, 621–623
MeshSmooth, 626–629
Human torsos, modeling, 306–314, 315–320

I

Image Filter Events, 519–520
Image Input Events, 519–520
Image Layer Events, 519–520
Image Motion Blur, 473–474
Image Output Events, 519–520
Implicit mapping coordinates, 405–409
Inbetweening, 538
Inheritance, overriding, 75–76
Instances, Schematic View, 39–41
Instancing objects, 14–18, 93–94. *See also* Cloning objects.
Inverse kinematics
definition, 598–599
Relative Repeat, 607
walking/stepping action, 599–607
Isolate tool, 41
Isoparametric curves, 341

J

Joint blending, 615

K

Key frames, 538–539
Keyboard shortcuts, 128–129
Keys
creating, 550–553
definition, 538
in Track View, 540–548
Knee, bending, 626–629

L

Lathe modifier, 252–253
Lathe Surface, 341
Lattice deformation, 248–250
Legs, animating
applying Skin modifier, 623–626
bending the knee, 626–629
building, 621–623
MeshSmooth, 626–629

Lens Effects, 481–492
Level of detail, 234–235
Light Lister panel, 439–441
Light parameters, setting, 429–432
Lighting. *See also* Shadows.
 ambient, 373–374, 423–424, 495
 attenuating, 432–434
 bulb lights, 429
 contrast, 431
 diffuse reflection, 421–423
 Directional Light, 428–429
 global illumination, 421–423
 including/excluding objects, 426–428
 intensity, 432–434, 495
 luminosity. *See* Shaders.
 managing, 439–441
 Omni Light, 429
 point lights, 429
 radiosity, 423
 Reflection, Map channel, 386
 reflection maps, 416
 reflection material parameter, 364
 reflections, 377, 416. *See also* Shaders.
 refraction. *See* Refraction, Shaders.
 restricting to an area, 431–432
 self-illumination, 364, 382–383. *See also* Shaders.
 shadow maps, 436–439
 specular intensity. *See* Shaders.
 specular reflection, 362, 421–423
 specular spread. *See* Shaders.
 Spot Light, 429
 tint, 495
 Volume Lights, 514–518
Lights, creating, 429
Link button, 74–75
Link mode, 74–75
Linked XForm modifier, 638–639
Linking
 definition, 68–74
 overriding inheritance, 75–76
 vs. groups, 48–49
Lips, animating, 636–639
List Position controller, 588–590
Local coordinate system, 54–56
LOD, 234–235
Loft deformation tools, 263–264
Loft Object, 255–264
Loft Surface, 341
Lofting splines, 318–320
Lofting surfaces
 creating a loft, 342–344

 definition, 342
 editing a loft, 344–347
 relofting a surface, 347–348
Loop Events, 519–520
Low-poly modeling
 definition, 154–155
 human head example, 183–196
Luminosity. *See* Shaders.
Luminosity material parameter, 364

M

Macro Recorder, 30–32, 34
Map channels
 Ambient Color, 382–383
 Bump, 383–386
 Diffuse Color, 382–383
 Displacement, 383–386
 Filter Color, 382–383
 Glossiness, 382–383
 layering maps, 401–405
 Opacity, 382–383
 Reflection, 386
 Refraction, 386
 Self-Illumination, 382–383
 Specular Color, 382–383
 Specular Level, 382–383
Map objects, 366
Mapping coordinates
 creating, 386–388
 editing, 394–397
 implicit, 405–409
 and parametric primitives, 134
 projecting, 389–394
Mapping material parameters, 381–383
Mapping multiple surfaces, 397–401
Maps
 ray tracing, 416
 reflection, 416
 refractions, 416
Material Editor
 displacement mapping, 245–248
 Material Library, 370
 Material/Map Browser, 368–369
 materials, getting from objects, 368–370
 maximum number of materials, 368–369
 objects, 367–368
 slots, 367–368
 starting, 366–367
Material Library, 370

Material parameters
 ambient color, 363–364
 definition, 362–363
 diffuse color, 363–364
 luminosity, 364
 mapping, 381–383
 opacity, 364
 reflection, 364
 refraction, 364
 self-illumination, 364
 and shaders, 363–364
 specular color, 363–364
 specular intensity, 363–364
 specular spread, 363–364
 transparency, 364
Material type, 365–366
Material/Map Browser, 368–369
Materials. *See also* Mapping, Map(s), Procedural
 maps, Textures.
 ambient lighting, 373–374
 assigning to regions of an object, 378–380
 Blend Material, 380
 brushed metal, 375–376
 color, 362
 Composite Material, 380
 definition, 361–362
 Double-Sided Material, 380
 getting from objects, 368–370
 glass, 375–376
 layering, 380
 Matte/Shadow Material, 377
 maximum number of, 368–369
 metallic surfaces, 374
 Multi/Sub-Object Material, 378–380
 opacity, 363, 374
 Raytrace Material, 377
 reflections, 362, 377
 refractive effects, 377
 rough texture, 376
 shadows, 377
 Shellac Material, 380
 specular highlights, 371–374, 376
 specular reflection, 362
 specularity, 362
 Standard Material, 365–366, 370–371
 Top/Bottom Material, 380
 transparency, 363, 374, 377
 vs. textures, 364–365
Mattes, 377
Matte/Shadow Material, 377

MAX 3 interface
 customized, saving/loading, 26–27
 customizing, 22–26
 dialog boxes, creating, 34–35
 illustration, 22
 instances, 39–41
 introduction, 21–22
 Isolate tool, 41
 Macro Recorder, 30–32, 34
 MAXScript, 27–35
 modifiers, 39–41
 object hierarchies, 36–38
 panels, hiding/unhiding, 23
 Schematic View, 35–41
 scripting language, 27–35
 Tab panel, 22–26
MAX 3 interface, objects
 isolating, 41
 Schematic View, 36–38
MAX 3 interface, toolbar buttons
 creating, 32–34
 scripting, 28–32
MAX 3 interface, toolbars
 creating, 25–26
 editing, 24–25
 floating, 23–24
MAXScript, 27–35
Mesh modeling. *See also* Edit Mesh modifier,
 Editable Mesh object, Modifiers, NURBS surfaces,
 Patch modeling, Spline modeling.
 beveling, 164–168
 bridging meshes, 275–278
 converting parametric objects, 7
 creases, preserving, 172
 cutting a mesh, 177–181
 elements, as selection units, 160–164
 extrusion, 164–168
 modeling in halves, 200
 organic modeling, 154–155
 prerendered animation, 154
 realtime animation, 154
 selecting, 159–160
 slicing a plane, 177–181
 smoothing groups, 171–172
 smoothing meshes. *See* MeshSmooth tool,
 Optimize modifier, Polygon optimization.
 subobjects, editing, 157
 vs. NURBS, 153–154
Mesh modeling, edges
 chamfering, 181–183
 dividing, 173–176
 turning, 173–176

Mesh modeling, faces (of objects)
 creating, 168–171
 deleting, 168–171
 detaching, 168–171
 as selection units, 160–164
Mesh modeling, low-poly
 definition, 154–155
 human head example, 183–196
Mesh modeling, polygons
 creating, 168–171
 deleting, 168–171
 detaching, 168–171
 as selection units, 160–164
Mesh modeling, vertices
 chamfering, 159
 welding, 158–159, 184
Mesh tesselation, 331–334
MeshSmooth tool
 car example, 201–206
 Classic smoothing, 197–198
 definition, 196
 edges, open, 199–201
 edges, rounding, 197–198
 NURMS smoothing, 199–201
 organic smoothing, 199–201
 Quad Output, 199–201
 weights, 200–201
Metal shader, 375
Metallic surfaces, 374
Minimizing/maximizing viewports, 85
Min/Max Toggle, 85
Mirror curves, 340
Mirroring objects, 115–121
Modeling
 definition, 237
 in halves, 200
Modifier stack
 definition, 7
 multiple modifiers, 10–11
 rearranging, 11–14
 single modifier, 7–10
 transforms and, 14
Modifier-Based space warp, 644–645
Modifiers
 Bend, 208–213
 Bias value, 223
 CrossSection, 318–320
 definition, 207, 611–612
 Displace, 239–245
 Edit Mesh, 155–157
 Extrude, 251–252

 Flex, 641–642
 Free Form Deformation, 248–250
 Lathe, 252–253
 Linked XForm, 638–639
 Morpher modifier, 629–636
 Noise, 224–229
 Optimize, 231–237
 Schematic View, 39–41
 Skew, 224
 Skin modifier, 612–629
 spline-based, 250–253
 Stretch, 219–220
 Taper, 214–219
 Twist, 220–223
 Unwrap UVW, 394–397
 UVW Mapping, 389–394
 vs. space warps, 646–650
 XForm, 636–639
Morph Object, 284–286
Morpher modifier
 animating morphs, 634–635
 applying, 630–632
 definition, 629
 morph targets, 629–630, 632–633
 morphing materials, 635–636
Morphing
 Conform Objects, 284–286
 definition, 610–611
 Morph Object, 284–286
Motion blur, 470–474
Motion panel, 565
Mountainous terrain. *See* Noise modifier, NURBS
 surfaces, Patch modeling.
Multi-Layer shader, 376
Multi/Sub-Object Material, 378–380

N

Navigation, camera, 450–456
Noise
 2D maps, 412–413
 3D maps, 413–415
 fractal, 225–229
 nonfractal, 225
 surface texture, 224–229
Noise modifier, 224–229
Noise Position controller, 588–590
Nonfractal noise, 225
Non-Uniform Rational B-Splines. *See* NURBS.
Normal direction, 88
Normals, 125

Null objects, creating coordinate systems, 76–79
NURBS
 definition, 323
 materials, assigning to objects, 380
 vs. Bezier splines, 143–144
 vs. mesh modeling, 153–154
NURBS Creation Toolbox, 339–341
NURBS Curve object, 335
NURBS curves
 CV Surfaces, 341
 editing, 339–341
 isoparametric curves, 341
 Mirror curves, 340
 Offset curves, 340
 Transform curves, 340
 U Iso curves, 341
 V Iso curves, 341
NURBS modeling
 CVs (control vertices), 324
 extracting curves from surfaces, 324
 overview, 324
 trimming surfaces, 324
NURBS surface curves
 cutting holes in, 352–355
 projecting, 349–352
 trimming, 348–355
NURBS Surface object, 335
NURBS surface primitives, 341
NURBS surfaces. *See also* Mesh modeling, Patch
 modeling.
 approximation, 355–357
 basket concept, 334–336
 Blend Surface, 341
 blended surfaces, 331–334
 branching architecture, 331–334
 breaking dependencies, 336
 displacement mapping, 246–248
 editing, 339–341
 Extrude Surface, 341
 Lathe Surface, 341
 Loft Surface, 341
 lofting. *See* Lofting surfaces.
 mesh tesselation, 331–334
 object and subobject levels, 338–339
 overview, 329–331
 skinning. *See* Lofting surfaces.
NURBS surfaces, subobjects
 dependent and independent, 336–337
 finding, 339
 hiding, 339

O

Object hierarchies, Schematic View, 36–38
Object Motion Blur, 470–473
Objects
 aligning, 124–126, 590
 angles between, measuring, 127
 animating. *See* Animating, Animation.
 assigning materials to, 378–380
 compound. *See* Compound objects.
 copying. *See* Cloning objects.
 creating, 578–579
 cutting recesses in. *See* Boolean operations.
 definition, 3–4
 deforming along a path, 639–641
 distance between, measuring, 127
 duplicating. *See* Cloning objects.
 freezing, 89–90
 hiding, 89–90
 instancing, 14–18, 93–94
 intersecting. *See* Boolean operations.
 isolating, 41
 in Material Editor, 367–368
 overlapping, assembling, 268–269
 parametric. *See* Parametric primitives.
 putting to a path, 578–579
 random arrays of, 281–282
 referencing, 14–18, 93
 resizing. *See* Scaling/objects.
 rotating. *See* Rotating objects.
 Schematic View, 36–38
 selecting. *See* Selecting objects.
 semi-transparent, 89
 snapping to values, 122–124
 translating. *See* Translating objects.
 vs. subobjects, 47
Offset curves, 340
OilTank option, 139–140
Omni Light, 429
One-dimensional arrays, 97–100
Opacity, 363, 374. *See also* Shaders.
 material parameter, 364
Opacity, Map channel, 382–383
Optimize modifier, 231–237
Orbit Camera tool, 454
Orbiting a camera, 454
Oren-Nayar-Blinn shader, 376
Organic modeling, 154–155
Orthographic view, 81–84

P

Pan tool, 85, 454–456
Panels, hiding/unhiding, 23
Panning, 85
Panning a camera, 454–456
Parameters (animation)
 definition, 537
 out-of-range, 555–557
Parametric objects. *See* Parametric primitives.
Parametric primitives
 bevels, 139
 Capsule option, 139–140
 ChamferBox option, 139
 ChamferCyl option, 139
 cones, 137–139
 converting to mesh data, 7
 definition, 4–7, 133
 extended, 139–140
 Generate Mapping Coordinates option, 134
 geospheres, 134–137
 mapping coordinates, 134
 OilTank option, 139–140
 prisms, 139
 pyramids, 139
 Smooth option, 136
 smoothing, 136
 spheres, 134–137
 Spindle option, 139–140
 standard, 134–139
 3D, 134–140
 tubes, 137–139
 2D, 140–143
Parametric primitives, boxes
 beveling, 139
 creating, 134
Parametric primitives, cylinders
 beveling, 139
 creating, 137–139
 pointed caps, 139–140
 rounded caps, 139–140
Parametric splines. *See* 2D primitives.
Parent coordinate system, 56
Parenting. *See* Linking.
PArray particle system, 659
Particle effects. *See* Environment Effects,
 Particle systems.
Particle systems. *See also* Animation,
 Space warps.
 Blizzard, 659
 definition, 657

deflecting particle streams, 666–667
fountains, 658–659
gravity effects, 664–666
PArray, 659
particle generation, 661–662
particle rendering, 662–664
PCloud, 659–661
rain, 659
shaping with space warps, 664–667
snow, 659
Super Spray, 658–659
types of, 657–658
wind effects, 664–666
Patch modeling. *See also* Mesh modeling.
 adding patches, 293–295
 connecting splines, 318–320
 coplanar vertices, 295–298
 corner vertices, 295–298
 definition, 287
 extruding patches, 303–306
 human arm, 310–312
 human torso, 306–314, 315–320
 materials, assigning to objects, 380
 Quad Patch, 287–290
 spline cages, 315–320
 spline networks, 315–320
 subdividing patches, 299–303, 312–314
 Tri Patch, 291–292
 vector handles, 298
 vertices, binding to edges, 299–303
Path controller, 576–587
Path deformation, 639–641
PCloud particle system, 659–661
Perspective flare, 451–452
Perspective tool, 451–452
Perspective view, 81
Phong shader, 371–374
Pick coordinate system, 56
Pivot points
 definition, 50
 temporary, 58–62
 true, 62–66
Planes, slicing from a mesh, 177–181
Point lights, 429
Point objects, 76–79
Polygon optimization
 Bias, adjusting, 232–234
 definition, 229–230
 edge visibility, 236–237
 Face Threshold, 231–232
 level of detail, 234–235

maximum edge length, 235–236
open edges, 235
Polygonal mesh modeling. *See* Mesh modeling.
Polygons
creating, 168–171
deleting, 168–171
detaching, 168–171
as selection units, 160–164
Position Expression controller, 588
Position Script controller, 588
Position XYZ controller, 560–576
Precision tools
alignment, 124–126
protractor, 127
snaps, 122–124
tape, 127
Prerendered video sequences, 532–533
Primitives. *See* Parametric primitives.
Prisms, 139
Procedural maps. *See also* Mapping, Map(s),
Materials, Textures.
2D maps, 412–413
definition, 412
Procedural shading. *See* Procedural maps.
Procedural texture. *See* Procedural maps.
Production vs. Draft renders, 457–459
Projecting mapping coordinates, 389–394
Protractor tool, 127
Pyramids, 139

Q

Quad Patch, 287–290

R

Radiosity, 423
Rain effects, 659
Ranges
child and parent, 553–555
definition, 553
Rattle effect, 588–590
Ray Element, 491–492
Ray tracing, 416
Raytrace Material, 377
Referencing objects, 14–18, 93. *See also*
Cloning objects.
Reflection. *See also* Shaders.
material parameter, 364
Reflection, Map channel, 386

Reflection maps, 416
Reflections, 362, 377, 416
Refraction, 416. *See also* Shaders.
Refraction, Map channel, 386
Refraction maps, 416
Refraction material parameter, 364
Refractive effects, 377
Relative Repeat, 607
Renaming cloned objects, 94–95
Render Effects
Blur effect, 492–493
Brightness and Contrast effect, 492
Color Balance effect, 493
definition, 479–481
Depth of Field effect, 494
File Output tool, 493
Film Grain effect, 493
Glow Element, 481–489
Lens Effects, 481–492
Ray Element, 491–492
Ring Element, 489–491
Rendering
anti-aliasing, 474–476
Default Scanline renderer, 468–470
Image Motion Blur, 473–474
motion blur, 470–474
Object Motion Blur, 470–473
output size, 465–466
outputting to disk, 459–461
previewing results, 459–461, 476–477
Production vs. Draft, 457–459
resolution, 465–466
saving as bitmap sequence, 463–464
saving as video file, 464–465
selected regions, 466–468
Resetting
bounding boxes, 68–72
rotation, 68–72
scale, 66–68
transforms, 66–72
Resolution, rendering, 465–466
Ring Element, 489–491
Ripple space warp, 648
Roll Camera tool, 452–453
Rolling a camera, 452–453
Rotating objects, 50
Rotation
animating. *See* Animating rotation.
around an object, 86–87
and coordinate systems, 57–58

and motion blur, 470
resetting, 68–72
Rounding edges. *See* MeshSmooth tool.

S

Scale
 animating, 607
 inheritance, disabling, 76
 resetting, 66–68
Scaling
 bitmaps, 410
 objects, 50–52
Scatter Object, 281–282
Scene Events, 519–520
Schematic View, 35–41
Screen coordinate system, 53–54
Screen projections, 495–497
Scripting language, 27–35
See-Through option, 89
Selecting objects
 clicking, 45
 dragging, 45
 multiple objects, 46–47
 named selection sets, 47–48
 picking from a list, 46
 undoing a selection, 46
Selection sets vs. groups, 49
Self-illumination. *See* Shaders.
Self-Illumination, Map channel, 382–383
Self-illumination material parameter, 364
Semi-transparent objects, 89
Shaders
 Anisotropic, 375–376
 Blinn, 371–374
 and material parameters, 363–364
 Metal, 375
 Multi-Layer, 376
 Oren-Nayar-Blinn, 376
 Phong, 371–374
 Strauss, 377
Shading, procedural. *See* Procedural maps.
Shading models. *See* Shaders.
Shadow maps, 436–439
Shadows. *See also* Lighting.
 casting, 425–426
 color, 435
 edge sharpness, 436–439
 Matte/Shadow Materials, 377
 parameters for, 434–435
 ray traced, 436–439

ShapeMerge Objects, 273–275. *See also*
 Boolean Compound Objects.
Shapes
 creating. *See* Bezier splines, Extrusion, NURBS,
 Patch modeling.
 definition, 255–264
Shellac Material, 380
Shrink-wrapping surfaces, 648–649
Skeletal deformation, 610
Skew modifier, 224
Skewing, 224
Skin modifier
 adjusting envelopes, 616–620
 deforming a mesh, 612–613
 Editable Mesh cages, 620
 joint blending, 615
 vertex weighting, 613–616
Skin modifier, human legs
 applying Skin modifier, 623–626
 bending the knee, 626–629
 building, 621–623
 MeshSmooth, 626–629
Slanting, 224
Slots, Material Editor, 367–368
Smoke. *See* Environment Effects.
Smooth option, 136
Smoothing
 Classic smoothing, 197–198
 edges. *See* Anti-aliasing.
 groups, 171–172
 NURMS smoothing, 199–201
 organic smoothing, 199–201
 primitives, 136
Snapping objects to values, 122–124
Snaps tool, 122–124
Snapshot tool, 109–115
Snow effects, 659
Space warps. *See also* Animation,
 Particle systems.
 Bomb, 649–650
 collisions, 655–657
 Conform, 648
 definition, 611–612, 643–644
 dynamic simulations, 651–657
 geometric deformation, 646–650
 Modifier-Based, 644–645
 Ripple, 648
 shaping particle systems, 664–667
 shrink-wrapping surfaces, 648–649
 vs. modifiers, 646–650
 Wave, 648

Specular Color, Map channel, 382–383
Specular color material parameter, 363–364
Specular highlights, 371–374, 376
Specular intensity. *See* Shaders.
Specular intensity material parameter, 363–364
Specular Level, Map channel, 382–383
Specular reflection, 362, 421–423
Specular spread. *See* Shaders.
Specular spread material parameter, 363–364
Specularity, 362
Speed of animation, 584–587
Spheres, 134–137
Spindle option, 139–140
Spiral staircase, example, 110–115
Spline cages, 315–320
Spline conversion vs. path animation, 577
Spline modeling, definition, 153–154
Spline networks, 315–320
Spline-based modifiers, 250–253
Splines
 Bezier. *See* Bezier splines.
 definition, 133–134
 drawing, 578–579
 parametric. *See* 2D primitives.
 revolving around an axis, 252–253
Spot Light, 429
Standard Material
 definition, 370–371
 mapping, 382–383
Standard primitives, 134–139
Stepping action, 599–607
Strauss shader, 377
Stretch modifier, 219–220
Stretching, 219–220
Subdividing patches, 299–303, 312–314
Subobjects
 editing, 48, 157
 mirroring, 115–121
 vs. objects, 47
Super Spray particle system, 658–659
Surface controller, 590
Surface deformation, 639–641
Surface texture
 geometric, 225–229
 noise, 224–229
 rough, 224–229. *See also* Displacement mapping.
Surfaces, creating. *See* Bezier splines,
 Extrusion, NURBS, Patch modeling.

T

Tab panel, 22–26
Tape tool, 127
Taper modifier, 214–219
Tapering, 214–219
Target Cameras, 443–445
Target morphing, 610–611
TCB Rotation controller, 592–595
Teapot, example, 117–121
Temporary pivot points, 58–62
Terrain Object, 278–280
Tesselation, 331–334
Texture mapping, 365
Texture space, 386–388
Textures. *See also* Displacement mapping,
 Materials, Procedural maps.
 geometric, 225–229
 illusion of, 383–386
 layering, 401–405
 noise, 224–229
 rough, 224–229, 376
Texturing, definition, 237
Three-dimensional arrays, 103
Tiling bitmaps, 409–411
Toolbar buttons
 creating, 32–34
 scripting, 28–32
Toolbars
 creating, 25–26
 editing, 24–25
 floating, 23–24
Top/Bottom Material, 380
Topological maps, 278–280
Torsos, modeling, 306–314, 315–320
Track Bar, 550–553
Track View, 18
Trajectories, 89, 566–568
Trajectory keys, 569–571
Transform curves, 340
Transform tools
 constraints, 52–53
 disabling, 53
 selecting, 52–53
Transforms, resetting, 66–72
Translating objects, 50
Transparency. *See also* Shaders.
 bitmaps, 410–411
 definition, 363
 material parameter, 364

Phong and Blinn shaders, 374
refractive effects, 377
Tri Patch, 291–292
Trimming surfaces, 348–355
Truck Camera tool, 453–454
Trucking a camera, 453–454
True pivot points, 62–66
Tubes, 137–139
Turning gears, example, 667–674
Tweening, 538
Twist modifier, 220–223
Twisting, 220–223
Two-dimensional arrays, 100–102

U

U Iso curves, 341
Unlink button, 74–75
Unwrap UVW modifier, 394–397
User interface. *See* MAX 3 interface.
User view, 84
UVW Mapping modifier, 389–394

V

V Iso curves, 341
Vector handles, 298
Vertex Sub-Object level, 157–160
Vertex Ticks option, 89
Vertex weighting, 613–616
Vertices
binding to edges, 299–303
chamfering, 159
welding, 158–159, 184
Vibration effect, 588–590
Video, editing and compositing
cross fades, 530–532
cutting between views or cameras, 527–530
External Events, 519–520
fading, 525–527
fading, cross fades, 530–532
fading to black, 525–527
Image Filter Events, 519–520
Image Input Events, 519–520
Image Layer Events, 519–520
Image Output Events, 519–520
Loop Events, 519–520
prerendered sequences, 532–533
Scene Events, 519–520

Video Post Events, 519–520
Video Post panel, 520–521
Video Post Queue, definition, 519
Video Post Queue, setting up, 521–525
Video, saving animation as, 464–465
Video Post Events, 519–520
Video Post panel, 520–521
Video Post Queue, definition, 519
Video Post Queue, setting up, 521–525
View coordinate system, 53
Viewing windows. *See* Viewports.
Viewports (camera), 450–456
Viewports (MAX windows)
color gradients, 89
culling back faces, 88–89
Display Properties, 88–89
freezing objects, 89–90
grids, 88, 90–92
hiding objects, 89–90
layout options, 87–88
minimizing/maximizing, 85
navigating, 85
normal direction, 88
Orthographic, 81–84
panning, 85
Perspective, 81
rotating around an object, 86–87
semi-transparent objects, 89
switching from the keyboard, 82
trajectories, 89
User, 84
wireframe display, 89
zooming, 83, 85
Views, cutting between, 527–530
Volume Lights, 514–518
Volumetric effects, 479

W

Walking action, 599–607
Water. *See* Environment Effects.
Wave space warp, 648
Welding vertices, 158–159, 184
Wind effects, 664–666
Windows. *See* Viewports.
Wineglass example, 148–151
Wireframe display, 89
World coordinate system, 54–56

X

x, y, z directions, 50
XForm modifier, 636–639

Z

Zoom All tool, 85
Zoom Extents button, 85
Zoom tool, 85
Zooming in viewports, 83, 85

COLOPHON

From start to finish, The Coriolis Group designed *3D Studio MAX R3 In Depth* with the creative professional in mind.

The cover was produced on a Power Macintosh using QuarkXPress for layout compositing. Text imported from Microsoft Word was restyled using the Futura and Trajan font families from the Adobe font library. It was printed using four-color and spot UV coating.

Select images from the color studio were combined with new figures to form the color montage art strip, unique for each Creative Professionals book. Adobe Photoshop 5 was used in conjunction with plug-in filters to create the individual special effects.

The color studio was assembled using Adobe PageMaker 6.52 on a G3 Macintosh system. Images in TIFF format were color corrected and sized in Adobe Photoshop 5. It was printed using four-color process.

The interior layout was built in Adobe PageMaker 6.52 on a Power Macintosh. Adobe fonts used include Stone Informal for body, Avenir Black for heads, and Copperplate 31ab for chapter titles. Adobe Photoshop 5 was used to process grayscale images, lightened to accommodate for dot gain. Text originated in Microsoft Word.

Imagesetting and manufacturing were completed by Courier, Stoughton, Massachusetts.

WHAT'S ON THE CD-ROM

3D Studio MAX R3 In Depth's companion CD-ROM contains elements specifically selected to enhance the usefulness of this book, including:

- More than 250 MAX files that illustrate practical exercises from the book, covering the entire MAX 3 toolset, including the supporting image files.

System Requirements

Software

- Your operating system must be Windows NT, 95, or 98.
- You must have installed 3D Studio MAX R3.

Hardware

- An Intel Pentium III (or equivalent) processor is recommended.
- 64MB of RAM is the minimum requirement; 128MB or more is recommended.
- 3D Studio MAX R3 requires from 70MB to 300MB of hard disk storage space, depending on which options are chosen during installation.
- A 17-inch (or larger) color monitor is required. A 16-bit (high color) monitor is the minimum requirement; a 24-bit color (true color) monitor is recommended.